New
Latin
American
Cinema

Contemporary Film and Television Series

*A complete listing of the books in this series
can be found at the back of this volume.*

General Editor
PATRICIA B. ERENS
Rosary College

Advisory Editors

LUCY FISCHER
University of Pittsburgh

MIRIAM WHITE
Northwestern University

PETER LEHMAN
University of Arizona

CAREN J. DEMING
University of Arizona

ROBERT J. BURGOYNE
Wayne State University

New Latin American Cinema

Volume Two
Studies of National Cinemas

Edited by
MICHAEL T. MARTIN

 WAYNE STATE UNIVERSITY PRESS • DETROIT

Library of Congress Cataloging-in-Publication Data

New Latin American cinema / edited by Michael T. Martin.
 p. cm. — (Contemporary film and television series)
 Includes bibliographical references and index.
 Contents: v. 1. Theory, practices, and transcontinental articulations —
v. 2. Studies of national cinemas.
 ISBN 0–8143–2705–2 (alk. paper) ISBN 0–8143–2585–8 (pbk. : alk.
paper)—ISBN 0–8143–2706-0 (alk. paper) ISBN 0–8143–2586–6 (pbk. :
alk. paper)
 1. Motion pictures—Latin America—History. 2. Motion pictures—
Social aspects—Latin America. 3. Motion pictures—Political aspects—
Latin America. I. Martin, Michael T. II. Series.
 PN1993.5.L3N48 1997
 791.43'098—dc21 96–46741

About the cover illustrations: Top: After a poster done for the film *Lucía,* directed by
Humberto Solas. Middle: Victor Canifrú, *The Supreme Dream of Bolivar:* building the
New Nicaragua after the Revolution. Managua, Avenida Bolivar. Below: Carlos
Fonseca and Che Guevara (above), Sandino and Archbishop Romero (below). A detail
from the Boanerges Cerrato Collective, The Birth of the New Man. Managua, Batahola
Community Center. Courtesy of Patricia Cane. From *The Murals of Revolutionary
Nicaragua.* Courtesy of David Kunzle.

For E. Hope Anderson

. . . a petal lost to the wind.

For the native, objectivity is always directed against him.
Frantz Fanon
Les damnés de la terre, 1961

Art frequently creates a comfortable, self-sufficient world removed from action.
Edmundo Desnoes
"The Photographic Image of Underdevelopment," 1967

We understand what cinema's social function should be in Cuba in these times:
It should contribute in the most effective way possible to elevating viewer's
revolutionary consciousness and to arming them for the ideological struggle which they
have to wage against all kinds of reactionary tendencies and it should also contribute to
their enjoyment of life.
Tomás Gutiérrez Alea
The Viewer's Dialectic, 1988

Contents

Preface

The essays, interviews, and programmatic statements collected here are devoted to the study of a theorized, dynamic, and unfinished Latin American cinematic movement. In challenging the "history of cinematic representation," the New Latin American Cinema movement is at once national and continental. Its practices reverberate throughout the First World as well as other regions of the Third World. Parented by the continent's colonial experience and forged by its continuing underdevelopment and dependency, the movement has inscribed itself in Latin Americans' struggles for national and continental autonomy.

This collection is deployed in two volumes. Volume 1 addresses the formation and continental development of the New Latin American Cinema, its theoretical foundations, thematic and aesthetic concerns, and transcontinental articulations. Contributions by pioneering filmmakers foreground the programmatic writings of the movement as they theorize the practice of an aesthetically and radically alternative cinema. Volume 2 surveys the development of the New Latin American Cinema as a national project. The contents of the volumes include significant but diffusely published essays along with several new and revised essays and interviews. While these writings are varied and extensive, they cannot pretend to exhaust all the perspectives on the subject under study. To the contrary, revisionist and other perspectives will no doubt emerge as the movement's first three decades become increasingly historicized and reassessed by film scholars and critics alike.

The volumes are intended to achieve two principal objectives. First, they serve as a basic reference tool for the study of Third World cinema in general and Latin American cinema in particular; and as primary reader/texts for faculty and students in film, cultural, and Third World studies courses. As such, readers can easily avail themselves of critical writings which first appeared in journals and monographs of limited circulation.

This collection's second objective is to map and account for the movement's diversity and innovativeness in order to explicate the socio-historical and cultural contexts of its development. In so doing, the editor hopes to invite larger debates about identity, nation, and devel-

opment in Latin America. Essays in the collection should arouse read-
ers to study the cinematographic (and increasingly video) corpus of
work of this movement, its traditions and place in world cinema.

<div align="right">—M.T.M.</div>

Acknowledgments

This project has taken nearly three years to complete. For an anthology of readings this seems excessive. Identifying the numerous writings selected for the volumes, many only available in obscure film, cultural and ethnic studies periodicals and monographs, was instructive. Interminable telephone discussions punctuated by fax exchanges with authors and publishers both here in the United States and abroad rendered the experience of assembling this collection arduous at best. I have readily convinced myself that the next project I undertake will, most assuredly, not be an anthology.

However, during the development of this project I benefited, in no small measure, from the generosity and encouragement of individuals and organizations to whom I am indebted and grateful. They include my friends and comrades Lamont Yeakey, Howard Gadlin, Robert Shepard, and Leslie Damasceno; and colleagues Hamid Naficy and David Maciel. Michael Chanan, Dan Georgakas, Julianne Burton-Carvajal, Robert Stam, Randal Johnson, Paulo Antonio Paranaguá, John Hess, and Roma Gibson I thank for their generosity in granting me permission to reprint essays in this anthology.

To E. Hope Anderson and Kathryne V. Lindberg I am eternally grateful for their editorial assistance in the early drafts of the Amaral interview and the final draft of the introductory essay, respectively; to Louise Jefferson, for her translation of a section of an essay on Cuban cinema; to Timothy Barnard, for his translation and reworking of Octavio Getino's essay; and to Chuck Kleinhans and Robert Burgoyne, for their review of the prospectus and helpful suggestions for the redeployment of the contents of the anthology.

I also thank Arthur Evans, the director of the Wayne State University Press, who first suggested I had two volumes, given the scope and size of these readings. I am also indebted to my editor Kathy Wildfong, copyeditor Mary Gillis, and production manager Alice Nigoghosian of the Press for their patience and collaborative interventions during the production of these volumes.

For financial support to complete this project, I am grateful to Garrett Heberlein, Vice President for Research and Dean of the Graduate School, and to the Office of Research and Sponsored Programs at Wayne State University.

The Unfinished Social Practice of the New Latin American Cinema: Introductory Notes

Michael T. Martin

Latin America's cinematic traditions are not of recent vintage; rather, they emerged during the first half of the twentieth century, beginning in the late 1890s, when European producers exhibited films to the local bourgeoisie in Rio, Montevideo, Buenos Aires, Mexico City, and Havana, and local film production was started in Venezuela, Argentina, Brazil, Uruguay, Cuba, and Mexico.[1] While European films served as the early models for Latin American filmmakers, and European followed by Hollywood companies dominated distribution, local production, arguably innovative and culturally distinct, alternately sparse and prolific, was established in Brazil, Argentina, Mexico, Cuba, and Venezuela, among other countries, during the first several decades of this century.[2]

Until the 1960s, however, European and North American film scholars and critics largely ignored the cinematic works of filmmakers from Latin America and other regions of the Third World, or, at best, condescendingly relegated Third World cinema to the margins of film history. During the 1970s, fiction and documentary films by Third World, particularly Latin American, filmmakers were recognized at international film festivals; and through art house exhibitions in the United States and Europe, their films received critical and popular audience acclaim. Concomitantly, North American and European, along with Latin American, film scholars have generated, in recent years, a substantial corpus of criticism and research on Latin American film practices. Monographs, anthologies, and articles in specialized film journals have put this important area of study on the cultural map.[3]

The essays, interviews and declaration/manifestoes collected here
are devoted to the study of a loosely constituted, dynamic, and unfin-
ished movement of "films of a new kind." Referred to as the "New
Latin American Cinema," the movement's cultural productions and
theoretical writings have increasingly and significantly contributed to
film history and critical theory. Arising in Argentina, Brazil and Cuba
in the late 1950s and 1960s, in response to the deepening underdevel-
opment and economic and cultural dependency of the continent, the
movement has inscribed itself in Latin Americans' struggles for na-
tional and continental autonomy.

While of great theoretical and historical importance to the develop-
ment and study of world cinema, especially to Third World cinema,
the New Latin American Cinema is not a spontaneous, autonomous,
unified, and monolithic project. As one observer has pointedly noted,
its development as a cinematographic movement and oppositional so-
cial practice has been uneven temporally, formally (by cinematic
mode/genre), and spatially between Latin America's cinematic tradi-
tions.[4] And while the proponents and pioneer filmmaker/theorists, of
the New Latin American Cinema have shared aesthetic and thematic
concerns, their representational strategies are as diverse as the popula-
tion groups and hybrid cultures of Latin America. The differences that
exist among these filmmakers are apparent in the cinematic represen-
tations of culture and identity, and arguably most evident in the films
of Latin Americans who, in exile, live in the metropolises where
"postcoloniality" displaces traditional community and cultural affilia-
tions, and memory is attenuated and reconstituted.

This collection provides the setting and expanse for the considera-
tion of the New Latin American Cinema as a national and continental
project (including the diasporic/exilic experience), committed to a so-
cial practice that at once opposes capitalist and foreign domination
and affirms national and popular expression. Further, these essays
consider the movement's transcontinental articulations in the First
World and in other regions of the Third World. The period under
study begins with the formative years of the movement, the 1950s and
1960s, through developments of the 1980s; several of the essays ac-
count for developments in the 1990s. Together, the writings of film-
makers, theorists and scholars revisit the cinematic works and
practices of this movement, critically explicate the socio-historical and
cultural contexts of their production, and in doing so invite larger de-
bates about cultural and national identity, and the processes of
"development," underdevelopment and dependency in Latin America.

I

The collection is organized into two volumes: volume 1, *Theory, Practices, and Transcontinental Articulations;* and volume 2, *Studies of National Cinemas.* In part 1 of volume 1 the central question of a Latin ("Third World") American aesthetic is taken up in the major programmatic statements by Glauber Rocha, Julio García Espinosa, Jorge Sanjinés, and Fernando Solanas and Octavio Getino. By "aesthetic," I mean what Robert Stam has described as "the search for production methods and a style appropriate to the economic conditions and political circumstances of the Third World."[5] These declarations, along with other polemical writings by Fernando Birri and Tomás Gutiérrez Alea, delimit an "active cinema for an active spectator," and constitute the ideological and aesthetic foundations of the New Latin American Cinema movement.[6] These writings, notes Julianne Burton, were "written by film-makers whose theoretical propositions derive from the concrete practice of attempting to make specific films under specific historical conditions."[7]

Influenced by the Afro-Caribbean theorist, Frantz Fanon, Fernando Solanas and Octavio Getino, in "Towards a Third Cinema" (1969), call for a clandestine, subversive, "guerilla," and "unfinished," cinema that radically counteracts the hegemony of Hollywood and European capitalist production and distribution practices.[8] Solanas and Getino conceive of cinema, especially in the documentary mode, as an instrument for social analysis, political action, and social transformation.[9] In "An Esthetic of Hunger" (1965; "Estética de la violencia"), the Brazilian filmmaker, Glauber Rocha, inverts the social reality of underdevelopment and dependency—the "themes of hunger"—into a signifier of resistance and transformation where violence is the authentic and empowering expression of the oppressed; he inserts the filmmaker allied with the movement, *Cinema Novo*, in the continent's struggle against neocolonial domination.

Concerned with the development of a participatory and collective cinema, the Bolivian filmmaker, Jorge Sanjinés, in "Problems of Form and Content in Revolutionary Cinema" (1978), delineates a film practice in which the struggles of peasant communities are the thematics of a revolutionary cinema, and peasants are the protagonists in the cinematic recovery of their identity, culture and history. The fourth major polemic of the New Latin American Cinema, distinguished, in part, from the above statements by its post-revolutionary concerns, is "For an Imperfect Cinema" (1969), authored by the Cuban filmmaker Julio García Espinosa. Written ten years after the Cuban Revolution, Espinosa's essay rejects the technical perfection of Hollywood and

European cinema and calls for "an authentically revolutionary artistic culture" in which, drawing on popular art, filmmaker and (active) spectator are co-authors, and the problems and struggles of ordinary people are the raw material of an alternative and "imperfect" cinema.[10]

The issues addressed in the above declarations reverberate in "Cinema and Underdevelopment" (1962), and "For a Nationalist, Realist, Critical and Popular Cinema" (1984) by the Argentine documentarist and founder of the Documentary Film School of Santa Fe (Escuela Documental de Santa Fe), Fernando Birri. In "Some Notes on the Concept of a 'Third Cinema'" (1984), Octavio Getino provides important contextual information about the historical development of the "Cine Liberación" movement in Argentina, and in "Meditations on Imperfect Cinema . . . Fifteen Years Later" (1984), Espinosa clarifies and elaborates his premises for an imperfect cinema. And the recently deceased Cuban filmmaker Tomás Gutiérrez Alea, in "The Viewer's Dialectic" (1988), extends Espinosa's concerns about the relation of the cinema to the spectator and society in postrevolutionary Cuba to its mobilizing role in the ideological struggle against "reactionary tendencies" in socialist society, and, more importantly, to shaping the social process itself as a "guide for action" in which the spectator has an "active role."[11]

The writings in part 1 advance a conception of cinema as a transformational social practice, and, especially in the essays by Espinosa and Alea, as a conception in which the social processes that generate problems in society are revealed and indeterminate. Collectively, they feature a "notion of a cinema which incorporates in itself a discourse on its social and materials conditions of production,"[12] and in which the participants' principal task is to develop a "socially productive cinema" that, argues Alea, is "genuinely and integrally revolutionary, active, stimulating, mobilizing, and—consequently—popular."[13]

In assessing the early films and theoretical writings of the New Latin American Cinema, Ana M. López, resolves that they:

> signaled a naive belief in the camera's ability to record "truths" —to capture a national reality or essence without any mediation —as if a simple inversion of the dominant colonized culture were sufficient to negate that culture and institute a truly national one. Gradually, the kind of knowledge that the cinema was asked to invoke and produce acquired a different character. "Realism," no longer seen as tied to simple perceptual truth or to a mimetic approximation of the real, was increasingly used to refer to a self-conscious material practice. The cinema's powers of representation—its ability to reproduce the surface of the

lived world—were activated not as a record or duplication of that surface, but in order to explain it, to reveal its hidden aspects, to disclose the material matrix that determined it. This process was, furthermore, not an end in itself . . . but was articulated as part of a larger process of cultural, social, political, and economic renovation.[14]

In part 2 of this volume, four essays examine the development of the New Latin American Cinema as a national and continental movement. In a detailed analysis of the historical evolution of the New Latin American Cinema, Ana M. López is concerned with its dual development as a national and "pan-Latin American" cinematic movement. The movement's key practical concern to redefine the concepts of "nationality" and "nationhood" in cinema, and thereby create an alternative (and oppositional) national cinema, is illuminated by López's contrast of the elitism and failed efforts of the *Nueva Ola* to transform Argentine cinema in the 1960s, to the popular and enduring initiatives of the Documentary Film School of Santa Fe (see also the Birri essays in part 1). Moreover, in her analysis of the national contexts in which the New Latin American Cinema has developed, and is differentially manifest in the 1980s, López challenges those filmmakers of the movement who have declared that it no longer has "a special utility or serve[s] a social function."

Rejecting the extremes of "self-refexivity" and "materiality" for an approach that emphasizes the relation (and determinancy) of "contextual" factors to the film text and its interpretation, Julianne Burton draws on Western critical traditions in order to examine the New Latin American Cinema's efforts to transform, under diverse social conditions, the modes of "filmic production" and reception/exhibition, during the first twenty-five years of the movement's development.She concludes that "Latin American filmmakers' attempts to create a revolutionary cinema took as their point of departure not simply the introduction of a new content or the transformation of cinematic forms, but the transformation of the subjective conditions of film production and film viewing."

The two essays that follow are by Michael Chanan. In the first essay, Chanan takes up the key problem of cultural imperialism under global capitalism in Latin America. Tracking the North American distributors' domination of the Latin American film market, he shows how they have historically impeded local production. And conversely, he examines the counter-hegemonic efforts of several Latin American states (Brazil and Cuba), in the contemporary period, to protect their national film industries from United States transnational corporations.

In the second essay, Chanan emphasizes like Burton, contextual factors—"cultural context" and "intentionality." He is concerned with the central position and paradigmatic role of the documentary form in the New Latin American Cinema. In the context of postrevolutionary Cuba, he examines two categories of documentary—*cine didáctico* and *cine testimonio*—in a typology that conveys "the preoccupations and objectives of the New Latin American Cinema movement," and he concludes by noting that what distinguishes oppositional from Hollywood studio and European commercial cinemas is its redeployment and positioning of the spectator and filmmaker in the social process.

Part 3 of volume 1 is devoted to the articulations of the New Latin American Cinema in the First World and in other regions of the Third World, of which Latin America is a part, and to its theoretical elaboration and cultural specificity among oppositional cinemas. However Third World cinema is distinguished by national, gender, linguistic, racial and ethnic categories, among others, it shares three fundamental and dislocating factors: (1) the dual impact of the colonial and neocolonial (underdevelopment/dependency) historical and contemporary processes; (2) the enduring presence and defining influence of Western culture; and (3) the determinancy of capitalist production and distribution practices.[15]

In a recent study, Ella Shohat and Robert Stam offer four tentative criteria of Third World cinema:

> 1. A core circle of "Third Worldist" films produced by and for Third World people (no matter where those people happen to be) and adhering to the principles of "Third Cinema";
> 2. a wider circle of the cinematic productions of Third World peoples . . . , whether or not the films adhere to the principles of Third Cinema and irrespective of the period of their making;
> 3. another circle consisting of films made by First or Second World people in support of Third World peoples and adhering to the principles of Third Cinema;
> 4. a final circle, somewhat anomalous in status, at once "inside" and "outside," comprising recent diasporic hybrid films . . . , which both build on and interrogate the conventions of "Third Cinema."[16]

Three of the four categories (1, 3 and 4) predicate Third World cinema as political and historical categories, while in one (2), the geographical site of film production is the identifying characteristic. In defining Third World cinema as a political and transcontinental project, Clyde Taylor asserts that:

Films become Third World, in short, by their function, once made, "by their usefulness for the people," as Fidel Castro said, "by what they contribute to man [and women], by what they contribute to the liberation and happiness of man [and women]."

Yet even though the Third World is a mental state for which no one holds an official passpost, it would be wrong to emphasize Third World cinema's local and national preoccupations at the expense of its resolute internationalism. The making of *0 Povo Organizado* in Mozambique by Bob Van Lierop, an African American, or of *Sambizanga* (1972), about Angola, by Guadaloupian Sara Maldoror, or the Ethiopian Haile Gerima's *Bush Mama* (1975), set in Los Angeles, or Gillo Pontecorvo's *The Battle of Algiers* (1965), or the several Latin American and African films created by Cubans, or the many Third World films made by Europeans and white Americans—all suggest the cross-fertilization of an embryonic transnational Third World cinema movement.[17]

Paul Willemen's essay elaborates the "Third Cinema," concept described by Taylor, Shohat and Stam in the broader context of the debates about Left cultural theory in the 1980s. The essay, derived, in part, from the deliberations of a conference hosted by the Edinburgh International Film Festival in 1986, critically explicates the evolution of the concept of Third Cinema from the classic Latin American texts to its reformulation, as a "programme for the political practice of cinema," by Teshome Gabriel and others.[18] Willemen links the cultural theories of Bertolt Brecht and Walter Benjamin to the Latin American texts, and calls for the deployment of Bakhtinian concepts to elaborate Third Cinema's challenge to Euro-American critical theory, and contribution to the achievement of "socialist ideals."

Willemen's essay is followed by the "Resolutions of the Third World Film-Makers Meeting," a declaration made at an international conference of Third World filmmakers held in Algiers in 1973. This document remains seminal to the study and production of Third World cinema. Among the Latin American filmmakers at the conference were Fernando Birri, Humberto Rios, Santiago Alvarez, Jorge Silva, and Manuel Perez. The resolutions of the three committees formed at the conference catalog the major challenges to filmmakers in the production and distribution of Third World films, and they detail the role of and locate the filmmaker in the Third World's struggles against neocolonialism and imperialism. The Resolutions, perhaps overly ambitious, constitutes a tricontinental organizing effort during the 1970s to establish alternative and counter-hegemonic production/co-production and distribution venues for filmmakers in the Third World.

The final essay in part 3 is by Antonio Skármeta. In assessing the state of Chilean cinema in exile, Skármeta examines the supportive though problematic role of Europe in the production and exhibition of Latin American cinema. He asserts that in the aftermath of the 1973 coup against the Popular Unity Government of Salvador Allende, the Chilean filmmakers forced into exile became the motivating force in the development of Chilean cinema by gaining access "to a proper film industry" in Europe. Thus, Skármeta argues for the recognition of Europe as a site for the articulation of the New Latin American Cinema, and calls for the creation and deployment of "a distribution network of South American [and more generally Third World] cinema on a Pan-European level," in "permanent" sites of exhibition in defense of the cultures and democratic struggles they represent.

Part 4 concludes the volume with essays by B. Ruby Rich and Zuzana M. Pick. Though these essays overlap in their accounts of the formative development of the New Latin American Cinema, they address, from widely different approaches, the issues of the movement's adaptability, renovation, and identity addressed in Ana López's essay (see part 2). Rich argues for a revisionist history of the New Latin American Cinema in which spatial and temporal specificities are distinguished in the study of the movement. In discussing the evolution from "exteriority" in the 1960s, where political engagement/action against events is the central motif and *raison d' tre* of the New Latin American Cinema, to "interiority" in the 1980s, where "private life . . . is assigned priority . . . [and] the emotions demand as much commitment, engagement, and action, as events did a few decades earlier," and identity, personal agency, and sexuality are foregrounded, Rich examines the films, representative of this shift, of Zuzana Amaral, Tizuka Yamasaki, Maria Bemberg, Paul Leduc, Jorge Toledo, and ironically, Fernando Solanas. And Pick discusses the idea of a "continental identity," embodied in the New Latin American Cinema, as a challenge to and critique of the notions of "progress" and "development," and as a project of recovery and "self-definition" in the Latin American imaginary.

II

Whereas volume 1 focuses on the continental development of the New Latin American Cinema, volume 2 comprises a comparative approach to national cinema in Latin America. Any discussion of national cinema, however, must of necessity consider the ambiguous categories of "culture" and "identity," and the socio-historical factors that determine a national cinema's development.

Since the fifteenth century, in the ubiquitous, though uneven, development of capitalism as a global system in which international migration and settlement are a part, distinct multi-racial and multi-cultural formations have been forged, especially but not only in the Third World.[19] "Mixed" formations precede colonialism. In Latin America, though, they were reconfigured and racialized in the colonial process. However tentative and problematic the category, race is a defining, though historically contingent, feature in Latin America in that it is inscribed in a historical process as a social fact.

Mixed racial/cultural formations are most evident in megalopolises of the Third World, where population groups converge and cohabitate. A country like Brazil is exemplary; it is perhaps the most mixed and "hybrid" of nation-states in the world. Robert Stam and Ismail Xavier maintain, in their essay in part 2 of this volume, that "apart from the question of class, there are many 'Brazils'—urban and rural, male and female, indigenous, black, immigrant, and so forth. The view of the nation as a unitary subject has the effect of muffling the 'polyphony' of social and ethnic voices characteristic of a heteroglot culture."

The development of these "mixed" formations, where race, gender, ethnicity, and class intersect, pose complex questions about the premises upon which the concepts of "identity" and "culture" are based and understood.[20] Correspondingly, the concept of the "national" is increasingly unstable, especially given the processes of "globalization" and an inclusive and homogenizing international media environment. What constitutes a national identity and what are a nation's "extra-national" boundaries, and how they reshape national cultures, transform and create "new" identities are the subjects of renewed and critical study that challenge the normative assumptions on which these categories traditionally rest.[21] In this context, Zuzana Pick points out in her essay in volume 1, that "The experience of exile . . . has been crucial to the production of a new political agency whereby community associations are relocated, cultural specificity is renegotiated, and cultural affiliations are reconstructed. Geographic and cultural displacement has fostered decentered views on identity and nationality, stressed the dialectics of historical and personal circumstance, and validated autobiography as a reflective site."

However we interpret the above concepts, Paul Willemen contends, "The issue of national-cultural identity arises only in response to a challenge posed by the other, so that any discourse of national-cultural identity is always and from the outset oppositional, although not necessarily conducive to progressive positions" (see volume 1).

In counterpoint to the traditional discourses of identity, Shohat and Stam have theorized a dynamic model—"polycentric multicultural-

ism"—that conceives of "identity" as a multilayered and transnational concept.

> It thinks and imagines "from the margins," seeing minoritarian communities not as "interest groups"to be "added on" to a preexisting nucleus but rather as active, generative participants at the very core of a shared, conflictual history. . . . [It] rejects a unified, fixed, and essentialist concept of identities (or communities) as consolidated sets of practices, meanings, and experiences. Rather, it sees identities as multiple, unstable, historically situated, the products of ongoing differentiation and polymorphous identification. . . . [It] goes beyond narrow definitions of identity politics, opening the way for informed affiliation on the basis of shared social desires and identifications. . . . [It] is reciprocal, dialogical; it sees all acts of verbal or cultural exchange as taking place not between discrete bounded individuals or cultures but rather between permeable, changing individuals and communities.[22]

Useful, too, are the authors' formulation of nationality ". . . as partly discursive in nature, [that] must take class, gender, and sexuality into account, must allow for racial difference and cultural heterogeneity, and must be dynamic, seeing 'the nation' as an evolving, imaginary construct rather than an originary essence."[23] Their critical reworking and redeployment of the concepts of identity and nationality, in contrast to racialist/nationalist discourses, is relevant to the study of the cultural-historical development of Latin America, and to the analysis of the thematics and representational strategies of the New Latin American Cinema. Their model also intersects and frames, within broader historical and cultural categories, the more recent writings in cultural criticism about black identities and diasporic culture(s).[24]

The relationship between cinema and nationhood is also a problematic and contested issue, especially among filmmakers in the Third World. What consitutes a "national cinema," in consideration of the continuing underdevelopment and dependency of the Third World and the international processes of globalization under "late" capitalism, is of ideological importance to the practices of Third World filmmakers in general, and to the New Latin American Cinema movement in particular. Ana López (see volume 1) elaborates this important aspect and objective of the movement:

> The New Latin American Cinema fits in with national cinema projects because the issue of how to define, construct, and popularize national cinemas has always been one of its primary con-

cerns. Although it has not always been discussed as such, the New Latin American Cinema posits the cinema as a response to and an activator of a different kind of nationhood or subject position of nationality than the one sponsored by dominant cultural forces. The goal has been to develop through the cinema (and other cultural practices) a different kind of national and hemispheric consciousness by systematically attempting to transform the function of the national cinema in society and the place of the spectator in the national cinema.

Roy Armes has distinguished two categories of national cinema: one that is commercial and financed by local capital that performs a largely entertainment function for local audiences, and the other that addresses "the demands of a national culture."[25] Paul Willemen, in a recent and critical review of Manthia Diawara's book on African cinema, claims that: "A 'national' cinema is a cinema that addresses—directly or indirectly, and regardless of who pays the bills—the specific sociohistorical configurations obtaining within nation states. This means that a national cinema must be able to engage with cultural and historical specificities."[26] And Andrew Higson distinguishes between two variants of national cinema:

> First, there is the possibility of defining national cinema in economic terms, establishing a conceptual correspondence between the terms "national cinema" and "the domestic film industry," and therefore being concerned with such questions as: where are these films made, and by whom? Who owns and controls the industrial infrastructures, the production companies, the distributors and the exhibition circuits? Second, there is the possibility of a text-based approach to national cinema. Here the key questions become: what are these films about? Do they share a common style or world view? To what extent are they engaged in "exploring, questioning and constructing a notion of nationhood in the films themselves and in the consciousness of the viewer"?[27]

Together, these analytical descriptions of "national cinema" imply that its defining characteristic is the cultural and historical specificities of the nation from which it emerges and develops. Moreover, Armes and Willemen concur that a national cinema can be partly constituted by a commercial sector, while all three authors seem to agree that a national cinema, to be national, must perform an important social (and transformational) function in society. In, arguably, its most revolution-

ary, transparent and popular form, a national cinema, to quote Roy
Armes:

> . . . can be summarized in terms of the four general principles
> underlying the formation of the Salvadorean Film Institute: to
> respond to the interests of the working class and peasants by
> providing them with a cinematic instrument of expression; to
> produce films that will publicize the people's struggle; to con-
> tribute to raising the level of political awareness of both the
> masses and the peoples and governments of the world concern-
> ing the struggle; to combat disinformation and to contribute to
> the reordering of the international information network. Always,
> the aim is to forge new bonds between filmmakers and the peo-
> ple—the filmmakers then become one with the people, and the
> people become the true authors of their own national cinema.[28]

The essays, declarations, and interviews in this volume are differ-
entiated and grouped by nation in the two regions under study—the
Middle/Central America/Caribbean basin and South America. Because
this approach encompasses the specificities of time and space, it facili-
tates the comparative study of the development of the New Latin
American Cinema in the context of larger cultural and political proc-
esses within a national framework. This method of organization also
invites comparisons between the movement's development in pre/rev-
olutionary capitalist and postrevolutionary socialist nation-states in
Latin America. In part 1, the national cinemas of Mexico and Cuba
are studied, along with the emergent (national) cinemas of Nicaragua
and El Salvador, followed by an essay on the film practices of Puerto
Rican women video/filmmakers. Part 2 consists of essays on the na-
tional cinemas of Brazil, Chile, Argentina, and Bolivia, Peru, and Ec-
uador (the last three countries are grouped together and discussed in
one essay).

As was noted earlier, and as the essays in this volume substantiate,
cinematic traditions have not developed autonomously, spontaneously
or evenly in Latin America (nor in other regions of the Third World).
Similarly, the representation of national cinemas in the volume is un-
even. Brazil, Argentina, Cuba, and Chile are given prominence be-
cause of their importance to the formation and development of the
New Latin American Cinema. Mexican cinema, because of the state's
near total control of film production, has tended to serve state policy
rather than aesthetic programs. The essays extend my comments about
the historical importance of "nationalism" in the development of the
movement, the cultural and political effects of exile on the filmmaker,

how co-productions financed abroad influence filmmaking, and other current issues.[29]

I conclude with a quote from Julianne Burton who, in assessing the first twenty-five years of the movement, writes that: "the most compelling and significant aspect of the New Latin American Cinema movement, as it has evolved over the past quarter-century, has not been merely its ability to give expression to new forms and new contents, but above all its capacity to create alternative modes of production, consumption, and reception—ranging from the only apparently atavistic recourse, to artisanal modes, to the anticipation of more socialized industrial ones."[30]

Given the widening inequality and poverty in the continent, can we anticipate that Latin American filmmakers will return to or approximate the cine "denuncia," "testimonio," and "didáctico" models of political cinema prominent in the 1960s to oppose the persistence of underdevelopment and dependency in the post-Cold War 1990s?

Notes

1. See Roy Armes's critical study, *Third World Film Making and the West* (Berkeley: University of California Press, 1987), 163–173.

2. Along with Armes's study cited in note 1, see Allen L. Woll, *The Latin Image in American Film* (Los Angeles: UCLA Latin American Center Publications, 1977), 76–83; *Brazilian Cinema*, ed. Randal Johnson and Robert Stam (East Brunswick, NJ: Associated University Presses, 1982), 17–30; John King, *Magical Reels: A History of Cinema in Latin America* (New York: Verso, 1990), 7–64; and Jorge A. Schnitman, *Film Industries in Latin America* (Norwood, NJ: Ablex, 1984), 11–34, 49–54, 77–83, 91–95.

3. See the select bibliography of this volume for readings about Latin America's film practices and traditions.

4. See Armes, *Third World Film Making and the West*, 173–187.

5. Robert Stam, "Third World Cinema," *College Course Files*, monograph no. 5, ed. Patricia Erens (University Film and Video Association, n.d.).

6. These writings in translation are better known to and more widely circulated among readers. Many other essays and manifestoes by Latin Americans that are part of the New Latin American Cinema's corpus of critical writings are largely unpublished in English. Among them are: *Sobre Raymundo Gleyzer. Declaración del Comité de Cineastas* (Comité de Cineastas de América Latina); *Síntesis argumental de los films del Grupo Ukamau; Manifesto por um cinema popular* (Nelson Pereira dos Santos); *Cine e imaginación política* (Leon Hirszman); *Diez años de cine nacional* (Geraldo Sarno, Carlos Diegues, Arnaldo Jabor, Joaquim Pedro de Andrade); *Cine e imaginación poética* (Ruy Guerra); *El nuevo cine colombiano* (Ciro Duran, Mario Mitriotti, Carlos Alvarez, Jorge Silva, Luis Alfredo Sanchez, Marta Rodriguez); *Lo desmesurado, el espacio real del sueño americano* (Miguel Littín); *Una*

Cinemateca para el Tercer Mundo(Eduardo Terra); *Primer Conqreso Latinoamericano de Cineístas Independientes promovido por el Sodre a través de su departamento de Cine-Arte; Constitución del Comité de Cineastas de América Latina; Resolución de la Federación Panafricana de Cineastas y el Comité de Cineastas de América Latina;* and *Acto fundacional y estatutos de la Fundación del Nuevo Cine Latinoamericano,* among others. For a publication that includes the above writings and others in Spanish, see *Hojas D Cine: Testimonios y Documentos del Nuevo Cine Latinoamericano* (Mexico: Consejo Nacional de Recursos, Universidad Autonoma de Puebla, 1986).

7. Julianne Burton, "Marginal Cinemas and Mainstream Critical Theory," *Screen* 26, no. 3–4 (1985): 4.

8. Solanas and Getino distinguish between European commercial and European auteur cinemas. The latter, "art cinema," is viewed by the authors as preferable to the Hollywood and European film industries, but it, too, is determined by commercial interests.

9. See Peter Rist's essay, "The Documentary Impulse and Third Cinema Theory in Latin America: An Introduction," *CineAction,* no. 18 (1989): 60–61.

10. For a discussion of this important essay, see Armes, *Third World Film Making and the West,* 97–99.

11. See Julia Lesage's Prologue to Tomás Gutiérrez Alea's *The Viewer's Dialectic* (Havana: José Martí Publishing House, 1988), 11–16.

12. Rist, "The Documentary Impulse," 61.

13. Alea, *The Viewer's Dialectic,* 18.

14. Ana M. López, "At the Limits of Documentary: Hypertextual Transformation and the New Latin American Cinema," *The Social Documentary in Latin America,* ed. Julianne Burton (Pittsburgh: University of Pittsburgh Press, 1990), 407–8.

15. For a detailed explanation of these factors, see Armes, *Third World Film Making and the West,* 9–49.

16. Ella Shohat and Robert Stam, *Unthinking Eurocentrism: Multiculturalism and the Media* (New York: Routledge, 1994), 28.

17. Clyde Taylor, "Third World Cinema: One Struggle, Many Forms," *Jump Cut: Hollywood, Politics and Counter Cinema,* ed. Peter Steven (New York: Praeger, 1985), 332–33.

18. For example, see Willemen's and Gabriel's essays in *Questions of Third Cinema,* ed. Jim Pines and Paul Willemen (London: BFI, 1989).

19. Mixed formations are also manifest in First World states, where Third World people are defined as "minorities" though they may be among the numerical "majorities" in the Third World. For example, the racial and ethnic formations that have evolved in Europe were forged largely by Third World immigrants who have historically served as a source of cheap labor in European metropolises in the post World War II period.

20. Group identities—racial, ethnic, or religious—are rendered most fluid and tentative in metropolitan sites and in the urbanized areas of the Third

World, especially among elite and intellectual strata, where traditional culture and group associations are most problematic.

21. On the question of what constitutes a national identity, see the recent work of Gregory Jusdanis, "Beyond National Culture?," *boundary 2* 22, no. 1 (1995): 23–60.

22. Shohat and Stam, *Unthinking Eurocentrism*, 48–49.

23. Ibid., 286.

24. See, for example, Stuart Hall, "What Is This 'Black' in Black Popular Culture?," *Social Justice* 20, nos. 1–2 (1993): 104–14; and Paul Gilroy, *The Black Atlantic: Modernity and Double Consciousness* (Cambridge: Harvard University Press, 1993).

25. See Armes, *Third World Film Making and the West*, 65–72.

26. Paul Willemen, "The Making of an African Cinema," *Transition*, no. 58 (1992): 146.

27. Andrew Higson, "The Concept of National Cinema," *Screen* 30, no. 4 (1989): 36.

28. Armes, *Third World Film Making and the West*, 187.

29. Published research on exile includes: Zuzana M. Pick, *The New Latin American Cinema: A Continental Project* (Austin: University of Texas, 1993), 157–161; Kathleen Newman, "National Cinema after Globalization: Fernando Solanas's *Sur* and the Exiled Nation," in *Mediating Two Worlds*, ed. John King, Ana M. López, and Manuel Alvarado (London: BFI, 1993), 242–57; Abid Med Hondo, "The Cinema of Exile," in *Film & Politics in the Third World*, ed. John D. H. Downing (New York: Autonomedia, 1987), 70–76.

30. This quote is taken from the abstract of Burton's essay in volume 1, n.p.

Part I
Middle/Central America and the Caribbean

Mexico

Mexican Cinema

Decline, Renovation, and the Return of Commercialism, 1960–1980

Carl J. Mora

In 1958 Adolfo López Mateos was designated the PRI (Partido Revolucionario Institucional) candidate for president. During his administration (1958–1964), the film industry was to enter upon its darkest days. The new director of the Banco Cinematográfico, Federico Heuer, in an assessment of the film industry and the Banco's role in it, declared that "had the Banco . . . not existed, the result would have been that all Mexican cinematic production would have fallen into the hands of foreign investors."[1] Although many thought that the Banco's main purpose was to sustain a group of well-connected Mexican capitalists rather than to keep out foreigners from the film industry, it can be argued with equal force that growing state intervention had indeed preserved the industry, even if precariously, and prevented Hollywood producers and distributors from monopolizing filmmaking and exhibition in Mexico and the rest of Latin America. But producers of nonexistent social vision in combination with nervously conservative officials were to render the film industry almost totally unreflective of the problems and tensions of Mexican society. The industry lost its most significant international voice when Luis Buñuel began making more of his pictures outside of the country, mostly in France. Others, like Galindo, were reduced to turning out stock melodramas. Fernández was eventually boycotted by the producers and he lashed out bitterly at the industry, at one point claiming that it was run by Jews.[2] All in all, the outlook for the 1960s was anything but bright.

Carl J. Mora, *Mexican Cinema: Reflections of a Society, 1896–1988.* Berkeley, CA: University of California Press, 1982, pp. 101–41. By permission of the publisher.

Under the administrations of López Mateos and Gustavo Díaz Or-
daz (1964–1970), Mexico's contradictions reached unprecedented pro-
portions. On the one hand, the continuing developmentalist policies
resulted in impressive and continuous economic growth; on the other,
this growth was made possible by protectionist measures that re-
warded a small class of capitalists and entrepreneurs as well as offi-
cials of state enterprises. The result was a small and slowly expanding
middle class concentrated largely in Mexico City but also to be found
in other industrial urban centers like Querétaro, Guadalajara, Puebla,
and Monterrey, and a huge unemployed and underemployed popula-
tion that flocked to these and other centers in search of scarce jobs.
Driven by want from their unproductive land and unable to find em-
ployment on vast, irrigated mechanized farms in the north, millions of
these people found that the sophisticated, automated industrial tech-
nology of the cities could only absorb a small percentage of the job-
less rural and urban population. Many of them gravitated to the
northern border towns and thence into the United States, as Galindo
had already dramatized in *Espaldas mojadas.*[3]

Yet these massive population movements and dislocations and the
resultant societal tensions were largely ignored by the film industry
which adhered more tenaciously than ever to its timeworn formula
movies. Rising costs and collapsing foreign markets made the produc-
ers respond to the crisis in simple economic terms. Thus in a memo-
randum to the Secretary of Gobernación, the Dirección General de
Cinematografía, and the STPC [Sindicato de Trabajadores de la Prod-
ucción] on August 17, 1962, the Asociación de Productores de-
nounced the STPC's call for nationalization of the movie industry as a
"magic formula to solve any and all problems." The statement went
on to say that all that was needed was to cut the artificially high prod-
uction costs (which were the fault of the STPC) and to maintain and
increase the pace of production.[4] The government had previously
stated its position, asserting that the "solution did not focus on resolv-
ing the problems of the industry, but rather of the producers. . . . We
cannot aspire to improve the returns on Mexican films either in the
domestic or foreign markets as long as their quality is not improved."[5]

The producers responded to this crisis by increasing production at
the América studios which were staffed by STIC personnel and where
costs were considerably lower. The films turned out there were osten-
sibly serials designed for television; however, their marketability on
that medium was so restricted that the producers turned to combining
the separate serials into one or more full-length features that were re-
leased to neighborhood theaters. One of these, which spawned a
never-ending series that continues to the present day, was *Santo con-*

TABLE 1
Mexican Film Production, 1958–1963

YEAR	"REGULAR" (STPC)	SERIALS (STIC)	COPRODS	INDPNT	TOTAL
1958[a]	116	16	6	—	138
1959[b]	84	21	8	—	113
1960[c]	90	22	1	1	114
1961[d]	48	14	6	3	71
1962[e]	56	24	1	1	82
1963[f]	41	30	10	—	81

SOURCE: [a]*Historia* 7:8; [b]Ibid., p. 201; [c]Ibid., p. 325; [d]Ibid. 8:8;
[e]Ibid., pp. 210–346; [f]Ibid., p. 348

tra el cerebro diabólico (Santo versus the Diabolic Brain) (1961) (El Santo was a popular wrestler); it made 125,000 pesos at its premiere in spite of its atrocious quality.[6]

Another gambit of the producers to avoid high costs was to film outside of Mexico where expenses were lower. An additional advantage of foreign filming was that by using those locales and local actors, the movies thus produced might recoup the evanescing Latin American markets. Two examples of these coproductions were *Rumbo a Brasilia (En route to Brasilia)* (1960) and *Los expatriados (The Expatriates)* (1963). In the former, a Mexican engineer (Antonio Aguilar), who is assisting in the construction of the highway to the new Brazilian capital, becomes romantically involved with a Brazilian girl (Angela María da Cunha). Together they help Paulo (Antonio Carlos Pereira), a young black boy, attain his objective of seeing the president to ask for help for his flood-devastated village.[7] *Los expatriados* was made in Puerto Rico and starred Luis Aguilar and Mapy Cortés, the veteran Puerto Rican–born actress. The film related the trials and tribulations of young Puerto Ricans who emigrated to New York. Obviously inspired by *West Side Story*, it transmitted its message by means of a plenitude of musical numbers.[8]

Mexican filmmakers ranged widely in the effort to find a profitable coproduction formula—they went to Puerto Rico, Colombia, Ecuador, Guatemala, and Venezuela. But such peripatetic recourses could not reverse the painfully clear trend: the markets for Mexican movies in Latin America and the United States were disintegrating. Economic and political problems in the various countries, stricter currency controls, and a general rejection by the publics of the steadily worsening Mexican product took their toll and the results can be seen in table 1.

The revolution in Cuba had eliminated that formerly important market since Fidel Castro's blueprint for a new society hardly in-

cluded run-of-the-mill Mexican films. However, the new leaders of Cuba well realized the educational and political value of motion pictures and purposefully set out to create a new cinema that shortly would be eliciting the world's plaudits. Interestingly, one of the first efforts of this new Cuban cinema followed in the footsteps of the traditional coproduction relationship with Mexico: this was *Cuba baila (Cuba Dances)* (1959), a joint effort between the newly formed ICAIC (Instituto Cubano de Artes e Industria Cinematográficas) and Miguel Barbachano Ponce, producer of *Raíces*.[9] A member of Barbachano Ponce's team, José Miguel (Jomí) García Ascot, unable to breach the STPC's Directors' Guild which as always remained shut tight to new talent, returned to Cuba to work on *Cuba 58*, a full-length feature in three segments. García Ascot directed two of them: "Un día de trabajo" and "Los novios."[10]

Jomí García Ascot was a member of the "Nuevo Cine" group, an assemblage of young, generally leftist, critics, scholars, and aspirant cineasts. The group arose from a series of conferences held in 1960 attended by such luminaries as Luis Buñuel, Luis Alcoriza, Carlos Fuentes, and the painter José Luis Cuevas. Although these individuals did not form part of Nuevo Cine, those who did went on to publish a magazine, *Nuevo Cine*, which in its seven issues published (April 1961–August 1962) carried on a lively debate with the "establishment" filmmakers and journalists and called for a renovation of Mexican cinema. The editorial board consisted of Emilio García Riera, José de la Colina, Salvador Elizondo, Jomí García Ascot, and Carlos Monsiváis. Others who became part of Nuevo Cine were: Rafael Corkidi, Paul Leduc, Manuel Michel, Manuel González Casanova, José Maria Sbert, Tomás Pérez Turrent, Jorge Ayala Blanco, and Salomón Laiter, among a number of other individuals who were to become better known in the coming years.[11]

Even though the movie industry was stagnant and close to bankruptcy, there were hopeful signs in the early 1960s that filmmaking at some time in the future might yet be put on a more rational basis. For instance, ever since a long-forgotten effort during the Carranza presidency there had been no training facilities for young cineasts. The STPC had never attempted to provide such instruction because the Directors' Guild was interested only in protecting the prerogatives of its members. Fernández, Galindo, Gavaldón, Bustillo Oro, and all the others had learned their craft in the early days when the industry was still open to all comers. Some, like Buñuel, received their training in Europe; others, like René Cardona and Tito Davison, in Hollywood's Hispanic movies or elsewhere in Latin America. Aside from the cineclubs or film societies, there was no place in Mexico where estab-

lished or would-be directors could study in detail the works of the world's great cineasts. But it was unlikely that a film repository would be established because of official indifference; and most producers cared not a whit for cinema as art or for its social or historical significance. Carmen Toscano, daughter of the pioneer filmmaker, organized a film archive in 1963 wholly on the basis of private contributions. It was called the Cinemateca de México. The organization petitioned President López Mateos for a subsidy and quarters in which to locate the archive. A part of the old Ciudadela building was turned over to Carmen Toscano but due to its decrepit state another location had to be found. The Cinemateca was finally placed on the third floor of the old Palace of Communications. In December 1964, shortly after Gustavo Díaz Ordaz was inaugurated president, the Cinemateca was forced to vacate its premises.[12]

Not all cinematic developments in the first half of the decade were as unpromising. A hopeful sign was the establishment in 1963 of a cinema department at the National Autonomous University of Mexico (UNAM); this department was called the Centro Universitario de Estudios Cinematográficos (CUEC) and was under the direction of Manuel González Casanova, one of the Nuevo Cine group.[13] Another encouraging development was the directorial debut of Buñuel's close associate and friend Luis Alcoriza with *Los jóvenes (The Youths)* (1960). This film was a cut above the average movie about "rebellious" middle-class youth popular in this period, and Alcoriza in the following years was to turn out a number of well-made and provocative films.

García Ascot made *En el balcón vacío (On the Empty Balcony)* (1961), an independent production that in spite of being refused distribution by the official channels was a great international success. Collecting money from friends, García Ascot gathered enough funds to buy a 16mm camera. A script was written by Emilio García Riera in three months of "long nocturnal sessions."[14] The filming itself took one year because they could only work on weekends since all the members of the crew had full-time jobs. The film was based on the childhood memories of a woman (García Ascot's wife) wrenched from her native Spain by the Civil War. Even though she has reached adulthood in Mexico, the trauma of flight from her home many years before remains vividly in her consciousness. *El balcón*, as its makers called it, skillfully managed to see such shattering events through the sensitive eyes of a woman projecting herself back to her childhood and recreating the little girl's sense of fear and wonder as she observes the concerned adults about her making secretive preparations for flight. *En el balcón vacío* was invited to be shown at the Locarno

Film Festival in 1962 where it was awarded the International Film
Critics' Prize and won universal and enthusiastic praise while the offi-
cial Mexican entries were all but ignored.[15]

Internationally, the best-known Mexican film of this period is Buñ-
uel's *Viridiana* (1961). More accurately it was a Mexican-Spanish
production since it was shot entirely in Spain and coproduced by Gus-
tavo Alatriste and Uninci Films of Madrid. It starred the popular Mex-
ican actress Silvia Pinal in the title role of the religion-obsessed girl
who thinks she has been raped by her uncle, don Jaime (Fernando
Rey, best-known to American audiences as the French drug trafficker
in *The French Connection*). In *Viridiana*, Buñuel developed all his fa-
vorite anti-Catholic and anti-bourgeois themes within a sombre set-
ting. The film was a huge artistic and economic success, except of
course in Spain where it was not unexpectedly banned.[16] In 1962 Buñ-
uel filmed *El ángel exterminador* in Mexico, which concerns a bizarre
dinner party in which the guests, for no apparent reason, find them-
selves unable to leave their host's mansion. Alatriste was the producer
and he again backed Buñuel in the latter's last Mexican film, the short
feature *Simón del desierto* (1965). In 1965, Buñuel transferred all his
filmmaking activities to Europe.

Buñuel's close friend and protegé, Luis Alcoriza, directed *Tlayucan*
(1961), a study of small-town life which displayed Buñuelian sym-
bolic techniques, such as the juxtaposing of a young couple with hogs
in a comparison of their eating habits. In 1962, Alcoriza made *Tiburo-
neros (Shark Fishermen)*, the story of Aurelio (Julio Aldama), a busi-
nessman who has chosen to forsake urban cares for the simplicity of a
shark fisherman's life on the coast of Tabasco. The familiar theme
was handled by Alcoriza with sensitivity and realism making the film
stand out among the run-of-the-mill products being churned out by
Mexican studios.[17] This "new" director gave promise of being a major
talent, capable of making distinguished films if given the opportuni-
ty.[18]

However, one director like Alcoriza was not about to renovate the
film industry. The STPC looked on with increasing frustration as the
producers took ever greater advantage of the lower costs of filming at
the América studios and the use of STIC personnel. As a conse-
quence, the STPC membership confronted a serious unemployment
problem as the production of "regular" films declined steeply. In an
effort to break the industry's impasse and influenced by the work of
young university-based cineasts, the STPC announced in August 1964
the First Contest of Experimental Cinema. All those aspirant camera-
men, scriptwriters, actors, musicians, and directors who would not or
could not enter the industry got together and sought financing from

friends, their own savings, or independent producers.[19] Thirty-two groups signed up when the contest officially opened, but by the time the films were delivered the following year, only twelve groups were represented with an equal number of 35mm full-length motion pictures.[20]

The entries were judged in July 1965 by a jury of thirteen persons representing the industry, various cultural institutions, and critics. First prize was awarded to Rubén Gámez's *La fórmula secreta (The Secret Formula)*, a cruelly humorous probing of the Mexican's "lack of identity with himself."[21] It consists of a series of vignettes, some surrealistic, like the one showing a blood transfusion using Coca-Cola, and others brutally realistic, like the scene of the slaughter of a steer to the strains of spiritually inspiring music.

Second prize was given to *En este pueblo no hay ladrones (In This Town There Are No Thieves)* by Alberto Isaac. Adapted by Isaac and García Riera from a story by the famous Colombian writer, Gabriel García Márquez, the film traces the experiences of Dámaso (Julián Pastor), a small-town ne'er-do-well. One night he breaks into the tavern and steals the town's only billiard balls. However, once he has taken them, Dámaso realizes that the tedium of life in the village is completely unbearable without even the opportunity of playing billiards. He returns the balls but is caught. The merit of the film is in the directness of its cinematic language, although its slow pace is at times unnerving. The style is generally well adapted to the subject: the social examination of a small, poverty-stricken town where nothing ever happens. Dámaso is seemingly the only resident who dreams of better things, but is finally overcome by the stultifying inactivity of the town.[22]

The STPC film contest was obviously not a major event in international film history nor even in the Mexican cinematic milieu. It did not cause great excitement among the old-line producers who certainly did not perceive Gámez, Isaac, or any of the other directors as portending any "new wave." But the fact that such a competition took place at all and that it was sponsored by one of the industry's most sacrosanct institutions was significant and it pointed to the possibilities inherent in the future. A number of the individuals participating in the contest were in a few short years to become part of the industry.[23] The competition also symbolized the recognition by the STPC of the growing importance of independent, university-based filmmakers who had heretofore been engaged in literary pursuits, experimental theater, or film criticism, among these being Juan Guerrero, Salomón Laiter, Manuel Michel, Alberto Isaac, and Juan José Gurrola.[24]

The STPC was also no doubt well aware of the struggling indepen-
dent cinema, especially after the international success of García As-
cot's *En el balcón vacío* in spite of a boycott of the film by the
official distributors and exhibitors. A number of talented people—di-
rectors, writers, photographers—were obviously being excluded by the
cinematic unions' closed door policies, and the STPC itself was one
of the chief culprits in this situation. But now that severe unemploy-
ment was widespread in the Mexican film industry, the STPC's voice
was added to the many others that for years had been urging reform
and renovation. Even though the Banco Cinematográfico in 1960 had
bought out the Jenkins group's Operadora de Teatros theater chain,
and also become the major stockholder in the Churubusco studios,[25]
the same commercialist-minded elements still dominated decision
making throughout the official film hierarchy. Thus independent films
could not be exhibited in the commercial theater chains but were re-
stricted to the film clubs and private "art" houses, making it impossi-
ble for producers of such films to recoup their costs, much less make
a profit.[26]

Official protectionist policies failed to satisfy the producers, how-
ever. As Tomás Pérez Turrent summarizes the situation in the late
1960s and early 1970s:

> Traditionally, these producers operated on credit from the Na-
> tional Cinematographic Bank. . . , inflating their budgets to such
> an extent that the loan, theoretically designed only to cover a
> percentage of the total cost, was enough or almost enough to
> pay for the whole film. To this was added advance royalties for
> distribution to some South American countries, and thus bad
> quality cinema became a sure-fire business with few risks.[27]

The tension in Mexican film circles in the late 1960s was generated
by the conflict between the entrenched bureaucratic/business groups in
the official agencies and the leftist, intellectual, restless "outsiders"
being shaped by the universities. Aware of their country's problems
and inequities, concerned by the cultural influence being exerted by
Hollywood, these young cineasts and scholar-critics longed for a cin-
ema that would deal honestly with Mexican reality. They were famil-
iar with the best of world cinema—Italian neo-realism, the French
new wave, the new American filmmakers—and consequently the
Mexican "packaged" cinema degenerated in their eyes to an
"artistically irrelevant enemy."[28] They looked toward the "new" Latin
American cinema, the now quiescent Brazilian Cinema Novo and the
exciting and vigorous Cuban filmmakers, as well as to experimenta-

tion by such independent cineasts as the Chilean Miguel Littín and the Bolivians Jorge Sanjines and Antonio Eguino.[29]

On a larger scale, a restless resentment was growing among the country's youth, especially in the universities. In 1968 Mexico had been chosen as the site for that year's Summer Olympics, the first Latin American country to be so honored. The country's official and business circles saw it as an international recognition of Mexico's improved status in the Western family of nations, an acknowledgment that the world no longer looked upon Mexico as a "backward" Latin American republic but rather as a progressive, modern state. However, on the eve of the Olympics, massive demonstrations were organized against the administration of Díaz Ordaz. The results led to the greatest tragedy in the history of Mexico since the Revolution and to a bitter schism between the generations that persists to this day.

> One of the origins of the student movement was resentment that a quarter-century of rapid economic growth was benefiting only a tiny minority of politicians, bankers and businessmen. There was also growing middle-class irritation over the way the administration of President Gustavo Díaz Ordaz censored movies, books and newspapers, persecuted independent intellectuals and summarily jailed outspoken opponents. In the eyes of many Mexicans, the system had become both economically and politically repressive.[30]

The students continued their ever-larger demonstrations, the date for the Olympics drew closer. Díaz Ordaz and his minister of Gobernación, Luis Echeverría Alvarez, seeing Mexico's international prestige on the line, panicked—or perhaps decided to nip this opposition in the bud. The army was sent against the students and many innocent bystanders at the Plaza of the Three Cultures in Tlatelolco. In a night of blood and horror, over three hundred persons were shot down and hundreds more wounded. The carnage was little noted at the Olympic Village and fleetingly reported by the world press,[31] with the honorable exception of the Italian journalist Oriana Fallaci, who was caught in the midst of the massacre.[32]

Nineteen-sixty-eight was a pivotal year in modern Mexican history: the economic, political, and social tensions that had been building up since the 1930s exploded in this bloody confrontation. Many students became radicalized by the experience and whatever guerilla movement has existed in the country dates from that year. Some Marxist students tried to politicize the peasantry, although perhaps the best-known organizer of the peasants was Lucio Cabañas, a rural schoolteacher.

When organizing efforts failed to produce the desired effect among the peasantry, some groups turned to urban terrorism. But more important than such sporadic violence, which has had little direct effect on Mexico's political events, has been an angry undercurrent persisting in Mexican society, especially among the youth.

The events of Tlatelolco gave a greater urgency to the antiestablishment cineasts and, according to Ayala Blanco, a stronger independent cinema "arose on the heels of the politization of certain middle-class nuclei as a consequence of the student movement of 1968."[33] But in the existing political climate, independent filmmakers, even if they could obtain financing from individuals or from university sources, still were up against the stone wall of official distributors and exhibitors. Thus it is not surprising that one of these "new" cineasts, Alberto Isaac, directed the officially sponsored *Olimpiada en México (Olympiad in Mexico)* (1968) and utilized the services of other young filmmakers like Rafael Corkidi, Paul Leduc, and Felipe Cazals who "had no scruples in collaborating" in the project.[34] The film itself, which was the "most favored, best-organized, and costliest made during the presidential term of Díaz Ordaz," was the subject of much controversy.[35]

On the other hand, Centro Universitario de Estudios Cinematográficos (CUEC) at UNAM made its own unique contribution to the student movement of 1968. Being a small, relatively unknown department of the National University and located far from the centers of student activism, CUEC went unnoticed by the authorities. Its members decided to record the student movement on film, utilizing the raw film allocated to the department for its coursework. Leobardo López Aretche directed the project with the assistance of Alfredo Joskowics. So, while other departments and faculties in the institutions of higher learning throughout the Federal District and some of the states were being taken over by student revolutionary committees, the members of CUEC took action in the most effective way they knew: with their cameras. According to Ayala Blanco, *El grito (The Shout)* (1968) is "the only objective record that exists of any popular movement that occurred in the last thirty years of national life . . . [it] is in the final analysis, the most complete and coherent filmic record that exists of the Movement, seen from the inside and contrary to the calumnies spread by the rest of the mass media."[36]

The bitterness arising from the bloody events of October 1968 and the subsequent wholesale arrests of student activists and left-wing intellectuals was still widespread when Luis Echeverría Alvarez assumed the presidential office in December 1970. Since he had been head of Gobernación under Díaz Ordaz, many considered him directly

responsible for having unleashed the army on the students and their sympathizers. Echeverría was never to overcome this suspicion on the part of the Mexican left, in spite of his openly pro-left and "Third Worldist" foreign policy. Although the ideological stance of his administration is beyond the scope of this study, it is necessary to be aware of it when observing the repercussions it had on the film industry. Unlike Díaz Ordaz, Echeverría was quite interested in films.[37] His brother had for many years been a well-known actor as well as Jorge Negrete's successor as head of ANDA [Asociaciaón Nacional de Actores].[38] In fact, Echeverría appointed Rodolfo Echeverría to head the Banco Cinematográfico and it was under the latter's direction that the State became directly involved in filmmaking to the almost total exclusion of the private producers.

In its cinematic policies, as well as in all other aspects of its program, the Echeverría administration was highly controversial. The radical left remained skeptical, even hostile, while the business community denounced the president as a Communist. Certainly there had not been a so apparently leftist administration since Cárdenas[39] or such an economically activist one since Alemán.[40]

On January 21, 1971, Rodolfo Echeverría proposed a "Plan for the Restructure of the Mexican Film Industry" in order to "renovate objectives and means during the six-year period so as to change the image of the national cinema, so deteriorated and maligned at the beginning of the decade."[41] In 1971, the State owned outright the Banco Cinematográfico, the theater chain Compañía Operadora de Teatros, and the Churubusco studios; of mixed public and private ownership were the distributors Películas Mexicanas and Cimex, and the promotional firm, Procinemex. Rodolfo Echeverría declared that "although this group of firms seemed to be sufficient to maintain the film industry in a state of equilibrium, their financial status was precarious."[42] Besides, the entire structure was maintained by the government "at high cost" primarily for the benefit of "a group of industrial or private producers—in their majority guided exclusively by the criteria of rapid recuperation and maximum rentability—who produced a commercialist cinema and took advantage of the established mechanisms, from the financing to the exhibition facilities provided by state firms." The result, Echeverría concluded, was a "false product, deformed and rejected by numerous domestic and foreign social sectors."[43]

Some significant accomplishments between 1970 and 1976 were the building of a filmmaking school, the Centro de Capacitación Cinematográfica—a dream of many cineasts since the days of silent movies in Mexico[44]—and nearby, the conversion of two Churubusco sound stages into the Cineteca Nacional, another long-deferred dream

finally fulfilled. Here the historically important task of obtaining and preserving prints of commercial Mexican film production was finally undertaken with the full backing and resources of the federal government. In addition, copies of a wide assortment of foreign films were and are being obtained for the benefit of young cineasts and film students, both Mexican and foreign. The Cineteca consists of two theaters open to the public, "Sala Fernando de Fuentes" and "Salón Rojo"; one 35mm private screening room, "Salvador Toscano," for staff use and accredited researchers; and three private 16mm screening rooms.[45] In 1974, the Cineteca's holdings consisted of 1,476 films, including both 35mm and 16mm, full-length and short; by 1976 there were 2,500 films in its archives.[46] By 1976, the State was sole owner of the América studios, Procinemex, Películas Nacionales (which absorbed Cimex), and the only remaining privately owned theater chain, Cadena de Oro, in addition to many other individually owned movie houses as well as a number of new ones built by the Banco.[47]

The most important development of the Echeverrías' *sexenio* was the direct participation of the State in the production of films through three production companies. These were: Corporación Nacional Cinematográfica (CONACINE); Corporación Nacional Cinematográfica de Trabajadores y Estado I (CONACITE I); and Corporación Nacional Cinematográfica de Trabajadores y Estado II (CONACITE II). CONACINE was created in October 1974 as a branch of the Banco Cinematográfico and it served as a model for CONACITE I (June 19, 1975) and CONACITE II (May 8, 1975). The Banco had been coproducing films with Churubusco-Azteca studios ever since the latter's nationalization in 1960, but the system was cumbersome and the decision was made to regulate production through these officially created companies. Besides, the almost total suspension of private moviemaking since the Banco's curtailment of credit to the producers necessitated the State's intervention if only to assure work for the thousands of skilled workers in the industry. In fact, thirty-nine films coproduced by the Banco and Churubusco between April 1971 and the time of CONACINE's creation were immediately turned over to the latter.[48] The activities of CONACINE and CONACITE I were similar, that is, they both functioned as sole producers or as coproducers with film workers, private investors, and foreign producers. CONACITE II worked exclusively with STIC and América studios.

Total production, both "regular" and "serials," totaled seventy-two films in 1970 (before the inauguration of Luis Echeverría).[49] In 1971, the figure was also seventy-two not including nine independent full-length features and seven films made abroad. However, in comparison to the previous year's output, which was singularly undistinguished,

1971 saw the appearance of a number of interesting films such as Felipe Cazals's *El jardín de tía Isabel (The Garden of Aunt Elizabeth)*, Rafael Corkidi's *Angeles y querubines (Angels and Cherubim)*, Luis Alcoriza's *Mecánica nacional (National Mechanics)*, Juan López Moctezuma's *La mansión de la locura (Mansion of Madness)*, Paul Leduc's *Reed: México insurgente (Reed: Insurgent Mexico)*, Gustavo Alatriste's *QRR (Quién resulta responsable) (Who is responsible)*, and Alfredo Joscowics's *Crates* and *El cambio (The Change)*. Of course, there were still plenty of "package" films such as Miguel M. Delgado's *Santo vs la hija de Frankenstein (Santo versus Frankenstein's Daughter)* in addition to the regular fare of *comedias rancheras*, tearjerking melodramas, and "westerns."[50]

In 1972, the figure rose to seventy-five full-length features in addition to twelve "official" films such as *Cartas del Japón (Letters from Japan)*, about a Mexican engineering student in Japan, *Historia del P.R.I. (History of the P.R.I.)*, *Tarahumara—Drama del pueblo (Tarahumara—Drama of the People)*, and *Compañero presidente (Comrade President)*, a documentary of Echeverría's visit to Chile. Although commercial production included such standbys as *Bikinis y rock* and *Capulina vs las momias (Capulina versus the Mummies)*, there were also superior films like Arturo Ripstein's *El castillo de la pureza (Castle of Purity)*, Gonzalo Martínez Ortega's *El principio (The Beginning)*, José Estrada's *El profeta Mimí (The Prophet Mimi)*, Alberto Isaac's *El rincón de las vírgenes (The Corner of the Virgins)*, Alejandro Jodorowski's *La montaña sagrada (The Sacred Mountain)*, Mauricio Walerstein's *Cuando quiero llorar no lloro (When I Wany to Cry, I Can't)*, and *Fe, esperanza y caridad (Faith, Hope, and Charity)*, a film in three segments directed respectively by Alberto Bojórquez, Luis Alcoriza, and Jorge Fons.[51] These films were generally well received by the critics and, even if some were flawed, did at least explore new directions previously unsought by Mexican cineasts; more importantly they were made by new directors supported directly by the Banco Cinematográfico through its production companies, an arrangement deeply resented by the old-line producers and directors.[52] Table 2 gives an idea of the scope of state participation in the film industry and the resultant lack of activity on the part of private producers.[53]

The decline in production was a serious matter and was undoubtedly exacerbated by the Echeverría policies. True, better movies were made by young, often leftist directors but this was small comfort to the industry as a whole. Echoing the opinions of his conservative-minded colleagues, one long-time film executive placed the blame entirely on the Echeverría brothers, saying that the Mexican cinema

TABLE 2
Mexican Film Production, 1971–1976

YEAR	BANCO & PRIVATE	PRIVATE	STATE PROD	TOTAL
1971[a]	63	7	5	75
1972[b]	34	8	20	62
1973[c]	26	4	20	50
1974[d]	23	10	21	54
1975[e]	13	7	23	43
1976[f]	—	5	37	42

SOURCES: [a]*Informe general*, p. 46; [b]Ibid., p. 49; [c]Ibid., p. 52;
[d]Ibid., p. 55; [e]Ibid., p. 58; [f]Ibid., pp. 59–60 and
Excélsior, January 19, 1977, Section Cine, Teatro,
Radio y TV, p. 5.

from 1971 to 1976 was "tendentious . . . and up to a certain point, procommunist." He blamed the Banco Cinematográfico for withdrawing credit facilities from the private producers and forcing them to use their own capital or seek backing from other sources. He concluded that under President Echeverria and his brother, filmmaking had a "communist slant, totally to please [Echeverría]"; that a film's commercial potential was of "no importance" and public funds were invested "to line pockets," presumably those of the Echeverrías and their cronies. As to films with a political or social message, this executive felt that Mexico's problems "are not political . . . we go to the movies for entertainment. . . . Of what use could a Marxist idea be to the people?"[54]

While many of the preceding remarks are true, others are not entirely accurate. Production had been falling off since 1960 due to the effects of constantly diminishing quality and the producers' desire for quick profits on minimal personal investment.[55] Public monies accomplished this, since films were being financed up to 80 percent by the Banco Cinematográfico. Inflating the budgets was also common practice, so that the Banco's "80 percent" share actually paid for the entire film and left some over for the producer to pocket. This system was leading the industry from stagnation to ruin, a truth that did not require a great deal of insight to discern. The Echeverrías recognized the problem and tried to do something about it by backing new directors, as well as veteran ones, in officially financed films. Such films as Alcoriza's *Mecánica nacional* (1971), Alfonso Arau's *Calzonzín inspector* (1973), and Alberto Isaac's *Tívoli* (1974) were also more expensive, a fact that fueled the charges of massive corruption in the official film establishment. Such charges might very well have been

true, since the system of official corruption was nothing new in Mexico. However, the money spent on these and other films was evident in their superior production values. The infusion of new blood in the directorial ranks was discernible from the controversial themes that these films took on and presented in a realistic, often raw, manner.

A precursor of such films was Alejandro Jodorowski's *El topo* (1970) (*The Mole*), a confused, occasionally brilliant mélange of Eastern metaphysics and satire of the western genre. It also incorporated surrealist techniques borrowed from Buñuel and Fellini but lacked their humanism. Jodorowski's satire is heavy-handed and often sado-masochistic. The film was independently produced and for years was not screened in Mexico; however, it proved a great success on the underground film circuit in the United States and Europe. Jodorowski himself is Chilean by birth and has been better known in Mexico for his work in experimental theater.[56] In 1967 he had made *Fando y Lis*, his first film, based on a work of the same name by Fernando Arrabal. With his cameraman, Rafael Corkidi, Jodorowski filled the screen with images of sado-masochistic and deviant sexual symbolism in an attempt to express his personal view of the universe. *Fando y Lis*, *El topo*, and *La montaña sagrada* proved heavy for popular tastes, but the possibilities that they illustrated of making a filmic statement through the combined use of realism and surrealism was not lost on other cineasts. True, the technique was hardly new: Buñuel had experimented with it in *Un Chien andalou (1928)*, as had many French avant-gardists and German expressionists in the 1920s. But Jodorowski's films showed how such techniques could be used to interpret the tensions and malaise of contemporary Mexican society, something that had not even been attempted since Bustillo Oro's rather timid experiment in *Dos monjes* (1934) or De Fuentes's *El fantasma del convento* (1934).[57]

If a summarization can be made of the direction taken by Mexican cinema in the 1970s, it is that the new directors—Isaac, Cazals, Fons, Arau, Corkidi, Leduc, and many others—were allowed the freedom to interpret controversial political and social themes. Some established directors like Galindo and Alcoriza took advantage of this climate to also make their own statements. In this they were assured by President Echeverría that they were "at liberty to bring whatever theme they wished to the screen, be it social or political."[58] There was disagreement whether a "new" Mexican cinema in reality existed. Alcoriza compared his colleagues with the initiators of the Brazilian Cine Novo and concluded that no such movement existed in Mexico.[59] Eduardo Maldonado, an independent filmmaker, opined: "None of the films which have been made within the new Mexican cinema truly respond

to the necessity of analysis and critical interpretation that is required by the current social reality of Mexico."[60]

Any attempt here to analyze meaningfully all the important Mexican films made in 1971–1976 is impossible. The choice of the few films discussed is dictated entirely by the fact that this writer happens to be familiar with them and does not imply that, in his judgment, they were superior to others. Also, to discuss thoroughly the complex cinematic, cultural, and literary influences operative on Mexican filmmakers is too extensive an undertaking for this brief survey.[61]

Mecánica nacional (1971) was Luis Alcoriza's most popular film, and his most outspoken.[62] Focusing on the urban lower middle class and their uncertain suspension between traditional, rural values and the anomie of a rapidly growing, modern metropolis, Alcoriza aimed devastating barbs at this group. He employed a number of well-known performers in roles that were veritable antitheses of their popular images. Manolo Fábregas, grandson of the famed Virginia Fábregas, and one of Mexico's best-known actor-producer-directors, played the role of Eufemio, a crude, stupidly *macho* garage owner.[63] The popular *ranchera* songstress Lucha Villa was Chabela, his equally crude wife, and the quintessential mother-figure, Sara García, did a grotesque parody of herself as Eufemio's mother.

Eufemio, his wife, mother, family, and friends set out in a holiday mood to catch the end of an Acapulco-to-Mexico City auto race. The women prepare vast quantities of food since the plan is to spend the night at an area near the finish line so as to observe the end of the race early in the morning. They set out in a caravan through huge traffic jams; a lot of horn-blowing and insults are exchanged with other drivers. The mass of cars finally arrives at an open spot and jams itself into the area so tightly as to make further movement impossible. The occupants of the automobiles, joined by swaggering motorcyclists, proceed to await the dawn by eating, drinking, and indulging in as much sex as possible. Eufemio's mother gorges herself all night long until she is stricken by a massive attack of indigestion. The cars are so packed in that it is impossible to go for a doctor; finally one motorcyclist volunteers to go, but too late to save granny. She is laid out as if at a wake with her family and friends grieving around her. However, the announcement that the race cars are nearing the finish line draws the mourners away, including Eufemio and his family; granny's corpse is left alone in the midst of a sea of autos and refuse, with just a dog picking at the garbage for company. The final indignity occurs as the weary racing fans start for home. Eufemio props his mother up on the front seat. When he gets caught in the middle of the inevitable traffic jam, word gets out that there is a

corpse in Eufemio's car and soon hundreds of people leave their cars to gape at the body. A high-angle panoramic shot recedes from the mass of cars and people to the strains of a lusty *ranchera*.

Alcoriza has a Buñuelian disdain for bourgeois society in general and in *Mecánica nacional* he ruthlessly satirizes the new Mexican middle class, those people who have recently begun to share in the country's economic "miracle" but in the process lost whatever cultural integrity they once had. To emphasize this, he shows two American girls who somehow joined the unruly group, exclaiming in English, "Why, there's nothing *Mexican* here!" Throughout the film, a young couple in white sports outfits and driving a white sports car is repeatedly shown in brief segments. All they do is gorge themselves with paella, omelets, and various other dishes of Spanish cuisine until their at first spotless white outfits and car become a multicolored mosaic of food stains. *Mecánica nacional* was Alcoriza's interpretation of the structure of contemporary Mexican society—materialistic, uncultured, irrational, while responding in a semiconscious way to certain half-remembered folkways. A searing commentary, but evidently a popular one since the Mexican public flocked to the movie.[64]

Alcoriza's depiction of the "common man" was a far cry from the affectionate paternalism of Rodríguez in *Nosotros los pobres* and *Ustedes los ricos*, or even Galindo's expressions of working-class solidarity in *¡Esquina bajan!* of some twenty-odd years before. While Rodríguez idealized the poor in a static social system and Galindo showed the working class as intelligent and motivated if not radical, Alcoriza sees the children of the *lumpenproletariat* of the 1940s as being completely coopted by the worst of petty bourgeois values. Clearly no new Mexican revolution is possible from such as Eufemio or, even more tellingly, from the shallow, sybaritic young people of *Mecánica nacional*. Alcoriza seems to be saying that it was people such as these that looked unemotionally upon the Tlatelolco massacre and quickly shrugged it off. Fifty years of the official Revolution had succeeded admirably in depoliticizing an entire generation and convincing it that the consumer society was its inevitable destiny.

The theme of disillusion with Mexican society in the wake of Tlatelolco was continued in Alfredo Joscowics's *Crates* (1970), produced by CUEC, and *El cambio* (1971), produced by UNAM's Department of Cinematic Activities. The former dealt with the difficulties that the militant students of 1968 had in trying to pick up the pieces of their lives in the face of government repression and society's indifference.[65] In *El cambio*, "dropping out" is what its young protagonists, an artist and a photographer, opt for. Disgusted by the materialism of urban life, the two young men escape to an unspecified seacoast. They build

a shack on the beach and are soon joined by their girl friends. For a while they enjoy a simple, bucolic existence, but soon the real world intrudes upon their reverie. Waste from a local factory is poisoning the fish in the surrounding waters, threatening the fishermen's livelihood. When the company's bulldozer flattens their shack, the young men decide to take up the local people's fight. They collect the sludge from the factory in pails and, at a banquet in honor of the company representative, hurl the liquid waste all over him and the local dignitaries. The youths run from the banquet laughing hysterically, naïvely seeing their act as no more harmful than a prank, albeit politically significant. The local lawman sees it quite differently—he hunts down the two city youths and shoots them down in cold blood. Clearly an allegory of Tlatelolco, *El cambio* is also a bitter commentary on the futility of meaningful change in Mexico.[66]

The most powerful and unsettling statement on the bloody repression of 1968 was to come in the 1975 CONACINE-produced *Canoa* directed by Felipe Cazals. The title refers to the village of San Miguel Canoa, a small community of seven thousand inhabitants twelve kilometers from Puebla. On September 14, 1968, five young employees of the University of Puebla arrived in Canoa intending to climb the nearby Malinche peak, a dormant volcano. A downpour forced them to seek lodging in the town. They were turned away everywhere by the hostile villagers until Lúcas García offered them his hospitality. During the night a mob of over a thousand townspeople formed, went to Lúcas's house, killed him, and dragged away the five young Puebla men. Two were murdered and the remaining three were savagely beaten, one having three fingers cut off by a machete blow. The mob was about to pour gasoline on the three remaining men and burn them alive when the army and Red Cross intervened. These events occurred in the tension-filled days preceding the Tlatelolco killings and they became the basis for a powerful film by Felipe Cazals, one of the new young directors who was able to work thanks to the Echeverría regime.[67]

Cazals structured *Canoa* in a documentary style with titles giving the dates, and then hours, of the events about to be depicted. In addition, a villager speaks directly to the audience giving socioeconomic data on the town. Thus the film provides a background and attempts an explication of the townspeople's behavior. Economic hardship, illiteracy, a lack of skills necessary in the increasingly technological Mexican economy, ancient superstitions, and official indifference all served to make San Miguel Canoa an isolated community, even though it was but a short distance from Puebla, one of the largest and most heavily industrialized cities in the country. An autocratic and ob-

scurantist priest, aided by a fanatical lay organization, maintained strict control over most of the town, including the constabulary. The priest had convinced the townspeople that they were threatened by Communist revolutionaries from outside, and in fact shortly before the events described in the film a group of militant students from Puebla had been in the town trying to politicize the people. Thus when the five unsuspecting and completely apolitical university employees arrived in the town with nothing more in mind than an innocent weekend outing, it was a simple matter for the townspeople to suspect them of being Communist agitators "who are trying to place a black and red flag in the church."

Cazals develops his film against the backdrop of the momentous demonstrations in Mexico City. While the five university employees are making plans for their mountaineering outing, a radio commentator attacks the student movement, declaring "peace and progress means the Olympics." One of the employees feels that they should show solidarity with the students; his friend dismisses the idea, saying that they, as workers, have nothing to do with the movement.

Canoa is a skillfully crafted film, as well as a remarkable one in the Mexican context. It is nothing short of miraculous that the regime would permit, much less produce, such a statement on the events of 1968, especially so since at the time the incumbent president was widely thought to have been directly responsible for the army's attack on the demonstrators. Of all the "new" Mexican cinema, *Canoa* is perhaps the finest example of the government's commitment—for whatever political reasons—to greater freedom for artists and intellectuals.

In 1975, Cazals also made *El apando* adapted from a novella by José Revueltas on prison life, which the latter based on observations he made during his own imprisonment. This is also a powerful, brutal film although not as well structured as *Canoa*. Nonetheless it is a compelling account of the degradation wrought by an unfeeling penal system. Three prisoners use their wives and the aged mother of one of them to smuggle drugs into the penitentiary. They are caught and the men placed in solitary confinement. At the end, they turn on their captors and are finally subdued in an extremely brutal sequence. *El apando* is most impressive in its images of prison life—the hopelessness, the corruption, the brutality—all presented in a starkly realistic manner.[68]

Although young directors like Cazals were experimenting with topics and techniques new to Mexican cinema, it should not be forgotten that the old directors were still around. Emilio "El Indio" Fernández, his most creative days long past, overcame a boycott against him by

most producers to make a few films like *La Choca* (1973) and *Zona roja (Red Zone)* (1975). A shooting on a film location in Coahuila which resulted in the death of a young man for a time seemed to jeopardize what remained of his career.[69]

By the 1970s, Alejandro Galindo was the most respected of the old generation of cineasts. His populist films of the 1940s and 1950s were still admired by the younger critics and filmmakers as being the most socially relevant cinema of the "old" Mexican film industry. But times changed for Galindo as they did for Fernández, Ismael Rodríguez, Gavaldón, and all the other veteran directors. The necessity of earning a living had obliged him to direct adaptations of television soap operas like *Simplemente vivir (Simply to Live)* (1970) or children's movies like *Pepito y la lámpara maravillosa (Little Joe and the Marvelous Lamp)* (1971). He made a populist comedy in his old style, *Tacos al carbón (Barbecued Tacos)* (1971), which was generally considered anachronistic. In 1973 Galindo made two films of which he was especially proud even though the critics did not share his opinion—*El juicio de Martín Cortés (The Trial of Martín Cortés)* and *Ante el cadaver de un líder (Before the Corpse of a Leader)*. The latter was a black comedy in which the chief protagonist is the corpse of a labor leader discovered in a cheap hotel. His death is due to natural causes, but once the news gets out, the room becomes a gathering point for the labor leader's friends, associates, and two women each claiming to be his legitimate wife. The official investigation of the death is complicated by union delegations accompanied by brass bands paying their final respects in the midst of much speech-making, a rival union official making political capital of the situation, and a taco vendor setting up shop in the hotel room.

More interesting is Galindo's *El juicio de Martín Cortés*, a subject he had been considering for some years. Martín Cortés was the illegitimate mestizo son of Hernando Cortés, conqueror of the Aztecs, by Malinche, the Indian woman who was his invaluable interpreter as well as mistress. There was also a *don* Martín, Cortés's legitimate son by a well-born Spanish woman. In the mestizo Martín's story, Galindo saw the fundamental dilemma of Mexican society: half Indian and half European, Martín was suspended between two worlds, neither belonging fully to nor being accepted by either.

In *El juicio de Martín Cortés*, the action unfolds on a theater stage where a play on Martín Cortés had been presented. It seems that the actor who was playing Martín (Gonzalo Vega) identified so completely with his role that during the premiere performance he actually killed the actor playing don Martín. The police arrive at the theater with "Martín" to conduct the investigation. It is decided to perform

the play for the police investigator's (David Reynoso) benefit. The film thus proceeds as a "play within a play" with the play's director and the playwright describing the historical background of each scene about to be performed. As the play progresses the tragedy of Martín Cortés, the mestizo, has a deep effect on the spectators. It is clear, at least according to Galindo, that deep racial antagonisms still tear at Mexican society. Even the police inspector, who at the beginning had declared that racial feeling could not be acceptable as a motive because "In Mexico there is no prejudice," becomes so emotionally involved with the play that by the time the pivotal scene comes up—in which Martín attacks his half-brother—he leaps to his feet yelling "Kill him! Kill him!" The police inspector is so shaken by his own display of a racial hatred he had not thought existed within him that he disqualifies himself from the case on "the grounds of being a mestizo." In Galindo's final, sardonic comment, a mestizo reporter in the audience is wakened at play's end—he had slept through the entire performance.

The film was not well received and was panned by some critics.[70] Galindo insists that Mexicans, though professing officially to be proud of their origins, really look upon themselves as the bastard off-spring of a symbolic rape. Some students in Veracruz, the director relates, upon being told that the film was the story of the "first Mexican in history," responded "Ah . . . then he was the first son of a bitch."[71] Whatever the truth behind the nonacceptance of *El juicio de Martín Cortés*, it is a provocative and well-made, albeit somewhat complicated, work, possibly the only Mexican film that has attempted to explore the complex emotions underlying Mexico's racial composition. It might be that Galindo is right: perhaps Mexicans by and large do not wish to reflect on the problem, or even to admit that one may exist. If so, it is no surprise that *El juicio de Martín Cortés* was a commercial and critical failure. It may very well remain the only Mexican film to ever deal at length with the country's racism.

Although the racial prejudice among Mexicans dealt with in *El juicio de Martín Cortés* did not have box-office appeal, films concerned with other types of social and political themes continued to be favored by the public. Gustavo Alatriste scored a resounding success with *México, México, ra, ra, ra* (1974), an outrageous satire of Mexican society that was enjoying a successful revival in late 1977.[72] Alberto Isaac dealt with censorship and the unfettered developmentalism of the 1950s in *Tívoli* (1974), which concerns the closing down by the Federal District authorities of a popular burlesque theater.[73]

Tivoli may be placed in the genre of *cabaretera* films although the action unfolds in a burlesque theater. The main thrust of the plot deals

with a city administration working hand-in-glove with developers
seeking to profit from Mexico City's rapid growth. The Tívoli Theater
lies in the path of a grandiose urban renewal project and the authori-
ties decide to close it down. The main protagonist is a burlesque com-
ic, played by Alfonso Arau, who leads his fellow performers in a
futile struggle to save their theater. The film is also an exercise in nos-
talgia, since all the musical and comic routines are faithful recreations
of those popular in the 1950s, and many of them had been performed
by Arau when he worked in burlesque at that time.

 Tívoli sparked a new generation of the *cabaretera* films, according
to Arau. Among these movies are *Las ficheras (The B Girls)*(1976)
and *Muñecas de media noche (Midnight Dolls)* (1979) which featured
physically attractive but superficial performers such as Sasha Monte-
negro and Jorge Rivero. These films demonstrate the utter decadence
of the genre: while Alberto Gout's *Aventurera* (1949) was imbued
with both eroticism and social commentary, the new crop of cabare-
teras featured female nudity, soft-core sex, and puerile music-hall
jokes. In spite of such flaws, these movies were immensely popular
and garnered handsome profits; for instance, *Las ficheras* was being
shown simultaneously in twelve first-run movie houses in Mexico
City in the summer of 1977.

 However, the cabaretera/prostitute genre in the 1970s was not all
cheap eroticism. Felipe Cazals combined social commentary with real-
ism in *Las Poquianchis* (1977), a disturbing film dealing with a true-
life incident. Three sisters, "Las Poquianchis," kidnapped or bought
young girls from poverty-stricken rural families to stock their brothel.
Worse still, they resorted to murder to maintain control over the un-
fortunate women. In the late 1960s, the authorities finally broke up the
notorious prostitution ring, although too late for the many girls who
had been murdered—or others who had been forced to become kill-
ers.[74]

 Actas de Marusia (Letters from Marusia) (1975), a major CONA-
CINE production, received favorable attention from European critics,
partly as a result of extensive international promotion, and was the
only recent Mexican film to generate significant foreign interest.[75] The
widely favorable response was also elicited by the fact that the direc-
tor of the film was Miguel Littín, the famous Chilean cineast, creator
of *El chacal de Nahueltoro* (1969) and *La tierra prometida* (1973),
who had fled for his life from the bloody coup that took the life of
President Salvador Allende on September 11, 1973. Since President
Echeverría was a close personal friend of the Marxist Chilean chief
executive, Mexico generously opened its doors to many refugees from
the Pinochet junta.[76] Littín was a prize catch for the Mexican movie

industry, since he was internationally known and admired, especially in Europe where a good many cineasts and critics are leftist. Associated with Littín's name, a Mexican film would be more likely to be noticed. And it was. *Actas de Marusia* was entered at the Cannes Film Festival where, Littín claimed, it came within one vote of being named best film.[77] It was also Mexico's entry for best foreign film in Hollywood's Academy Awards presentations, but it received scant notice from American critics. *Actas de Marusia* did well in Mexico, setting box-office records for a Mexican film.[78] The motion picture tells of a strike in Chile in 1907 against a European-owned mine. The army was called in to quell the strike and the entire town of Marusia was massacred with the exception of two miners who escaped to tell the tale. It was filmed in northern Mexico with six hundred extras, many of them nonprofessionals.[79]

The Echeverría government's identification with international radical causes facilitated the resumption of coproductions with Cuba. *Mina: Viento de libertad (Mina: Wind of Liberty)* (1976) was a CONACITE I/ICAIC coproduction directed by the Spaniard Antonio Eceiza. However, *Caribe, estrella y águila (The Caribbean, Star and Eagle)*, a documentary that Alfonso Arau made to coincide with Echeverría's state visit to Cuba in 1975, has not yet been released. The Dirección General de Cinematografía, the censoring agency, apparently felt that it would exacerbate political divisions within Mexico, where there was already much criticism of Echeverría's policies. Of course, since the Dirección General was unlikely to act on its own authority on such a politically sensitive issue, it was evident that the government wished to limit the degree to which it was identified with the international left.[80]

The Chicano movement in the United States was another subject seen as profitable by Mexican filmmakers in the 1970s. Mexican-American characters had occasionally appeared in Mexican films throughout the industry's history, albeit generally in secondary roles. Surprisingly, in view of the large Mexican-American moviegoing public, films dealing with subjects directly relating to their experience had been few and far between. Galindo, in *Espaldas mojadas*, was one of the first directors to deal at length and sensitively with the problems of Mexican Americans, but other filmmakers showed scant interest in the subject. The reason seems to be many-sided. There was the traditional Mexican disdain for *pochos* and the very real danger that a movie entirely devoted to Mexican Americans would not be commercially successful in Mexico and certainly not so in the rest of Latin America.

As a result of the black civil rights movement in the United States, ethnic and racial pride spread to other groups including Mexican Americans, some of whom, usually the younger and more militant ones, adopted the label of "Chicano." The Chicano movement gained strength first in the universities and then among some of the general Mexican-American populace. News of this new militancy on the part of Mexican Americans filtered back to Mexico and aroused some sympathy on the part of leftist activists, since many Chicano militants also professed radical ideas. In time, some producers felt that commercial exploitation of the subject would be feasible. Pepito Romay directed the first "Chicano" film, *De sangre chicana (Of Chicano Blood)* (1973), which he claimed did very well in Los Angeles.[81] A few other movies followed: *Soy chicano y mexicano (I Am Chicano and Mexican)* (1974), *Soy chicano y justiciero (I Am Chicano and a Seeker of Justice)* (1974), *Chicano grueso calibre (Chicano Heavy Caliber)* (1975), and *Chicano* (1975). Their small number indicates that they did not prove to be quite as popular with Mexican-American audiences as their producers expected they would be. Perhaps Mexican filmmakers had little understanding of the nature of the Mexican-American population in the United States.[82] Carlos Monsiváis characterizes these films as a "series of catastrophes" motivated by the "growing importance and prosperity of the Chicano public."[83]

In spite of the opportunistic approach to the subject of Chicanos or Mexican Americans in general by the state-controlled Mexican cinema, the Chicano films suggested a type of coproducing with U.S. filmmakers in which Mexicans could eventually make a real contribution. In late 1977 and early 1978 Alfonso Arau was in the United States shooting *The Promised Dream*, a film on Mexican illegal workers.[84] A distinguished precedent was the 1953 independent film, *The Salt of the Earth*, produced by the Mineworkers' Union, which concerned a strike in Silver City, New Mexico. The cast included a Mexican actress, the recently deceased Rosaura Revueltas, who was deported from the United States for her association with the controversial film.[85]

Actually, there had always been some cooperation between the American and Mexican film industries. The fad for Mexico that lingered on for a few years after World War II resulted in a spate of mostly terrible Hollywood movies filmed in Mexico in the late 1940s and 1950s like *Sombrero, The Bullfighter and the Lady*, and the crowning disaster, *Pepe* (1960), Cantinflas's only starring role in a Hollywood movie.[86] Yet such foreign filming in Mexico provided much-needed work for Mexican technicians and extras, especially in the 1960s and 1970s when Mexican production fell off so sharply.[87] In

the 1980s serious overpopulation and economic pressures have driven millions of Mexicans to the United States. Cooperation between Mexican and American filmmakers could result in motion pictures that would fulfill a vital educational role in informing the citizens of both countries of the mutual responsibility they share in solving these and other problems. To this end, perhaps the "Chicano" films, as well as Hollywood westerns made in Mexico and showing it as a perennially undeveloped and violent land, have performed a valuable service in demonstrating the need for something better. Perhaps Arau is making a start toward providing this and it is to be hoped that others—from both countries—will follow suit.

Interestingly, the one "Chicano" film that did have artistic merit was written and directed by an American of Mexican descent—Jesús Salvador Treviño. The film was *Raíces de sangre (Roots of Blood)* (1976) produced by CONACINE and filmed on location in Mexicali. It relates the efforts of Mexican Americans and Mexicana to form an international labor union to represent workers employed in *maquiladoras*, the largely American-owned assembly plants along the border. The film is well-made with realistically drawn characters and the case includes both Mexican-American and Mexican performers. However, since *Raíces de sangre* reflects Treviño's militant Chicano philosophy, commercial distributors have shied away from the film and it is generally screened only within the university circuits in both Mexico and the United States.[88]

By the middle of the 1970s the Mexican film industry was in a precarious but still promising condition. The policies of Luis and Rodolfo Echeverría had brought mixed blessings. On the negative side, production of feature-length films was down to the lowest point since the 1930s. The frantic scrambling for the little work available had perpetuated the rivalry between the Churubusco and América studios even though both were government owned. This rivalry was fueled by the old bitter competition between the two cinema workers' unions—the STPC and the STIC—which continued unabated.[89] In the first half of the 1970s the industry was nationalized,[90] and among the most positive results of this was that the directors' ranks were opened to new talent, and films dealing with heretofore prohibited social and political themes were made. For many of these achievements, Rodolfo Echeverría, as director of the Banco Nacional Cinematográfico, was responsible. In addition to opening new directions for the industry, Echeverría traveled widely in the United States and Europe promoting his country's films and succeeding in awakening some international interest in Mexican motion pictures.[91]

The new administration of José López Portillo (1976–1982) re-versed the cinematic policies of the Echeverría *sexenio*, although some films like Julián Pastor's *La casta divina (The Divine Caste)* (1977) overlapped into the new administration. The transfer of power began, innocuously enough, with the customary resignations of Echeverría appointees; thus Rodolfo Echeverría handed over his post as head of the Banco Cinematográfico to Hiram García Borja.[92]

López Portillo named his sister, Margarita López Portillo, as head of the Directorate of Radio, Television, and Cinema (DRTC), a newly formed agency for the coordination of all government-owned produc-tion activities in the electronic mass media.[93] As regarded the film in-dustry, this was the first step in the implementation of López Portillo's overall economic program to encourage private enterprise and discard government-owned enterprises that were wasteful and inefficient. In the movie industry this meant the retreat of the State from direct par-ticipation in filmmaking and the return of private producers.

Shortly after Ramón Charles, a self-declared enemy of official filmmaking, was made the DRTC's chief counsel in early 1979, the Banco Cinematográfico was dissolved, its functions transferred to the DRTC, and its top officers, including García Borja, charged with fraud and corruption. Reflecting the new state of affairs, the Centro de Capacitación Cinematográfica (CCC) seemed to be facing imminent demise as an independent film school.[94] Murky, semiofficial state-ments threatened the CCC with merger with Churubusco studios or CUEC. In the midst of all this, Bosco Arochi, head of Churubusco, was jailed on charges of fraud as were Fernando Macotela, the stu-dio's Director of Cinematography, and Jorge Hernández Campos of CONACINE, among others.[95] And in July 1979 CONACITE I was dissolved.[96]

These moves were the result of a sweeping reorganization of the film industry in favor of the private sector initiated by Margarita Ló-pez Portillo as early as July 1977. Her policies have naturally caused alarm and resentment among those cineasts who favor a state-financed cinema of leftist-oriented social commentary—García Riera reportedly called for a directors' strike to force the government to "respect . . . freedom of expression."[97] But such militancy arouses little support among cineasts who must depend on the film bureaucracy for what-ever work opportunities they have.

Regarding the above problems, Margarita López Portillo has stated: "Any line of social films is acceptable if they are made with talent. There exists a group of young cineasts who work in cooperatives producing good things that debate problems of political or bourgeois life—they do it well. I have faith in them, I am moved that they want

to change the world. Who has not dreamed of doing that at the age of 25 or 30?"[98] A propos censorship: "I detest the word 'censorship'— why not say 'supervision'?"[99] And continuing: "We will avoid the presentation of coarse themes that poison the mind. . . . The people have the right to be respected."[100] And on official filmmaking: "The State will not retreat from production since it will meet its responsibility of producing a cinema that orients, educates, and entertains."[101]

Although such statements are not reassuring to antiestablishment filmmakers, it must be pointed out that the Mexican film industry has always been a business that had to make money to survive. When the State has stepped in, as in the Echeverría years, it was to try to revive a faltering industry as much as to use it to bolster the regime. Luis and Rodolfo Echeverría encouraged a franker and more committed cinema because they believed that in this way Mexican films could find new international markets. However, leftists apparently are neither a profitable nor numerous movie audience and by 1976 Mexican production was at its lowest point since the mid-1930s.

Since 1977, the financial health of the film industry seems to have improved, even though the organizational problems of 1977–1978 caused a 13% drop in production.[102] However, the outgoing president of the National Chamber of the Cinematic Industry, Manuel Ampudia Girón, reported that "since 1977, average production has increased to 86 films per year . . . an average rate of increase of 32.7% compared with the 1971–1976 period." As a result, from a total of 20,602 workers in the film industry in 1977, "there was a 5% increase in 1978 [and in 1979], 18.2%—in only two years the number of workers has increased to 25,600." Among other statistics: the fastest-growing sector was exhibition, accounting in 1979 for 75.4% of total industry employment; production employed 20.9% and distribution 3.7%. In 1978 private investment increased by 58%; in production this translated to an increase of 84%. By 1979, total investment in the movie industry amounted to almost 69 million dollars. Foreign receipts increased in 1977–1980 by 35.6%, from 10.4 to 14.1 million dollars. In the meantime real production costs, taking inflation into account, decreased by 60% in state-financed films in comparison with 1975 costs; private producers reduced their costs by 35% in this same period.[103]

This improvement in the film industry's financial ledger has been achieved by a commercialist thrust that exploits traditional genres, soft-core sex, and whatever timely topics can be quickly taken advantage of. There has also been a renewed emphasis on coproducing, a system that lessens somewhat the financial risk for the individual producer and assures distribution in the coproducing countries. Illustrative of this current direction of Mexican cinema is the election in

1980 of Guillermo Calderón Stell as president of the National Chamber of the Cinematic Industry, an association of private producers founded in 1942 which has become considerably more visible since 1977; Calderón Stell is the producer of successful cabaretera movies such as *Las ficheras* and *Muñecos de media noche.*

RE-AL Productions is described by *Variety* as "about the biggest Mexican producer making a product geared to the world market." René Cardona, Jr. wrote and directed *Guyana, The Crime of the Century* (1979) as well as an earlier film, *Survival* (1975), based on the crash in the Andes of a Uruguayan plane, whose survivors, a rugby team originally headed for a match in Chile, had to resort to cannibalism while waiting for rescue. *Hostages* (1980) was loosely based on the American hostage situation in Iran. Both *Guyana* and *Hostages* used American actors to ensure the widest international distribution. *Guyana*, for instance, starred Stuart Whitman, Joseph Cotten, and Yvonne de Carlo along with an international cast.[104]

Another significant development is the entrance of the giant conglomerate Televisa, S.A. into the arena of film. Already the producer and owner of most Mexican commercial television, Televisa has acquired a 75% controlling interest of the television Spanish International Network (SIN) in the United States. Its film production and distribution subsidiary, Televicine Distribution International Corporation, recently bought out Columbia Pictures Spanish Theatrical Division. Columbia's disposal of its Hispanic operation, which is 40% of the United States Spanish-language market, signals the new domination of the American Spanish-language movie and television market by Mexican interests. The government-owned U.S. distributor, Azteca Films, has some 50% of the market. Columbia turned over its entire Spanish-language film library of five hundred motion pictures to Televicine, as well as licensing its United States subdistrict rights to Cantinflas comedies which it produces and distributes worldwide.[105]

Televicine apparently was convinced of the market potential of the United States market by the box-office success of such movies as *El changle* (*changle* is Mexican slang for "shoe"; the reference here is to the footwear used by soccer players) and *La ilegal (The Illegal Alien Woman)* (both 1980), which took in receipts of more than 1 million dollars apiece shortly after being released in this country. The United States Hispanic market is estimated at 25 million people and represents 40% of Mexico's film export sales. There are about 450 Spanish-language theaters in the United States that bring in $45 million a year.[106] These figures have attracted the giant Televisa, through its filmmaking arm, Televicine, to the American scene in production and distribution for both theaters and television.[107]

Commercialism has won out in Mexico and the movie industry is enjoying an economic recovery. This is the logical, usual pattern for a capitalist country. That segment of the Mexican population which would support an avant-garde cinema of social significance is much too small to maintain any sustained commercial production of such films. As a Mexican film executive stated:

> The so-called art cinema is accepted and supposedly enjoyed by a select minority or elite whose capacity to judge and profoundly analyze a film in all its different phases is the result of a long process of culturization, of refined taste, and a sophisticated mentality.[108]

The mass audience within Mexico and outside its borders has not developed the above-described capacity to enjoy avant-garde cinema, or at least in the judgment of the businessmen who are running the movie industry it has not. If, as the Marxists say, film can be used to awaken the progressive instincts of a people and mobilize them toward meaningful social change, a commercial movie industry is not about to knowingly encourage such a cinema. Margarita López Portillo's patronizing remarks about idealistic young filmmakers are ample evidence of official thinking regarding such a cinema and a reflection of the bitter taste that the Echeverría experiment has left in much of the Mexican film community. The *auteur* cinema was left to the young cineasts in the universities and film clubs during the López Portillo *sexenio*. But new administrations invariably have had a marked effect on the film industry, and it remains to be seen what directions Mexican cinema will take under the presidency of Miguel de la Madrid Hurtado (1982–1988).

Notes

1. Federico Heuer, *La industria cinematográfica* (Mexico City: self-published, 1964) p. 179.

2. *Historia*, 6: 132; "Acusaciones del 'Indio,'" *Hispanoamericano*, 27 September 1954, p. 47.

3. For a detailed analysis of the Mexican political system and its role in economic development see Roger D. Hansen, *The Politics of Mexican Development* (Baltimore: Johns Hopkins University Press, 1971). See also Pablo González Casanova, *Democracy in Mexico*, trans. Danielle Salti (New York: Oxford University Press, 1972). For a more up-to-date assessment see "Mexico's Reluctant Oil Boom," *Business Week*, 15 January 1979, pp. 64–74; James Flanigan, "Mexican Oil: The U.S. Is Most Definitely *Not* in the Driv-

er's Seat," *Forbes*, 22 January 1979, pp. 29–32; idem, "Why Won't the Mexicans Sell Us More Oil?," *Forbes*, 29 October 1979, pp. 41–52.

4. *Historia*, 8: 195.

5. Ibid., p. 194.

6. Ibid., p. 10. The "Santo" series may have been of bad quality but it was remarkably enduring nonetheless as well as continuously profitable. See Agustín Gurezpe, "'Rencor y Envidia Porque mis Películas Siempre Ganan Dinero,' Dice El Santo," *Excélsior*, 6 April 1977, Section Cine, Teatro, Radio y TV, p. 1; and Jorge Ayala Blanco, *La búsqueda del cine mexicano* (1968–1972), 2 vols., Cuadernos de Cine #22 (Mexico City: UNAM, Dirección General de Difusión Cultural, 1974), 1: 295–304.

7. *Historia*, 7: 389.

8. Ibid., 8: 436.

9. Ibid., 7: 321–22.

10. Ibid., pp. 459–60.

11. Ibid., 8: 11–26.

12. Ibid., pp. 358, 361–62.

13. Ibid., p. 354.

14. Jomí García Ascot, "El cine y el escritor," *Cine cubano*, no, 31/32/33 (1966), p. 104.

15. See ibid., pp. 104–5 and *Historia*, 8: 114–36 for an extensive recapitulation of the commentary on this film.

16. See *Historia*, 8: 139–86 for an extensive commentary. See also Emilio García Riera, "Viridiana," *Film Culture* 24 (1962), p. 74; David Stewart Hull, "Viridiana," *Film Quarterly* 15 (Winter 1961/62): 55–56; Freddy Buache, *The Cinema of Luis Buñuel* (London: Tantivy Press, 1973), pp. 117–27; and Francisco Aranda, *Luis Buñuel* (London: Secker and Warburg, 1975), pp. 190–205.

17. *Historia*, 8: 292–96. See also Jorge Ayala Blanco, *La aventura del cine Mexicàno* (Mexico City: Ediciones Era, 1968), pp. 284–88.

18. See Reyes Nevares, *The Mexican Cinema: Interviews with Thirteen Directors* (Albuquerque: University of New Mexico Press, 1976), pp. 63–76 and Alberto Isaac, "Cine latinoamericano: reportaje a Luis Alcoriza," *Tiempo de cine*, año 5, no. 20/21 (Spring–Summer 1965), pp. 38–40, 80.

19. Ayala Blanco, *La aventura*, p. 304.

20. Vivian Lash, "Experimenting with Freedom in Mexico," *Film Quarterly* 19 (Summer 1966): 19. Lash writes that 18 films were completed while Ayala Blanco specifies and lists 12. For a complete listing of the films entered in the competition, see Ayala Blanco, *La aventura*, pp.3–5 and Appendix above, pp. 223–24.

21. Ayala Blanco, *La aventura*, p. 306.

22. Ibid., pp. 308–10. An interesting footnote to the film is that Luis Buñuel appeared in a cameo role.

23. With the exception of Miguel Barbachano Ponce, already well established in film circles as a producer of "quality" cinema.

24. Ayala Blanco, *La aventura*, p. 305.

25. Tomás Pérez-Turrent and Gillian Turner, "Mexico," in Peter Cowie, ed., *International Film Guide 1976* (London: Tantivy Press, 1977), p. 207.

26. Ayala Blanco, *La búsqueda del cine Mexicàno (1968–1972)*, 2 vols., Cuadernos de Cine #22 (Mexico City: UNAM, Dirección General de Difusión Cultural, 1974), 1: 13. *En el balcón vacio* was premiered at the French Institute and later shown at UNAM. Apparently it has never been shown commercially in Mexico. García Ascot, "El cine y el escritor," p. 104. The film is easily available at the Cineteca Nacional. Also included in the STPC's 1965 awards was distribution of the prize-winning film through the state channels. Independent filmmaking is not any easier in other countries, including the U.S. See for example Janet Stevenson, "Why So Few Independent Feature Films?" *In These Times*, 6–12 December 1977, p. 22.

27. Pérez-Turrent and Turner, "Mexico," in Cowie, ed., *International Film Guide 1974*, p. 237.

28. Ayala Blanco, *La búsqueda*, 1: 11.

29. See Elena Poniatowska's comments in *Historia*, 8: 200 and the *Visión* article quoted in ibid., pp. 202–3.

30. Alan Riding, "Mexico Elects a Symbol," *The New York Times Magazine*, 13 June 1976, p. 14; see also Sergio Zermeño, *México: Una democracia utópica. El movimiento estudiantil del 68*, prologue by Carlos Monsiváis (Mexico City: Siglo Veintiuno Editores, 1978).

31. Much more extensive coverage was given by the U.S. press to the American black athletes who gave a "black power" salute during the playing of the "Star-Spangled Banner" after being awarded their gold medals.

32. See also Elena Poniatowska, *Massacre in Mexico*, trans. Helen R. Lane (New York: Viking Press, 1975), originally published as *La noche de Tlatelolco: Testimonios de historia* (Mexico City: Ediciones Era, 1971).

33. Ayala Blanco, La búsqueda, 1: 13.

34. Ibid., 2: 333.

35. Ibid. For a discussion of the film, see pp. 332–37.

36. Ibid., pp. 339–40. For a discussion of *El grito*, see pp. 337–48.

37. Díaz Ordaz was quoted as saying, "If what you desire is to bury the cinema industry, I will preside over the funeral. The government is not interested in that industry." Alejandro Galindo, *¿Qué es el cine?* (Mexico City: Editorial Nuestro Tiempo, 1975), p. 129. Luis Echeverría had been appointed to the governing board of the Banco Cinematográfico in 1963. *Historia*, 8: 351.

38. Rodolfo Echeverría's professional name was Rodolfo Landa. He had been politically active as well as having been a performer; in 1952 he was elected a deputy to congress, "La Probable XLII Legislatura," *Hispanoamericano*, 13 June 1952, p. 9.

39. Cárdenas is considered by some to have been Marxist; Echeverría was nothing of the kind. Many observers looked upon the latter's wooing of the international left as little more than political opportunism.

40. For an assessment of the Echeverría presidency, see Riding, "Mexico Elects a Symbol," pp. 14–15, 19, 22.

41. *Informe general sobre la actividad cinematográfica en el año 1976 relativo al Banco Nacional Cinematográfico, S.A. y sus filiales* (Mexico City: Banco Nacional Cinematográfico, 26 November 1976), p. 11.

42. Ibid., p. 13.

43. Ibid., pp. 11–12.

44. Manuel Michel, "CCC: Un retrato escrito," *Otrocine*, no. 1 (January–March 1975), pp. 62–68.

45. "Edificio," *Cineteca Nacional 1974* (Mexico City: n.p., n.d. [compiled for in-house reference]), pp. 30–31.

46. "Acervo," *Cineteca National 1974*, pp. 35–38; *Informe general*, p. 408.

47. *Informe general*, p. 16.

48. Ibid., pp. 159–60. For more information on CONACINE see ibid., pp. 159–68; for CONACITE I, see pp. 187–91; and for CONACITE II, see pp. 201–204.

49. *Anuario de la producción cinematográfica mexicana, 1970/Mexicon Film Production, 1970/Production cinématographique mexicaine, 1970* (Mexico City: Procinemex, n.d.)

50. *Anuario . . . , 1971.*

51. *Anuario . . . , 1972.*

52. Alejandro Galindo characterized Alcoriza's *Mecánica nacional* as falsely portraying the way Mexicans behave, and bitterly attacked the Echeverría brothers for their policies toward the film industry. This writer suspects that Galindo's resentment was occasioned by the favoritism shown to young directors like Cazals. Galindo's own pet projects were realized in 1973: *El juicio de Martín Cortés* and *Ante el cadáver de un líder* (the latter his personal favorite), but they were not given the distribution or promotion he felt they deserved. Personal interview, Mexico City, 5 July 1977.

53. There are discrepancies between the Banco's figures and those from Procinemex's *Anuario*. For instance, the latter shows 72 full-length features and 8 independent films for 1971 for a total of 80 films, while the Banco indicates a total of 75. However, the *Informe general* also lists 7 films made by foreign companies in Mexico for a total of 82, a figure not reflected in the table.

54. Interview with Sigifredo García Sanz, Mexico City, 15 July 1977. García Sanz was associated with the film industry from 1947 to the early 1970s, principally in accounting but often becoming involved in other areas of filmmaking. In July 1977, Margarita López Portillo, in her capacity as General Director of Radio, Television, and Cinema—a post created especially for her—ordered a thoroughgoing reorganization of the film industry's financial structure and García Sanz was designated as a consultant to coordinate the project. At the time, he was hopeful that this meant a retreat from state participation in filmmaking.

55. However, it is true that the lowest yearly number of films made up to that time in the decade—42 films—was made in 1976. "México y Argentina

Dominados por el Sexo en su Cinematografía," *Excélsior*, 19 January 1977, Section Cine, Teatro, Radio y TV, p. 5.

56. See Sergio Guzik, "A Mass Changes Me More: An Interview with Alexandro [*sic*] Jodorowski," *The Drama Review* 14 (Winter 1970): 70–76. In the same issue, see also "The Mole: Excerpts from a Film Script," pp. 57–69.

57. For more on Jodorowski, see Miguel Barbachano Ponce, "Crítica de Cine: La Montaña Sagrada," *Excélsior*, 6 October 1976, Section Cine, Teatro, Radio y TV, p. 1. Jodorowski expressed impatience with the Mexican public's reception of his films. Complaining about censorship and the cuts he was obliged to make, Jodorowski said that "here in Mexico they are afraid of me, others are not censored." "La Gente de Mexico no Está Preparada Para ver mis Películas: Jodorowski," *Excélsior*, 1 October 1976, Section Cine, Teatro, Radio y TV, p. 1. For commentary on *Fando y Lis* and *El topo*, see Ayala Blanco, *La búsqueda*, 2: 407–15.

58. "Reitera LE que hay Libertad Para Tratarlo Todo en Cine," *Excélsior*, 28 June 1976, p. A–29. See also "El Gobierno Mexicano Nacionalizó la Industria del Cine y Ahora se Producen Películas que antes se Consideraban 'Tabúes,'" *Excélsior*, 26 October 1976, Section Cine, Teatro, Radio y TV, p. 1.

59. Reyes Nevares, *The Mexican Cinema*, pp. 67–68.

60. Agustín Gurezpe, "Ninguna Película del Nuevo Cine Mexicano Responde a la Necesidad Crítica de la Realidad Actual de Nuestro País," *Excélsior*, 22 July 1976, Section Cine, Teatro, Radio y TV, p. 1.

61. For this, the reader may consult Ayala Blanco's two invaluable works, already extensively cited here: *La aventura del cine mexicano* and *La búsqueda del cine mexicano*, 2 vols.

62. Its gross receipts up to January 1974 were second only to *The Godfather*—7,558,000 pesos. Sam Askinazy, "Mexico's Own Film $600,000 Behind 'Godpop,'" *Variety*, 9 January 1974, p. 10.

63. Manolo Fábregas has produced, directed, and acted in Spanish-language versions of *Life with Father, My Fair Lady*, and *Fiddler on the Roof* as well as many other adaptations of hit American shows. Marvin Alisky, "Fábregas's Broadway-to-Mexico Theater," *The Christian Science Monitor*, 2 October 1970, p. 4.

64. See Ayala Blanco, *La búsqueda*, 1: 164–69; Reyes Nevares, *The Mexican Cinema*, pp. 63, 69; Marvin Alisky, "Mexico versus Malthus: National Trends," *Current History* 66 (May 1974): 229–30; "Lo Mejor de los Estrenos en 1972," *Hispanoamericano*, 15 January 1973, p. 56; and Angel A. Pérez Gómez, "Luis Alcoriza: Mecánica nacional," *Reseña* (Madrid), año 14, no. 103 (March 1977), p. 29.

65. Ayala Blanco, *La búsqueda*, 2: 503.

66. Ibid., pp. 503–6. See also Alvaro Uribe, "Entrevista a Alfredo Joskowicz," *Otrocine*, no, 3 (July–September 1975), pp. 64–67; José Luis Peralta, "El cambio," ibid., pp. 68–70.

67. For an account of the town and the actual events, see Elsa R. de Estrada, "Ecos de un linchamiento en el pueblo de las bocinas," *Contenido*

(Mexico City), June 1976, pp. 72–82. For a description of how the screenplay was written see Tomás Pérez-Turrent, "Una experiencia alrededor de Canoa," *Otrocine*, no. 2 (April–June 1975), pp. 8–12. See also Fernando Gaxiola, "Canoa, memoria de un hecho vergonzante," *Otrocine*, no. 1 (January–March 1975), p. 10; "Reportaje y Denuncia," *Hispanoamericano*, 16 February 1976, p. 59; Antonia Landa G., "Canoa," *Otrocine*, no. 4 (October–December 1975), pp. 14–15; and Martha L. Sepúlveda, "Sobre Canoa," ibid., pp. 16–18.

68. Poli Délano, "El apando," *Otrocine*, no. 6 (April–June 1976), p. 33; Douglas Sánchez, "El apando," ibid., pp. 34–35; Jaime A. Shelley, "Conversación con Felipe Cazals," ibid., no. 3 (July–September 1975), pp. 34–43.

69. Agustín Gurezpe, "'Nunca más Traeré Pistola al Cinto,' Prometió el 'Indio' Fernández ayer en los Churubusco," *Excélsior*, 14 December 1976, Section Cine, Teatro, Radio y TV, pp. 1, 5; Juan de Ayala, "A Ultima Hora el 'Indio' Fernández Tuvo que Pagar $150,000 de Fianza," ibid., 11 December 1976, p. 1; Ayala Blanco, *La búsqueda*, 1: 19–39.

70. See Luis Reyes de la Maza, "De cómo el papá de Martín Cortés se fue mucho para el Tivoli," *Otrocine*, no. 1 (January–March 1975), pp. 33–39.

71. Reyes Nevares, *The Mexican Cinema*, p. 29.

72. Letter from Christon I. Archer, 1 December 1977. See also Stanley Meisler, "Is This Democracy?" *Los Angeles Times*, 7 March 1976, p. IX–4.

73. Francisco Sánchez, "Tívoli," *Otrocine*, no. 1 (January–March 1975), pp. 19–25; Jaime A. Shelley, "Entrevista con Alberto Isaac," ibid., pp. 23–32.

74. Jesús Salvador Treviño, "The New Mexican Cinema," *Film Quarterly* 34 (Spring 1980): 30–31.

75. There has been scant attention paid to recent Mexican films by American critics. *Canoa*, which won a "Silver Bear" at the 1976 Berlin Film Festival (Ricardo Perete, "¡Corte!" *Excélsior*, 1 October 1976, Section Cine, Teatro, Radio y TV, p. 1) apparently has never been released to general audiences in the United States. However, the Museum of Modern Art in 1977 did acquire for its permanent holdings eight recent Mexican films including *Actas de Marusia* (*The New Yorker*, 17 January 1977, p. 18). The series was sent on tour around the country and reviewed by Dennis West ("Mexican Cinema in 1977: A Commentary on the Mexican Film Festival Presently Touring the U.S.," *The American Hispanist* 2 [May 1977]: 6–7, 13–14). For reviews of Paul Leduc's *Reed: México insurgente* see Lewis H. Diuguid, "AFI's Latin American Film Festival," *The Washington Post*, 17 March 1974, p. E4; Kevin Thomas, "'Reed' Treats Mexico Revolt," *Los Angeles Times*, 9 March 1976, p. IV–8; and Michael Goodwin, "Reed: Insurgent Mexico," *Take One* 4 (December 1974): 31. Rafael Corkidi's *Pafnucio Santo* (1976) was shown at the 15th New York Film Festival—the first Mexican film ever included—and reviewed by Lawrence van Gelder, "Film Festival: Pafnucio Santo," *New York Times*, 27 September 1977. See also Carl Mora, "Let's Screen More Latin Films," *Nuestro*, October 1977, p. 59; and idem, "Mexico's Commercial Films: Sources for the Study of Social History," *PCCLAS Proceedings* 6 (1977–1979): 205–15.

76. Pedro Chaskel, another exiled Chilean cineast, praised Mexico for the support it had given Littín: "it represents not only a courtesy, but also backing for the Chilean resistance which struggles for the liberation of our country." He also said that the cameraman Jorge Muller and the actress Carmen Bueno had last been reported in "a concentration camp where they had been tortured." Agustín Gurezpe, "Habla Pedro Chaskel, Chileno en el Exilio —Tarea de Cineastas Latinoamericanos: Luchar por Descolonización Cultural," *Excélsior*, 29 May 1976, p. 30-A.

77. He singled out Tennessee Williams, one of the jurors, as being responsible for the negative vote. Williams had attacked violence in films, presumably with *Actas de Marusio* in mind. Agustín Gurezpe, "Littín Afirma que Perdío en Cannes por un Voto," *Excélsior*, 18 June 1976, p. C–1.

78. It opened at 14 theaters in the Federal District and took in 668,767 pesos in one day's receipts. Miguel Pareja Donoso, "Actas de Marusia," *Mañana*, 24 April 1976, p. 10.

79. Betty Jeffries Demby, "The 30th Cannes Film Festival," *Filmmakers Newsletter*, October, 1980, pp. 28–33. The special treatment accorded Littín in Mexico did not fail to elicit criticism; he denied that he "ever pretended to leadership or to take the attitude that he was a hero or saviour of the Mexican cinema . . . he received the normal salary of a Mexican film director." "Respuesta de Miguel Littín a Avila Camacho," *Excélsior*, 27 October 1976, Section Cine, Teatro, Radio y TV, p. 1. See also Fernando Gaxiola, " 'Actas de Marusia'—la posibilidad de un cine popular," *Otrocine*, no. 1 (January–March 1975), p. 9; "Actas de Marusia," *La Revue du Cinéma—Image et Son*, no. 306 (May 1976), pp. 66–67; "Film in Chile: An Interview with Miguel Littín," *Cineaste* 4: 4–9; "Nuevo cine, nuevos realizadores, nuevos filmes: Entrevista a Miguel Littín," *Cine cubano*, no. 63–65 (1970), pp. 1–6; "Premios para 'Actas de Marusia' y 'Universidad Comprometida,' en Huelva," *Excélsior*, 14 December 1976, Section Cine, Teatro, Radio y TV, p. 1; "It's Been a Great Year for International Films," *The Hollywood Reporter*, 26 October 1976, p. 18; "Chilean Exile Makes Hit with 'Letters from Marusia,' " ibid., 26 October 1976, p. 61; David Wilson, "Letters from Marusia," *Sight and Sound* (Winter 1976/1977), pp. 60–61.

80. "El Arte Como Función Social," *Hispanoamericano*, 11 April 1977, pp. 41–42. See pages 39–43 for an interview with Arau. See also Agustín Gurezpe, "En 'Suspenso' la Película que Arau Filmó en La Habana," *Excélsior*, 9 October 1976, Section Cine, Teatro, Radio y TV, p. 1.

81. Ricardo Perete, "¡Corte!" *Excélsior*, 29 July 1976, Section Cine, Teatro, Radio y TV, p. 1.

82. From personal observation, it seems apparent to this writer that most young Chicanos have little fluency in Spanish—a disadvantage that would effectively preclude them from being a major audience for Mexican films, "Chicano" or otherwise. For instance, *Chicano* (1975) is purportedly based on the exploits of the New Mexico land grant activist Reies López Tijerina, yet the film apparently has not been shown commercially in New Mexico. At any rate, following the brief spate of publicity on Tijerina as a result of his and his

followers' seizure in 1967 of the courthouse at Tierra Amarilla, New Mexico, he retreated into general anonymity with the exception of a visit to President Echeverría that seems to have been reported only in Albuquerque (Tomas Martinez, "Echeverría Meets Group," *Albuquerque Journal*, 13 June 1976, p. 1). The fact that Jaime Casillas, director of *Chicano*, thought that Tijerina was still a major figure among Mexican-American militants points to the lack of knowledge in Mexico regarding the situation. See Charles R. Garrett II, "El Tigre Revisited," *Nuestro*, August 1977, pp. 16–18, 20. Katy Jurado, a well-known Mexican actress with long experience in Hollywood, voiced criticism of Chicanos saying that she "did not understand" the Chicano movement because they are "North Americans" fighting their own country, an attitude which she found "absurd." "Katy Dijo en París que no Entiende a los Chicanos," *El Sol de México*, 22 July 1977, p. E4.

83. David R. Maciel, ed., *La otra cara de México: el pueblo chicano*, prologue by Carlos Monsiváis (Mexico City: Ediciones "El Caballito," 1977), p. 16. The "Chicano public," it seems, prefers the "traditional" package films. The new Mexican cinema with its slow-paced intellectualizing in the European style did not prove popular among Mexican-American audiences according to Gonzalo Checa, president of the California Association of Spanish Film Exhibitors. Carl Hillos, "Gonzalo Checa Espera el Envío de 'Tradicionales,'" *Novedades*, 7 January 1975, Section Novedades en los Espectáculos, pp. 1, 4. See Ayala Blanco's discussion of Mexican Americans in Mexican films and Chicano filmmaking in the United States in *La búsqueda*, 2: 353–58; Carlos Morton, "Why No Chicano Film Makers? Platica con Luis Sedano y Antonio Orgaz," *La Luz*, June 1977, pp. 25–28; Rafael C. Castillo, "Films: Cine Festival," *Nuestro*, December 1979, pp. 51–52; Victor Valle, "Let the Chicano Films Roll," ibid., pp. 51–52; David R. Maciel, "Del pocho, al bracero, al chicano: Perspectives on the Chicano in the Contemporary Mexican Cinema," in Linda B. Hall, ed., *Popular Culture in Mexico and the U.S. Southwest* (San Antonio, Texas: Trinity University Press, forthcoming); and Jesús Salvador Treviño, "Chicano Cinema" (unpublished paper).

84. Letter from Alfonso Arau, 7 November 1977. In 1979 Arau completed *Mojado Power*, a musical comedy filmed in Tijuana and California. It was produced by AMX Productions. "Alfonso Arau's Latest, 'Mojado Power,'" *The Hollywood Reporter*, March 1979, p. S–18.

85. "En Defensa de una Actriz," *Hispanoamericano*, 13 March 1953, p. 47. See also Larry Ceplair and Steven Englund, *The Inquisition in Hollywood: Politics in the Film Community, 1930–1960* (Garden City. N.Y.: Anchor Press/Doubleday, 1980), pp. 417–18.

86. *Historia*, 7: 367–71. Cantinflas's debut was in the supporting role of Passepartout in *Around the World in 80 Days*.

87. Wini Scheffler, "Foreign Filming Leaves Below-the-Line Income," *Mex-Am Review* 43 (August 1975): 4–5, 7, 9.

88. Luis Torres, "Raices de sangre: First Feature Film Directed by a Chicano," *Somos*, June/July 1978, pp. 17–19; Jesús Salvador Treviño, "Chicano Cinema," pp. 15–16; Maciel, "Del pocho"; Armando Mora, "Qué Actores Irán

con los Chicanos" and idem, "Actores de la Metrópoli Alternarán con Chicanos," *El Sol de México*, 30 August 1976; Agustín Gurezpe, "El Cine Estadounidense Está Cerrado Para los Actores y Realizadores 'Chicanos,'" *Excélsior*, 26 August 1976, Section Cine, Teatro, Radio y TV; and Eduardo de la Vega Alfaro, "Butaca: 'Raices de Sangre,'" *Uno Más Uno*, Mexico City, n.d.

89. For instance, CONACINE II lodged a protest on behalf of STIC when the filming of Mariano Azuela's novel, *Los de abajo*, was assigned to Churubusco. "En Octubre se Rodará 'Los de Abajo,' de Mariano Azuela," *Excélsior*, 13 September 1976, Section Cine, Teatro, Radio y TV, p. 1. See also Agustín Gurezpe, "Técnicos y Manuales Contra los Largometrajes en los 'América,'" ibid., 21 July 1976, p. 1; idem, "Es Necesario que se Reanude la Comunicación Entre STIC y STPC," ibid., 10 September 1976, p. 1; idem, "Maximino Molina Pide que se Establezca la Competencia Entre Churubusco y América," ibid., 12 October 1976, p. 1; and Beatriz Reyes Nevares, "Entre cretinos y voraces naufraga el cine mexicano," *Siempre*, 3 January 1973, pp. 40–41, 70.

90. "El Gobierno Mexicano Nacionalizó," p. 1; Gregg Kilday, "Mexico's Revolution in Film-Making," *Los Angeles Times*, 24 March 1976, p. IV–14.

91. Sam Askinazy, "Echeverría Exit: His Film Reforms Open Up Mexico," *Variety*, 5 January 1977, pp. 16, 56; Agustín Gurezpe, "RE Acabo con el Cine Vacío de 30 Años: que Continúe de Director del Banco," *Excélsior*, 22 May 1976, p. 24–A; Wilson McKinney, "Mexican Film Industry Improving Its Quality," *San Antonio Express-News*, 5 October 1975, p. 8–A; Louis Margorelles, "Le Renoveau Mexicain," *La Revue du Cinéma—Image et Son*, no. 280 (January 1974), pp. 72–90; "Cinéma Mexicain," ibid., no. 295 (April 1975), pp. 20–28; Beatriz Reyes Nevares, "El cine mexicano es hoy de mejor calidad," *Siempre*, 27 December 1972, pp. 42–43; Martha Naranjo, "Echeverria—Giant of Mexican Filmmaking," *The Hollywood Reporter*, 26 October 1976, pp. 1, 64; "Mexico Carves Out Share of World Film Market," ibid., p. 9.

For additional readings on the Echeverría *sexenio* and its impact on films see Alberto Ruy Sánchez, "Cine mexicano: producción social de una estética, "*Historia y Sociedad*, no. 18 (Summer 1978), pp. 71–83; Javier Solórzano, "El nuevo cine en México: Entrevista a Emilio García Riera, "*Comunicación y cultura* 5 (March 1978), pp. 7–18; David Ramón, "Un sexenio de cine en México," *Comunicación* 21 (March 1977), pp. 24–33; Emilio García Riera, "Seis años de cine mexicano (1)," *Proceso*, 6 November 1976, pp. 68–69; idem, "Del cine mercantil al cine de autor," ibid., 13 November 1976, pp. 72–73; idem, "El choque con la censura hipócrita," ibid., 20 November 1976, pp. 72–73; Cristina Pacheco, "El Cine, Su Vicio" [interview with Emilio García Riera], *Siempre*, 1 November 1978, pp. 32–34, 70.

92. Agustín Gurezpe, "Reyes Heroles dió Posesión a García Borja en el Banco Cinematográfico," *Excélsior*, 9 December 1976, Section Cine, Teatro, Radio y TV, p. 1.

93. Rubén Torres, "Crean la Productora Nacional de Radio y Televisión, Dependiente de la Sría de Gobernación," *El Heraldo de México*, 5 July 1977, p. 1D.

94. In a letter received by this writer dated 23 July 1980 from Humberto Enríque Hernández, an official of the Secretaría de Gobernación, the CCC is mentioned as being headed by Alfredo Joscowicz. In the same letter it is stated that Benito Alazraki is director of CONACINE and Carlos Ortiz Tejeda is head of CONACITE II. A subsequent description of CUEC as "the only advanced school of cinema in the country" indicated that the CCC was no more. Germán Ramos Navas, "de todos modos CUEC te llamas," *Excélsior: Diorama de la Cultura*, 7 September 1980, p. 3. However, as of early January 1981, the film school was still in operation, with Joscowicz in charge. Martha Aurora Espinosa, "Actualización técnica, temática, de exhibición, y distribución, necesidades del cine nacional," *Uno Más Uno*, 13 January 1981, p. 22. See also Pérez Turrent and Turner, "Mexico," *International Film Guide 1981*, pp. 218–21.

95. "Cabos sueltos: Víctimas del pecado: el fin del Centro de Capacitación Cinematográfica," *Nexos 24 (December 1979), pp. 4–5, 9, 11*.

96. *According to Ying Ying Wu, "Trying Times in Mexico," Nuestro,* May 1980, p. 27.

97. Ibid.

98. Luis Suárez, "Habla Margarita López Portillo," *Siempre*, 11 July 1979, p. 29.

99. Ibid.

100. "Pido buena fe y sentido de responsabilidad para afrontar la crisis del cine mexicano, dice Margarita López Portillo," *Siempre*, 13 June 1979, p. 58.

101. Ibid.

102. Wu, "Trying Times in Mexico," p. 27; "Margarita López Portillo Hails Impact of Revitalization of Film Production," *The Hollywood Reporter*, March 1979, p. S–3 (this issue contained a special section on Mexican cinema).

103. "Informe de labores del periodo lectivo del Sr. Manuel Ampudia Girión," *Organo Informativo de la Cámara Nacional de la Industria Cinematográfica*, 10 March 1980, pp. 12–19.

104. *Guyana* was a Mexican-Spanish coproduction with Izaro Films; CONACINE financed 20% of the total production costs which were almost 2,600,000 (U.S.) dollars. *Variety*, 19 March 1980, p. 39. This was a special issue devoted to Latin American filmmaking. The Mexican section begins on p. 65. See also Alejandro Sigler M.'s interview with René Cardona, Jr., in *Organo Informativo*, January 1980, p. 11.

105. Stephen Klain, "Televicine Rolls Yank Hispanic Link," *Variety*, 28 May 1980, p. 3; " 'Televisa' Moves Ahead," *The Hollywood Reporter*, March 1979, p. 5–4.

106. "Mexican Conglom in U.S. Toehold," *Variety*, 26 March 1980, pp. 1, 99.

107. Televisa's U.S. operation prompted a charge by the Spanish Radio Broadcasters of America that the Mexican corporation is monopolizing Spanish-language television broadcasting in this country. Specific allegations include charges that Televisa-controlled SIN illegally owns five of its affiliated stations and that it owns a sales representative firm which sells advertising to its own network affiliates. SIN claims to have 57 affiliates in the United States. Paul R. Wieck, "FCC Investigates Spanish TV Network," *Albuquerque Journal*, 13 September 1980, p. B–8.

108. Ignacio Rodríguez C., "El cine comercial no puede ser elitista," *Organo Informativo*, 10 March 1980, p. 31.

The Indian Question

Charles Ramírez Berg

There are things that upon touching begin to bleed. This is one of them.

The Narrator of María Candelaría

The roughly eight to ten million Indians in Mexico that make up approximately 10 percent of the population belong to more than fifty distinct Indian groups, each with its own language and tradition. They constitute a sizable population in a nation where mestizos are the vast majority, creoles a small minority. But though numerically inferior, white creoles are the nation's phenotypical ideal.

This ideal was institutionalized by a colonial caste system that placed the European at the pinnacle and the Indian at the bottom. Social standing and privilege accrued to mestizos who could demonstrate —ideologically, culturally, and genetically—their allegiance to the conquering Spaniard. Mexicans have been divided subjects ever since. They honor their native heritage but understand that, within the hierarchical system in which they live, aligning themselves with light skin is socially advantageous. Seen in this existential light, paying lip service to their Indian roots while adopting Eurocentric ways is a survival tactic, though not one to be proud of.

The presence of unassimilated Indians recalls that shame and provides the sociopsychological rationale for their marginalization. It is easier for mestizo Mexico to disregard the Indians' pitiful existence

Charles Ramírez Berg, *Cinema of Solitude: A Critical Study of Mexican Film, 1967–1983.* Austin: University of Texas Press, 1992, pp. 137–56. By permission of the publisher.

than to come to terms with its own history of cultural compromises. Furthermore, unassimilated Indians—separated from the rest of the nation by skin color, geography, language, tribal customs, and low social status—are another reminder that egalitarian revolutionary ideals go largely unrealized. Mexico is caught between the pride it proclaims for its Indian roots and the sad reality of the Indian experience—past and present.

Mexicans who try to help come face-to-face with a segregation-assimilation dilemma, with neither alternative resolving the Indian question. Segregation is morally indefensible. Promoting assimilation is problematic because mainstreaming involves a kind of cultural amnesia associated with selling one's soul to the colonizing devil. Seemingly any treatment of the Indians—ignoring them or helping them—returns Mexicans to the same shameful starting point. Truly the Indian question is a hypersensitive national sore. Revered in history, Indians are neglected in fact, relegated to the fringes of Mexican life. The same is true in the movies where, in the main, *los indios* are Mexican cinema's structured absence.

When Indians do appear, they are usually stereotypical minor characters—rural simpletons who provide comic relief or servants who cook, clean, and open the doors for the lighter-skinned protagonists. Villains are seldom identifiable Indians, though they often exhibit the Indian's key iconographical marker—dark skin color. Other film conventions that have become stereotypical signs by which Indians are recognized include their straight black hair and white peasant dress, their extremely submissive attitude and hopping, short-stepping gait, and their sing-song Spanish with mispronounced words. In general, this long-standing pattern of representing minor Indian characters continued relatively unchanged in films of the 1960s, 1970s, and 1980s.

The exception is a well-established genre of Indian films in which Indians are the protagonists. Initiated by *Janitzio* (1934, directed by Carlos Navarro, starring Emilio Fernández), the genre crystallized with Emilio Fernández's *María Candelaría* (1943). To the "question" posed by Mexican Indians, films like these repeatedly offered a bleak answer—the encounter between Indian and non-Indian results in death, customarily of the Indian, who was often a woman.

By varying the standard genre formula, more recent films in the genre investigated the Indian's contradictory place in Mexican history—and in the Mexican consciousness—for a new generation of viewers. But although the genre was revised and updated, the films continued to affirm that Indians were still a "problem," a question without an answer. It reintroduced *mexicanidad* because one way the self is

defined is in relation to others. And historically *indios* are Mexico's inescapable Other.

The Tormenting Presence of the Indian

> Everyone knows what these Indians are, with their incomprehensible language . . . [they are] inexpressive, sly, without the least bit of ability to express themselves like normal human beings.
>
> Eduardo in *Llovizna*

Sergio Olhovich's thoughtful and perturbing film, *Llovizna* (*Drizzle*, 1977), is a demonstration of the way the idea of the Indian works on the Mexican mind to produce neurosis. It argues that the marginalization of Indian is destructive for all concerned. It is the story of Eduardo (Aarón Hernán), a traveling salesman who picks up four Indian men on a remote highway late one night. Carrying 100,000 pesos in cash from a business transaction, Eduardo's paranoid anxieties intensify, building upon his racism. At one point, he even imagines the Indians murdering him to steal his money. When he has to stop to change a flat tire (caused when one of the Indians, hopelessly drunk, makes Eduardo lose control of his van), Eduardo is at the breaking point. "These Indians are making a fool of me," he says to himself, "damned tire, damned night . . . damned Indians." The drunk comes up to him and Eduardo pushes him away. When another Indian rushes up to help, Eduardo, interpreting this as an assault, panics and shoots him. Then he turns his gun on two of the others. Leaving the drunk crying but unharmed, he drives off.

A shaken Eduardo arrives home to his wife and daughter the next morning. He reads about the death of the three Indians in the afternoon newspaper and confesses to his wife that he is the murderer. Momentarily stunned, she collects herself and says, on her way out to supervise their daughter's birthday party, "They were only some Indians." Alone in his den, as he watches the children attempting to burst a piñata, Eduardo decides that his wife is right. "Defend our home," he says to himself, "protect our daughter, our security—that's what's important." When the film concludes, Eduardo is telling us that the newspapers soon dropped their investigation of the killings and that the police apparently never began one. "They were only Indians," he muses. "They're not worth remembering."

Seemingly, Eduardo has successfully exiled the Indians to the dim corners of his consciousness—and his conscience. The film's final shot of Eduardo in peaceful sleep would seem to confirm his equanimity. But his interior monologue gives the lie to his professed clear con-

science. "What happened that night," he says as the camera moves in from a medium shot to a close-up of his tormented face, was "something terrible that I can't forget." Far from being easily dismissed, Eduardo's murder of the Indians has become the recurring nightmare produced by his nagging conscience.

Eduardo's guilt is like Mexico's: primed with insecurity and loaded with guilt, precariously balanced between fear and violence. *Llovizna*'s comment is that the mistreatment of Indians harms both *indios* and mestizos. We are left with the frightening moral vacuum of a man who lives a lie and dreams a nightmare. The Indians are dead, and Eduardo might as well be. The oppressors, says *Llovizna*, are worse off than the victims.

To be fair, there have been earnest attempts by the state to help the Indians. Through educational reform and a policy of *indigenismo* (indigenism, or Indianism), the state did try to improve the Indians' lot after the Revolution. But from their very inception these, too, like all of Mexico's dealings with the Indian, were riddled with contradictions.

The Contradictory Policy of Acculturation

> As long as Mexico's Indians do not participate in the civic, intellectual and productive life of the country, they will be foreigners in their own land, exposed to the abuse of those who possess most and excluded from the benefits of civilization. . . . We talk of Mexicanizing our natural resources without realizing that it is also necessary to Mexicanize our human resources.
>
> President Luis Echeverría Alvarez[1]

Indians accounted for nearly half of Mexico's population around the turn of the century, so it is not surprising that they made up a substantial part of the fighting forces in the Revolution.[2] As landless peasants, they had a considerable stake in the outcome, but their political leverage was nil. Afterward, the Indians had little to show for their crucial contribution to the revolutionary effort. They had been duped into spilling their blood and fighting the Revolution for their commanders, just as centuries before they had done much of the Spaniards' conquering for them.[3]

Some Mexican leaders recognized the Indians' plight and worked to help them. As Minister of Education, José Vasconcelos instituted a nationwide education program. Its primary goal—teaching the Indians Spanish in order to "civilize" them—may have been naive and elitist but was nevertheless a key governmental initiative that honestly sought to improve the native's status.

The president who did the most for the Indian cause was Lázaro Cárdenas del Río (1934–1940), who declared that the "indigenous problem is not to maintain the Indian as an Indian nor of 'Indianizing' Mexico, but it lies in how to 'Mexicanize' the Indian [while] respecting his blood."[4] Cárdenas established the Department of Indian Affairs in 1936 to direct a national Indian program. The precise meaning of "Mexicanizing," however, remained hazy, and it was unclear how such a plan could be implemented and still respect Indian tradition. Later, in 1948, the National Indian Institute (INI) was formed with the expressed purpose of involving the Indian in Mexico's economy. *Indigenismo*, as defined by INI founder Alfonso Caso, encompassed both an awareness of the Indian's predicament and a state plan for dealing with it. Once again, the same contradictions arose. How could the integrity of the Indian communities be respected if simultaneously they were to be integrated, in Caso's words, "into the economic, social, and political life of the nation"?[5] By mid-century Mexico's attitude toward the Indian, though benevolent, still had not changed significantly from the days of the Conquest. The state had not yet found a workable way to incorporate the Indian and, some would argue, was uncertain whether it really wanted to.

More recently, President Luis Echeverría Alvarez, in the spirit of Cárdenas, redoubled the state's commitment to bettering the native's life. During Echeverría's term of office, for example, the number of INI centers increased from twelve to seventy. In some instances tribal land rights were recognized: more than 600,000 hectares of Chiapas jungle were deeded to the Lacandón Indians, and the Seri Indians recovered Tiburón Island in the Gulf of California.[6] But despite these measures, the state's relationship to Indians remained on the whole what it had always been: contradictory, paternalistic, separatist.

And exploitive. As Mexican anthropologists Ricardo Pozas and Isabel H. de Pozas have written, the use of "such mystified terms as . . . 'acculturation,' 'ethnic integration,' or the dichotomies such as the conquerors and the conquered . . . the participants and the marginalized . . . should be replaced with 'the exploiters' and 'the exploited,'" terms that more accurately reflect both the Indians' original colonial situation as well as their current one.[7] In a similar vein, sociologist James D. Cockcroft charges that INI "either masks or legitimizes the exploiting and cheating of Indians routinely carried out by *caciques* [local bosses], *neolatifundistas* [large landowners], merchants, moneylenders, migrant-labor recruiters, agribusiness henchmen, and private or state factory and workshop owners."[8] During this century the internal Indian nation became in effect an internal colony and Indians were

subjected to "the renewed loss of their communal lands" and exploited "as cheap labor at harvest time."[9]

Spanning more than 450 years, the history of the Indian in Mexico remains a sadly consistent pattern of isolation, submission, and silence on the part of the native and a policy of domination, exploitation, and marginalization on the part of the state. A recent group of Mexican films retraces that history from colonial times to the present, reiterating that in most significant particulars nothing has changed.

The Cinematic History of the Indian

El juicio de Martín Cortés: The Chilling Symmetry of Then and Now

> For us . . . there is not just one time; all times are alive, all the pasts are present.
>
> Carlos Fuentes[10]

Past and present coexist and come to life in *El juicio de Martín Cortés* (*The Trial of Martín Cortés*, 1973; written and directed by Alejandro Galindo), and one man dies because of it. An actor, Oscar Román (Gonzalo Vega), is accused of the on-stage murder of another actor during the premiere performance of a new play entitled *Martín Cortés, the First Mexican*. An investigating police officer (David Reynoso) arrives at the theater with the accused, his attorney, and the police to inspect the scene of the crime. Oscar's defense attorney argues that his client killed because he completely immersed himself into his role. Evidently the play was just as compelling for audience members —they screamed their approval of Oscar's attack on the other performer.

The play focuses on Cortés's two grown sons, one the first mestizo (Oscar's part), born to La Malinche out of wedlock, the other a full-blooded Spaniard (the part played by the actor who was killed), the legitimate offspring of the don's Spanish wife—half-brothers both named Martín Cortés. Recounting the beginnings of racial prejudice in Mexico, Oscar's defense attorney contends that the play fanned ancient animosities and consequently Oscar's act is a justifiable homicide. The investigator is skeptical. "There is no racial prejudice in Mexico," he says, mouthing the official credo. Why, he himself is part Indian.

Just to make sure, the important scenes of the play are reenacted. After the death of Don Hernán Cortés, the Spanish Martín (now played by an understudy), supported by his mestizo half-brother, plots

the overthrow of the colonial government in order to set himself up as king of Mexico. When the conspiracy is discovered, the Spanish Martín proclaims his innocence and accuses his half-brother of treason.

Mestizo Martín realizes that he is as much betrayed by his creole half-brother as by history. "I am a cornered beast who never knew peace," he says, in words that apply not only to himself but to his mestizo descendants as well. "Men have deposited in me their hatreds, their darkest sentiments. I am . . . condemned." He is granted clemency and his death sentence is lifted, though he loses his legal inheritance and property. But when his creole half-brother demands his exile from Mexico, mestizo Martín attacks him. At this moment, the very point at which Oscar killed the actor the previous night as the audience screamed its consent, the investigator stands and shouts "Kill him!" Composing himself, he disqualifies himself from the case because he is mestizo. "Four centuries of history," he says, "four hundred years of hatreds and humiliations neither resolved nor overcome. In one moment it all exploded."

The film does a credible—if overly literary—job of illustrating how mestizo Mexico remains torn between loving and hating its parents, though it can't avoid traces of the same ambivalence. Galindo's title of the play within the film attests to this. *Martín Cortés, the First Mexican* implies that mestizos are Mexican but Indians are not. In fact, in the film the Indians are shunted to the background as Mexico's racial problem is framed as how mestizos can come to terms with their dual heritages. As such, it becomes primarily a matter of how to construct a coherent mestizo identity rather than how to incorporate the Indian. Again *los indios* get lost in the shuffle. As if to prove how treacherous the Indian problem is, *El juicio de Martín Cortés* embroils itself in the very dilemma it seeks to expose.

As I pointed out earlier, Mexico's love-hate relationship with its Spanish and Indian ancestors is a complex cultural schizophrenia that may well be unresolvable. It's no wonder that the state's attitude toward the Indian is conflicted and unsuccessful. INI's programs don't work—or work only superficially—because attempts to involve the Indian economically do not address the deeper levels of the Indian issue. Rather than grapple with this dilemma, Mexico has historically formulated two ways to deal with the Indian Other: oppression or neglect. These are illustrated by a striking pair of films made by director Julián Pastor that bring the filmed history of the Indian into the twentieth century.

Endless Servitude: Pastor's Nativist Couplet

> Thousands of wretches . . . languished from generation to generation
> . . . with their soul and their conscience subject to an invisible iron
> will, to a bitter enslavement in which they had learned . . . that they
> could not have any dream of happiness but alcohol, nor any hope of
> liberation but death.
>
> Salvador Alvarado

This description of the Indians of Yucatán, from General Alvarado's revolutionary memoirs, scrolls on the screen at the beginning of Julián Pastor's *La casta divina* (*The Divine Caste*, 1976). The film's title refers to the aristocracy of Yucatán who prospered during the Porfirio Díaz regime and considered themselves part of a divine plan. As the *hacendado* (landed gentry) protagonist (Ignacio López Tarso) explains it, his class's concern for the Indians must be exhibited in accordance with their God-given superiority over them. This divine system is threatened when the Revolution and its libertarian ideals advance from the north in the form of General Salvador Alvarado's (Jorge Martínez de Hoyos) army. The *hacendados* order the Indians to defend them, but they refuse, and in the film's final scene the "divine caste" flees to Cuba.

La casta divina is highly critical of the landowners' treatment of the Indians, but it can't help being at least partly a self-congratulatory revolutionary fantasy. Once upon a time in a remote part of the country a perverse band of aristocrats abused the Indians, but the Revolution drove them from the land. Now things are better. But when paired with Pastor's other Indian film, *Los pequeños privilegios* (*Small Privileges*, 1977), the director's critique of Mexico's conduct toward the Indian is clarified. *Los pequeños privilegios* reveals that neglect rather than coercion is the current method used to oppress Indians.

The film contrasts the pregnancies of Cristina (Cristina Moreno), the bourgeois wife of Pedro (Pedro Armendáriz, Jr.), an up-and-coming Mexican businessman, and Imelda (Yara Patricia), their fifteen-year-old unmarried servant, who has left her rural village to hide the shame of her pregnancy. Cristina cheerfully prepares for her baby's arrival, receives money from her mother, goes to birthing classes, and does the proper exercises. In the meantime, Imelda attempts to abort her baby in several crude ways. She bounces down a stairwell on her rear end, for example, hoping to jar the fetus loose. She finally succeeds by using a coat hanger, but serious hemorrhaging leaves her sterile.

It is only when her postabortion hemorrhaging necessitates hospitalization that Cristina and Pedro become aware of Imelda's condition.

They never saw her problem because they never saw her. Existing only to serve, the more invisibly she performed her duties, the better. After her recuperation, she becomes a quaint, live-in example of the ignorance of rural ways. In the film's last shot, Imelda walks Cristina and Pedro's baby in a park. Her sterile servility is *Los pequeños privilegios*'s final commentary: Mexico's blithe disregard of the Indians conveniently promotes the status quo, maintains creole-mestizo domination over the natives, keeps them in their place, and will eventually eradicate them.

During the six decades that have transpired between the events recounted in *La casta divina* and *Los pequeños privilegios*, the languishing of Indian wretches continues. Mexico's Indians remain enslaved by their low social standing, their depressed economic position, and their almost absolute lack of opportunity. Today the petit bourgeoisie enjoys institutionalized class privileges that make it modern Mexico's divine caste.

The Uses of Glorification

Besides oppression and neglect, Indians have been dispatched to Mexico's psychological hinterlands by glorifying them. Just as males try to tame the feminine threat by overvaluing women, Indians are marginalized by being ennobled and exalted. Ultimately, this is what Ismael Rodríguez's *Mi niño Tizoc* (*My Son Tizoc*, 1971) does.

As a director, Rodríguez contributed significantly to the Indian genre. The title, *Mi niño Tizoc*, recalls his earlier *Tizoc* (1956), a popular film with an Indian theme that won a posthumous Best Actor award for Pedro Infante at the Berlin Film Festival, was given a Best Foreign Film Golden Globe award in Hollywood in 1958 by the foreign press, and won the Best Film Ariel in Mexico. Rodríguez also directed *Animas Trujano* (1961), starring Japanese actor Toshiro Mifune as a native Indian, which was similarly honored with a Golden Globe and awards at film festivals in San Francisco in 1961 and Valladolid, Spain, in 1963. But the implications of Rodríguez's genre revision in *Mi niño Tizoc*—an informal remake of *María Candelaria*—are problematic to say the least.

Mi niño Tizoc takes place in Xochimilco (Augustín Lara's song of the same name is sung over the title credits) and tells of a simple Indian and widowed father, Carmelo (Alberto Vásquez), who lovingly raises his son, Tizoc (Cuitláhuac Rodríguez, the director's son). They make their living by selling flowers to the tourists and are so hardworking and honest that they are disliked by the other vendors at the market. Besides the envy of the townsfolk, father and son must over-

come a number of typically knotty melodramatic problems. Carmelo has his eye on an Indian woman, Soledad, but her mother wants Soledad to marry the mayor's affluent, non-Indian son. Father and son are separated when Carmelo is imprisoned (falsely accused of a theft) while Tizoc recuperates from food poisoning in a hospital. In the end, Tizoc and Carmelo are reunited and happily resume their lives. The one sad note is that Soledad chooses the mayor's son over Carmelo.

A major difference between this film and *María Candelaria* is its happy ending. In the formula that *Janitzio* and *María Candelaria* established (and that Emilio Fernández continued with films like *Maclovia* [1948]), the results of an Indian woman's involvement with a non-Indian interloper were dire, usually fatal. Here, in contrast, the non-Indian (the mayor's son) successfully woos the native woman without deadly repercussions for anyone. With *Mi niño Tizoc*, Rodríguez inverts the genre formula and its traditionally separate-but-equal message.

In so doing, Rodríguez destroys Fernández's isolationist Indian fantasy, which was long overdue, only to replace it with a mestizo integrationalist fantasy. According to *Mi niño Tizoc*, the way out of the Indian dilemma is for well-meaning (and handsome and wealthy) mestizos to selectively intermarry with attractive natives. But this elitist interracial program operates via an Indian compromise. By having Soledad bend to the will of her mother and reject the poorer but morally superior Carmelo, she literally sells herself to the non-Indian. Her assimilation smacks of opportunism—even prostitution.

As for the stoic Carmelo, his righteousness is a shortcoming. Though Rodríguez attempts to depict him idealistically, in the end *Mi niño Tizoc* shows that Indians like him only hurt themselves by their stubborn separatism. Rather than being the intended advocate of an ostracized and misunderstood minority, *Mi niño Tizoc* is an elegy for a dying breed. Indians cannot win. They are condemned for abandoning their heritage, like Soledad, or for taking the moral high road and isolating themselves, like Carmelo. Either way will eventually cause their race's extinction. The film conveniently gets mestizo Mexico off the hook by intimating that the problem is not that the majority society will not accept the Indian, it is that the Indian will not integrate into society.

Chac, dios de la lluvia (*Chac, God of Rain*, 1974; directed by Rolando Klein) also centers on the Indian's specialness. Shot in Chiapas and featuring Mayan Indians speaking their native languages, the film is about villagers who seek to end a long drought by appeasing the gods. Its Indians practice occult arts and pray to powerful gods who hurl fiery balls through the sky to show their displeasure. But even

well-meaning films like *Chac* that portray Indians as noble natives can be instruments of marginalization by setting Indians apart. Making Indians exotic makes them peculiar: strangers in their own land.

Another film, Manuel M. Delgado's lively comedy *No tiene la culpa el indio* (*It's Not the Indian's Fault*, 1977), builds its laughs on the very assumption that Indians are extraordinary. Lencho (Chucho Salinas) is an Indian from Xochimilco with the power of divination. Juan (Mauricio Garcés) is a slick operator who discovers Lencho and takes him to Mexico City, dresses him in a business suit, and uses his talent to make them rich. Curiously, what activates Lencho's forecasting ability is sexual: when he sees pretty women, he is put in a trance that allows him to predict the future.

Like many a raucous comedy, *No tiene la culpa el indio* gets its laughs where it can find them and ends up doing all sorts of contradictory things. It makes fun of the Indian. One of the first things Juan must "correct" about Lencho upon arrival in the capital is his hopping Indian walk, and much humor is derived from the Indian's mispronunciation of Spanish. (The film's title is a well-known Mexican saying to excuse Indians for their "backward" ways.) And there is a dark undercurrent to his being "turned on" by beautiful women that presents his difference as sexually perverse and menacing. But *No tiene la culpa el indio* also makes fun of the Indian's mestizo exploiters. Plenty of gags are made at Juan's expense, for example, and when some aspiring politicians seek Lencho's help with a campaign, the film takes the opportunity to take some healthy swipes at the government's corruption and its opportunistic manipulation of Indians.

No tiene la culpa el indio foregrounds Lencho's specialness, but by an interesting plot twist the film subtly liberates Lencho from being a curiosity. At the end of the film Lencho and Juan recuperate in a hospital. Juan has just had a transfusion of Lencho's blood and jokingly proclaims them blood brothers. But when Juan begins forecasting the future, Lencho finds he has lost his gift. For most of its running time, *No tiene la culpa el indio* concurs with the films that marginalize by idealizing the Indian. Then *No tiene la culpa el indio* felicitously reverses fields. Democratizing Lencho's powers makes the Indian not different but the same. In its own innocuous way, *No tiene la culpa el indio* makes the Indian an equal partner, something many more serious films have not been able to do. Moreover, by demonstrating that associating with the *indio* can be beneficial to both Indian and mestizo, the film is a progressive alteration of the narrative formula begun by *María Candelaria*. A more pointed genre reversal and political commentary comes from *Cascabel*.

Cascabel: The Fatal Futility of Good Intentions

Raúl Araiza's *Cascabel* (*Rattlesnake*, 1976) agrees with *El juicio de Martín Cortés* and Julian Pastor's Indian films that the state's attitude toward the Indian has not changed over the years, and it shows how Mexico's hypocritical handling of the Indian neutralizes, handicaps, maims, and finally kills good, talented people. Finally, and most powerfully, *Cascabel* implicates cinema, saying that it too misuses and marginalizes Indians even when it wants to help them.

It tells of a young Mexican theater director, Alfredo (Sergio Jiménez), who is offered a job directing a documentary film being produced by the government. The movie's subject is the Lacandón tribe of Indians, who live around Chiapas in southern Mexico. In *Cascabel* —and in real life—the Lacandóns had just been deeded the rights to more than 600,000 hectares of Chiapas jungle. In the film, the administration would like to promote this for public relations advantage, thus the production of a self-serving documentary. Despite misgivings about having to adhere to the government's carefully censored script, Alfredo takes the job.

Once on location, Alfredo disregards his instructions to shoot the standard footage of the noble savages and their curious customs. Instead, he records what he finds—an impoverished tribe scratching out a miserable existence. Naturally, this unvarnished version of the Lacandón story upsets the bureaucrats back in Mexico City who review his footage. After ignoring repeated warnings to comply with the script, Alfredo is fired.

The night before Alfredo returns home, director Araiza places two incidents in bold counterpoint. While the wife of one of the natives goes into labor, Alfredo discovers that a rattlesnake has crawled into his sleeping bag with him. His Lacandón friend, Chankin (Ernesto Gómez Cruz), makes several unsuccessful attempts to coax the snake out of the bedroll. When the Indian woman screams at the moment of childbirth, the frazzled Alfredo screams too, startling the rattlesnake. Alfredo is attacked by the snake and dies an excruciating death. Dramatically juxtaposed are birth and death, Indian and creole, the sudden, capricious terror that characterizes the Indians' reality and the noble ideals of the well-intentioned Alfredo.

Because a fair-skinned mestizo rather than an Indian dies, *Cascabel* inverts the Indian genre narrative formula, as did an earlier landmark Indianist work, Luis Alcoriza's *Tarahumara* (1964). Alcoriza's semi-documentary film told of a good-hearted anthropologist (Ignacio López Tarso) who intervenes on behalf of the Tarahumara Indians (whose homeland is in the northern state of Chihuahua). He is eventu-

ally killed by the local *caciques* for disrupting their exploitation of the Indians. But *Cascabel* pushes beyond *Tarahumara* in its examination of the nature of "truth" in Mexico during Echeverría's so-called democratization, as well as its self-reflexive analysis of the "truth" contained in films about Indians.

The film's characters continually define and redefine "truth," recognizing that in Mexico its nature is relative, lying somewhere between what everyone knows and what the political system will admit. Because of Echeverría's liberalizing *apertura democrática*, it was thought that his administration regarded truth more highly than most previous regimes. But by the end of Echeverría's *sexenio*, when the film was produced (1975–1976), his *apertura* was beginning to look like political business as usual. *Cascabel* takes Echeverría—who once told filmmakers in Santiago, Chile, that "a cinema that lies is a cinema that brutalizes its public[11]—harshly to task. It implies that the president's commitment to open filmmaking was mostly political grandstanding.

"Today you can say the truth," proclaims a government official to the film's producer in *Cascabel*'s opening scene. By the end of their conversation, though, the official explains what he means—the truth is whatever the state provides the media for public consumption. As such, the Lacandón story, the producer is informed, needs some revision. "There are certain things," the official says, "that shouldn't be said." In another conversation, he underscores this sentiment with a sterling example of the logic of bureaucratic doublethink. "The truth," he says, "is not always the truth." Evidently the "truth" of Echeverría-era liberalization was that it wasn't much of a change at all.

Certainly the Indians' truth changed little. Isolated attempts by a few concerned individuals, like Alfredo, are subsumed—and erased—by self-serving governmental programs. All that rare governmental acts, like Echeverría's, achieve in the long run is to provide the state with promotional opportunities to display its social sensitivity. It all boils down, as Ricardo Pozas and Isabel H. de Pozas say, to exploitation.

Condemning governmental posturing and naive do-goodism, *Cascabel* is confident enough about what it is doing that it includes itself among the accused. To typify the primitive living conditions of the Lacandón Indians, Alfredo asks his friend Chankin to allow him to film his wife giving birth to their child. Thus the undeniable irony: he, like the government (and like Araiza), wants to use the Indians in order to make his own cinematic statement. The finished government documentary, the approved version that we see at the end of *Cascabel*, exposes the malleability of the cinematic apparatus: words and

.

images can be plied into any number of "truths." *Cascabel* realizes that it is only one more feeble attempt to help the Indian. No film-maker or state agency—in or out of this film—can deal with the Indian without abusing them or without being implicated.

In this way the film cleverly resists being appropriated by the status quo. The Echeverría regime could congratulate itself for allowing a film like *Cascabel* to be made but not without indicting itself in the process for its massive neglect of the Lacandóns. *Cascabel* sees to it that, regarding the Indian question, no one gets off scot-free. Every dealing with the Indians in effect exploits them. The Indian problem takes its toll on all of Mexico—the corrupt become more corrupt, the righteous are compromised or eliminated.

The Indian and the Other Mexico

Help me!

Alfredo in *Cascabel*

Instead of focusing on how to help the Indian, Octavio Paz and Carlos Fuentes have suggested a way that the Indian can help Mexico. They propose that the Indian "problem" is emblematic of a larger Mexican dilemma. Just as the male identity crisis is a reflection of a crisis in the nation-state, so too the Indian dilemma is indicative of a more all-encompassing contradiction. It has to do with developed and underde-veloped in today's Mexico, and it has to do with how Mexico defines progress.

The Indian presence conflates issues of race and class in Mexico. As Woodrow Borah says, the term "Indian" as used in Mexico today "no longer seems to be racial in significance." Since the misery of the people called "Indian" is rooted in their poverty, it would appear that the primary consideration for the application of the term is economic. According to Borah, in Mexican popular and even learned usage "Indian" today designates "the more primitive and poverty-stricken part of the peasantry." Indians "are not a separate ethnic group but a depressed group within a single culture which they share with those they envy."[12] Therefore "Indian" is a class signifier that stands for un-derdeveloped Mexico. This is borne out in *Los pequeños privilegios*, where it was not clear whether Imelda, the poor servant, was Indian or not. To her employers it didn't matter: they would have mistreated her in exactly the same way. Indians, then, are one contingent of a large Mexican underclass that the Revolution failed to incorporate into so-cial, political, and economic spheres. The urban poor, the rural peas-

ants, the unskilled, the unemployed or underemployed, together with
the Indians, all form what Paz refers to as the "other Mexico."

This notion of two Mexicos, "one developed, the other undevel-
oped," says Paz, "is the central theme of our modern history, the
problem on whose solution our very existence as a people depends."[13]
It calls the notion of progress into question. The Indian, Mexico's liv-
ing tie to its origins, is a disengaged witness forcing the country to
weigh its development carefully. In effect, the Indian "question" is an
interrogation of Mexico's future. What should progress mean for
Mexico? Which model of development should Mexico adopt—capi-
talist, socialist, or some other way?

Mexico's foremost problem today, according to Paz, is not just the
division between the haves and the have-nots, but that the haves in
developed Mexico have subscribed to the North American version of
progress, an imperfect one probably unsuited to the Mexican situation.
"The developed half of Mexico," writes Paz, "imposes its model on
the other [undeveloped half], without noticing that the model fails to
correspond to our true historical, psychic, and cultural reality and is
instead a mere copy (and a degraded copy) of the North American ar-
chetype. . . . we have not been able to create viable models of devel-
opment, models that correspond to what we are."[14] Carlos Fuentes
agrees, arguing that what is being accomplished is not only the slow
eradication of the Indian's culture, but the forced replacement of it
with a North American one.[15]

Just how ill-suited this model of progress is for Mexico is the sub-
ject of a fierce critique of the whole of modern Mexican society in
two films produced, distributed, and exhibited independently by Gus-
tavo Alatriste, *México, México, ra, ra, rá* (1975) and *La grilla* (*The
Lie*, 1979). The title of the first, *México, México, ra, ra, rá*, comes
from a popular cheer in Mexico, heard, for example, at international
soccer matches. It's a shout of loyalty, an automatic declaration of
unquestioned allegiance from the masses. Mexicans' unexamined at-
tachment to their status quo is what these films satirize. Both films
consist of a string of vignettes depicting the compromised quality of
Mexican life at all social levels. They conclude that the country is a
collection of swindlers and chiselers, cheaters and crooks, loafers and
opportunists. The films' point of view is not that Mexicans are inher-
ently dishonest, but that the Mexican system necessarily makes them
act that way.

México, México, ra, ra, rá begins with short scenes punctuated by
a blank screen with the title chant on the sound track. These early
scenes show a poor, middle-aged man in Mexico City literally pissing
his life away: lying in a park, cursing at the passing automobiles, uri-

nating on expressway traffic from an overpass. If his life away from home is full of frustration, emptiness, and hostility, his life at home—two tiny rooms, one above the other—is worse. The man tries to get some sleep in the attic bedroom teeming with children (he has fourteen), near and distant relatives, and an assortment of spongers. An unforgettable overhead shot makes them appear to be a swarming field of larvae just coming to life.

In the Mexico of *México, México, ra, ra, rá*, the poor—like this man—survive by shrewd salesmanship. For them everything is marketable. They sell themselves (a woman, arrested for shoplifting, sleeps with a policeman to gain her release), their property (a poor man, through a political favor, manages to get his family into a government housing project, then proceeds to auction off the plumbing fixtures), and even their family name (a man marries a pregnant girl and after the wedding night, goes home to his "real" family—another pregnant wife and five children). Middle-class Mexicans scramble to keep what they have by adapting to the whims of the powerful (in one episode, a bureaucrat procures a woman for his boss for an evening—his wife). The rich escape the grinding reality of the Mexican life by privilege.

Curiously, despite its blunt language and its bleak outlook, the film has a light touch. A biting social satire, *México, México, ra, ra, rá* finds human folly funny. Obviously Alatriste learned something by producing some of Luis Buñuel's best-known Mexican films (*Viridiana* [1961]; *El ángel exterminador* [*The Exterminating Angel*, 1962]; *Simon del desierto* [*Simon of the Desert*, 1965]). But the laughter the film evokes has a kick. Singly, the scenes go down easily enough, but they gain power incrementally. As they roll by, the comedy loses the first innocence of intoxication and the hangover headache—the social reality—takes over. And just to make sure that he gets his point across, in an epilogue Alatriste has one of the actors (who played a government secretary in the body of the film) deliver a sobering speech directly into the camera. Speaking to the film's Mexican audience, he says,

> The worst of all is not the corruption that downs us, nor the ignorance that weakens us, the worst of all is that we don't want to learn. . . . An ignorant country is an indefensible one. Mexico is a country on its knees which has never wanted to stand up. . . . Enough of demagoguery! What we don't do for ourselves will go undone. If the country refuses to learn, Mexico will continue being "Mexico, Mexico, Ra, Ra, Ra."

The searing exploration of a nation out of control that is begun in *México, México, ra, ra, rá* is continued in *La grilla*. Mexico got into such a mess, Paz charges, by imitating North American progress without adequately assessing the costs. "Development has been a straitjacket," Paz contends, and "a false liberation." Progress has improved the lives of only a minority of Mexicans, and accordingly the way out of this inhumane system is true democracy, "a plural society, without minorities or majorities."[16]

It is here that the Indian can be valuable. A link to Mexico's past, the Indian can serve as a helpful guide to its future. The Indians' unadorned life-style could be the yardstick Mexico holds up to the flashy visage of progress. As Fuentes says, "The great contribution of the world of the Indian consists of obliging us to doubt the perfection, the immutability, and the intelligence of progress which, as Pascal said, always ends by devouring what it has spawned."[17] It would seem that the Indian question needs to be reformulated. Instead of "What does Mexico do with the Indian?" perhaps the question should be "What can the Indian offer Mexico during *la crisis*?" By allowing Indians a part in charting the course of Mexican history, they share in the shaping of the national destiny. In this most favorable outcome, the answer to the Indian problem becomes, like Lencho in *No tiene la culpa el indio*, a fully participating Indian who can share his talents with his mestizo "blood brother."

But until that happens, Indians are the nation's wretched Other, completely disenfranchised, ignored, and voiceless. But metaphorically *los indios* speak eloquently for all Mexicans left out of the decision-making process. From the margins, Indians look askance at Mexico's rush to progress. Ostracized from Mexican society, they mirror Mexico's frustrating failure to gain admission to the First World. Troubling the Mexican conscience, they are an unsettling reminder of the betrayal rooted in the inception of Mexico and of the Revolution's failure to change that. The "Indian problem" is the governing metaphor for an entire nation. In the movies and in Mexican life, it remains the open wound on the body politic that still bleeds when touched.

Notes

1. Quoted in Riding, *Distant Neighbors* (New York: Knopf, 1985), p. 292.

2. Ibid., p. 289.

3. As Justo Sierra wrote, "If there is a single proven fact in our history, it is that the conquest of New Spain was accomplished for the kings of Castile

by the Indians themselves, under the direction and with the help of the Spaniards." See Justo Sierra, *The Political Evolution of the Mexican People*, trans. Charles Ramsdell (1900–1902; rpt. Austin: University of Texas Press, 1969), p. 80.

4. Quoted in Riding, *Distant Neighbors*, p. 291.

5. Alfonso Caso, "Ideals of an Action Program," *Human Organization* 17 (Spring 1958): 27.

6. Riding, *Distant Neighbors*, p. 293.

7. Ricardo Pozas and Isabel H. de Pozas, *Los indios en las clases sociales de México* (Mexico City: Siglo Veiniuno Editores, 1974), pp. 161–62.

8. James D. Cockcroft, *Mexico: Class Formation, Capital Accumulation, and the State* (New York: Monthly Review Press, 1983), p. 149.

9. Riding, *Distant Neighbors*, p. 292.

10. Fuentes, *Tiempo mexicano* (Mexico City: Editorial Joaquín Mortiz, 1972), p. 9.

11. Quoted in Jesús Salvador Treviño, "New Mexican Cinema," *Film Quarterly* 32, no. 3 (Spring 1979), p. 26.

12. Woodrow Borah, "Race and Class in Mexico," Latin American Series, reprint no. 294 (Berkeley: University of California, Institute of International Studies, Center for Latin American Studies, n.d.), p. 337.

13. Octavio Paz, *The Other Mexico: Critique of the Pyramid*, trans. Lysander Kemp (New York: Grove Press, 1972), p. 71.

14. Ibid., p. 73.

15. Fuentes, *Tiempo mexicano*, p. 36.

16. Paz, *The Other Mexico*, pp. 67–68, 73.

17. Fuentes, *Tiempo mexicano*, p. 38.

Serpientes y Escaleras

The Contemporary Cinema of Mexico, 1976–1994

David R. Maciel

To Ernesto Gómez Cruz and *La Mujer de Benjamín*

I. Introduction

Since its origins in the late-19th century to the present, the national cinema of Mexico has consistently been one of its most important cultural manifestations and art forms. Today, it continues to be so. Thematically, Mexican cinema has addressed questions of traditions, values, societal issues, gender roles, political topics, the historical past, identity, national character and culture. Aesthetically, the cinema of Mexico has reflected all the beauty, grace, passion, color and expression of its art and national culture.

Contemporary Mexican cinema can be subdivided by a distinct typology. These types of features involve questions of purpose, exhibition, production and post-production, casting, and direction. In the order of films produced yearly, the three distinct cinemas are:

a. Private sector productions. These are films solely produced by the private sector, which account for close to 90% of the entire film production of the country.[1] These productions had their high point in the late 1970s and early 1980s.[2] Since then, they have had a continuous decline in both box-office and video revenue both nationally and internationally.[3] The one exception is the case of María Elena Velas-

co, "La India María" who remains as the one "superstar" of private industry productions.

Most of these films are similar in structure, format and discourse. As a rule, these cinematic productions follow certain characteristics. The overriding objective is to make the least expensive film product possible in order to minimize the investment and maximize the profit. A standard, and often repeated, storyline is adhered to. It usually includes a heavy dosage of nudity, sex, violence and raunchy language in the scripts. Thematically, private sector productions focus on such issues as crime, immigration, humor, urban and rural violence, *rancheras* (a type of singing western made popular during the Golden Age of the 1940s), and to a lesser degree, politics.

The audience markets of the private sector productions have been the popular sectors of Mexico and U.S. Latino immigrants. Not only do those productions cater to a particular audience, but to an exclusive segment of the film community. In contemporary times, these productions have declined considerably in attendance, box-office returns, and number of productions yearly.

b. State co-productions. Since the 1970s, the Mexican state became intimately involved in the production, exhibition and distribution of films. In the last two decades, the state has been the principal supporter of quality artistic cinema. The measure of the success of these films is not exclusively determined by box-office returns, but rather by critical acclaim. Those directors, actors and other members of the film community who have principally been interested in the production of artistic cinema tend to be associated with state-sponsored or state co-produced films.[4] State productions tend to be the most cyclical of all film trends in Mexico since governmental film policies, like all other aspect of national politics, change every six years with every new presidential regime.

c. Independent productions. These films are generally produced without the support of commercial or state sponsors. At times, the state, upon the achievement of success of a particular independent film, incorporates it in its distribution and exhibition network. Many of these films are produced or co-produced by the two leading Mexican film schools, the Centro Universitario de Estudios Cinematográficos of the National University (CUEC) and the Centro de Capacitación Cinematográfica (CCC), other universities, or official cultural agencies.

The number of outstanding contemporary independent films and documentaries produced is truly remarkable, and displays the tenacity and creativity of filmmakers. Both established directors and aspiring ones have adhered to this format. In fact, certain acclaimed directors

like Paul Leduc have produced all their films independently. Jaime Humberto Hermosillo is a second example who prefers the independent mode of production. Certain of the most celebrated contemporary films, such as *María de mi corazón* (*Maria My Dearest*, 1982) and *Reed: Mexico insurgente* (*Reed: Insurgent Mexico*, 1971) were completed independently. Student films and almost all documentaries done in Mexico also fall into the category of independent films.

To a large degree, the artistic cinema of Mexico parallels the fortunes of the country itself. As with Mexico, its contemporary cinema has experienced at least two marvelous cinematic movements: from 1970–1978 and from the late 1980s to the present. Yet these rebirths have been derailed by not only the lack of continuity, but grave downturns.

At present, though, the cinema of Mexico is undergoing a remarkable resurgence. Recent generations of filmmakers have introduced fresh themes, a novel artistic discourse, innovative approaches to the creative process and, most importantly, have begun to attract sizable national and international audiences. This current artistic ambience has prompted veteran directors to return to their craft. Recent Mexican films have not just received high acclaim and impressive box-office returns in Mexico, but have been the recipients of prestigious international awards in such film festivals as Berlin, Cannes, Havana, Moscow, San Sebastian, Toronto and Venice. In fact, between 1991 and 1992, Mexican films received 45 major awards from these festivals.[5] This example solidifies the fact that Mexican cinema today is unquestionably the leading artistic cinema in present day Latin America.

What follows, then, is an essay intended much more as an interpretative overview than a comprehensive treatment of the subject matter. It accounts for the critical moments, the principal films, and certain of the most salient issues facing the contemporary cinema of Mexico. The films reviewed were chosen on the basis of artistic quality and innovation of theme and narrative discourse.

Methodologically, this essay combines a cultural history perspective with a contextual analysis of the major films. Besides the films themselves, extensive other primary and secondary sources were consulted. Invaluable were the multitude of oral history interviews conducted with diverse members of the Mexican film community as well as with other pertinent Mexican officials, industry administrators, critics and scholars. Their generosity with their time and information made much of the research a most gratifying endeavor. To all, I am deeply grateful.

II. The Tragic Decade, 1976–1985.

a. *The Demise of the Cinematic Flowering*

Rodolfo Echeverría's cinema project, as Director of the Banco Cinematográfico from 1971 to 1976, showed much promise by laying the groundwork for the renovation and flowering of films and the film industry, and certainly accentuated the positive potential of state intervention. In his last official speech, industry director Echeverría stated emphatically that his policies and measures were irreversible and the momentum would continue.

In fact, Rodolfo Echeverría's policies were completely reversed with the close of Luis Echeverría's *sexenio* in December 1976. Since the nationalization of the film industry had been only partially accomplished during Rodolfo Echeverría's tenure, the reversal of his policies by the succeeding administration was not a difficult task.

Besides the detrimental changes that the political winds brought forth, there existed an additional limiting factor to the cinema project of the 1970s. With a few exceptions, the generation of 1968[6] as a whole was not able to fully achieve its potential. Given all the substantial resources, the absolute state support, and the conducive political climate, the generation should have achieved greater artistic and social issue features. Yet their overall productions were most uneven. A few extraordinary films were indeed produced, certain other features merit some interest, but numerous ones fell far short of expectations.

Thus, at the close of the regime in December 1976, the cinematic resurrection, which emerged in the period 1971–1976, would meet the traditional fate of all presidential programs at the end of the *sexenio:* pass on to history, be overturned, or just be forgotten.[7]

b. *La Sombra del Caudillo.[8] State cinematic policies.*

When José López Portillo (1976–1982) succeeded Luis Echeverría as president of Mexico, there existed high anticipation from his regime in the area of arts and culture.[9] After all, the new president came from an academic and intellectual tradition. Yet, in the case of the film industry, not only would the expectation not be realized, but the *sexenio* overall was one of the darkest chapters in the entire history of Mexican cinema.

President López Portillo named his sister, Margarita López Portillo, director of the Dirección General de Radio, Televisión y Cinematografía, a new powerful media agency within the Ministry of the Interior in charge not only of cinema, but of radio and television as well. Initially, the changes were slight and, for a short time, there even seemed

to be certain continuity in film policies with the past. Several out-
standing contemporary Mexican films, which were in various stages of
production at the end of Echeverría's years, were completed in the
first two years of Margarita López Portillo's administration: *El lugar
sin límites* (*A Place without Limits*, 1977); *Llovizna* (*Drizzle*, 1977);
Los pequeños privilegios (*Small Privileges*, 1977); *Los indolentes*
(*The Indolent*, 1977); *Amor libre* (*Free Love*, 1978); *Cadena perpetua*
(*Life Imprisonment*, 1978); *En la Trampa* (*In the Tramp*, 1978); and
El Retrato de una Mujer Casada (*Portrait of a Married Woman*,
1979).[10] Collectively, these films marked the high point of this genera-
tion. Never again would they achieve the excellence of these films.

Once Margarita López Portillo extended her sphere of influence,
she completely changed state policies toward such productions.[11] A
persistent critic of the themes of films produced earlier, she repeatedly
spoke out against political or social issues in the cinema. The official
policy toward the cinema ranged from her vague comments regarding
"the need for family-oriented films" to co-productions with other
countries.[12] Her justification for co-productions with the outside world
was that Mexican filmmakers did not possess the talent that could
compete with foreign filmmakers. She sought out numerous foreign
directors, attempting to interest them in poorly conceived co-produc-
tions. To their credit, the great majority of those contacted flatly re-
fused or showed no interest in such projects.[13]

Toward the middle of the second year after assuming power, Mar-
garita López Portillo dismantled various agencies in charge of sup-
porting the state-film industry. This was the case of the state's lending
institution for film production, the Banco Cinematográfico. In addi-
tion, she withdrew all support for the two production companies, Con-
acite I and Conacite II, thus eliminating almost all state-sponsored
film production. These policies resulted in the near impossibility of
securing production resources for Mexican filmmakers who were in-
terested in making quality artistic movies.[14]

Because the generation of 1968 had been almost entirely financed
by the state for their productions, when this option faded, most direc-
tors turned to other means of employment. Many of them, since then,
have been on the payroll of Televisa—Mexico's largest private televi-
sion and media conglomerate— mostly directing soap operas. Some
filmmakers of this generation gave up altogether and have never di-
rected another motion picture again.[15]

With the state diminishing its support for production and excluding
an entire generation of directors, the private sector once again re-
turned to the forefront of national film production, exhibition, and dis-
tribution. Having no competition to speak of, the private producers

embarked on a sustained filmic project whose only interest in film-making was profit making. Uninteresting, repetitive and often degrading films were the dominant characteristic of the majority of the Mexican cinematic private productions of the period. From 1978 to 1988, private sector producers contributed close to 95 percent of the total films produced and exhibited either in theaters or through video in Mexico and internationally.[16]

Shortly before the close of López Portillo's *sexenio,* the Cineteca Nacional, the principal Mexican film depository, caught fire as a result of negligence and lack of critical renovation. Before the fire was extinguished, over five thousand prints and other valuable materials were lost.[17] It was a cruel legacy that the López Portillo regime left not only to the cinema industry, but to Mexico itself.

After the tragic period of the directorship of Margarita López Portillo, it was speculated within the film community that the situation could only improve under the incoming administration of Miguel de la Madrid (1982–1988). Positive changes did begin to occur and initially there was optimism. The Instituto Mexicano de Cinematografía, (IM-CINE), which repeatedly had been called for, was created. Its main function was to oversee all cinema policy and matters including production, exhibition, and distribution.[18]

The first appointed director of IMCINE was the respected veteran filmmaker, Alberto Isaac. It was believed that because the officials in charge of cinema affairs were part of the film community, the overall situation would certainly improve. It was not to be so. Even the best of intentions and a close personal friendship of Alberto Isaac with President Miguel de la Madrid could not triumph over the negative structures, corruption, and vested interests which had become institutionalized in Mexican cinema.[19]

In his capacity as director of IMCINE, Alberto Isaac provided generous production resources to various directors in a democratic manner, so as not to be accused of favoritism. Not all the funding decisions were correct ones. Features, such as *Orinoco* (1984), *Astucia* (*Cunning*, 1985), *Robachicos* (*Thieves of Children*, 1985), and *Viaje al paraíso* (*Trip to Paradise*, 1985) were some of the poorest, ill-conceived Mexican films. All were box-office and critical disasters.

In 1984, Alberto Isaac, frustrated in futile attempts at reform, resigned, only to be replaced by Enrique Soto Izquierdo, a politician whose only familiarity with Mexican cinema was a short-lived marriage to an actress. His policies and administrative actions plunged the state cinema to an all time low, even topping some of the worst moments of Margarita López Portillo's direction. Soto Izquierdo's tenure as head of the IMCINE was characterized by outright corruption, au-

thoritarianism, a total lack of policy direction, and outlandish favorit-ism.[20] An example of such actions were the unreported sale of negative prints of the majority of state productions in the 1970s and 1980s to video companies in the United States for mass distribution. The profits from the sale went exclusively to those officials who initiated the sale and to the video companies. Not a cent went to the film-makers themselves, or to the Mexican movie industry.

The only important state-produced film completed during his administration was Arturo Ripstein's impressive, *El imperio de la fortuna* (*The Empire of Fortune*, 1985). In actuality, though, the project was well-advanced when Soto Izquierdo assumed power.

c. The generation of the crisis.

In spite of such official policies and bleak trends, there existed certain significant films produced in this period. Suppressing great odds, a transition generation of directors followed the one of 1968. They can be correctly named "the generation of the crisis." This important, yet little discussed generation, contributed some of the most creative and significant films of the decade of the 1980s. This incoming generation shared certain collective characteristics.

1. Their films addressed the social disintegration of traditional institutions and social relationships. This generation was the first group of directors who intimately reflected the effects of the profound crisis on contemporary Mexico. Their films clearly addressed the crisis in its various dimensions and consequences, be it in national politics, the economy, identity crisis, or the subsequent loss of values and direction. This is clearly the case of *La víspera* (*The Eve*, 1982) *Nocaut* (1982), *Amor a la vuelta de la esquina* (*Love Around the Corner*, 1985) and *Crónica de Familia* (*Chronicle of a Family*, 1988).

2. A significant characteristic of the films of this generation is that they are basically developed through individual character study of the central male characters. Women's roles and representations generally tend to be quite secondary. One probable explanation for this aspect is the fact that all the members of this directorial generation are male. A further note is that several of the films, plots and themes are autobiographical in nature, including *El día que murió Pedro Infante* (*The Day Pedro Infante Died*, 1982) and *Vidas errantes* (*Wayward Lives*, 1984).

3. This generation of filmmakers showed much promise with their *opera prima*: Nicolás Echeverría, *El niñõ Fidencio* (*The Child Fidencio*, 1981); Claudio Isaac, *El día que murió Pedro Infante*; Alejandro Pelayo, *La víspera*; José Luis García Agraz, *Nocaut* (1984); Juan de la Riva, *Vidas errantes*; Guillermo Lara, *Diamante* (*Diamond*, 1984);

Alberto Cortés, *Amor a la vuelta de la esquina*; Diego López, *Crónica de familia*; Oscar Blancarte, *Que me maten de una vez* (*Kill Me Quick*, 1986); Raúl Busteros, *Redondo* (*Round*, 1986); Arturo Velasco, *La banda de los Panchitos* (*A Gang Named Los Panchitos*, 1986); and Mitl Valdés, *Los confines* (*The Limits*, 1989).

4. The directorial members of this generation had a close and supportive relationship with the previous generation. Many received formal studies from them and served apprenticeships as assistant directors.

5. Of all the generations of filmmakers in Mexico, no previous generation debuted in a more difficult political and economic period of Mexico. The "generation of the crisis" was faced with prolonged double digit inflation, an astronomical foreign debt, and the massive earthquake of 1985 that deepened Mexico's economic and social crisis. Most important, their films were produced in the midst of the most acute decline of Mexican commercial cinema ever.[21]

The most innovative and well-crafted films of the new directors that debuted in the early 1980s were Alejandro Pelayo's *La víspera*, Juan de la Riva's *Vidas errantes*, Alberto Cortés's *Amor a la vuelta de la esquina*, and José Luis García Agraz's *Nocaut*. Each reflected a fresh cinematic perspective, excellent utilization of artistic talent, an imaginative screenplay, and thoughtful direction.

La víspera wonderfully recreates the tense ambiance of the expectations of a previous influential politician hoping to be called to service in the incoming administration. The political games, intrigues and closed-door deals are masterfully captured on film. Moreover, *La víspera* captivates the beginnings of the demise of the traditional politicians (known in Mexico as the "dinosaurs") and the emergence of the new upstarts: the technocrats. The changes in philosophy and political style are effectively illustrated. A truly outstanding performance by the lead actor, Ernesto Gómez Cruz, and a solid supporting cast makes *La víspera* a classic in Mexican political cinema.

Vidas errantes is a charming homage to all those who traveled to the rural areas exhibiting Mexican films at any place and under any circumstances, to those who endured hardships and little profit, all because of their love for cinema. An outstanding script, solid performances, particularly by lead actor José Carlos Ruíz, and a vibrant reconstruction of the period made this movie one of the most acclaimed of contemporary Mexican films.

Amor a la vuelta de la esquina vividly captures the days and nights of Mexico's underground residents and their life experiences, as told in the escapades of the protagonist, alluringly portrayed by newcomer Gabriela Roel.

Nocaut is a hard-hitting portrait of the rise and fall of a boxer, well-played by Gonzalo Vega. The protagonist ultimately self-destructs as a consequence of the forces of corruption and moral decay. The main character can be viewed as a metaphor for modern Mexico.

In the late 1980s and early 1990s, most of these filmmakers were able to secure the funds necessary to complete their second, and even their third films: Juan de la Riva's *Pueblo de Madera* (*Wooden Town*, 1990); José Luis García Agraz's *Noches de Califas* (*Nights at the California Club*, 1985) and *Desiertos Mares* (*Desert Seas*, 1994); Alberto Cortés's *Ciudad de Ciegos* (*City of the Blind*, 1990); Diego López's *Goitia* (1989); Jose Buil's *La leyenda de la máscara* (*The Legend of the Mask*, 1991); Oscar Blancarte's *El jinete de la Divina Providencia* (*The Rider of the Divine Providence*, 1989); Alejandro Pelayo's *Dias difíciles* (Difficult Days, 1987), *Morir en el Golfo* (*To Die in the Gulf*, 1989), and *Miroslava* (1993); and Nicolás Echeverría's *Cabeza de Vaca* (1990).

This generation as a whole somehow, though, seemed to have lost their early promise. Most of their recent productions have been disappointing. The explanation for this decline is varied and complex. The issue of length of production time between their films was critical. For these filmmakers, in spite of the success and high acclaim of their initial features, making a second film did not come easy. Many of these directors spent an average of five years in constant struggle, attempting to secure the resources necessary to fund their second feature. As frustration built, certain directors, in acts of desperation, made ill-advised concessions required by producers or officials as a condition for funding of a second feature. Whereas the directors held total artistic control of their initial films, this was not generally the case with the productions that followed. The years invested in trying to overcome the difficult obstacles needed to make a second film clearly took their toll. If and when they were able to complete a film, they no longer reflected the freshness of style, themes, or polished scripts shown earlier.[22]

Yet this trend might be reversed in the near future. In the 1990s, there are signs that some of these filmmakers from the "generation of the crisis" are able to return to their early form. A case in point is José Luis García Agraz with *Desiertos Mares*.

d. Additional films and trends.

A select few established directors from previous generations were able to contribute certain excellent films during this most difficult period. Arturo Ripstein in *El imperio de la fortuna* traces masterfully a condition of decadence through the life, and ultimately the destruction, of

the lead character, unforgettably acted by Ernesto Gómez Cruz, who exemplifies the demise of rural and traditional Mexico. This film received well-deserved *Arieles* in Mexico for best picture, director, actor and supporting actress of the year.

Veneno para las hadas (Venom for the Fairies, 1988), written and directed by Carlos Enrique Taboada, is an excellent horror thriller based on the friendship of two girls, and the games they live out and play. Flawless acting by the young actresses as well as a outstanding script and an effective, surprising ending made *Veneno para las hadas* one of the most unique and heralded Mexican contemporary films of the decade.

Director Felipe Cazals followed with two other important films, *Bajo la metralla* (*Under Fire*, 1982), which addresses the theme of the urban guerrilla in Mexico, and the even better *Los motivos de Luz* (*The Motives of Luz*, 1985). Patricia Reyes Spíndola, in the title role, delivers an electrifying performance as a woman victimized by poverty, abuse, *machismo* and societal institutions. The protagonist, in an act of desperation and temporary insanity, allegedly killed her four children. Her trial was one of the most contested in Mexico's legal history. The controversial film captures the alienation and oppression faced daily by Mexico's underclass, particularly women.

Notwithstanding these few significant major films produced, on the whole this decade was a tragic one for the country and its national cinema. The policies of state officials in charge of cinema and the poor quality of private productions deepened the overall crisis of the film industry. Specifically, the deep crisis of Mexican cinema could be subdivided into four specific and equally adverse concerns:

1. A cinema in search of a lost audience. Historically, Mexican cinema had, until the late-1950s, the largest audience in the Spanish-speaking world. The films of the Golden Age (1940–1954) had made Mexican cinema the most important and popular of the Spanish-speaking film industries.[23] However, with the decline of the Golden Age and no immediate generation to replace it, Mexican films became repetitive, imitative of Hollywood, and lacked the originality and focus of the earlier period. Thus, even before the 1970s, Mexican and other Spanish-speaking people began to prefer foreign films, particularly North American, to Mexican cinema.[24] In the recent period, entire sectors of the Mexican population had abandoned its cinema.

2. Exhibition and distribution. As audiences preferred U.S. and foreign films to Mexican ones, exhibitors and distributors followed suit. Theaters throughout Mexico switched from exhibiting Mexican productions to foreign ones. This practice occurred not only in the major cities of Mexico, but in the entire country. There was also the

question of which theaters would show Mexican films. In Mexico City, the most luxurious theaters, almost without exception, were exclusively showing Hollywood features. Only the lesser quality theaters continued exhibiting Mexican films. The Cineteca Nacional in Mexico City, government operated and sponsored, was the only first-rate theater chain that continued to premiere Mexican films and organize special film showings.[25]

3. Government's inconsistent and ill-defined cinematic policies. With the private sector providing only low-budget formula films, the state became committed to fill the void in producing an alternative artistic cinema. Yet, state involvement in cinema has been a double-edge sword. In the last two decades, state influence has grown immensely. Currently, there is no single aspect of films or the film industry that escapes state involvement. In production, the state has acted as sponsor, co-producer or even sole producer of numerous recent films. In exhibition and distribution, the state has played a major role by establishing film distribution companies for national and international markets. Moreover, it has been a major partner and stockholder in the ownership and management of movie theaters.[26]

In the contents or themes of national films, the state has manifested a consistent preoccupation and direct influence. The state has devised a rigorous system of "artistic supervision," which is in actuality censorship of filmic content. Censorship, or the so-called "artistic supervision" by the state, is practiced from the project stage to the exhibition of a completed film.[27]

The one other major area of state influence in the recent film industry has been through the policies and personal agendas of the government officials placed in charge of the cinema and its institutions. The actions of these official administrators as well as the lack of a coherent state cultural policy that transcends presidential administrations has impacted significantly upon the cinema.[28] Because of the nature of their political appointments, these officials not only set the tone and direction for state cinema policies, but, in actuality, they personally decide on questions of production, distribution, publicity and censorship. These administrators are in a position to greatly promote certain careers or projects, or they can in turn stymie others.[29]

4. The Economic Abyss. Since the 1980s, Mexico has been engulfed by its most profound economic crisis of the 20th century.[30] Double digit inflation, an astronomical foreign debt, negative growth, capital flight, and dramatic decline in the standard of living from the middle class down, among other factors, made the last years difficult to nearly impossible for Mexico. The state placed its major subsidies in basic expenditures, reducing such areas as culture. Specifically,

government subsidies and sponsorship for cinema were relegated to a very low priority in the national agenda.[31]

The deep-reaching economic crisis had a direct and adverse consequence for Mexican cinema. Throughout the 1980s, the costs of filmmaking steeply escalated. Entrepreneurs and producers were much more reluctant to invest in films because of the risk of losing on their investment.[32] Directors have had to seek even more creative and alternative means of securing the necessary resources to produce their films.

Collectively, these issues prompted many informed observers to predict the total demise and, perhaps, even the eventual disappearance of Mexican cinema.

III. The Contemporary Renaissance, 1985–1994

a. The political and cultural context

Fortunately for contemporary Mexican cinema a new dawn was unfolding. In the advent of the presidency of Carlos Salinas de Gortari (1988–1994), Ignacio Durán Loera, an established member of the film and political community, was named to serve as director of IMCINE. He is, in fact, the first truly experienced administrator to direct this agency. The mandate set forth by director Durán was clear: to lessen the role of the state in the production of national films; to seek out and promote a new generation of filmmakers as well as stimulate veteran directors to return to their craft; to give new impetus and direction to co-productions; and to aggressively promote the national and foreign exhibitions of Mexican artistic films.[33]

In attempting to carry out the objective of lessening the expenditures of the state in production, IMCINE turned toward new alliances. Out of this initiative, the Fondo para el Fomento de la Calidad Cinematográfica (Fund for the Stimulus of Artistic Cinematography) was created with the support of various sectors of the film industry, such as the unions, and also the private sector. The financial support allocated by the Fondo has been critical in many recent productions. A second important effort of IMCINE to seek new producers was the signing of agreements with major Spanish television networks of Spain for co-productions of Mexican films. Such incentives have helped the state spread its resources to more projects by serving more as a provider of initial seed monies than as a sole producer.[34]

Another seminal achievement by Ignacio Durán was the successful transfer of IMCINE from the Ministry of the Interior to the newly established Consejo Nacional para la Cultura y las Artes (CONA-

CULTA). The change was much more than symbolic. It meant that finally cinema was regulated by officials in charge of culture and education, and not those whose priority was "national security."

It was, however, a new generation of filmmakers that in actuality began the flowering of the contemporary cinema of Mexico. This recent "generation of the 1990s" has achieved, in a brief period, high praise and critical acclaim from both national and international cinema circles. As a group, they debuted with full-length films in the late 1980s and early 1990s. Their rise was due to several factors: the current cinematic policies of key officials, particularly IMCINE; the support of certain film agencies and sectors; the beginning of a gradual economic recovery in Mexico, which in turn has resulted in a more positive general political and cultural ambience; and, above all, the creativity, artistry and resourcefulness of this generation.

b. The generation of the 1990s

In general terms, this generation of the 1990s can be defined as follows:

1. Unlike previous directors who received study and training abroad, all the current directors received their training and apprenticeships in the two leading Mexican film schools, the Centro de Capacitación Cinematográfica, and the Centro de Estudios Cinematográficos, and on the job, serving as assistants to established Mexican directors.

2. The generation of the 1990s developed a fruitful working student-teacher relationship with the two previous generations. This point is unique and important. Unlike the distant and even at times conflictive relationship that existed between the Golden Age directors and the "generation of 1968," the newest generation has enjoyed not only mentorship, but outright support and camaraderie from directors of the generation of 1968 and the generation of the crisis.[35]

3. Unlike previous directors, the generation of the 1990s have established much more control over most aspects of their productions. The economic conditions of the country and the current cinematic policies have forced these young directors to become much more creative and involved in all aspects of filmmaking, including fundraising, production, exhibition, publicity, and even distribution. They are fully conscious that much of their success will depend on themselves.[36]

4. The directors of the generation of the 1990s have been forced to seek and form new production partnerships, cooperatives or international co-productions. Spanish television has invested substantial capital in the production of recent Mexican cinema. By purchasing the viewing rights for television in Spain, through advanced payment, both parties have benefited. The Mexican directors received the

needed funds to complete their films, and Spanish television is assured of having quality premier films for its audience.[37]

5. The influence of documentary filmmaking is most evident in the productions of the contemporary generation. Many, if not all of the current directors, began as documentary filmmakers, and some continue to shoot documentaries.[38]

6. There exists much more camaraderie and mutual support among members of this generation than has previously existed with other directors. One reason is that these filmmakers were students together in the two film schools in Mexico City and, thus, worked side by side through their formative years and in their initial productions.

7. This generation encompasses filmmakers who debuted in the late-1980s and 1990s. They are: Francisco Athié, José Buil, Luis Carlos Carrera, Busi Cortés, Alfonso Cuarón, Guillermo del Toro, Eva López Sanchez, María Novaro, Hugo Rodriguez, Dana Rotberg, Marisa Sistach and Guita Schyfter.

8. Unique in the history of the cinema of Mexico is the fact that over a third of the directors of the generation of the 1990s are women. Among them, María Novaro, Busi Cortés, Dana Rotberg, and Marisa Sistach have completed at least two feature films.

9. This is perhaps the youngest generation of filmmakers ever. Some of its members, such as Luis Carlos Carrera and Guillermo del Toro, debuted as directors of feature films in their mid-twenties.

c. Cinematic themes of the 1990s. The emergence of a new generation of filmmakers in Mexico brought forth exciting new themes, a fresh narrative discourse and innovative models and means of production. The single most dramatic aspect of present-day Mexican cinema is the rise of feminism and the participation of women in all aspects of contemporary Mexican filmmaking. In addition, more varied film genres have been cultivated by this latest generation: women's stories, historical revisionist narratives, comedy, contemporary political and social issues, as well as adventure and science fiction.

Feminism, women's issues and heterosexual relationships.

Women's roles in recent cinema represent a clear departure from the films of the past.[39] Important roles and representations have finally been written for women in recent films. Women have been portrayed in a variety of settings, representing all age groups, classes and professions. From the elite to the poor (*Nocturno a Rosario, Homage to Rosario,* 1991; and *La mujer de Benjamin, Benjamin's Woman,* 1991); grandmothers to young girls (*Mi querido Tom Mix, My Dear Tom Mix,* 1991; and *Serpientes y escaleras, Ladders and Serpents,* 1992);

and notable women (*Gertrudis*, 1992, and *Miroslva*, 1992), women
characters in today's cinema are diverse, multi-dimensional and re-
flective of the complexity of contemporary Mexican society.[40]

Important is the theme of middle class women in several recent
films. This is the case of *Serpientes y escaleras* and *Los años de
Greta* (*The Years of Greta*, 1992). Many of those characters are in a
struggle against the current economic and social crises of the country,
such as in *El costo de la vida* (*The Cost of Life*, 1991) and *Lola*
(1989). Women from three different generations, at odds with oppres-
sive traditions and *machismo*, are featured in *El secreto de Romelia*
(*Romelia's Secret*, 1988). The theme of young women's sexuality and
self-discovery are portrayed in the excellent film *La mujer de Benja-
min*, and also in *Serpientes y escaleras*.

In addition, *Danzón* (1991), *Lola* (1989) and *Los pasos de Ana*
(*Ana's Way*, 1988–1989) deal with contemporary single mothers in
their plight for self-discovery and survival within their reality. *Dan-
zón*, María Novaro's second film, convincingly traces the odyssey of
the lead character in search of meaning in her life and personal inde-
pendence. Both María Novaro's *Lola* and *Los pasos de Ana*, directed
by Marisa Sistach, vividly recount a woman's attempts to reconcile
the pursuit of career, motherhood and an intimate relationship in a do-
cudrama format. The two films exemplify the harsh realities of urban
life faced by single female heads of households in the Mexico of to-
day. As Ana states at the concluding scene: "each one of us copes and
manages to survive in her individual way."

An unconventional woman's story, and also a religious allegory set
in contemporary Mexico, is Dana Rotberg's impressive *Angel de
Fuego* (*Angel of Fire*, 1992). The director masterfully exposes,
through this complex psychological character study, glimpses of Mex-
ican souls that reside on the outer fringes of society and life.[41] This
dark and disturbing vision is perhaps the most extreme version of nu-
merous recent films which postulate a depressing and rather hopeless
future, with few positive alternatives for Mexican women.

Como agua para chocolate (*Like Water for Chocolate*, 1992) is
one of the most creative and skillfully realized women's stories of
contemporary Mexican cinema. The film centers upon the tradition
that the youngest daughter should remain unmarried to take care of
her mother in her old age. Yet the film narrates much more than that.
The interactions of the members of the household, particularly the
women, are beautifully developed. Sensitive and memorable perfor-
mances are delivered by lead actresses Lumi Cavazos and Regina
Torné. The performance of the supporting female cast is excellent, as
is the photography and the historical recreation of the period.[42]

Novia que te vea (*I Hope I See You as a Bride*, 1993) is Guita Schyfter's opera prima. This movie interweaves effectively various themes. At center's stage is the close friendship over time of two women from two different Jewish groups which emigrate to Mexico. The movie follows these women from childhood to adulthood. The film addresses questions of ethnicity, feminism, identity and national culture. Sensitively written, and effectively acted and directed, *Novia que te vea* succeeds in linking complex issues, particularly the immigrant experience in Mexico. This theme had not been well-recounted since the Golden Age in the 1940s.

Women directors also have branched out in themes traditionally addressed by men. Such is very much the case of Marisa Sistach. In *Anoche soñé contigo* (*Yesterday I Dreamed of You*, 1992), she focuses on the sexual awakening of a teenage boy in the tradition of *The Summer of '42*.

Unconventional relationships between characters in contemporary films is a recurrent theme of the cinema of the 1990s. In features like *Amor a la vuelta de la esquina, Angel de fuego, El costo de la vida, Lola, La Tarea* (*The Assignment*, 1991) *La Tarea Prohibida* (*The Forbidden Assignment*, 1993), *Intimidades de un cuarto de baño* (*Intimacies in a Bathroom*, 1989), *La mujer de Benjamín*, and *Solo con tu pareja* (*Only with Your Partner*, 1991), the messages are similar. Relationships can serve different needs, are more unstable than in the past, and few last forever.

No longer is the image projected of stable roles, conventional couples or family. In fact, the representation of the disintegration of the traditional family and its values is striking in the recent films. Alternative lifestyles, individual survival and the loss of optimism for the future seem to be the norm in the film characters of the contemporary cinema of Mexico. On a related note, the recent filmic male characters are no longer portrayed as the super *macho* types. They are multi-dimensional with all the strengths, weaknesses, problems and facets of modern men, such as in *La mujer de Benjamín* and *El costo de la vida*.

Historical perspectives

As in other periods, historical topics continue as a major theme of inspiration in the recent cinema of Mexico. For the most part, three aspects of the Mexican past have been the focus of the films of the last generation: the Pre-Columbian period, the Conquest and its legacy; and the decades of the 1940s and 1950s.

The Quincentenary celebrations of the meeting of two worlds in 1992 made available considerable resources, grants, and arts endow-

ment, mostly from Spain, for works that address the various aspects of
the European legacy in Latin America. Filmmakers in Mexico and
elsewhere wasted no time in submitting projects in an attempt to cash
in on their share of Quincentenary funding. Indeed, many did secure
funds for film projects on Conquest themes. Thus, it would be for op-
portunistic reasons more than for other concerns that the historical
theme of the 1990s would be the Conquest and the Spanish legacy.

On the early Mexican period, Juan Mora Carlett's *Retorno a Aztlán*
(*Return to Aztlán*, 1990) is Mexico's finest and most original film to
date that deals entirely with the recreation of the Aztec world. The
storyline of this movie was based totally upon indigenous sources and
legends. The production leads with the attempt of Aztec Emperor
Moctezuma to seek the mythical Aztlán with the hope of returning to
their homeland and avoid the perceived inevitability of the downfall
of the Aztec empire. Another unique aspect of this visual and sym-
bolic feature is that all the dialogue is spoken in Nahuatl, for added
authenticity. In spite of such an experiment of method, the film has
been a modest box-office success and recipient of high acclaim.

The epic *Cabeza de Vaca* (1990) is Nicolás Echeverría's provoca-
tive debut historical production. The movie offers a revisionist view
of the conquest and the colonial legacy of Spain in Mexico. Through
the interaction between the people of two worlds, *Cabeza de Vaca* at-
tempts to sensitively portray both cultures and individual perspec-
tives.[43] This film is most successfully able to captivate and transmit
the beautiful imagery and symbolism of Mexico's indigenous legacy.

The veteran film director Felipe Cazals completed yet another his-
torical feature on this period: the biography of Father Eusebio Kino,
who was instrumental in the Spanish spiritual conquest of native peo-
ples in the borderlands. The co-production of Kino (1992) adds a
unique interpretation of the building of the Spanish empire, and the
clash of cultures in colonial Northern Mexico. Unfortunately, a con-
fused screenplay, indecisive ideological constructs, and a weak narra-
tive discourse resulted in a most disappointing production from
Cazals.

Along similar lines, but with different results, director Sergio Ol-
hovich produced a striking filmed theater drama, *Bartolomé* (1993).
The film is based on the life and times of the "Apostle of the Indies,"
Father Bartolomé de las Casas. The focus of the narration is on the
crusading efforts of Father de las Casas to secure and enforce a more
human Spanish Indian policy in the Americas, a cause he championed
until his death. These deeds are well captured by the film.

Together, these contemporary visions of the Pre-Columbian and
Colonial legacy of Mexico subscribed to a classic *indigenista* interpre-

tation of history. This historical view adheres to a glorification of the indigenous heritage and a condemnation of the Spanish legacy in America. All three films are most critical of the policies and actions of Spain in the colonization of the new world. They recount the price of colonialism and the high cost of the birth of the Mexican nation through forced *mestizaje*[44] and oppression.[45]

Consistent with the emphasis upon women's stories, film biographies of celebrated historical feminine figures are a clear trend of the 1990s. Veteran film and television star Ofelia Medina, who had already masterfully portrayed the legendary Frida Kahlo on the screen, starred as two important historical and cultural figures of the Mexican past, Gertrudis Bocanegra and Rosario de la Peña.

Director Ernesto Medina and sister star Ofelia Medina brought to the screen *Gertrudis*. This film is an important first step in recounting the events and processes of Mexican independence through the actions and world view of a feminine heroine, Gertrudis Bocanegra.

In *Nocturno a Rosario*, Golden Age veteran director Matilde Landeta, after a 30-year directorial absence, returned to her craft. She aspired to recreate the cultural and social ambience of Mexico City in the 19th century through the relationship and lives of two of the best-known literary figures of that era: the intellectual diva of the period, Rosario de la Peña, and poet Manuel Acuña. Although well-intentioned and with certain merits, the film was not able to achieve its ambitious goals. Exaggerated performances and miscasting did not help.

Miroslava (1993), directed by Alejandro Pelayo, attempted an in-depth psychological study of the last days in the life of the beautiful and talented Golden Age actress Miroslava Stern. The film offers her childhood immigrant experience in Mexico, her youth, her acting and her turbulent romantic life as explanations for her ultimate self-destruction. The strengths of the film are its aesthetics, color and the recreation of the times.

A related trend of recent Mexican cinema is to situate films in previous historical eras, particularly in the decades of the 1940s and 1950s. These specific films examine and revise aspects of Mexican society, attitudes and practices with special reference to the condition and to the role of women in a patriarchal society. Features, such as *El secreto de Romelia, Modelo antiguo* (*Old Fashioned Model*, 1992) and *Serpientes y escaleras* use the past to critically revaluate the social history of Mexican women. A careful reading of such stories reveals the difficulties, powerlessness, and pre-arranged societal positions of women. In addition, vividly recounted are how few options or alternatives in life Mexican women have had historically.

The political and economic order

The effects of the profound economic, political and social crisis of recent Mexico upon members and sectors of society is another central theme in current Mexican cinema. *Lola*, María Novaro's *opera prima* in narrative film, sketches days and events in the life of a single working-class young mother. The dreary and harsh realities that such women confront on an everyday basis for mere survival is a major theme of the film. *El costo de la vida*, directed and written by Rafael Montero, squarely focuses upon the adverse effects of the current economic crisis on a struggling, young middle class couple. The film vividly recounts how the inability to succeed in a world of layoffs, rejections, and lack of opportunities desperately drives the couple to crime, and ultimate destruction.

The societal effects of the crisis is solidly treated by director Marcela Fernández Violante in *Golpe de suerte* (*Stroke of Luck*, 1992). The narrative revolves around raising a middle class family in Mexico, headed by a senior government employee. Without any notice, this character is suddenly fired from his job, all in the name of the modernization plans for the Mexican state. The desperate aftermath of the effects of this situation on the family members are insightfully captured. This story is not only recurrent and relevant in Mexico's recent history, but is universal in its message.

Political themes are an essential part of contemporary Mexican cinema. The Mexican political system is certainly one of the most complex and intriguing of contemporary political orders, one which could render endless plots, yet it is precisely the theme of politics which is a major concern of the state. Therefore, it is the most censored or "artistically supervised" by official channels. Nonetheless, various directors have contributed important cinematic perspectives on Mexican policy.

Director Alejandro Pelayo followed *La víspera* with two additional films that center upon political issues. *Dias difíciles* and *Morir en el Golfo* focus upon the dispute of regional versus national power, political corruption, conflicts between the private sector and the state, and the loss of political legitimacy by the contemporary Mexican state. Although well-made, these films exemplify one major limitation of political cinema in Mexico. Fearing censorship, directors either make significant concessions or practice auto-censorship, which weakens their initial message and, ultimately, the films themselves. It is evident that attempting to walk the fine line between critical statement in film and censorship is a most difficult proposition for any director in Mexico.

Rojo amanecer (*Red Sunrise*, 1991) is a seminal film, politically as well as thematically. It is a powerfully written, acted and directed movie, which directly focuses upon the social movement of 1968. This upheaval and its resolution plunged Mexico into its most acute political crisis of the 20th century. This is the first commercial film to be produced and exhibited solely on this subject. The entire action of the movie takes place within the confines of an apartment in Tlatelolco, the place where the tragic events actually occurred. The narrative discourse is developed through the lives of the members of a middle-class family and their involvement in the 1968 student movement. The violence directed at the family is analogous to the massacre of hundreds of victims by the repressive army and police forces.

Gabriel Retes's *El bulto* (*The Lump*, 1991) is the most recent political film. The director, who also wrote and starred in the picture, imaginatively employs a modified Rip-Van-Wrinkle format to address the profound changes that have occurred in the past twenty years in Mexico. The protagonist is a political activist who had been a victim of brutal official repression which resulted in a two-decades-long comma. Miraculously, after a 20-year span, one day he regains consciousness. Slowly as he recuperates, he is faced with a dramatically changed Mexico: a country presently governed by technocrats and their supporters who are little concerned with issues of social justice, only with "modernization." The political opposition is weak or non-existent, and even his family members and friends no longer care for the progressive causes that were the pilar of the generation of 1968.[46] *El bulto* is a film that certainly raises critical questions and prospects facing Mexico's citizenry and its political leadership in the present and future.

Lolo (1992), directed by Francisco Athié, is perhaps the most solemn of the recent films. It addresses the theme of police repression in Mexico and those individuals who do not conform to models of modernity. The story reveals the marginal existence and hopelessness of Mexico's extensive young underclass. A production reminiscent of Luis Buñuel's *Los olvidados* (*The Forgotten Ones*, 1950), *Lolo* is a sobering glimpse of the neglected side of those that the Mexican state have surely neglected.[47] Well-acted, imaginatively photographed and written, *Lolo* is one of the most realistic representations of an all too real segment of Mexico today.

Comedy revisited

Comedy had a wonderful tradition in Mexican cinema in past decades, particularly in the Golden Age, although it had declined both in quality and quantity in recent times. Fortunately, the generation of the

1990s has successfully returned to this genre. Dana Rotberg's first full-length film, *Intimidad* (*Intimacy*, 1989), is a successful comedy of middle-class situations and characters. A second, and even better crafted and well-received comedy is *Solo con tu pareja*. This is a delightful film, directed by Alfonso Cuarón. The romantic misadventures of a contemporary playboy in the age of AIDS and feminism flows with grace and humor. Superb acting, an excellent script and creative direction made this film one of the most popular and highly acclaimed of recent Mexican cinema.

La tarea is an equally praised erotic comedy, directed by veteran Jaime Humberto Hermosillo. In the title roles are noted veteran actors María Rojo and José Alonso, who deliver excellent performances. The film appears to be an exercise in experimental cinematic photography, yet as the narrative unfolds, feminine sexual self-discovery and experimentation are paramount. An unexpected ending adds to the overall fine attributes of *La tarea*.

The many faces of Mexico

Cinema, like so much of recent Mexico, has been highly centralized, reflecting a dominant perspective of only its capital, Mexico City. Other states and regions have been minimized even in the arts. A distinct thematic characteristic, especially in the films of certain directors of the generation of the 1990s, is to emphasize regional themes and settings of Mexico. Juan de la Riva, in fact, filmed stories and characters that reflect his native state of Durango. This director believes that an essential aspect of reaching out to current Mexican audiences is to provide films which depict and incorporate the other faces and regions of Mexico.[48] His recent *Pueblo de madera* is consistent with this purpose.

Another contemporary director, Oscar Blancarte, follows in this tradition in his films *Que me maten de una vez* and *El jinete de la Divina Providencia* by providing the regional perspectives and local themes from the state of Sinaloa.[49] In addition, María Novaro's *Danzón* takes place in the state and city of Veracruz. Her aim is not just to depict regional settings or stories. She reclaims the regional traditions, values, music and settings so popular during the Golden Age but forgotten by the contemporary cinema of Mexico.

María Novaro continued this trend with her most recent film, *El Jardín del Edén* (*The Garden of Eden*, 1993) which focuses upon another setting and theme. The film develops complex character stories of residents on both sides of the U.S.-Mexico border, in the Tijuana-San Diego area. The shooting was done entirely on location with input from border artists. To date, this is the one production of the

"generation of the 1990s" to directly address the border and the Chicano community as the central storyline.

Adventures and science fiction

Missing to a large degree, if not altogether, from the current scene are adventure films. One possible explanation is the cost of such productions. Another is the fact that the private sector action features were of such horrid quality that directors are leery of such audience reception. Director Luis Estrada is one of the exceptions to this generalization. His films *El largo camino a Tijuana* (*The Long Road to Tijuana*, 1990), *Bandidos* (*Bandits*, 1992), and *Amber* (1994) attempt to narrate an action/adventure which traces storyline to character development. The other exception is *Cronos* (1993). This film, written and directed by Guillermo del Toro, combines fantasy, horror and science fiction genres. The film deals with a story of alchemy, vampires and the dream of eternal life.[50]

Both Estrada and Del Toro are striving to direct films they consider universal cinema. Director Estrada also emulates Hollywood action and adventure models in his movies. It remains to be seen whether their cinematic constructs will appeal to international audiences or to Mexican ones.

IV. Current and Future Perspectives

It is an undeniable fact that, currently, Mexican artistic cinema is enjoying a remarkable renaissance. This revival has impressed not only Mexican society and critics, but the international film community as well. Not since the 1970s has there been such a positive ambience for that segment of the Mexican film industry interested in producing quality artistic cinema. This new era is characterized by an impressive production movement, and by new and veteran generations of filmmakers working side by side. Moreover, there exists a progressive and steady return of Mexican audiences to their cinema.

Yet these very positive factors are tenuous, at best. Such cinematic flowerings have occurred in recent Mexican history, only to be followed by periods of marked decline. There still exist certain elements in the film industry of Mexico which make the future of its cinema uncertain. As scholars and journalists have documented, Mexico is a country governed by the individual policies of key officials of each six-year presidential administration. Because there is no reelection for the President, each incoming administration assumes a distinct agenda, including aspects of culture, such as cinema. Thus, although this administration—particularly the director of IMCINE—has led the way

and set the tone for the rebirth of the current cinema, there is no as-
surance that the successors will continue these positive policies. In
fact, the recent past has demonstrated the opposite.

Unfortunately, it is still the case that Mexican artistic cinema is
heavily dependent upon economic and other support from the state
and its institutions. Presently, there is less than one year left of this
presidential administration, and it is difficult to predict what the cine-
matic policies of the following one will be. There is still no real alter-
native for the role and support by the state for artistic cinema. In
addition, the obvious priority in a country that is being run more and
more by technocrats is economics. Culture, within the overall scheme,
has minor importance.

Moreover, in spite of good attendance and box-office success of re-
cent films, it is premature to state that Mexican artistic cinema has
truly recaptured its lost audience. Thus, it is still critical for filmmak-
ers to find creative and aggressive ways to successfully distribute and
exhibit their films in Mexico and outside its borders, since interna-
tional audiences are essential for Mexican cinema's future survival.

Mexican filmmakers will have to explore other and more varied
sources for production revenue in order to continue their recent suc-
cess.[51] The Mexican state, Spanish television, select North American
producers, and a combination of Mexican cooperatives have financed
contemporary films. It is to be expected that if the films continue to
do well at the box-office in Mexico and elsewhere, production financ-
ing should be easier to secure. Yet the search for additional national
and international producers is key if this renaissance is to continue.

There already exist other danger signs for the future of Mexican
cinema. The Spanish commercial television, which had served as a
substantial co-producer for Mexican films, was recently transferred
from state to private sector ownership. The new leadership has not re-
vealed any interest in continuing such investments in Mexican film
production. Just as detrimental has been the takeover of spaces and in-
stitutions of the Estudios Churubusco by other state entities, thus re-
ducing substantially the facilities devoted to cinema of the oldest and
best equipped film studio in Mexico.[52]

Exhibition continues to be a major problem for Mexican cinema.
The state sold its theater holdings, the Compañia Operadora de Tea-
tros, to the private sector. So far, the new owners of this chain have
not shown much interest in exhibiting and distributing artistic Mexi-
can cinema.

At the same time, though, and just as important, is the fact that the
problems and the factors which led to the institutionalized crisis of
Mexican cinema need to be firmly addressed and solved. Ultimately,

issues such as corruption, favoritism, lack of legal enforcement of screentime for Mexican cinema, better distribution, and continued and expanded cooperation between sectors within the film industry are all factors in dire need of resolution.

In spite of these concerns, there is, however, much to be optimistic about for the immediate future of Mexican cinema. Above all else, though, the future of Mexican cinema will be determined by the creativity, tenacity and commitment of the various generations of filmmakers involved in this cinematic renaissance. Clearly, it is evident that there exists an abundance of exceptional talent in all phases and areas of filmmaking. There exists a new aggressive, self-reliant, and self-assured present and incoming generation of directors, actors, cinematographers, screenwriters and other members of the film community, that have already demonstrated their artistic worth. Their productions have served to motivate veteran filmmakers to return. to the seventh art.

At present, a multitude of artistic films are now in the planning stage, shooting, post-production or completed.[53] This year will see the premiere of such artistic films as Arturo Ripstein's *Reina de la noche* (*Queen of the Night*) and Mitl Valdés's *Los vuelcos del corazón* (*Sentiments of the Heart*). Besides these productions from established directors, certain other premiered films will feature debuting directors: *Señas Particulares* (*Particular Clues*) by Fernando Sariñana, *En el aire* (*In the Wind*) by Juan Carlos de Laja, and *Dos crimenes* (*The Two Crimes*) by Roberto Snider. Altogether, the achievement of these six years for Mexican cinema has been noteworthy. Thus, for the first time since the Golden Age, it might be predicted that the cinema of Mexico will have an exciting future as well as a glorious past.

Notes

Serpientes y Escaleras is a very popular game which involves at the role of the dice either landing on a *serpiente* (snake) moving downward, or landing at an *escalera* (ladder) and going upward. The game is a metaphor for the process of life. In 1992, a well-made film by the same name, directed by Busi Cortés, was released.

1. Juan Felipe Coria critically analyzes this theme in his recent article "Un cine popular mexicano. El progreso de un libertino," *Intolerancia* VII (November–December 1990), pp. 53–63.

2. Interview with Gustavo García, Mexico City, July 3, 1989.

3. Coria, "Un cine popular," p. 54.

4. Interview with María Rojo, Mexico City, June 12, 1992.

5. Héctor Rivera, "Con el resurgimiento de nuestro cine, México volverá a sonar en los premios de Cannes," *Proceso* (May 18, 1992), pp. 48–51.

6. As an artistic group, the members of the generation of 1968 encompass certain characteristics:

1. This generation came of age highly influenced by the political activism and social change of the period.
2. In thematic and aesthetic perspectives, political and social issues took precedent in its films.
3. On the whole, members of this generation received little mentorship or support from the previous generation. This new generation of directors generally studied filmmaking outside of Mexico—Europe and the Soviet Union.
5. Generally speaking, this generation was male dominated.
6. The representation of gender roles in their films reflected the profound societal changes of the post-1960s era, particularly on the role of women.
7. These new directors became the most privileged filmic generation in Mexican cultural history, in terms of receiving generous production resources and state support during the years 1970–1978.

7. Miguel Basañez offers a solid interpretation of this theme in his study *La lucha por la hegemonía en México 1968–1976* (Mexico, 1981).

8. *La sombra del caudillo* (Shadow of the Tyrant, 1960) is one of the most famous novels of the Mexican Revolution written by Martín Luis Guzmán. In 1960, it was brought to the screen by director Julio Bracho in perhaps the finest Mexican political film of all time. Its release was censored for 30 years due to pressure from the military and the state because of its critical view of the misuse of presidential and military power in Mexico. Finally, this film received limited commercial showing in 1990.

9. Interview with Héctor Aguilar Camín, Mexico City, July 18, 1990.

10. See the last two chapters of Emilio García Riera's study *Historia del cine mexicano* (Mexico, 1985).

11. Rossbach, Alma, and Leticia Canel, "Política cinematográfica del sexenio de Luis Echeverría, 1970–1976," in *Hojas de Cine* II (1988), pp. 87–89.

12. Interview with Tomás Peréz Turrent, Mexico City, June 24, 1987.

13. Interview with Fernando Macotela, Mexico City, June 24, 1989.

14. Sánchez, Francisco, *Crónica antisolemne del cine mexicano* (Mexico, 1989), pp. 99–101.

15. Rossbach and Canel, "Política cinematográfica," pp. 89–92.

16. Leonardo García Tsao, "Entrevista con Nicolás Echeverría," *Dicine* 38 (March, 1991), pp. 8–12.

17. Interview with Eduardo de la Vega, Mexico City, November 19, 1985

18. Interview with Alberto Isaac, Mexico City, August 18, 1984.

19. See the perceptive essay by Gustavo García, "Enemigos de las promesas: decadencia y caída del cine mexicano," *Intolerancia* 1 (January, 1986), pp. 21–38.

20. Interview with Alejandro Pelayo, Mexico City, June 14, 1989.

21. Claudia and Germaine Gómez Haro, "El nuevo cine mexicano," *Nitrato de Plata*, no. 12, pp. 6–8.

22. Interview with Ernesto Román, Mexico City, August 4, 1989.

23. See the first part of chapter two in the important study by Charles Ramírez Berg, *Cinema of Solitude: A Critical Study of Mexican Film, 1967–1983* (Austin, 1993).

24. Interview with Carlos Monsivais, Mexico City, May 20, 1992.

25. See the first two chapters of the study by Paola Costa, *La apertura cinematográfica* (Pueblo, 1988).

26. Gustavo García, "El cine de gobierno. La muerte de un burócrata," *Intolerancia* 7 (November–December 1990) pp. 15–22.

27. Interview with Mario Hernández, Mexico City, July 10, 1987.

28. Carlos Monsivais, "Notas sobre la cultura mexicana en la década de los setentas," in Jean Franco et al, *Cultura y dependencia* (Mexico, 1976), pp. 197–229.

29. Interview with Alberto Isaac, Mexico City, June 14, 1989.

30. Pablo González Casanova and Hector Aguilar Camín's two-volume edited work, *México ante la crisis* (Mexico, 1985), discusses the various aspects and effects of the recent crisis in Mexico.

31. Gustavo García, "El cine de gobierno," pp. 16–18.

32. José de la Colina, "Situación de los nuevos cineastas," *Revista de la Universidad* X (June, 1972), p. 8.

33. Conchita Perales, "Tres generaciones haciendo cine a la vez. Entrevista con Alejandro Pelayo," *Textual* 2:III (July, 1991), pp. 27–31.

34. Interview with Alejandro Pelayo, Mexico City, May 20, 1990.

35. Interview with Dana Rotberg, Stanford, California, April 18, 1990.

36. Susana López Aranda et al., "Cine mexicano actual," *Dicine* 3 (August–September 1992), pp. 64–73.

37. See the various articles on contemporary Mexican cinema in the second issue of *Nitrato de Plata* (Mexico City). All are written by respected critics who share their thoughts on important issues and themes.

38. Jorge Ayala Blanco, *La disolvencia del cine mexicano* (Mexico, 1991) addresses this aspect in great detail.

39. Carlos Monsivais, "El fin de la diosa arrodillada, *Nexos* (February, 1992), pp. 79–82.

40. Interview with Busi Cortés. Mexico City. July 26, 1989.

41. Paul Lenti, "Angel de Fuego," *Reviews* (April 27, 1992), p. 81.

42. An important note is that *Como agua para chocolate* has already broken all box-office records for foreign films in the U.S.

43. Leonardo García Tsao. "Entrevista con Nicolás Echeverría," *Dicine* 38 (March, 1991), pp. 8–12.

44. *Mestizaje* is the process of racial mixture that occurred as a result of the sexual interactions between Europeans and the indigenous people.

45. Eduardo de la Vega, "El cine como fuente de la historia," *Dicine* 46 (July, 1992), pp. 18–22.

46. Paul Lenti, "El Bulto," *Reviews* (April 27, 1992) p. 82.

47. Leonardo García Tsao, "Crimen y castigo en Neza," *El Nacional* (May 6, 1993).

48. Interview with Juan de la Riva, Mexico City, June 26, 1989.

49. Interview with Oscar Blancarte, Mexico City, June 18, 1991.

50. Roberto Pliego, "Los emblemas del metal. Una entrevista con Guillermo del Toro," *Nexos* (June, 1993), pp. 85–86.

51. Conchita Perales, "Nuevos caminos para filmar. Entrevista con María Novaro," *Textual* 2:III (July, 1991), pp. 36–40.

52. Interview with Marisa Sistach, Tucson, Arizona, June 3, 1993.

53. For specific information on the numerous current films in production or post-production stage, see the informative articles by José Luis Gallegos in *Excelsior* (March, April and June 1993).

Cuba

Film and Revolution in Cuba

The First Twenty-Five Years

Julianne Burton

In the initial moments of Tomás Gutiérrez Alea's *La Muerte de un Burócrata* (*The Death of a Bureaucrat*, 1966) there is an audacious and brilliantly comic sequence. The deceased worker around whose disinterred remains the plot will revolve is seen in semi-animated flashback at his workplace. An "exemplary" proletarian artist, he has reduced art to a science, having devised a machine which produces busts of Cuban national poet and patriot José Martí with the monotonous regularity of cogs emerging from a press. In a moment of carelessness, the worker falls prey to his own invention. The last bust to emerge is his own; he has been martyred to his misguided concept of art.

The sequence imaginatively conveys the Cuban film industry's rejection of mechanical concepts mechanically imposed on the creative process. In 1973, to their surprise, American audiences discovered the delightful unpredictability which characterized many Cuban films of the 1960s and 1970s with the theatrical release of *Memories of Underdevelopment* (Tomás Gutiérrez Alea, 1968). Disarmed by its complexity and inventiveness, by its sophisticated wit and sympathetic portrayal of its bourgeois protagonist, U.S. critics greeted the film with ringing praise. *The New York Times* listed it among the year's ten best films. The National Society of Film Critics offered its

Originally published in Sandor Halebsky and John Kish, eds., *Cuba, 25 Years of Revolution, 1959–1984* (Praeger Publishers, an imprint of Greenwood Publishing Group, Inc., Westport, CT, 1985). Copyright © 1985 by Sandor Halebsky and John Kish.

director a special award, though the State Department's refusal to grant him a visa prevented him from attending the ceremony. However regrettable, such a response was not unexpected given how the Treasury Department had shut down the First New York Festival of Cuban Cinema the previous year, confiscating all prints on the second day of the week-long program and eventually driving American Documentary Films, co-sponsors of the festival, into bankruptcy.[1]

For a quarter century, the U.S. has sought to isolate Cuba from the rest of the world by imposing an economic and cultural blockade on the island. During this period, Cuban cinema and the related arts of music and poster design have continued to break through the cultural blockade to assert the creative energy of this struggling socialist society.

Cinema and Cultural Priorities

The leaders of the guerrilla struggle were quick to perceive the artistic and educational supremacy of the film medium. In early 1959, soon after Fidel became head of the new revolutionary government, he ranked cinema and television, in that order, as the most important forms of artistic expression. A decade later, the First National Congress on Education and Culture pointed to radio, television, the cinema, and the press as "powerful instruments of ideological education, molders of the collective consciousness whose use and development must not be left to improvisation or spontaneity." The congress singled out film as "the art *par excellence* in our century."

Histories of postrevolutionary Cuban cinema customarily begin by observing that the decree which founded the Cuban Institute of Cinematographic Art and Industry (ICAIC) on March 24, 1959, was the first cultural act of the revolutionary government, coming less than three months after the overthrow of Batista. In fact, another revolutionary film organization preceded ICAIC. Cine Rebelde, part of the Rebel Army's National Board of Culture, was founded as soon as the rebels took power. After producing two documentary shorts, Tomás Gutiérrez Alea's *Esta Tierra Nuestra (This is Our Land)* and Julio García Espinosa's *La Vivienda (Housing)*, Cine Rebelde became part of the newly founded film Institute. Alfredo Guevara, founding Director of ICAIC, insists that film was in fact the second priority of the new government, preceding but subordinate in importance and in impact to the national literacy campaign of 1960–61.

Prerevolutionary History

Cubans frequently stress the absence of a cinematic tradition in prerevolutionary Cuba, as Fidel did in his Report to the First Party Congress (1975) when he commended the achievements of "a new art form, without a history or a tradition in our country." Leading filmmaker and theorist Julio García Espinosa concurs regarding the dearth of constructive models but emphasizes the potential impact of what was in fact a powerful negative heritage.

Cuban film historians emphasize the parallel historical development of the film medium, the U.S. drive toward extraterritorial expansion, and the history of Cuba as a nation. Cubans were exposed to the moving image as early as citizens of any country on the continent when the first Lumière films made their debut there in 1897. By 1898, Cuban audiences were already being treated to the cinema as a vehicle for historical falsification imposed upon them by their neighbors to the north. *Fighting with Our Boys in Cuba, Raising Old Glory Over Moro Castle, The Battle of San Juan Hill*, and the like alternated authentic footage with blatant simulations filmed not in Cuba but in the U.S. Their purpose was less to relay an accurate picture of the Cuban War for Independence from Spain than to rouse patriotic Yankee sentiment in favor of U.S. intervention in that war.

In the early years of the American movie industry, independents fleeing the watchful and monopolizing eye of Edison's Motion Picture Patents Company took refuge on Cuban shores before eventually setting up shop in southern California. Sporadic attempts to establish a national Cuban film industry capable of competing with entrenched foreign concerns seemed doomed to perennial failure and were virtually abandoned after the advent of sound. Film production, distribution, and exhibition in Cuba became the province of American and Mexican companies. From the thirties through the fifties, Cuba's major cinematic role was to furnish exotic sets, sultry sex queens, and a tropical beat for Hollywood and Mexican productions. Cuba offered an audience as well. In proportion to its population, the Cuban movie market was the most lucrative in Latin America. A population of less than seven million produced the astonishing number of one and a half million movie-goers per week despite the fact that large segments of the rural population had never seen a single film.

Escapist tropical musicals, melodramas, and detective flicks characterized national film production during the twenty years preceding Batista's overthrow. The 8,000 workers in the industry were primarily employed in the production of advertising shorts for theaters and television, newsreels for local consumption, and technical or scientific

films for specialized audiences. One other specialty of the prerevolutionary film industry deserves mention: Cuba had more than its share of enterprising pornographers.[2]

During the fifties, most serious film activity was centered in film societies, in particular the *Nuestro Tiempo* (Our Times) and *Visión* groups. In 1954, two members of the former, Julio García Espinosa and Tomás Gutiérrez Alea, fresh from two years of film study at the Centro Sperimentale in Rome, collaborated with several other Cubans on a short dramatic feature in the style of the Italian Neorealists, called *El Mégano* (The Charcoal Worker). This denunciation of the hardships of charcoal production on the island's southern coast was confiscated by Batista. Though its style and formulation now seem embarrassingly naive, the film still enjoys the special distinction of being the only recognized antecedent of postrevolutionary cinema. All who collaborated on it have gone on to become leading figures in ICAIC: screenwriter Alfredo Guevara was head of the Film Institute from its founding until 1982; production assistant Jorge Fraga, now a director in his own right, has also served as Head of Film Production since 1978; cameraman Jorge Haydu is a leading cinematographer; Gutiérrez Alea is ICAIC's foremost director, and Julio García Espinosa—filmmaker, script consultant, theoretician—was appointed to succeed Guevara as Head of ICAIC in 1982.

Despite the remarkable size of the national film audience, the most reliable estimates conclude that the Cuban film industry produced no more than 150 features in its six decades of prerevolutionary history. Aside from newsreels, noncommercial documentaries were virtually unheard of. In the succeeding 24 years, ICAIC produced 112 full-length films (feature and documentary), some 900 documentary shorts —educational, scientific, and technical as well as animated and fictional films—and more than 1,300 weekly newsreels.[3]

Emphasizing Documentary

As these production statistics demonstrate, ICAIC has given priority to documentary over fictional subjects. Both economic and ideological factors motivate the preference. The economic motivations are obvious: when funds and equipment are limited, professional actors, elaborate scripts, costuming, and studio sets can be regarded as nonessentials. In a society which subscribes to the principles of Marxism-Leninism, it is believed fitting that creative activity be based on the confrontation with material reality. The impulse to document the euphoria of the rebel victory and popular response to the resulting social transformations brought aspiring filmmakers out into the streets. What

had previously been an impossible dream—making serious cinema in Cuba—was now an immediate possibility for scores of young cinemaphiles. This attempt to record the first convulsive moments of revolutionary victory had a profound effect on artists who had previously conceived of filmmaking as above all a vehicle for personal expression. In their documentary apprenticeship, Cuban filmmakers came face to face with unimagined aspects of national life. Their newly found growth in awareness and social sensitivity is largely responsible for the intense dialectic between historical circumstance and individual response which informs fictional as well as documentary production in postrevolutionary Cuban cinema.

The newsreels, produced under the direction of Santiago Alvarez and aimed not just at Cuban audiences but toward all of Latin America, are exceptional examples of the genre. Alvarez explains that his concern

> has not been to make each news item independent of the others, but to connect them in such a way that they pass before the spectator as a unified whole, according to a single discursive line. This accounts for the deliberate structuration which we use to achieve this thematic unity. For this reason, many classify our newsreels as genuine and autonomous documentaries.[4]

Initially restricted by the shortage of funds, material, and resources, Alvarez was one of many Cuban filmmakers to successfully turn practical handicaps into expressive assets. Obliged to draw from existing film archives and such "second-hand" sources as news photos and television footage, he developed a methodology which circumvented the need for on-the-spot footage and elevated the film-collage to a high level of political and artistic quality.

The innovative display of secondary footage, rhythmic editing with dramatic variations in pace, graphically innovative titles and eclectic musical selections (in preference to any spoken narration), superimposition and other experimental montage techniques characterize his early films. Material and political circumstances encouraged Alvarez, like his spiritual ancestor Dziga Vertov, to create the essence of his art on the editing table. As circumstances changed and more resources were put at his disposal, he shifted from black and white to color and began making longer films in which primary footage predominates. More recent films are characterized by more traditional cinematography, longer takes and less experimental editing, and the frequent use of voice-over narration.

In general, we can loosely divide Cuban documentary production into five thematic categories. Films which deal with *domestic politics* promote governmental policies and encourage popular participation and mass mobilization. *Historical* films chart various aspects of the formation of national identity through the five centuries of the island's recorded history. Documentaries of a *cultural* nature may be either national or international in their focus. Films which take *international relations* for their theme might focus on Cuba's role in international affairs, analyze the developed sector, or express solidarity with other Third World nations. Finally, *"didactic"* documentaries, highly technical or scientific in nature, are generally produced by specific agencies rather than ICAIC.

Project and Process

Two central themes run through all of Cuban cinema, fictional and documentary production alike—history and underdevelopment. Cubans interpret each of these terms in a broad and fluid way: underdevelopment as the economic and technological heritage of colonial dependency which has its more stubborn manifestations in individual and collective psychology, ideology, and culture; history as a complex of formative influences which elucidates the present and informs the future. Both themes have had an impact on the form as well as the content of revolutionary Cuban cinema. The dialectical tension between practical limitations and artistic aspirations has encouraged innovation and spontaneity. The filming of *Memories of Underdevelopment*, for example, became itself a "memory of underdevelopment" as Gutiérrez Alea describes it: "At each step we felt the touch of underdevelopment. It limited us. . . . It conditioned the language with which we expressed ourselves." "I have to say," he concludes, "that this is the film in which I have felt most free . . . in spite of the ever-present limitations imposed by underdevelopment. Perhaps I felt free precisely because of those limitations."[5] After his visit to the island in 1975, Francis Ford Coppola attempted to compare the situation of Cuban filmmakers with their U.S. counterparts. Having perceived the kind of creative freedom which comes from overcoming practical constraints, he observed, "We don't have the advantage of their disadvantages."[6]

At an early stage in the development of ICAIC, founder Alfredo Guevara expressed the organization's determination to lay bare the form and technique of the filmmaker's craft, formulating the purpose of the Cuban film project as follows: "to demystify cinema for the entire population; to work, in a way, against our own power; to reveal

all the tricks, all the recourses of language; to dismantle all the mechanisms of cinematic hypnosis."[7] In part, this determination grows out of the conviction that all forms of artistic expression carry an ideological dimension. If this ideological bias is veiled in the vast majority of art works produced in capitalist societies, Cuban filmmakers reason, it should be made explicit in the artistic production of a revolutionary socialist regime. Thus the eclecticism of Cuban film style is in part the result of the effort to appropriate forms of cinematic expression from the developed capitalist sector in order to dismantle them and expose their inner workings. Cubans call this operation "decolonization" and consider it the first priority of their film effort.

Cuban filmmakers have used many formal devices in their attempt to convert the audience from passive consumer into active participant. The Bazinian realism of the first postrevolutionary feature, Tomás Gutiérrez Alea's *Historias de la Revolución (Stories from the Revolution,* 1960), soon gave way to more self-reflexive forms, exploring the paradoxical Brechtian contention that dislocation and distancing, rather than unbroken identification, increase the conscious and critical participation of the spectator. Formal self-consciousness, initially apparent in the allusions to leading world filmmakers in the early feature *The Death of a Bureaucrat* (1966) and in García Espinosa's picaresque farce, *The Adventures of Juan Quin Quin* (1967), has subsequently found expression in multiple self-reflexive devices. García Espinosa's feature-length documentary *Third World, Third World War* (1970) incorporates the actual filmmaking process into the finished picture, as do the subsequent feature-length documentary *Bay of Pigs* (Manuel Herrera, 1972) and the historical biography *Mella* (Enrique Piñea Barnet, 1975). Established film genres are often parodied and subverted: the Hollywood war movie in *Bay of Pigs;* the ahistorical Latin melodrama in *The Other Francisco* (Sergio Giral, 1974). Octavio Cortázar's poignant account of one mountain community's first exposure to moving pictures—*For the First Time* (1967)—is an early example of the film-within-a-film device. *With the Cuban Women* (1974), by the same director, opens with startling disjunction between aural and visual information. Films like *Memories of Underdevelopment* (1968), *Lucía* (1968), and *The Other Francisco* (1974) are characterized by a marked shift between lyricized and naturalistic visual styles. Experimentation with film stock, laboratory techniques, lighting, and camera lenses accounts for the visual expressionism of films like Manuel Octavio Gómez's *The First Charge of the Machete* (1969), Part I of Solas's *Lucía* (1968), and the same director's first color film, *Simparele* (1964), as well as many of the Alvarez documentaries. Other self-reflexive devices include the experimentation with musical and nonmus-

ical sound and the print medium which also characterizes Alvarez's work and that of several other directors and, finally, the dramatization of the documentary form through the appropriation of narrative techniques traditionally associated with fictional filmmaking as in shorts like Alejandro Saderman's *Hombres de Mal Tiempo* (*Men from Mal Tiempo*, 1968), Oscar Valdés's *Muerte y Vida en El Morrillo* (*Death and Life in El Morrillo*, 1971) and Miguel Torres's *Historia de una Infamia* (*History of an Infamy*, 1983). The reverse of this operation informs films like *Memories of Underdevelopment* (1968), *The Other Francisco* (1974), *Bay of Pigs* (1972), *One Way or Another* (1974/ 1977), and Gutiérrez Alea's latest feature, *Hasta Cierto Punto* (*Up to a Certain Point*, 1983).

But formal self-reflexiveness is not a *sine qua non* of Cuban film production. As Jorge Fraga, head of artistic production at ICAIC, puts it in our first interview, "We are not in favor of firing merely for the pleasure of hearing the shot. We shoot in order to hit the target." Many recent films seem to have subordinated issues of formal candor to other considerations and other goals. Gutiérrez Alea's *The Last Supper* (1977) and Pastor Vega's *Portrait of Teresa* (1979) are but two examples of recent films which opt for classical over modernist form. The power of Hollywood's "transparent" style continues to fascinate the Cubans, whose goal is to use that capacity to galvanize an audience for less ideologically veiled and alienating ends. In a society which purports to derive its vitality from a constant process of reexamination and renewal, even apparently conventional strategies can be used in innovative ways, and what was once innovative can become constrictive.

ICAIC's leadership stresses each film's potential for "communicability" (*comunicabilidad*) as the crucial determinant of its worth but continues to recognize multiple strategies for achieving this end. In Julio García Espinosa's words, the greatest responsibility of Cuban filmmakers is to create a kind of cinema "where the human factor, imagination and talent are more important than technical considerations; where artistic conception is completely in tune with actual existing resources."[8]

However impressive the quantity and quality of film production in a country which had no national film industry prior to 1959, this is but one aspect of a comprehensive national film program whose primary goals are universal film literacy and universal access to the medium. Consistent with the priority placed on human development over technical acquisition in the production sector, scarce financial resources channeled into exhibition in the early years were concentrated on providing the largest number of uninitiated viewers with access to film.

Faced with the dire shortage of movie theaters in rural areas, and the financial and temporal obstacles to constructing the number needed, the Cubans devised the famous "mobile cinemas." Trucks, mule teams, even small boats, fitted out with projection equipment and stocked with an eclectic repertoire of film titles, were sent to the most remote sections of the island. In more densely populated regions, topical film "cycles" are continually presented at eleven theaters throughout the island. This program, run by the Cinemateca de Cuba, a division of ICAIC, provides films for 100,000 spectators per week— presumably a world record for an institution of its kind.[9] Two national television programs provide ongoing education in film history, language and technique.[10]

Though the prevalence of praxis (filmmaking and active organizational work) over theoretical deliberation in written form has been characteristic of the Film Institute to date, ICAIC's contribution to film theory has been far from negligible. Alfredo Guevara, founder and director of ICAIC, has continually given ideological direction and theoretical orientation through speeches and essays. His leadership has been a guiding force not only within Cuba but for politically committed filmmakers throughout Latin America who have been invited to Havana to use ICAIC's facilities or to participate in the International Festivals of the New Latin American Cinema held annually since 1979.

Efforts to define in writing the nature and role of film in a revolutionary society began in 1960 with the first issues of the Cuban film magazine *Cine Cubano*, and related deliberations continue to appear in its pages. The first theoretical formulation to generate broad impact outside the island was Julio García Espinosa's "For an Imperfect Cinema" (1970; see volume one for full text). García Espinosa has subsequently written several other essays which attempt to build a bridge between practice and theory. In 1979, these were collected under the title *Una imagen recorre el mundo* (Havana: Letras Cubanos). Tomás Gutiérrez Alea has also recently turned to parallel pursuits. His *Dialéctica del espectador* (Havana: Cuadernos de la Revista Unión, 1982) was named one of the ten best books of the year (see volume one for essay by Alea).[11]

The Evolution of ICAIC: A Chronology

My research suggests a tentative chronological division into four periods: 1959–1960, 1960–1969, 1970–1974, 1975–1983. The initial period, from 1959 to 1960, was characterized by explosive optimism and a great sense of release, by the jubilant return of many exiled artists,

the influx of foreign talent, and the artistic debut of many young and
untried nationals. Enthusiastic organizational activity included the
founding of ICAIC and the nationalization of all film-related holdings
in foreign hands. The attitude of the government and the population at
large was one of uncritical enthusiasm for artistic and intellectual ac-
tivity of all sorts. Among the artists themselves, united-front politics
predominated. The first film efforts were generally celebrative works
in an epic or journalistic style which focused on the trajectory and
triumph of the insurrection and on the corruption and injustice of the
former regime.

In the second period, 1960 to 1969, the concept of revolutionary art
and of the revolutionary artist became gradually more defined through
a series of debates and polemics as well as the lived experience of the
Revolution. Ideological maturation and intensified class conflict began
to curb the "anything goes" atmosphere in the artistic sector. The con-
cept of art as praxis and of the artist as militant participant rather than
detached observer began to dominate. The broad and initially uncriti-
cal assimilation of foreign models, the virtually unlimited hospitality
to visiting artists and intellectuals, and the attentive quest for their ap-
proval gave way to a more critical stance and to the growing influence
of artistic inspiration from national sources and other Third World
countries—particularly other Latin American nations—in preference
to the developed sector.

At the beginning of this period, the prevalence of visiting foreign
filmmakers at ICAIC and the organization's involvement in a number
of co-productions with various countries contributed to a rather super-
ficial and exotic interpretation of Cuban culture. The celebration of
"One Hundred Years of Struggle" in 1968 to commemorate the fight
for national autonomy which began a century before sparked a much
richer and more penetrating analysis of national history and identity.
The pervasive influence of Italian Neorealism in the early sixties and
the fascination with the French New Wave in mid-decade had, by the
end of this period, given way to broad-based stylistic experimentation
and characteristically Cuban eclecticism. By 1964, the Cuban docu-
mentary was beginning to gain international attention through the
work of Santiago Alvarez. Fictional production came into its own four
years later with the release of *Memories of Underdevelopment* and
Lucía. This period also saw signs of diminishing tolerance for a lib-
eral interpretation of artistic freedom and responsibility. For numerous
reasons, the process of defining the role of art in a revolutionary so-
cialist society met with more difficulties in the realm of letters, with
its centuries-long tradition of isolated individual production, than in
the film sector or the other more cooperative and social arts. The ten-

sions between individual ambition and the needs of the collectivity were played out between the years 1967 and 1971 in the life and career of one particular poet, Heberto Padilla, who became an international *cause célèbre* upon his imprisonment in 1971.[12]

The failure of the projected ten-million-ton sugar harvest in 1970 brought about a critical reappraisal of policies and priorities in all sectors of society, beginning with Fidel himself and including ICAIC and other cultural agencies. The period between 1970 and 1974 saw an increased emphasis on mass participation and the search for more indigenous cultural forms. Elitism and manifestations of artistic privilege were rejected in favor of an attempt to define and produce a genuine people's culture. At ICAIC there was a consequent decline—by no means absolute—in formal experimentation, which had reached a peak of virtuosity in the late sixties. The emphasis on documentary production extended during these years to the realm of feature-length films, where for the first time nonfictional subjects outnumbered fictional ones.

Nineteen hundred and seventy-five, the year of the first National Congress of the Cuban Communist Party, marks the inception of a period of sweeping reorganization within ICAIC, a process which may or may not have culminated with the naming in 1983 of Julio García Espinosa to succeed Alfredo Guevara as head of the Institute. In 1976, the process of "institutionalization of the Revolution" which began in 1970[13] reached the cultural sector. The formation of a national Ministry of Culture, which incorporated ICAIC under Guevara's continuing direction as one of its five vice-ministers, marked the symbolic loss of the privileged autonomy the Institute had enjoyed since its founding. Lest the motivations for the economic reorganization and redefinition of ICAIC appear to have come largely from outside the agency, it is important to note that these directives coincided with internal concerns to lower costs and increase productivity which date from the beginning of the decade. As Jorge Fraga, Head of Artistic Programming, explained in a personal interview in 1977:

> Filmmaking is a living contradiction, because as an industry, it would have its optimal technical-economic efficiency if it were producing standardized products. But as an art form, it cannot be governed by standardized norms. This contradiction lies within the nature of film itself because film cannot cease to be an industry nor can it cease to be an art. The only possible answer is to seek out the organizational mechanisms that will prevent these two factors from entering into conflicts which might be harmful to the development of either component.

FIGURE 1. Phase I: Before 1975

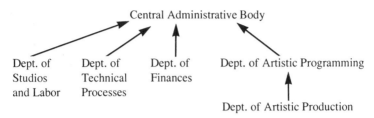

Central Administrative Body

Dept. of Dept. of Dept. of Dept. of Artistic Programming
Studios Technical Finances
and Labor Processes

Dept. of Artistic Production

Predictably, ICAIC's structure has grown progressively more complex during the successive stages of this reorganization process (see Figures 1, 2, and 3).

Alfredo Guevara has stated that the greatest innovations of the Cuban film industry have been in the social relations of the labor process, and other leaders within ICAIC have seconded this claim. The Cubans have tried to balance the needs of the collectivity with those of personal creative expression through their commitment to workers' control and the collective evaluation of each other's work, as well as through the high degree of initiative granted to the director. *Conciencia* (sociopolitical awareness and sense of responsibility) and *subjetividad* (personal artistic judgment) are regarded as the dual components of the creative process.

The reorganization process has included a revision of the salary system (under discussion since 1979) and the introduction of a system of bonuses (*primas*) to encourage directors to finish their films within the time and budget allotted to them. Differential pay has been instituted as a means of rewarding those who perform their job particularly well, as judged by a blue-ribbon committee of their peers. Whether such changes will eventually have a positive or negative impact upon the social relations of production at ICAIC remains to be seen.

The prolonged and time-consuming efforts to restructure the film sector constitute a tentative response to a number of ongoing problems within ICAIC and within the larger society. These include: limited financial and technical resources; a demand for film products which exceeds existing production capacities; lack of procedures and resources to develop and incorporate new talent; a tendency to rely excessively, for both artistic and organizational leadership, on a limited number of recognized figures without adequate mechanisms for distributing responsibility; the persistent separation and subordination of documentary to fictional filmmaking in practice if not in theory.

ICAIC's entire annual budget is only 7,000,000 pesos ($7,-000,000). According to Jorge Fraga, this allocation must cover not

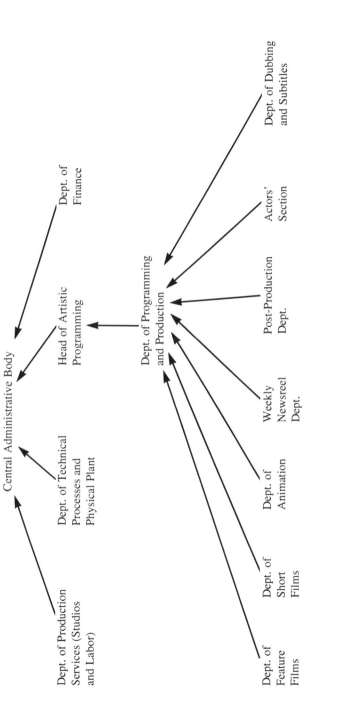

FIGURE 2. Phase II: Interim Structure

FIGURE 3. Phase III: After 1981

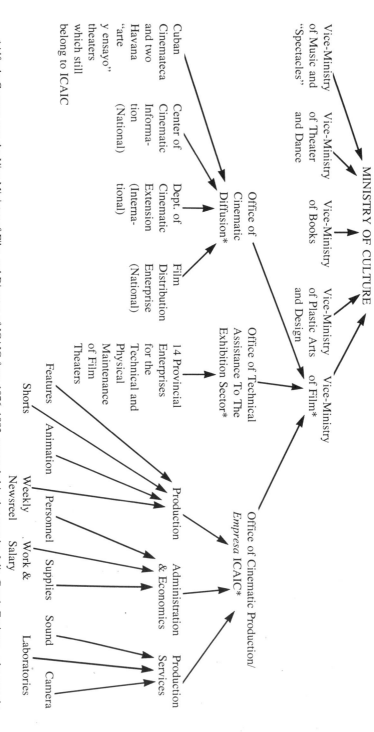

*Alfredo Guevara was the Vice-Minister of Film and Director of ICAIC from 1976–1983, succeeded in that year by Julio García Espinosa, who was the Vice-Minister of Music and Spectacles during the same years, after having served as Head of Artistic Programming at ICAIC. The Heads of the three "Enterprises" which now make up ICAIC are: Diffusion, Benigno Iglesias; Technical Assistance to the Exhibition Sector, José Manuel Pardo; Cinematic Production, Jorge Fraga.

only production expenses but salaries for all of ICAIC's 1,100 em-
ployees.[14] Current production levels stand at approximately 40 docu-
mentaries, 5–10 animated cartoons, 4–6 features, and 52 weekly
newsreels. Though documentary production has remained fairly steady
over the past decade (1972–1983), with high points of 47 in 1976–77
and 1980–81, it declined to below 40 in 1979 and 1983. Production
levels for feature films have remained chronically lower than pro-
jected targets. The projected goal for 1985 is 12 features annually, or
one per month, though to date feature output has never exceeded
eight, and has in fact only risen to about five if one includes feature-
length documentaries in the tally. The decade of the 1960s saw only
two feature-length documentaries; nearly twenty times this number
were produced between 1970 and 1983, closely rivaling the number of
fictional features.

As Julio García Espinosa and a number of others have pointed out,
though nationalization gave Cubans ownership of the movie theaters
in the early sixties, they have still not been able to claim full owner-
ship of the screens. Of the 130–140 feature films annually premiered
in Cuba to supply the 510 theaters on the island, only about 3 percent
are national products; the vast majority are imported from abroad.
Cuban audiences' potential demand for Cuban features far exceeds
current ICAIC production levels. The institution of positive and nega-
tive material incentives to increase efficiency and productivity is one
strategy to make greater use of existing resources. International co-
productions are another. Whether or not one views these methods as
constructive and consistent with ICAIC's ideology and goals, they do
not seem fully proportionate to the dimensions of the problem.

Despite the ideological importance conferred upon the documenta-
ry, fictional filmmaking continues to be regarded as the highest ex-
pression of the cinematic vocation, at least as much by the members
of ICAIC as by the filmgoing public. With a single exception (Hum-
berto Solas) all of ICAIC's filmmakers have begun as documentarists.
The opportunity to make feature-length fiction films is a "promotion"
earned through a long process of "documentary apprenticeship."
Rather than increasing over time, the number of documentarists who
"graduate" to fiction has declined. Since 1977, only three directors
have been awarded this distinction: Pastor Vega made his first fic-
tional feature *Retrato de Teresa (Portrait of Teresa)* in 1979; Manuel
Herrera made *No Hay Sábado Sin Sol (There's No Saturday Without
Sunshine)* the same year; and Jesús Díaz's fictional debut came in
1981 with *Polvo Rojo (Red Dust)*. (All three had previously made at
least one full-length documentary.) Between 1974 and 1976, as a re-
sponse to the need to inject "new blood" into the institution, ICAIC

took on a score of university graduates (the vast majority women) for training as "*analistas,*" using them as apprentices in all sectors of the production process from script research to assistant direction. These aspiring filmmakers face an additional hurdle, the jump from assistant or apprentice to documentarist. Here, too, the process of ascent seems deplorably slow.

North American visitors to ICAIC continue to question the dearth of women directors and the limited number of blacks. Sara Gómez, who belonged to both the above categories, died in 1974 of acute asthma on the verge of completing her first feature, *One Way or Another.* Sergio Giral, the only black feature director, made his third feature (*Maluala*) in 1979. Among the documentarists, there is one black (Rigoberto López) and three women (Marisol Trujillo, Belkis Vega and Rebeca Chávez). In response to this criticism, the Cubans reply that they reject any notion of quotas as inherently discriminatory, and that they have had only twenty-five years to try to reverse centuries-old legacies of discrimination. Mayra Vilaris, assistant director, stated in a recent interview, "I would feel personally offended if I were told to start working on a film as the director because we need more women directors."[15] Her position is representative of many women at ICAIC. In a 1977 interview, Sergio Giral stated, ". . . not even I, as a black man, can conceive of a 'black' filmmaker or a 'black' film. . . . We have to retain the concept of race as an historical, social category."[16] Their primary identification, these Cuban cineasts declare, is as Cubans, not as women, or blacks, or Chinese, and it is as Cubans that they feel they can best work together to create a society that, in Jorge Fraga's words, "permits everyone the possibility to develop fully."[17]

As an island, Cuba has always been very aware of how much a vigorous national culture depends upon the quantity and quality of visits to and visitors from abroad and what baggage they bring ashore. Under Minister of Culture Armando Hart, Cuban artists and intellectuals have enjoyed increased opportunities for foreign travel, but even more important to the people and the project of ICAIC has been the influx since 1979 of filmmakers and critics from all over the world to attend the International Festival of the New Latin American Cinema held annually under its auspices. This remarkable forum for cultural exchange and discussion also testifies to the support and leadership role which ICAIC continues to play in the evolution and development of oppositional cinema in Latin America. In order to increase the worldwide diffusion of Latin American films, the Latin American Film Market (MECLA) was launched at the Second International Festival in 1980. The Fifth International Festival (December 1983) ex-

panded its exhibition scope northward to include more than a decade of American independent filmmaking in a program called "The Other Face: Independent Films in the United States."

Cuban poet and patriot José Marti said that the only way to do away with the need for soldiers is to become one. Leery of professional critics, Cuban filmmakers decided early on to assume the critic's task in *Cine Cubano* themselves rather than cede it to specialists. Twenty-five years later, ICAIC has only two full-time critics: Carlos Galiano, who also writes reviews for the national daily *Granma*, and hosts a weekly TV show called "History of the Cinema," and Enrique Colina, whose prime-time program "Twenty-four Frames a Second" has been one of the most popular in Cuba for over a decade. If the televised film history and criticism is remarkably sophisticated, its print counterpart is deplorably limited—both a legacy and a confirmation of the general view of the critical act as arbitrary, intrusive, superfluous. As García Espinosa wrote in 1970, ". . . imperfect cinema rejects whatever services criticism has to offer and considers the function of mediators and intermediaries anachronistic."[18]

García Espinosa's assumption of the directorship of ICAIC has been greeted with general approval and optimism. More than for his experience as a filmmaker or theorist, this founding member of ICAIC is valued for his ability to unleash the creative energies of others. He has served as adviser on scores of Cuban films and a list of his screenplay collaborations contain some of ICAIC's most outstanding and experimental films: Humberto Solas' *Lucía*, Manuel Octavio Gómez' *First Charge of the Machete*, and the feature-length documentaries *Bay of Pigs* (Manuel Herrera), *¡Viva la República!* (Pastor Vega) and *The Battle of Chile* (Patricio Guzmán).

Throughout his career, García Espinosa has been concerned with reconciling artistic practice and mass society. His goal has been to displace elitist cultural forms in favor of genuinely popular ones created with the participation of broad sectors of society. His longstanding interest in problems of genre stems from his perception of both the mass appeal and transformative potential of conventional narrative formulae. In a recent interview he recalled:

> Through the experience of filming *The Adventures of Juan Quin Quin* (1967), it became clear to me for the first time that it is in fact impossible to question a given reality without questioning the particular genre you select or inherit to depict that reality. Normally the artist's critique of the genre is done independently, and only the results of the process are shared with the viewer. The challenge I faced was to discover how this critical process

itself, rather than simply the results of that process, could be in-
tegrated into the film.[19]

In an earlier essay, he maintained:

> Until now, we have viewed the cinema as a means of reflecting
> reality, without realizing that cinema in itself is a reality, with
> its own history, conventions, and traditions. Cinema can only be
> constructed on the ashes of what already exists. Moreover, to
> make a new cinema is, in fact, to reveal the process of destruc-
> tion of the one that came before. . . . We have to make a specta-
> cle out of the destruction of the spectacle. This process cannot
> be individual. . . . What is needed is to perform this process
> jointly with the viewer.[20]

García Espinosa envisions a Tarzan film in which the hero takes
part in contemporary political conflicts, marries an African woman,
and is assimilated into African culture. He believes that the musical is
a "natural" genre for Cuba, and his own *Son O No Son* (an untranslat-
able pun on Hamlet's "to be or not to be" and the Cuban musical
form, *son*), which obtained a belated and limited release in 1980, is a
delightfully comic imitation of the genre, both subversive and self-
critical without ceasing to be enormously entertaining. Manuel Octa-
vio Gómez' *Patakin*, billed as "the first Cuban musical," which
premiered at the 1983 Festival to mixed reviews, testifies to García
Espinosa's continued encouragement of such efforts. His previous ex-
perience with documentary suggests that this area, site of so much ex-
traordinary creativity over the last decade, will not be neglected.

Beyond the production sector, García Espinosa envisions differen-
tiated viewing environments (workplace-associated or workplace-dis-
associated depending upon the nature of the films screened) and a
future time when Cuba will have the technological resources to make
filmmaking a genuinely mass activity: "Short of this, we have only
made it halfway as filmmakers." He believes that as the electronic
media invade the home and make conventional movie theaters obso-
lete, people will seek out cultural products which offer a more direct,
less vicarious, interaction, and that this *reto de masividad* (challenge
of mass society), the greatest challenge facing cultural workers today,
must not be ceded to purely commercial interests. As he wrote in
1970, in the closing lines of his famous essay "For an Imperfect Cine-
ma," whose ideas still reverberate through ICAIC, "the future lies
with folk art but then there will be no need to call it that [since there

will be no need to connote the limits of popular creativity]: Art will not disappear into nothingness, it will disappear into everything."[21]

Notes

1. See Gary Crowdus, "The Spring 1972 Cuban Film Festival Bust," *Film Society Review*, vol. 7, nos. 7–9 (March/April/May 1972), pp. 23–26.

2. Regarding this last point, see Peter Brook, "The Cuban Enterprise," *Sight and Sound*, vol. 30, no. 2 (spring 1961), pp. 78–79. The principal source for prerevolutionary film history is Arturo Agramonte, *Cronología del cine cubano* (Havana: Ediciones ICAIC, 1966). See also Julio Matas, "Theater and Cinematography" in Carmelo Mesa-Lago, ed., *Revolutionary Change in Cuba* (Pittsburgh: University of Pittsburgh Press, 1971), pp. 436–42.

3. My own updating of original figures from *Granma Weekly Review*, January 1977, based on *Filmografía del cine cubano*, 1959–1981, and Supplement: January 1982–November 1983 (Havana: Producción ICAIC 1982, 1983).

4. "Santiago Alvarez habla de su cine," *Hablemos de cine*, 54 (July–August 1970), p. 30.

5. Tomás Gutiérrez Alea, *"Memorias del subdesarrollo: Notas de trabajo,"* *Cine Cubano*, 45/46 (1968), pp. 24–25.

6. Francis Ford Coppola, "Robert Scheer Interviews Francis Ford Coppola on Cuba, Castro, Communism and the Mafia," *City of San Francisco*, vol. 9, no. 21 (December 2, 1975), p. 22.

7. Cited in Marjorie Rosen, "The Great Cuban Fiasco," *Saturday Review*, June 17, 1972, p. 53.

8. Julio García Espinosa, "Cinco preguntas a ICAIC," *Cine al día*, 12 (March 1971), p. 22.

9. See José Manuel Pardo, "El Cine-movil ICAIC," *Cine Cubano*, 73/74/75 (1971), pp. 93–104.

10. On the most successful of these programs, see Jorge Silva, "Film Criticism in Cuba: An Interview with Enrique Colina," *Jump/Cut: A Review of Contemporary Cinema*, 22 (May 1980), pp. 32–33.

11. See *Jump/Cut: A Review of Contemporary Cinema*, nos. 29 and 30 (spring 1984 and forthcoming) for Julia Lesage's translation of this text under the title "The Viewer's Dialectic."

12. For full documentation of this famous case, see Lourdes Casal, *El caso Padilla: Literatura y revolución en Cuba: Documentos* (Miami: Nueva Atlatida, 1971). Padilla's poetry of the period appeared in Heberto Padilla, *Fuera del juego* (Buenos Aires: Aditor, 1969) and in J.M. Cohen, trans., *Sent off the Field: A Selection of the Poetry of Heberto Padilla* (London: Deutsch, 1972).

13. See Nelson P. Valdés, "Revolution and Institutionalization in Cuba," *Cuban Studies/Estudios Cubanos*, vol. 6, no. 1 (January 1976), pp. 1–37.

14. Susan Fanshel, "The Cuban Film Institute: Past and Present: An Interview with Jorge Fraga," in Fanshel, *A Decade of Cuban Documentary Film: 1972–1982* (New York: Young Filmmakers Foundation, 1982), p. 10.

15. Susan Fanshel, "Three Women in ICAIC: An Interview with Gloria Argüelles, Mayra Vilasis, and Marisol Trujillo," in *A Decade of Cuban Documentary Film*, p. 27.

16. Julianne Burton and Gary Crowdus, "Cuban Cinema and the Afro-Cuban Heritage: An Interview with Sergio Giral," *The Black Scholar*, vol. 8, nos. 8–10 (Summer 1977), p. 65.

17. Fanshel, "An Interview with Jorge Fraga," p. 13.

18. Julio García Espinosa, "For an Imperfect Cinema," trans. Julianne Burton, in Michael Chanan, ed., *Twenty-Five Years of the New Latin American Cinema* (London: British Film Institute and Channel Four Books, 1983), p. 32.

19. Julianne Burton, "Theory and Practice of Film and Popular Culture in Cuba: A Conversation with Julio García Espinosa," *Quarterly Review of Film Studies*, vol. 7, no. 4 (Fall 1982), p. 345.

20. Julio García Espinosa, "Carta a la revista chilena *Primer Plano*," *Una imagen recorre el mundo* (Havana: Letras Cubanas, 1979), pp. 26–27.

21. García Espinosa, "For an Imperfect Cinema," p. 33.

Death Is Not True

Form and History in Cuban Film

Timothy Barnard

"The true history of Cuba," the Cuba ethnologist Fernando Ortiz wrote in 1940, "is the history of its extremely intricate transculturations."[1] Ortiz went on to explain that "transculturation" was coined to oppose the Anglo-American sociological term "acculturation," which described a process of complete assimilation of minority cultures into dominant ones. Ortiz maintained that the process of cultural transformation set in motion by the meeting of races and cultures was better described as one of mutual influence resulting in new hybrids. The colonial era in the New World, of course, had provided the setting for the most extensive and sustained such "encounter" in history. At its center lay Cuba, a colonial crossroads, the site of a major New World port and a destination for peoples of vastly different cultures. The process of transculturation that took place there over the centuries was so extensive that Ortiz was led to claim:

> In Cuba, there were so many and such diverse cultures which influenced the formation of the Cuban people, and they were so geographically disparate in their origins and distinct in their characteristics, that the immense mixing of races and cultures there surpasses all other historical phenomena in importance. (*Contrapunteo*, p. 87, see note 1.)

John King, Ana M. López and Manuel Alvarado, eds., *Mediating Two Worlds: Cinematic Encounters in the Americas.* London: British Film Institute, 1993, pp. 231–41. By permission of the publisher.

Ortiz did not suppose that cultures entered into a free and equal exchange, a cordial and voluntary transculturation. Rather, he saw cultural transformation as a violent confrontation, the result of the "shock" of social upheaval. Transculturation was in fact the third, syncretic phase of this process, following an initial "deculturation," the traumatic and wholesale loss of culture during the initial encounter between stronger and weaker cultures, and the subsequent periods of "inculturation," when the suppressed culture regroups and begins to infect the dominant culture. In Cuba, the arrival of the Europeans was so overwhelming—a "hurricane of culture," Ortiz described it—and their genocide of the native population was so rapid that the deculturation-inculturation-transculturation cycle was carried out between the Europeans and their African slaves, with many other cultures added along the way. Ortiz reflected that this course of events could ultimately be seen as propitious for transculturation, remarking that all cultures were now "foreign" to the island and that all, albeit disproportionately, had been "torn" by the "trauma of uprooting."[2]

Although Ortiz's *Contrapunteo (Cuban Counterpoint)* approaches transculturation obliquely, through a novel study of the cultivation, trade and uses of sugar and tobacco in Cuba and around the world, he later extended his methodology to various studies of Afro-Cuban music, building on his earlier studies of black culture in colonial Cuba. Long one of the most diverse, dynamic and influential in the world, Cuban music presents tremendous opportunities for transcultural analysis, not just for historical research but for assessing its present-day relationship to other music. Significantly, the transcultural methodology has also proven invaluable to the continuing struggle in Cuba— both pre- and post-1959—to defend and encourage continued hybridization and experimentation. Before 1959 in particular, (white) cultural elitists periodically decried the black, foreign or popular contamination of their canon, blissfully unaware that the "authentic" musical tradition they sought to preserve was itself almost invariably the product of such cross-fertilization.[3]

After 1959, despite many progressive cultural changes, this fear of "contamination" persisted, although the categories of "authentic" and "alien" were now redefined in keeping with the country's political transformation. Thus a concerted attack on Western pop music was launched in the mid-60s, the effect of which on a music industry whose lifeblood had always been foreign contact should not be underestimated. In any event, armed with the insights of Ortiz's and others' historical research demonstrating the fundamental role of hybridization in the development of Cuban music, a group of Cuban intellectuals, musicologists and musicians in the post-1959 period has been able

to hold at bay the periodic isolationism and xenophobia of Cuban cultural policy. Today Santana and Michael Jackson (not coincidentally strongly syncretic performers) can be heard from street-corner boom boxes. Furthermore, one of Cuba's most popular contemporary dance-pop bands is Irakere, which has joined the rhythms and instruments, including synthesizers, of ritual African and contemporary pop music.[4] One of Cuba's leading novelists and intellectual figures, Alejo Carpentier (1904–80), himself a musicologist, waded into the fray by stressing that a dichotomy between "cultured" and "popular" music was false, bourgeois and driven by racial prejudice. Carpentier also characterized Latin American music as the product of continuous "grafts and transplants" which problematize its national character: "if electronic music and synthesizers have no nationality, whoever uses them brings to them his own nationality."[5]

In 1969, Cuban filmmaker Julio García Espinosa proposed that the Cuban cinema should carry out a radically different synthesis. In his essay "Por un cine imperfecto" (see volume 1 for text) he rejected U.S. and European influences out of hand: "Today a perfect cinema—one that is technically and artistically polished—is almost always a reactionary cinema."[6] In a tone consistent with the cultural rhetoric of the post-1959 political leadership, which regularly proclaims that European culture is "decadent" and "sterile," García Espinosa continued:

> When we look at Europe we rub our hands. We see the old culture today incapable of responding to the problems of art. What's really happening is that Europe can no longer respond in the traditional manner nor, at the same time, can it easily do so in an entirely new way. (*Hojas de cine*, p. 71, see note 6 below.)

García Espinosa's essay makes no suggestion that some accommodation between imperfect cinema, a radical liberationist aesthetic, and European cinema can exist. Rather, a complete break is urged, a rapid revolutionary cultural reconstruction breathtaking in its scope: "[the revolution] will allow us to sweep away once and for all minority artistic ideas and practices" (*Hojas de cine*, p. 72).

What then was the synthesis that García Espinosa proposed? It was to be the formulation of a "new poetics" which, together with sweeping political change, would bring about a Utopian merging of life and art: "Art will not disappear into nothing. It will disappear into everything" (*Hojas de cine*, p. 77). García Espinosa sketched out some of the effects of this process: the role of professional artists would gradually be taken over by workers, who would produce films in consultation with "sociologists, revolutionary leaders, psychologists,

economists, etc.," bringing to an end the "star" system of film direct-
ing and eliminating the quest for personal fulfillment on the part of
the filmmaker and the need for specialized filmmaking instruction
(*Hojas de cine*, pp. 77, 73). Furthermore, the passive spectator would
become a critical subject, a "spectator-creator" rendering film criti-
cism obsolete: "imperfect cinema rejects the services of criticism. It
believes the function of mediators and intermediaries to be anachron-
istic" (*Hojas de cine*, p. 77). New film-production technologies, higher
levels of education and more leisure time would make film-making
the activity of many and not just the few (*Hojas de cine*, p. 64). Gar-
cía Espinosa based his theory on his understanding that a successful
resolution of the class struggle would precipitate "the definitive disap-
pearance of the specialized division of labor." From this, he specu-
lated that revolutionary culture would also put an end to cultural
fragmentation and alienation: "revolution is the highest form of cul-
tural expression, because it will cause artistic culture as fragmentary
culture to disappear" (*Hojas de cine*, p. 72).

García Espinosa's "new poetics" was to be the aesthetic means to
this end. While his comments about the form of this new poetics are
vague, it is clear that it would rely on a strategy of radical synthesis:
"Imperfect cinema can use documentary or fiction techniques, or both.
It can use one genre or another, or all" (*Hojas de cine*, p. 76). The re-
sult of this all-encompassing aesthetic would be a transparency, an
aesthetic final solution: "It is no longer a question of substituting one
school for another, one 'ism' for another . . . imperfect cinema can't
forget that its essential objective is to disappear as a new poetics"
(*Hojas de cine*, p. 77). Or again: "This new poetics' true end, how-
ever, will be to commit suicide, to disappear as such" (*Hojas de cine*,
p. 72).

Echoes of these ideas resurface in an essay published ten years
later by Cuba's other leading filmmaker and theorist, Tomás Gutiérrez
Alea (see volume 1), who describes "the process of an organic inte-
gration of form and content" as a dialectic "in which both aspects are
indissolubly united and, at the same time as they oppose each other,
they interpenetrate each other, to the point where they can take over
each other's functions."[7] Rather than articulate the oft-repeated dictum
that revolutionary content must be accompanied by a revolutionary
form, this statement implies a necessary synthesis of form and
content: a form which embodies content and assumes diegetic func-
tions.

A synthesis such as García Espinosa and Alea describe is discerni-
ble in some of the political billboards that decorate Havana streets.
For example, in 1989–90 a long and narrow billboard featured at its

center a young Fidel and Raúl Castro striding towards us, arm-in-arm with Camilo Cienfuegos, the young revolutionary hero who disappeared in 1960 (neither his body nor the wreckage of the plane he was in were ever recovered).[8] On either side of these three, arm-in-arm in a line, are groups of three or four students, police, workers, striding smilingly towards us. But the police uniforms were introduced several years after Camilo's death; the construction mini-brigades, not until the 1980s. The past has been brought into the present with a seamless stroke of the brush. "Death is not true" *(La muerte no es verdad)*, hero of the Cuban war of independence José Martí once wrote. Although I once thought of this as a way of saying "one's deeds live on after death," one can also see in the phrase the billboard's propensity to confound past and present. Cuban cinema incorporated and further elaborated this synthetic aesthetic, creating in many of its historical fiction films a cinematic past-present tense via the conflation of documentary and fictional modes of address.

It is often said that with the popular revolution of 1959 and the founding of the national film institute, ICAIC, that same year, Cuban film "started from zero." If by this it is meant that before 1959 Cuba had no established feature film industry, and much less a tradition of "social" or "art" cinema, then this is certainly the case.[9] However, Cuba was a particularly large market for foreign films before 1959, and the young Cuban filmmakers who began working in the 1960s encountered well-established viewing habits which were to have a marked influence on the evolution of post-1959 film theory and practice, determining, for example, an insistence on the popular (the use of genres, the recourse to comedy and melodrama, the fast pace) which distinguished Cuban films from the other Latin American "new waves" of the period.

Perhaps, by borrowing Ortiz's terminology, we could say that a process of inculturation had taken place in Cuba before 1959. For decades a cultural commodity, a finished industrial product seemingly closed to transculturation, is said to have had its way with Cuban audiences. Cinema even seemed to carry with it predetermined modes of consumption. But it was precisely at the level of consumption that Cuban audiences were able to carry out a remarkable inculturation of this foreign cultural commodity via "audience participation": in theaters to this day, members of the audience speak to the screen, cajoling and chiding actors, and expressing shock and dismay. This is the manifestation of a virtual cultural imperative in Cuba, to make foreign culture "Cuban," and an expression of the powerful legacy of transculturation in the formation of Cuban culture and identity. Here then

is our first indication of a "perforation" of narrative structures and a mingling of voices in the cinema.

These viewing habits are complemented by a typical Cuban custom. With the exception of the Cinemateca and ICAIC (which have fixed-schedule archival and retrospective screenings) cinema theaters project their daily program in a continuous, uninterrupted loop. The program generally consists of a five-minute newsreel, a ten- to twenty-minute documentary or animated short, and the feature. Cuban audiences, including the middle class at first-run shows in downtown cinemas, seem to wander in and begin watching the show whenever they arrive (which can never be predicted when travelling on Havana's erratic transportation system). Thus the feature is often interrupted, made to straddle the short films, and viewed out of sequence.

In the above-mentioned essay, Alea draws attention to this program format but neglects entirely to mention this critical aspect of the mode of consumption. He contemplates how this format may influence formal strategies without considering how the viewing habits associated with it may determine them further:

> [This program format allows viewers to] experience *various levels of mediation* [author's italics] . . . which can offer them a better understanding of reality . . . seeing various genres at one screening does not always have the greatest coherence. . . . Nevertheless, this possibility of connections throws light on what could be achieved here, *even if we are just considering the framework of a single film* [my italics] (Alea, 1988, p. 27).

We know that the recent introduction of the remote-control TV channel-changer in the West was a decisive factor, along with the roughly contemporaneous stylistic innovations of the music video, in the recent radical change in the style of television commercials. No longer certain of the viewer's attention, commercials are abandoning their 'narratives' in favor of bursts of rapidly edited images. Sellers hope that exposure to a few seconds of these images will continue to sell their product, that form can do the job that content once did. Did Cuban viewing habits established in the pre-1959 period help determine post-1959 formal strategies in a similar way? We have already noted the broad impact they had, the emphasis in Cuba on popular entertainment, the manipulation of generic codes. More specific formal questions should also be considered, such as the construction of the diegesis (how can closure operate under the viewing conditions described above?).

Historical features were among ICAIC's earliest productions, and at most times in the past 30 years have formed the bulk of Cuban film production.[10] One critic has described this genre as *cine rescate*, a way to correct the distorted images of Cuba's own history.[11] In the early 1960s, Cuban films predictably enough turned to themes of the recent past, the years of revolutionary struggle. However, something curious happened as the young Cuban filmmakers matured in the late 1960s. The 1968–76 period, when Cuban cinema produced its greatest works, was dominated by historical narratives which reached even further into history, from the 1930s to the earliest colonial times. It could be argued that this evolution was a logical extension of the filmmakers' historical enquiries and that these new themes offered better opportunities for more subtle and profound analysis than the revolutionary themes, as indeed they did. Yet at the same time it is true that many in Cuba expected that, as the topic of the revolutionary years ran its course, these talented young directors would set their sights on contemporary reality, and there is considerable evidence that the filmmakers themselves attempted to move in this direction. That they were unable to do so was clearly the result of political pressure, as the doctrine of not casting a critical eye on contemporary Cuba was consolidated in those years.[12]

As it became clear that it was far easier to shepherd a historical theme through the ICAIC project-approval bureaucracy than a contemporary topic, this new generation of filmmakers in a "revolutionary" society worked overwhelmingly with topics from the distant past. We can expect that a complex depiction of the past would develop as a result, that the present might appear in phantom forms. Yet no doubt because widespread disillusionment with the political leadership was not yet evident in Cuba, an aesthetic of political allegory and irony through an 'encoded' depiction of the past did not develop (as it did during roughly this period in the past of Eastern Europe). Two films from this period dealing with the recent past best illustrate how the present was submerged in the historical narrative. In Manual Octavio Gómez's *Ustedes tienen la palabra* (*Now It's Up to You*, 1974), a tale of corruption and opportunism is told in flashback. The conflicts and contradictions of that recent period are explored, but contrasted with present-day sequences, when these conflicts have been dissolved in a display of popular revolutionary unity and resolve. It is significant that the only images we see of the present are those of the trial which purges the corrupt elements from the community. In Alea's *Memorias de subdesarrollo* (*Memories of Underdevelopment*, 1968), arguably the most ambivalent Cuban film produced, Alea's ambivalence is not only filtered through the past (the Bay of Pigs in-

vasion of 1961), it is embodied in the figure of Sergio, a representative of the national bourgeoisie, a class dismantled, exiled and reviled by the time of the film's production. In each film, the narrative is carefully constructed to ensure that the contradictions of the past are banished from the present.

In 1971 Alea filmed *Una pelea cubana contra los demonios* (*A Cuban Struggle Against the Demons*, 1972), one of his least seen and most experimental works. Based on Fernando Ortiz's account of a case of religious fanaticism in 1672, the setting is the furthest back in history that Cuban film has reached. On viewing Alea's treatment, one suspects that part of the story and the setting's appeal lay in the opportunity to create a radical abstraction of form against such a remote and delirious backdrop. Virtually every frame of the film is animated by a moving camera which circles dinner tables and follows people through buildings.

Alea's moving camera creates a structure which seems not so much stitched together through montage as a continuous image, a two-hour zoetrope. The surface image, described by some critics as "fluid," could really be said to be "liquid," a flowing river of images. Near the end of the film there is a scene of a canoe being paddled along a still river. While a shaman speaks in trance off screen, the screen goes black with leader and then flickers with brief, ethereal black and white photographs of José Martí, Che Guevara and Fidel Castro. The surprising thing is how little we are taken aback by this juxtaposition of historical moments, so porous and elastic is Alea's image. Alea has created a form which has allowed him not to depict the past but to foretell the future from the vantage point of the past.

In Manuel Octavio Gómez's *La primera carga al machete* (*The First Charge of the Machete*, 1969) a variety of techniques are used to produce a similar, if less transparent, transposition of past and present. Something of a *cinéma vérité* docu-drama on the war of 1868, when poor *mambís* fought the Spaniards armed only with their cane-cutting machetes, the film employs mostly a jarring hand-held camera and is shot on a grainy, high-contrast black and white stock. Among the film's "documentary" techniques are battlefield interviews and a segment on the history of the machete, while the film is punctuated with periodic appearances of a roving troubadour, Cuban folk-singer Pablo Milanés. But the most startling segment, the one which most conflates documentary and fiction, past and present, occurs on a Havana street when an individual, described by Michael Chanan as an "accomplice of the camera" (Chanan, 1985, p. 248—see note 9 below) accosts passers-by and asks them their political views. A disturbance develops

and Spanish soldiers arrive to quell it; Gómez's camera has travelled into the past and taken an active role in the history unfolding there.

In describing his approach to the film and the reasoning behind the use of the hand-held camera and sequences like the one above, Gómez has said: "we set about trying to give the idea that we were developing the story as if it were being filmed at that very moment, as if it had been possible at that time to use a camera and recorder to collect the facts," to which Chanan, in citing these comments, adds "the net result of these techniques is not so much to transport the viewer of the film into the past as to bring the past into the present" (Chanan, 1985, p. 248). Again, a form has been created which does not just depict the past, it inhabits it and films it in the present tense. It is interesting to note that this film was put into production when another film of Gómez's with a contemporary theme was shelved six months into production.[13] The sequence described above is the invention of a young film-maker unable to take his camera out onto the streets of contemporary Havana. The spectator not only sees history presented with the immediacy and "authenticity" of an on-the-spot newsreel; he or she also sees history and the present cohabit the film frame, uniting past and present, creating a revolutionary film tense which corresponds to the appropriation of Cuban history by the post-1959 political leadership and their own appeal to an "eternal past" which has been brought to life by the revolution.

Yet another instance of the appearance of past and present in the same frame can be cited: in Manuel Herrera's *Girón* (1972), also a docu-drama reconstruction, this time of the Bay of Pigs invasion of 1961, battle participants speak to the camera as they re-create their activities during the invasion. In one scene, a combatant appears as a commentator only, standing upright in the battle zone beside comrades in trenches, somehow safe from enemy fire. "At this point," he says, pointing down into the trench at one of his comrades, "X was hit in the shoulder," as we see X clutch his shoulder and grimace in pain, a few feet and ten years away.

Like *Primera carga*, *Girón* is a mishmash of styles, that "one genre or all" that García Espinosa spoke of: we see in it direct address, interviews, dramatic re-enactments, voice-over narration, archival footage. There is even a brief "romantic interlude" incongruous with the other footage: far from the muddy battlefield, a young couple stroll hand-in-hand on the beach in the setting sun, while a guitar softly strums on the soundtrack. By no means irrelevant to the narrative or without function in the film, this sequence recalls García Espinosa's call for a "new poetics," an all-encompassing aesthetic which could contain elements of all forms and narrative strategies.[14]

Many important films (Humberto Solás's *Lucía*, 1968; Sergio Giral's *El otro Francisco*, 1974) and formal devices (the zoom, voice-over narration) have been overlooked in this brief survey of formal devices in Cuban historical narrative. While I drew attention to those instances where a cinematic past-present tense was clearly at work in specific films, a broader discussion might uncover other examples of the genre's radical formal experimentation and situate them within the framework of my argument: that these films developed formal means for embodying diegetic signification where the conditions for a more conventional construction of the diegesis may have been lacking, and that this process reflected currents and traditions in Cuban culture and society.

This is certainly a time for critical reappraisal of Cuban cinema: unable to build on the success of the first 15 years or to train a second generation of filmmakers as talented as the first, Cuban film has been floundering now for more than half of ICAIC's existence. This is partly a result of the bureaucracy, gerontocracy and petty censorship which riddles Cuban society, but partly it may also be traced, paradoxically enough, to the success of the historical genre in those first 15 years. It is no coincidence that Cuban film in general declined when the historical genre showed signs of having run its course in the mid-1970s, since Cuban filmmakers had never really developed an aesthetic approach to contemporary life worthy of their talents. As the historical genre became a decadent, insipid shadow of its former self (Solás's *Cecilia*, 1981, and Enrique Pineda Barnet's *La bella del Alhambra* (*The Belle of the Alhambra*, 1989), come to mind) neither younger nor older directors were able to forge art out of contemporary reality. Even Pastor Vega's *Retrato de Teresa* (*Portrait of Teresa*, 1979), one of the most controversial Cuban films because of its topical subject matter of working women and machismo, is ultimately an extremely pedestrian film.

The idea for this essay grew out of my response to the work of a previous generation of foreign critics who saw greatly different things in Cuban film of this period, particularly, it seems, the specter of Brecht at every turn.[15] While this is undoubtedly a valid critical perspective in many instances, when I viewed the films 20 years later, removed from the context of their production and from the fever of Brechtian analysis, I found instead that the range of formal devices these films employed conspired to the construction of an integrated, formal whole. Rather than being constructed to afford multiple readings, I found that many of the films spoke instead with one voice, that there was an ideological ventriloquism at work able to express itself through a wide variety of narrative and stylistic techniques. My gen-

eral query, which this essay has only suggested, and that in a roundabout way, is: "Are these films formal representations of an ideology which has set about to intervene in history in order to create a need for the present?" And I end with yet another unanswered question: "What is the relationship between the insertion of a photograph of Fidel Castro into a film set in 1672 and the airbrushing, 300 years later, of discredited revolutionary heroes out of photographs where they appear at his side?"

Notes

1. Fernando Ortiz, *Contrapunteo cubano del tabaco y azúcar* (Havana: Editorial de Ciencias Sociales, 1983), rev. ed., p. 86. Unless otherwise noted, all translations are my own. For a general discussion of Ortiz and transculturation, see Jean Lamore, "Transculturation: naissance d'un mot," *Vice versa*, no. 2, November 1987.

2. Fernando Ortiz, *Africanía de la música folklórica de Cuba* (Las Villas, Cuba: Universidad Central de las Villas, 1965), rev. ed. For his studies of black culture, in particular, his trilogy *Los negros brujos* (1906), *Los negros esclavos* (1916) (Havana: Ciencias sociales, 1975), rev. ed., and *Los negros curros*, published posthumously (Havana: Ciencias Sociales, 1986).

3. See, for example, Leonardo Acosta's account of such a lament in the 19th century in "From the Drum to the Synthesizer: Study of a Process," *Latin American Perspectives*, vol. 16, no. 2, Spring 1989, p. 35. I am indebted to Acosta's analysis of musical transculturation for my own comments here.

4. See Acosta, p. 43.

5. Alejo Carpentier, "América Latina en la confluencia de coordenadas históricas y su repercusión en la música," *América Latina en su música* (Mexico: Siglo XXI, 1977), cited and translated by Acosta, p. 33.

6. Originally published in *Cine cubano*, no. 66–67, 1969. Reprinted in translation in *Afterimage*, no. 3, Summer 1971 in abridged form, and in *JumpCut*, no. 20, May 1979. Reprinted in Spanish in *Hojas de cine: testimonios y documentos del nuevo cine latinoamericano*, vol. II (Mexico: Fundación Mexicana de Cineastas, 1988). All page references are to the Mexican edition.

7. Tomás Gutiérrez Alea, "Del espectáculo en su sentido más puro al 'Cine de Ideas,'" *Dialéctica del espectador* (Havana: José Martí, 1988), p. 28.

8. A considerable death cult has grown up around Camilo Cienfuegos and to this day in Cuba, on the anniversary of his "physical disappearance" (never his death) large numbers of people throw a single rose into the sea in his memory.

9. For an overview of early Cuban film history, see Michael Chanan, *The Cuban Image* (London: British Film Institute, 1985), and Paulo Antonio Paranaguá (ed.), *Le Cinéma cubain* (Paris: Center Georges Pompidou, 1990). These are the two most comprehensive publications on Cuban film.

10. In a recent poll of ICAIC's "Artistic Committee," the 30 top films of the post-1959 period were selected. Of these, 13 were depictions of the recent

past, from the 1950s on, as time progressed; 8 were set in the distant past (I include *Lucía* here); and 9 addressed contemporary issues. Even these figures are unrepresentative, because the ICAIC officials were careful to represent each decade equally, even though the earlier films are by far more accomplished than the later ones, which tended to have contemporary themes (5 of the 8 contemporary themes can be found in films made between 1983 and 1985). See Paranaguá (ed.), *Le Cinéma cubain*, p. 105.

11. See Chanan, *The Cuban Image*, pp. 247–49.

12. See Andrés Hernández, "Film-making and Politics: The Cuban Experience," *American Behavioural Scientist*, vol. 17, no. 3, January–February 1974, for a reasoned account of censorship and political pressures at ICAIC in those years. There are many other indications of filmmakers having problems getting productions off the ground and a certain amount of turmoil at ICAIC in those years: there is, for example, an interview with Solás in *JumpCut*, no. 19, pp. 27–31, where he describes a project with a contemporary theme, whereas his *oeuvre* consists of only one film with a contemporary theme, made before this interview and whose release had been delayed by ICAIC, and there is also a 1971 *International Film Guide* report whose list of upcoming productions bears no resemblance to that year's completed films.

13. Hernández, "Film-making and Politics," p. 346.

14. It is interesting to note that, following his manifesto "Por un cine imperfecto" in 1969 and until his appointment as head of ICAIC in 1982, Julio García Espinosa virtually ceased filmmaking and became a frequent co-author of Cuban film scripts, including those for *Primera carga* and *Girón*.

15. The literature on Brechtian influences in Cuban film is large; much of it can be found on three special issues of *JumpCut* in the late 1970s, nos. 19, 20 and 22.

"Transparent Women"

Gender and Nation in Cuban Cinema

Marvin D'Lugo

Lucía is not a film about women; it's a film about society. But within that society, I chose the most vulnerable character, the one who is most transparently affected at any given moment by contradictions and change.

Humberto Solás[1]

The female figure has long been identified with the emergence of a truly national cinema in Cuba, that is, with the expression of the narratives that embody and circulate the values of the revolutionary community. During the first decades of operation of the Cuban Film Institute, and in films as striking as Humberto Solás's *Lucía* (1988), Sara Gómez's *De cierta manera* (*One Way or Another*, 1974), and Pastor Vega's controversial *Retrato de Teresa* (*Portrait of Teresa*, 1979), the ethos associated with a revolutionary national identity was elaborated in fictional films through an insistent focus on the narrative destiny of female characters. The mobilization of "female narratives" on behalf of the nation were, of course, much more complex than merely the structuring of stories about women. The underlying objective of such films was to develop a form of address to, and identification by, the Cuban audience through the mediation of a new revolutionary mythology rooted in the female figure.

John King, Ana M. López and Manuel Alvarado, eds., *Mediating Two Worlds: Cinematic Encounters in the Americas*. London: British Film Institute, 1993, pp. 279–290. By permission of the author.

In the last decade that line of development has intensified, but with a distinctive feature. While the allegorical condition of women as embodiments of a concept of nation has been sustained, the female figure has emerged in Cuban films as the agency through which a new range of critical discourses about Cuban culture in general and the revolution in particular are enunciated. Evolving as a series of responses to the development of contemporary Cuban society, the cinematic representation of women retains the one cardinal feature that Humberto Solás had designated as the essential feature of the female characters of *Lucía:* transparency.

For the three female protagonists in *Lucía*, transparency meant at once the social condition in which male characters did not so much see women as see through them. Solás's repertory of heroines were all socially marginalized beings, "unseen" within the patriarchal power structure before and after the revolution. But beyond that diegetic notion of transparency, the film was configured discursively in such a way as to motivate the audience to read into the narrative destiny of the three heroines the larger panorama of a century of the struggle for national liberation and self-realization. This "propensity" to read the nation through the transparency of the female allegory of *Lucía* was no mere accident but derived from the cluster of textual practices Solás employed that defined the cinematic text not merely as a reflection of social reality, but also as the occasion of a particular type of audience engagement. In *Lucía* the female figure, rather than functioning simply as the mimetic representation of gender or class struggle, thus became the "site" in which the audience participated metaphorically in the process of national self-realization.[2]

Cuban film has undergone intense transformation since Solás's landmark film, just as Cuba itself has undergone important historical and political change. Yet as the films of the last decade attest, despite such change, that fundamental notion of transparency—the textual motivation of the audience to read the discourse of nation through female characters—has remained an indelible constant.

Tomás Gutiérrez Alea's *Hasta cierto punto* (*Up to a Certain Point*, 1988) is perhaps the most striking example of the ways in which this type of cinematic tradition and innovation converge in Cuban film of the 1980s. Conceived as a homage to Sara Gómez's 1974 film, *De cierta manera* (*One Way or Another*), *Hasta cierto punto* understandably holds a conceptual similarity to the earlier film's feminist thematics and to its interweaving of documentary footage and fictional narrative. Gómez's film grows out of the twin thematics of feminism of the late 1960s and 1970s in Cuba: the centrality of women within the revolutionary activity of the nation, and the rebuke of persistent

machismo. These were themes that enjoyed the prestige of official support with the formulation of the Family Code in 1975. Yet popular cultural attitudes about the status of women in Cuban society were slow to change, as evidenced, for instance, by the ferocious polemics that surrounded Pastor Vega's 1979 film, *Retrato de Teresa* (*Portrait of Teresa*), and the official position was clearly at odds with popular cultural attitudes about the status of Cuban women. Though made nearly a decade after *De cierta manera*, *Hasta cierto punto* inscribes much of that same polemical discussion into the formulation of the film.

The most striking formal feature of Alea's film and the principal element borrowed from Gómez's film is the staging of an on-screen audience within the film who comment on and assess the themes that shape the film's narrative. From the very beginning of *Hasta cierto punto*, a pre-credit documentary sequence establishes that dramatized audience as an essential paradigm. The sequence consists of a brief interview with a young male black dockworker in Havana who appears to be responding to a question posed by an off-screen voice about how the revolution has changed his machista attitudes. The dockworker says:

> Oh, they've managed to change my attitudes on that score. I've certainly changed up to a certain point (*hasta cierto Punto*). I'm probably at 80 per cent now. Maybe they can work on me and get me up to, say, 87 per cent. But they will never get me up to 100 per cent, no way. That thing about equality is OK but only up to a certain point.[3]

This is followed by a series of five other brief documentary interviews interspersed within the narrative. These interviews at first appear to be ironic self-referential counterpoints to the story of Oscar, a Cuban intellectual involved in directing the videotaping of interviews with Havana dockworkers as background for a film on proletarian attitudes toward machismo. As scriptwriter for the proposed film, Oscar is attempting to corroborate the thesis of the film's director, his friend, Arturo, that machismo in Cuba remains a vestige of pre-revolutionary thinking in the working classes. In the process of videotaping, Oscar is forced, however, to confront his own machista attitudes.

But beyond their immediate function as an ironic counterpoint to the narrative, the interviews serve a more fundamental social function in depicting the larger cultural community as the source and arbiter of the social meanings presented and contested within the filmic narrative. In *De cierta manera*, the status of this community was even

more pointedly depicted as the audience of a workers' council hear-
ing, in which the guilt or innocence of a worker was to be determined.
While serving as a form of direct address, the device of dramatized
on-screen audiences also reinforces the theme of the community's par-
ticipation in the maintenance of revolutionary values. This radical nar-
rational aesthetic coincides with Stanley Fish's notion of "interpretive
communities." According to Fish, interpretive communities are made
up of:

> those who share interpretive strategies not for reading (in the
> conventional sense) but for writing texts, for constituting their
> properties and assigning their intentions. In other words, these
> strategies exist prior to the act of reading and therefore deter-
> mine the shape of what is read rather than, as is usually as-
> sumed, the other way around. . . . The ability to interpret is not
> acquired; it is constitutive of being human. What is acquired are
> the ways of interpreting and those same ways can be forgotten
> or supplanted or complicated or dropped from favor.[4]

This staging of the interpretive community within the film helps rein-
force in the viewer a sense of audience as nation.[5] The narrational dy-
namics of *Hasta cierto punto* thus suggests a self-conscious effort to
align cinematic spectatorship with the interpretive community of the
nation and thereby to engage that audience in the full appreciation of
the revolutionary meanings attributed to the female within Cuban
society.

Tellingly, the dockworkers who constitute the on-screen interpre-
tive community of the film, all of whom are non-professional actors
speaking in spontaneous, unscripted interviews, effectively enunciate a
sense of individual and collective identity by defining a view of
women within the home and workplace pointedly at odds with Arturo
and Oscar's contention. An additional important scene takes place out-
side the context of the videotaping, in which Oscar and Arturo meet
informally with several of the men they have already filmed in order
to continue discussing the status of machismo and the social role of
working wives. This scene serves as a bridge between the documen-
tary interviews and the fictional narrative of *Hasta cierto punto*, in ef-
fect collapsing the neat divisions *petit-bourgeois* intellectuals like
Oscar and Arturo have about machismo in the working class and the
reality of the workers' views on this subject. What the dockworkers
tell the two men when they are off camera further points up the dis-
crepancy between social reality and the views of intellectuals.

The two final interviews in the series do not focus on issues of gender but rather on the question of pride and commitment that particular individuals have to their work. The final clip is a statement by one worker, an older black man, about efficiency and his sense of personal commitment. Taken as individualized expressions of a unified discourse on gender and society, these documentary interviews can readily be identified by the off-screen audience as part of a larger national effort to define social and personal identity in terms of work. Machismo, in this light, is viewed as debilitating the work force by undermining the female's potential for contributing.

Indeed, what passes for an innocent plot in *Hasta cierto Punto* is continually subjected to intense scrutiny and critique through the agency of the interpretive community, both on screen and off. At a union meeting of the dockworkers that Oscar attends at the beginning of the film to get more documentary footage, he meets Lina, a female dockworker who protests about the hazardous conditions to which the workers are subjected. Lina is the unmarried mother of a small boy. A relationship develops between bourgeois, intellectual Oscar and the proletarian dockworker, which produces a crisis in Oscar's marriage with Marianne. The film ends ambiguously as Lina appears to depart by plane from Havana for Santiago.

Lina functions as the catalyst for Oscar's confrontation with the confining patterns of his own consciousness. Having come to the docks to discover hard-core machismo, he encounters in her a woman who tells him from experience that much of the heavy macho bravado he has videotaped "is just talk." From the very start of their relationship, in fact, Lina seems unimpressed by Oscar's view of machismo as the problem. When she tells him that she had a child out of wedlock by choice and that her parents were not happy with the mulatto father of her son, Oscar's reactions appear to expose for the audience his own implicit class bias.

In Alea's conception, Lina turns out to be not the expression of the long-suffering Cuban woman as often depicted in Cuban films of the 1960s and 1970s, but a more expansive expression of broader cultural values of the revolution, values that transcend the conventional notions of gender to which Oscar is himself bound. Alea identifies Lina metaphorically with a bird in flight, both through the images of gulls we see in the port area and also in the inclusion of a Basque song that serves as an epigraph to the film. The song's lyrics include the verse: "I could clip her wings if I liked/ Then she couldn't fly/ and she'd be mine/ but what I love is the bird." By consciously imaging Lina as a bird, the film reinvests in the female the soaring aspirations of an earlier generation's revolutionary exuberance.

The song's words also sum up the problematic nature of Oscar's relation to Lina. On a formal level that problematic is transposed to the chain of documentary interviews which, by the film's end, has shifted from talk about machismo to reflections on the individual's dedication to those revolutionary ideals that have become reified with the passage of time. In this context the female figure constructed by the narrative is recognized as transcending her identity as either sexual object or subject and becomes more clearly the cipher of a revolutionary ethos badly in need of rededication. We can read that inscription of the meaning of the nation in the final documentary interview that follows the scene in which Lina breaks off the relationship with Oscar.

That last videotape, in which an old black worker speaks of his need to continue to struggle on behalf of the revolution, even in the face of the faltering dedication of his fellow workers, is now viewed by Arturo and his wife in their home. The feelings expressed by the worker coincide with the values of dedication and vigilance within the revolutionary community expressed by Lina from her very first appearance in the film. The logic of this admittedly eccentric sequencing of what in a more clichéd genre film would be the melodramatic ending draws the viewer's attention to the essential linkage between the narrative's female figure and the interpretive community within which that figure circulates.

Lejanía

Alea's development of Lina reveals another critical dimension of transparency that to varying degrees is a common factor in the subsequent treatment of female narratives, namely, the effort to bring the audience to read into these female characters narratives of the nation. The bulwark of that allegorizing process is its very discursive transparency, that is, the way in which it has been naturalized within the cultural practices that situate cinema within a particular political and cultural context in revolutionary Cuban society.[6] In such a context we come to recognize the logic of the female figuration as an effort to forge a complex rhetorical strategy of social reference whereby the textual claim to be representative of the national community is based on a process of identification between the audience and the fictional character.

One of the most striking examples of this process is Jesús Díaz's *Lejanía* (*Parting of the Ways*, 1985), in which the female figure is used not merely to embody a static concept of patriotism but rather to problematize issues of national identity around one of the most emo-

tional contemporary cultural themes: the return of Cubans who had emigrated to the United States. The film chronicles the return to Havana of Susana, a woman who ten years earlier had left her son with relatives when the rest of the family fled to Miami. Now, thanks to the recent agreement with the U.S. government, she returns for a brief visit only to receive her son's rebuke and recriminations from his wife.

Originally filmed for television, *Lejanía* is modestly scaled to the television medium with a limited number of sets, characters, and actions. Michael Chanan argues that this reduction of space and time of action to one day, that of Susana's arrival at the Havana apartment where she once lived and which is now occupied by her son Reinaldo and his wife Aleida, along with the film's thematic emphasis on the exile and reunion of Cubans, inevitably establishes an allegorical quality within a social-spatial discourse.[7] The reduction of the setting to the space of the apartment operates, as it often does in theatrical works, to promote the audience's reading of the space of action as a symbolic *mise en scène*. In this instance, a Cuban audience is led to read a decisive historical intertext through the presence of Susana who discovers in objects and spaces of her former home a nostalgia for a Cuba that exists only in her mind.

This allegorical dimension is foregrounded by the reduction of the film's dramatic conflict to a tension embodied in the film's three female characters, Susana, Aleida, and Ana, Reinaldo's cousin who has accompanied her aunt on this painful return. All three women are seen as figuring social and historical positions that transcend their status either as women or as representative members of a family. The Cuban audience is thus engaged in the simulation of a polemic not unlike that inscribed into the interpretive communities of earlier films. Here, the axis of dramatic tension lies squarely in the conflict between emotionally compromised positions and intellectually and politically "correct" postures with regard to Susana, whom we are brought to see either as an anguished maternal figure or as a political enemy.

The audience's culturally determined ambivalence toward Susana is never resolved within the film, nor apparently can it be within the social world to which the film alludes.[8] In one sense the entire film revolves around Susana's contradictory status. She embodies the unfulfilled "historical" desire for a reunion among the two parts of the allegorical family of the nation but, as the narrative suggests, that union cannot be achieved simply by bringing the parties together.

Although there is scarcely a reference made in the dialogue to political questions, Susana voices the social and cultural prejudices that clearly mark the differences between the old Cuba, supported by the

United States, and revolutionary society under Castro. One brief but telling dialogue between mother and son crystallizes this condition of the text. Susana is alone with Reinaldo and begins a painful conversation about their past by asking her son about his wife. "Why did you marry a divorced woman? She has black blood. She's mulatto. We've never had one in the family." Voicing the classist and racist positions that are synonymous both with pre-revolutionary society and with the popular characterization of the U.S. society in which she has resided for ten years, Susana leads the audience to transpose the figure of Aleida from the initial realist presentation of the wife meeting her husband's mother for the first time into a symbolic field in which conspicuously she emblemizes the egalitarian aspirations of revolutionary society that Susana's mentality and values have historically opposed.

That condition of Americanized values is pointedly depicted through a visual intertext early in the film. Susana has brought a home movie of the "family" in Miami for her Cuban relatives to see. In this brief sequence the family is depicted as proto-typical American suburbanites who have so successfully integrated themselves into American culture that they have even assumed American names, thus making them indistinguishable from "the enemy." The home movie, in effect, establishes the basis for the off-screen audience to break any emotional bonds with friends and relatives whom they once viewed as countrymen. The exile family has been metamorphosed into Yankee capitalists.

Two other sets of visual intertexts further delineate that cultural cleavage. The first of these occurs in a scene in which Ana, Reinaldo's childhood sweetheart, returns to the apartment and an awkward conversation ensues. Ana turns on the television set, which just happens to be showing a musical program. Omara Pontuondo, a popular black singer, is singing "Veinte años atrás" (Twenty Years Ago), which describes the separation of two lovers and the impossibility of rekindling their love. The song's lyrics aptly describe Ana's relation with her cousin, but the allusion to "twenty years ago" seems to imply a larger historical context of separation for the Cuban audience, roughly the period of the massive flight of middle- and upper-class Cubans during the early 1960s. The presence of the black singer prefigures Susana's later conversation regarding Aleida's racial background and speaks to the larger schism that both time and cultural values have erected as barriers to the reunion of the two generations.

That cultural schism defined by race is reiterated in a later scene when Susana responds disapprovingly to a scene from Alea's film *La última cena* (*The Last Supper*, 1976), which is being shown on televi-

sion. In this instance, the cinematic intertext serves to align Susana's cultural mindset with that exploitative tradition that for centuries enslaved and exploited the Cuban people. Both scenes, while underscoring the racial dimensions of Cuban identity, also serve as modes of subject address, establishing for the audience the dichotomy between Cubanness and alien "otherness" in terms of class, race and, ultimately, national history.

As critics have often noted with regard to *Lejanía* and as critical reaction in Cuba has reaffirmed, the film's insistence upon the problematic status of the mother as the enemy produces the intolerable situation in which Reinaldo is seen rejecting the *emigré* population. While such a painful polemic has no simple solution, *Lejanía*'s enunciative strategy is revealing of the shifting nature of female figuration, for here the audience is forced to engage in a painful debate focalized around the most intimately emotional female image, that of motherhood. Yet, tellingly, the female figure is used not simply to reaffirm cultural beliefs but also to promote in the audience a critical interrogation of contemporary society and values.

Recent Films

Lejanía's discursive structure reflects the increasing stylistic penchant among a number of filmmakers of enunciating the theme of nation through patterns of allegory. Yet this allegorizing tendency is not as static and unoriginal as it may at first appear. In Carlos Tabío's highly self-conscious comedy *Plaff!* (1988), for instance, the tradition of allegorizing the nation through female characters is intentionally parodied. The film focuses on two women, Concha, a widow in her fifties who explicitly embodies the revolutionary values of the 1960s, and Clara, her daughter-in-law, a chemical engineer, who is the spokesperson for a younger generation that sees the pervasive patterns of waste and inefficiency in Cuba as the result of the ways of the previous generation, particularly people like Concha.

That generational schism is reiterated through the film but never more pointedly than in the juxtaposition of scenes in which Clara is first seen receiving a prize for her development of a new polymer made from turtle excrement, and then Concha is given an award at a block party held by the local Committee for the Defense of the Revolution. What is particularly striking about Tabío's film is the way in which it avoids the heavy-handed moralizing style of an earlier tradition of Cuban film-making that also dealt with important themes of the conflict and critique of contemporary society. Indeed, the self-consciousness of the comedic elements of *Pfaff*, which includes the

comic reduction of recent Cuban history to the conflict between mothers and daughters-in-law, clearly functions as a way of addressing and engaging a Cuban audience in serious national issues.

Another use of allegory is to be found in the collective film *Mujer transparente* (*Transparent Woman*, 1990), developed under Solás's general direction, and conceived of as an update on the progress of women in Cuban society through its choice of five stories of representative women of different ages and social strata. While the five stories attempt to provide a social panorama of the lives of contemporary women, it is perhaps most pointedly in the last episode, Ana Rodríguez's "Laura," where the potential for audience engagement is most fully realized. "Laura" deals with the ways in which the protagonist prepares to reunite with a childhood friend visiting from Miami in one of the so-called "community" trips following the Mariel exodus. Laura's reminiscences of the two decades she has known her friend, Ana, thus sketch a more generic history with which a whole generation of Cubans can easily identify. The most powerful moment of the story occurs when Laura comes to the tourist hotel where she will meet Ana and is ignored by the desk clerk, thus making her feel that she is an alien in her own country and bringing an audience of both men and women to identify with Laura's sense of marginalization.

That same effort to address and engage the audience in a reflection on the themes of national identity is the motivational force of Fernando Pérez's 1990 film, *Hello Hemingway*, a film which historicizes the female figure by situating its protagonist in the Havana of the final year of the Batista dictatorship, thereby aligning the notion of female identity with the revolutionary concept of struggle. The film's plot is developed in much the same spirit as Solás's original *Lucía*, that is, as a way of looking through the transparency of the vulnerable female to the larger image of the nation's struggle.

Set in 1956, during the Batista dictatorship, in the Havana suburb in which Hemingway resided, *Hello Hemingway* tells the story of Larita, the illegitimate daughter of a kitchen maid who has been recommended by her high school teacher for a scholarship to study English in the United States. First, however, she needs to collect the various letters of support from members of the community and to pass a series of interviews. The film traces Larita's efforts as she slowly comes to realize the impossibility of achieving her goal given her humble background and her precarious financial resources.

The process through which Larita reaches that consciousness, fails to proceed with the application, and finally resigns herself to remain in Cuba is structured around her contact with three women: her grandmother, Josefa, her teacher, Dr. Martínez, and "Miss Amalia," the rep-

resentative of the American Embassy who interviews candidates for the scholarship.

As allegory, *Hello Hemingway* functions in a complex manner, for not only does the narrative involve the schematization of political and cultural scenarios through female characters that has, by this time, become a staple of Cuban cinema, but it is also built upon a subtle historical theme in which the fairly familiar view of Batista's Cuba as "bastard child of the U.S.A."[9] is reimaged through the protagonist of Hemingway's novella, *The Old Man and the Sea*. In this intricate structure Larita is seen first as the economically oppressed, socially marginalized Cuba of the neo-colonial period, her desire to go to the United States reflecting precisely the kind of mental colonization in which the objects of individual desire and of social aspiration are those of the American cultural empire. In such a context the proper Miss Amalia, who voices unsubtle classist comments about Larita, embodies the evil of the United States.

What saves the narrative from such a simplistic schema, however, is that gradually Larita undergoes a transformation when she reads *The Old Man and the Sea*. Instead of identifying with Hemingway, the author, she comes to identify with his creation, the fisherman Santiago, whose indomitable spirit will lead her on. The film thus displaces the historical Hemingway by the image of a Cuban fisherman whom Larita views at Cojimar where *The Old Man and the Sea* is set. When she stands on the rocks at Cojimar and views the old fisherman casting his net, we understand that Larita is replicating the identical situation of the little boy, Manolín, in Hemingway's story, who also deeply identified with Santiago's indomitable spirit. That moment, which ends the film, makes apparent not only the repatriation of the Hemingway narrative into a Cuban context, but also, strikingly, its regendering into a female narrative.

Thus Larita's failure to go to the United States is figured as part of a grander design in which she will become heir, as the film implies, to the struggle that will shortly lead to revolution's triumph. In this, Pérez's script appears to follow the Utopian reading of the past in which the contemporary audience of the 1990s is conditioned to view in Larita's character a precursor to the revolutionary ethos that connect her with them. Even Hemingway's theme, stated by Dr. Martínez as a translation exercise for her English class—"a man may be destroyed, but he cannot be defeated"—is recuperated into the political struggle against Batista that serves as a historical background to the film.

In this way, *Hello Hemingway* re-semanticizes Hemingway's writings as a form of national mythology and, in addition, a spiritual precursor to the revolutionary spirit of post-1959 Cuba. Like Solás's

"historical" heroines in *Lucía*, and the other "transparent women" who have followed in her wake, Larita is ultimately understood as a figure gestating towards the future, and the audience is once again given the opportunity to ponder that future through her struggle.

Notes

1. Marta Alvear, "Every Point of Arrival Is a Point of Departure," *JumpCut* no. 19, as quoted by Michael Chanan in *The Cuban Image: Cinema and Cultural Politics in Cuba* (London: BFI Publishing, 1985), p. 226.

2. Homi K. Bhabha, "DissemiNation: Time, Narrative, and the Margins of the Nation," in Homi K. Bhabha, *Nation and Narration* (London: Routledge, 1990), p. 297.

3. As quoted by James Roy Macbean, "A Dialogue with Tomás Gutiérrez Alea on the Dialectics of the Spectator in *Hasta cierto punto*," *Film Quarterly*, vol. 38, no. 3 (Spring, 1985), p. 22.

4. Stanley Fish, *Is There a Text in This Class?: The Authority of Interpretive Communities* (Cambridge, Mass.: Harvard University Press, 1980), pp. 171–72. In describing the function of interpretive communities in a cinematic context, Rick Altman notes how "a specific interpretive community arrests the free play of a text's signifiers and freezes them *in a particular way*, thus producing a meaning proper to the particular community in question by foregrounding certain patterns the recognition of which leads to an apprehension of that particular meaning." See Rick Altman, *American Film Musical* (Bloomington and London: Indiana University Press, BFI Publishing, 1987), p. 2.

5. Gerardo Chijona, "El cine cubano, hecho cultural de la revolución," *La cultura en Cuba socialista* (Havana: Editorial Letras Cubanas, 1982), p. 221.

6. As Fish observes of the cultural contexts that inform allegory, allegorizing as an interpretive act may be performed on such a deep level of consciousness that "it is indistinguishable from consciousness itself." See Fish, p. 272.

7. Michael Chanan, "Algunos prefieren proyectarse," *El nuevo cine latinoamericano en el mundo de hoy* (Mexico: UNAM, 1988), p. 92.

8. In an interview with U.S. film critics, Díaz acknowledged the painful ambivalence many Cuban audiences felt towards the character of Susana. See Dan Georgakas and Gary Crowdus, "Parting of the Ways: An Interview with Jesús Díaz," *Cineaste*, vol. 15, no. 4 (1987), p. 23.

9. Richard Fagen, *The Transformation of Political Culture in Cuba*, Stanford Studies in Comparative Politics (Stanford: Stanford University Press, 1969), pp. 6–10.

Cuban Cinema's Political Challenges

Paulo Antonio Paranaguá

Preface

In May 1991, the authorities in Havana restructured the organization of film production: ICAIC was to merge with the television studio and with the Armed Forces studio under the direction of Enrique Roman, the former editor of the paper *Granma* and president of the Cuban Radio and Television Institute since 1990. ICAIC, the first cultural organization created by the Cuban revolution, would thus lose the autonomy it had vigorously defended for all that time. Consequently, the filmmakers mobilized to contest such a decision while ICAIC's president, Julio García Espinosa, tendered his resignation.

One month later, tension mounted further: the film *Alicia en el pueblo de Maravillas* was withdrawn four days after its release in ten cinemas in Havana, on 13 June. *Granma* condemned the "exaggerated pessimism" of this political satire and resolutely rejected its "defeatism, hopelessness and bitterness."

The following article was written shortly before those developments and outlines the recent currents in Cuban cinema together with the conditions that led up to the crisis.[1]

The collapse of *really existing socialism* in Eastern Europe places Cuba at a crossroads. In a way, the *rectification* process initiated by Fidel Castro was almost immediately overtaken by perestroika. An

A version of this essay was first published in *Framework*, nos. 38/39, 1992, pp. 5–26, under the title of "Letter from Cuba to an Unfaithful Europe." This version is published with permission of the author.

economy completely based on the existence of a socialist bloc and dependent on the Soviet Union now finds itself left high and dry. The fact remains that the unfavorable international context has only lent greater urgency to the questions already being asked. Faced with a pressing need for change and for greater openness, this isn't the first time Cuban socialism has been challenged. At the same time, it is as big a mistake to pretend that the island offers no more than yet another avatar of Stalinism, some tropical Gulag, than it is to affirm, as sometimes happens in Havana, that Stalinism doesn't figure in the picture at all. It is true that the Cuban revolution happened outside of the Stalinist orbit and even went diametrically against its assumptions. Nevertheless, the break with the United States, the East-West polarization, the setbacks experienced in the sixties in Cuba as in the rest of Latin America, all this in the end helped to engender a profound ideological and institutional mimetism in the seventies that took the form of a tensing up, intolerance and blockages in the cultural domain. Stalinism is a fundamental fact of our era, as unavoidable in Moscow and in Paris as it is in Havana. But although there certainly are Stalinists on the Caribbean island, it is important to try and aim at the right target.

As for the anti-Castrists, they believe that the bulk of the really active forces are to be found amongst the exiles. And that includes the cultural area because they believe there can be no independent artists or intellectuals in Cuba (it is a safe bet that they would never have been able to recognize a Kieslowski since he used to be as much of a bureaucrat as his Cuban colleagues). Questionable as this view may be in general, including regarding writers, such an opinion is particularly gross when it comes to the cinema. The only noteworthy feature made in exile (*El Super* by Orlando Jimenez Leal and Leon Ichaso in the U.S., 1979) remained a unique exception, whereas the revolution sparked an upsurge of authorial cinema in Cuba itself. Besides, the exiles' attitude leads to a dead end: no country has really been able to evolve in conditions of exile, not in Latin America, as can be seen from the Chilean and the Brazilian cases, nor in Europe. Cuban society is more monolithic than any other. It is just as riven by conflict. Any analysis of its changes, its evolution and reforms must take into account both the external and the internal forces which obstruct or fuel that dynamic. That is the approach we will adopt to try and come to grips with the political position of the Cuban cinema through an analysis of its recent developments.

A National Debate

The recently initiated renewal, accelerated by the restructuring of ICAIC, has been consolidated and is now undeniable.[2] The cinema's political position vis-à-vis the current challenges has correspondingly been fine tuned, the sense of direction has been sharpened and the debates have become further reaching. One straight away gets an impression of greater homogeneity and solidarity at ICAIC. The best proof of this is the way its staff participated in the great national debate of 1990. The debates around the Fourth Congress of the Cuban Communist Party involved a very wide range of participants, regardless of whether people were actual militants or not. Amongst the cineastes, the most notable interventions came from Jesús Díaz and Tomás Gutiérrez Alea, one a member, the other not. Some of the plenaries lasted for three days, especially the one at ICAIC. Discussion was in no way limited solely to the affairs of a particular category or sector but concerned itself with wider problems and dilemmas.

There was a demand for the clarification and thorough analysis of the crisis in the socialist countries, with all that that implies for Cuba, while pointing out that restrictions only produced bad quality information. The pervasive corruption was addressed from two angles. One targeted the double standards, the duplicitous language, the ideological hypocrisy and opportunism that go together with the heavy social pressures exerted by voluntarist mechanisms. The other angle looked at the need to get a clearer picture of the economy through the legalization of the so-called informal, underground economy, i.e. all those little bits of work and activities without which daily life would be harder still. Some people talk of freeing individual initiative, demarcating themselves forcefully from the reintroduction of salaried dependence. At any rate, what is being questioned is nothing less than the hypercentralized command economy built up since the revolutionary offensive of 1968 which nationalized small businesses. Different sources agree that the parallel economy is probably bigger than the official domestic economy, even though prices are kept artificially low and shortages squeeze the informal economy even further. This gives an idea of how big it really is. The tensions created by scarcity and by the existence of a privileged sector reserved for tourists, foreigners and the possessors of hard currency, have led to a virulent reaction: some went so far as to talk of a "touristic apartheid," an explosive phrase in a country at war with South Africa for a number of years. Over and above the social-economic issues, the desire for freedom of movement takes the form of the demand that everyone should be is-

sued with a passport (problems can be addressed in terms of the issu-
ing or the withholding of visas for particular countries). The issue of
freedom itself is articulated in terms of criticism against the formal
authorities (such as the institutions of the General Assembly and those
of the People's Power) and in terms of a series of propositions such as
everybody's right to participate in elections at all levels and not sim-
ply at the municipal level. Although the question of the one party sys-
tem is not raised, what is firmly on the agenda is political diversity
and the respect for other people's views, beyond even the integration
of believers, which has already been achieved and now functions as a
sign of rehabilitation all along the line. To sum up, a thoroughgoing
reform plan is being articulated which is pushing towards greater in-
ternal openness, whereas the island has been living very much with a
sense of being under siege.

This program is by no means limited to sectors such as ICAIC, the
University of Havana, the Higher Institute of the Arts, the Cuban
Writers and Artists Union (UNEAC), or television. Indeed, the latter
can hardly be said to have distinguished itself by its renovatory spirit.
It appears to enjoy a fairly large consensus in various professional
sectors and regions. Some general assemblies or interventions did go
further: although the critics didn't spare Fidel Castro himself, the uni-
versity population of the capital took the minister of education so se-
verely to task that the *gallego* José Ramón Fernandez was promptly
dismissed. Elsewhere, in relation to the exiles, there was talk not sim-
ply about the need to reconsider those who had left (previously, only
public vilification had been their lot) but of actual reconciliation. And
it has been barely ten years since the very minoritarian Catholic
church advocated a "theology and ministry of reconciliation" (Father
Rene David, 1981). But for the present, a minimal consensus around
the earlier propositions is already quite important in itself.

Although the 1990 debate does constitute a political advance, a
sign of mobilization and militancy in spite of the uncertainty and the
isolation of the Cuban situation, other events are more disquieting.
Firstly, one year earlier, there was the trial of the officers accused of
drug trafficking and various other abuses; four of them were executed,
including General Ochoa. Corruption and a sense of crisis had eaten
into two pillars of the system: the Ministry of the Interior and the
Armed Forces. The authorities banned two Soviet publications includ-
ing *Moscow News*, which was a very popular symbol of perestroika
on the island. The commotion caused by the young contestatory paint-
ers has left some wounds. Scarcity of paper led to the closure of most
periodicals, including some titles noted for the freedom of their tone.
Generally speaking, those in power seem to be hesitating between

confusion and immobilism, even though the latter seems untenable. At the end of 1990, all expectations were still focused on the debates and the decisions of the Party Congress while its nature, even its timing and the way delegates are selected are being debated amongst the leadership.

However, the Cuban cinema didn't wait and went ahead with its drive towards greater dramaturgical complexity and aesthetic sophistication, the accelerated promotion of new generations of artists and greater clarity in its treatment of social problems. And it did so especially with an increasingly political sense of humor, taking off from social comedy to reach the official liturgy. All this happened just at the time when directors had to turn towards forms of international co-production to ensure the continuation of their work. The setting up of three creative groups, each able to make decisions autonomously, under the direction of Tomás Gutiérrez Alea, Humberto Solás and Manuel Perez, is no longer a promise: it has started showing results.

Papeles Secundarios

The first real success of this phase of renewal is without a doubt *Papeles secundarios* (*Supporting Roles*, Orlando Rojas, 1989). It fully assumes the need to achieve greater complexity without blunting the sharpness of its look at contemporary Cuba. The complexity is firstly a matter of dramaturgy and script: the choice of the microcosm presented by a theater group putting on a play in the film already introduces a plurality of levels. The imbrication of cinema and theater is already more complex than the film-within-a-film device because the disjunction between the stage and the screen can be felt more clearly in every respect: in the acting registers, lighting, dialogues, sets, etc. This choice is all the more stimulating when the play in question is itself replete with meanings which resonate with the first level of the plot: the play, perfectly integrated by Orlando Rojas, is Carlos Felipe's *Requiem for Yarini*, a standard of the contemporary Cuban repertoire. In this way, the microcosm put before us acquires an extra metaphoric layer, enriched by Carlos Felipe's dialogues and by the situations he invented, which in turn have been re-actualized in the film by means of a particularly apposite reading. Of course, the recourse to allegory is not necessarily a mark of sophistication; it could equally have been a makeshift device, due to an inability to express the story better.

However, the allegorical dimension of *Papeles secundarios* takes off from an underpinning narrative which itself teems with meanings and conveys a non-conformist vision. Mirta's monologue (Luisa Pérez

Nieto's bravura piece) exposes a wound that is at the same time emotional and social—politically one of the film's strongest moments—and it is rendered completely straight and direct and unencumbered by any allusions. Similarly, the collective sequence on the theater's roof, referring us to the lyrical illusions and enthusiasm of the sixties shared by the sacrificed generation Mirta belongs to, is one of the least artificial sequences. The games of power and seduction at work in the film operate at all levels: amongst the actors of the group as well as amongst Carlos Felipe's characters, and on the allegorical level which relates to the viewer's contribution but is nevertheless inscribed into the film: Rosa Solo is not the only *sacred cow* resting on her laurels whose inertia helps to block any attempt at renewal. . . .

But more than that, *Papeles secundarios* bears witness to a concerted search for expressive density which strengthens its impact and further multiplies its meanings. The actors are mostly new to the screen and the film thus propels to the foreground actors who are still developing or who have remained in the shadows. The Cuban cinema required new blood: *Papeles secundarios* proves it's there; the young Leonor Arocha and Ernesto Tapia were students at the Higher Institute of Art. Rosita Fornes, the only member of the cast with experience spanning nearly forty years, is cast against type, at least as far as her screen image is concerned, which has been associated more with comedy.

Still more fundamentally, the film shows that a great deal of attention was paid to the achievement of a rigorous and sophisticated aesthetics of the image. The expressionist decors are echoed by various signs of modernity producing a different sense of the contemporary landscape. The director doesn't mind at all running the risk of overdoing it, obviously preferring to have too much rather than emptiness, banality and sloppiness. It is worth drawing attention to the calibre of the collaborators gathered together by Orlando Rojas: Flavio Garciandia, a young painter whose work is exhibited in the film but who also worked on the overall art direction; Mario Daly, a musician also responsible for the soundtrack; Carlos Celdran, a member of the Buendia Theater Group; and the poet Osvaldo Sánchez for the dramaturgical structure as well as for the script; not forgetting the director of photography, Raul Pérez Ureta, who succeeded in totally overturning the lighting, the framing and the colors that have prevailed in the Cuban cinema, proving that the insipidity of the images since the change-over to color could not be blamed on the quality of the stock or on other technical constraints.

If a precursor has to be found, the primary importance Orlando Rojas attaches to the mise-en-scène would put him close to Humberto

Solás. *Lucía* (1969) did in fact spark the director's vocation and he was Solás's assistant on *Cantata de Chile*. But like Tomás Gutiérrez Alea, with whom he also worked, Rojas is wary of improvisation and prepares very detailed and precise story boards, the script having gone through eleven re-writes as a result of his interactions with different collaborators. The construction of a personal universe is as important to Orlando Rojas as his view of society. In other words, his micro-cosm is not merely an allegorical instrument: his characters are lively and full of emotion, they are made of flesh and blood, tears and hopes; they are every bit as imbued with a sense of lived experience as the characters of *Una novia para David* (1985), Rojas's previous film. The creation of form and the production of meaning cannot be dissociated in his work. Artistic ambition thus reinforces his ethical unrest. Rarely has the Cuban cinema aimed so high since the great classics of the sixties which explored cinematic language as if that too was a domain for the confirmation of collective identities: films such as *Lucía*, *Memorias del subdesarrollo*, *La Primera carga a la mach-ete*, *Las Aventuras de Juan Quin Quin*. This desire for innovation fits beautifully with what the author wants to say. Although he himself belongs to the intermediate generation, sacrificed in various ways and for various reasons (not the least of which was the immobilism of the founding fathers), he puts on the screen the life and expressions of a younger generation, rebellious and impatient. He banks on renovation and dynamism while demonstrating that this is perfectly compatible with the contemporary traditions, constituted in Cuba by the intellec-tual avant-garde. The will to open minds echoes a drive towards an aesthetic break, including a break with his own previous film. The commitment to complexity is as much a reaction against expressive simplification as it is against dogmatic schematisms.

Papeles secundarios is thus in sync with the current debates and aspirations. It has even turned into an emblem of the period: the young actress Maria (the stunning Leonor Arocha) pulling faces in front of the mirror and wearing a T-shirt with the slogan "glasnost" in Russian is one of the leitmotifs in Manuel Marcel's animation film paying tribute *To Malcolm MacLaren* (1990). Marcel belongs to the new generation and is a member of the Hermanos Saiz Association. The local bureaucrat, now a standard figure in Cuban films, blends in well with the overall vision because the metaphor refers to the whole of the social network. It's no longer just a matter of some local mal-function or of some nefarious characters taken in isolation, but we are presented with a vision operating at different levels and therefore all the more severe. A series of issues the Cuban cinema used to treat one at a time thus acquire an unprecedented power: the film calls into

question machismo, the bureaucracy, corruption, the painful divisions of exile (presented with tremendous emotional force in Mirta's five minute monologue), the marginalization of youth, the social pressures experienced by individuals together with a plea for the dignity of artistic creation and against utilitarian reductiveness. Contrary to those who reproach the film for its sophistication, a reproach that quickly slides into accusations of cosmopolitanism (as used to happen in Eastern Europe), I think *Papeles secundarios* extends the affirmation of a Cuban identity by conjugating cultural tradition with the signs of a modernity in full ferment (hence its syntonism with the plastic arts).

It is the merit of Orlando Rojas that he achieves far more than an ideological or a political critique, and that he simultaneously takes up the challenge of aesthetic renovation. In doing so, he has joined Latin America's most ambitious cineastes, those who succeeded both in bearing witness to their time while creating new forms running against the recent tide of one-dimensional academicism: such as the Argentinian director Fernando Solanas and the Mexican Paul Leduc, to name only the best known ones, whose work has been seen and received awards at the Havana Film Festival.

Cuban Comedy

Other films also sought to achieve greater complexity capable of giving a better account of the contradictions and the issues at stake, as in *La vida en rosa* (Rolando Díaz, 1989). The director, a past master at comedy, has taken a new direction, although a few gags still recall his first vocation. Here too, the subject could be summed up with the questions: to what extent do we make our own destiny? What role do individual renunciation, personal decisions and constraining social force play in a society like socialist Cuba? Rolando Díaz imagined a dramaturgical solution diametrically opposed to the usual schema: instead of a retrospective narration using flashbacks, his young characters are projected into the future, seeing themselves as old, as they will become . . . unless they manage to change their destinies. One of the author's innovations is that he uses doubling and simultaneity, i.e. past and present exist on the same plane but are acted by different actors without changing the decor, which intensifies the imaginary aspects of the film's basic premise. Opportunism and bureaucracy are at the center of the debate, approached from an ethical and an affective angle as the Cuban youth tends to do: in Havana, the tenth anniversary of John Lennon's death was marked by an emotional tribute. The star of the Cuban adolescents, Carlos Varela, is the author of a kind of protest song about the inequalities in Cuban socialism and the values

he stands for are not very different from those of the Beatles—whose work couldn't be found on the island at the time. When the crowd joins in with him singing that the time has come for William Tell to put the apple on his own head, one gets a sense of his rapport with the youth.

The same search for more substantial and complex artistic structures able to address contemporary challenges can be seen in comedies. Ill-tempered people are wrong to underestimate them. Humor corrodes all schematic ways of thinking, dogma and ritual. It is surprising by definition, liberating if not always libertarian. Derision, the *choteo*, has long been a weapon of the Cubans, a way of resisting oppression and set-backs. The intellectual avant-garde of the twenties held learned debates about the nature of humor while the theater and variety dispensed its more popular forms. Together with music and dance, humor could be regarded as one of the principal expressions of the Cuban spirit. ICAIC started out exploring the comic genre but that went into an eclipse, as if doctrinal rigidity prevented people from loosening up. After that, comedies contributed to attempts to reconnect with contemporary problems. It took only a few films to become popular successes for directors to make the jump from social comedies to political satire, the explosion of which is never quite controllable. *Plaff* (Juan Carlos Tabio, 1988) symbolizes that evolution and manages to crack the specifically Caribbean aspects of superstitions, prejudice and nasty gossip as well as targeting bureaucracy. With *Plaff*, putting the family on the screen no longer conveys *costumbrismo* but refers more to the wider society it represents, its shortcomings and pettiness. In it, religious beliefs no longer appear as odd residues of the past but as something sufficiently widespread and familiar to be able to sustain the comic genre. Another comedy, *Vals de la Habana Vieja* (Luis Felipe Bernaza, 1989) also starts from the persistence of old values: in this case, the attachment to the lavish celebration of young girls' fifteenth birthday (which was also the subject of *Cuba baila* by Julio García Espinosa, 1981).

Adorables mentiras (*Adorable Lies*, Gerardo Chijona, 1991) goes one step further in trying to connect the particular and the general. Senel Paz's script manages to make the link between a critique of individual hypocrisy in sexual and conjugal relations with double standards in social life: the bureaucrat's corruption is part of a chain of deceit that includes the apprentice intellectual as much as the prostitute eking out a living on the black market, all of them with a very human, innate taste for appearances at the expense of true feelings. There is another swipe at machismo but the women aren't spared either amidst a multitude of funny observations about everyday life.

Like Tabio, Chijona and Senel Paz light-heartedly come to grips with cinema itself: *Adorables mentiras* shows the petty underworld trying to make a "critical" film to please some European specialist; *Plaff* transforms the obsession with payment schedules and targets, typical of a planned economy, into a gag inscribed into the very body of the film which is supposedly suffering all kinds of delays because of some commemoration or other at ICAIC.

The evolution of Enrique Colina shows a similar approach. Colina had succeeded in getting the most conventional kind of documentary, the didactic film, to implode with a dose of corrosive humor. He found a way of getting the most surprising images possible for his topic in spite of the very limited amount of footage available for the production of shorts in Cuba. The tight editing perfectly matched the soundtrack, with the commentaries of the actual people involved ironically counterpointed by popular songs. With the same kind of ease and wit he tackled questions around productivity and production quality (*Mas vale tarde que nunca*, 1986; *Chapucerias*, 1987), the misadventures of the consumers in Cuba's counter-consumption society (*Yo tambien te hare llorar*, 1984), the most persistent and irritating habits of his fellow citizens (*Estetica*, 1984; *Vecinos*, 1985), including their mania for dogs, which he shares (*Jau*, 1986). Rolando Díaz and Juan Carlos Tabio also introduced humor into some of their documentaries but Colina has made it his hallmark. For him, it almost amounts to a method, a world view. And it looks as if he is beginning to have followers, judging by *El desayuno mas caro del mundo* (Gerardo Chijona, 1988, co-written with Senel Paz) which presents an advertisement against professional irresponsibility.

Colina subverted the documentary by "fictionalizing" his subjects. His first straightforwardly fictional short, *El Unicorno* (1980), is the hilarious portrait of a bureaucrat who has to attend a meeting but has lost this written "opinion" and no longer knows what to say or do . . . Colina uses the famous song by Silvio Rodríguez, *El Unicorno*, to suggest that behind a bureaucrat devoid of personal ideas one can often find lost illusions. Bureaucracy is thus not some moral curse descended from god knows where but the outgrowth of a revolutionary society which lost something of itself along the road. His next short is totally unclassifiable: in *El rey de la selva* (1990) he puts himself in the place of one of the bronze lions on the Prado, the boulevard going through old Havana. This king of the jungle recalls in a most caustic manner all the events of the century. Feeling the pull of freedom, the majestic narrator attempts a rebellion but pitiably collapses, rotten with age. Another old man, a soldier, bellows the slogan of the moment: "Resist, resist, resist," three times in a row to make sure of

being heard, as Fidel Castro did in a recent speech. In short, political satire is now tackling the liturgy, the holy of holies: ideology.

The official discourse, a mixture of voluntarism and bluster, also takes a knock in *Alicia en el pueblo de Maravillas* (Daniel Díaz Torres, 1991). With this film even comedy turns to the more complex allegorical mode, not to veil or to disguise the targets but to encompass if not all then at least the main wrongs of the social system. The reference to Lewis Carroll allows for some parodic touches but, more importantly, opens the way to hallucinatory distortions of perspective as Alice goes through the mirror. Here, it is left unclear whether she dreams or whether reality in fact surpasses her nightmare. Alicia finds herself in the village of Maravillas to re-educate the *tronados*, people who have been summarily fired for mistakes or for more obscure reasons. From the start, the film tackles the expedient ways in which situations tend to be resolved. She learns from the mouths of the people concerned, by no means blameless lambs themselves, how they came to be gathered in this place where the "marvels" of the system are reproduced with therapeutic relentlessness—unless the learned and gentle organizers are in fact the ones who are demented. *Alicia en el pueblo de Maravillas* (written together with young humorists and Jesus Díaz) is a ferocious film teeming with poisoned darts shooting off in all directions. Slogans, ways of thinking, the clichés of political propaganda (the *tec tec*), all are pilloried in spite of the problem that such a demystification risks alienating the public. Of course, the story has its own requirements in terms of acting styles, atmosphere, sets and especially the lighting, which are entrusted to the talent of Raul Pérez Ureta. The director, Daniel Díaz Torres, successfully managed to shift from one register to another without any hitches. An antecedent of this kind of comic fable is *Un señor muy viejo con unas alas enormes*, directed by the Argentinian Fernando Birri in 1988 from a story by Gabriel García Marquez and also shot by the same Pérez Ureta.

Literature and Cinema

A similar concern for complexity inspired the second novel of the cineaste and writer Jesus Díaz, one of the key people at ICAIC as well as in the wider Cuban culture since the publication of his book *Las iniciales de la tierra* (1987). *La palabras perdidas* (1991) returns to the time of 1968 but with a less linear and markedly more sophisticated structure. Jesus Díaz, who founded the paper *Caimán Barbudo*, evokes an intellectual adventure: that of the young lovers of literature who want to set up a magazine, *El Guije*. The protagonists are El

Flaco (Jesus Díaz himself), El Rojo (the much regretted poet and
scenarist Luis Rogelio Nogueras, "Wichy"), El Gordo and Una, each
treated with poetic license. Around them evolve other characters de-
scribed in very human, even familiar terms whereas in fact they are
the emblematic figures of Cuban literature: Alejo Carpentier, José Le-
zama Lima, Eliseo Diego, Virgilio Piñera and the Salvadorian Roque
Dalton (assassinated by his own guerilla comrades). Since writing was
their obsession, the author incorporates into his novel all kinds of
texts emanating from his characters, deploying a wide range of styles,
genres and themes. All this is perfectly fitted together as the diverse
kinds of expression are in fact discussed by the characters themselves,
thus introducing a network of intertextual relations that avoids the
simple device of collage. An entire era, with the utopian dreams and
sacrifices, the hopes and renunciations, the disputes and the aspira-
tions of the various literary chapels is evoked with a sustained elan,
with a supreme and irreverent passion. The novel ceaselessly spills
over into the most unexpected areas, changes tone with superb inven-
tiveness and yet never loses its thread. The lost words alluded to in
the title refer to the missing pages of José Martí's diary of the second
war of independence: the leader already worried about the risks of
caudillismo inherent in a struggle which by necessity had to be con-
ducted in a military manner. At any rate, humor, fairly rare in the con-
temporary Cuban novel, is very much present both in *Las iniciales de
la tierra* and *Las palabras perdidas*, to our delight.

Senel Paz, a young writer deeply involved in the cinema, also
achieves increased complexity in his story *El lobo, el bosque y el
hombre nuevo* (Juan Rulfo Prize 1990). His novel *Un rey en el jardin*
(1983) had been written from the point of view of a child, endowing
the story about a peasant family with an intimist and magical aura.
The narrator of this prize-winning story (currently being adapted for
the cinema by Tomás Gutiérrez Alea together with Senel Paz) is
called David, like the protagonist of his script *Una novia para David*,
filmed and co-written by Orlando Rojas. The character is a student
born, like the author, in the Las Villas province. Although the narra-
tion's point of view shifts from one character to another, as it does in
the novel, the story moves forward in a less linear manner. The ques-
tions it asks are very different: homosexuality, intolerance and preju-
dices connected with the notion of the "new man" dear to Che
Guevara. As in Jesus Díaz's second novel, Senel Paz invokes the ov-
erarching tradition of Cuban literature by making his homosexual
character a passionate connoisseur of his country's culture, while
David is a tight-assed militant, suspicious and ill at ease.

The return of the repressed not only concerns sexual minorities but all types of behavior labelled as marginal. Julio García Espinosa, one of the founders of ICAIC and its president since 1982, unexpectedly returned to directing with *La inutil muerte de mi socio Manolo* (1989), a minimalist adaptation of a two-character play by Eugenio Hernández. García Espinosa didn't try to hide the film's theatrical origins. On the contrary, he embraced all its constraints and even stressed them by way of his tight framing of the actors (the extraordinary duo Mario Balmaseda and Pedro Renteria). In this way, he maintained his commitment to experimentation visible in *Las Aventuras de Juan Quin Quin* (1987), *Tercer mundo, tercera guerra mundial* (1970) and *Son . . . o no son* (1980). The characters aren't the kind of marginal people usually presented: one is an avant-garde worker, the other a veteran of the Rebel Army. But the meeting of the two who were friends in their youth reveals how deeply they remained imbued with macho values. Their mentality and their attitudes contradict both the conventions of socialist realism, which seeks to make proletarians into exemplary heroes, and the idealist conception of marginality, which seeks to relegate it to another time (the past) or space though it is a pervasive, permanent presence in society.

With the playwright Eugenio Hernández absent from the stage from 1967 to 1984 despite his wholly deserved reputation, the popular language achieves a poetic force without losing any of its authenticity (he is the co-author of *Patakin*, the musical comedy directed by Manuel Octavio Gómez in 1982). His classic play, *Maria Antonia* (1990), has now been directed by Sergio Giral. Maria Antonia is a daughter of Oshum, rebelling against men and against the divinities of Yoruba origin, the melting pot of Cuban syncretism. Giral doesn't treat the syncretic values as if they were social epiphenomena but he recovers their mythical dimension and gives them a dramatic function as active forces. Not only is machismo depicted without any blandishments, shown in all its brutality, but also its opposite and complement, *hembrismo*. A whole religious, moral, familial and sexual psychology is exposed with sweltering sensuality. Never before have the Cuban screens cast such a raw light on the carnal relations between men and women. Sergio Giral's mise-en-scène convinces through its passionate fusion of social tragedy and popular mythology in an atmosphere dripping with eroticism. You have to see the film in an overheated cinema in Havana to appreciate fully how directly he manages to touch a hidden side of the Cubans. *Maria Antonia* marks a bifurcation in Sergio Giral's work, between his historical films (i.e. *El otro Francisco*, 1974; *Maluala*, 1977) and an excursion repressed at the time: *Techo de vidrio* (1982). With a beautiful final tracking shot, he connects up

the pre-revolutionary conflicts with contemporary actuality: the ending
is set in a symbolic backyard where a modern Maria Antonia gets out
of a car, dressed as a *Jinetera*, a term for the prostitutes who roam
around Havana's hotels (even though this displeases the official critic
of *Granma*). Alina Rodríguez embodies with magnificent cheekiness
this archetypical mulatto woman.

Even animation films bear witness to this re-found frankness in
dealing with the issue of marginality. Perhaps this can be put down to
the work of Juan Padron who can just as easily create a children's
hero like Elpidio Valdés as breathe life into vampires, executioners
and other figures who break with the sugary sweetness of the old ani-
mated films. *El hombre agradecido* (1990) by Tulio Raggi is a feast.
The grateful man of the title is an inveterate drunkard, so thoroughly
and permanently soused that he looks like a creature from Mars.
Saved from being run over by a car, he so overwhelms his benefactor,
an ordinary, decent man, with such relentless solicitude that the poor
man ends up losing his job, his girlfriend, his flat and his dignity. Tu-
lio Raggi has drawn a delirious, outrageously baroque Havana. And
he inserts into that a succession of perfectly orchestrated gags, en-
hanced by a great soundtrack and the intrusive monologue of his
drunken loony spoken in the purest accents of the Cuban *aseres*.

However, the exemplary workers still haven't quite vanished, judg-
ing by *Bajo presion* (Victor Casaus, 1989), which is adapted from *Ac-
cidente* by Roberto Orihuela, an adept of the militant dramaturgy of
the Escambray theater. It is a play tailor-made for the campaign "to
rectify mistakes and negative tendencies" that has been running since
1986: because they tried to cheat over the targets set them in the Plan,
overlooking safety rules and the production goals, the managers of a
steelworks get into trouble (the Party nevertheless saves its invest-
ment). The film tried to humanize the issue by submitting its protago-
nist to some extra pressures: his family (torn apart because a daughter
is in exile, which is significant) and youth, in the shape of a female
technician graduated from one of the new schools. In spite of the con-
ventional format—the mitigating circumstances offered for the older
generation, a certain totalism as they learn on the job—it is genera-
tional change which thus becomes the issue of the rectification cam-
paign, which of course, sweeps the problem of bureaucracy under the
carpet. Carlos Varela's music is worth noting.

The current political campaign gives backing to the course ICAIC
took, orienting itself towards contemporary subjects, in the early
eighties. Some ideas are in the air, so to speak, and find expression in
various films which try to communicate with a public overburdened
with daily problems. Amongst them are *En el aire* (Pastor Vega,

1988) and *Venir al mundo* (Miguel Torres, 1989). But their superficiality and timidity confine them to a regurgitation of the *rectification* rhetoric and come close to some avatars of Cuban television.

Three films with a more or less literary inspiration deserve respect for the way they contribute to the enrichment of the viewers' memory and for the way they help anchor their cultural identity more solidly. *Cartas del parque* (Tomás Gutiérrez Alea, 1988) is part of the series of *Difficult Loves* co-produced by Spanish television and based on stories by Gabriel García Marquez. Like the Brazilian *Fabula de la Bella Palomera* (Ruy Guerra, 1987), this story was taken from the novel *Love in the Time of Cholera*; it is nicely transposed to Matanzas, the Cuban Athens, retaining its turn of the century setting. *La Bella del Alhambra* (Enrique Pineda Barnet, 1989) is the third musical comedy produced by ICAIC in thirty years. As the proverb predicted, third time lucky. At any rate, it succeeded with its choreography, scenography, rhythm and interpretation, things that are difficult to improvise when the genre does not exist and depends strictly on a act of will. *La Bella del Alhambra* evokes the start of the century, when Cuban music blossomed, and harks back to the golden age of popular theater, the melting pot of the Caribbean rhythms today gathered under the label *Salsa*. The film is based on one of Miguel Barnet's best works, *Cancion de Rachel*, which is both nostalgic and devoid of any condescension, it is half way between a testimonial novel and poetry. Enrique Pineda Barnet, one of ICAIC's veterans, beat all the attendance records with this directorial comeback.

Although not an adaptation, Fernando Pérez' feature, *Hello Hemingway* (1990) can be linked with the previous two films. It is the portrait of a young woman from Havana's suburbs, poor but anxious to continue studying. She is also the neighbor of the famous American writer. Handled with sensitivity and a genuine kind of intimacy (without stressing the fact that Cubans no longer have to beg for a scholarship), the picture acquires an unexpected commentary through a reading of passages from *The Old Man and The Sea*. With just a few touches, Fernando Pérez succeeds in reconstituting the look of the capital before the revolution (as he had done in his earlier film *Clandestinos*, 1987). *Hello Hemingway* seeks to communicate with the young audience, without condescension and without preaching at them.

A New Generation

In Cuba, young people make up a particularly high proportion of the cinema audience. The new generation isn't only in front of the screens

but also behind the cameras. In addition to ICAIC's promotion of new directors in the eighties, a far younger generation has emerged, often in their twenties, who are much more in tune with the new audience. What is unprecedented is that the budding cineastes come from another milieu, outside of the established film production institutions. The film societies and the so-called *amateur* movement have spawned these young cineastes. It would be more accurate to talk of an independent cinema because you can't buy film stock just on any Cuban street corner and this activity slips through the institutional nets, finding ad hoc support from one group or another. The Hermanos Saiz Association has a special importance. It is involved in various creative areas, including the most turbulent and contestatory ones. While theater experiments and *happenings* staged by young painters multiply, the blossoming of the *amateur* movement in 1987 surprised everyone with the richness of its thematic and formal registers. The doyen of the movement is Tomás Piard, born in 1948. He has been shooting incessantly since 1979 and managed to put together an amazing 16mm feature, *Ecos* (1987), about the intersecting destinies of three women from different epochs, each of them abused equally by men and by tradition. The tribute to Humberto Solás' *Lucía* is obvious, but sustaining a lyrical force while having to rely on makeshift materials was a far less likely bet. And yet, there are more surprises: *Amigos* by Jorge Luis Sánchez describes a return from Angola without erasing the traumatic aspect of the experience; *Insomnio* by Ricardo Vega is inspired by Virgilio Pinera, an author not always surrounded by an odor of sanctity; *Imagen y semejanza* by Lorenzo Regalado goes into science fiction; *En la trampa* by Aaron Yelin and Pilar Ayuso tackles television.

The films shown on the occasion of the tenth anniversary of the National Film Society Movement in 1988 open up the terrain even further, stressing the experimental side, somewhat reminiscent of *the underground* in other countries, not least because of its links with the avant-gardes of the plastic arts: e.g. *En la noche* and *El sueño* by Tomas Piard, *La Mancebia* by Ricardo Perez Capetillo, *Geminis* by Miguel G. Fernández, *Ritual para un viejo lenguaje* by Marco Antonio Abad, *Resolución* by Patricio Wood and Rudy Mora. *Un pedazo de mi* by Jorge Luis Sánchez especially reveals a talent for documentary, a way of looking and an ability to listen deployed in relation to the young marginals called *friquis*, i.e. freaks. Finally, the parable *Basura* (1989) by Lorenzo Regalado brilliantly proves that there is indeed a political undercurrent running through this apparently *formalistic* generation: a parcel of crap, mistaken for an important dossier, travels through all the highways and byways of an anonymous bureaucracy,

right up to the top, in an atmosphere recalling Cuba's absurdist litera-
ture (Virgilio Pinera), and then there is the anecdote maintaining that
Kafka fled from the island because it beggared his imagination. In
spite of the shortages, the movement continues, even if reduced to the
use of video. *Cazador de imagenes* by Laura López (1989) returns to
the losses sustained in Angola at a time when such evocations weren't
the done thing.[3]

The independents' work resonates with the first films of the stu-
dents of the International Film and Television School (often called the
School of Three Worlds) in San Antonio de los Baños in Havana
Province. Many of the new cineastes emerge from the new schools
and especially from the Higher Institute of Art, an engine for renova-
tion in all directions. At the San Antonio school the Cubans don't out-
number the students from other Latin American countries but they
share a common sensibility. Because the means to make films weren't
available, the school had to go through a period when students were
confined to the classroom and suffered formal exercises. But now the
international students have swarmed out and are tackling a wide range
of subjects, undeterred by any taboos (some wit launched the label *Pi-
lastroika*, restructuring the pillars of society). The Argentinian Maria
Civale posed the burning question of the succession of the *lider max-
imo* in the streets of Havana and to a few choice interlocutors, includ-
ing Alfredo Guevara, the founder of ICAIC: what will happen after
Fidel Castro? The film's title reminds us that *Todos los hombres son
mortales* (1988). The American Graciella T. Sánchez chose to broach
the subject of homosexuality in Cuba, which used to be a topic caus-
ing anxiety and intolerance and still causes controversy. For the first
time, those who elected to stay on the island and to oppose the secular
prejudices, bear witness: *No porque lo diga Fidel Castro* (1988). The
Colombian Walter Rojas takes the radio serials and the telenovelas so
appreciated in Cuba, travesties and provokes the form and exposes it
mercilessly to ridicule: *Lagrimas al desayuno* (1989). The Cuban Fran
Rodríguez criticises the mediocrity of the media in *Hilo directo*
(1988). Another Cuban, Aaron Yelin Rozengway tackles with great
insight the relations between teachers and children, exposing the mix-
ture of narrow-minded authoritarianism and unthinking conformism
conveyed in the sugary tones typical of the Caribbean: *Muy bien*
(1989).

The city of San Antonio de los Baños has been rediscovered under
the gaze of the Latin American students. Wolney Oliveira, a Brazilian,
rescued the memory of the amateur filmmakers of the fifties, compet-
ing with Hollywood on its own terrain, and made the genre film *El
Invasor Marciano* (1988). Having demonstrated his inventiveness and

his sense of humor, Wolney Oliveira did it again and invented the figure of a complete mythomaniac which led to an incredible hoax in which the entire locality participated, obliterating the dividing line between fantasy and reality (*Los regalos de Don Jose*, 1990). They also reveal aspects of Havana other documentaries haven't brought to light. The Argentianian Marcos López pursued the traces of the tangos with great fervour in his *Gardel eterno* (1988). The Peruvian Marite Ugas warmly describes the zone of ill repute near the harbor in her *Barrio Belen* (1988). The Puerto Rican Juan Carlos García and the Dominican Jaime Gómez reconstitute the links between a black saxophone player and the old quarter with its mestizo culture in *Ache* (1988). And the ethical dilemmas of the militant cinema have been exposed with honesty and sympathy by the Salvadorian Ricardo Rios in *Y en aquellos momentos* (1988).[4] Those exercises impressed through their talent and through the diversity of their inspiration. The School of San Antonio de los Baños now publishes a good journal, *Mirada de tres mundos* (1990). Its beneficial influence on the cinema and on Cuban cultural life in general is bound to intensify.

ICAIC has shown great intelligence in opening itself to the new generation just when at times skewed debate contested its orientation and put the crisis of the cinema back on the table. In 1990, ICAIC and the Hermanos Saiz Association organized a competition open to people outside of the institution and some worthwhile shorts were produced: Tomás Piard shot *La posibilidad infinita* and the doors of television have been opened to him; Aaron Yelin Rozengway, the son of the sadly missed Saul, was able to recall for the first time the lot of the Jewish community in a film bathed in a kind of familial and poetic nostalgia: *A mis cuatro abuelos*. Finally, Jorge Luis Sánchez, an assistant director for a few years and now an active member of ICAIC's Newsreel team, made *El Fanguito*.

El Fanguito

Psychological frankness seems to go together with greater social transparency in feature films. The documentary could hardly remain untouched by this development. One of the transformative directions is that of Enrique Colina. Another avenue was to go beyond the limits of conventional subjects of the straightforward inventorizing of the cultural heritage. Even there, some areas had remained in the shadows: *El Mensajero de los dioses* (1989) by Rigoberto López dispenses with anthropological or folkloric alibis to show two drumming sessions of Shango and of Yemanja (that same year, the re-publication of Lydia Cabrera's *El Monte*, the Afro-Cuban bible, sold almost nothing

but then went on to repay its costs many times over on the black market). The newsreels, the famous *Noticiero ICAIC Latinoamericano*, didn't escape from the transparency therapy. Francisco Puñal, with irony worthy of Colina, dealt with the food shortages (*Reportaje a la vinagreta*, Noticiero ICAIC n. 1459) and with the high rate of marriages and divorces (*Nos casamos y nos divorciamos*, n. 1478). Lazaro Buria broached religious faith without disguising his own religious and political affinities (*La te*, n. 1483). Jose Padron made an undoubted impact with his report on the people living in Havana's collective hostels because of the dangers presented by these old buildings (*Los Albergados*, n. 1460). The inhabitants of the poor quarters are no better off, as Jose Padron reminds us (*Un dia en Atares*, n. 1488). These instalments end up questioning the public powers because the housing problems haven't been given the necessary priority. For his *Noticiero*, still in 1990, Jorge Luis Sánchez airily questions the identity of the Havanese and their image amongst other Cubans while showing the degeneration of the capital.

It is interesting to note that the newsreels tackle the questions of the day head on, in spite of the institutional weightiness of such a thoroughly coded genre. But most of the newsreels don't depart from the accepted conventions, although these rules have been made more supple by Santiago Alvarez' practice. Voice-over commentaries still guide the viewer from beginning to end and prompt him/her with the inevitable conclusion. On the other hand, *El Fanguito* is something else, as far removed from the *Noticieros* as are the *underground* hotheads. As in his *Un pedazo de mi*, Jorge Luis Sánchez remains attached to marginal people. *El Fanguito*, literally *The Little Gutter*, is a marginal quarter of Havana, almost a shanty town. Many of its denizens are marginals themselves and often have had trouble with the police. Sánchez concentrates on the people rather than on the social problems. He questions, listens, films people who aren't at all pleased, quite the contrary (as one can hear *off* in the films's prologue as well as during the end credits). Others still harbor the hope that a television program or ICAIC's newsreel may draw attention to their plight and help solve the problem. That is not the case here. As one pathetic testimony puts it very clearly, there are no more illusions, no more ambitions here. The man who thus admits to his desperation no longer feels he has any stake in society. Why? He himself explains: no matter how hard you work, you don't get what you want. As proof, he cites his father who did 27 *zafras* and has absolutely nothing. Twenty-seven years of sugar cane cutting without recompense, even though the *machetero* was supposed to be the focus of attention. At one time, he was supposed to receive a house but the Party members noticed

that his mother kept the dead in the traditional manner: those popular beliefs, inherited from what was said to be a bygone age, no longer had a place in the new dwellings and so his family was passed over. This witness of *El Fanguito* is deeply moving, through his confession as well as through his silences, expressions of a deep wound, marked as he is by the experience of imprisonment. Others have passed that way before and yet, as a fat woman selling snacks says, they aren't nasty people, they are mostly the products of their circumstances.

El Fanguito refuses to use a voice-over commentary. Instead, it renders the voice, the image and restores the dignity of people who have been deprived of them and who have been left behind by a society whose very reason for existing was precisely their emancipation. Each of the people in the film reveals a part of their truth and contributes to the construction of a composite picture: one tells of his living conditions, a woman tells of her love for a man who is so ashamed of his tattoos and scars that he always puts out the light. The only one who really took an interest in them was a cop, also from a poor background. But rather than an attempt to retrieve the situation, this helps bring out into the open the failure of institutions all along the line, the municipal and the political ones just as much as the *mass* ones, as they say in Cuba. At the end, the camera slowly moves away in successive shots and we discover how *El Fanguito* fits into Havana, by the banks of the river Almendares.

Jorge Luis Sánchez punctuated the testimonies with overviews of the quarter and an obsessive music track that strengthens every minute of the film. Rigorous framing, superb photography, a rich soundtrack, very subtle editing, everything reinforces the impact of the film's images and words. But it is the empathy and the sensitivity Sánchez shows towards the people, the real subjects of the film, which constitutes the film's difference and originality. He succeeds in establishing rapport with them which recalls Sara Gómez' famous trilogy about the island of youth (*En la otra isla* and *Una isla para Miguel* in 1968; *Isla del Tesoro* in 1969). But there is a difference in so far as Sarita's interlocutors experienced the hope and the utopian wishes characteristic of those times of lyrical illusions. Other members of the Hermanos Saiz Association also acknowledged their debt to the prematurely deceased filmmaker (*Sara Gómez: homenaje*, Ricardo Acosta, 1990). Since her trilogy, marginality had been removed from the Cuban documentary and had become a genuine taboo area. What's more, nobody had been able to recover their ability to listen, a way of being open to those fragile, hurt people. Material constraints cannot be used as an excuse that a four-to-one shooting has often been the reason why the interviews filmed in the seventies and in the eighties are so still, be-

cause Jorge Luis Sánchez had even less footage at his disposal. It is more a matter of sensibility and of conception, a kind of fingertip sensitivity that precludes the notion that this would be merely a *little white man* who found amongst the blacks of *El Fanguito* a means of furthering his career. This kind of documentary tends to make the bureaucrats sick because it is guilty of not offering *solutions* to the problems presented, not to mention that dirty linen shouldn't be washed in public and that it is better not to look at what's happening on the banks of the Almendares smack in the middle of the capital. It is worth repeating that there is more to *El Fanguito* than the interest of the problem it raises: it restores humanity to individuals who have all too often been dissolved into *the social*, especially those at the bottom of the ladder. To a solidarity that tended to be rather abstract, Jorge Luis Sánchez preferred a sense of fraternity—the most forgotten of the three values of 1789.

What's at Stake

Since ICAIC's different creative groups have started taking up their responsibilities, it now pursues a policy of renewal and internal promotion with fewer formalities. For instance, Humberto Solás suggested to the people he works with to address the problem of *prejudice and taboos* in Cuba. The result is *Mujer transparente* (1990), a feature consisting of five sketches directed by beginners who did their apprenticeship as assistants or in documentaries. Orlando Rojas has succeeded in giving the film a sense of coherence and pace in spite of the disparities between the episodes. One of them is a failure: *Adriana* by Mayra Segura. Hector Veitia's *Isabel* and Mayra Vilasis's *Julia* provide convincing pictures of middle-aged women prey to the contradictions inherent in couple situations. *Zoe* by Mario Crespo goes further and creates an original aesthetic universe in a few minutes, with two diametrically opposed characters: the disciplined militant who studies fine art purely as a career move and a young non-conformist woman artist frustrated by the rigid framework in which she has to live and study. This sketch can be seen as moving onto the ground opened up by *Papeles secundarios*, so it isn't surprising to find in the credits the names of Osvaldo Sánchez and Carlos Celdran for the script, Raul Pérez Ureta for the cinematography, and the amazing Leonor Arocha in the cast. But it is the episode called *Laura*, signed by the same scriptwriters and masterfully directed by Ana Rodríguez, which offers the most daring political conclusion one could imagine for *Mujer transparente*. The meeting between two old girlfriends, one an exile and the other having stayed in Cuba, provides an

appropriate setting for doing the rounds of a fair number of topics for reflection and sources of vexation for someone taking stock from the perspective of the Revolution's heroic years, the sixties. Issues are no longer tackled within a narrow frame of reference but in terms of the individual's links to the collective and to politics. The tensions created by tourism, the bureaucratization of the elites, lost illusions, wasted energies, the refusal to admonish those who left the country and, therefore, the need to re-start the interrupted dialogue with them, all that Laura delivers in the space of a short wait, some walking about and an internal monologue.

As if the divisions of exile had become a pressing question in spite of the blockages on both sides, the split between the Cubans in Havana and those in Miami also animates *Vidas Paralelas*, written by the young poet Zoe Valdés. The script received a prize at the 12th Festival of the New Latin American Cinema and will therefore be co-produced by Spanish television.

Like their colleagues in other parts of Latin America, Cuban cineastes are now looking for outside support in the form of co-productions, especially from Europe. For about ten years now, the Cubans have contributed to the progress of the region's other national cinemas, most of them even poorer than theirs. Today, the crisis is hitting the island hard and endangers the continuity of its film production just when ICAIC has embarked on a course wholly in support of a positive social evolution. We shouldn't forget that the political position adopted by the Cuban cinema used to be a source of conflict in the past and remains in blatant opposition to other sectors . . . and very powerful ones at that. Even a casual look at the productions emanating from the Armed Forces studios suffices to notice that they are not at all on the same wavelength. For many years now, those productions have found an outlet on television as well as on the big screen. *La Gran Rebelion* (Jorge Fuentes, 1988) was released theatrically after its broadcast as a television series. *Caravana* (Rogelio Paris and Julio Cesar Rodríguez, 1990) proved to be disturbingly successful: not only does it rely exclusively on the old clichés of the patriotic war film and on the novelty of seeing Angola recreated by the cinema, but its wait-and-see conservatism which simply advocates resistance against external threats and against the Wind from the East, found an echo amongst the public, even if that means supporting the corrupt rather than the cowardly, as the film does.

Nevertheless, ICAIC remains aligned with the other cultural domains, as it did in the past. In the old days it used to stimulate the graphic artists and the poster designers, today it supports the young painters. Having extended patronage to Silvio Rodríguez, Pablo Mil-

anes and La Nueva Trova, the cinema now seeks the collaboration of Mario Daly, Carlos Varela, the Sintesis group and new forms of musical expression. Its elective affinities with literature now go deeper than ever because they relate to the most lively aspects of film creation (we only have to recall the key roles played by Jesus Díaz, Senel Paz, Ambrosio Fornet, Osvaldo Sánchez, Zoe Valdés, etc). In moments of difficulty, ICAIC has offered a refuge to heterodox intellectuals (such as Jesus Díaz, who came from the journal *Pensamiento Critico*). Today, it welcomes the young *amateurs* and the Hermanos Saiz Association, roundly trounced in *Granma* (the organ of the Central Committee) on the occasion of the UNEAC 1990 awards for a spectacle directed by Jorge Luis Sánchez. In their turn, the cineastes find a more favorable echo in the least sclerotic parts of the press (*Caiman Barbudo, Juventud Rebelde*). The links with theater extend beyond mere adaptations of plays and directly involve the more inventive theater groups (see, for instance, the *Buendia* polemic which became the subject of a documentary by Humberto Solás, or the ballet-theater filmed by Irene López Kuchilan in *Hablas como si me conocieras*, both in 1989). The impact of the cinema on Cuban society, via the screen as well as through television, no longer requires further proof, a fact confirmed by the ongoing success of the Havana Festival.

The polarization between official and dissident intellectuals, schematically stuck onto Cuba by new-fangled would-be Kremlinologists, completely misses the conflicts actually happening on the island. The dividing line between critical and conservative elements goes right through the Cuban Communist Party itself (just as formerly it went through the old guard of the Popular Socialist Party, as the Blas Roca-Alfredo Guevara debate of 1963 proves). But differences and separations shouldn't make us forget the lessons provided by the Eastern Block countries since well before the Berlin wall came down: to stifle left alternatives in the end only benefits all kinds of conservatism, first those on the *left*, then the out and out *right* ones. That's why it is so fundamentally important that the Cuban cinema should be able to continue on its trajectory.

<div align="right">Havana, December 1990</div>

Notes

1. Subsequent to the publication of this essay, the author updated events concerning the crisis in ICAIC. He wrote: "The force for protest and the capacity for renewal represented by the cinema have been underlined by the manifestation of conflicts former latent.

In spite of their surprise and the inequality of existing forces (their numbers), the mobilization of filmmakers, ICAIC workers and artists in general was such that the reorganization [which had been] publicly announced and decided at the highest level was suspended—an event almost unheard of under Castro. Alfredo Guevara, fired ten years ago under pressure from "hardliners" (dogmatists) and neo-Stalinists, was recalled to head ICAIC again. He had in fact made of it a center of resistance to Stalinism, capable of contributing to the affirmation of individual and collective identities, to the emancipation of women from *machismo*, to the defense of creative freedom against the advocates of "social realism," to the fight against bureaucracy, to the advantage of equality and openness. In the month of October, the Party Congress elected Guevara to the central Committee for the first time, while [at the same time] a young intellectual Abel Prieto (a president of UNEAC who had not spared his support of the cinematographers during the preceding events) made his entry into the Political Bureau. Minister Armando Hart lost his rank, while the director who replaces him, Carlos Aldana, will no longer be the sole spokesman for those who create culture in Cuba. In December 1991, the Festival of Havana was again held in spite of growing difficulties: passing from the defensive to rehabilitation in the space of a few months, Alfredo Guevara and Daniel Diaz Torres solemnly (ceremoniously) presented [there] *Alice in the City of Wonders*. However, the joint pressure of practically paralyzed production and of a rarefied political climate does not encourage creation. A fierce affirmation of cultural ambition, *El Siglo de las Luces* (*The Century of Enlightenment*, 1992) of Humberto Solás incarnates the hopes of the new management of ICAIC: is it chance that Carpentier's novel favors the reflection on the tragic destiny of a revolution (that of the French in 1789), transplanted to the West Indies?" [This note was translated from the French by Louise Jefferson.]

2. See "News from Havana: The Restructuring of Cuban Cinema," *Framework* no. 35 (1988), pp. 88–103.

3. The young writer Angel Santisteban Prats received a special mention on the occasion of the Juan Rulfo Prize of Radio France Internationale for his terrifying story *Songe d'un jour d'été* about the Cubans in Eastern Africa, published in *Le Monde Diplomatique*, Paris, November 1989.

4. See the catalogue of the 12th Festival Cinéma du Réel, Centre Georges Pompidou, Paris 1990, pp. 14–15.

Nicaragua and El Salvador

Nicaragua and El Salvador

Origins of Revolutionary National Cinemas

John Hess

Introduction

The origins of a national cinema in Nicaragua and in El Salvador follow remarkably similar paths, but with a very obvious difference. In July 1979, the Sandinista revolution in Nicaragua overthrew the Somoza dynasty. In the ensuing collapse and confusion, the state apparatus which Somoza had built and which supported him was dismantled. The construction of a national cinema in Nicaragua belongs to the reconstruction of a new nation on the ruins of Somocismo. Originating in the war of liberation, film and then video became part of official state institutions and are both produced and supported by government ministries.

In El Salvador, on the contrary, film and video remain part of the revolutionary political-military organizations that are facing a formidable state power which receives extensive military, economic and financial support from the U.S.A.. Though united now in the FMLN-FDR, Radio Venceremos is attached to the Ejército Revolucionario Popular (ERP) centered in Morazán province, while the Instituto Cinematográfico de El Salvador Revolucionario (ICSR) is attached to the Fuerzes Populares de Liberación (FPL) centered in Chalatenango province. These film and video producers share the life of the guerrillas, and the nature of their work clearly indicates the strength of El Salvador's opposition forces, which control nearly a third of the country.[1]

Altaf Gauhar, ed., *Third World Affairs 1988*. London: Third World Foundation, 1988, pp. 467–76. By permission of the publisher.

Revolution and Culture

The military violence accompanying social upheaval—storming the barricades, guerrilla armies filing through the tropical jungle, street fighting, gathered masses of people—represents the most dramatic aspect of Third World revolutions. Less obvious (because generally suppressed in the dominant Western media), but equally important, are the cultural aspects of these revolutions—their reclamation of long-suppressed histories, the growing cultural identity, new images, languages, forms and cultural experiences. Here the new revolutionary cultures take shape and set the path for a nation's future development.

Most twentieth-century revolutions have taken place in underdeveloped countries with large rural populations and impoverished urban masses. In them, urban artists and intellectuals serve as soldiers, guerrillas, literacy workers, and technicians and have come to know their countries for the first time. They have come into contact with the masses in their countries and learned of the full extent of the people's exploitation and their resistance to that exploitation. This experience has often profoundly affected these artists and intellectuals who have integrated their work, their art, and themselves into the new experience of their country and begun, as it were, a new cultural life. In the following quotations the Soviet revolutionary filmmaker, Sergei Eisenstein, and the Chilean revolutionary filmmaker, Miguel Littín, artists in very different times and places, express this new political-cultural awareness in a very conscious way.

> The Revolution gave me the most precious thing in life—it made an artist out of me. If it had not been for the Revolution I would never have broken the tradition, handed down from father to son, of becoming an engineer. I had the urge to become an artist, but it was the whirlwind of the October Revolution that gave me the one thing that really mattered—the freedom to decide for myself. The Revolution introduced me to art, and art, in its own turn, brought me to the Revolution. So that another thing that the Revolution gave me was the *idea content* of art.[2]
>
> We do not want to judge from afar nor ascribe our moral values to the people, but to rid ourselves of all our petit-bourgeois ideology, which we have, like it or not, because we were born and educated in a bourgeois society. We want to go to the people and become ourselves, day by day, a fighting people. And every day we must approach our reality with more humility, until we reach the highest possible rank—that of the worker, the builder of a new, revolutionary, socialist homeland.[3]

At the same time as artists and intellectuals are changing, revolutions unfetter the people and give them their own voice.[4] Tremendous growth and development take place in all realms of human activity, including culture. As intellectuals and artists discover their exploited and silenced brothers and sisters, the people discover themselves as persons. They begin to speak for themselves. Eduardo Galeano, the Uruguayan writer, has spoken eloquently about the Nicaraguan Revolution as a *revelation* of national culture, discovered for the first time by the Nicaraguans themselves. This culture, he says, has been "enriched and amplified by the rebellion of a people who have stopped being witness to their own misfortune. . . ."[5]

This double cultural discovery has become a major element of film and video practice in revolutionary Nicaragua and El Salvador. The first films made about the Nicaraguan Revolution in 1978–79 were mainly made by foreign filmmakers and a few of the educated elite of Nicaragua. The same happened in El Salvador after the military coup in 1979. In Nicaragua, as the revolution progressed, Nicaraguan worker and peasant activists acquired the necessary skills and began making films and then video tapes about their own reality. In El Salvador, after the repression of 1981 had forced all alternative media underground, some of the urban artists followed the guerrillas into the countryside, made films, and trained peasants and worker activists in the use of filming equipment.

Two genres play an important part in this process of reclaiming national identity and history, and giving voice to the people. One genre, reclaiming history, depends upon resurrecting national events and heroes, usually unsuccessful past rebellions and their leaders, which have been forgotten in official histories. The Nicaraguans revere Augusto César Sandino, who fought the U.S. marines to a standstill until murdered by Anastasio Somoza in 1934. In El Salvador, Agustin Farabundo Marti led the unsuccessful rebellion of 1932 and was murdered in the repression that followed. Both revolutions honor fallen fighters and civilians by attaching martyrs' names to everything imaginable: military campaigns, organizations, brigades, places, streets, barrios, radio stations. This practice replicates the rural, village experience from which most of the fighters come. There, individual and family names mark significant places and events. A revered family name, like a pedigree, bestows honor and responsibility on the owner. These names signify an example the rest must live up to. Memory, as Eduardo Galeano has said, is revolutionary.

In the midst of the Revolution, testimony becomes the second important genre, so important that Cuba's Casa de las Americas now gives a literary prize in testimonial literature. Often this genre entails

people talking directly to the camera about their lives and their partici-
pation in the revolutionary struggle—commenting on the visual testi-
mony we are shown. In one way these films give new meaning to the
much disparaged "talking head," combining it with equally important
visual testimony. In films like *Morazán* (1980) by El Salvador's Radio
Venceremos, peasant participants talk about making weapons and
clothing, and about their training, while we also see their activities.
One senses that the reality "on the door-step" has become so poignant
and dramatic, so new and exciting, that media artists have felt driven
to record as much of it as possible. The character, history, and strug-
gles of the Nicaraguan and Salvadoran people conveyed through these
works confirm the wisdom of the original intuition to record it. This
priceless material will form the basis for new national cultures and
histories.

Nicaragua

> During the war for liberation, our cultural expression, our folklore, our
> pre-colonial heritage, was converted into a weapon of struggle against
> the Somoza dictatorship.
>
> Ramiro Lacayo[6]

In Nicaragua very little film-making of any kind existed before the
revolution. PRODUCINE, a company partly owned by Somoza and a
Mexican businessman, made advertisements for Somozan business in-
terests and reverential newsreels for the national patriarch. Television,
which began in the 1960s, broadcast mostly foreign, especially U.S.
fare.[7] Nicaraguan national cinema, then, is a direct outgrowth of the
revolution. The Puerto Rican filmmaker, Emilio Rodríguez, told Ju-
lianne Burton that a

> Costa Rican group called Istmo Films, sympathetic to the cause
> of Nicaraguan liberation and convinced of the need to create a
> Central American film industry, began developing a funding
> structure and presented a film proposal to the FSLN leadership.
> With a concrete proposal in hand, members of the Frente got
> excited, daring for the first time to believe that it was actually
> possible to make a film about their struggle.[8]

Over the ensuing months in 1978, with organizational and logistical
help from the FSLN, Antonio Yglesias, Victor Vega and their Istmo-
film collective made *Patria Libre o Morir* (*Free Homeland or Death*).
 Although filmed completely in and around FSLN guerrilla camps
in Costa Rica, the film purported to show life in the guerrilla camps in

the mountains of Nicaragua. Amongst scenes of guerrilla training, Father Ernesto Cardenal led religious discussions among the troops. Julia Lesage assessed the film:

> Because of its subtle manipulation of sound and image and its long, searching look at routines of camp life, this film provides one of the most cinematically interesting documentary portraits of the revolution—one that gains more interest as we become aware that the guerilla camp is a way of life for many South American militants.[9]

The effectiveness of this film can be seen in the fact that, after seeing it, Emilio Rodríguez sought out the FSLN in order to join up, saying, "The film confirmed the ideas of the Cuban theorist, Julio García Espinosa, about *imperfect cinema*; despite its technical shortcomings, it moved me deeply."[10]

Following the successful experience of this film, the FSLN organized, in the spring of 1979, the War Correspondents Corps, composed mostly of people with some photographic or film-making experience. Many of its earliest members were from other Central and Latin American countries. Typical was the young student at the film school of Mexico's National Autonomous University, Adrian Carrasco. According to Carrasco, Saul Lewites, a Sandinista representative in Mexico City, got together a group of people in the winter of 1978–79. Two would go to Nicaragua for three months and then be replaced by a second team. Carrasco and Fausto Corrales became the first team.[11]

Zafra, a film distribution company in Mexico, donated a 16mm Bolex camera. On the way to Costa Rica, Carrasco went to Panama to get more equipment, including a reel-to-reel Uher audio recorder and equipment for working in combat conditions—ponchos and canteens—as well as photographic equipment. In Costa Rica they met up with Emilio Rodríguez and Ramiro Lacayo, a Nicaraguan architect who was political head of the group. They went to Liberia, near the border with Nicaragua and set up in a house on the outskirts of town. After filming the various training camps, they went into combat during an offensive across the border and with other teams filmed the rest of the revolution, amassing more than 60,000 feet of color film.[12]

When the filmmakers accompanied the revolutionary armies into Managua on 19 July 1979, they instantly set about forming a committee to begin the process of establishing a national cinema. They elected Emilio Rodríguez as head of the committee and requisitioned the PRODUCINE offices, reclaiming the equipment which Somoza's Mexican partner was trying to spirit out of the country, cataloguing

the combat footage, filming the reconstruction, and beginning production of newsreels and other short films. They received 35mm black-and-white footage from Cuba's ICAIC and edited some of their first films in ICAIC facilities. The first INCINE film was Adrian Carrasco's sixty-minute color documentary on the trip to Havana of the Nicaraguan delegation to attend the 1979 meeting of the Non-Aligned Movement. A co-production with Cuba's ICAIC and Cuban television, the film was called *De la Dependencia al No Alineamiento* (*From Dependency to Non-Alignment*).

In Rodríguez's 1983 film, *Historia de un Cine Comprometido* (*History of a Committed Cinema*), we see a picture of *La Gaceta*, a government publication of record, for Friday, 16 May 1980 in which is published Decree 100, establishing INCINE. But this only codified what was a reality from the moment of the revolution. The Sandinista leadership, according to Carlos Vicente Ibarra, who had worked as a photographer on the southern front and with Radio Sandino during the insurrection,

> invited me and two other compañeros, Franklin Caldera and Ramiro Lacayo, to head the newly founded film institute. Caldera is an impassioned "film freak"; he is steeped in film history and is a fine critic. Lacayo, who headed the Press and Information Corps (Equipo de Presa y Propaganda) on the Southern Front during the war, is the director of the first INCINE newsreel and president of the Institute.[13]

Nicaragua is a pluralist and very energetic country and this does not end the story. While INCINE produced *Noticieros* (newsreels) and documentary films on the outskirts of Managua, Alfonso Gumucio Dagron, the exiled Bolivian filmmaker, teacher, and theorist, who advocated using 8 mm film with the working class, arrived to put his theories into practice. He became involved in a project, funded by UNESCO, that the Minister of Planning, Henry Ruiz, set in motion. Ruiz had set up a media project as part of the Campaign for Economic Literacy, a project designed to help the workers and peasants understand the economic realities of Nicaragua. He wanted to reach a point where the workers could participate fully and knowledgeably in economic planning. He invoked all aspects of mass media in the campaign.[14]

For his part, Gumucio Dagron helped to found the Taller de Cine Super 8 to teach workers how to make films about their own reality. The first six-month class included people from the Sandinista Labor Central (CST), the Association of Salaried Farm Workers (ATC), the

Sandinista Youth, the Civil Defence Committees (CDS), the Sandinista Association of Children, and one from the Ministry of Planning. Each participant made a five-minute film and together they made a forty-minute film called *Cooperativa Sandino*, which Gumucio Dagron showed at Super 8 film festivals in Europe and Latin America as an example of his theories at work.[15]

Originally, the student filmmakers intended to return to their respective organizations and set up film-making groups there. But when Gumucio Dagron invited Julia Lesage to Nicaragua in July 1981, the CST and ATC filmmakers had come together to form the Taller de Cine Super 8. Lesage worked with the young trade unionist filmmakers on editing and the use of non-synchronized sound as an inexpensive and effective way to make a film. The group soon became the Taller de Video Popular when cost factors, the U.S. boycott, expanded possibilities for exhibition, and new opportunities (Tercer Cine, a group of internationalist video-makers working in Nicaragua, received a grant from Holland to train them in video) encouraged the switch to video production.[16]

According to Gumucio Dagron, the real originality of the Taller was that it "established a new relation of production of audiovisual messages," it transferred the necessary technology into the hands of the workers themselves. "It appeared that Nicaragua would be the first country in Latin America to develop a workers' cinema, enacted by them without the need for intermediary filmmakers."[17] Yet it is important to point out here that the Taller people were already experienced organizers. They were "organic intellectuals" in Gramsci's sense and were very developed politically. They had already set up the workers' theater movement and had put on two national workers theater festivals.

El Salvador

The origin of a national cinema in El Salvador has followed a somewhat similar path, but greatly attenuated in time and as yet incomplete. In the throes of their war of liberation, the Salvadorans have sown the seeds of a national cinema and have nurtured those seeds with great care. They have produced exciting and innovative work that has gained a world-wide reputation. If they have not yet won the military war, they have certainly won the cultural war.

In late 1979 or early 1980 various Salvadoran activists put together a short compilation film on the BPR (Bloque de Pueblo Revolucionario), a mass organization founded in 1975. People who have seen this elusive film say that it contains footage of student demonstrations in

the mid-1970s which the police fired on. Such footage, one assumes, must have come from various local news sources. Because of the close connection between the BPR and the political-military organization, the FPL, we can see in this film the origins of the Instituto Cinemagráfico de El Salvador Revolucionario (ICSR). In 1980–81, Diego de la Texera from Puerto Rico and Têtê Vasconcelos from Brazil made *El Salvador: el Pueblo Vencera* (*El Salvador: The People Will Win*) with a crew of Salvadoran university students who had become involved in the student movement and the rebel movement against the oligarchy. They trained this group which then formed the core of the ICSR, one of the two media groups currently operating in the "Zones of Popular Control" in El Salvador.

At almost the same time in San Salvador, a group of artists calling themselves the Taller de los Vagos (Workshop of Vagabonds) made *Zona Intertidal* (*Intertidal Zone*), dedicated to assassinated teachers. The film counterpoints the body of a young male teacher, lying on the beach just where the water and beach meet, with scenes from his life in school, at home, and reading in a hammock. It is a montage of beautifully composed and photographed images with only music and live sounds. *Intertidal Zone* demonstrates that a group of talented Salvadoran artists, with access to resources and contacts with the mass organizations, existed in San Salvador at this time.

On the basis of this early film work one could easily imagine the development of a national, politically-committed cinema based in the cities, drawing on a wide range of artists, in association with the mass organizations. A successor collective to the Taller de los Vagos, called Cero a la Izquierda (literally: Zero to the Left; colloquially, it means "to be a nobody") made *Violento Desalojo* (*Violent Eviction*), about a student take-over of a church being violently broken up by the police, and *La Canta* (*The Song*), about which I know only the name. It is quite possible to trace a trail from the Taller de los Vagos to Cero a la Izquierda to the Radio Venceremos media group as a second thread in the development of Salvadoran national cinema.[18]

Before either of these threads of development could consolidate itself, draw in more participants and initiate more ambitious projects, El Salvador went through a horrifying period of repression. The military, the police and death squads initiated a bloody campaign of murder throughout the country, killing thousands of Salvadorans; they assassinated Archbishop Oscar Romero; kidnapped, tortured, and murdered five opposition leaders; raped and killed four U.S. church workers; and, finally, shot down two AFL-CIO advisers and their Salvadoran colleague in a hotel dining-room, in January 1981. As a result of this carnage the popular organizations dispersed and went underground.

Any hope of peaceful change disappeared. For the next few years, activity shifted to the guerrilla war in the countryside.

In 1981, the FMLN (a coalition formed from five separate guerrilla forces in November 1980) began to establish "zones of popular control." In that year the ERP (Popular Revolutionary Army) founded Radio Venceremos in Morazán Province. (Dissident members of the Christian Democratic Party, various people moved by their religious convictions, and independent leftists had formed the ERP in 1971.) At about the same time, the Popular Liberation Forces (FPL) founded Radio Farabundo Martí in Chalatenango Province. (Salvador Cayetano Carpio, who had broken with the Salvadoran Communist Party over the issue of armed struggle, had formed the FPL in 1972.)[19]

In Morazán remnants of Cero a la Izquierda, working with Radio Venceremos made two *cinéma vérité*-style war documentaries, *Morazán* (1980) and *Decision to Win* (1981). Then they formally joined Radio Venceremos and became part of its multi-talented media collective which runs a radio, and produces films, videotapes and various printed materials for distribution within the country and around the world.

Once settled, so to speak, in the Zones of Control, the Radio Venceremos and ICSR filmmakers developed in different ways; this followed from their differing access to resources and from the politics of the political-military force of which each is a part. Radio Venceremos has tended toward a very experimental approach to its work, changing the style from film to film, as if searching for the best way to express different aspects of the fast changing Salvadoran reality.

Letter from Morazán (1982) is the first film credited to "a collective of cameramen, soundmen, and editors of Radio Venceremos." The film has a voice-over narration in the form of a letter from "El Flaco" and "Maravilla" who shot the material and are sending the letter along with the material to their friends outside the country who will edit the footage. Daniel Solis, an editor based abroad, told Julia Lesage that they needed a commentary for this film.

> So we did it in the form of a letter. The advantage was that a letter could describe situations we couldn't film, such as things that happened at night. Later, we realized that this narrative strategy of a letter let us use and valorize people's everyday vocabulary . . .[20]

The film reveals many other advantages. The relatively simple *cinéma vérité*-based form of *Morazán* and *Decision to Win* made it impossible to present any historical or political analysis. Those films

simply show a series of activities in which people participate. *Letter to Morazán* is more specific. It presents the elements of an actual historical campaign: the second stage of the "Commander Gonzalo Campaign" in July–August 1982 in Morazán and San Vincente provinces. Here the film details the planning, prior training and execution of a major campaign. At the end, prisoners-of-war are turned over to the Red Cross organization.

The letter/narration is a retrospective commentary on the events covered by the film. The "letter" accompanies the raw film and tape materials out of the country and, in a sense, functions both as instructions for cutting the film and as narration for that film. The letter can also explain and fill in events that could not be filmed. We see part of a battle, but are informed that most of it happened at night. We are told about Colonel Castillo's earlier capture prior to the film's interview with him. The prisoner exchange is "narrated" by the letter because there is no synchronized sound available for that scene. The letter also functions to personalize in an economic way: "Javier's people approach the city." "Licho's column is preparing to ambush the army reinforcements." Because the voice-over is a personal letter rather than a conventional voice-over narrative, these comments are informal and more personal—friends commenting on friends.

Sowing Hope (1983) represents another stylistic change, based on political need. The title refers to the legacy of Archbishop Oscar Romero who was assassinated in his cathedral in March 1980; the Pope's visit to Central America in March 1983; and the popular church, based in the community and on the tenets of liberation theology. It is the only one of these films with an extensive voice-over narration and seems to have been made in a hurry to explain the rural religious communities to urban Salvadorans as well as current events in El Salvador to a foreign audience. In many ways the film demonstrates both the limitations of the previously used *vérité*-style films— they depict but cannot explain or analyze very much—and the difficulty in making a clear, analytical film without proper archival material or enough time to overcome the usual problems of guerrilla cinema.

The change in style also represents a return to the city. In fact, by 1983 the guerrilla movement had become strong enough to influence events in the city. Both *Sowing Hope* and the subsequent *Time of Daring* (1983) demonstrate this new strength by using footage shot in the cities, under the noses of the enemy, and by contrasting the urban-based government forces with the rural-based guerrilla forces. In these two films we see that the FMLN-FDR's successes, both in the field and diplomatically, have forced Radio Venceremos to deal with

broader and more complex issues. From the point of view of the FMLN-FDR, a situation of dual power exists in El Salvador,

> within which, independent of where one lives, one is exposed to two powers. It is a country where, in order to live, produce, conduct business and partake in political life, all must deal with two existing powers, with two distinct authorities. There are two opposing enemies that project distinctly different lines with regard to the entirety of the economic, social, cultural, political and military structure.[21]

Without giving up the freshness and immediacy of the *vérité* footage, *Time of Daring* uses a contrapuntal structure to make sharp and lucid comparisons between the Salvadoran regime and its U.S. backers, on the one hand, and the liberation forces, on the other. It is an extremely sophisticated documentary, a daring film—aesthetically, technically, and politically. It uses a precise montage aesthetic to compare the contending forces in El Salvador—U.S. imperialism and the people of El Salvador. A brilliantly edited sequence early in the film typifies the work. First comes an image of troops on parade. It is cold, formal, and official—the power of the oligarchy on display. At the end of this part, the camera picks out a poor, apparently confused man with several brooms over his shoulder. He is an urban peddlar come upon this scene of military finery and power of which he is the victim —past, present, and future. The filmmakers then cut to an image of two young boys following a team of cows pulling a cart up a dirty road away from the camera, inviting us to follow. In long shot we see a group sitting around an open area and "Jorge," a representative of the People's Commission, addresses the group. "Jorge" looks very much like the broom-peddlar. He too is a poor man, oppressed by the oligarchy. But he lives in a zone of control, he has been able to develop himself and now participates in democratic self-governance. So the move from the stiff, formal world of the oligarchy to the natural, warm world of the zones of control also represents a move from oppression to liberation.

This transition, not just a formal device of editing but a dialectical movement, contains, symbolically and concretely, all of Salvadoran history. The impoverished, uncomprehending broom-peddlar represents, not merely as a visual symbol, but in his actual person, all the awful oppression—economic, social, intellectual, and physical—of the people at the hands of the Salvadoran oligarchy and its U.S. backers. In the same way, "Jorge" symbolizes and embodies the liberation of the Salvadoran people. Their similar physical appearance indicates

that they are the same person on a continuum of potential. The broom-peddlar can and has become "Jorge" while "Jorge" was once the broom-peddlar. Fundamental human development takes place within the revolutionary situation as long suppressed and alienated talents, needs and skills—potential—emerge from a liberated people.

The ICSR, expressing the FLP's heavy emphasis on building international solidarity for the struggle in El Salvador, began to involve itself in co-productions with solidarity activists abroad—especially in the U.S.A. and Canada. In part, this development seems to have been spurred by what their supporters in the U.S. felt was the failure of *El Salvador: el Pueblo Vencera* as an organizing tool. Kevin Pina spent six months travelling around the U.S.A. showing the film in 1982:

> *El Pueblo Vencera* reflected the cultural, political, and military realities that those people were living under. People in the United States are not living under those same conditions and they usually can't relate to those conditions. How the Salvadorans describe their life is going to be very different than how someone from this country might describe their life. North Americans were especially critical of what they say as the indoctrination of children. They thought that these kids in the film couldn't even know what it's all about, couldn't understand the slogans they were chanting. They accused us of being communists. We were always on the defensive when we went out with the film and spent all our time arguing rather than in building support for the Salvadorans.[22]

Communications: El Salvador, formed to distribute the film in the U.S.A. was beginning to fall apart because of this experience. If they wanted to do solidarity work, to slow U.S. intervention by educating people there, Pina and others felt they needed a film that would do that effectively.

In her important article on films in Central America, Julia Lesage puts her finger on the crucial issue Pina raises: cross-cultural sensibilities. She points out that the most effective films with North-American and European audiences, according to the activists in these countries, are those that follow those areas' television aesthetics.

> Films made by Latin Americans on the revolutionary struggle often elicit a different and even unsympathetic response from anglo audiences than from latino ones. Certain connotative details and rhythms of presenting material cinematically seem to make more sense to audiences in a Spanish-speaking environment than in an English-speaking one.[23]

She also draws examples from *El Salvador: The People Will Win*. The militarism of people with guns, the red flags and rhetorical speeches, and the eloquent young boy all seemed hard for U.S. audiences to accommodate or understand in a sympathetic way.

As a solution to this problem the ICSR and its U.S. supporters went to work on *In the Name of Democracy*. Intended to focus on the 1982 elections in El Salvador, the film took more than two years to make because of the lack of resources, the tension between the co-producers on what a film on the Salvadoran election should be, and the disruption of the FPL resulting from Cayetano Carpio's murder of Anna Maria Montoya and his subsequent suicide. Ironically, the final film came out in time for the 1984 elections which were so similar in form and content that the film remained topical. *In the Name of Democracy* has been successfully used around the country to build support for the Salvadoran people, shown on television in some areas and viewed by members of the U.S. Congress.

In traditional television fashion, the film uses "expert witnesses" to lay out the various important elements of the elections. Carefully marshalled evidence clearly demonstrates that people fear the consequences of not voting and that the voting procedures allow the government to know who voted for whom. U.S. Representative Tom Harkin, Dr. Charlie Clements (the Vietnam vet turned Quaker activist who worked as a doctor in El Salvador's zones of control)[24] and various international observers and journalists denounce the elections as a fraud. In a wider sense, the whole situation in El Salvador comes into focus: the civil war/revolution, massive U.S. aid to a brutal and fraudulent government, the dire health and social welfare problems that go unattended, and the effort to build a participatory democracy in the rural zones of control.

Both these groups' approaches have benefits and limitations in respect to their particular contexts. The Radio Venceremos films seem to me to give a clearer, more interesting picture of life in the zones of control and of the Salvadoran struggle from the inside. They seem to work better in Latin America and with Latino audiences elsewhere. The ICSR co-productions seem to be more useful for the purposes of solidarity work as it is presently constituted in the U.S.A., gaining a larger and broader audience, and gaining more credibility. Perhaps the best situation is that where two groups produce few different media, thus meeting a wider range of needs. In this regard, it will be especially interesting to see how the new Unidad de Cine y TV develops.

Conclusion

Revolutionary upsurges in Nicaragua and El Salvador have released tremendous creative energy in all areas of human endeavor, and particularly in the cultural fields. Film- and video-makers in these two countries have greatly enriched their national cultures and our lives, and will continue to provide deep insights into the revolutionary process in Central America.

Notes

I want to thank the many people and organizations who helped me research this article and have given advice on various portions of it: Canyon Cinema (S.F.), Cinema Guild (N.Y.), Icarus Films (N.Y.), The El Salvador Film and Video Project (S.F. & N.Y.), Camino Films (L.A.), and both INCINE and the Taller de Video Popular in Managua all supplied prints to view; the Pacific Film Archive (Berkeley) provided screening space; the Center for Cuban Studies (N.Y.) helped me obtain necessary information. Adrian Carrasco, Kevin Pina, and other participants who chose not to be named kindly shared their knowledge of this filmmaking. Teshome Gabriel encouraged the writing of this article; Julianne Burton gave important advice; and my co-editors, Chuck Kleinhans and Julia Lesage are a constant source of feedback, inspiration and support.

1. In late 1986 the FMLN formed the Unidad de Cine y TV to coordinate and, I assume, ultimately to unify the two main communications collectives. Representatives from the Unidad showed their first video tape at the Havana Film Festival in December 1986. It was a short compilation tape based on footage from radio Venceremos and the ICSR. Though it is too early to say very much about this unification effort, it will be interesting and exciting to see how the effort proceeds.

2. Quoted in Norman Swallow, *Eisenstein: A Documentary Portrait* (New York: E. P. Dutton, 1977), p. 30.

3. Quoted in Zuzana M. Pick (ed.) *Latin American Film Makers and the Third Cinema* (Ottawa: Carleton University Film Studies Program, 1978), p. 172.

4. Unfortunately, this liberating process has not always lasted. As most twentieth-century socialist revolutions have developed and defended themselves against counter-revolutionary activity, they have tended to narrow the scope of acceptable artistic expression. This should not, however, discredit the tremendous liberation and explosion of creativity that has taken place. These are the authentic goals and potential of socialism.

5. Walter I. Bradbury, "The Revolution as Revelation," *Socialist Review* 125 (65) September–October 1982, p. 9.

6. Steve Karian, "Nicaragua's revolutionary cinema" [An interview with Ramiro Lacayo], "Inside Magazine," *The Daily Californian*, 7 October 1983, p. 9.

7. See John Ramírez, "The Sandinista documentary: a historical contextualization," in Thomas Waugh (ed.) *"Show us Life": Toward a History and Aesthetics of the Committed Documentary* (Metuchen, N.J.: Scarecrow Press, 1984), pp.465–79 and "Introduction to the Sandinista Documentary Cinema," *Arieto* 10 (37) 1984, pp. 18–21 [reprinted in this volume].

8. Julianne Burton, "Film Making in Nicaragua from Insurrection to IN-CINE: An Interview with Emilio Rodríguez Vazquez and Carlos Vicente Ibarra," *Cineaste* 10 (2) Spring 1980, p. 28.

9. Julia Lesage, "For our urgent use, films on Central America," *Jump Cut* (27) July 1982, p. 20.

10. Burton *op. cit.*, p. 28.

11. Interview with Adrian Carrasco on 9 June 1986 in San Francisco, California.

12. For a detailed history of the War Correspondents Corps see Fernando Pérez Valdes (ed.) *Corresponsales de Guerra* (Havana: Casa las Americans, 1981).

13. Burton *op. cit.*, p. 29.

14. Alfonso Gumucio Dagron, "Cine Obrero Sandinista," *Cuadernos de Communicación Alternativa* (Mexico), No. 1 (nd). The translations are mine.

15. Of course, during these early years many filmmakers from around the world were making films and video tapes about the revolution in Nicaragua, often in cooperation with Nicaraguan film- and video-makers. Also many other institutions in Nicaragua make films and video tapes, especially Sandinista TV, the Ministries of the Interior and of Agrarian Reform, the Army, and many others. See Julia Lesage *op. cit.*; Alfonso Gumucio Dagron, "Cine Y Revolucion en Nicaragua," *Plural* (Mexico City), Jan–Feb 1982; DeeDee Halleck, "Notes on Nicaraguan Media: Video Libre O Morir," *The Independent* 7 (10) November 1984, p. 12–17; Dennis West, "Revolution in Central America: A Survey of Recent Documentaries," *Cineaste* 12 (1) 1982, p. 23; Dennis West, "Revolution in Central America: A Survey of New Documentaries," *Cineaste* 14 (3) 1986, pp. 14–21.

16. See Carole Isaacs and Julia Lesage, "Learning from Our Compañeras," *Voices from Nicaragua* (Chicago) 1 (2–3), pp. 3–6, 47–48.

17. Dagron *op. cit.*, p. 23.

18. For a more detailed description of Radio Venceremos, see my article, "Synthetic Forms of Collective Experience: El Salvador's Radio Venceremos," in *Documentary Strategies: Society/Ideology/History in Latin American Documentary, 1950–1985*, Julianne Burton (University of Pittsburgh Press, 1987).

19. Though now somewhat out of date, a good source of basic information about the early stages of the Salvadoran revolution is Robert Armstrong and Janet Shenk, *El Salvador: The Face of Revolution* (Boston: South End Press, 1982). A new and particularly important book for understanding the situation in Chalatenango province is Jenny Pearce, *Promised Land: Peasant Rebellion in Chalatenango El Salvador* (London: Latin American Bureau, 1986).

20. Julia Lesage, "Betamax and Super-8 in Revolutionary El Salvador: An Interview with Daniel Solis," *Jump Cut* (29) February 1984, p. 15.

21. *Anon.*, "Dual Power: An Analysis," *Signal of Liberty* [English-language version of *Senal de Libertad*] (4) January–February 1985, p. 11.

22. Interview with Kevin Pina on 16 June 1986 in Oakland, California.

23. Lesage, "Urgent Use," p. 16.

24. Clements' account of his transformation makes particularly interesting reading, *Witness to War* (New York: Bantam Books, 1984).

Introduction to the Sandinista Documentary Cinema

John Ramírez

Aquí el cine ha desempeñado tradicionalmente un papel colonizador. Entonces nosotros concebimos el nuevo cine nicaragüense precisamente como un frente de batalla al imperialismo, con un cine descolonizante, liberador, como un instrumento político que va a luchar contra la penetración cultural e ideológica del imperialismo, que va a ayudar a desarrollar y consolidar la ideología sandinista en el pueblo nicaragüense.[1]

Ramiro Lacayo, Instituto Nicaragüense de Cine (INCINE)

The Sandinista documentary shares as a legacy from the New Latin American Cinema the important purpose of affirming the aspirations, achievements and potential for cultural rediscovery and reclamation. This purpose indicates, first and foremost, national advancement: from foreign domination and shattered self-image to independent cultures restored to cohesive national identity. The Sandinista documentary stands in dialectical relationship to the national need for renovation on all social fronts. Its objective is to serve the interests of development, which is to say independence from the effects of imposed economic, cultural and psychological dependency.

In the early 1900s, U.S. and European film dominated Latin America. With the exceptions of Argentina, Brazil and Mexico, whose relative economic independence could support local film infrastructures, the Latin American continent was reduced to an exhibition market for U.S. and European fare. Even the few developing local industries soon abandoned their efforts in the areas of documentary and histori-

AREITO, vol. 10, no. 37, 1984, pp. 18–20. By permission of the publisher.

cal docu-drama in favor of more light-hearted entertainment. Taking advantage of Europe's difficulty in maintaining foreign markets during World War I, U.S. studios effectively displaced their European competition from Latin America. Thereby they established a monopoly that went virtually unchallenged at least until the early 1920s, and then again in 1932, when Mexico mobilized a number of Latin American nations to close their film-exhibition circuits to U.S. productions. These efforts were in protest against Hollywood representations considered ethnically and nationally insulting to Latin American audiences.[2] The resulting boycotts and a handful of legislative acts banning Hollywood films accomplished little more than to impress upon the studios that large profits could be made through a few token gestures of hemispheric goodwill. Nevertheless, a simpler solution for Hollywood often was to eliminate Hispanic characters and situations from their films.

From the standpoint of Pan-Latin American cultural unity, however, those protests were, of course, salutary. First, they demonstrate a continental awareness of the nature of imperialistic cultural designs, and also speak well for the emergence of an aggressive healthier Hispanic self-image. By the same token, in questioning the portrayal of things Hispanics by Hollywood, an unprecedented international challenge, Latin Americans confronted one principal mechanism of imperialist ideology and sought to redress the power balance.

What is significant here about these protests is the fact that Nicaragua, which had been under direct U.S. military occupation from 1912–1925, and again from 1927–1933, took part in the 1932 protests against Hollywood. Given this fact, it is historically inaccurate to assume that no film culture predates the Sandinista cinema since Nicaraguans definitely recognized a history of cinematographic imperialism. Nicaragua's participation in the 1932 protest coincided with one of the most overt U.S. occupations in twentieth-century Latin America—an occupation that by 1935, was well on its way to guaranteeing the security of U.S. economic and political investments in Nicaragua through the manipulation of internal-political strife.

In 1934 Augusto César Sandino was assassinated by the National Guard which was then under the command of Anastasio Somoza García. Somoza gained enough leverage to make the Guard his personal army, enabling him in 1935 to secure the presidency. Soon after taking office, he assigned to the Guard administrative responsibilities for the country's major institutions, which were eventually appropriated for the profit and aggrandizement of the Somoza family.

Among those institutions were the communication industries: press, radio, film-exhibition, Nicaragua's own film studio established in the

1950s, and television, which was introduced in the 1960s. During the several years prior to his assassination in 1956, Somoza García took steps to install within his political machine a film production facility, PRODUCINE. The facility never ventured beyond cheap advertisements promoting products within the family's monopoly holdings, self-serving newsreels glorifying the family's privileged lifestyle, and visual training manuals for the Guard. In spite of PRODUCINE's creative shortcomings, it did provide a vehicle for the centralization of national film-exhibition revenues while deepening the cultural poverty of Nicaragua's media.

A crucial factor in the course of material and aesthetic integration of the Nicaraguan revolutionary experience was, in fact, the alienating distance between the popular daily experience under the Somoza dynasty and that dynasty's prevailing communications apparatus. However incompetently structured and aesthetically lacking the Somoza media network might have been, it was nonetheless bound firmly to the politics of domination—both Somoza's and that of the foreign interests which the Somoza dynasty accommodated. Somoza's productions, together with carefully selected foreign commercial fare, supported a film-culture completely closed to the participation and input of those it addressed.

The ideological and aesthetic poverty of that film industry may be seen as part and parcel of the generally deplorable spiritual landscape of Nicaragua before the Sandinista victory of 1979. Civil liberties affecting the press, public speech, artistic expression, education, labor rights, and health care were virtually nonexistent, save for a handful of nominal concessions made in the interest of maintaining U.S. financial and military aid. Illiteracy stood at 50%, unemployment at 28%, 80% of the employed earned a per capita income of less than $805 a year and, for two-thirds of these, annual income was barely $300. At this same time the country's inflation rate was 60%.[3] Like the tip of an iceberg, these figures do not begin to reflect the full scope of public deprivation and abuse suffered during the forty-five years of the Somoza regime. The recognition of contributions made to this paradigm of misery by Somoza's media apparatus has informed the development of Sandinista documentary. This has led to the task of altering and correcting the effects of that apparatus. The Sandinista approach to this challenge has been to seize the mechanisms of cultural address while at once applying them against generations of de-culturation, national deformation, and psychological manipulation. This approach can be traced to the documentation practices of the Sandinista National Liberation Front—Frente Sandinista de Liberación Nacional (FSLN).

In 1978, a coalition of opposition parties united under the leadership of the FSLN. Through a concerted program of guerilla struggle and popular education, the Somoza regime was successfully dismantled in July 1979. Inspired by the support of the international community of documentary filmmakers and photo-journalists covering the War of Liberation, the FSLN chose to implement its own information network in April of 1979. Combatants were invited to volunteer for technical training in Mexico, to be followed by photographic and 16mm film documentation assignments in Nicaragua's strategic war zones, thus constituting the War Correspondents Corps. These documentarists were joined by a number of cineastes and photo-journalists from around the world who responded to an FSLN appeal for professional international media assistance. That appeal aimed to complement, via international solidarity, Nicaragua's own filmmaking resources and expertise which were understandably scarce.

An immediate function of the Corps was to gather evidence on the developments of the war—evidence that could effectively challenge Somoza's distorted official version. Through the Corps' formation the first steps were taken to seize the mechanisms of cultural address and rectify their abusive application. The Corps' most significant long-term effect was the infrastructural base it provided for Nicaragua's first national cinema. Three days after the July 1979 victory, the Government of Reconstruction offered to Corps members the task of coordinating, as a branch of the Ministry of Culture, Nicaraguan Film Institute—Instituto Nicaragüense de Cine (INCINE). Three men who had fought in and documented the war, Ramiro Lacayo, Carlos Ibarra and Franklin Caldera, were invited to direct the new institute, housed in the abandoned PRODUCINE facilities. With only a small studio, an editing room, a dark room and a recording studio, the facility never boasted film processing capabilities. Moreover, Somoza managed to take virtually all filmmaking equipment with him out of the country.

Today, in spite of severe shortages of equipment and technical expertise, the INCINE coordinates an effective production and distribution policy designed to meet the needs of national reconstruction. In terms of production, INCINE set forth the goal of making maximum use of some 60,000 feet of 16mm footage taken by the War Correspondents Corps during the final months of the war. Together with an estimated 300,000 feet of PRODUCINE footage left behind by Somoza, INCINE has outlined a three-part agenda of projects consisting of: *Noticieros*, or newsreels, *Feature Documentaries*, and *Special Projects*.

INCINE *Noticieros* are ambitious 10–20 minute black and white projects distributed through Nicaragua's 150 movie houses to supple-

ment feature programming. The *Noticieros* treat significant events of the Sandinista resistance more broadly than television newscast or press reportage formats allow. *Noticieros* also offer a training-ground for Nicaraguan filmmakers to experiment with and refine those skills acquired through war coverage experience and during their production training in Mexico and, since the victory, at the Cuban Film Institute —Instituto Cubano del Arte e Industrias Cinematográficos (ICAIC). These tightly edited, fast-paced productions demonstrate capable and creative filmmaking in a context where scarcity determines the way to social reconstruction. Having to rely generally on archival footage from both the Correspondents Corps and the Somoza collections, the *Noticieros* make innovative use of all evidence about the War of Liberation: newspaper and magazine spreads, television newscasts, still photographs. These, together with contemporary footage depicting public participation in the reconstruction—Nicaraguans in acts of national defense, education, health care, labor and leisure—provide an arsenal of visual elements. These elements are matched and mismatched in dialectical relations that introduce new meanings and signifying possibilities not only for popular visual language but also for the codes of national history.

The *Noticiero*'s dynamic and unconventional combinations of visual elements accompany soundtracks that are also produced under technically unsophisticated conditions. For example, since sync-sound is not always available or economically feasible, there is a recurring use of voice-over strategies such as first person narration, anonymous public interviews and citizen opinions, crowds in revolutionary chant, traditional folk music, and radio broadcasts. In cases where sync-sound is utilized, as in dialogue accompanying television newscasts or interviewees, the visuals often shift in and out of correspondence with the sound so as to make full use of the possibilities a continuous length of sound may have alongside different visual images. The resulting fluctuation between sync and non-sync creates a visual-sound system that can reinforce such dramatic effects as irony, humor, sorrow, and horror.

Close to the tasks of cultural renovation, the *Noticieros* provide the structural basis for a genuine Nicaraguan film culture which influences the *Feature Documentary* and *Special Projects* categories of INCINE's production program. *Feature Documentaries* are generally 30 to 60 minute black and white and/or color productions that offer more expanded treatment on points of history and social reconstruction. *Special Projects* consist of specific projects designed to fulfill needs of particular ministries in the Reconstruction Government, such as an educational series that was produced for use in the Literacy Cam-

paign. *Special Projects* also include international co-productions such
as the 1982 film *Alsino y el cóndor*, directed by exiled Chilean film-
maker Miguel Littín, and combining Nicaragua's talents and resources
with those of Costa Rica, Cuba, and Mexico. *Alsino y el cóndor* is the
first and so far only fiction feature from INCINE.

INCINE's distribution policy incorporates an internal and interna-
tional agenda. Nationally, INCINE makes use of Nicaragua's existing
film-exhibition channels such as the country's movie houses located
largely in the urban centers, the nationalized television studio, and the
school and college circuits. This internal agenda also includes the co-
ordination of a Mobile Film Units Department which is responsible
for supplying film screenings to remote, rural regions of the country.
INCINE's national distribution policy also seeks to provide the popu-
lation with films from the U.S., Latin America, European and other
Third World alternative and independent film markets. In this endeav-
or, INCINE has had to rely on generous donations of films from the
international film community. Finally, INCINE includes an interna-
tional distribution arm for its own productions, an enterprise which
recognizes both the opportunity to share with the world the course of
Nicaragua's reconstruction, and a means to raise much needed funding
for future productions.

In conclusion, while the new Nicaraguan cinema does not fit con-
ventional patterns of mass commercial appeal, it does certainly at-
tempt a broad-based social dialogue grounded in a democratic respect
for the popular mind and its understanding. Media address in Nicara-
gua no longer descends from the heights of personalized privilege and
power. On the contrary, Sandinista film culture supports true social
communication, a quality in human interchange where film plays a
crucial role. In fact, Nicaragua's media have shown again and again
their commitment to the reclamation of cultural identity through a
consistent expression of an ever more authentic national point of
view.

Notes

1. "En busca de la imagen de Sandino: Entrevista con Ramiro Lacayo,"
Cine Cubano, 96 (1979), p. 18.

2. Allan L. Woll, *The Latin Image in American Film* (Los Angeles:
UCLA Latin American Center Publications, 1977).

3. George Black, *Triumph of the People: The Sandinista Revolution in
Nicaragua* (London: Zed Press, 1981).

Redefining Documentary in the Revolution

An Interview with Paolo Martin of the El Salvador Film and Television Unit

Catherine Benamou

Since 1980, alternative filmmaking in El Salvador has expanded beyond the immediate documentation of guerrilla activity in the "liberated zones' and on the frontlines of battle into a socially and technically diversified media movement active in urban as well as remote rural areas. To facilitate this expansion, the two groups most active in political filmmaking in El Salvador, the Radio Venceremos Collective and the Revolutionary Film Institute of El Salvador (see "Behind Rebel Lines: Filmmaking in Revolutionary El Salvador" by Susan Ryan in *Cineaste*, Vol. XIV, No. l, May 1985), decided in early 1987 to pool their resources and merge their activities to form a single El Salvador Film and Television Unit. The following interview traces the history of the merger over a two-year period, along with the production of two recent films—*Tiempo de Victoria* (Time of Victory, 1988) and *Doble Cara* (Two Faces, 1989)—that are expressive of the Unit's singular capacity for balancing the urgent demand for reportage with in-depth video analysis of the Salvadoran sociopolitical situation. Paolo Martin is a founding member of the Radio Venceremos Collective and a leading proponent of the El Salvador Film and Television Unit.

Cineaste: The two groups most responsible for alternative documentary filmmaking in El Salvador, the Radio Venceremos Collective and the Film Institute of Revolutionary El Salvador, have recently merged to form the El Salvador Film and Television Unit. What is the histori-

Cineaste, vol. 17, no. 3, 1990, pp. 11–17. By permission of the publisher.

cal background of each group, and why have they decided to join forces?

Paolo Martin: The two film teams began working in 1980, and, with their formation, the history of Salvadoran cinema began. Before that, there was hardly film production of any kind in El Salvador. The first film—*El Salvador: The Pueblo Vencerá* (*El Salvador: The People Will Win*, 1981), produced by the Film Institute of Revolutionary El Salvador—was a documentary on the conflict which was then taking shape. It has been distributed in the U.S., in Europe, and elsewhere internationally. At about the same time, some *compañeros* went to Morazán, and, with very modest resources and under difficult conditions, produced the first film on the emerging guerrilla army, titled *La Decisión de Vencer* (*Decision to Win*, 1981). This was the first film made entirely within a zone liberated by the FMLN, and it was shot with the support of those of us who had already been working there in radio. We also collaborated in the editing of the film, but it was released under the name *Cero a la Izquierda* (Zero on the Left), rather than in association with the Radio Venceremos Film Collective, which is the name later adopted by the group.

The intention was not to show the entire trajectory of El Salvador, but the historically new situation then in formation. At that time, nobody believed that in a densely populated country, without mountain ranges, and with an extensive communications network, a guerrilla army could be successfully organized. The first filmmakers who went to Morazán had the job of showing everyone that, *yes*, it *was* possible. This was an immediate political task: the film had to be taken quickly to the cities, to the popular movements, to the universities, to the young workers, in order to show them that conditions existed for radical change.

From that point on, more permanent groups were formed. Since we had been working with Radio Venceremos, our main effort was devoted to setting up the radio station. We succeeded in doing that in 1981, and we have been able to keep the radio station on the air all these years. In conjunction with this, we began to develop a media network, including film and video, known as the Radio Venceremos System. The *compañeros* of the Film Institute continued with 16mm film production in a parallel fashion, and, over a three year period, were able to make an important film just about every year. Now we've succeeded in unifying these two nuclei, because we need to increase our work capacity. We currently have very complex tasks at hand since we've discovered that, in addition to making film documentaries, it is now possible to use the electronic medium, video, as a

means of mobilization and organization within our revolutionary struggle.

Cineaste: In the early years, when you began producing these films, to whom were they directed?

Martin: The first efforts [in which I participated] were aimed at documenting a totally new reality, one which even those of us participating in it had trouble believing was a truly stable, national reality. We had to show this to the rest of the world, and, if one is in Morazán or Chalatenango, the rest of the world begins ten kilometers away. Even people in the next city, in San Miguel or in San Salvador, don't have access to that reality, much less those outside the country. We ourselves were living through an experiment in a controlled zone which, in a way, was very isolated at the beginning. We had to break this isolation, because we needed political and economic support. For that reason, we have always defined our audience as the general public. We try to make films which can carry our message to the people of San Salvador, as well as to people in the U.S. or Europe.

Cineaste: Didn't the two Salvadoran groups originally differ over the decision whether to use film or video?

Martin: Yes, those in the Film Institute conceived of themselves as a *cinematic* institute. They decided to produce in 16mm film, and to undertake the corresponding forms of distribution under wartime conditions, with all that that meant. The *compañeros* who were working at that time in the Film Institute demonstrated that this was much more possible than one would have thought. One could do very good projects. But they also realized that it wasn't really possible to follow the war in an agile way; they could make perhaps one film per year. This was the combined result of technology, isolated working conditions, and the logistical difficulties of communication. Sometimes just the shipment of exposed film out of the zone of production to a laboratory could take half a year. That is why those of us at Radio Venceremos who were working in a parallel fashion made the decision to use video.

Cineaste: Historically, the two film groups also differed in terms of their political affiliation. The Film Institute was closely affiliated with the Popular Liberation Front, which constitutes a different grouping within the FMLN than the organization with which Radio Venceremos has been associated. Does the current merger represent an actual merger of political interests between different political groups, or has it been separately determined by people working in the alternative media who felt they could become more active in covering both fronts of action by pooling their resources and equipment?

Martin: Both. On one hand, the unification of the two film teams is a reflection of the unity achieved by the revolutionary movement. It is true that the two teams had previously been working with two different organizations within the FMLN. The *Frente Farabundo Martí de Liberacion Nacional* (Farabundo Martí National Liberation Front) is a coalition of five politico-military organizations. They have recently achieved a level of unity that permits us to work together. We are going to transform the *Frente Farabundo Martí* into a unified political party, but we're still at the stage of unification. This process is already very advanced, and it is reflected in the unification of the two film teams. We—not us as filmmakers, but the movement—have formulated unified political proposals. What remains to be solved are technical and operational problems. We realized, however, as soon as we began to work together, that these no longer appear to be problems, but provide a great opportunity to draw from our different experiences in the areas of production, conceptualization, technique, and distribution. This possibility will permit us to work much more effectively now.

Cineaste: Previously, both groups were producing films and videos within the "liberated" or "controlled" zones; yet since about 1984, fighting has not been restricted to Morazán or Chalatenango, but has been developing on a number of fronts. Do you plan as a Unit to move the exhibition and circulation of your material outside of the liberated areas into other rural areas and the cities?

Martin: We are working, and will continue to work, wherever there is a guerrilla presence and movement. While it is true that we have our base in the zones controlled by the FMLN in Chalatenango and Morazán, that does not mean that we work only there. These zones form the "rearguard" from which the FMLN is developing popular organizations and the struggle throughout the country, so our resources and our base of coordination and communications are concentrated there. From there the film crews as well as the popular television crews—that's what we call the mobile video teams that go around showing tapes and conducting workshops—move out to any location where the guerilla movement can go, which right now means most of the country. At times it's difficult to gain access to some areas, but one can establish contact with the people. It's possible to work with video in the countryside—programs can be made and exhibited. In the cities, there are enough popular organizations that have taken on that task already, so we don't need to do it ourselves. We place ourselves at the disposal of anyone who wishes to use these videos.

Cineaste: How are you currently carrying out this form of exhibition?

Martin: When we began to work with video, our production units were automatically converted into exhibition units. For example, the video crew would arrive in a town and cover an activity or a cultural event. Immediately, people would approach us with great curiosity to see it, so we realized that we had in our hands a very valuable instrument for establishing communication with the people, a means whereby they could recognize their own reality, the national reality, could broaden their vision and educate themselves. The next step was logical—we began to make very rudimentary assemblages of this taped material. As a result, an entirely new line of work emerged for us, one which suddenly took on a high priority—the production of educational videos.

Perhaps I should explain the war a little. We no longer use the "liberated zone" as a concept, for us this is our "rearguard," our base of action. Just as the guerrilla army moves as a military force, as a political and organizational force our crews, as part of that force, go to Morazán, to Chalatenango, and anywhere else. These are mobile crews, which sometimes combine exhibition with production. There are also specialized crews that do only exhibition. The form that is most developed to date, however, is that of the workshop. Within the guerrilla encampments, we provide information to help with education. We have made videos for the political school, and for technical tasks such as the training of health brigades and the training of radio-operators. We also tackle more complex issues such as historical themes, the history of the popular movement. So whatever was useful we would edit there with the few resources at our disposal. This has given us a presence, a much deeper connection to the people in the zone. They see that this is an important instrument, and that the camera is really at their service.

Cineaste: To what extent have these spectator-participants, in both the rural and the urban areas, affected not just the themes you have chosen, but the form, the cinematic language?

Martin: Obviously, we can't make films or tapes with a language too complicated for an audience not used to seeing television, which is not equipped with a very developed visual culture, and which therefore will not be able to understand it. So our films must use a language adapted to these circumstances. For example, the technical device of the flashback is something that, in the U.S. or Europe, any child understands. These techniques are part of a language that is generally understood. For example, there might be a wipe-out or a wipe-in that moves on to an iris, or a change of music, and viewers understand: "Aha! Now something is happening in the story . . .

someone is waking up, someone is dreaming." A peasant in Morazán
is not going to understand these devices, so we don't use them.

This "limitation" is also expressed in our technical abilities. To
make a formal statement, and yet to do it in a way that everyone will
understand, implies a certain type of montage. So we are able to work
with simpler methods and scarce resources and, at the same time,
avoid confusing people. Normally, we don't use the available range of
special effects in video, not only because they are expensive, but also
because they are not necessary and it would be counterproductive for
our public. On the other hand, where politics are concerned, we are
confronted with an audience that has a political education and experi-
ence which I would dare to say is more developed than that of the
U.S. audience. When I say that we need a simple language, it does not
imply a simplicity of concepts in terms of political content. I am refer-
ring to cinematic form. So we try to develop a simple language, with
little adornment, conveying clear political messages.

Cineaste: There appears to be a clear interdependence between the
strategies of the guerrilla army and the strategies of the collective film
and video groups within the Unit: it's as though you formed a "front"
arriving prior to the guerrilla forces, to the actual fighting, in a certain
area. How else do you consider your filmmaking to be revolutionary?

Martin: Yes, they are integrated. In order for us to arrive, a certain
guerrilla presence is necessary; but in order for the guerrilla forces to
grow, politically and militarily, our work is a necessary, if modest,
part of that process. It is also important to stress that our filmmaking
is no longer guided by a sheerly documentary concept—documentary
in the classic sense of documenting what is happening and revealing
its structure only in the editing. Instead, our filmmaking involves a di-
rect intervention in the documentary subject. We are participants, not
observers: we are part of this movement.

This relates to what we discussed before—how does this work
come across to an audience in the U.S? We could try to edit our films
in a way that demonstrates that the camera is part of the struggle and
that whoever edits the film is part of the movement. But what purpose
would it serve? I think it would lose a lot of its meaning. When we
made the effort to build Radio Venceremos, which really meant a
great sacrifice for many people and the movement, it was to find our
own voice. Just as we need our own voice, we need our own image,
which should not be confused with the image that other people have
of us, be they friends or enemies. Even though they may be our
friends, people on the outside have another image of our country and
of the process. Our task is to project our own image. I think this is the
principal contribution of a national cinema, of an authentic cinema in

a Third World country which has never had the infrastructure or the space to create a proper voice, a proper image. These countries are always talked *about*.

Cineaste: This has been a shared concern of other film movements in Latin America over the last few decades. Do you feel your practice has benefitted from those other experiences, or is this an indigenous concept, shaped by the specific situation in El Salvador?

Martin: When we began working we were mostly disconnected from the experience in other Latin American countries. Obviously, we knew that a Cuban cinema had already come into being, but that was an experience we couldn't transfer to our country, because it entails a form of production which emerged after a very different revolution. Once we had accomplished a certain level of production and could travel to other Latin countries, we discovered that we were doing very similar things, that we could learn from one another. We know that in Chile for example, several projects very similar to our own are being created, and they have told us that the inspiration which gave rise to their work stemmed from an exposure to ours. For us it's going to be very interesting to see what becomes of this experiment which, in a sense, has travelled from Central America to Chile.

Cineaste: One of your new films, which involves the cooperation of North American filmmakers, analyzes the current situation in El Salvador. How did the idea for this film come about?

Martin: The *Doble Cara (Two Faces)* project came out of the first meetings which, over a year, led to the formation of the Film Unit. It was always clear from the beginning that one of the main efforts of the new organization would be to regain the ability to produce documentary films showing complete and interesting depictions of El Salvador.

Cineaste: As it is a sort of "coproduction," will this film be shown mainly outside or within the country?

Martin: Both. *Two Faces* is a project which represents the possibility of making a film intended both for the El Salvadoran public and a foreign audience. The premise of this film, which we have been preparing for two years, is to once more take up a very central aspect of the situation in El Salvador—the parallel existence of distinct realities which don't coincide. This is the experience of many people who live in San Salvador. They know that the war has a very different face in other parts of the country, but they don't experience it, and they have problems understanding it. At the same time, there are people in the mountains, not only the *guerrilleros*, but also the organized civilian population, the peasant population, which experiences the war in different ways. In the capital city, meanwhile, there are changes which

have to do with the North American presence, with economic aid, with the contradictions between the Christian Democrats and the old oligarchy that are creating a very pronounced crisis. All of these urban developments have been felt by people in the countryside, but they have very little information on them.

The coexistence of two realities is also reflected in the experience of observers, journalists for example, who might spend a few days in San Salvador and then have the chance to visit the countryside for a few days. They get the impression that they are two different countries. As filmmakers in this situation, what can we do? We could make two films—one on the capital city and another on the guerrilla forces. Instead, we chose to make one film—where these two realities and the contradiction between them—which is the expression of a civil war, of deep divisions within the society—are reflected. This is a central theme of *Two Faces*. From there, we determined the method of producing it—almost logically, it would have to be produced by way of parallel shoots. So two film crews worked on *Two Faces*, one composed of Salvadorans, of people from the Film Unit, who, working in the countryside, represented the perspective not only of the guerrilla army but also of the rural civilian population. A parallel perspective was provided by three different North American film crews, including Latin Americans living and working in the U.S., who worked on what can be called the "surface" of the question. They dealt with the army, the oligarchy, and the government, as well as with legal organizations of the popular movement, to portray the situation from the vantage point of those sectors of society.

Cineaste: In contrast to Salvadoran films and videos, in which the approach has been to arrange the footage with direct sound in such a way that it provides a direct expression of the situation, many North American films on Central America try to provide a historical context for the events by way of an authoritative voice-over narration. This is necessary in order to orient an audience which is not familiar with the struggle in El Salvador, and may confuse it with what has occurred in other countries, such as Nicaragua. As you intend to distribute this film here in the U.S., are you thinking of giving such an historical treatment to the subject matter?

Martin: In this film, there will be neither a historical treatment nor an explanatory narration. The film will have many scenes in which a number of people interact and speak to others within their own situation at meetings and in discussions, and our plan is to structure these scenes so they will constitute an explanation.

Our main objective is to show that in El Salvador there are *two powers*, and these different realities are the expression of the differ-

ence between those powers. There is the governmental power—with the whole economic apparatus, international relations, the army, the police—and there is an opposing power made up of the *guerrilla* forces and the people's organizations. The places where we were doing most of the filming are precisely those zones which in El Salvador are called "in dispute," where both powers are present in the military and political sense. For example, a North American crew could arrive and find one reality within a town, a certain power structure, and the next day or the following week, another crew would arrive with the guerrilla army and discover another reality, reflecting another power structure in that same town. This dual reality has to do in part with the current strategy of the FMLN, of a guerrilla army which is no longer working with the idea of liberating zones and defending them, but instead of disputing, of entering into conflict over control of the entire territory, so they do not propose to provide continuous security for the population. The security of the population lies in political struggle, social organization, and the defense of one's right to a minimum of organization. It can't only be the arms of the FMLN which defend the population at each moment. So everyone in El Salvador has to put on both an "official" face and a true face. If not, they wouldn't be able to handle this situation of two powers.

If we are able to show this situation, which for the majority of North Americans is new, what we will have done is perhaps not give answers to all of the questions they might have, but rather to open a space for debate. What we see as fundamentally necessary is that there be a debate on El Salvador in the U.S. This is why it is an urgent film, with the objective of opening a debate, not closing it. Many more people should be included in this debate, and North Americans must join it.

If we are able to make an authentic cinema—in the sense of really expressing what the Salvadoran people are about, what the revolutionary movement is, and how it works—if our productions are authentic in this sense, they will make a great contribution to the North American people. Our overall objective is not so much to gain their sympathy, but to supply information. We don't need the North American people to become sympathetic to our movement. What we demand is that they respect the decisions made by the people in Central America and that they not intervene. Thus, when people here claim to more or less know what is going on in El Salvador, our reply is, "No, that's not true. You don't know. It's different." With that understanding, they should begin looking themselves for the answers to the questions.

Cineaste: The North American media usually portray the conflict in El Salvador as a permanent state of combat between the FMLN guer-

rillas and the Salvadoran army. Apparently there is another struggle, which does not always take a violent course, such as anti-government protests in the city by the teachers' union, people within the university, and other unions, protests which may or may not be directly related to the guerrilla struggle.

Martin: They are different forms of organization, employing different forms of struggle, but they share the same goals, and have the same needs.

Cineaste: There is also the question of the large estates, of the farms where the FMLN is trying to change the form of payment, the wages of the workers on the farms, and also demand payment from the landowners for the war. Here not very much is known about this rural situation. Are you thinking of covering these two forms of opposition in the film?

Martin: Yes. This is not a "war movie." The war will inevitably be present in the film, because it is such an important aspect of the national reality: there is no way not to see it, not to reflect it. *Two Faces* is a film which has much more to do with the organization of the opposition—with the discussion around the plans for a solution, and how to arrive at this among a populace with thousands of forms or organization and the guerrilla forces—than with the war itself. This is a very complex discussion, sometimes it is very indirect, sometimes direct, and serves as an indication that this is a national debate involving everyone, including the FMLN.

Cineaste: At what point is the project now?

Martin: The film is now in the final phase of editing, and we hope to get it out by this winter. It took us a lot more time and money than we thought. It was an extremely ambitious project and it's too early to really make an evaluation, because the final result will be on the screen. What we can say now is that we obviously could not have expected to accomplish everything we wanted, especially making this kind of documentary. We had to adapt to a lot of problems, including the death of one of the cinematographers in our underground crew. It was the first casualty in our film work: a camerawoman who was shooting from the side of the guerrilla army in *Two Faces* fell in combat. We had never anticipated that someone in our crew would get killed, although we always realized this was possible. Everyone who has participated on this side, who has picked up a camera and accompanied the FMLN, knows that this can happen to them. It's only logical. During armed confrontations or bombings, there is no distinction between those who have a camera and those who have a gun: both can die. We make great efforts, and the FMLN even more so than us, to protect our people. Thanks to those efforts, we hadn't had that type

of problem until this happened. This was a serious complication for this project, but everyone was committed to going ahead with it, so we finished the production. We also had problems with the arrest and killing of some of the main characters in the film.

Cineaste: Was this in the city or the rural areas?

Martin: In the countryside. One character in the film, a labor union organizer, got killed in May of this year. Another main character an organizer for an agricultural workers' organization, was arrested and imprisoned, as was a character in the part of the shooting we did with the guerrilla forces. We might not be able to use this footage in the film, because it might influence his legal situation.

Cineaste: How did you coordinate the activity of the crews to make a single film over such a long time? Did you regularly reassess the direction it was taking with one another?

Martin: This was a very important experience for us. We thought this kind of film, with three or four crews working separately, would be possible only if we had a common understanding of what we were going to do, and a decentralization of direction. In part this worked and in part it didn't. The first two crews sent down from the U.S. worked on their own. We had discussions beforehand, we had phone contact, but I didn't go with them. When the first crew was shooting, I was in the mountains with the underground crew, and there was no communication at all. When the second crew went down. I was in the U.S. doing fundraising and we kept in close contact by phone. I personally accompanied the third crew, and worked very closely with them. They had their own producer and sometimes I was directly involved in the production, sometimes I wasn't for security reasons.

In this last phase of the production, I mediated between the underground crew and the North American crew. Obviously, these different approaches to directing the crews is reflected now in the editing in the sense that the last American crew was the most productive. It was coordinated more directly, there was a permanent discussion with them, and I was able to maintain communication with the local crew. We achieved a level of coordination we couldn't achieve with the first two American crews. So the main body of the film will be made out of the footage shot by the third crew, and the rest will serve as very important support material.

Cineaste: How have recent political developments affected your film? Do you still plan to reflect the two perspectives furnished by each crew, or is it rather a matter of incorporating material from both sides and fusing it into a whole that presents a single viewpoint?

Martin: It's going to be a little bit different. When we conceived the main idea for *Two Faces*, one of our central concerns was how to

make visible a sort of invisible situation. We had a political situation in which a lot of things happening in the country were not reflected in the news, they were not visible for observers—that's why we came up with this idea of showing the two faces of El Salvador. One of the major changes in El Salvador is that what was invisible in 1987 is very visible now, and it's not as important as we felt it to be when we conceived the idea in 1986, and then worked it out in 1987, and shot it in 1988. So in 1989, we have a situation where this is not really the point. Everybody recognizes that the social and military conflict has deepened, and it should no longer be our main goal to reveal these formerly invisible processes.

On the other hand, when we actually went to shoot—and this has to do with both our production capability and with the political situation we were confronting at that moment—we decided to focus on the legal popular movement. Now the two aspects which will be reflected in the film, and which still constitute the "problem" of *Two Faces*, are, first, the incredible variety of popular organizing—legal organizing—involving all those people who are accused by the government of being subversives, when what they're actually doing is normal labor union or peasant organizing. In a sense, this is subversive, because it puts the government in a very difficult position—it's subversive in the political sense, but not in the sense of being "terrorist," or directly related to the armed struggle. The other aspect is what the actually subversive, clandestine armed revolutionary movement is doing at the same time. So in part we didn't achieve what we set out to do, and in part we chose to change the focus—we didn't really try to film the oligarchy, to portray the Salvadoran power elite. They appear in the film, but it's a very reduced portrayal.

What the film will reveal, then, is that there is one popular struggle which arises out of the same social and political causes—repression, poverty, the question of land ownership, the question of the right wing, and the need for true freedom of organization. This movement working for social change in El Salvador has two expressions: one is the popular movement which is organized in a thousand different ways, depending on the sector of society and the political and legal space which people find to organize within. In some places, for example, people are not able to organize as labor unions, because they risk getting killed, so they organize as neighborhood committees. In other places, it's the opposite. On the other hand, there is a revolutionary movement organized by the FMLN, which is underground and armed. We want very much to show the concrete relationship between the guerrillas and the mass movement—yet you can't actually show this because you would put people in danger, so what you're going to see,

for example, is the peasant organization talking about what is really happening in this country. And they've come to a very simple conclusion—as long as there is no radical change in who owns the land, this country will continue to be in crisis, full of misery, and at war.

It's been this way since the last century—this is the same social conflict and the same war we have been fighting for about one hundred years. That's why the *muchachos* are in the mountains. So people are coming to exactly the same conclusions as the FMLN: they don't need to be incorporated by the FMLN, they don't need to be armed, but they are struggling for the same thing. We also show the situation from the side of the guerrilla army, although you don't see their networks of support in the civilian population—we saw them, of course, but we couldn't film them. We are trying to edit the film in such a way that everybody will come to these conclusions—all these people, from different positions in the struggle, want the same thing.

Cineaste: How have these changes affected your use of the footage? Do you plan to reflect these historical shifts, or will you simply show what is more stable as a process?

Martin: When we realized we would not be able to finish this film by the end of last year, we thought we were in big trouble. We shot most of the footage in the first part of 1988, and now it's going to be released more than a year later. Since last year, the government has changed: Duarte is out. Alfredo Cristiani with ARENA is in, the far right took power, and everything has changed. When we started editing, however, we noticed that nothing had changed in terms of the basic conflict. It didn't make any difference, for example, when interviewing peasants about the history of the country, about their general experiences with landowners, the government, and the army, whether Duarte or Cristiani was in power. We did some shooting during the election campaign in 1988 and in 1989: it's exactly the same, you see the same faces. So this is a film which won't deal with formal political power struggles between the Christian Democrats, the U.S. Embassy, private industry, and ARENA, for example. It deals more with the roots of the conflict, and there's very little footage which is not still valid. The only problem is that we wanted very much for this film to be actively involved in popular organizing so that it could intervene right now in the national debate—but there's no reason to think that the film will be too late. We have never tried this kind of approach before—to make a narrative film, to build up characters, and so on.

Cineaste: What other projects have you been engaged in, or have you completed as a Unit?

Martin: Aside from this, we have been maintaining the coverage on the war fronts and we have also reinforced the permanent work going

on in San Salvador. In 1987, we also produced a short video on those wounded in combat—people who have had limbs amputated or been blinded, and who are being treated abroad, most of them in Havana. It's a very beautiful piece called *Todo el Amor (All the Love)* which portrays the moral strength behind the revolutionary war.

By the end of last year, when we knew we wouldn't be able to get *Two Faces* out very quickly, we also saw the urgent need for a film about recent events in El Salvador and decided to form a different team to edit *Tiempo de Victoria (Time of Victory,* 1988). This involved a totally different approach to filmmaking, because it responded to totally different priorities. We wanted to put out something like an analytical document of what is happening right now, that would throw us into the debate, without paying much attention to esthetic criteria. This is a political document—it was not even conceived as a "film"—but then it got a bit more complicated, and people insisted that we show this "video-film." It was not that easy to work at the same time on two projects, and it affected the timing of the *Two Faces* project. But I think it was the right decision to get this film out, because it was really important to have a current document you can show both within El Salvador and abroad, and then afterwards come out with a film which goes more to the roots of the conflict.

Cineaste: What are your plans once you finish *Two Faces*?

Martin: The most important project involves the consolidation of video work in San Salvador which we managed to initiate through the *Two Faces* project. While we were shooting, we were teaching people on video; we were incorporating people related to the popular movement into our work: the three camera crews took equipment down to San Salvador and left it there. Once we finish this film, most of the people involved in production of *Two Faces* will go to San Salvador and work in this popular video project.

Cineaste: In what sense do you see the work you have been doing as forming the basis for an alternative system of communications in the future in El Salvador, given that there is no established "tradition" of filmmaking?

Martin: In the long run, this vision, this perspective, is the most important one for our work. We know that not only during the war, but also afterwards, we are anticipating a great task. It is ridiculous and absurd that in this country—a poor country, where the great majority of people do not have enough food, and are not educated, with a seventy percent illiteracy rate—there are six television channels, either commercial or government-owned, which show programs almost identical to those on North American television. This television system, with its huge human, technical, and financial apparatus, does not in

any way reflect the situation of the country or the interests of the people. Our task is to lay the groundwork so that the communications media can be at the service of the people, so that they will not only express political messages, but change the way in which they are formulated—the problems of the people, their political will, their cultural reality. So we are trying to find ways of involving as many people as possible in video work, in film work, and not to form a team or network that is very professional or alienated from the popular organizations.

To speak of an infrastructure any more than this is difficult. In our present circumstances, we aren't really going to be able to construct the infrastructure for a future television system. What we are forming are conceptions. Each film that is made generates discussion, criticism, and proposals. It also generates an awareness of the role of the communications media not only in the present liberation struggle, but also as regards the conception of a different society in the future. In our present work, therefore, we are preparing for the future media system in El Salvador.

Puerto Rico

Of Lonesome Stars and Broken Hearts

Trends in Puerto Rican Women's Film/ Video Making

Frances Negrón-Muntaner

Note on the Revised Version: The following essay first appeared in the media journal *Jump Cut* as part of a special section on "Latinos and the media" edited by Chon Noriega. My original intent in writing the piece was to investigate the diverse contexts in which Puerto Rican women have made and continue to make film and video. However, as most of my time was occupied by the draining labor of contacting and identifying filmmakers, collecting the work and reviewing scarce critical writings, I realized that the essay was instead part of the process of creating a dialogue; a work-in-progress. The resulting text thus became more of a resource for future research than an extended commentary on history, aesthetics and critical perspectives regarding Puerto Rican women's film and video production. For purposes of this new printing of the text, I have done some revisions to the original.

Introduction

Despite the fact that Puerto Rico's film history has been fragmented and erratic, the so-called "golden age" of Puerto Rican cinema associated with the División de Educación de la Comunidad,[1] trained a whole generation of Puerto Rican filmmakers who continued to produce films for decades to come. However, the DIVIDECO initiative failed to train a single woman producer or director. When women finally began to produce films during the 1970s as part of media collec-

A version of this essay first appeared in *Jump Cut*, No. 38, 1993, pp. 67–78. By permission of the publisher and author.

tives or organized political struggles, they remained mostly ignored by both Puerto Rican and U.S. historians, critics and curators. The obscurity of this history ultimately returns to haunt emerging Puerto Rican women filmmakers as the lack of a historical and critical context to discuss more recent work re-creates the vacuum that earlier filmmakers indeed reconfigured, but without acknowledgment.

Although much research on Puerto Rican cinematic practices and contexts is needed before the analysis of specific trends and films/videos can surpass the basic questions explored in these pages,[2] I propose the following questions to guide this reflection: What strategies (thematic and representational) have Puerto Rican women used in constructing their films and videos? Are there any significant points of divergence and/or convergence between the work of Puerto Rican women film/video makers in Puerto Rico and the United States? And if they exist, how can these similarities and differences be accounted for? Finally, and perhaps more important for this paper: How can we read films and videos produced by Puerto Rican women to enhance and multiply spaces of debate concerning crucial political and cultural questions for Puerto Ricans on the Island and the U.S.?

In this essay, I will attempt to map several constructions of community, spectatorship and politics in a number of independent productions. Within this category of independent production, I have selected films and videos which allow for the problematization of issues that I consider important to a discussion of Puerto Rican post-colonial film/video making practices. These issues include hegemonic constructions of Puerto Rican history and identity, and the relationship between anti-colonial and gender politics. In this sense, the text is (purposely) an invitation to debate and disagreement.

Less than a Quinceañera?

Cleo de Verberena's *O Misterio de Dominio Negro* (1930) is generally credited to be the first major film produced by a woman in Latin America.[3] While a number of women in the region managed to produce some works during this century (particularly in countries where national film industries existed such as Mexico and Brazil), it is not until the 1970s that women in Latin America and Latina women in the U.S. begin to produce film and video at an increasing rate. The reasons often cited for this minor explosion relate to at least three factors: the rise of feminism as a movement and political discourse, the institutionalization of film education through universities and colleges (partially as a result of ethnic and feminist struggle), and the entry of women into the journalistic/broadcast professions.[4] In the case of Lati-

nas in the United States, the civil rights movement and the articulation of different versions of radical politics among women of color,[5] also contributed to Latina involvement in the media.

In Rosa Linda Fregoso's recent article on Chicana cinema,[6] she mentions that Chicana filmmaking in the U.S. was (in 1990) fifteen years old, thus marking its *quinceañero*. Given the important points of contact between Chicano and Puerto Rican film history, it is not surprising that one of the first important films made by a Puerto Rican woman in the U.S. was co-produced by Beni Matías during the late 1970s (*The Heart of Loisaida*, with Marci Reaven, in 1979). Coincidentally, it was also during the mid 1970s that Poli Marichal began producing Super 8 film experimental animations in Puerto Rico. Despite the fact that Matías's documentary on housing organizing in the Lower East Side and Marichal's hand written animations on Super 8 may not be the "first" films/videos to be produced by Puerto Rican women,[7] I have selected these filmmakers to begin this discussion since they inaugurate two of the most productive traditions in Puerto Rican women's filmmaking to date: the "political" documentary and the hybrid experimental short.

Political Allegory and Women as Metaphor: Anti-imperialist Master Narrative and the Self-Empowerment Tradition

Given the recency of production, but the overwhelming number of works which easily fit traditional genre categories, I have grouped the films and videos to be discussed here by genre. This analytical choice is mostly artificial since most films and videos included here share many representational and political premises beyond the conventions of a specific genre. At the same time, the fact that most production falls into two genres is a useful way to begin to inquire about the contextual reasons for the preference of these conventions and, what this may suggest in terms of production possibilities and audiences. Furthermore, this framework allows comparison of films made by U.S. and Puerto Rican raised/born women with substantial freedom.

It has been suggested by Lillian Jiménez and Liz Kotz that, in general, Latina and Puerto Rican women's filmmaking has concentrated on documentary production because of its low cost, accessibility and efficacy as well as its perceived superiority in representing the "reality" of women's lives. On this last issue, Kotz comments:

> But there is another kind of appeal that documentary media may
> have for women film/videomakers in Latin America—the attrac-
> tion of those people who are ignored or underrepresented in the
> dominant media to forms that document their own reality, cul-
> ture and perceptions.[8]

Despite the fact that documentaries are an important trend in Puerto
Rican women's filmmaking, it is also relevant to note the centrality of
the experimental narrative short in the history of Puerto Rican wom-
en's cinema, particularly on the Island. Some of the same reasons of
accessibility and low cost may explain this second choice, although I
would suggest that in part, the preference for this genre is related to
the fact that a number of Puerto Rican women filmmakers have come
to film or video through their engagement in other fine art forms such
as photography (Frieda Medín) or other visual arts (Poli Marichal and
Mari Mater O'Neill). This particularity (along with issues of education
and class) accounts for a widespread practice of "film art," on the
margins of the commercial media world in Puerto Rico. In this sense,
these filmmakers do not yearn for the cultural "center" but self-con-
sciously produce for the margins (elite audiences) in Puerto Rico.
Kotz's point seems more in tune with the potential premises of U.S.
focused women filmmakers and women filmmakers from the left who
are also, however, making films for a minority constituency (not al-
ways overlapping).

While notions among some intellectuals on the traditional left re-
garding the "non-political" consequences of "form" versus the trans-
parency of "content" may be part of the context for many filmmakers'
tendency towards documentary conventions, it is also relevant to pose
the question of why documentaries constitute the most *successful*
productions among both critics and politicized sectors in Puerto Rico
and the U.S. In this sense, the assumptions of the documentary form
as more apt to tell the stories of the "oppressed" may account for the
popularity of documentaries among certain audiences. Furthermore,
the assumption of Puerto Rico's cultural and political "identity" as
"Latin American" may also contribute to a problematic understanding
of Puerto Rican cultural production since it often leads to the suppres-
sion of significant cultural histories and tendencies.

Twelve Years of Puerto Rican Women
Film/Video Production

Beni Matías, a New York-born Puerto Rican filmmaker collaborated
with Marci Reaven in the production of *The Heart of Loisaida* (1979).

This film, like a significant number of the early Chicano and Puerto Rican films, is strategically constructed to foreground and celebrate the self-empowerment actions of a group of people, specifically, working-class Puerto Ricans in New York City. By "self-empowerment" I am referring to a set of rhetorical and representational conventions designed to highlight the possibility and effectivity of collective action in the process of changing structurally maintained oppressions. As activist and journalist Blanca Vázquez comments:

> We became active in the 1960s and 70s in order to mobilize and organize. Media coverage of struggles and takeovers was an essential strategy of the Puerto Rican civil rights movement, a lesson not lost on the government or the press, who have moved in the 1980s and 90s to minimize the coverage of social movements and to deny access to an activist press.[9]

The textual strategies used in this type of film/video narrative often include: the positioning of "ourselves" (Chicanos or Puerto Ricans) as central and capable agents of change, the identifying and naming of the obstacles to social transformation not within ourselves, but in the dominant structures which reproduce the conditions of poverty, sexism, economic oppression (ignoring homophobia, however), and the representation of triumph against the odds. In this sense, the ultimate desired effect of films such as *The Heart . . .* is mimetic since they attempt to construct a seamless identification between the "we" of the protagonists and the spectators. "Taking over" the means of representation is equated with "taking over" your community, your block or your house (as identical processes). Cinematic representation becomes a form of literally "projecting" collective struggles back into the consciousness of community members.

Specifically, *The Heart . . .* tells various success stories of Puerto Rican residents and organizers in improving housing conditions in a section of the Lower East Side. Yet this struggle (for improved housing) is never "only" that, but a metaphor for broader community and collective struggle. The opening voice-over (unlike the voice of God in *La Operación* and *La Batalla de Vieques*) does not resurface as a structuring strategy throughout the film, but instead has the primary function of "introducing" the viewer to the community s/he is about to *hear* (in the metaphoric sense of alternative "voice"). The voice-over also re-affirms, by enunciation (language), the community's symbolic empowerment measured by its capacity to name and transform:

> This is a community that has given a new name to its communi-
> ty, this is Loisaida. But Loisaida is a community that is also
> struggling to survive. People are organizing their buildings ask-
> ing on many levels how can we make this ours.

The narrator's location as part of the "we" marks a very significant
difference from the anti-imperialist narratives in which the voice-
over narration is designed not to "introduce" but to instruct and pro-
vide a reading of the "evidence" to be presented (the spectator as
judge rather than participant). In this sense, the "individuals" in *The
Heart. . .* are never "individuals" but rather *members* of a community;
the spectators are always invited to become part of the struggle.
Thus, both the represented individuals and the interpellated viewers
stand (synecdochically) as the will of the collectivity (since the
"collectivity" as such is unrepresentable). It is not surprising then that
two of the most significant strategies of this narrative mode are the
frequent group interview and the insistent use of the pronoun "we."

In sum, *The Heart of Loisaida* (like *The Devil is a Condition*,
1972, before it) is a story of empowerment (not an "objective" ac-
count of housing organizing) which seeks to convey the fundamental
idea that "we" (poor, urban, New York Puerto Ricans) can have con-
trol over our own lives. Even the "landlord," which would be essential
in a dichotomous narrative of conflict through the ever ominous and
omnipresent "they," is almost completely absent in this narrative. In-
terestingly, when the center of the narrative shifts to the professional
community organizer towards the end of the film, *The Heart . . .* loses
its epic strength. However, even the organizers are cemented within
the community-building narrative; a young organizer declares: "We
are doing something for our community." The production of consen-
sus among an imagined community of organizers, "ordinary people,"
and activists is thus at the heart of the documentaries stemming from
the post 1970s ethnic struggles.

A second significant quality of *The Heart . . .* is the lack of major
historical contextualization for its struggles. This contrasts sharply
with the Island-focused media which share a tendency towards a
"compulsion to history" where all contemporary problems are rooted
in specific aspects of colonial history. The U.S. focused documentary
films made by women tend to concentrate on specific issues, relevant
to large sections of the "community"[10] seeking to directly modify the
behavior of the viewer. These choices may be related to the assump-
tion of the "community" in the U.S. as mainly defined by class and/or
"race" and secondarily as histories of (unequal) cultural exchange
(particularly in this period).

Issues related to poverty and "identity," while present in many of the works by Island-born/resident Puerto Rican women, are consistently linked to colonialism and macro-histories as systemic abstractions and not "everyday" problems. In these narratives, there seems to be what I call a "sadist" impulse: to tell stories of something that is being done to "us" and let the spectator judge the breadth of its cruelty. In the U.S. focused narratives, as suggested above, the stories tend to focus on the need of "we" doing something for "us" despite the acceptance of an oppressive situation. In *The Heart . . .*, for example, the most prominent gesture which ideologically locates the film within the broader nationalistic current present in Island-focused films is the use of the song "Cuando tenga la tierra" which "stretches" the notion of "land" to "home" and "motherland." Within this slippage, the film makes an acknowledgment of the colonial status of the Island in the most permissive way possible.[11]

Another significant strategy used in *The Heart . . .* as well as most U.S. made films by Latina women of this period is the frequent portrayal of women as actors, and the inclusion of their positions as shapers of the struggles represented. In this sense, although a "feminist" direct statement is rarely made, the "we" of this film clearly includes women. This contrasts markedly with, for example, *La Batalla de Vieques*, where not a single woman is interviewed in the 40 minute film. This focus on women may be partly explained (or not) by the maker's own feminist (or womanist) politics. However, as we discuss *La Operación, Burundanga* and *La Batalla de Vieques*, it is important to note that in *The Heart . . .* and other U.S. focused films, the presence of women is asserted less for its national allegorical possibilities (i.e. as metaphor for the intervened nation) and more for its interpellative ones (based on the notion of spectator mimesis).[12] In this sense, even when the films are not exclusively focused on women's struggles, or gender-specific experiences, they are much more about representing women's empowerment (taking over their lives) than feminist-Marxist analysis of state power.

La Operación (1982) made by Cuban-Puerto Rican Ana María García is probably the first high impact film made by a woman born and/or raised in Puerto Rico. It is also the first and still one of the few documentary films to focus on an issue which directly affects women. The film uses voice-over narration, interviews and archival footage to tell the story of the political practice of massive sterilization in Puerto Rico. *La Operación* is a highly provocative and problematic film in various ways, some of which I will attempt to suggest.

The principal question which *La Operación* raises within the context of this discussion relates to the possibility of a feminist voice

within the anti-imperialist narratives which have occupied Puerto Rican documentary filmmaking for decades. Thus, while the film is focused on a policy which affects women as women (and very specifically, women's reproductive choices), the film is not *about* women as gendered subjects in a patriarchy. Instead, it uses the stories of women as metaphor to reveal and critique U.S. colonialism on the Island.

There are at least two strategies used in the film to bring about this effect. The film does not, despite some of the assessments made about it by many reviewers, represent women's resistance to the policy of massive sterilization or the reasons why women were chosen as the target of the policy. To engage in this analysis would force the film to confront issues that specifically address women as subordinated subjects in a patriarchal culture (gender and family power relations), a position the text resists. Hence, instead of examining (and, as in all other sections, editorializing) the family context (which is greatly, if not exclusively responsible for the success of the policy), the film is centered on the ideological underpinnings of the sterilization policy and the State apparatus which puts it in place.

To the film's significant credit, however, (and this is one of the reasons this is such a rich text), there are a number of moments where a certain "excess" makes manifest the need for both a gender-specific reading of the sterilization policy and a counter-reading of the nationalist framework of the film. For example, in one scene a woman who was sterilized comments that her husband preferred her to be sterilized despite the fact that he was aware his operation was much simpler:

> Me puse de acuerdo con mi marido y me operé. Me dijeron que yo le dijera a mi esposo que se operara él porque la operación para él no era cuestión de un ratito y a él no le iba a afectar en nada, pero él que no porque mucha gente decía que el hombre cuando se opera pierde energía, verdad, y la energía no tengo que explicarla porque ustedes saben más o menos que es. El no quiso y yo dije pues entonces me arriesgo yo.

> My husband and I agreed that I would have the operation. They told me to tell my husband to get operated because his operation was a matter of minutes and it wasn't going to affect him in any way. But he didn't want to because people used to say that when a man is operated he can lose his energy. And I don't have to explain what energy means because you know more or less what it means. He didn't want to have the operation so I said, well, I'll take the risk. (Author's translation).

In another instance, a black woman comments:

> A veces me siento triste, tu sabes, porque Carlos cuando deso
> dice que hace falta una nena aquí. Me gustaría adoptar una nena
> para mi esposo pero tiene que ser una nena bien especial, prie-
> tita igual que yo . . . igual. Que se parezca mucho a mí como la
> quiere él, porque él no la quiere blanca . . .
>
> Sometimes I feel sad, you know, because Carlos sometimes
> says that we need a little girl here. I would like to adopt a little
> girl for my husband. But it has to be a very special girl, black
> like me. One who looks a lot like me, because he doesn't want
> her white . . . like him.

Finally, the film's last image, wonderfully contradictory, shows a young pregnant woman wearing a tee-shirt which reads: "Made in Puerto Rico." This image, assuming we believe that women are more than victims, begs the question: why do most Puerto Ricans (men and women), despite colonialism, forced sterilization and poverty, favor a close association with the United States?

Two other problematic instances in the film suggest the ways in which Puerto Rican women's film practices are deeply rooted in a master narrative of anti-imperialism which impedes a gender specific analysis or an anti-colonial reading which questions its own national-ist premises. One of the most emotionally charged images of *La Op-eración* is a woman being taken to the operating room. On the soundtrack of this visual sequence, a well-known Puerto Rican singer, El Topo, laments (in counterpoint to the scene) the plight of women who are sterilized. The song is an ode to women's reproductive vir-tues and the horror of not bringing life forth:

> Sé que a los veinte años fue perdida/la esperanza de dar un fruto
> nuevo/y al volver a mirar en el espejo me ví en en tierra estéril
> convertida.
>
> I know that at twenty you lost/the hope of giving new seed/
> and when I looked at myself in the mirror I saw myself turn into
> sterile land. (Author's translation).

The dominant association of women as the metaphor for the mother-land is also prevalent in this song and in the use of the song with the images described above. Furthermore, the cut leading the spectator from this image (the women giving birth) to that of American "invading" troops in the late 19th century, seals the possibilities for the questioning of *Puerto Rican men's* constructions of motherhood. The particular oppression of women (and the sterilization practice) to-day is explained by a *single* cause: the American invasion of Puerto Rico. The final result of the combination of these strategies (in this

suggested reading) is that women (as metaphor for the true Puerto Rico) are mostly the victims of colonialism, the surfaces on which both American and right wing Puerto Rican forces encode their victories. Women's bodies emerge just as intervened before as after "la operación."

In sum, *La Operación* is ultimately a film about the ideological underpinnings of a government policy. It impressively traces the various sources of this practice, some of the agents which made it operant. In the process, however, it does not examine the ideological content or important premises relevant to the practice. Thus, for example, it effectively argues that the idea of the two child family is an ideological proposition promoted by the government to control the working classes' reproductive behavior. On the other hand, the film leaves intact the (also ideological) notion that women *should* have a great number of children. In this sense, one of the two main structuring voices in the film, Frank Bonilla, accurately summarizes what the film's main (despite its excess) ideological position is:

> The real problem is how the conditions of life can continue to worsen for most Puerto Ricans even as the island's human energies produce massive profits and wealth for U.S. corporations.

To this premise, all other struggles are ultimately subordinated.

In *La Batalla de Vieques* (1986) by architect-filmmaker Zydia Nazario, some of the strategies used in both *The Heart of Loisaida* and *La Operación* are present. *La Batalla* critically explores the consequences of increased militarization on the small island of Vieques, off the east coast of Puerto Rico. The film points to three of the major players in the process: the American military establishment, its allied interests within the dominant Puerto Rican power structures, and a group of anti-militaristic *viequenses*. On the one hand, the film constructs a "we/they" dichotomy (as *La Operación*) and uses it to defend a space as "home" (similar to *The Heart . . .*). This strategy is exemplified in the words of a spokesperson for an activist group which establishes the subject of discourse in the film ("we"):

> Yo estoy hablando a nombre de un grupo de viequences que sentimos la responsabilidad, es hacer de Vieques *nuestra* casa, porque de *nuestra* casa ya *nos* sacaron. (Emphasis mine).
>
> I am talking on behalf of a group of *viequenses* who feel the responsibility of making of Vieques *our* house, a house *we* have been thrown out of already. (Author's translation).

Despite the potential of *La Batalla* to be structured as a self-conscious empowerment narrative, its extensive authoritarian use of voice-over and the positioning of the first-person narrative within the structuring voice-over instead reproduces a "victim" narrative. Specifically, this is often strategically translated into, for example, the embedding of a statement made by the narrator ("Many were deceived by false promises made by the military") followed by an interview which corroborates the point. In this way, the subjects are treated as guarantees of the political discourse unilaterally proposed by the film. This narrator, unlike the one in *The Heart* (but similar to the one in *La Operación*), is not a "viequense": "Viequenses compare themselves to the brown pelican, an endangered species that lives on the island." The narrator's primary objective is the creation of trust in the viewer in order to produce a consensus with the proposed interpretation. The weight of the "evidence," often presented with maps, statistics and archival footage, is constructed as irrefutable. The voice-over, which is the only feminine voice in the film, digests all the information, suppressing ambiguity to the highest degree possible: "Lacking educational and job opportunities, they [school age youths] are drawn to the claimed goals: the pursuit of leadership and strength to be brought to bear in a competitive and aggressive world."

The "we/they" dichotomy, because it does not either decenter or resignify the proposed subject positions, ultimately results in the oversimplification of the political forces at play in the process. The film's strategy to "expose" the military's callousness ultimately undermines the analysis of the more complex "internal" issues which greatly contribute to this criticized state of affairs. For example, a crucial question not addressed in the film raises the question of why, despite the obvious abuses of the military in Vieques, there is not a more widespread movement in Vieques and Puerto Rico to expel the military. The reasons for this are not only related to the political economy of the Island (which the film addresses), but also to popular feelings about the United States. The avoidance of these, more difficult issues, results in the creation of victim narratives where Puerto Rican history is represented as a David and Goliath myth. To still assume that the majority of Puerto Ricans reject the American presence ("deep, deep down") is to participate in the same fundamental political mistake that the left has incurred in Puerto Rico for the last 20 years. In this sense, the film goes as far as misrepresenting the political will of the majority by suggesting Puerto Ricans would prefer an end to the American presence on the Island:

> The accord [between the Puerto Rican government and the military], acclaimed as historic, in fact has only one historic quality: it sets out to reaffirm a colonial relationship which the Puerto Rican people are increasingly moving to change.

Finally, it is significant that a film which attempts to represent how a whole society is affected by the military presence does not include a single woman's voice.

The Politics of Form: Experimental Narratives and Animation

Contrary to the U.S. focused Puerto Rican production (by both U.S. and Island born women) where the political documentary has dominated, the experimental short in Puerto Rico has produced some of the most innovative pieces of women's filmmaking. In this section, I would like to refer to the work of pioneer Poli Marichal and young visual film/video makers Mari Mater O'Neill and Mayra Ortiz.

Poli Marichal is considered by many women filmmakers working today as simply the "pioneer." She started working in the mid 1970s in Super 8 film and within collective structures as the Taller de Cine de la Red. In some of her most successful works, there is a mix of genres and forms, and a complete faith in the power of experimentation. However, many of her films are meant to be seen in sequence, since they are obsessed representations of one of Marichal's central concerns: Puerto Rico. Although ideologically similar to *La Operación* and *La Batalla*, Marichal's work takes on the form of existential anger and despair; a pain so deep it can only surface in flashes of color and texture, beyond the optimism of political organizing.

In general, Marichal uses color and written language to signify psychological and social realities. The use of language is particularly significant since it is through language that power relationships and collective survival strategies are articulated. The constant switch between English and Spanish (sometimes French) addresses the split consciousness of Puerto Rican subjectivities. The themes of environmental destruction, the need to "snap out" of the consumerism and materialism of Puerto Rican society, and the necessity to create alternatives which will ensure our survival are central to this work. While the social and political "ills" of Puerto Rico are still (mechanically) rooted in American colonialism, Marichal does not construct Puerto Ricans as victims. In order to explore her representation of Puerto Rican colonial politics, I will concentrate on Marichal's last piece,

Dilemma I: Burundanga Boricua (1990), which in turn is the product of several earlier pieces which explore the "Island dilemma."

The use of color (particularly blue and red) to represent both the specificity of the landscape of the Island and its potentially oppressive connotations is first used in *Underwater Blue* (1981), an animated/live action meditation on the island space. Here, the ocean is a self-enclosed, entrapped space which can be metaphorically read as the space of the maker of the piece *as* a Puerto Rican subject. The multiple shades of blue suggest levels of submersion in an exasperating reality where the supposed actors cannot transform it. The use of the star as the fundamental symbol of empowerment and freedom is inaugurated in this piece where it is linked, however, to the ocean: it is a sea star. These images tend to constitute a tropicalized representation of the national as political destiny.

In *Blues Tropical* (1983), a visceral animated piece, the use of language is more overtly political, and the imagery is more literal. Thus, for example, words painted on film read: "Ay bendito, Puerto Rico, USA" and the "USA" letters are transformed (animated) into the figure of a shark (usually associated with American imperialism). The role of the star as symbol becomes more central in this piece, although it is still an image which has not reached its full potential as a symbol of liberation: it is in limbo; only attempting to survive. Thus, the common "refranes" used in *Blues Tropical* are of a great despair: "Sálvese el que pueda" and "A Mal tiempo, buena cara." Towards the end of the work, a glimmer of resigned hope is summarized in the following phrase: "Nos come la miseria pero tenemos nuestra estrella."

Marichal's latest piece, *Dilemma I: Burundanga Boricua*,[13] starts with the painted image of a live action character, significantly, a black woman dancing plena. This technique of painting on film or interrupting the live action now by animation or insertion of text is one of the most important strategies of Marichal's work. The image is never just an image (there is no transparency of meaning) but a surface to begin addressing the fundamental issues of representation (e.g., language, politics and subjectivity). In general, *Burundanga* is a tragicomic parody of the Operation Bootstrap initiative, pointing to its many failures. It is also a call for re-enchantment, a desperate hailing to ("Puerto Rican") audiences to overcome apathy and repossess what is "ours."

The humor of this film is one of its most innovative strategies. Within the landscape of oppression, Marichal manages to force us to see certain petrified symbols and images differently, something which the documentaries (often with the same ideological underpinnings) fail to do. Thus, in *Burundanga*, the transformation of the calf in the Puerto Rican national "escudo" (national shield) into an animated goat

loafer, drinking beer and smoking cigarettes on the beach, is framed
by new slogans like "936" and "food stamps." Despite the simplifica-
tion of the meaning of a socially conquered right such as food stamps,
the freshness of the treatment marks an important departure from the
authoritarian historical narratives of the political documentary tradi-
tion.

The use of popular sayings and the poetic use of language, hand
written on film, functions as the "collective consciousness" of the
film, providing political analysis, states of consciousness and hope.
The twisting and deconstruction of dominant ideological discourses
are frequent in this film. Hence, images of tropical beauty are glossed
as "Isla tropical," while a garbage dump with stray dogs is framed as
"isla mendiga." The play on language and the use of irony also pro-
duces political insight in a painfully self-conscious way: "Welcome to
the Shining star" is only a step away from "Welcome to the Shining
Scar . . ." "Island" becomes "Ay, land" in a constant meditation on
the ways that language constructs our realities. Lastly, in the various
images of an abandoned movie theater's coming attraction boards, we
find that the old "Imperial" theater is playing (what else), "The
Curse."

Marichal's call for re-enchantment is crucial in assessing the ques-
tion, asked by many of these films, "what is to be done?" concerning
Puerto Rico's colonial relationship to the U.S. For Marichal, the gen-
eralization of commodity relations in Puerto Rico is drowning all
imagination, creativity and sensibility. In this sense, Marichal locates
the "imaginative" and creative in the two most discursively marginal-
ized elements of Puerto Rican culture: the Taíno Indians and the Afri-
cans. At the same time, she locates the "essence" of the Puerto Rican
in a third group: the jíbaros. Following this partial resignification of
culture, *Burundanga* begins by narrating the Taíno origin myth where
the Island is represented in a magical and mythic splendor. This repre-
sentation is promptly destroyed by a sailing Spanish ship which trans-
forms itself into a weapon and ultimately destroys the Morro fortress.
In this sequence, Marichal questions the dominant elitist notion that
the Spaniards brought "culture" and progress to the Island.

The second move towards historical resignification relates to the
symbolically central representation of Puerto Ricans of African de-
scent. The presence of black Puerto Ricans, men and women as well
as children, is not a form of tokenism within this text, but a sign of
resistance. Following this, the guardian of the star (the "nation") and
the symbol of a better order of things to come ("post-capitalism") is a
black woman. The recurrent images of boys at play as well as the
omnipresence of black musical forms based on the drum and *pleneras*

also reinforce the centrality allocated to black cultural forms in this version of Puerto Rican culture. However, the "soul" of the culture, in a very contradictory conclusion, remains the white, mountain-dweller *jíbaro* who is represented as "an endangered species." In this instance, Marichal is claiming a key monolithic and hegemonic myth which constructs the Puerto Rican countryside as a sort of paradise, and the peasant as a privileged political subject:

> En cada puertorriqueño, late un corazón de jíbaro y late un cora-zón de patriota. Aunque parezca otra cosa, en cada puertorri-queño late un corazón de jíbaro, late un corazón de patriota. Es más, yo diría, que Borinquen entero es un jíbaro.
> In every Puerto Rican, a heart of a jíbaro and a patriot, beats. Even when it looks like something else, in every Puerto Rican, a heart of a jíbaro and a patriot, beats. What's more, I would say that Borinquen as a whole is a jíbaro.

This last voice-over (a male voice) in some ways reverses the ambigu-ity of the work, denies racial tensions within Puerto Rican society and homogenizes Puerto Rican experience. The implication in the phrase "aunque no lo parezca" suggests that Puerto Ricans "deep down" (once more) are "patriotic," meaning they yearn for independence de-spite a collective, historical rejection of this option, particularly after the Operation Bootstrap initiative.

Finally, there is one last strategy in this piece which is characteris-tic of a number of makers who originate from visual arts backgrounds (Medín) or are engaged in that community (Fritz): the construction of art as a privileged space for social transformation. It is perhaps this assumption which makes Marichal's work boldly experimental and of-ten politically ambiguous and contradictory. Thus, although *Burun-danga* does not construct an authoritarian narrative about capitalism and colonialism, it does propose independence as the "cure" of all economic, political and social ills of Puerto Rico. Within this framing of anti-colonial struggle, artistic practice is represented as the neces-sary consciousness of a liberationist movement.

Visual artist Mari Mater O'Neill's *Flamenco* (1991) is also en-gaged in an exploration of Puerto Rico's colonial history (Spanish and American) through different representational strategies. In the opening sequences, flags framed by monitors are literally "flying" on the screen. Similar to Marichal's work, language is a tool for comment, irony and parody. Predictably, the American and Spanish flags func-tion as symbols of oppression while the Puerto Rican one stands for liberation. The initial commentary of the piece alludes to the persis-

tent condition of colonization of the "New World," using irony as representational strategy:

> En el 1492, Colón descubrió a América. En 1992 se filmó una película al respecto. Los indios hablaban inglés.
> In 1492, Columbus discovered America. In 1992, a film was shot about the subject. The Indians spoke English. (Author's translation).

Part of the voice-over's humorous effect is reinforced by the soundtrack's (non-sequitur) hysteric voices suggesting that "Puerto Ricans have more fun than blondes." The use of floating monitors with images of flags and other icons, foregrounds the self-awareness of the video as construction, not absolute truth.

The second segment of the video, also disjointed from the first, is an elliptical narrative about the routine existence of a middle-class Puerto Rican woman (a "blonde"). The protagonist is bored with local television and decides to play a video showing two *flamenco* dancers. As she goes to get dressed to go out in her "American car" (which is why she, as metaphor for all Puerto Ricans, "wants to live in America"), a *flamenco* woman dancer appears in her life. The "apparition" resurfaces while the woman is in a daily traffic jam, by gliding off her car. As in *Aurelia* (1989) by Frieda Medín, there are multiple voices articulating the narrative and soundtrack, reinforcing the ambiguity of the relationship between the two women and their respective societies.

While the piece constructs Puerto Rican everyday life as insane and makes colonialism at least partly responsible, it also shows an ambivalent (complicit?) relationship between the light-skinned Puerto Rican woman and her Spanish past. Contradictorially, the woman curses the *flamenca's* presence in the traffic jam at the same time that she is jealous and seduced by her. Appropriately, the last image represents the woman dressed in the *flamenca's* clothes, in what can be read as both the seduction of the Puerto Rican by the Spanish and the ambivalent, yet ridiculous attempt of Puerto Ricans to remain "Spanish," with all its connotations of "racial purity" and Eurocentrism. Ultimately (and ironically), the *flamenca* is more centered than the Puerto Rican woman although she is nothing but a phantom. Within this critique, it is not surprising that when the woman asks the *flamenca* when will "she" go home, the *flamenca's* almost brutal answer ("you are at home") articulates one of the central questions of Puerto Rican contemporary cultural and political ambiguities.

Finally I would like to briefly comment on Mayra Ortiz's *Groundswell* (1988), a meditation on the relation between politics and art on a

global scale. The video is constructed around a montage of a young painter (white, male) who is working on a wall with the live figures of a man (of African descent) and a woman (of Asian descent), and appropriated imagery from the news representing global political resistance. Rap and reggae—African diaspora music once more—structures the rhythms of the montage. It is very significant, in the context of the works discussed, that this piece does not address, in any way, political issues related to Puerto Rico or Latinos. It does, however, make a claim to the power of African diaspora music as a form of cultural resistance. An ambiguous piece, one of the possible readings relates to the activist role of the artist in "breaking the walls" and liberating not only the political structures which oppress us but our own bodies from the constraints of reactionary politics and representations.

One of the obstacles in this purely "liberationist" reading, however, is the fact that the artist (as privileged consciousness) is male and white; while the bodies which are acted upon by his hand are black and Asian. This can be read as a comment on Western representation strategies regarding non-white peoples, but I would argue that the structure does not favor this reading since the "lone" artist is primarily "inspired" by the politics and not necessarily engaged in it (as a body), nor is there a questioning of his artistic production. The power of art to break down the walls of the incommunication of the world as television spectacle is another central premise in *Groundswell*. Hence, the struggles of South Koreans, Chileans and Germans are brought together "by the hand" of the filmmaker. In this sense, without necessarily representing Puerto Ricans, Ortiz is re-articulating a long ideological tradition among Puerto Rican women filmmakers which makes art a privileged political practice, and artists, heroic figures.

Claustrophobic Narratives

The few narrative films made by Puerto Rican women allow us to make only some general comments on their impact in problematicizing the representation of women in films/videos and Puerto Rican cultural politics. I will consider three narrative shorts which have been circulated in Puerto Rico and the United States, including: *Los Angeles se han fatigado*(Teresa Previdi, 1987), *Alba* (Mayra Ortiz, 1989) and *Aurelia* (Frieda Medín, 1990).

In general, all these films are women-centered narratives where either one or multiple voices are articulated through the "consciousness" of a woman (or girl in the case of *Alba*). The stories are told in a non-linear manner, allowing the contradictions of con-

sciousness to determine the structure of the narrative and/or making use of the surreal to destabilize the "normality" of the story. The three also take place within a single space or within constrained spaces, where women's mobility and freedom are minimal. Finally, at least two of them are based on literary texts by successful Latin American and Puerto Rican writers.

Inspired by Luis Rafael Sánchez's play of the same name, *Los Angeles se han fatigado* is the story of the daughter of formerly wealthy landowners. Angela becomes a prostitute in the city and, ultimately, goes mad. The film is structured on the reminiscences of the protagonist, as she wakes up and is mortified by her immediate surroundings. The reminiscences of Angela are non-linear and oscillate between her past and present situation with frequent "hallucinations" (early on in the narrative, she believes she has a baby). The adaptation does not follow Sánchez's text as a whole, and takes some freedoms in creating a surreal environment where music and moving objects are part of a "reality" which the viewer is forced to share.

Los angeles se han fatigado constructs a portrait of a victimized woman in the melodramatic tradition of the "fallen woman," but without any reflexive awareness of this construction. In this sense, the central character is a victim of the dominant constructions of femininity and womanhood, the capriciousness of men, and dominant institutions such as insane asylums. Her own acritical comments concerning her class origins and sexism make her an unsympathetic character and a trapped woman. The space she occupies is dark and bare, and even when windows or doors are present, she cannot escape. In fact, her single most liberating gesture, the murder of her pimp, only leads her to another enclosed space: the asylum, where she will be taken "care" of by other men, this time dressed in white.

Despite the fact that this piece is not overtly "political" (in the documentary tradition) there is a possible reading which points to, once more, the use of women's experience as metaphor for society's oppressions. Angela's body becomes the surface of class and gender oppression. In this sense, the question of whether the woman "speaks" is answered in a way similar to *La Operación*. Ultimately, Angela's inability to speak can be read not as an incapacity on her part but as the result of a sexist culture's resistance to listening. This didactic message overdetermines the narrative, limiting its possibilities to explore the complex web of resistance and desire which are part of women's experiences.

Similar to *Los angeles se han fatigado*, *Alba* is inspired by a literary text, Isabel Allende's *The House of the Spirits*. A family dinner is experienced through the eyes of the main character, a little girl called

Alba who inherits the magical qualities of her dead grandmother and thus inhabits "another" world, that of the (good) spirits. Unlike *Aurelia* and *Los angeles*, the world of Alba is a "positive" woman-centered world (in the post 1970s feminist sense) where only marginal men seem to be of any interest (these in turn are feminized by their interest in magic or "telling stones"). The most significant and enduring relationship is among women, particularly between Alba and her dead grandmother. The men take on different positions around this centering relationship, becoming symbolic figures: the grandfather embodies the Lacanian law of the father (identifying the family oppression of patriarchy with the broader political context); Uncle Marcos inhabits the world of imagination and alchemy, and is a teller of stories, while Uncle Nicolás is a loser, interested in santería, but without the necessary aptitude.

Alba's world is a world of "spirituality" unconcerned with social or political tensions, and grounded in the constructed communicative bliss between grandmother and daughter. Assumptions about class privilege are untouched and the absence of the mother is also avoided in the narrative. We see the world through a young girl's eyes, but these eyes are those of a well-to-do, privileged girl who will "inherit" everything (including the woman who works as a maid). Thus, the text privileges gender and the marginal as the more transgressive qualities, while it erases class as a social inequality. Finally, the space of the narrative, a single dining room, and the painting from which the grandmother metaphorically originates, contribute to the construction of a self-enclosed environment. The insistence on closed spaces in these two narratives suggests the privileging of the "internal" (female space) vs. the oppressiveness of the "external," frequently embodied by male figures. The danger of this is, of course, the potential to read women as self-contained, "spiritual" creatures without any engagement in the world or in politics. However, it is significant to mention that Ortiz's work is importantly questioning conventions of "realism" and integrating elements of the surreal and the fantastic within an intellectual and artistic context which has actively resisted them. In this sense, the enclosure of the space is partly opened up by the magical.

Frieda Medín's *Aurelia* is an experimental narrative centered in the internal, multi-voiced and conflictual dialogues of the female protagonist's consciousness. From the opening of the film, self-reflexivity is perhaps *Aurelia's* most important innovation as a woman's figure unfolds the titles printed in loose pieces of paper located in an abandoned lot. As soon as the scene shifts to an enclosed space, the positive black and white images alternate with the negative of the images suggesting an "altered" state. In this sense, naturalistic represen-

tation becomes distorted and the cinematic apparatus mediates Aurelia's consciousness. The use of negative images is one of various strategies used to construct a "split" subjectivity: screeching and water sounds and frequent unconventional cutting (jump cuts) also contribute to the sense of "unconscious" space. The voices which form the fragmented soundtrack suggest that Aurelia is faced with social pressures and prejudices for being what she is: a woman artist and mother. The few aural interventions which remain distinct such as "Ella es artista," "Yo brego allá afuera, tú quédate aquí adentro," and the "Donde están los nenes?" all constitute a subjectless dialogue between conflicting social discourses on the limits of women's subjectivity.

As in both *Alba* and *Los angeles*, multiple symbols populate the character's environment, with ambiguous significations. In *Aurelia*, however, the exploration of subjectivity is taken further since Aurelia's consciousness is not her "own" but a confrontation of her own and others, split and fragmented around social categories. Interestingly, however, the inability to cope with these contradictions leads her to escape even more within herself and the world of "disposable" objects critiqued at the beginning of the film by an anonymous voice. The various readings allowed by the text do not exclude the construction of the protagonist as mad and isolated; but seems to favor a reading of Aurelia as the miscomprehended woman artist whose source of creativity lies within (in this sense, art is once more privileged as a source of liberation). Hence, when Aurelia rejects the mirror as distorting, she walks out the door into an open space and a voice is heard: "Pues, si fueras mediocre." As she leaves the room, a set of clocks set at different times all go off suggesting the impossibility of objectivity, even when measured by "instruments."

Aurelia can thus be read as a reflection around the split subject, torn by American consumer culture, Catholic and ancient spirituality, gender conventions and a corrosive social environment. However, unlike *Alba*, spirituality is not a refuge from alienation as she confronts deforming conventions about the feminine. Aurelia articulates a space of refuge within herself ("sanity"), not as a subject but as a malleable image: clown, reversed mirror, spectacle. Freeing herself from the "exterior" into "art," Medín's meditation meets the work of Marichal, Ortiz and Fritz but in a transgressive and self-reflexive way.

Getting to Feel at Home: The Works of Sonia Fritz

Mexican filmmaker Sonia Fritz has been living in Puerto Rico for over five years. During this period, she has been steadily producing documentaries. Her first Puerto Rican production was *Myrna Baez:*

Los Espejos del Silencio (1989), a documentary portrait of Puerto Rican visual artist Myrna Baez; followed by *Visa for a Dream* in 1990, a documentary about the economic and social context of Dominican women's emigration to Puerto Rico. Her latest piece, *Puerto Rico: Arte e Identidad* (1991), returns to the preoccupation of the first work, that of the interconnections between art, landscape, politics and identity.

In general, the work of Sonia Fritz usually seeks internal consistency through narrative devices such as portraits and linear histories. In *Los Espejos del Silencio*, for instance, the voice of the artist is uncontested and unquestioned; she is allowed to tell her own story and the filmmaker acts as "midwife" to the story, facilitating the telling. In common with the narratives and most of the work produced by women in Puerto Rico, the central character is a woman for whom politics and art merge, although politics is narrowly understood in the sense of colonial politics (the independence struggle). The politics of gender and sexuality are systematically suppressed in this film although Baez's work is saturated with it.

In *Visa for a Dream*, a potentially explosive issue—that of Dominican immigrants to Puerto Rico—is contained by the portraits of several women and their process of "positive adaptation" to Puerto Rican society. By emphasizing the "positive" of the women's experiences and avoiding the hostility of the new context, Fritz constructs a picture of success similar to the empowerment narrative of *The Heart* . . . , although "individual" personal stories do not merge in the collective. This strategy allows Fritz to produce an alternative but conservative discourse to counter anti-Dominican hysteria in Puerto Rico through images of Dominican women which are acceptable to mainstream social values. Finally, I would like to briefly concentrate on *Puerto Rico: Arte e Identidad*, since this film is an achievement as an innovation of the "educational" documentary form, at the same time that it raises important questions regarding dominant assumptions about Puerto Rican art, identity and politics among important sections of the art establishment in Puerto Rico. The importance of addressing this last issue is essential, as many of the Island Puerto Rican women artists and film/videomakers either have been formed or actively participate in this community.

Puerto Rico: Arte e Identidad uses a series of strategies to formally convey one of its central premises: that Puerto Rican art is Puerto Rican because it is rooted in a particular landscape and politics which embodies the Puerto Rican "soul" ("alma"). Thus, the barriers between art and "reality" are constantly being blurred: a shot of a tree becomes a painting of the tree, the copula of a church re-emerges in

another image. It also uses interviews, voice-over and docudrama conventions to synthesize over 100 years of history. Like most "history of art" films, *Puerto Rico* . . .not only "tells" a story but makes a number of choices, inclusions and omissions which make it a crucial text for debating the relationship between art, politics and identity in Puerto Rico among a significant sector of artists, curators and teachers. In general, this film is part of a more general and influential discourse on identity which desperately needs to be examined.

Puerto Rico . . . , despite its attempts at inclusion, is a teleological narrative. It seeks to demonstrate that what is essentially Puerto Rican can be "captured" in art, and that this art "object" is an embodiment of Puerto Rican common "values" (which are never really addressed or questioned). The closest any of the narrators reaches to proposing a Puerto Rican value is within the (supposedly) safe example of the landscape: it is a Puerto Rican value to place a "piña" rather than an apple at the edge of a portrait. A particularly clear moment regarding the difficulty of maintaining this analysis occurs when Oller's well known painting, *El Velorio,* is interpreted. If we are to accept the premise that all Puerto Rican art re-affirms "our values," how can we read Oller's critique (racism?) of the African diaspora tradition of the "baquiné?" Whose values are being addressed? Within this discourse, the concept of "lo puertorriqueño" takes over all other relevant categories of analysis like class, race and/or sexual orientation. It only concedes a space for gender, but with a highly problematic interpretation of the importance of gender politics. Thus, some of the most questionable statements are precisely articulated by women (narrators) around the issue of gender. For example, "feminism" is defined as "a quest for the personal" and as "revealing new aspects of identity." Does this last suggestion mean that gender is a *new aspect* of Puerto Rican identity in the twentieth century? Another instance of the difficulty of the inclusion of the "other(s)" in this narrative is the selection of Juan Sánchez as the token U.S. Puerto Rican artist. The condescension to Sánchez is disturbing. Contrary to the "Islanders" or those U.S. born artists which have returned to the Island, it is "natural" that Sánchez paints as "he does" because:

> Cada cual busca su identidad a su modo. Los artistas que se han ido del país a los Estados Unidos la buscan, como era de esperarse, desde sus propias perspectivas personales de discrimen, marginación social, de opresión.
>
> Everyone looks for their identity as they see fit. The artists who have left the country for the United States look for it, as we

should expect, from their own personal perspectives of discrimination, social marginalization and oppression.

Aside from the fact that discrimination, social marginality and oppression are not "personal" perspectives but collective experiences, the comment underscores the possible reading that Sánchez's work is, in many ways, closer to the historical narrative presented in the film than works included as "soulfully" Puerto Rican (from the Island). The ideological connections are obscured in this argument by the notion of "identity."

The premise that Puerto Rican art "reflects" history and that by looking at "our" art we can understand our history (as a transparent object), shows very little understanding of the distribution, exhibition and regulation of art production and of its mediated quality. It also leaves completely unexamined the consistent political tendencies of many artists (a sociology of artists may be appropriate here), at the same time that it ignores the ambiguities, contradictions and tensions which are part of all works of art. If Puerto Rican art "reflects" Puerto Rican history and struggles, why isn't there a poster commemorating 15 years of gay and lesbian struggles in Puerto Rico? If Puerto Rican art reflects "our cultural values," why isn't there a series of murals glorifying, what many Puerto Ricans consider "Puerto Rican": virginity, sexism, pro-U.S. sentiment? *Puerto Rico: Arte e Identidad* provides us with a powerful articulation of one of the most important discourses in Puerto Rican culture, albeit one still in need of critical examination.

Afterthoughts

As I finish writing, I realize how incomplete and tentative these observations are, and how only when more spectators/critics/makers begin to write, can these propositions and assumptions become really meaningful. I have suggested there are various trends in Puerto Rican women film/video production when watched as a "body" of works. First, in the U.S. focused work of the 1970s and 1980s, is a tendency to treat issues of immediate concern and to adopt textual strategies towards the transformation of behavior and self empowerment through a strategy of consensus building. Second, in the Island-focused documentary production, is a "compulsion to history," a need to investigate the colonial "origins" of particular issues avoiding internal political tension in favor of nationalist master narratives. Third is a woman-centered narrative and experimental production with various emphases on voice and representing women's "unconscious" processes and sub-

jectivities, with little exploration of sexuality and the relationships between women and public culture. However, once these tendencies have been suggested, they only beg the question "why" these issues, treated in this way, by these particular film/videomakers. The investigation into these questions will require a long term research effort on various relevant aspects, such as the sociology of the makers, the relationship between the works and audiences (including critics), and funding structures, and a more detailed examination concerning references, strategies and intertextuality. This work is yet to be done.

Notes

1. The División de Educación a la Comunidad was a government-sponsored initiative to use art (visual, photography, film) in educating and promoting change in the Puerto Rican countryside. Over 100 films were made from the 1940s to the 1950s, including a few on women's issues.

2. Kino García's book on Puerto Rican cinema, *Breve Historia del Cine Puertorriqueño* (1984) is a useful starting point but not a work of criticism or interpretive history.

3. Catherine Benamou, "Filmmaking in Latin America," *Point of View: Latina, A Study Guide for the Women Make Movies Punto de Vista: Latina Film Collection.* No date. 7–8. Although placing Puerto Rico within a strictly Latin American context is a faulty assumption, I opted for not re-writing this part of the paper. For a more expansive debate on the challenges in defining Puerto Rico's political identities, see the upcoming anthology, *Beyond Colonialism and Nationalism: Rethinking the Puerto Rican Political Imaginary*, edited by Ramón Grosfoguel and Frances Negrón-Muntaner.

4. Liz Kotz, "Unofficial Stories: Documentaries by Latinas and Latin American Women," *El Centro* (Spring 1990): 58–69.

5. Lillian Jiménez, "From the Margin to the Center: Puerto Rican Cinema in the United States," *El Centro* (Spring 1990): 28–43.

6. Rosa Linda Fregoso, "La Quinceañera of Chicana Counter Aesthetics," *El Centro* (Spring 1990): 87–91.

7. It has been suggested by Kino García that the first film made in Puerto Rico by a woman was *Laguna Soltera* by journalist Maggie Babb in 1969.

8. Liz Kotz, "Unofficial Stories," *El Centro*: 61.

9. Blanca Vázquez, "Puerto Ricans and the Media: A Personal Statement," *El Centro* (Spring 1990): p. 4–15.

10. I have addressed the difficulties of using the notion of Puerto Rican "community" in a number of articles including: "Shifting Communities/ Forming Alliances" (with Kelly Anderson, Alex Juhasz, Indu Krishnan), *Felix*, Vol. 1., No. 2 (Spring 1992): 66–72, and "The Ethics of Community Media," *The Independent* (May 1991): 20–22.

11. The use of the concept of identity among leftist filmmakers and the more concrete focus of U.S. filmmakers may be linked not to radically diverse political ideologies regarding U.S./P.R. relationships, but to assumptions

about their subjective positioning in society. Whereas the left in Puerto Rico is a political minority with significant cultural influence, U.S. filmmakers are an ethnic minority for which dissent can sometimes represent an obstacle in the process of gaining basic spaces within social structures.

12. Much U.S. minority filmmaking and discourse is premised on the notion that identification is the only process taking place between a visual text and spectators. I have challenged this notion in later works such as "Watching Tongues Untie(d) While Reading Zami: Mapping Boundaries in Black Gay and Lesbian Narratives" (in *Global Feminisms*, edited by Angharad Valdivia) and in my segment *Puerto Rican ID* (part of the ITVS series Signal to Noise) about the relationships between Puerto Ricans and American television.

13. "Burundanga" is a word used literarily and colloquially to mean "mess."

Part 2
South America

Brazil

Cinema

A Trajectory within Underdevelopment

Paulo Emílio Salles Gomes

Brazil is a prolongation of the west, and Brazilian cinema is firmly rooted in western culture. Unlike some Third World countries, Brazil was never colonized as such. The European "colonizer" found the native "colonized" inadequate and opted to create another. The massive importation of Europeans followed by widespread miscegenation assured the creation of a new colonized, although the incompetence of the colonizer aggravated natural adversities. The peculiarity of this process, by which the colonizer created the colonized in his own image, made the colonized, to a certain point, his equal. Psychologically, the colonized and the colonizer do not see themselves in these roles; in fact, we are ourselves the colonizer; it would thus be sociologically absurd to imagine expelling the colonizer as the French were expelled from Algeria. The events of our history—Independence, the Republic, the Revolution of 1930—are merely quarrels among the colonizers in which the colonized have no role. The situation is more complicated because the real colonizer is elsewhere, in Lisbon, Madrid, London, or Washington.[1]

We are neither Europeans nor North Americans. Lacking an original culture, nothing is foreign to us because everything is. The painful construction of ourselves develops within the rarified dialectic of not being and being someone else. Brazilian film participates in this mechanism and alters it through our creative incapacity for copying. Cinema in Brazil witnesses and delineates many national vicissitudes.

Randal Johnson and Robert Stam, *Brazilian Cinema*. East Brunswick, N.J.: Associated University Presses, 1982, pp. 245–55. By permission of the publisher.

Born in developed countries, it soon arrived in Brazil. If cinema did not become a Brazilian habit for approximately a decade, it was due to our underdevelopment in electricity. Once energy was industrialized in Rio de Janeiro, exhibition halls proliferated like mushrooms. The owners of these halls at first merely traded in foreign films, but soon began to produce their own, and thus, for a period of four or five years, starting in 1908, Rio experienced a flourishing of cinematic production that the period's major film historian calls the *Bela Época* of Brazilian cinema. Awkward copies of what was being done in Europe and America, these films, dealing with topics of immediate public interest—crimes, politics, and other diversions—were Brazilian not only in their choice of themes, but also in the lack of sophistication with which they handled the foreign instrument. The first Brazilian films, technically inferior to imported films, were nevertheless more attractive to the still naive spectator unaccustomed to the high-level finishing of foreign products. No imported film enjoyed the box-office triumph of Brazilian films dealing with local crimes or politics. The public for these films included the intelligentsia that circulated along the Rua do Ouvidor or the recently inaugurated Avenida Central. This florescence of an underdeveloped, necessarily artisan, cinema coincided with the definitive transformation, in the foreign metropolises, of the invention into an international industry whose products stimulated and disciplined world markets. Brazil, which imported everything—even coffins and toothpicks—happily opened its doors to mass-produced entertainment, and it occurred to no one to protect and foster our own incipient cinematic activity.

Early Brazilian films were soon forgotten. The line of development was broken, and our cinema began to pay its tribute to the premature and prolonged decadence so typical of underdevelopment. Scrounging for sustenance, reduced to a marginal activity, it was a pariah in a situation very much like that of the colonized whose image it frequently reflected, provoking revulsion or amazement. Such documents, when truthful, are never pretty, and they traumatized not only the liberal commentators in Rio's press, but also such conservatives as Oliveira Vianna. Images of human degradation also abounded in the narrative films then being produced from time to time and that occasionally obtained normal exhibition thanks to the ephemeral complacency of North American commerce. Meanwhile, the dauntless defenders of Brazilian cinema in the silent era attempted to discourage images of destitution, substituting them with the pleasant photogeneity of North American inspiration.

Shortly after the strangulation of the first surge of Brazilian cinema the North Americans swept away their European competitors and oc-

cupied the terrain almost exclusively for themselves. Because of them and to their benefit, exhibition was renovated and expanded. European productions continued to trickle in, but during the three generations in which film was the principal form of entertainment, cinema in Brazil was North American and, to a lesser extent, Brazilian. American cinema so saturated the market and occupied so much space in the collective imagination of colonizer and colonized alike, excluding only the lowest strata of the social pyramid, that it seemed to belong to us. Once again, nothing is foreign because everything is. The consumption of American films did not, however, satisfy the desire to see Brazilian culture develop its own vigor and personality. The traditional arts of spectacle, although challenged by the cinema, found ways to persevere, because they corresponded to profound necessities of cultural expression. Radio gave new life to these arts, and at the first opportunity popular culture manifested itself cinematically, breaking through the North American monopoly. The advent of talking films, which coincided with the Wall Street crisis, brought a transitory alleviation of the North American presence, and resulted almost immediately in a renewal of our production. At this time, *caipira* ("rural, hillbilly") culture, originally common to landowners and tenant farmers and with a large urban audience, took cinematic form, as did urban musical expression. These films attracted an immense audience through Brazil, but soon the market reverted to the North Americans and Brazilian cinema returned to its marginal status despite the artistic quality of some films of the thirties. Obligatory exhibition furnished a solid base for the production of short documentary films, now without the revelatory function that had previously characterized them. They continued, in any case, to reflect the colonizer, notably in his official ceremonies. Generally, however, talking films favored national expression more than silent ones.

The cinema that developed in Rio de Janeiro in the forties marked a milestone in the development of Brazilian cinema. The uninterrupted production during nearly twenty years of musical films and *chanchadas* occurred independent of the tastes of the colonizer and contrary to foreign interests. The young, popular audience that guaranteed the success of these films found in them, re-elaborated and rejuvenated models that, although not without links to broad Western traditions, also emanated directly from a tenacious Brazilian heritage. To these relatively stable values the films added ephemeral *carioca* features in the form of anecdotes and manners of speech, thought and behavior, a continuous flow that the *chanchada* crystallized even more effectively than caricature or variety theater. It goes without saying that these films carried with them, along with their public, the cruel

mark of underdevelopment. The relationship between the films and the spectator was incomparably more lively than with the corresponding foreign product. In the latter case the relationship entailed consumer passivity, while with the *chanchada* it involved an intimate relationship of creative participation. The universe constructed by North American films is relatively distant and abstract, while the rudimentary fragments of Brazil proposed by our films at least described a world lived by the spectators. American cinema provided model forms of behavior to young men and women linked to the colonizers; in contrast, the mass enthusiasm for the rascals, scoundrels, and loafers of the *chanchada* suggested a struggle of the colonized against the colonizer.

The profit obtained by this unpretentious and artisan *carioca* production played, in the early fifties, a determining role in São Paulo's attempt to create a more ambitious industrial and artistic cinema. The *carioca* producers were also involved in exhibition, and in this the economic structures created in the forties resembled those of the *Bela Época*. The São Paulo entrepreneurs, in contrast, nurtured the naive illusion that movie theaters would screen any film submitted, including national films. Culturally the project was disastrous. Dismissing the popular virtues of *carioca* cinema, the *paulistas* decided—encouraged by recently arrived European technicians and artists—to point Brazilian cinema in a totally different direction. When they finally discovered the *cangaceiro* genre, or when they turned to radio-style comedies, it was already too late.

The enthusiasm that aroused this attempt at industrialization was nonetheless positive, and its failure did not alter the quantitative and qualitative progress of Brazilian cinema. The marginalization of our fiction films ceased to be a "natural" phenomenon. Large sectors of the colonizer became concerned with national cinema, making it a sensitive topic of discussion. Mediocrity did not impede its functioning nor hide its presence. Filmmakers began to demand from the state something more than occasional paternalistic support. Once again the government fostered the illusion that a national film policy was being designed, but the basic situation remained the same. The market continued to be colonized by foreign cinema. Although pressured by Brazilian producers, representing in this case the interests of the colonized, the government limited its efforts to reserving a small portion of the market for local production. State power was fundamentally allied with the colonizer, whose pressure remained decisive. Even after cinema lost predominance to television, the scandalous imbalance between national and foreign interests did not change. At any rate, this concession, however modest, assured our fiction films a brief

respite. Foreign saturation did not prevent our films from reflecting our culture. The vogue of Neo-Realism had extremely fruitful consequences for us. The diffuse socialist sentiment spreading in the late forties touched many people linked to cinema, including the most creative personalities to arise in the wake of São Paulo's failed attempt at industrialization. Even orthodox communist politics came to have a cultural function in so far as it tried, however clumsily, to understand the life of the colonized and encouraged the reading of great writers who were members or sympathizers of the party: Jorge Amado, Graciliano Ramos, Monteiro Lobato. This intellectual climate and the practice of the Neo-Realist method led to some films in Rio and São Paulo that dealt artistically with popular urban life. The idle hero of the *chanchada* was supplanted by the worker, but the occupied was much more present on the screen than in the audience. In their dramatic construction, these works went far beyond both the tenacious *chanchada* and the products of São Paulo's ephemeral industrialization. Their intellectual contribution was even greater. Without being politically didactic, they expressed a social consciousness frequent in post-Modernist literature but as yet unseen in our cinema. These few films constituted the seed from which Cinema Novo grew.

After the *Bela Época* and the *chanchada*, Cinema Novo constitutes the third important moment of our cinema. Like the *Bela Época*, Cinema Novo thrived for only a half-dozen years—both of them were truncated, the former by the economic pressure of foreign imperialism, the latter by the impositions of internal politics. Despite different circumstances, what happened to both is inserted in the general context of occupation. Cinema Novo formed part of a broader and more profound current that also expressed itself through popular music, theater, the social sciences, and literature. This current—composed of individual spirits of luminous maturity and the uninterrupted explosion of young talents—was the most polished cultural expression of a broad historical phenomenon. Our close proximity to this movement renders a balanced perspective difficult. Only the colonizer/colonized framework allows for an understanding of the overall significance of Cinema Novo.

Statistics confirm what our intuition tells us about the deformations of Brazilian society. Only thirty percent of the population participates actively in what we regard as normal production and consumption. The urban and rural productive forces, the middle class in its complex gradations, the masses of people who once attended political rallies and who are now limited to soccer games are included in this minority of 30 million people. One has the impression that the colonizer uses only a small portion of the colonized and abandons the rest to God's

will. This remainder of around 70 million people provides a reserve labor force that the colonizer uses for such activities as the construction of Brasília or the interminable reconstruction of the urban monster that is São Paulo, the most progressive face of our underdevelopment. Those who thus escape the shapeless universe of the marginalized millions acquire an identity, however condescending: *candango* or *baiano*.[2]

Governmental initiatives in the second half of the fifties were designed to promote a more just national equilibrium. The colonizer, without much imagination, indicted the social fervor that accompanied such measures with a slogan: subversion on the march. Possibly even the optimistic colonizer, desirous of seeing the seventy percent marginal population integrated into the nation, did not fathom the singular situation that had been created. The word subversion, narrow minded and in the final analysis naive, can be opposed with the notion of "superversion," which summarizes with greater honesty the events that developed until mid-1964. The true marginals, it came to be understood, were the thirty percent that ruled the nation. Communication between this minority and the immense remainder of the Brazilian population began to lead to the dislocation of the traditional axis of Brazilian history. The first step was to encourage the discovery of the potentialities of all human beings. The state participated in this noble hope, notably through an emerging literacy program. The young artistic and intellectual sectors undoubtedly best reflected the creative and generous climate that then reigned. In this process cinema played an important role.

The people involved in the production and, to a great extent, in the consumption of Cinema Novo were young people who disassociated themselves from their origins as colonizers. Their aspiration was to be at the same time the lever of dislocation and one of the new axes around which our history would begin to revolve. They saw themselves as representatives of the colonized, charged with a mediating function in the reaching of social equilibrium. In reality they were speaking and acting primarily for themselves. These limitations were clear in Cinema Novo. The social homogeneity between those responsible for the films and their public was never broken. The spectators of the *chanchadas* or *cangaceiro* films were barely reached and no new potential public was developed. Nevertheless, the significance of Cinema Novo was immense: it reflected and created a continuous and coherent audio-visual image of the absolute majority of the Brazilian people. Cinema Novo created a mythical universe made up of the impoverished interior, urban slums, lower class suburbs, fishing villages, dance halls, and the soccer stadium. Just as this model universe was

expanding, the process was interrupted in 1964. Cinema Novo did not die easily, however, and in the phase that led up to the Fifth Institutional Act it turned toward itself and its public, as if trying to understand its suddenly revealed weakness, in a perplexed reflection on their own failure, often accompanied by notes about the terror of torture or fantasies of guerrilla warfare. It never achieved the desired identification with the Brazilian social organism, but it remained to the end an accurate barometer of young people aspiring to interpret the will of the colonized.

When Cinema Novo disintegrated, its principal participants, now without a public, were dispersed in individual careers according to their personal temperament and taste. None of them, however, became as pessimistic as might have been expected, given the agony of their cinema. The line of desperation was represented by a current frontally opposed to Cinema Novo that called itself, at least in São Paulo, *Cinema do Lixo* ("Garbage Cinema"). The new movement began toward the end of the sixties and lasted approximately three years. The twenty or so films produced had, with rare exceptions, a clandestine existence partially by choice and partially because of the customary obstacles of commerce and censorship. Most of the participants of the *Lixo* movement received training with Cinema Novo. These filmmakers, in other circumstances, could have prolonged and rejuvenated Cinema Novo, whose universe and themes they in part adopted, but that they express in terms of degradation, sarcasm, and a cruelty that becomes almost unbearable in their best works due to the neutral indifference of their approach. A heterogeneous conglomerate of the nervous artists, the *Lixo* movement proposes an anarchistic culture and tends to transform the populace into rabble, the colonized into trash. This degraded subworld, traversed by grotesque processions, condemned to the absurd, mutilated by crime, sex, and exploitation, hopeless and fallacious, is, however, animated and redeemed by its inarticulate wrath. The *Lixo* movement managed, before embarking on its suicidal vocation, to produce a human image unique in national cinema. Isolated in clandestine showings, this last current of cinematic rebellion constitutes a kind of graph of the desperation of youth in the last five years.

It was not only *Cinema Lixo* that acutely expressed the preoccupations of the period. A documentary movement with cultural and didactic intentions reassumed, with a higher level of awareness and accomplishment, the earlier revelatory function of the genre. Focusing on the anachronistic forms of life in the northeast, it constituted a prolongation of Cinema Novo's perspective, patiently documenting the intrinsic nobility and competence of the colonized. Turning toward the

cangaceiro, this cinema evoked his existence with a depth of which even our best fiction was incapable.

Each film expresses its epoch. Much contemporary production cheerfully participates in the current stage of our development: the Brazilian economic miracle. Despite their lack of interest in our cinema, the owners of the world find means of transmitting their euphoria in our films. This euphoria is manifest especially in light comedies and trivial dramas, situated, almost invariably, in the colorful and luxurious wrappings of prosperity. The style resembles that of commercial documentaries, adorned with photogenic images of the colonized and with the lovable sway of women's hips on the "in" beaches, exuding affluence and flattering military and civilian authorities. The eroticism of these films, despite their hurried, inefficient vulgarity, their self-destructive obsession with breasts and buttocks, is, in fact, what is most truthful about them, particularly when they describe the sexual obsessions of the adolescent. At any rate, these films constitute but a part of the approximately 100 Brazilian films produced annually within the usual web of obstacles maintained by the metropolis.

The range of our cinema today confirms its vocation of expressing the complex reality of our culture. While the *chanchada* and the melodrama have largely been absorbed by television, the *caipira* film retains its vigor. Small cities nourish dramas and comedies associated with country singers as well as diverse sentimental films that pass almost unperceived in the large cities. The current crop of rural adventure stories derived from the *cangaceiro* film is seen exclusively in the interior and occasionally in the smaller capitals. A public difficult to define or to precisely locate assures the continuity of psychological dramas that mirror the crisis in the middle-class family. The figure of the colonizer is not embodied only through the lewdness of erotic comedies. Historical films, whether pompous superproductions or exemplary intellectual and artistic efforts, serve useful functions: the first type furnishes a succession of conventional colored lithographs of an official version of history, while the second type stimulates critical reflection about that history. Public authorities benevolently encourage the first type and distance themselves from the second.

Paternalist legislation, designed to counteract foreign domination of the market, has important economic consequences, but the frequent governmental hostility toward our best films forces their authors to seek financing in the same cultural metropolises where Cinema Novo first acquired its prestige, thanks in part to the First World's fascination with the Third World. The best of our cinema still derives from Cinema Novo. The rupture of the creative process in which they were involved some time ago impeded any kind of collective maturing. The

ideological and artistic individualism that began in 1968 dislocated the axis of creativity. Individual crisis replaced social crisis, permitting middle-aged filmmakers a new beginning. Old beliefs were fractured by private gods and devils, but the dust of collective construction dreamed of by all continued to be fertile. The work of the greatest figures that Brazilian cinema has yet known is far from complete; their films are still being woven before our eyes, and it would be premature to try and approach them objectively. Friendship had an important role in Cinema Novo, and the permanence of the comradeship born in the golden age of the movement would seem to indicate a persistent vision whose new face has yet to be revealed. The nostalgia that reigns in the best current Brazilian films reflects, possibly, a feeling of national remorse coalescing around the Indian, a reaction to the holocaust provoked by the original colonizer. Once again, what is best in Brazilian cinema nourishes an identification with the oppressed and maintains a critical distance from the oppressor.

Notes

1. Although Salles Gomes uses the terms "occupier" and "occupied" rather than "colonizer" and "colonized," the latter term strikes [the editors] as a more familiar rendering of his conception.

2. Candango refers to the workers who constructed Brasília; *baiano* is pejoratively used in the south to refer to immigrants from the northeast.

Cinema Novo

Carlos Diegues

Cinema Novo has no birthdate. It has no historic manifesto and no week of commemoration. It was created by no one in particular and is not the brainchild of any group. It has no official theoreticians, no popes or idols, no masters or guiding lights. Cinema Novo is not *novo* merely because of the youth of its practitioners. Nor does *novo*, in this context, suggest novelty or modishness. Cinema Novo is only part of a larger process transforming Brazilian society and reaching, at long last, the cinema.

In the beginning there were Humberto Mauro, Mário Peixoto, Adhemar Gonzaga, and other pioneers of our cinema. Despite obstacles, they left a body of work. Humberto Mauro, for example, remains an important model for anyone making films in Brazil. Then came the *chanchadas*, mid-year comedies or carnivalesque celebrations. A specifically Brazilian genre, it offered some valid alternatives, but, at the same time, was defiled by bad taste and by the most sordid commercialism, representing, finally, a form of cultural prostitution. Then Vera Cruz was founded, a bizarre structureless monster, without roots in our culture, nourishing itself on the dream of a European cinema in an illiterate and impoverished Brazil. Its failure was both financial and cultural. In its wake, the *chanchada* once again dominated Brazilian production, with "serious" cinema—sometimes cerebral and often ridiculously pretentious—running a very distant second.

Randal Johnson and Robert Stam, *Brazilian Cinema*. East Brunswick, N.J.: Associated University Presses, 1982, pp. 64–67. By permission of the publisher.

At the same time foreign producers, distributors, and the exhibitors allied to them (and who were at times the same people) continued to dominate the market. Co-productions, invented as a kind of salvation for Brazilian cinema, resulted only in an absurd cost increase for *all* cinematic production in Brazil. There were also experiments with protectionist laws, and the state timidly turned its attention to the small, independent producer.

The independent producer arrived just in time. He became angry, stuck out his chest, closed his eyes, opened his hands, and threw his scanty resources into the cinematic adventure. He discovered miraculous ways of creating adequate technical conditions, begged for raw film stock, contracted capable people (discovering that Brazil was very well supplied in terms of excellent and inexpensive talent), outwitted the distribution mafia, exhibited his films, and made just enough money to be able to make more films. Gradually, the independent producer began not only to share his experience with others, but also to incorporate, with the same drive and audacity, the ideas of others. Soon, independent producers took on considerable importance.

Low-budget productions, while lowering the technical level of films, nevertheless offered the conditions—in conjunction with a policy of freedom of creation, invention, and treatment—for the emergence of Cinema Novo.

Brazil and its people became the central preoccupation of the new group of Brazilian filmmakers. They avoided both the touristic and picturesque attitudes that characterized co-productions and the cultural alienation inherent in an enterprise like Vera Cruz. Their goal was to study in depth the social relations of each city and region as a way of critically exposing, as if in miniature, the socio-cultural structure of the country as a whole. To take the people as theme, to give human form to fundamental conflicts, to make the people the center and master of the cinematic instrument. A critic from São Paulo, taking this option to its logical conclusion, exploded: "We don't want to make films. We want to hear the voice of Man." And the human voice will have to be heard in the northeast, in the southern latifundia, in Rio's *favelas*, in São Paulo's factories, and on the beaches of the fishermen of Bahia, indeed in all that is authentic and experiential.

Cinema Novo is a committed cinema, a critical cinema, even when, because of the youth and inexperience of its members, this commitment and this critical attitude become somewhat naive and lacking in analytical focus. But even this naiveté is valid, for Cinema Novo is, above all, freedom.

Freedom of invention, freedom of expression. Because Cinema Novo is not a school, it has no established style. On the contrary, a

unanimous style makes a movement retrograde, bourgeois, frivolous, manifested merely, or at least most intensely, in the formal, artisan aspect of its expression. In Cinema Novo, expressive forms are necessarily personal and original without formal dogmas, because form is merely one of the terms of a totality of simultaneous instruments directed toward the communication of a truth.

Without wasting time on the relative merits of close versus long shots, without worrying about whether the specifically filmic resides in the camera or in editing, without slothful theorizing, but rather technically rationalizing the practical questions of cinema, Brazilian filmmakers (principally in Rio, Bahia, and São Paulo) have taken their cameras and gone out into the streets, the country, and the beaches in search of the Brazilian people, the peasant, the worker, the fisherman, the slum dweller. Many have already presented the results of their work, but the great majority will release their first films this year.

1962 will doubtless be a key year for national cinema, the year of Cinema Novo. In Bahia, *A Grande Feira* (*The Big Market*), by Roberto Pires, has already been released. The same director is now preparing *Tocaia no Asfalto* (*Asphalt Ambush*). Glauber Rocha is ready to exhibit *Barravento* and is preparing a film about peasants in the state of Rio along with Paulo César Saraceni. Rex Schindler, producing these Bahian films, will probably soon direct a script of his own. Nelson Pereira dos Santos is preparing *Barren Lives* in the northeast. In Rio, Guerra's *Os Cafajestes* has already reached the theaters. *Assalto ao Trem Pagador* (*Assault on the Pay Train*), by Roberto Farias, and *Cinco Vezes Favela*, by five young directors (Joaquim Pedro de Andrade, Marcos Farias, Miguel Borges, Carlos Diegues, and Leon Hirszman) are being readied for distribution. In São Paulo Roberto Santos is finishing his adaptation of Guimarães Rosa's *Matraga*. And there are many other projects either in preparation or in production. Cinema Novo is also defending itself with short films, a recent phenomenon in Brazilian cinema that contributes, for its part, to the training of filmmakers: Linduarte Noronha, Orlando Senna, Glauber Rocha, Paulo César Saraceni, Rex Schindler, Mário Carneiro, Joaquim Pedro de Andrade, Sérgio Ricardo, Paulo Huchmacher, Marcos Farias, David Neves, Affonso Henriques, and many others. Unfortunately, these shorts will probably not have commercial distribution.

Thus Cinema Novo is being created with spirit and invention and without official policies, cliques, or snobbery. Turned toward Brazil and its people, Cinema Novo is ready to take the streetcar of national cinema that has been off track for too many years.

History of Cinema Novo

Glauber Rocha

There is nobody in this world dominated by technology who has not been influenced by the cinema. Even without ever having been to the cinema, man is influenced by it. National cultures generally have not been unaffected by a certain way of doing things, a certain sort of morality, and, above all, a tendency towards the fantastic, all supplied by the cinema of the imagination.

When one talks of cinema, one talks of *American* cinema. The influence of cinema is *the influence of American cinema*, which is the most aggressive and widespread aspect of American culture throughout the world. And this influence has so affected the American public itself, that, despite its conditioning, that public demands that the cinema furnish an image in its own likeness.

For this reason, every discussion of cinema made outside Hollywood must begin with Hollywood, especially as far as Brazilian cinema is concerned. Being economically and culturally much closer to the United States than to Europe, our public has created an image of life through the American cinema. Therefore when a Brazilian decides to make a film, he decides to make an "American-type" movie, and it is essentially because of this that the Brazilian audience expects a Brazilian film to be an "American-type" Brazilian movie. If a film is not American, simply because it is Brazilian, he is disappointed. The audience does not accept the Brazilian filmmakers' image of Brazil because this image does not coincide with the one of a technically developed and morally ideal world supplied by Hollywood movies.

Framework, No. 12, 1979, pp. 19–27. By permission of the publisher.

Thus it is not difficult to see which Brazilian films enjoy popular acclaim: they are those which, while dealing with national themes, do so by making use of a technique and an art which imitates the Americans. Two obvious examples are *O Cangaceiro* by Lima Barreto, and *O Assalto ao Trem Pagador* by Roberto Farias.

The plot of *O Cangaceiro* is taken from American Westerns and transposed to a setting of the "cangaço." To do this, it hacks out all aspects of the social life of the "sertão" (a zone of the Brazilian interior) and, following the traditions of the Western, only makes use of that imagery which is a part of those traditions: long hair, aggressive landscapes, fire-arms, horses (even when, as is well known, the cangaceiros rarely went on horseback) music and folk dances. The plot, as will be remembered, divided the four men into goodies and baddies. When Teodoro escapes with the young schoolma'am, the story follows, step by step, the classic scheme of many Westerns. The action is divided between the pursued goodies and the baddie pursuers. In the final scene, the schoolma'am, pure good itself, is saved. Teodoro, who had previously been bad, has no possibility of becoming good and dies heroically. He dies, however, with an act of nationalistic fervor, kissing the earth. The film's technique is provided by American models. At no time does the camera stop to analyze a character.

As can be seen, this *realism* is completely *unreal*. The illusion of the world of the cangaço is created in terms identical to those of the illusion of the world of Texan outlaws. Brought up on hundreds of "cowboy" films, the public need make no effort to understand the film, which is offered to it as a rich imitation of what the public's deformed taste expects.

Satisfied that this imitation is possible, the audience will naturally react against any film whatsoever, which wanting to show that Brazil is not the United States, proposes a different sort of conflict, and consequently uses a different sort of language.

In the context of the detective genre, *O Assalto ao Trem Pagador* repeats several elements which go to imitate the American "gangster" movie. Since, however, the detective genre is much more realistic than that of the Western, and for this very reason carries a bigger dose of social statement, Roberto Farias' film achieves a distinctive cultural level. It does not, all the same, avoid making use of the techniques of "suspense" which are fundamental to the genre.

The same Roberto Farias decided, in another film, to confront a social question. Making *Selva Tragica*, he tried with great effort to free himself from American formulae by broaching the problem of slavery in the farming of "maté" in Central Brazil. He ceased dividing society into goodies and baddies and sought to carry out a more profound

analysis. By penetrating a complex structure and attempting to articulate a language which suited this structure, Roberto made a film which was regarded at that time (1964) as disconnected. The lack of connection of this film, however, was much more realistic and national than the closed and predetermined formula adopted for *O Assalto ao Trem Pagador*.

The public's rejection of this film made Roberto Farias realize that his ability to communicate to them was not linked to his talent as director, but to the use to which he could put his talent in the service of a determined theme. And so the director once more resorted to the theme of the City and morality, with a vision of the middle classes' attitude toward the bourgeoisie, in the film *Todo Donzela Tem Um Pai Que E'Uma Fera*. He confirmed the notion whereby the formula for success consists in applying the American narrative form to a theme which is socially and morally false.

The welcome accorded internationally to *Selva Tragica* by the critics and the arts cinema circuit created a dilemma for Roberto Farias, however the artisan director finally succeeded in overshadowing the auteur director; hence his latest film *Roberto Carlos em Ritmo de Aventura* represents a Brazilian concoction of American formulae, and it seems destined to become our biggest box-office hit.

The Challenge

But by exploiting alienation in this way, will Roberto Farias really succeed in *conquering* this public? Does giving to the public what it *wants* represent a form of conquest, or rather a form of commercial exploitation of the a-cultural conditioning of this public? Is it not, perhaps, in *Selva Tragica* that the true path resides, the path which leads to the conquest of the spectator?

Roberto would undoubtedly answer that the cinema is an industry and that Brazil needs a film industry which might later give him the chance of creating an original cinema concerned with the country's problems.

But how to create a national film industry? The cinema is an industry which generates culture. American cinema has created a taste for itself, and if Brazilian cinema, in order to develop, wants to follow the easiest path, all it has to do is make use of American formulae. But in doing so, Brazil's industrial cinema will be nothing more than the propagator of a greater force, that of the dominant culture. This culture might just as easily be French or Russian or Belgian—it would make no difference; but in an underdeveloped country, it *does* make a

difference whether or not the society can obtain a practice generated out of the conditions of its own specific social and economic structure. The first challenge is to propose to the Brazilian filmmaker how to conquer the public without making use of American formulae which, already today, have spread into European sub-forms. Is it worth forcing oneself to make a cinema which would pass on neither the bad nor the good to the specific culture of the society to which it belongs? This "impasse," which reflects the modern conception of the underdeveloped societies of the tropical countries, has a two-sided and conflicting moral repercussion: on the filmmaker who "produces the imitation," to his obvious discredit, and on the public which "rejects the original effort" with manifest annoyance.

For the public, however, the undertaking is more arduous, because it is unaware of the process of creating an original cinema in opposition to an imitative cinema which more easily satisfies the concept of perfection demanded by the spectator. It is more difficult for an original cinema to reach perfection since, being new, it is imperfect and thus less well-received by the public which, by consenting to an imitative cinema, tends to stimulate imitation.

Out of the concept of imitative cinema and original cinema emerged in Brazil the term "Cinema Novo." But having chosen to confront the Brazilian reality, "Cinema Novo" gives rise to a second challenge: having rejected the language of imitation, what then will be the original form employed?

'No' to Populism

Cinema, inserted into a cultural process, will need to be, in the final analysis, the language of a society. But of which society? A country "em transe," Brazil is an Indianist country / Vainglorious, Romanticist / Abolitionist, Symbolist / Naturalist, Realist / Parnassian, Republican / Positivist, Anarchist / Cannibal, Nationalpopular / Reformist, Concretist / Underdeveloped, Revolutionary / Conformist, Tropical / Structuralist, etc. An awareness of the oscillations of our culture so packed with superstructures (given that I am referring to an art produced by elites, very different from the "popular art produced by the people") is not sufficient to provide an awareness of who we are. Who are we? What sort of cinema do we have?

The public cannot be bothered with all this—it goes to the cinema to be entertained but all of a sudden discovers that it is watching a national film which demands an enormous effort to establish a dialogue with the filmmaker who, in turn, is making an effort to talk to the public . . . in a new language!

The discussions on the topic of this language are involved and revealing. By rejecting imitative cinema and choosing a different form of expression, Cinema Novo has also rejected the easiest path represented by the usual new language of so-called nationalist art, "populism," reflected in a typical political position adopted by us. Like the "caudilho," the artist feels himself father of the people: the order of the day is "speak simply so that the people understand."

My feeling is that "to create simple things for a simple people" shows a lack of respect for the public, however underdeveloped this public may be. The people may be diseased, starving and illiterate, they are not simple, they are complicated. The paternalistic artists idealizes popular types as subjects of fantasy who, even in their poverty, possess a philosophy and poor creatures, only have to get a bit of "political consciousness" in order, from one day to the next, to be able to invert the historical process.

The primitiveness of this concept is still more pernicious in its effect than imitative art, since imitative art has the courage, at least, to know itself to imitate and to justify the "industry of artistic taste" by putting forward, as its aim, gain.

Populist art, on the other hand, seeks to justify its primitiveness with a "clear conscience." The populist artist is always declaring, "I am not an intellectual, I run with the people, my art is beautiful because it communicates," etc. It communicates to the people their own illiteracy, their own vulgarity, born out of their state of poverty which leads them to despise the way they live.

The Brazilian people, while accepting their poverty, are always critical of it. One finds in popular music a great many "samba" which say, "I've got no beans, I make soup out of stones" and "I'll die on the sidewalk, but smiling all the while" or "the 'favela' is the entry to paradise." Populism draws from these sources and serves them back to the people, ungarnished by any deeper interpretations. The people, seeing how the art clothes itself in the primitive comicalness of underdevelopment, find their misfortune hilarious and die laughing.

Thus is explained the success of the "chanchada," based on the pretty poverty of the "caboclo," or the middle class. Thence is derived the success of any drama containing social statement. The populist will also defend the idea according to which "the forms of communication should be used . . . to unalienate." But these "forms of communication" as we have already seen are the colonizing culture's instruments of alienation.

An underdeveloped country is not necessarily obliged to have underdeveloped arts. It is ingenuous and in some ways reactionary to think that art offends. Sharing the general malaise of Brazilian culture,

Cinema Novo has rejected populism thus reducing the possibility for it to manoeuvre the public. Could it have chosen the way of subterfuge?

While they spend so much time considering the problem of communication, Cinema Novo considers the problem of creating. Are creation and the cinematographer reconcilable? The majority of observers reply that cinema is, and can only be, the art of communication. For these observers, *creating* is opposed to *communicating*. The apostles of communication will avoid at any cost, however, asking themselves this: on how many levels is communication produced, and, more than this, what is real communication?

Cinema Novo claims to have been successful in attaining real communication. Stating this, it frees itself from the certainty of the communication propounded by "populism," which is a misleading boast because, deep down, populism hardly cultivates the "cultural values" of an underdeveloped society at all. These "values" are worthless— our culture, a product of a lack of ability at the level of artisanal skills, of laziness, of illiteracy, and of impotent politics, of social stagnation, is a "Culture Year Zero." So burn down the libraries!

With every film, Cinema Novo, like the Lumière, starts from zero. When filmmakers organize themselves to start from zero, to create a cinema with new types of plot lines, of performance, of rhythm, and with a different poetry, they throw themselves into the dangerous revolutionary adventure, of *learning while you produce*, of placing side by side theory and practice, of reformulating every theory through every practice, of conducting themselves according to the apt dictum coined by Nelson Pereira dos Santos from some Portuguese poet: "Don't know where I'm going, but I know I'm not going over there."

The public feels itself propelled into the theaters. It feels obliged to read a new genre of cinema: technically imperfect, dramatically dissonant, poetically rebellious, sociologically imprecise just as the official Brazilian sociology is itself imprecise, politically aggressive and insecure, just as the political avant-garde in Brazil is itself violent and sad, rather more sad than violent, like our Carnival which is much more sad than gay.

For us, new does not mean *perfect*, since the notion of perfection is a concept inherited from the colonizing cultures which have determined their concept of *perfection* to take up the interests of a *political ideal*.

Modern art which is truly revolutionary in its ethics and aesthetics is opposed, through its language, to a dominating language. If the sum of guilt felt by bourgeois artists leads them to be opposed to their own world, in the name of that awareness which the people need but do

not have, the only way out is to oppose through the impure aggressiveness of true modern art all the moral and aesthetic hypocrisy that lead the artists into alienation.

Thus the Cinema Novo's ambition comes to be considered as something over and above the cinema. The cinema, everybody says, is a form of entertainment. Those who go to the cinema, go to enjoy themselves. Nobody wants to have to face problems at the cinema. Art is the territory of the theater, of painting, of poetry. Cinema, on the other hand, costs money. The filmmaker artist is an irresponsible, a cretin, or else an intellectual.

In Brazil, intellectual is synonymous with homosexual. So you need a lot of courage to be an intellectual and, as an intellectual, attack the power of the cinema. I think that Brazil is a country which desperately needs the cinema and, above all, that the cinema will be the art of Brazil par excellence. Rome, however, was not built in a day, and Cinema Novo only began in 1962 and, to date, has produced a mere 32 films.

The Distribution System

Because cinema is a business, the secret lies in the distribution. Once the film is ready, the producer needs to sell it, but before it gets to the exhibitor, it must first pass through the hands of an intermediary, the distributor, who pays only for the drawing up of contracts and the organization. The publicity costs are divided into three, but the proportion for which the producer is responsible runs to 80%. The exhibitor takes 50% of the gross earnings, the producers between 35-40% (paying 80% of the publicity costs), while the distributor takes between 10-15% having to lay out only the minimum necessary. But it is the distributor who bills the exhibitor and thus manages the producer's capital outlay.

It is usual for the producer, on completion of a film, to find himself penniless. So . . . he goes to the distributor for help. Usually, the distributor will give him an advance, but the money lent is deducted at source from the first returns, so that the producer, who gives up the initial income to the distributor, must pay off the bank with the subsequent returns . . . always smaller than the first.

The Brazilian cinema went through this for years. When some São Paulo capitalists organized the large scale *Vera Cruz* film venture, they saw to everything apart from the distribution which was entrusted to Columbia Pictures. Columbia organized distribution, but with less publicity and commercial drive than was usual for their own films.

In that "age of Titans" the theorists of São Paulo (the same ones, who, today, are to be found at the National Institute of Cinema) believed that the cinema of "studios," stars, wardrobe managers, floodlights, astronomical salaries, Italian directors, was an ideal cinema. After eighteen years, Vera Cruz collapsed. Not even the success obtained by *O Cangaceiro*, could prevent this cinematographic empire from crumbling. Were the backers to blame? I don't think so, it was the fault of ad-hoc producers, imported directors, irresponsible actors, and of idealists who hoodwinked the São Paulo bourgeoisie by declaring that art costs money and that, thanks to art, even with a small market, São Paulo would have acquired an industry that could rival the United States.

Distribution, we should add, can perform no miracle to make the public enjoy a bad film or to enable them to understand a good art film. But distribution can, via intelligent and persistent programming, and via efficient control, market a film throughout the Brazilian territory and stand a very good chance to recover production/distribution costs and even make a profit. By consolidating and extending the distribution network in Brazil one would, at a conservative estimate, create a 35 percent increase in the earning potential of films in black and white that do not exceed the average budget of 150,000 cruzeiros. Thus, even if a film is "unsuccessful" it can still pay for itself by means of what we call minimal "natural" returns.

The Heart of the Cinema

It is at this point that distribution becomes the heart of the cinema. A well-organized distributor can create a public for a particular type of product. The best example of this is provided by the birth of the Art Cinema market, which has come to be a worldwide phenomenon. As the public was absorbed into the television, the cinema market made inroads into that part of the public which expected something greater from the cinema. Thus arose the Art Cinema market, which is constantly growing and now threatens to compete with the major cinematographic market.

The most courageous exhibitors realized that the only way to attract the spectator, generally attached to the television, was to summon him to see "art" in his theaters. And so was established a business that came to be called the "Old Business" of . . . art. In this market, the French Nouvelle Vogue, Fellini and Antonioni, Ingmar Bergman, Luis Buñuel, and many other old and young directors, established themselves. In the way Art Cinema was presented, one tended to read the name of the director in the place of that of the ac-

tors. And with the exception of three or four, the work of very few American directors was being shown in these cinemas.

Thus the auteur, and with him the Art Cinema, emerged. And we thus conclude without much effort that Cinema Novo's struggle with the public is not a regional but a universal struggle. This struggle has the dimensions of a cultural revolution, with all the risks that any revolution involves.

In 1964, Luis Carlos Barreto became aware of this phenomenon and, with great difficulty, managed to convince the producer-directors of Cinema Novo that it would only be possible to propose an original language through the direct control of the market. He further proposed that the films would take a long time to modify the public's moral and artistic conceptions. To do this, he added, the films would need to be supported by a self-sufficient distribution structure that could distribute this sort of product in a planned way. Thus Difilm emerged which today competes on an equal footing with the other distributors in Brazil.

The increase in receipts has been fast, and the public attendances at Cinema Novo film jumped by 40% between 1964 and today. Each Cinema Novo film, thanks to efficient distribution, is seen by an average of 50,000 to 100,000 people, in Rio de Janeiro alone. A transitional film like *Todas as Mulheres do Mundo*, which betrays a spontaneous, if somewhat unrigorous maker, has been seen by about 40,000 people.

Today Difilm has fifteen films in distribution and this year will add another ten titles. Without much effort, the profit on the gross income would be about 10% to 15%, automatically re-invested in the concern's organization and in film production. This profit margin has enabled the co-production of nearly ten films. The company has also started to export its films, through agents in Paris and Buenos Aires, which are the centers for international distribution.

The majority of Cinema Novo's films being accepted into the Art Cinema's circuits abroad, beyond constituting a supplementary market which nurtures big perspectives, have vested Cinema Novo with a prestige that enables it to confront pressures from all sides.

It is an undeniable fact that an artistic language cannot consolidate itself in the abstract, that is to say that without economic power, there cannot be cultural power. Difilm has managed to insert itself into the system by acknowledging the system's objective reality, that of *business*, and can thus sell a subjective product, that is . . . art. What is more, the growth of the art cinema market represents an increasing need felt by the public, to be informed about, and to be able to discuss, its own destiny. This need mirrors the mobilization, though still

slow, of a real Brazilian culture, to which our avant-garde in the universities contributes, along with the publishing movement, popular music, the new theater, literature, the new press . . . and Cinema Novo. Cinema Novo is inserting itself into our society as an agent which, by participating in the creation of quality products, is striving for a form of expression, different from and more effective than that of American cinema.

All the same, the question, which is an important one, remains unanswered: what is this cinematographic language I have defended, which I have differentiated from the others without having so far defined?

The Hero Without Character

Mario de Andrade, the theoretician and creator of great importance in the 1922 Modern Art Movement, wrote a book *Macunaíma, The Hero Without Character* which, like *Os Sertoes*, is fundamental with regard to knowledge and understanding of Brazil. Joaquim Pedre de Andrade is currently involved in preparing the adaptation of the book, which will have the title *O Heroi de Mau Carater*(*The Hero of Bad Character*). Beginning with the concept of "hero," we shall attempt to analyze, in the most objective way possible, what the *language of Cinema Novo* is.

The hero is an exceptional character which any novelist, playwright or filmmaker chooses for his drama. Even the typical hero, that is to say one who embodies and expresses a social group, is transformed when he is syntheticized, into something exceptional. A drama without heroes would be a drama without men. Using cleverly the key characters of the nineteenth century novel and play, the American cinema created heroes who corresponded to the cinema's vision, violent and humanitarian at the same time, of the "world of progress." Handsome, strong, honest, sentimental and implacable men. Independent, maternal, loving, sincere and understanding women.

American producers have always made films which were adapted to the needs of the moment. Only a small number of the films have ever obtained critical penetration which, however, never went outside the sphere of social statement. Even courageous and topical subjects, as in John Steinbeck's novel *The Grapes of Wrath*, could be submitted to fantastic changes: John Ford, a great technician gifted with a sense of humor, transformed the political theme of the book into the social-sentimental theme of the film.

The example of *The Grapes of Wrath* helps one to see that the most important thing about a film is never the story but always the

mise-en-scène. One of the main errors committed by the public and the critics is that of considering the *story* to be *the basis of the film*. In cinema, the story is only one element in the mise-en-scene. The director, the man who has the job of creating a world of images, makes use of the story, actors, photography, technical effects, rhythm, landscape, dialogue and titles to realize his work. And he will never create his work from the vision of the writer, but from his own.

To understand a film properly, the spectator must look, at the same time, at the landscape, the tonality of the photography, the interpretation of the actors; he must listen properly to the dialogue and the score and must read properly the titles; he must observe the camera movements; finally he must be properly aware of when the actor's face alone is shown in a closeup, or when the actor is shown full-frame, alone in the landscape, or else in the company of others.

In classic American cinema, in *The Grapes of Wrath* for example, everything was conceived so as not to create conflict for the spectator. The director sought to break everything, down to the smallest particular, into little pieces. Into these he inserted his ideology and served up the whole all ready for the spectator to swallow. The public goes to see the film and can understand it without having to think. It comes out of the cinema satisfied because, really, it has nothing in common with what it has seen. It feels only the stimulus which enables it to obtain some of the physical attributes of the hero or the heroine: beauty, will-power, courage, integrity and victory. Because life offers none of these things to it, the public takes refuge in the cinema.

A French critic once told me how much he liked Metro movies in color because, being so unhappy with reality, Metro, for him, was a new paradise.

Today the American cinema is full of self-doubt, just as American society itself is perplexed as never before. The death of Kennedy seems to have opened the gates to new questions, and today American commercial films no longer reflect on the old ideas of John Ford or Howard Hawks. At the moment in which the American character itself enters a crisis, it is only right that the idea of the hero changes. Thus emerges the anti-hero.

One Who Is Living the Crisis

The Brazilian filmmaker is interested in everything that happens in Brazil, in the world, in society and in the cinema. It is not possible to isolate art, still less the cinema—the filmmaker is a man who is constantly moving. He goes from the corridors of banks to the labyrinths of laboratories, from the sophisticated world of actors, to the violent

world of renters, from luxury appointments to the most distant corners of forests, and through this, if he has a grain of sensitivity, he will experience at close quarters a reality so complex as to make him constantly unsure of the world in which he lives.

For this reason, our hero must be the *multiplex Brazilian man* who is living every crisis where it occurs. The instability of this active and reflexive character cannot be found in our cinema, but may be encountered in our country's novels and plays, and is bound to that same consciousness which our writers have of reality. And we cannot ignore the precariousness of a concept of realism. In a *revealed*, developed society, it is a lot easier to conceive of and practice a dramatic realism than, as we have already seen, it is in a society which lacks any information. Our filmmaker takes part in the discovery of the consciousness of what is Brazilian, through his wish to record via direct images, and his wish to discuss in the light of what he knows (or thinks he knows) of man, ourselves and others.

Vidas Secas, the film made by Nelson Pereira dos Santos in 1963, taken from the novel by Graciliano Ramos, did not have any popular success even though it was a work rich in cultural polemics. Fabiano, the protagonist, is a "retirante" (a man who emigrates from the arid regions in the North East of Brazil, to escape the drought); he is a weakling, timid, ugly and starving; he is not a coward, but he is led by his fear of an unknown political power which oppresses him, to consider his honor, which lacks any idea of revenge, to be the compensation for his humiliation.

For *Vidas Secas*, Luis Barreto developed direct camerawork. He tried to sing of the suns of the North East, of its effect on the landscape and on the men. The scorched characters, at the beginning, move across the vast flat "caatinga."[1] Already, at the first shot, a new cinema is proposed. For four minutes, we contemplate the same image. We see the characters in long shot, slowly getting nearer the audience. They are led by a dog called Balaia (Whale). As a background there is the sad creaking of the bullock cart, the sound growing louder without changing pitch.

The spectator who has made his way to the cinema to watch a drama about the drought is assailed by the opening scene which attempts to oblige him not to watch, but to participate in the tragedy of the drought. The whole film takes place in the same way: the white and dazzling shots follow on monotonously one from another, but with each shot revealing some new aspect of this world: parched world, parched lives. The spectator is made to think about what he sees, but this irritates him: if the hero himself, the spectator asks himself, does nothing to change the situation, if Fabiano merely confines

himself to running away at the point when the drought threatens to kill him, then why should he, the spectator, bother about Fabiano, let alone get bored watching this good-for-nothing Fabiano on the screen?

The spectator can see that this film is different—he read in the newspapers that it had an artistic touch—but it does not hold up and, he complains, if it had at least been made in color, it would have been less sad.

A populist film would have shown Fabiano singing his "xaxado" (folk song) by the fire, creating a sub-literary genre around his little blade of grass; Fabiano, at the end, would have killed the Yellow Soldier. Sinha Vitoria, the grumpy sour woman, would have died, and Fabiano would have married the beautiful peasant girl after having received the bit of land allotted to him by the agrarian reform, where he would plant his vegetables next to the dike built by the Sudene (State Organization for the Irrigation of Northeast Brazil).

The spectator of *Vidas Secas* is not seeing a film which elicits his tame monkey's mentality to react in a predetermined way—he will refuse to follow the movement of the film as he must do, if he is to understand why Fabiano does not make the best of all possible worlds, that for Fabiano to change, he and the others must change the world, etc.

The protagonist irritates us. Nobody sympathizes with his fate, just as nobody sympathizes with ours. Lost and abandoned in the "sertao," or in the city, our destiny is in our own hands.

Vidas Secas is a film which is absolutely dramatic. Nelson Pereira dos Santos analyses through it an aspect of "sertaneja"[2] society; he tells the truth, but few people can see or hear it: has the director made a mistake?

In shooting *Os Fuzis* (*The Rifles*) Ruy Guerra has taken another position. He shows us a group of "retirantes" (this time a group of men like the Yellow Soldier who humiliated and beat up Fabiano). The soldiers have been called into the region to maintain order: they shoot any "flagelado" (drought victim) who tries to raid the food store. The soldiers are human beings, but they have a world of their own. For them the "flagelado" is an inferior being who, for some reason, has not managed to get out of his miserable state, probably because he is lazy. He, the soldier, has already had his revolution.

In a small town, they meet Gaucho, formerly a soldier, now a lorry driver. He is an adventurer, a sceptic, ready for anything. He is a man without moral values, who is fed up with their passivity, and capable of taking a gun to defend the "flagelados." He is shot down by the soldiers. Gaucho does not manage to pull it off quite like a Texan

sheriff, and the spectator goes against a film, which, in the final analysis, has offered him neither any solutions nor a story which is easy to follow.

Os Fuzis is quite a different sort of film from *Vidas Secas*, and presents us with a different aspect of the problem of the North East: the relationship between the forces of order and the suffering. To express all the aspects of this tragedy, it was a violent language.

For Ruy Guerra, the story is relatively unimportant—the spectator must dwell, as Ruy Guerra has done, on a lengthy shot which shows a "sertanejo" scratching the earth for a root to eat, or another where a soldier, thanks to the training which has deformed him, loads a rifle blindfold, and kills by reflex, without knowing who or why he is shooting.

In this exuberant natural setting where the action takes place, the spectator would like a cowboy film with its gradual and natural rhythm, spared the conflicts between man, landscape and social environment.

In *Deus o Diabo na Terra do Sol*, made around the same time, I took as starting point some popular legends to show still another aspect of the drama of the North East. Manuel, a down-and-out ox-driver, kills his boss and goes off with the boss's woman in search of truth, and finishes up by becoming the "cabra" (a hitman) for a cangaceiro. With the death of the cangaceiro, he loses faith in everything and goes mad, leaving his wife and running off to an imaginary sea to free himself.

This film, a cultural polemic like *Vidas Secas* and *Os Fuzis*, upset the public and failed to obtain the success which was hoped for. A young film-programmer told me that had Manuel joined up with Antonio das Mortes to kill cangaceiros and the "holy men," had he afterwards been rewarded by receiving a "fazenda" (land holding) from some rich colonel, then the film would have been a success. But to have changed the direction of Manuel's progress would have meant changing Manuel's very character, for he is weak, starving and perplexed, like Fabiano. Fabiano, because of his perplexity, gives up and stays. Manuel, in the same state of mind, keeps on going, along the paths indicated by a bloody mysticism, using up his energies through an abstract morality and a physical and spiritual purge.

So the protagonist's behavior, decided beforehand by the director and developed in the course of constructing the film, is directly linked to the technique of shooting. When the director tells the cameraman that he wants a close-up or a distance shot of the protagonist, or when he tells the leading actor to walk right or left, he does so because all

this has got to do with the protagonist, both objectively and subjectively.

A Moral Problem

But if the Brazilian hero is without character, lost and perplexed, without traditions or a future, how is he to be filmed? The instability of the technique adopted for shooting is linked to this fact. Never has Godard's idea, whereby a "camera movement is not a question of technique, but a moral question" been shown so clearly to be true, as in the case of Brazil. If so far the character of the Brazilian has not been successfully defined, if we reject the image of an absolute hero, it is because the search for our Man has been hampered by a great deal of mistakes.

The price of the search for truth is incomprehension on the part of the public. But by perfecting methods through the overcoming of mistakes, by building a greater awareness of reality, starting from that which we already know, we can forge the key to a language capable of circumscribing, analyzing, stating and demonstrating the truth. But all this lies outside of the cinema and is part of socio-political phenomenon. Cinema Novo is intimately tied to this phenomenon, and though it would rather be an agent of the process than a reflection of it, it is much more of a reflection than an agent. From this it can be seen, as with politics and economics, that Cinema Novo does not adhere any longer to traditional values. It does not define clearly our future and is not quite clear about what system it should be striving for. A country "em Transe," a cinema "em Transe."

Is it enough to propose this state of trance, induced by underdevelopment and life in the Tropics, to explain Brazilian cinema's isolation? This for me is the most important question, since the cinema must overcome the trance stage in order to reach a stage of lesser neurosis and greater effectiveness. The passage from cultural neurosis to cultural action will be the first act of the "show." At the moment, we are still in the overture, in which all the themes are orchestrated in such a way as to announce the melodies to follow.

Various other films, such as *O Desafio, O Padre e a Moca, A Falceida, Menino de Engenho*, and *A Opiniao Publica*, met with serious comprehension and communication problems. But in the case of each of these films, the makers threw themselves into the task of analyzing the darker aspects of our reality: these films, in short, showed the painful nature of our underdevelopment and, above all, dismantled the preconceptions of an old culture. The brave self-criticism in *O Desafio*, the rejection of traditions and underdevelopment in *O Padre e a*

Moca, the sadness expressed in *A Falecida* (a debut work of international value), did not manage to communicate themselves directly, but were relayed, at more complex levels, to the extent that these films became polemical works constituting a cultural statement.

Watching and Listening

In many studies of the problems of communication, one finds that the specialists do nothing other than describe the state of affairs brought about by imperialism. As propaganda, Socialism fails, and is publicized on the fiftieth anniversary of the Russian Revolution as the work of New York advertising agencies. . . .

The creators of the technology of treating the public as idiots are expanding their activities over the whole world. Articulating this structure is not difficult for the careful technician. The problem the Brazilian filmmaker sets himself is rather different: we know better than anybody the communication structure of the American cinema, from artistic techniques to the mechanics of distribution. We are all too familiar with the star system, the narrative devices, the attractions of the genres and publicity stunts: we know it all, the whole works.

But if we knew it, does this mean that, fascinated by its effectiveness, we should accept it? The attitude of certain groups of intellectuals has made a major contribution to our state of underdevelopment. They have decided to import theory upon theory from the developed world, without any disinfecting of the customs. Their theoretical schematization has generated a sub-art based on imitation. We were so preoccupied by what the developed world might think about us, that we forgot to worry about ourselves. Cinema Novo, on the other hand, only worries about itself, and only refers to what they say abroad in order to draw a comparison between foreign opinion and national incomprehension.

The fact that Cinema Novo is well received abroad in no way justifies the difficulty it has in getting accepted in Brazil. The fundamental problem, a problem of economic and cultural factors which are closely interrelated, lies with the public. In trying to deal with the essential aspects of our society, Cinema Novo, as we have seen, came up against a precarious cultural practice. So it tried to elaborate a cultural practice which was based on that precariousness. As Gustavo Dahl so felicitously expressed it, Cinema Novo is forcing itself to wreak qualitative change to overcome cultural underdevelopment, a project undertaken by certain other Brazilian artists, especially the 1922 movement.

Neither is familiarity with the technology of communication, nor participation in it, particularly important. What is important is to attack that technology and propose alternatives to it. The cinema in Brazil has one great advantage: in creating a structure for itself aimed at self-sufficiency, it benefits, with the exception of the struggle against the censors, from infinitely greater room to manoeuvre than the television has.

The real trial for the cinema is that, with a public hooked on foreign films and suffocated by television, communication is problematic. But it is not impossible to break through the barrier of general insensitivity. The immediate and partial failure of Cinema Novo with the public is partly due to the immaturity of the filmmakers who, flung into the abyss, without technical expertise or much experience, hit this barrier face on while making contradictory efforts to get through it.

But one thing has managed to break through this barrier of glass, something so important as to upset the monologue: Cinema Novo has turned itself into political parties, both legal and illegal, from solitary confinement. But contrary to what the critic Jean Claude Bernardet asserts in his book *Brazil em Tempo de Cinema* (Editrice Civilizacao Braslieira), Cinema Novo does not take advantage of the prestige accorded to it by the official culture, rather it holds that prestige in contempt, and this contempt makes itself felt on the screen, in those films which acquire prestige for the fact that they are *films*. If they are films, that is to say that they represent something concrete: a technical production which is a creative affirmation, one which acknowledges and defeats the challenge offered by the official culture itself, according to which "Brazilians have not the know-how to do cinema."

Most of the bodies who award prizes to Cinema Novo films do not understand these films, they respect them. The same thing happened in the case of literature. The drama of misunderstanding which the cinema is experiencing today is the same one modern art experienced in the 1930s. But this misunderstanding should not be seen as the doom of artistic life but as the product of the immature state or the national consciousness.

The Breaking-Point

The phase of pure discovery and intuition, which began in 1964 with Cinema Novo's first experiences, the films *Os Cafajestes, Barravento* and *Porto das Caizas*, has developed into the phase of reflection and a break with Cinema Novo's own roots, marked by this year's experiences which are bound to give rise to much polemic. Cinema Novo is looking for a language derived from socio-politico-economic factors,

*in order to communicate to the public and influence it on its path of
liberation*. It has no intention of providing *the organization for a
school*, in the sense so loved by the theoreticians who wait on God's
salvation, but it does want to provide for a *proliferation of personal
styles* which will put permanently in doubt the concept of a special
language as a higher level of consciousness. From a cultural dynamic
which is *self-destructive*, we could develop one of *dialectics*.

The avant-garde in the Third World, as the poet Ferreira Gullar
used to tell me, is quite a different affair from the avant-garde of the
developed world. The cinema has an advantage over literature, in so
far as it has a medium at its disposal—the image—that has no need of
translation.

The problem, though, is not one of deciding between the *national*
and the *universal*, as some would have it. The problem is to create
from the position of one's insufficiencies, and build out of the quali-
ties of these the flexible foundations of a way of thinking which is in
the process of evolving. Thereby we would have an international style
of art: that of the avant-garde. Thus creation will be the only stimulus
for the development of styles in the Third World.

Creation, I would stress, results from the tactics of production; is
carried out through the "dialectically free" act of creating, and asserts
itself in the strategy and tactics of distribution.

A cinema that wants to create and seeks cultural quality obtains, at
various levels, political results. Although Cinema Novo lost the first
round going into one or two clinches with the public, it has won on
points, if not actually by a knock-out. The reality behind all this lies
in the ever-improving professional organization on the part of the pro-
ducers, which can be seen in the increase, both in quantity and quali-
ty, of the films in production.

The discussion will not stop there: *Garota de Ipanema*, dismissed
by the critics and the intellectual elites who have always accused Cin-
ema Novo of being anti-popular, is beating box-office records in Bra-
zil, and only *Roberto Carlos em Ritmo de Aventura* will make more
this year. But *Garota de Ipanema* has this great advantage over any
other type of commercial production made in Brazil: it is a film which
rejects imitation. It has opted for the solitude of an attempted critique
of a world, that of Ipanema, mythicized by "sun and beer literature";
it has opted for the solitude of an attempt at criticism rather than con-
form to the lie which is inherent in that literature's language, rather
than imitate Claude Lelouch and give a false impression of being like
other films by means of sub-art.

Leon Hirszman's film displays the author's disbelief in his subject,
a disbelief not found in *A Falecida*. Hirszman here saw himself as

being sacrificed on the Altar of Paradise by its priests, for denying the existence of a happy Atlantic seaboard society (might not a real good-humoredness exist in Ipanema, a poor part of the city, where a select few are washed away by their illusion of happiness?). This disbelief prevents the film from coming to grips with the other aspect of Ipanema, the inevitable aggressiveness. But Hirszman's *detachment* confers on the film a cultural value.

I think that the *demystification* phase will be surpassed in the coming films, but it will be by no means entirely absent. The filmmakers are convinced that the "critical eye" is not enough: another way of making an impact is necessary, one capable of shaking up the public as they sit in the stalls. *Terra em Transe* took a step in this direction and a bitter struggle was the result, a struggle which enabled a discussion to take place on many levels, thus opening up the way for new ways of communication. Certain left-wing critics labelled the film which encouraged a dialogue with the public. Didactic or raising an issue, aggressive or criticizing, agitating or organizing, demystifying or fabulous—Cinema Novo has realized that to be *realist* means *discussing the different aspects of the real*, and not employing some formula out of European Realism (Hail, Lukács!) in order to determine, *a priori*, a realism with a clear conscience.

For the most part, Brazilian criticism has not grasped this phenomenon, and only a few, such as Paulo Emilio Salles Gomes, Alex Viany, Ruda de Andrade, Almeida Salles, Walter da Silveira, Cosme Alves Neto, Fabiano Canosa, Wilson Cunha, Sergio Augusto and Mauricio Gomes Leito, have worked, as men of the cinema, for the discussion, defense, publicizing and recording of the history, of the phenomenon.

The other critical practice, the reactionary one, refuses to accept the obvious. In practice, it is working to undermine its own long-winded declarations on a national cinema, by proposing ideas that mystify and which were being put forward a long time ago by the audience and filmmakers whose practice was dominant.

The bureaucracy of the National Institute of Cinema does its good works, in the form of channelling 10% of box-office receipts throughout the country back to the producers. However it sows the seeds of the cinema's destruction in establishing a network of cultural sabotage against Cinema Novo. The composition of the juries, who give the prizes and who classify Brazilian films to be sent abroad, is openly biased against Cinema Novo, becoming even more radical when it fails to find films to put up against Cinema Novo's.

To the defeatists and denigrators, whilst acknowledging the shortcomings of Cinema Novo, I address the following questions:

What are the alternatives for Brazilian cinema, if there is a boycott of future films belonging to this tendency, and of those, made by their directors which are to be released this year?

Theories die if they are not put into practice. Cinema Novo exists; it is a creative response, an active practice, in a country so full of possibilities and misunderstandings.

It is not our intention, however, to turn Cinema Novo into a closed circle of filmmakers. Our struggle has as its aim the implanting of a mentality—Cinema Novo is for an assault on the power of the cinema; Cinema Novo is to make sure that Brazilian cinema really becomes a new cinema, one worthy of a new country (even if a premature decline might raise fears over the country's future). But the role of the intellectuals, whatever their approach, is to create and turn an adult culture into a source for popular inspiration. You do not, however, create an adult culture by using fear. If the choice is either to follow the cult of dubious traditions, or take the risk of making a discovery, Cinema Novo will soldier up the second path.

Translated by Jon Davis.

Notes

1. Area of scrub on the edge of the sertão.
2. Of the sertão.

Transformation of National Allegory

Brazilian Cinema from Dictatorship to Redemocratization

Robert Stam and Ismail Xavier

The Brazilian Cinema Novo movement was at its height when a military dictatorship seized power in 1964 and ruled Brazil for the next two decades, until power was officially transferred to a civilian government in March 1985. Our purpose here is to examine the impact of these twenty years of overtly authoritarian rule on Brazilian film, to examine the ways in which Brazilian cinema has reflected, refracted, and even "produced" this period of history. More specifically, we will examine Brazilian film history in terms of (1) the changing political context of the period; (2) the evolving nationalist discourse; (3) the refraction in the films of both "real" history and "discursive" history (the two being intimately linked), especially as reflected in films that constitute fragmentary texts projecting general statements about the Brazilian situation or destiny and thus qualify as what might be called "national allegories."

The Nature of Allegory

Brazilian intellectuals have been working with the concept of national allegory at least since the debates about "tropicalism" in the late 1960s, and arguably even since the debates about the national character conducted by "modernismo" in the 1920s.[1] Fredric Jameson, meanwhile, in a non-Brazilian context, argues in his essay "Third World Literature in the Era of Multinational Capitalism" that all Third World

Robert Sklar and Charles Musser, eds. *Resisting Images: Essays on Cinema and History.* Philadelphia: Temple University Press, 1990, pp. 279–307. By permission of the publisher.

texts are "necessarily allegorical," in that even those texts invested with an apparently private or libidinal dynamic "project a political dimension in the form of national allegory: the story of the private individual destiny is always an allegory of the embattled situation of the public third-world culture and society."[2] Without endorsing the somewhat hasty totalization of all Third World texts as "necessarily" allegorical—it would be problematic to posit any single artistic strategy as uniquely appropriate to the cultural productions of an entity as heterogenous as the Third World—and without denying the analytical relevance of allegory for all national cinemas, including First World cinemas, we would like to demonstrate the special relevance for Brazilian cinema of the concept of allegory, here conceived in a broad sense as any kind of oblique or synecdochic utterance soliciting hermeneutic completion or deciphering.

In the period of our discussion, we can trace at least two major strands of allegory: first, the teleological Marxist-inflected meliorist allegories of early Cinema Novo, where history is revealed as the progressive unfolding of an immanent historical design, and second, the modernist self-deconstructing allegories of the Brazilian underground, where the focus shifts from the "figural" signification of the onward march of history to the discourse itself as fragmentary, and where allegory is deployed as a privileged instance of language-consciousness in the context of the felt loss of larger historical purpose. Such a discussion, we would argue, touches on a number of issues relevant to radical film and cultural historians—issues having to do with "legibility" and "communication" with a broader public, with realism versus anti-realism as radical strategies, with the struggle against censorship and repression, and with the complex relationship between the "left" and nationalism.

The majority of Brazilian films, even the most apparently frivolous, demonstrate a clear penchant for allegory. If we take allegory in the broad sense as implying the use of metaphoric, synecdochic, microcosmic, or temporally transposed discourses to encode cultural-political messages about the larger society, we can discern allegory even in the 1950s musical comedies (*chanchadas*), which, as Joao Luiz Vieira argues, parody Hollywood films in order to allegorize the "inferiority" of Brazilian cinema in relation to the dominant Hollywood model.[3] But this pervasive allegorical tendency becomes exacerbated, as we shall see, in the work of intellectual filmmakers profoundly shaped by nationalist and Third World discourse, who feel obliged, with every film, to speak for and about the nation as a whole.

The Question of the National

It is impossible to discuss Brazilian cinema in any depth without engaging the complex question of the "national." Because of Brazil's neo-colonized Third World status, its intellectuals—and the filmmakers we will discuss see themselves, and are seen as, intellectuals—have necessarily been concerned with the ramifications of nationalism. If Hollywood filmmakers have enjoyed the luxury of being "above" petty nationalist concerns, it is because they can take for granted the projection of a national power that facilitates the making and the dissemination of their films. In Brazil, in contrast, national power does not provide a quiet substratum of confidence; instead, national powerlessness generates a constant challenge, a Sisyphusian struggle to conquer an elusive "authenticity" to be constructed anew with every generation. The cultural and ideological environment in which Brazilian filmmakers operate forces them to juggle diverse concerns—the desire for personal expression, a preoccupation with certain themes, an engagement with film language, an attitude toward the spectator—always mediated by the question of the "national." The Brazilian filmmaker is haunted by the specter of cultural colonialism, of being too imitative, too servile toward the dominant model. (That this specter came to haunt virtually all Brazilian filmmakers constituted a victory for Cinema Novo, since during the first four or five decades of Brazilian cinema copying the foreign model implied no shame.) Given the foreign domination of the market, and given the immense obstacles to making films, the cinema, for better or worse, has been evaluated by its contribution to "development" and "national liberation." The filmmakers express their creative personalities, but they also see themselves as part of a larger collective project: the consolidation of a national cinema.

The concept of the national, however, is hardly unproblematic. Quite apart from the historical ambiguities of nationalism—the slippage between its original meaning as racial group and its later meaning as politically organized entity, the oscillation between its progressive and regressive poles—there are also cultural and intellectual ambiguities at work. The early discussions of nationalism took it as automatic that the issue was simply one of expelling the foreign to recover the national, as if the nation were a kind of "heart of the artichoke," to be found by peeling away the outer leaves, or as if, to change the metaphor, the nation were the ideal sculpted form lurking within the unworked stone. Roberto Schwarz calls this view the "national by subtraction," that is, the idea that the simple elimination of foreign influences will automatically allow the national culture to

emerge in its native glory.[4] The project of eliminating the foreign and recuperating the national is shared, incidentally, by both left and right, except that each gives the words *national* and *foreign* a distinct political inflection. For right-wing "national-security" ideologists, it is an "alien" Marxism that must be excised for the nation to regain its integrity, while for the left it is imperialism and the multi-national corporations that must be expelled.

We will not linger here on the deficiencies of the right-wing analysis but will explore the ambiguities of the left position. First, the topos of a unitary nation elides the realities of class, camouflaging the possible contradictions between different sectors of Brazilian society and distracting attention from the internal mechanisms of Brazilian capitalism. Second, the exaltation of "the national" fails to provide criteria for distinguishing exactly what it is that is worth retaining in the national tradition. A sentimental nationalism that valorizes patriarchal social institutions simply because they are "ours" can hardly be seen as progressive. Third, even apart from the question of class, there are many "Brazils"—urban and rural, male and female, indigenous, black, immigrant, and so forth. The view of the nation as a unitary subject has the effect of muffling the "polyphony" of social and ethnic voices characteristic of a heteroglot culture. Fourth, the precise nature of the national "essence" to be recuperated is extremely elusive and chimerical. Some nationalist purists locate this essence in the past—for example, before North American or British or Portuguese influence—or in the rural interior of the country, or in an earlier stage of development (the pre-industrial), or in a non-European ethnicity (the indigenous substratum, Afro-Brazil). But in Brazil, even the most prized national symbols come with the mark of the foreign. Palm trees came from India, soccer came from England, and the samba traces its roots to Africa. National communities must be envisioned as "imagined" communities, in Benedict Anderson's apt phrase, just as many of the traditions valorized by nationalism must be seen as what E. J. Hobsbawm calls "invented traditions."[5] Any definition of Brazilian nationality, then, must be selective, must take class into account, must allow for racial difference and cultural heterogeneity, and must be dynamic, seeing "the nation" as an evolving, imaginary construct rather than an originary essence.

National Cinema in the Era of the Cultural Industry

Our discussion here will move from 1964, the year of the coup initiating military rule, to 1984–85, the years in which civilian rule was restored and the "New Republic" (Nova Republica) was called into

being by a collective act of political will. For Brazilian cinema, the first date represents the moment of rupture for a recently born Cinema Novo then in its first flushes of precocious brilliance, a creative explosion that generated the memorable trilogy of the arid northeast—Nelson Pereira dos Santos's *Vidas Secas* (*Barren Lives*; 1963), Glauber Rocha's *Deus e Diabo na Terra do Sol* (*Black God, White Devil*; 1964), and Ruy Guerra's *Os Fuzis* (*The Guns*; 1964). Made at a time when a populist government was promoting basic agrarian reforms, all three films make the *sertão* (backlands) the setting for a filmic anatomy of hunger, property relations, class struggle, and revolution. With the coup d'etat, however, leftist film production was interrupted: Universities and cineclubs were raided, copies of Soviet silent classics such as *Mother* and *Battleship Potemkin* were seized, and Cinema Novo, as a consequence, was forced to confront a political disaster.

The date 1984–85, meanwhile, evokes the agony of the dictatorship and the popular struggle for direct elections and the transition to the New Republic. But the present period in no way represents a euphoric millennium for either the cinema or the country; it is instead a time of acute crisis and self-questioning. While much of the questioning centers on the necessary rethinking of the role of the governmental film agency Embrafilme (now seen as an effective film distributor but otherwise an unproductive bureaucracy), there is also a pervasive feeling of a crisis in creative direction. The generational transition has gone less smoothly than was hoped. It is noteworthy, in this sense, that several early 1980s productions by Cinema Novo veterans brought to fruition projects first conceived in the late 1950s or early 1960s—for example, Eduardo Coutinho's *Cabra Marcado para Morrer* (*Twenty Years After*; 1984), Leon Hirszman's *Eles Não Usam Black Tie* (*They Don't Wear Black Tie*; 1981) and Nelson Pereira dos Santos's *Memorias de Carcere* (*Memories of Prison*; 1984), as if Brazilian cinema were still living off the residual energy of what one might call the "heroic period."

The present sense of crisis derives from the fact that if repression and censorship have disappeared, the endemic economic problems of Brazilian cinema have not. Brazilian filmmakers live in a situation of galloping inflation, of $130 billion national debt, where the *cruzeiro* (now *cruzado*) is forever in decline and the dollar ever stronger, where Hollywood "dumps" its films and television serials at low prices on the Brazilian market, and where, as a consequence, every year it becomes more difficult to make films. Brazilian television, in contrast, has largely escaped the negative effects of the crisis. By 1962, the same year that Cinema Novo was garnering its first international prizes, videotape was already rationalizing television produc-

tion. Also in 1962, the Congress approved Law 4117, the "Brazilian Code of Telecommunications," endorsing the idea of national integration, security, and development through television. The hope was to link all of Brazil through reliable telephones, telex, and televisual systems, accompanied by the provision of the technological infrastructure required for national networks. In 1965, the government created Embratel (Brazilian Enterprise for Telecommunications) to carry out this task, and in 1967 it created the Ministry of Communications as the bureaucratic agency providing financial and logistic support for the project. Brazilian television was then linked to Intelstat satellites, thus achieving its dream of addressing all Brazilians at the same time. The ideology of "national security" prodded the regime into modernizing the sphere of communications for purposes of national integration. In the era of the Brazilian "economic miracle," furthermore, television, unlike the cinema, directly served the national economy by integrating more and more consumers into a world-market economy. As a result, Brazilian television flourished, becoming a virtual paradigm of commercial success in a dependent Third World context—Brazil's TV Globo is now the fourth largest private network in the world in audience and resources—while Brazilian cinema suffered the triple whammy of runaway inflation, urban crisis, and dollar hegemony. And as the coup de grace, Brazilian television, unlike many of its European counterparts, has virtually boycotted national films. (In 1986, for example, out of 2,170 films screened on Rio's six television channels, only 35 were Brazilian.)[6]

All these factors generated an immense gap between the two media; while television was consolidated as a mass vehicle in the 1960s, cinema reached quasi-industrial status only in the 1970s, a temporal lag whose consequences are still with us. While Brazilian cinema has achieved only a precarious grip on the internal market—going from 13.9 percent of the market in 1971 to 35 percent in 1982—Brazilian television dominates the internal market with huge telenovela hits such as *Escrava Isaura* (Slave Isaura) and *Roque Santeiro*. (The latter was seen by a daily audience of over 70 million people.) In the same period, 1971–83, the percentage of foreign television programming declined from 60 percent to 30 percent (and during prime time to only 23 percent), a proportion placing Brazil on a par with such European countries as France, Italy, and the United Kingdom.[7] While Brazilian cinema existed under the fragile protection of the Ministry of Culture, Brazilian television was linked to the powerful Ministry of Communications. And while Brazilian films are screened sporadically in international film festivals and only exceptionally distributed abroad,

Brazilian television programs are systematically exported to Latin America, Portugal, Italy, France, Poland, and even China.[8]

The long-term implications of these processes were hardly clear to the young filmmakers of the 1960s. Their auteurist project with its artisanal utopia of "a camera in hand, and an idea in the head"—as the slogan of the time had it—merely postponed, as it were, a deeper reflection on the role of cinema within a larger "culture industry." Indeed, early Cinema Novo formulations largely avoided the question of the evolving nature and role of the mass media in Brazil. How was one to develop a national cinema while rejecting the idea of the market and of consumerism? How was Glauber Rocha's Brechtian-style attack on "digestive cinema" and his denunciation of the "public at any price" mentality to be reconciled with the desire to reach the popular audience? How could one reconcile an anti-industrial and even avant-garde cinema with the realities of mass-mediated culture and the consciousness industry? The struggle against authoritarian militarism after 1964, meanwhile, distracted attention from deep structural changes in the Brazilian cultural economy, masking the fact that the military regime in some ways constituted a modernizing force that consolidated capitalism, energized the media, and promoted the circulation of "cultural goods." (Left intellectuals continued to see even a right-wing state as a means for confronting foreign domination, whence their support for Embrafilme.) The period of military rule was marked by a dramatic expansion in cultural production—books, journals, television programs, films—as part of a general industrialization of culture. Cinema Novo theorizations symptomatically favored Frantz Fanon, with his notions of liberatory violence (see the essay by Rocha in volume one) and national fulfillment, and Antonio Gramsci, with his ideal of the "organic intellectual," over what are now seen as the more theoretically advanced formulations concerning the culture industry. Only in the late 1960s, when it became obvious that the audiovisual economy was revolving around television, did such issues come to the foreground, and by then the theme of debate was the crisis of cinema rather than its promise and potentialities. The consolidation of the hegemony of the cultural industry, in this period, was accompanied by a few compensatory mechanisms favoring the media marginalized by that hegemony. But in general the cinema, forced passively to suffer the vicissitudes of official cultural policy, saw itself outperformed by other cultural sectors, such as television and popular music, whose internal dynamics were more attuned to international currents.

The challenge confronting Brazilian filmmakers must be seen in the light of the socioeconomic transformations triggered by what might be called "conservative modernization," a model that promotes industrial

expansion built on repressed wages, the proletarianization of the middle class, and a general shift toward jobs in administration, communications, and services. It would be inaccurate to see the current crisis in the cinema as the simple product of "20 years of dictatorship." Brazilian cinema has always survived within a situation of scarcity, dependency, undercapitalization, and inadequate technical infrastructure. The crisis engendered by economic neo-colonialism and by Hollywood's stranglehold on the market preceded the dictatorship—indeed, it was precisely that crisis that motivated Cinema Novo to search for alternative methods of production. What the post-1964 period did bring was the additional "nuisance" of political censorship as the most visible aspect of repression: the interruption of leftist film production, the raids on cineclubs, the banning or delayed exhibition of films, and the exile of numerous filmmakers.

The negative effects of this conjunction of economic crisis and political censorship on the cinema were not "automatic," however, any more than the positive effects of the re-democratization known as *abertura* (opening) were automatic. Whereas in Argentina the end of dictatorship brought with it an impressive cinematic resurgence, in Brazil, some of the liveliest moments of creativity and debate coincided with the periods of the most intense repression. The cultural hegemony of the left, in terms of publication, filmmaking, and cultural production generally was stronger, ironically, during the dictatorship than it was later with re-democratization. The brutally repressive period 1969–74 produced more provocative films than the subsequent period of liberalization. While the earlier period offered the tropicalist subversion of *Macunaíma* (1969), the ironic cannibalism of *Como Era Gostoso Meu Frances* (*How Tasty Was My Little Frenchman*; 1971), the distanced (Brechtian) analysis of *São Bernardo* (1973), and the formal subversion of *Triste Tropico* (1974), the post-1974 period has generally featured more conventional works, including the eminently "safe" literary adaptations of major Brazilian writers such as novelist Jorge Amado (*Tent of Miracles* and *Gabriela*) and playwright Nelson Rodrigues (*Bei jo no Asfalto, Bonita mas Ordinaria* and *Dama da Lotacão*).

Cinema Novo in the Wake of the Coup (1964)

Cinema Novo was the Brazilian version of a "politique des auteurs" that undermined the bureaucratic hierarchies of conventional production in the name of "life" (that is, Brazilian reality), "actuality" (political commitment), and "creation" (the search for a language adequate to the precarious conditions of a Third World country and capable of

conveying a dis-alienating vision of social experience)—we find here a process of "translation" typical of Third World societies. In these allegories of underdevelopment, an "aesthetic of hunger" turns scarcity itself into a signifier, much as the Judaic allegorical tradition turned slavery and exile into a badge of honor. In a symbiosis of theme and method, the very lack of advanced technical resources was metaphorically transmogrified into an expressive force. The new political conjuncture after the coup d'etat forced a reconceptualization of goals and the means for realizing them. As one response, a number of filmmakers chose to perform tortured autopsies of the debacle, in films whose veiled or explicit theme was the coup itself or the failure of the populist left, the case of Saraceni's *O Desafio* (*The Challenge*; 1965), Marion Fiorani's *A Derrota* (*The Defeat*; 1967), Glauber Rocha's *Terra em Transe* (*Land in Anguish*; 1967), Nelson Pereira dos Santos' *Fome de Amor* (*Hunger for Love*; 1968), and Gustavo Dahl's *Bravo Guerreiro* (*Brave Warrior*; 1968). *The Challenge*, for example, satirizes what is known in Brazil as the "festive left," that is, a left more interested in wild parties than effective militancy, while *Hunger for Love* allegorizes the isolation of the left, embodied in a revolutionary figure who is blind, out of touch, and confined to an island.

In this period, two key films made a sharp break with all of the antecedent traditions: Rocha's *Land in Anguish* and Rogerio Sganzerla's *Red Light Bandit* (1968). Fusing an avant-garde aesthetic with a courageous denunciation of the populist politics that led to the coup d'-etat, *Land in Anguish* shocked its progressive audience by portraying left populism as a pseudo-democratic masquerade, a "tragic carnival." Leftists who initially denounced the film as "fascist" later came to recognize its incisiveness. Lumping together the conspiratorial right and the incompetent left as two faces of elite power, the film, set in the imaginary country of Eldorado, animates synthetic characters representing vast historical forces—Diaz the fascist, Vieira the populist, Sara the communist—and deploys clearly allegorical strategies, figuring a modern-day coup d'etat, for example, in the form of a Shakespearean coronation. The portrait of the leftist poet-intellectual Paulo Martins—a contradictory, at times even reprehensible figure, given to lapses of skepticism and despair, infinitely less coherent than he imagines himself—forms a critical portrait of a whole generation of leftist intellectuals, conveyed by a vulcanic effluvium of words, sounds, and images constituting a baroque allegory of disenchantment.

The originality of *Land in Anguish* consisted in superimposing the logic of political economy and geo-politics—for example, the alliance of multinational imperialism and the Brazilian bourgeoisie against workers, peasants, and left intellectuals—on another cultural-anthro-

pological dynamic involving gestures, symbols, and decors that trans-
form these historical agents into grotesque exempla of historical
forces. The protagonist condenses contradictions that are not his
alone, for the film establishes a resonance between his poetic delirium
as agonizing narrator and the general atmosphere of hysteria and
trance that marks the ambient political process. Drawing on fragments
of the allegorical pageantry of Brazilian carnival, *Land in Anguish*
shows Brazil as an unstable amalgam of Afro-indigenous mestizo cul-
ture subject to an overarching European domination. Rocha gives pro-
leptic expression to what Brazilian intellectuals came to call the
"crisis of totalizations," that is, the spreading skepticism about histori-
cal master-narratives such as Marxism with its faith in inevitable revo-
lution and a history ordered by the progressive laws of dialectical
materialism. The faith underlying first-phase Cinema Novo, in short,
was corroding. While the earlier films had a virile and prophetic tone,
the later ones are marked by disillusionment and a feeling of impo-
tence. While to be a cultural worker in Brazil in the 1960s was to feel
clearly and inexorably on the side of history, now ordinary social and
intellectual life came to be marked by agony and doubt, with no clear
vision of impending transformation on the horizon.

From Tropicalism to the Aesthetics of Garbage (1967–1972)

Epitaph of an era, at once anti-imperialist pamphlet and auto-critique,
Land in Anguish served as a final envoi to Cinema Novo proper, and
thus prepared, and concretely influenced, the subsequent artistic move-
ment called tropicalism, which first manifested itself in music, poetry,
theater, and film in 1967. Tropicalism drew partial inspiration from
the Brazilian modernist avant-garde of the twenties—a modernism
that fused political nationalism with aesthetic internationalism—and
especially from Oswald de Andrade's notion of "anthropophagy" as
metaphorically applied to cultural products. Inverting the binary pair
civilization/barbarism in favor of barbarism, modernism articulated
cannibalism as anti-colonialist metaphor in its "Cannibalist Reviews"
and "Anthropophagic Manifestoes" and its famous slogan: "Tupi or
not Tupi, that is the question," that is, whether Brazilian intellectuals
should "go native" by symbolically imitating the cannibalistic Tupi-
Guarani tribes or alienate themselves into European domination. The
notion of "anthropophagy" supersedes the ideology of "the national by
subtraction" by adopting a syncretic strategy that simply assumes the
inevitability of intertextuality and the impossibility of a nostalgic re-
turn to a pre-lapsarian purity untainted by the foreign presence.

Tropicalist modernism, then, offers a kind of nationalist interna-
tionalism; the idea is to devour foreign technique in order to turn it
against the foreigner. Within the cinema, tropicalist anthropophagy re-
jected Cinema Novo's Manichean opposition between "authentic Bra-
zilian cinema" and Hollywood alienation, as well as the dualism that
contrasted "pure" rural folklore with the imperialized mass culture of
the cities. For tropicalism, the "crisis of totalizations" was a given.
The pedagogic discourse of Cinema Novo was now an anachronism.
More urgent, for the tropicalists, was a kind of artistic shock treatment
designed to sabotage a falsely optimistic nationalism. The tropicalist
allegory presented its diagnosis by mingling the native and the for-
eign, the folkloric and the industrial, the supermodern and the hyper-
archaic, provoking the aesthetic prejudices of the middle-class
audience by foregrounding all that was incongruous and grotesque in
Brazilian society.

Red Light Bandit, a seminal independent production, brilliantly ex-
emplifies these strategies. The film outlines the rise and fall of a dull-
witted anti-hero mythologized by the media, in a milieu peopled by
marginals: thieves, drug addicts, smugglers, prostitutes, and artists.
The protagonist's recurrent question "Who am I?" encapsulates the
identity crisis "after the fall," that is, after the failure of the nationalist
project. A fractured, discontinuous figure, the protagonist forms a kind
of container filled with fragments, myths, and masks derived from
mass-media clichés, constructed in a manner that today would be
called "post-modern." Rogerio Sganzerla shows the other side, then,
of Rocha's totalizations but still within the allegorical mode. Sganzer-
la's proto-punk film inaugurates an iconography of urban development
that inspired many subsequent Brazilian films, much as Rocha's *ser-
tão* iconography had inspired a number of mythic-agrarian Third
World films. We find the same frenetic hand-held camera, the rhetori-
cal excesses, and discontinuous montage typical of Cinema Novo, but
now folk literature and the music of Villa-Lobos have given way to
tongue-in-cheek mambos, boleros, and cha-cha-chas.

Red Light Bandit inspired the epithet "aesthetics of garbage," an
approach in which garbage provides the emblem of the social world
portrayed and the key to the film's discursive procedures: the chaotic
piling up of residue and detritus. Thus the film posits a homology be-
tween a red-light district in a Third World country as a social "realm
of garbage" and the text itself as a collection of film and mass-media
refuse: sensationalist press reports, radio broadcasts, American B-
films, television serials, science fiction. *Bandit* is ostentatiously pe-
ripheral, on the very margin of the margins. Brazil is portrayed as a
pageant of misery and corruption, a tragi-comic province at the edge

of the civilized world. (The sophistication of the film itself, meanwhile, emits the opposite message of aesthetic vanguardism.) The only possible lucidity in the face of banality and repression, for Sganzerla, is that of a black, bitter laughter, of the type expressed by the film's protagonist: "When one can do nothing, one raises hell."

"Garbage Cinema," or "Underground Cinema," during the period 1969–73 was also referred to as "Marginal Cinema," not only because the films promoted identification with marginal, transgressive figures, but also because the films were marginalized by exhibitors or kept out of the market by censorship. Since the underground flourished in the period immediately following the proclamation in 1968 of Institutional Act Number Five (the law abolishing Congress, habeas corpus, and other political rights), it has been seen as an angry response to repression extending the mood of radical disenchantment already palpable in *Land in Anguish*. The underground films reject all utopias—and in this sense they parallel the punk reaction to hippie love-and-peace optimism—in favor of the grotesque and the scatological. But in its aggressive refusal of compromise with the box-office mentality, the "aesthetic of garbage" can be seen as a radicalization of the "aesthetic of hunger." But here the early 1960s metaphor of hunger, evoking the victim finding self-redemption through Fanonian violence, gives way to the late 1960s metaphor of "garbage" as appropriate to a Third World country picking through the leavings of an international system dominated by First World monopoly capitalism.

The Metaphor of Cannibalism

The film that best manages the synthesis of intellectual reflection and popular appeal in this period is Joaquim Pedro de Andrade's *Macunaíma*, based on the 1928 modernist novel by Mario de Andrade. *Macunaíma* managed this synthesis by fusing the erudite anthropophagy of the novel with a comic-episodic narration reminiscent of Buster Keaton and the Marx Brothers. *Macunaíma* insured its own success by renewing contact with the most popular Brazilian film genre—the *chanchadas*; the *"filmes carnavalescos"* that dominated production from the 1930s through the 1950s. The director cast key *chanchada* actors such as Grande Otelo and Zeze Macedo, and featured songs popular from the *chanchada* period. Like the novel, the film develops cannibalism both as theme and as artistic strategy, exploiting the anthropophagic motif in order to expose the predatory Social Darwinism of class society in the Third World. The film's tangential relationship with tropicalism is evident not only in its anthropophagic theme but also in its emphasis on camp and gaudy colors, on the lack of national

character (the subtitle of the novel is *The Hero Without Any Character*) and on the melange of high-art tradition and mass-mediated culture. In other respects, however, the film prolongs the allegorical social critiques of Cinema Novo, but here performed with an oblique humor and cunning that caught even the censors off guard. While exploiting the *chanchada* as a strategy for communication, *Macunaíma* rejects the shallow utopianism of the *chanchadas'* happy endings in favor of a socially derived melancholy conclusion. The ideal of the hustler-trickster-hero is revealed to be empty, a dead end, in contrast with later idealizations, in early 1970s films like Hugo Carvana's *Vai Trabalha Vagabundo (Go to Work, Bum*; 1973), of marginal figures as admirable rebels and identifiable models for the spectator.

Also forming part of the anthropophagic branch of Cinema Novo is Nelson Pereira dos Santos's *How Tasty Was My Little Frenchman*, a film deeply rooted in the cannibalist intertext of Brazilian modernism. This ironical film sends a message of cultural relativism, activating the imaginary utopia of an indigenous tropical society totally unmarked by occidental guilt, a society to all appearances idyllic yet historically condemned to extinction. Set in the period of Brazil's colonization, the narrative subverts the colonialist premises of the travel-adventure genre by leading us, if not to applaud the French colonizer's cannibalization, at least to cheerfully acquiesce in it.

The metaphorical representation of the colonizing process in terms of the opposition Europe/Amerindia brings to the foreground the cultural matrix of the Indian, provoking a heightened sensitivity, on the part of the filmmakers, to the fate of the most egregious victims of the Brazilian historical process. In a first phase, the films focalize the Indian as the symbolic source of national cultural identity in opposition to colonizing Europe. In a later phase, especially in late-seventies documentaries, the emphasis shifts to the concrete and immediate fate of specific Indian tribes threatened with extinction. *How Tasty Was My Little Frenchman* belongs to the first phase, deploying anthropophagy as a metaphor for anti-colonial resistance, indeed, literalizing the metaphor in such a way that the historical perspective of the vanquished of the past comes to form a positively valenced reference for the political debates of the present. Gustavo Dahl's *Uirá* (1974), meanwhile, based on an anthropological reportage by Darcy Ribeiro, approaches the question from another angle: the melancholy of the Indian seeing his world and its mythologies annihilated by Western aggression and expansionism. Thus Dahl fuses the two themes: the venerable theme of the Indian as symbol of Brazilian identity (the positive pole) and the Indian as victim of physical and cultural genocide (the negative

pole), along with a pragmatic concern with the actual relationship between the remnant of the genocide and the present regime.[9]

The Allegorization of the Past

Within the repressive atmosphere of a military-dominated present, the past becomes a kind of reservoir or fund of images available for allegorical re-elaboration, a kind of wardrobe of themes and costumes to be borrowed for contemporary purposes.[10] Two films from 1972 allegorically raid the past in order to speak of the present: Leon Hirszman's *São Bernardo* and Joaquim Pedro de Andrade's *Os Inconfidentes* (*The Conspirators*). Updating their sources, both Hirszman and Joaquim Pedro de Andrade distance themselves from their generic models—the conventional literary adaptation, in *São Bernardo*, and the historical costume-drama, in *Os Inconfidentes*. *São Bernardo* adopts Graciliano Ramos's 1934 novel, recounting the transformation of a peasant into a powerful plantation owner. The allegory lies in the fact that Hirszman, precisely at the height of the "economic miracle euphoria," chooses to expose the human cost of capitalist development. *São Bernardo* allegorizes the fascism of the 1960s and 1970s through a protagonist who, like Brazil's military leaders, comes to power through bribery and murder and who, again like the regime, enriches himself at the expense of others. The protagonist is treated as an exaggeration of deeper social tendencies, a heightened instance in which the system's fundamental logic is laid bare.

A similar distance, and the same attempt to reenact the past in order to allegorize the present, characterizes *Os Inconfidentes*, a reconstruction of an abortive eighteenth-century revolt against Portuguese colonialism, here used as a springboard for the discussion of the relation between intellectuals and the people, and between colonizer and colonized. (The film had an antecedent in the leftist theatrical adaptation of the same historical episode, in 1967, in *Arena Conta Tiradentes*, when the Arena Theatre, in keeping with the disenchanted political tone of the period, chose to memorialize an unsuccessful revolution from the colonial period.) Here one-shot sequences, direct-to-camera speeches, and stylized movements emphasize the primacy of the theatrical word, as well as the interplay of progressive politics and personal vanities and ambitions. By displacing events onto another century, the film analyzes the defeat of a political movement, using the past as allegorical vehicle for the analysis of present-day political process.

By sponsoring serious, mildly subversive literary and historical films, the regime entered into a kind of accord with the better-behaved of the opposition filmmakers, permitting some critique as long as it was confined to respectable literary adaptations or to historical dramas set in the safely remote past. The superpatriotic epics that the regime really favored—such as Massaini/Coimbra's *Independencia ou Morte* (Independence or death; 1972)—were extremely rare and not very popular. Thus Brazil lived under a Third World militarist national-security state, but its cinema, even at its worst, never became right-wing or propagandist. In the 1970s and the 1980s, the cinema became especially preoccupied with both recuperating and revising Brazilian history. Apart from the exempla of tacky patriotism promoted by the regime, this period features more significant films such as Tizuka Yamasaki's *Gaijin* (1980), the story of the exploitation of immigrant labor at the turn-of-the-century, Silvio Back's *Aleluia Gretchen* (*Hallelujah Gretchen*; 1976), a study of pro-fascist and pro-Nazi groups in Brazil during the interwar period, and Geraldo Sarno's *Coronel Delmiro Gouveia* (*Colonel Delmiro Gouveia; 1978), an account of the economic heroism of a nationalist entrepreneur struggling against British domination.[11]

From Monologue to Dialogue

The oppositional spirit of the Brazilian cinema in the 1970s and 1980s demonstrates an enhanced openness to new voices and to other witnesses of the historical process. If no longer capable of making major diagnostic-prophetic statements about the national destiny, Brazilian cinema now becomes more open to difference and more permeable to the cultural values of ordinary Brazilians. Rather than speak about or to the people, the director seeks to allow the people to speak for themselves in order to affirm their cultural values without forcing them into a larger teleological design or pedagogical purpose. The questioning of "totalizations" here takes the form of re-envisioning "the nation" as what Bakhtin would call a "polyphony," a many-languaged multiplicity of classes and ethnicities with distinct voices and trajectories.

This new "modesty" on the part of filmmakers is evidenced in several documentary and experimental films that discard the covert elitism of the pedagogical model in favor of an acquiescence in the relative and the contingent. Artists experience a salutary self-doubt about their own capacity to speak "for" the other. Some experimental films, for example, address the very impossibility of filmmakers successfully addressing areas outside of their experience. Artur Omar's *Congo* mocks the very idea of white middle-class filmmakers saying

anything of value about indigenous or Afro-Brazilian culture. Other documentarists simply hand over the camera to the "other." Andrea Tonacci uses cinema and video as a kind of facilitator for a two-way "conversation" between urban whites and indigenous tribes. At times the dialogue turns against the filmmakers themselves. In *Raoni*, the Indians discuss the wisdom of killing the filmmakers—for them just one more bunch of potentially murderous white men—ultimately deciding to spare them so "they can bring our message to other whites." In Sergio Bianchi's *Mato Eles? (Should I kill them?* 1983), a venerable Indian asks the director exactly how much money he was paid to make the film, the kind of inconvenient question that would normally make its way to the editing-room trashcan. Thus the filmmaker assumes some of the risks of a real dialogue, of potential challenge from his interlocutor. And whereas most of the militant documentaries of the sixties combined orthodox left politics (working class over lumpenproletariat, class over culture, gender, and race) with omniscient voice-of-God narration, the new "voice of the other" cinema combines interview and self-presentation with a principled self-effacement on the part of the director. The cinema, rather than an instrument of monologue, becomes an amplifier of polyphony. Rather than a patronizing explanation of difference premised on elite exteriority, we find the defense and celebration of difference itself.

While Cinema Novo, despite its revolutionary concerns, had largely bypassed the urban working class—Cinema Novo always seemed to prefer those both lower (the *favelados*) and higher (the elite) on the social ladder—the films of the 1970s showed the impact of workers' struggles, partly as a result of the immense coming-to-consciousness and political mobilization of the workers in São Paulo culminating in the strikes that paralyzed the city in 1978. Several films treat this theme, in a variety of styles and formats. Leon Hirszman's *They Don't Wear Black Tie* offers, within a style of conceptual realism, a gallery of synecdochic proletarian characters, ranging from the old leftist Otavio and his confused son Tiao through the impatient "adventurist" radical Sartini and the courageous black unionist Braulio, supporting, finally, a cautious, disciplined militancy. In allegorical terms, the veteran militant filmmaker "corrects" the lost generation of the dictatorship, and in this sense distorts history, for in fact, the São Paulo strikes were the product of a new generation typified by Louis Ignacio da Silva ("Lula") and his "Workers Party," rather than of the traditional left.

The Penchant for Metacinema

The films of this period are preoccupied with the issue of the relation between intellectuals and the marginalized masses to whom they offer what Walter Benjamin called "mediated solidarity." Accompanying the history not only of the cinema but also of general theoretical reflection, the filmmaker forms part of a collective intellectual trajectory and is conscious of working with issues having a long history of formulation in a body of filmic and extra-filmic texts. Working within, or in reaction against, this tradition, the filmmaker becomes almost necessarily reflexive, engaged in dialogue with the received body of belief and method, directly or indirectly discussing the cinema within the films. Each film becomes a methodological sample of possible strategies, at once "about" a subject and "about" itself. Here Brazilian cinema is in step with international cinema, with its ever-greater tendency to reflexivity, whether modernist (early Godard), Brechtian (late Godard) or post-modernist (Brian de Palma), but there are also national and continental specificities at work, rooted in the marginal and syncretic nature of the Latin American cultural experience. The Latin American artist/intellectual is almost by definition bicultural, at once inside and outside, defined as at the margins yet thoroughly penetrated by the center. As the product both of Third World marginalization and of cultural and ethnic *mesticaje* (racial mixing), Brazilian intellectuals, especially, tend to be multi-cultural and therefore language-and culture-conscious, inhabiting a peculiar realm of irony where words and images are seldom taken at face value.

Whatever the root cause of the phenomenon, metacinema and reflexivity have been virtually ubiquitous in Brazilian cinema of the past few decades. (We use the terms here in their broadest possible sense to refer to films that foreground the filmmaker, the film's textual procedures, its intertext or its reception.) We find reflexivity in *Sonho Sem Fim* (*Dream Without End*; 1986), Lauro Escorel's film about Brazilian film pioneer Eduardo Abelim, in *Bras Cubas* (1985), Julio Bressane's reflexive adaptation of a reflexive Machado de Assis novel; in *Nem Tudo e Verdade* (*It's Not All True*; 1985), Rogerio Sganzerla's witty documentary/fiction about Orson Welles's ill-fated attempt to make a film in Brazil; and even in the cinematic obsessions and films-within-the-film of *Kiss of the Spider Woman* (1985). While the "voice-of-the-other" films offer a cultural critique of earlier totalizations, the reflexive films propose an aesthetic critique, casting doubt on the mastery and confidence implicit in earlier modes of storytelling. This critique takes on an experimental dimension, for example, in the work of Julio Bressane, who with each new film throws the light

of his metacinematic obsession on another generic tradition, from the *chanchada*, in *Rei do Baralho* (*King of the Cards*; 1974) to the early Brazilian avant-garde as encapsulated by Mario Peixoto's *Limite* (*Limit*; 1930) in *Agonia* (*Agony*; 1978). *Cinema Inocente* (*Innocent Cinema*; 1979), meanwhile, documents the activities of a porno-*chanchada* editor while underlining the impossibility of the sophisticated filmmaker's ever returning to a state of innocence before the images he films and edits. *Tabu* (Taboo; 1982), for its part, tries to "transvalue" the codes of the *chanchada*. Bressane posits a hypothetical meeting between twenties popular composer Lamartine Babo and modernist poet and dramatist Oswald de Andrade, played by veteran *chanchada* actor Colé, thus evoking the dialogue of popular culture and the erudite avant-garde. At the same time, the film elegizes the Rio of the thirties as a lost tropical paradise by associating it with interpolated footage from Murnau's *Tabu*.

The Emblem of Carnival

Tabu is not the only film in this period to renew contact with the carnivalesque *chanchada*, by now seen as the quintessential symbol of successful communication with the Brazilian public, the fount of a cinema at once nationalist, pragmatic, and popular. (We have come a good distance since Glauber Rocha's almost total rejection of the genre in the early 1960s.) The process of revalorization of the *chanchada* began with tropicalism's provocative leveling, in the late 1960s, of high (erudite) and low (popular) culture. In the fields of criticism and history, meanwhile, the revalorization of the *chanchada* was furthered by the argumentation of film historian Paulo Emilio Salles Gomes, who claimed in "Cinema: A Trajectory Within Underdevelopment," not only that the *chanchadas* were of vital importance for having retained the loyalty of the Brazilian audience but also that all Brazilian films, even the most imitative, remained authentically Brazilian, thanks to what he was fond of calling the Brazilian "creative incapacity for copying."[12] Now that the *chanchada* is dead, it becomes history and therefore available for nostalgic or critical reelaboration, a legitimate urban tradition to be incorporated much as rural folklore was incorporated by Cinema Novo. The filmic revitalization of the *chanchada* takes a diversity of forms; romantic in Carlos Diegues's *Quando O Carnaval Chegar* (*When Carnival Comes*; 1972), conceptual-reflexive in Bressane's stylistic exercises, and comic-parodic-erotic in Ivan Cardoso's ironic "vampirization" of the horror film in *Segredo da Mumia* (*Secret of the Mummy*; 1982) and *As Sete Vampiras* (*The Seven Vampires*; 1986).

The *chanchadas* were called "carnivalesque films," and the latter-day recuperation of the *chanchada* goes hand in hand with the redis-covery of carnival as an emblem of national identity, a culturally rooted master-trope crystallizing a richly syncretic culture that still has a place for an orgiastic ritual at once sacred and profane. For the Cinema Novo veterans, the reaffirmation of carnival signifies a retreat from the old puritanical-leftist equation of party/festivity with aliena-tion and escapism, a tendency present, for example, in *Cinco Vezes Favela* (*Five Times, Favela*; 1962), where the popular classes were exhorted to abandon the samba in favor of union militancy. The evoc-ation of carnival, in the 1970s and 1980s, goes from the literal pres-ence of "samba schools" in such films as *Lira do Delirio* (*Delicious Lyre*; 1978) or *Idade da Terra* (*Age of the Earth*; 1980) to the concep-tualization of entire films, such as *Xica da Silva* and *Quilombo*, as the equivalents of "sambaenredos," that is, as analogous in their aesthetic procedures to the ensemble of songs, dances, costumes, and lyrics that form part of samba school pageantry. Farnando Cony Campos's *Lad-roes de Cinema* (*Cinema Thieves*; 1977) foregrounds this analogy by having his favelado protagonists, dressed symptomatically as Indians, steal filmmaking equipment from American tourists visiting Rio's car-nival. The favelados conceive the film they plan to make with the sto-len equipment—about the same eighteenth-century revolt analyzed by *The Conspirators*—as a kind of samba school narration. The only so-lution for Brazilian film, *Cinema Thieves* suggests allegorically, is car-nivalesque irreverence and the anthropophagic devouring of foreign equipment and technique.

These reapproximations with popular culture reflect an attempted identification, by the filmmakers, with the more perennial features of Brazilian cultural life, a compromise formation that allows for a dis-cussion of the intellectual's function and the assimilation of the popu-lar vision. At its best, this strategy leads to a kind of popular yet pedagogic cinema fusing social critique with carnival-style joy. At its most innocuous, it turns into the complacent recycling of the clichés about presumed Brazilian character traits and the Brazilian national style, eliding real conflicts in favor of the celebration of the "cordiality" of the fun-loving Brazilian. At its worst, a superficial view of carnival celebrates the Brazilian capacity for political concili-ation, mocked by Glauber Rocha as the historical tendency for the now-repentant-right to hold hands again with the now well-behaved left, while "tudo acaba em samba" (everything ends in the samba).[13] The happy togetherness of the party, in this apolitical version of Bakhtin's subversive carnival, forms the utopian horizon of a cinema with one eye on the samba and the other on the box-office.[14]

Parables of Modernization

In a more serious vein, any number of seventies and eighties films by Cinema Novo veterans offer a globalizing vision of society expressed in allegories of underdevelopment and modernization. Jorge Bodansky/Orlando Senna's *Iracema* (1975), for example, tells the exemplary tale of a poor Indian girl, Iracema (her name, an anagram of "America," alludes to the heroine of a nineteenth-century romantic Indianist novel) and her relationship with the truck driver Tiao Brazil Grande (Big Brazil Sebastian). Within this asymmetrical couple, Tiao is played by the well-known actor Paulo Cesar Pereio, while Iracema is played by the non-actor Edna di Cassia. Tiao is active agent, initiator, entrepreneur; Iracema is object, acted upon, prostitute. Tiao is associated with the pet project of the dictatorship, the Transamazonian Highway and the modernizing nationalism it represents. He is the mistakenly arrogant embodiment of the spirit of the Brazilian "miracle" and the ill-advised Pharonic ambitions that led to a $100 billion debt. The film develops a structural contrast between two filmic approaches: first, that of cinematic reportage with hand-held camera, registering the ecological devastation and human exploitation in the Amazon, and second that of fictional and allegorical procedures involving the relationship of Tiao and Iracema. In a total interpenetration of documentary and fiction—for example, the actor Pereio pretends to be a real-life truck driver around people who do not know him to be an actor— the film understatedly denounces the human toll of frontier "development."

Both Ruy Guerra/Nelson Xavier's *A Queda* (*The Fall*; 1978) and Arnaldo Jabor's *Tudo Bem* (*Everything's Fine*; 1977), similarly, build on the metaphor of construction to make a general statement about Brazilian modernization. *The Fall*'s local story about construction workers building Rio's subway system is "made to speak" more generally about the overall development of Brazilian society in the era of a consumerist development, national integration through satellite transmission, and the restructuring of urban space wrought by advanced capitalist development. The same metaphor subtends the allegorical *Tudo Bem*, where a bourgeois couple invites construction workers to remodel their Carioca apartment. As the construction workers and maids take over the apartment—the "slave quarters," in Rocha's felicitous phrase, "invade the Big House"—the apartment becomes a symbolic microcosm, the site of intersection of conflicting class discourses and interests. The theatrical-allegorical procedure of the closed space suggests an apartment, that is, Brazil, undergoing a

superficial modernization in which the illusion of "tudo bem" masks the traces of predatory class violence and relations of oppression.

Carlos Diegues's *Bye Bye Brazil* (1980) creates a kind of picaresque allegory in which the "Caravana Rolidei"—a motley troupe of ambulatory artists—wanders around Brazil to witness the advance of modernization heralded by a national television that flattens regional diversity and renders obsolete the troupe's old-fashioned entertainment. Here the social contradictions compressed into a single apartment in *Tudo Bem* are anamorphically splayed out over the wide screen of the Amazon basin. Alongside its self-flauntingly theatrical core fiction, *Bye Bye Brazil* presents a kind of seismological documentary registering the aftershocks of the "multi-nationalization" of the Brazilian subcontinent. The title of the film (whose original title was also in English) points to its generalizing intentions, and the film as a whole provides dramatic confirmation of the Americanization pointed out in the lyrics of the title song: pinball machines in the jungle, Indian chiefs sporting designer jeans, backlands bands that sound like the Bee Gees.

Glauber Rocha's last film, the avant-garde superproduction *Age of the Earth* (1980), picks up the old allegorical method with experimental audacity and gusto. The film proliferates in synecdochic allegorical characters: four Christs (an Indian, a black, a military man, a guerilla) along with personifications of Imperialism, the Indigenous Nations, the Amazons, and the New Woman. Bringing to its paroxysm the typical Glauberian tension between synthesis and fragmentation, the film immerses itself in the cultural multiplicity of lived experience in Brazil. Synthetic in its space and locations—Brasilia, Salvador, Rio de Janeiro, baroque interiors, exuberant exteriors—and in its generic nature—documentary, symphony, allegory, experimental film—it shows Brazil as profoundly syncretic, a peripheral country in the age of dying imperialisms, a social formation animated by diverse Western and non-Western religions, whose energy is suffocated by internal ruling-class and external neo-colonial oppression.

Rocha's schematic presentation of Brazil views urbanization as a kind of death, while all that is most vital comes from what is most archaic. The metaphor of civil construction, familiar from *Tudo Bem* and *A Queda*, reappears in *Age of the Earth*, but this time in the Biblical image of the people exploited by pharoahs in the edification of tombs. At the same time, Rocha emphasizes the immensity of the country, developing a geographical trope of capital importance in recent Brazilian cinema, suggesting that the present phase of its imaginary and its reflection involves the exploration of new frontiers, and a desire to verify *in loco* the actual effects of Third World capitalism.

This preoccupation is present not only in *Age of the Earth, Bye Bye Brazil*, and *Iracema*, but also in several first-feature "road movies" by young directors, such as Geraldo Morais's *A Difícil Viagem* (*The Difficult Voyage*; 1982) and Augusto Seva's *A Caminho das Indias* (*On the Road to the Indies*; 1982). This reaching out to the frontiers represents a historic return to one feature of the early Cinema Novo films. When Brazilian Cinema wants to speak for Brazil as a whole, when it wants to speak of national identity, it continues to reach beyond the urban centers, where the filmmakers live and work, to the strength and density of the "other Brazil:" the northeast, the Amazon, the vast Brazil far from the wealthy and Europeanized south. Brazilian Cinema observes the process of modernization at its frontier points, at the very edges of the national experience, and even when it immerses itself in the city, it is to encounter the traces of the margins at the center, whether in the form of migrants from the other Brazil, or in the northeasterners and obscure religious practices that invade the apartment of *Tudo Bem*, or the immigrant workers who build the subway in *The Fall*, in the hillbilly singers in *Estrada da Vida*, or the immigrants, football players, and prostitutes of countless films made in São Paulo.

Allegories of Abertura

Many latter-day Cinema Novo films, as we have seen, such as *They Don't Wear Black Tie, Twenty Years After*, and Nelson Pereira dos Santos's *Memories of Prison* bring to fruition projects conceived in the late 1950s or early 1960s. Despite political liberalization, Cinema Novo is faithful to allegorical methods elaborated even before the coup d'etat. Based on the prison memoirs of Brazilian novelist Graciliano Ramos, *Memories of Prison*, for example, charts Ramos's descent, in the late thirties, into the hell of the prisons of Getulio Vargas. With each successive attempt at dehumanization, Ramos gains character and humanity through resistance, becoming a more committed human being at the same time that he comes to appreciate his vocation as a writer. Within the prison, he discovers what separated him, the progressive intellectual, from the people. The Third World gulag becomes, for him, the scene of a purificatory rite. The dramatic situations of the film are arranged in a double and complementary crescendo: the writer's developing participation in the life of the prisoner parallels the prisoners' increasing collaboration in the work of the writer. Thus the film presents the author's vision of the role of the progressive artist, whose "witness" turns the common experience into remembered history, thus offering a ringing endorsement of the voca-

tion of literature—and by analogy, the cinema—as a critical register of social existence.

Memories of Prison is allegorical in still another sense, in that it encodes one set of events, transpired in the thirties, to speak about another set of events. Just as the "joke" in *Vidas Secas* consists in its being set in the past, yet nothing has changed, so *Memories of Prison* has everything to do with the Brazil of "abertura." The prison's "Freedom Radio" speaks of debts and bankers' agreements, and a soldier tells the writer, in a transparent allusion to two decades of military rule: "It will take you civilians a good while to get rid of us." The eagerness of the prisoners to come to decisions by vote evokes, for the Brazilian, the energetic 1984 campaign for direct presidential elections. The film begins and ends with the Brazilian national anthem, at a time when patriotism was back in style in Brazil, precisely because of the re-democratization. The anthem marks the film as a microcosmic statement, suggesting that Brazil has the aspect of a prison, yet one whose prisoners will soon be freed.

Eduardo Coutinho's reflexive documentary *Twenty Years After* offers a capsule history of Brazil and Brazilian Cinema during the two decades under discussion. Coutinho's initial project, conceived in the optimistic left-populist years before the 1964 coup d'etat, was to dramatically reconstruct the political assassination, in 1962, of peasant leader Joao Pedro Teixeira. The performers were to be Joao Pedro's comrades in work and struggle, the locale was to be the actual site of the events, and among the "actors" would be the deceased leader's widow, Elizabete. The coup d'etat interrupted the filming, however; the filmmakers and peasant participants were dispersed and the material already shot was hidden. Almost two decades later, encouraged by the liberalization of the eighties, the filmmaker sought out the hidden footage and the original "performers," now spread around the country by years of hardship and oppression. In the present-day film, the participants in the original film watch themselves on the screen, their faces and lives bearing witness to the scars left by dictatorship. A key figure in *Twenty Years After* is Elizabete, Joao Pedro's widow, bruised but still resilient and cautiously militant. The filmmaker discovers her living in another state, under an assumed name, cut off from former friends and much of her family, all necessary, as she explains, in "order not to be exterminated." After bitter repression, she re-encounters her family, reassumes her true name, and reaffirms her political convictions. In her capacity for disappearing, surviving, and then reappearing, she resembles, as Roberto Schwarz points out, the filmmaker himself.[15] The emotion generated by the film arises from the encounter of a committed filmmaker with an authentic popular heroine who, de-

spite everything, manages to connect the dots of her political trajectory, just as the filmmaker manages to complete his project. In a renewed confluence of political cinema and popular struggle, both cineaste and peasant leader reaffirm their struggle and solidarity.

In *Twenty Years After*, the vastness of Brazil is defined by the space of an exemplary diaspora: the dispersion and disintegration of the family and the erasing of identity by repression. But the descent into hell, as in *Memories of Prison*, is doubled by a reverse journey that leads, if not to paradise, at least to a historical situation where questions can be posed again. Tracing a two-decade process, the cinema literally intervenes in the life of the oppressed, and the story of the film begun, brutally interrupted, and now completed is mingled with the story of the people with whom the filmmaker dialogues. Thanks to the film, Elizabete Teixeira actually emerges from the underground and recomposes her identity. Between *Cabra* 1964 and *Cabra* 1984, the same questions continue to be relevant—repression, squatter's rights, agrarian reform, unionization, migration—but not in the same terms, just as the film is taken up again, but in a different mode.

The sixties meeting with the widow is paralleled by the highly didactic cinema of the period—a melange of *Salt of the Earth*-style realism with the populist idealism promoted by the Popular Centers of Culture, while the eighties meeting with the widow takes place in the era of network television and the accumulated experience of the Brazilian documentary. The filmic language is now more dialogical, less inclined to discourse omnisciently "about" the other, and more inclined to listen to and learn from the other. The film itself manifests this evolution by adroitly interweaving the procedures of the traditional documentary—and especially off-screen commentary—with more contemporary direct-cinema techniques—where we discern the presence of the author, the television professional, Eduardo Coutinho, from the well-known series "Globo Reporter." We see his crew working within the frame, making us acutely aware of a film-in-the-process-of-being-made before our eyes. *Twenty Years After* thus offers not only a telescoped representation of the history of both Brazil and of the Brazilian Cinema, but also a summa of our themes—the family as allegorical microcosm, documentary report, reflection on history, the voice of the other, metacinema, intertextuality (even in the most literal sense), in a synthesis at once political, social, anthropological, and filmic.

Epilogue

After the euphoric interlude of "abertura," we find a present situation characterized by perplexity and disorientation. In the middle of deep economic crisis and the interminable striptease of the "transition to democracy," we now encounter, in some quarters, a kind of fatigue with the very idea of the national, a disenchantment with the nationalist project (or at least with the idea that it can be realized) along with a loss of faith in its relevance for the cultural debate. In the wake of concrete political disappointments and the world-wide self-questioning of the left, nationalist discourse has lost much of its explanatory power and political persuasiveness. To many it has come to seem "empty," lacking in historical substance and cultural specificity. Here Brazil accompanies and is inflected by a more general disenchantment, in the "peripheral" countries, with the old Third World liberationist discourse, as well as by novel political and philosophical currents in the "metropolitan" countries.

Along with national disenchantment, a "post-modern" internationalist discourse has emerged, a discourse that argues that the lines between center and margin have been erased, that the category of nation has become irrelevant. Within the global village of transnational capitalism, the new internationalists argue, all cultures are caught up in the meaningless whirl of mass-mediated simulacra; there is no escaping the international standardization of human existences. On a micropersonal level, meanwhile, we find everywhere a retreat from common beliefs and collective heroism in favor of an atomized society devoid of collective purposes, broken up into an infinity of self-seeking monads. At the same time, an altered philosophical conjuncture also subtly undermines the idea of the national. The structuralist and post-structuralist attack on the "centered subject," while on one level seeming to promise a reformulation of old hierarchies, on another casts doubt, by extension, on the nation as the noble protagonist of a collective epic, as a trans-individual cogito or Sartrean "self-writ-large." The deconstructive assault on all that is "originary," meanwhile, also calls into question the idea of an "originary" nation. The old utopia of "authentic" national culture, under all these onslaughts, comes to seem a meaningless and hopelessly nostalgic chimera.

But theory is lived differently depending on whether one is "centered" in Paris or in São Paulo. The Brazilian internationalists, those whom we might call the "anti-nationalist internationalists," do not by their mere wish magically cease living a national situation they would desperately like to transcend; the pathos of their internationalism derives precisely from their status as intellectuals on the peri-

phery. A conscious option for internationalism does not short-circuit the mechanisms that effectively disappropriate peoples of their culture or nations of their power. The nationalism-versus-internationalism debate in this sense calls for revised formulations. The "center" penetrates the margins, but the margins also have an impact on the center. The "marginal" countries are not temporally "behind" the countries of the center; instead, they live the same historical moment, but in the mode of oppression. The nostalgic nationalists, for their part, cannot through an act of will of the nation-subject annihilate an internationalism built into a society inevitably molded by the planetary spread of Euro-American culture and the international media. For if postmodernism has spread the feel of First World consumerist culture around the globe, it has hardly deconstructed the relations of power between the metropolitan and the marginalized countries.

Throughout this century, Brazil has received, translated, and critically revised any number of First World intellectual and artistic movements, reformulating the dominant culture so as to subtly undermine its claims to universal authority. One finds the zenith of such creative/critical reformulation in Brazilian popular music, in the ways that composer-singers like Caetano Veloso or Gilberto Gil anthropophagically absorb all of the world's musics in order to crystallize their conception of "Brazilianness." In such cases, we find a progressive matching between the international movements and the vital necessities of the national culture. In the 1980s, however, with the pervasive sense of the end of all utopias, the various international "post" trends have yet to find a liberatory "translation" in Brazil. And the notion of "anthropophagy" requires modification in the era of the mass-media, when the "marginal" country is as likely to be devoured as devouring. (The First World media, in this perspective, are eminently anthropophagic.) Certain forms of internationalism, in this sense, can become a cover for hegemony, and the postmodern rejection of the national a figleaf masking an ongoing process of peripheralization.

Notes

1. See, for example, Roberto Schwarz, "Cultura e Politica, 1964–1969," written in 1970 and anthologized in *Pai de Familia e Outros Ensaios* (Rio: Paz e Terra, 1977); O. C. Louzado Filho, "O Contexto Tropicalista," in *Aparte*, no. 2 (1968); Gilberto Vasconcelos, *De Olho na Fresta* (Rio: Graal, 1977); Celso Favanetto, *Tropicalia, Alegoria, Alegria* (São Paulo: Kairos, 1979); and Ismail Xavier, "Alegoria, Modernidade, Nacionalismo," (São Paulo: Editora Funarte, 1985).

2. See Fredric Jameson, "Third World Literature in the Era of Multinational Capitalism," *Social Text*, no. 15 (Fall 1986). And for an excellent cri-

tique of the Jameson essay, see Aijas Ahmad, "Jameson's Rhetoric of Otherness and the National Allegory," *Social Text*, no. 15 (Fall 1986).

3. See Joao Luiz Vieira, "From *High Noon* to *Jaws*: Carnival and Parody in Brazilian Cinema," in Randal Johnson and Robert Stam, eds., *Brazilian Cinema* (East Brunswick, N.J.: Associated Universities Press, 1982).

4. See Roberto Schwarz, "Nacional por Subtracao," in *Que Horas São* (São Paulo: Companhia das Letras, 1987).

5. See Benedict Anderson, *Imagined Communities: Reflexions on the Origins and Spread of Nationalism* (London: Verso, 1983); and E. J. Hobsbawm and Terence Rogers, eds., *The Invention of Tradition* (Cambridge: Cambridge University Press, 1983).

6. Renato Ortiz, *A Moderna Tradicão Brasileira: Cultura Brasileira e Industria Cultural* (São Paulo: Brasiliense, 1988).

7. Data included in Livia Antola and Everett Rogers, "Television Flows in Latin America," *Communications Research* 2, no. 2 (April 1984); and Tapio Varis, "The International Flow of Television Programs," *Journal of Communication* 34, no. 1 (1984).

8. There is now emerging a significant body of work, in Portuguese and in English, on Brazilian television. See, for example, C. R. Avila Avemdola, *A Teleinvasão: A Participação Extrangeira na Televisão do Brasil* (São Paulo: Cortez, 1982); Sergio Caparelli, *Televisão e Capitalismo no Brasil* (Porto Alegre: L & PM, 1982); M. E. Bonavita Federico. *Historia da Comunicação: Radio e TV no Brasil* (Petropolis: Vozes, 1982); Randal Johnson, "Deus e o Diabo na Terra do Globo: *Rogue Santeiro* and Brazil's 'New Republic,'" in *Studies in Latin American Popular Culture* 7 (1988); Maria Rita Kehl, "Reflexão para uma Historia da TV Globo" (Rio: Funarte, 1982), mimeo; Renato Ortiz, *A Moderna Tradicão Brasileira: Cultura Brasileira e Industria Cultural* (São Paulo: Brasiliense, 1988); Carlos Alberto M. Pereira and Ricardo Miranda, *Televisão* (São Paulo: Brasiliense, 1983); and Joseph Straubhaar, "The Transformation of Cultural Dependence: The Decline of American Influence on Brazilian Television Industry," Ph.D. dissertation, The Fletcher School of Law and Diplomacy, Tufts University, 1982.

9. Even the avant-gardist Julio Bressane, finally, in his *O Monstro Caraiba* (*The Carib Monster*; 1973) explores the Indian as national symbol in a filmic dialogue with Oswald de Andrade's "Cannibalist Manifesto" from the twenties. But Bressane reveals the Indianist theme as purely textual, the trace of the intermingling of cultures and ethnicities, a process that turns the spectators into readers of signs, rules, inscriptions, documents of the winners, and residue of diverse civilizations. The attempt to recuperate the past here leads only to a kind of hermeneutic vertigo.

10. It is important to note that allegorical critiques of the dictatorship were hardly limited to the cinema. In an illuminating article, Charles Perrone points out similar strategies in Brazilian popular music of the period. The Gilberto Gil/Chico Buarque song "Chalice," which in Portuguese evokes "chalice" and "shut up," recounts the despair provoked by imposed silence (read censorship) and was banned by the government in 1973, while Chico Buarque's "Apesar

de Vocen" (Despite you), banned in 1971, allegorizes rage against the military state as the vindictive harangue of a spurned lover, who fantasizes the carnival-like joy of the people at the projected fall of the unnamed "you." The song crystallized popular resentment and became widely known as "letter to Medici," the then-dictator. For more on allegory in Brazilian popular music, see Charles Perrone, "Open Mike: Brazilian Popular Music and Redemocratization," *Studies in Latin American Popular Culture* 7 (1988).

11. At times, this dialogue with Brazilian history takes on an archival-historiographic dimension in the effort to recover material hidden in studio warehouses, government offices, and libraries. A number of seventies films deploy photographs, archival footage, interviews, and off-screen narration in filmic reflections on the past. Exemplary in this sense are two films in the genre by Silvio Tendler, both of which concern Brazilian presidents. *Os Anos JK* (*The JK Years*; 1980) concerns Juscelino Kubitschek, the president who inaugurated Brasilia in the fifties, while *Jango* (1982) concerns Joao Goulart, popularly known as "Jango," the duly-elected president deposed by the 1964 coup. Both films demonstrate that even documentaries can be "allegorical," using a coded language that manipulates past events to talk about present policies. Agile exercises in historical apologetics designed to heighten the stature of their subjects, the films use fluent verbal/visual narration to laud the conciliatory liberalism of Kubitschek and the leftist reformism of Joao Goulart, in ways that reinforce the general spirit of *abertura* characteristic of the moment of the film's production.

12. Paulo Emilio Salles Gomes, "Cinema: A Trajectory Within Underdevelopment," in Johnson and Stam, *Brazilian Cinema*, 244–55, reprinted in this volume.

13. See Glauber Rocha, *Revolução do Cinema Novo* (Rio: Alhambra/ Embrafilme, 1981).

14. For Bakhtin on carnival, see *Rabelais and His World* (Cambridge: M.I.T. Press, 1968).

15. See Roberto Schwarz, "O Fio da Meada," in *Que Horas São* (São Paulo: Compania das Letras, 1987).

Suzana Amaral on Filmmaking, the State, and Social Relations in Brazil

An Interview

Michael T. Martin

Suzana Amaral[1] is a Brazilian filmmaker. A member of a prominent family of intellectuals and artists in São Paulo, she is mother to nine children. Amaral first attended the University of São Paulo when she was in her late thirties. Upon completing her degree in film, she taught at São Paulo University for three years and then joined the Radio and Television Cultura (RTC), São Paulo's counterpart to Public Television, where she produced, directed, and wrote screenplays. In 1975, Amaral enrolled in graduate film school at New York University, where she developed and honed her skills as a filmmaker, and after having graduated in 1978, she returned to Brazil.

Before directing *Hour of the Star*, at age 52, Suzana Amaral had completed over forty shorts and documentaries; including the award winning *My Life, Our Struggle* (1979). Her first feature, *Hour of the Star*, was Brazil's Academy Award nominee for Best Foreign Film in 1986, and it received numerous awards at the Berlin Film Festival (1986); Brasilia Film Festival (1985); International Women's Film Festival, Creteil (1986); and the Havana Film Festival in 1986.

This interview occurred on November 7, 1989, during a visit by Amaral to Princeton University where she introduced and screened *Hour of the Star*. In the interview, Amaral discusses her film, race relations, women and the state of filmmaking and television in Brazil.

Michael Martin: What were your experiences and training in film and television before directing the *Hour of the Star*?
Suzana Amaral: After having completed my undergraduate studies in film, I taught at the University for three years. I then worked for a

television company (RTC) in São Paulo for fourteen years. Working for a television station means that you have to learn how to work fast. I shot *Hour of the Star* in four weeks on a budget of $150,000. Under these conditions you have to be very fast, very economical, and have to know exactly what you want and exactly what you're doing. It is a very good experience working for a television station in Brazil. In the U.S. it is very difficult to have this experience because television stations usually don't hire as many people as they do in Brazil. In Brazil, they hire people to be producers, directors and writers, and they work a lot. In the U.S. they only hire people for television news as anchors. Most of their projects are assigned to different producers and production companies. Television stations in Brazil either make their own programs or they buy American films. So, there is no room left for [independent] Brazilian productions.

Martin: Why did you move from shorts and documentaries to narrative features?

Amaral: Since I began making films, my aim was to make feature films, but I had to work. While making documentaries, I became more aware of the reality and social problems of São Paulo. My interaction with the problems of São Paulo helped develop my perception of reality and my style as a filmmaker. However, I didn't know how to make features so I applied to New York University's graduate film school and received a grant from a Brazilian foundation to study there. While I was in the U.S., I read the novel *Hour of the Star* by Clarice Lispector. I was enthusiastic about it because it is an interesting story and because the character, Macabea, represents for me this anti-heroine quality that the Brazilians have. Believing that she was soon going to die, Lispector wrote *Hour of the Star* because she had never written a book which would have social implications. She was a bourgeois writer. I believe that she felt guilty and wanted to write a book concerned with social problems in Brazil because *Hour of the Star* is absolutely different from the others she wrote.

Martin: What problems did you encounter in adapting the novel to film?

Amaral: For me there are no problems in life. There are only pebbles inside your shoes that you have to stop and pick out and walk. In the beginning I didn't know how to solve the problem of the narrator. I could have made a film like the French love to make, this kind of voice-over thing. It could be the voice of this god who never shows up but I don't like voice-overs. I think that when you have voice-overs in films it keeps everything very cold, very distant and I wanted people to be much more involved in the action. Once you have this figure of the narrator in a film, it's very difficult to really be involved

in the story. So I decided that this was something that I didn't want. The narrator had to be myself, very straight forward, just telling the story.

Martin: Why the biblical name Macabea for the protagonist? The name suggests resistance, revolt and opposition though the character is portrayed as passive and apolitical?

Amaral: Well, I never questioned this name. It was chosen by the author, Lispector. I took the name as it was in the novel. All the names in the novel are in one way or another related to the characteristics of the characters. For example, Olimpico means a strong, beautiful man. He, however, is mean, ugly and awful. Gloria means glory, but she is a very awkward girl. Macabea could represent, as you said, strength. These names are ironic. They represent the opposite of their characters' personalities.

Martin: What is the subtext of Macabea's statement: "I am a typist and a virgin and I like Coca-Cola"? The class and consumer implications are clear. However, how are North American audiences to understand the implications of her virginity in the context of Brazilian society and culture?

Amaral: Being a virgin in the countryside is a very important thing, and Macabea comes from the North of Brazil. Lispector wrote the novel in the mid-1970s. I don't know if it is now the same, but at that time if a woman lost her virginity in the countryside, the father and brothers would kill the man, or make the man marry the woman. She is very proud she is a virgin.

Martin: What is the significance of the character, Carlota, the fortune teller in the film? Is she there to underscore the pull and power of myth at the level of everyday life among Brazilians?

Amaral: I would say that Carlota represents, for me, fate, destiny. Brazilians are very much into going to card readers. It is mystical. Something that attracts us. Even if they are bullshitting me, I enjoy it. This is also connected with *Macumba*. They are not only card readers. They are everything. It is a kind of mixture. I am not saying they are right, I don't believe in witches, but we have to respect them. They are there.

Martin: While your film is critical of urban industrial life in the South, it also presents differences of the North in Macabea's urinating while she eats, refusing to shower and refusing to wash her hands. Do you attribute this to the cultural underdevelopment of the North by the South?

Amaral: No, it's the underdevelopment of them [Northerns]. They are not used to the cultural development of the South. They are people who come from a part of the country where they don't have bath-

rooms. When they get to São Paulo they take the rooms as pension boarders. Why did she urinate in the pot? She could have gone to the bathroom. For Macabea the pot is natural. This is the way she has always used the bathroom during the night, because probably in the place where she was working she had to go outside.

Martin: Published reviews about your film describe Macabea, among other things, as being unintelligent. You, however, describe her as "poor, ugly and passive but not stupid." You appear to be making an important distinction here that has implications about the misperception of Northerners as inferior to their Southern counterparts.

Amaral: In the novel, Lispector describes Macabea as poor and passive. I wanted to be faithful to the author's portrayal of Macabea. Obviously she is poor. She was raised in poverty in the North. She is not bright. I would say that she was potentially bright but she was culturally undeveloped. Those people have no chance. If you take those kids that are not well fed and put them in school they will never learn because they are weak, physically weak. They are tired, they do not eat well. Those people are brought up eating flour, carbohydrates.

Martin: Is Macabea's death the triumph of modern consumer culture in Brazil?

Amaral: Yes, I would say so. The moment that she goes to the card reader and the way she succeeds is a metaphor for [cultural] imperialism, European or American. This model of beauty—a blonde, blue-eyed boy the embodiment of the foreign—suggests that the winners are the First World and the large multinational companies. Consumerism is winning the battle in Brazil at the expense of the people there.

Martin: Your film left me with the feeling that Macabea and, by extension, Northerners are doomed upon migrating to the South. Are you suggesting that Northerners' only salvation is to remain in the North despite deteriorating economic conditions there?

Amaral: Yes. If I could interfere in the reality, what would I do? I would say, do not come to the South. Northerners are much better off if they stay there. But if they have to fight to struggle. . . . It's very difficult because I am not from the North. If I were a Northerner, probably I would come to the South, to the wonderland. There is a joke in Brazil. These people from the North they have a kind of flat head. The kids grow flat heads because when they are kids, everyday their fathers tap them over the heads and say: "You have to grow in order to go to the South, you have to grow in order to go to the South." It is destiny for these people coming from the North because the South has always been the wonderland. Now its a little different, everyone from the South is going North to mine the Amazon, now it's different.

Martin: In an interview with Dennis West in 1986, you said that "Brazilians don't make history, Brazilians suffer history. The Brazilian does not act, he reacts."[2] All the characters in your film are portrayed as passive rather than historical subjects. Do you still hold this view about your countrymen and women?

Amaral: I think when I said history, it was not "history" with "h," it was the "story." What I said was misunderstood. First, who is the hero? A hero is someone who makes a story, not history, happen. They struggle, they act, and then the story ends. But Macabea does not make the story happen. What makes the story happen is what other characters do during the story. Macabea only reacts to what the other characters do. There are only two times that she takes action in the story: When she asks to take a day off to go to the dentist, and when she goes to the fortune teller. But she does this only after being encouraged by what Gloria does. She was also pushed by Gloria to go to the fortune teller. When I was in the U.S. I discovered the real character of my people. Brazilians are so passive. Macabea's passivity is also a metaphor for the passivity of the people. Expanding this metaphor, we can go into history with an "h." In Brazil we have no history of being a revolutionary people. You have several coups d'etat. The militaries come and go. Nobody reacts. All of us say "ok, ok." We never, like the Argentinians, for example, react! They take history in their hands. They shape the social history of their country. But in Brazil, no matter what the governors do, we take it.

Martin: *Hour of the Star* only hints at racism, in the scene where Macabea's roommates comment on the quality of women's hair. Why only a passing and superficial reference to this aesthetic concern that signifies racial status in Brazilian society?

Amaral: In the first draft of the novel's film adaptation, I worked with an Argentinian. He did a very bad job. I didn't like what he did with the dialogue. At a certain point, I transformed the script that he wrote, but this particular dialogue I liked. While I decided to keep this it was not intended to raise issues about racism in Brazil. Racism is such a big problem in Brazil. It is a problem that cannot be approached this way. If you go to Brazil you would say: "There are no problems here, no fights, no anger." But the racism is worse in Brazil. There is no [visible] racism as long as people remain in their places. I think it is very difficult for blacks in Brazil to change their social status. It is much more difficult than here in the U.S. Even though you would say that there is racism in the U.S., there is more racism in Brazil. This is too big a problem. I don't think I could have addressed this issue in such a superficial way. If I were to make a point about

racism in Brazil, I would have chosen to make a stronger kind of statement.

Martin: Why are contemporary race relations not the subject of film-makers' concerns in Brazil today?

Amaral: Because what happens at the social level also happens artistically. We are like ostriches. We don't want to see what is in front of us. Race is something that never occurred to me to make a film about.

Martin: Haven't the subjects of race and racism been dealt with in film sagas of slavery and resistance? For example, in the historical narratives *Quilombo* and *Xica*.

Amaral: Yes, it's historical. I think that the only director who has addressed this subject is Carlos Diegues. I think it has to do with this passivity—the character of the nation. I think that this passivity of ours is something that we have a very loose memory of. For example, in Argentina they are still making political films about the military (*Official Story*). But in Brazil, we did not make more than two or three films about the military problems we had, and we don't even have censorship anymore. It's very difficult to understand.

Martin: I was recently in Rio attending a conference concerned with the issue of race and racial difference in Brazilian society. Contrary to the myth of Brazil as a "melting pot," it is apparent that blacks occupy the lowest status in society. Why is class and gender the subject of discourse, while race is silenced?[3]

Amaral: Because it's a paradox. I think it is because of the nature of the Portuguese people. The Portuguese were a different kind of conqueror unlike the Americans or the Spaniards. They integrated with blacks. There are many more mulattoes in Brazil than in the U.S. [White] Brazilians did not grow up being told that blacks are bad, different, or mean. They are there, and we don't care. We are not angry with blacks. But if you are black in Brazil you have to be *Black.* You're white in Brazil but people who are black have to be Black. They are very humble, they are too humble. However, I think that in the future blacks in Brazil have to be more angry.

Martin: Are Brazilian filmmakers perpetuating the myth that there is no racial antagonism in Brazilian society?

Amaral: I don't think they are doing it consciously. It's something [racism] that is not yet a preoccupation for filmmakers because blacks haven't expressed themselves yet. There is no anger. It is a problem, but it is not a problem. It's there, but it is not something that is about to explode.

Martin: You have said in earlier interviews that you try to get at "the feminine soul" in your film. Is there a woman's aesthetic in *Hour of the Star?*

Amaral: I don't think it was on purpose. Maybe, now having seen what I have done, I will, in the next film, be more conscious, more self-conscious, about this kind of feminine, subjective camera. But my main concern in doing this film was to do a very good internal construction of the characters. I went into several details because I think that the small details represent what the person is. If you do something, the smallest details of your everyday life say a lot about your personality. I think that it is very important that when you are making a film, and trying to describe a character, to look after the small details, the things they do in their everyday lives construct the character's personality. So, when I was directing the film, I was really concerned with this issue.

But, as a woman, I see what men don't see. If I were a male director I probably would have other concerns. This is a problem of the theory of communication, because I have a code. As a woman I codify the world according to my code and my code is a feminine one. This is why it is evident in the film. It is not just a matter of being a director. If I made a film about a man I would show how a woman sees a man, and not the way a man sees a man. A male director directing a woman depicts women as objects, as persons that have meanings only according to what they mean to men. I do believe there is a subjective feminine camera, even though there are some women directors that direct like men. For example, Lina Wertmuller directs like a man. She doesn't see the world as a woman sees it. She portrays women as if they are men, and sexual relations as if she were a man.

Martin: What would constitute a woman's film?

Amaral: What would constitute a real woman's film is the woman director being honest and directing according to her own characteristics as a woman. It is very difficult for me to intellectualize. I only have working principles that I follow in my work. And the most important principle that I follow is that I try to be honest and to do what I really feel in the depths of my heart. If I am going to portray a sexual relationship I will do this from my point of view. I am not going to think who would be thinking about this relationship. I want to be faithful to my own principles. I want to be honest. I don't face this problem as if I always have to have a reason. I just have feelings and I am a woman, and how am I going to react in this situation? This is how I'm going to use the camera. Let me put it this way, I have no anger in me. I am not a feminist, and I have no anger against men. I don't believe this talk about being a woman. We just have to work. We work. We do our work and, in doing so, we are being feminist.

Martin: What is the position of women filmmakers in Brazil's film industry?

Amaral: I think it is good. There are now more than six women directors in Brazil, who work in film, video, and commercial advertisement film. Many other women work in the industry as cinematographers, art directors, and editors. There are many women working despite a very difficult economic situation that does not permit the production of many feature films. There is only one film being made right now [1989] in Brazil.[4]

Martin: What are some of the obstacles to women filmmakers?

Amaral: The same as men, at least in Brazil. I have never felt that because I am a woman, no one would finance my projects. It is difficult to get money as a professional whether you are a man or woman. I never had problems directing thirty, forty, fifty men. I scream, I shout, I do whatever I want. I always have had a very good relationship with my crews and, in filmmaking, as long as you prove that you are capable, they will respect you, whether you are a man or woman. I never felt any obstacles. If there were any I was not aware of them.

Martin: Are there more possibilities for women to work in television than film?

Amaral: There are more possibilities, especially in producing commercials and promotionals in Brazil. These are now made in video because films are very expensive to make. The advertising sector is very closed. They are full of preconceptions. I don't want to go back to television. They invited me but I don't want to because they pay very little and it's always very fast work. The results are not very good or as good as they could be in films. If I had to make something that is not a feature film, I would go make commercials and videos, and promotional films. They are more fun to make and they pay very well.

Martin: What is the impact of television on the film industry?

Amaral: The film industry in Brazil was never a very strong one. However, video and television were strong since they began. They have much more money for production than the film industry. For many years we relied on the Brazilian Film Institute to finance film production. Today, they are not even funding one film because they have no money. The economic situation is critical in this country. Because of the debt the first thing the government cuts are the cultural arts, not only films but also theater and the arts. There are not even enough funds for schools and health. The situation is very critical.

Martin: Is there a crossover from film to television among Brazilian filmmakers?

Amaral: No. In Brazil every television channel produces its own programs and has its own staff. Filmmakers don't want to work for these

television channels. Filmmakers are doing other work: advertisements, commercial videos, or trying to make their own features.

Martin: You have said earlier that you no longer have censorship in Brazil. What do you mean?

Amaral: We don't have military-state censorship, but we have economic censorship. When I went back to Brazil in the late 1970s, I experienced economic censorship. People complained about [state] censorship. Some argued that we should ask them [the state] to cut all monies to the various censorship offices and bureaus. I said, I think it is better to have censorship the way it is now, where you know the offices' locations and phone numbers. You can complain and fight them back. This is much better than economic censorship where theoretically everything is possible.

Martin: How pervasive are foreign films in the domestic market?

Amaral: Ninety-five to ninety-nine percent. Brazilians don't like Brazilian films. Even if you show them in theaters, Brazilians don't go.

Martin: Why?

Amaral: Like German audiences don't go to see German films, or the Argentinian audiences don't go to see Argentinian films. American films are much more popular. Everywhere in South America it is the same.

Martin: But isn't there a quota system established by the State?

Amaral: Yes. You must show so many days a year of Brazilian films but exhibitors prefer to pay the fine. They lose much less if they pay the fine than show the Brazilian films.

Martin: What is the significance of the "pornochanchados," the erotic comedies in Brazil? Are they produced only to satisfy this quota system or do they have a social function?

Amaral: No. They are produced to satisfy certain movie theaters. Now they are doing less and less. Even these porno comedies are not making money anymore.

Martin: What about the economic censorship issue that you raised earlier?

Amaral: It does not matter if the film has a social message. The government does not censor the film because of its subject. The film is censored because it doesn't make money. What I am saying is that it is much more profitable for the movie houses to show American films than Brazilian films. This is what I call economic censorship.

Martin: Are fewer people going to movie theaters?

Amaral: No. However, there are now very few theaters in Brazil. They are closing. I don't have the statistics but they have been closing a lot of movie theaters in the last year because they are located on valuable real estate in urban areas. It is now much more profitable to

put up supermarkets and hotels or sell the real estate. So theaters have been closing a lot, especially in the smaller cities and towns in the countryside. And in the larger cities, in the marginalized neighborhoods (*favelas*), people don't go to movie theaters. It's very expensive and the theaters are located in the middle class areas. Its not because of disinterest. They watch television, it is much less expensive. Even in the slums there are many televisions. It's a symbol of status everywhere. It's the same story all over the world. Its the story of the Third World.

Martin: Has Cinema Novo, with its political concerns and commitments, influenced your work?

Amaral: Not at all. When I started making my first short films in 1971 I always did what I wanted to do because since the 1970s we have had more freedom to do, as filmmakers, what we want to do. Even though I was the same age as other filmmakers of the *Cinema Novo* movement, I did not experience the same problems they had because I started later.

Martin: For those filmmakers of Cinema Novo who are still working, like Paulo César Saraceni and Pedro Rovai, what are they now doing?

Amaral: Saraceni directed a film in France. It was a flop. A very bad film. It was not released in France, nor in Brazil. The film was kept in the archives. I think Saraceni had problems with the French producers. They didn't want to distribute the film. They didn't even want to give him a print. Rovai is working as a producer. He is producing commercials to make money. And he is making a lot of money. I think that their dreams are over. They are much more into this thing of working for the system. Nelson just did a very commercial film. He produced it and his son was the codirector. Its a very commercial film.

Martin: Are social documentaries now being made in Brazil:

Amaral: No, not at all. If they are, I don't know where they are shown in Brazil. I think the social documentary is over. Occasionally, we see documentaries about the Amazon on television, but most of them are made by foreigners, like the English, Channel 4. I don't know if Brazilian filmmakers are worrying about social problems right now. It's not a matter of their work being censored. We can do whatever we want. Filmmakers don't want to lose time making social documentaries. Everyone is trying to make money because the country is in such a bad situation. They have to survive. These filmmakers have families, they have to work.

Martin: The Brazilian film industry is alive but not well from what you have said.

Amaral: I would say that it is in bad shape and it is going to get worse, much worse, as the economic situation worsens.

Martin: Is a video revolution occurring in Brazil?

Amaral: I would call it a video explosion. Because Brazil is in a very bad economic situation filmmakers are making promotional, institutional and commercial projects in video because they are much less expensive than film.[5]

Martin: Are you working on any new projects?

Amaral: This year I have been working on commercials and videos. I have to earn a living because making feature films does not produce much money. I have two American projects. One of them is to be produced by a Los Angeles film producer. She is struggling to get funds for this project. The film is to be shot in Argentina. The project is based on a book called *The Four Seasons of Manuela.* The other film project is an original story to be shot in Toronto. It is about a woman whose character is similar to Macabea. What I want to do right now is to have several projects so that when I finish one I don't have to wait for the next one. I also don't want to have to produce my own films anymore. I would like to be hired as a director and not be involved as producer.

Martin: You're not concerned about control of the project?

Amaral: No. I have to give it a try and see what happens, but I want to have control of the editing and everything. I never had this kind of experience, so I would rather experiment first.

Martin: You know the rules, cultural nuances, and practices of filmmaking in Brazil. Are you concerned about working in an unfamiliar environment?

Amaral: No, I am not concerned because I learned filmmaking in the U.S. I think the human soul is the same here or anywhere. If I am honest and try to comprehend and apprehend the character as a person, and if I construct the character internally in a proper way, I think I will succeed.

Martin: The reason why I ask is because some filmmakers, for example Paolo and Vittorio Taviani and Wim Wenders' styles have changed and cultural nuances eluded them when they filmed outside of their "home" environments.

Amaral: Yes, there is also this danger. But I am not working in a studio, you know. It's very difficult to assume beforehand what will happen. I would rather give it a try. I have nothing to lose. The worst that could happen is that the film is a disaster.

Notes

1. For additional biographical information about Amaral and *Hour of the Star*, see the press packet by the distributor of the film, Kino International, New York.

2. Dennis West, *"The Hour of the Star*: An Interview with Suzana Amaral," *Cineaste* 15, no. 4 (1987): 42.

3. See Rebecca Reichmann, "Brazil's Denial of Race," *NACLA* 28, no. 6 (1995): 35–45.

4. See William Fisher, "Brazil: Film Finance in the Age of Hyperinflation," *Sight & Sound* 59, no. 2 (1990): 101–4.

5. See Arlindo Machado, "Inside Out and Upside Down, Brazilian Video Groups: TVDO and Olhar Eletronico," *The Independent* 14, no. 1 (1991): 30–33.

Racial Representation in Brazilian Cinema and Culture

A Cross-Cultural Approach

Robert Stam

A sequence from Glauber Rocha's *Terra em transe* (*Land in Anguish*, 1967), a baroque allegory about Brazilian politics and the 1964 coup d'etat, illustrates the usefulness of a comparative, relational approach to issues of racial representation. The sequence satirically reenacts the arrival of Pedro Cabral, the Brazilian Columbus, on the shores of Brazil in the year 1500. The right wing figure of the film (named Porfirio Díaz after the Mexican dictator) arrives from the sea with a flag and a crucifix. Dressed in an anachronistic modern-day suit, he is accompanied by a priest, a conquistador, and an Indian. Díaz approaches a huge cross fixed in the sand and performs a ritual evoking, for the Brazilian spectator, the famous "first mass" celebrated by Cabral in the newly "discovered" land, but in an anachronistic manner which stresses the continuities between the conquest and contemporary oppression; the contemporary dictator is portrayed as the latter-day heir of the conquistadores. But Rocha further destabilizes meaning by making Africa a textual presence. The very aesthetic of the sequence, first of all, draws heavily from the Africanized forms of the samba pageant, with its anachronisms, its polyrhythms, and its delight in extravagant costume; indeed, the actor who plays the conquistador is Clovis Bornay, a well-known figure from Rio's carnival. Secondly, the mass is accompanied not by Christian religious music, but by Yoruba religious chants of exaltation, evoking the "transe" of the Portuguese title. Rocha's suggestive referencing of African music, as if it

This essay is a significantly revised version of an essay that originally appeared in *Iris* no. 13 (Summer 1991), pp. 125–48. By permission of the author.

had existed in Brazil prior to the arrival of Europeans, reminds us not only of the "continental drift" theory that sees South America and Africa as once having been part of a single land mass, but also of the theories of Ivan Van Sertima and others that Africans arrived in the New World "before Columbus."[1] Africans, the music suggests, as those who shaped and were shaped by the Americas over centuries, are in some uncanny sense also indigenous to the region. At the same time, Rocha deploys the music as part of an ironic reversal, since the Yoruba chants of exaltation are repeatedly associated with the dictatorial figure of Díaz. Although Europe posits African religion as irrational, hysterical, the film suggests, in fact it is the European elite which is irrational, hysterical, entranced. The presence of a mestizo actor representing the Indian, furthermore, points to a frequent practice in Brazilian cinema, where Indians, who had the legal status of "wards of the state," were not allowed to represent themselves, and were often represented by blacks. While in the United States white actors performed in blackface, in Brazil blacks performed, as it were, in "redface."

The Relational Method

The question of ethnic/racial representation in the cinema, as the analysis of this sequence suggests, can be profitably studied in the larger context of the racial ideologies and cinematic representations offered by the other racially plural societies of the Americas, with their shared history of colonialism, conquest, slavery and immigration. Throughout the Americas and the Caribbean, we find variations on the same racial theme—the shifting relationalities of the fundamental triad of indigenous "reds," African "blacks," and European "whites."[2] The nature of the mix may vary—in Mexico indigenous and European (with an admixture of black), in Jamaica and Haiti a black-dominated mix, in Brazil an indigenous-black-European melange—just as the power relations between the diverse communities may vary, but the fact of racial heterogeneity obtains almost everywhere, including in the United States. One of the consequences of Eurocentrism, however, is that North Americans tend to look to Europe for specular self-definition rather than to the multi-racial societies of our own hemisphere. While it is a commonplace to say that Latin America is a mestizo continent, many North-Americans have been slow to recognize that "United Statesian" culture is also mestizo, mixed, hybrid, syncretic. While the syncretic nature of other societies is "visible," the syncretic nature of American society, at least within the dominant discourse, has often remained "hidden." And even the currently fashionable academic dis-

cussions of "hybridity" tend not to acknowledge the long history of such discussions within Latin American cultural criticism. While the North American vision of national identity has generally been premised on an unstated yet nonetheless normative "whiteness," the Latin American and Caribbean discussion of national identity—for thinkers such as Justo Sierra, Jose Vasconcelos, Carlos Fuentes and Octavio Paz in Mexico, for Edouard Glissant and Aimé Césaire in the Caribbean, and for Mario de Andrade, Paulo Prado, and Gilberto Freyre in Brazil—has generally been premised on racial multiplicity. While the North American national character has been explained as a function of the puritanical religious character of the country's founders (Perry Miller), or of the impact of the frontier experience on the national personality (Frederick Jackson Turner, R. B. Lewis), or of the shaping power of egalitarian political institutions (de Tocqueville), theorists of national identity have tended to downplay its specifically racial dimension.

Latin American intellectuals, in contrast, have tended, at least since the beginnings of the last century, to conceive national identity in racially plural terms. I am in no way suggesting that Latin American theorists were less racist—indeed many excoriated the black and indigenous presence as a source of "inferiority" and "degeneracy," or deployed the notion of *mestizaje* to mask oppressive racial hierarchies —only that they were more conscious of the primordial role of diverse races in the national formation. The Brazilian poet Olavo Bilac in the 1920s saw Brazilian art as the "loving flower of three sad races," while anthropologist Gilberto Freyre in the 1930s saw Brazil's racial diversity as the key to its creativity and originality.[3] What Freyre was fond of calling a "New World in the Tropics" was for him made possible by the cultural fusion of three genetically equal races—the Portuguese, the Indian, and the African—each of which made an invaluable contribution (even if Freyre tended to downplay slavery as a system of production while romanticizing slavery and "folklorizing" the black and indigenous contributions). Instead of miscegenation as an obstacle to a Eurocentrically conceived "progress," Freyre saw miscegenation itself as a progressive mechanism. In this myth of national origin, as Dain Borges sums it up, "the mestizo Brazilian son accepted and transcended his Portuguese, Indian, and African parents."[4] Brazilian filmmaker Joaquim Pedro de Andrade's planned adaptation of Freyre's *Casa Grande e Senzala*, never finished because of the director's untimely death, would have dramatically staged (and critically updated) Freyre's theories.[5] An examination of the script reveals that the film would have orchestrated a polyphonic encounter among Brazil's various source cultures, offering diverse racial per-

spectives—indigenous, Afro-Brazilian, Portuguese—on the national experience. There was to be a place for indigenous resistance (warfare, anthropophagy), black resistance (the *quilombos* or fugitive slave republics) and even for Sephardi Jews fleeing the inquisition.[6]

A cross-cultural dialogical approach makes entire cultures and film traditions susceptible to what Bakhtin calls "mutual illumination." (The metaphor of *mutual* illumination assumes that the "light" is generated from both sides of the cultural divide; it is not a question of a unilateral Promethean flame). As a vast New World country, similar to the United States in both historical formation and ethnic diversity, Brazil constitutes a kind of southern twin whose strong affinities have been obscured by Eurocentric assumptions. Both countries began as European colonies, one of Portugal, the other of Great Britain. In both, colonization was followed by the conquest of vast territories and the near-genocidal subjugation of indigenous peoples. In the United States, the conquerors were called pioneers; in Brazil they were called *bandeirantes* (flag-bearers). Both countries massively imported blacks from Africa to form the two largest slave societies of modern times, up until slavery was abolished, with the Emancipation Proclamation of 1863 in the United States, and the "Golden Law" of 1888 in Brazil. Both countries received waves of immigration, often the same waves of immigration, from all over the world, ultimately forming pluri-ethnic societies with substantial Indian, Black, Italian, German, Japanese, Slavic, Arab, and Jewish communities.

Comparative analysis stresses the analogies not only within specific national film traditions—e.g, analogies between the representation of African-Americans and native Americans within Hollywood cinema—but also the analogies/disanalogies between the representations of both groups in relation to their representation within the other multi-ethnic film cultures of the Americas. Such a comparative approach juxtaposes whole constellations of representional practices. It is revelatory, for example, to compare the cinematic treatment of the indigenous peoples in Brazil as opposed to the United States, and the relation of that treatment to the representation of blacks. While blacks were a frequent (if much abused) presence in North American silent cinema, they form a kind of "structuring absence" within silent Brazilian Cinema—the rare exceptions consisting of adaptations of race-conscious novels such as Harriet Beecher Stowe's *Uncle Tom's Cabin* (1910), Aluizio Azevedo's *Mulato* (1917), and Bernardo Guimaraes' *A Escrava Isaura* (*The Slave Isaura*, 1929). The film histories of both countries feature scores of silent films, on the other hand, devoted to the "native American" or the "native Brazilian." Both cinemas offer numerous adaptations of nineteenth-century "Indianist" novels, for ex-

ample of Jose de Alencar's *Iracema* in Brazil, or of James Fenimore Cooper's *The Last of the Mohicans* in the United States. (In Brazil, there were four filmic adaptations of *O Guarani* and three of *Iracema* in the silent period alone.) The tradition of "Indianist" works, in a broader sense, continues up to the present in both countries, as is evidenced by Guerra's *Quarup* (1989) in Brazil and Costner's *Dances with Wolves* (1990) in the United States.

Brazilian Cinema, however, lacks the western's racist depiction of Native Americans as dangerous war-whooping savages; there is no "imagery of encirclement" (Tom Engelhardt) pitting threatened whites against screaming hordes.[7] Instead, the early Brazilian films recapitulate the values of the romantic "Indianist" movement whereby the indigenous populace is portrayed as healthy, pure, and heroic, a nostalgic exemplar of a vanished golden age. The Brazilian films celebrate the *"bravo querreiro"* (brave warrior). The myths purveyed in these works, moreover, are myths of racial syncretism and fusion. They constitute what Doris Sommer calls "foundational fictions," in which "star-crossed lovers represent particular regions, races, parties, or economic interests which should naturally come together."[8] Like the Indianist novelists, the filmmakers saw Brazil as the product of the fusion of the indigenous peoples with the European element into a new entity called "the Brazilian," a fusion figured forth in the marriage of the Indian Iracema and the Frenchman Martins in *Iracema*, or the love of the indigenous Peri and the European Ceci in the same novelist's *O Guarani*. *O Guarani* concludes with the symbolic merging of two rivers, a figure for the melding of the indigenous peoples with those of Europe. North American novelistic and filmic treatments of the native American, in contrast, are more likely to emphasize the doomed nature of love between European and native American. The idea of racial miscegenation, then, is celebrated, if ambiguously, in Brazilian culture, while the very idea of miscegenation has tended to generate fear and paranoia in North America, a paranoia encapsulated in an intertitle from William S. Hart's 1916 film *The Aryan*: "Oft written in letters of blood, deep carved in the face of destiny, that all men may read, runs the code of the Aryan race: our women shall be guarded."[9]

But this difference in the representation of racial relations does not, ultimately, indicate that Brazilian cinema is more "progressive" toward the native Brazilian. First, the celebration, in Brazilian films, of the Indian as "brave warrior," the spiritual source and symbol of Brazil's nationhood, the mark of its difference from Europe, involved an element of bad faith toward Indians themselves. Since the behavior of white Europeans, in Brazil as in the United States, was fundamentally

murderous, this exaltation of the disappearing Indian, dedicated as it was to the very group being victimized by literal and cultural genocide, involved a strong element of hypocrisy. Second, the ambiguous "compliment" to the Indians was a means of masking the massive African presence in Brazil. The myth of the Indian Princess became an ingenious answer to an unstated question: "why are we Brazilians so dark?" The exaltation of the Indian was also a way to bypass the vexed question of blacks and slavery. (While the enslavement of Indians was abolished in the 1830s, enslavement of Africans was banished only five decades later). The proud history of black rebellion in Brazil was also ignored; the mythically brave Indian warrior, it was subtly insinuated, resisted slavery, while blacks did not. The white literary and filmmaking elite in Brazil, in sum, chose the exoticized and mythically connoted Indian, symbol of the national difference from the detested Portuguese, over the more problematically present black, subject to a slavery abolished just a decade before the inauguration of the cinema in Brazil.

A third intermediate group—European immigrants—also enters into this complex and shifting set of relationships. In both Brazil and the United States the cinema was profoundly inflected by the presence of immigrants, largely Italian in the case of Brazil and largely Jewish-European in the case of the United States.[10] In Brazil, this relationship meant that while immigrants were not responsible for the institution of slavery, and while they were often themselves the objects of exploitation by the Portuguese-based elite, collectively they were the winners, and blacks the losers, of this period of Brazilian history. Immigrant filmmakers, as a consequence, were not likely to filmically explore the oppressive situation of the very group that they themselves had economically displaced. (This displacement was quite literal, since the Brazilian elite consciously opted to recruit European immigrants as workers rather than employ the newly freed slaves.[11] In the United States, in contrast, the wave of immigration that contributed to the formation of Hollywood cinema came many decades after the abolition of slavery, not just one decade later as in Brazil. Blacks, furthermore, were numerically a clear minority in the United States, rather than the marginalized majority as in Brazil. That the Hollywood immigrants were Jewish, furthermore, a group which was not simply European but also the victim of Europe, its "internal other," in Todorov's apt phrase, meant that there operated a complex play of analogy and identification between Jews and blacks—seen in the black identification with the images and myth of the Hebrew Bible, and in the Jewish appropriation of black voices and musicality (Gershwin, Jolson)—an intricate dynamic of identification and appropriation

more or less absent from the relation between Italian immigrants and blacks in Brazil. While some North American films have thematized the black/Jewish encounter—from the *Jazz Singer* through *Angel Levine* to *Mo' Better Blues*—virtually no Brazilian films have focalized the black/Italian relationship. Tizuka Yamasaki's *Gaijin* posits a broad communality of interest between blacks and immigrants (be they Italian, Japanese or Spanish), but no specific ethnic dialogue structures the film. (Few Brazilian films, by the same token, focalize the black/Jewish relationship, although Carlos Diegues' *Quilombo*, as we shall see, constitutes a partial exception in this regard.)

The Multi-Racial Protagonist

A comparative approach also turns up surprising affinities and parallels between specific films. Both the Brazilian film *Macunaíma* (1969) and Woody Allen's parody documentary *Zelig* (1983), for example, feature multi-racial protagonists who are the products, ultimately, of the miscegenated histories of the Americas. *Macunaíma*, an adaptation and updating of Mario de Andrade's classic modernist novel (1928), concerns the racial and social transformations of a Brazilian anti-hero, while *Zelig* revolves around a chameleon man's uncanny ability to take on the ethnicity of his interlocutors. The protagonists of both films undergo racial metamorphoses. Born white and Jewish, Zelig subsequently becomes Indian, Black, Irish, Italian, Mexican and Chinese. Macunaíma is born Indian and Black, but subsequently transforms himself into a white Portuguese prince and even into a French divorcee. These metamorphoses are diversely handled in cinematic terms, of course: *Macunaíma* relies on the use of two actors and "magical" editing substitutions, while *Zelig* deploys a rich panoply of devices such as make-up, manipulated photographs, ironic "anchorage," and trick cinematography. The theme, in any case, is the same. Both Macunaíma and Zelig are oxymoronic protagonists, larger-than-life composite characters who epitomize ethnic interaction and hybridization. Macunaíma, the "hero without any character," as the novel's subtitle has it, lacks character not only in the conventional moral sense but also in that he is ethnically plural, simultaneously black, Indian and white European. Zelig, too, might be called a "hero without any character," again both in a characterological and in an ethnic sense. Both protagonists demonstrate the potentialities of chameleonism; both "try on" ethnic selves like the carnival revellers evoked in Mario de Andrade's poem "Carnival in Rio," who move from one identity to another simply by changing costume.

Both the novel and the film *Macunaíma* play on the same ethnic triad of "red," "black" and "white." In the first sequence, an improbably old white woman (actually a man in drag) stands and grunts until she/he deposits a wailing fifty-year old black "baby" on the ground. The names of the family members—Macunaíma, Jigue, Manaape—are Indian, but the family is at once black, Indian and European. Both protagonists personify the cultural "heteroglossia" or "many-languagedness" of the cultures from which they emerge. They resemble their cities—New York and São Paulo—which are like them the sites of constant metamorphosis, maelstroms of perpetual tension, disintegration, assimilation, and renewal. Roughly equivalent in population, New York and São Paulo share common features in terms both of historical origins and present-day ethnic composition. In both cities indigenous populations preceded the European arrival, and in both cases the indigenous presence left traces in place names: Manhattan and Montauk in New York, Ipiranga and Pacaembu in São Paulo. Historian Warren Dean points out that the historical destinies of New York and Brazil were linked from the beginning. In the seventeenth century, Dutch settlers brought Afro-Brazilian slaves with them from Brazil to what was then called New Amsterdam, and even granted them a measure of freedom in order to make them allies in the fight against the British.[12] The first Jews to arrive in New York were Sephardim who came from Recife, Brazil in 1636 and founded the synagogue which still stands on West 70th Street, in Manhattan. In the nineteenth and twentieth centuries, New York and São Paulo received some of the same waves of immigrants from the same countries: Germans, Italians, Jews from Poland and Russia, Arabs from Lebanon and Syria, Chinese, Japanese and so forth. Both received as well "internal immigrants" such as blacks from the South, in the case of New York, and blacks from Bahia and Minas, in the case of São Paulo. Both cities have their Italian neighborhoods—Little Italy in New York, Bras and Bexiga in São Paulo—their turn-of-the-century Jewish communities—the lower east side in New York, Bom Retiro in São Paulo—and their Asiatic communities—Chinatown in New York and the Japanese district called "Liberdade" in São Paulo.

It is a sigificant coincidence, perhaps, that both Mario de Andrade and Mikhail Bakhtin were elaborating theories of artistic "polyphony" in the twenties. For Bakhtin, polyphony refers to the co-existence, in any textual or extra-textual situation, of a plurality of voices which do not fuse into a single consciousness but rather generate dialogical dynamism among themselves.[13] De Andrade, for his part, defined polyphony as the "simultaneous artistic union of two or more melodies whose temporary effects of sonorous conflict collaborate to create a

total final effect," a definition in some ways not terribly distant from Bakhtin's.[14] And although neither author was thinking specifically of a polyphony of ethnic/racial voices per se, an ethnic interpretation is in no way excluded by the term.[15] Mario de Andrade, significantly, was himself of mixed race: he somatically embodied the indigenous, African and European inheritance, and multiplicity of identity was one of the leitmotifs of his work. Echoing Walt Whitman, Mario proclaimed that he contained multitudes: "I am three hundred, three hundred and fifty."[16] His identity was "harlequinate," simultaneously red, black and white, but also French, through his schooling, and Italian, because of his love of music.[17] The concept of multiple and simultaneous racial identities, at once personal and national, then, made it possible for Mario de Andrade to imagine the self as a polyphonic orchestration of racial and cultural identities, lived, of course, with asymetries of social power evoked by Bakhtin's "heteroglossia" or "many-languagedness."[18]

Racial Representation in a Comparative Perspective

While historians such as Eugene Genovese, Stanley Elkins and Frank Tannebaum have seen the necessity of understanding the history of slavery within a comparative perspective, and while theorists like Paul Gilroy and art historians like Robert Farris Thompson have insisted on an "Atlanticist" and "diasporic" perspective, historians of the cinema have rarely thought in such broad transcultural terms. They have rarely placed either United States or Brazilian Cinema within a broad, comparative context.

There is by now a vast comparative literature concerning slavery and race relations in the Americas. Historians have pointed out that slavery in Brazil and the United States, and the sequels of slavery, were hardly identical.[19] First, in Brazil, slavery existed across the entire national territory, while in the United States slavery existed only in the South, although it clearly implicated the entire national territory. Second, while the United States abolished slavery with a swift legislative stroke in 1863, during an apocalyptic civil war, Brazil abolished the institution only gradually, first freeing children born of slaves in 1871, then freeing slaves over sixty years of age (in 1885) before unconditional abolition in 1888. Indeed, abolition itself constituted a belated recognition by the state that the vast majority of Afro-Brazilians had already obtained their own emancipation. As a result there was a large number of free blacks, whose status, both before and after abolition, was not very different from that of lower-class whites. Thus the film *Chico Rei* (1982) portrays a freed black mining entre-

preneur in 18th century Minas Gerais, and *Xica da Silva* (1976) ex-
plores the historical case of a black woman who became a kind of
power behind the throne through her liaison with a Portuguese politi-
cian. Third, racial classification in Brazil as early as the nineteenth
century was pluralistic, involving not an epidermic black-white di-
chotomy based on ascendancy, but rather a subtle (if nonetheless rac-
ist) schema involving a complex interplay of color, facial features, and
social status. Fourth, in ideological terms, Brazilians rejected what
they saw as a retrograde segregationist racism in favor of a paternalis-
tic "ideology of whitening" which "allowed" a decidedly mixed popu-
lation to gradually "cleanse" itself through intermarriage. Faith in the
likelihood of whitening, in other word, led Brazilian elites to encour-
age miscegenation, rather than proscribe it in the phobic North Ameri-
can manner.[20] Some have also argued for the existence of what Carl
Degler calls the "mulatto escape hatch," by which Brazilians of mixed
ancestry were encouraged to abandon their darker brothers and sisters
in the name of their own upward social mobility. But if the "mulatto
escape hatch" ever existed in the past, there is more and more evi-
dence in the present that blacks and mulattoes are discriminated
against more or less equally).[21] Fifth, while North American racial
segregation ironically favored the development of parallel institutions
—the black Church, an independent black press, sports organizations
—the Brazilian situation encouraged a paternalistic dependency on
elite (i.e., white) institutions. On the other hand, while African-Amer-
icans largely adopted the Christian religion—even if "read" in a criti-
cal, subversive and at times even millenarian manner, Afro-Brazilians
managed to maintain African and Africanized religions such as *can-
domble* and *umbanda*—the partial subject of films such as *O Pagador
de Promessas* (1962), *Barravento* (1962), *A Forca de Xango* (1979),
Samba da Criacao do Mundo (1979), *Amuleto de Ogum* (1975), *A
Prova de Fogo* (1981), *Egungun* (1982) and many others.

An important demographic difference distinguishes North Ameri-
can from Brazilian racial patterns. While Blacks in the United States
have always formed a minority both in terms of numbers and in terms
of power, black and mulatto Brazilians form part of the marginalized
majority of Brazilian citizens. It is thus a Eurocentric misnomer, as
Abdias de Nascimento points out, to call Brazil a "Latin" country"; it
might better be called an Amerindian, Afro-Iberian country. The very
definition of blackness, furthermore, is quite different in the two coun-
tries. The North American vision has tended to incline toward bina-
rism: a person is either black or white; there is no intermediate
position. Even partial African ancestry defines a person as black.[22]
The 1980 Brazilian census, in contrast, lists four basic racial groups:

brancos (whites, forming 54.8% of the population); *pardos* (browns, mulattoes, 38.6%); *pretos* (blacks, 5.9%)) and *amarelos* (yellows, asiatics, 0.67%).[23] The combined figures for blacks and mulattoes give us a total of 45% of people who would be considered black within an American spectrum—a conservative number given the Brazilian tendency to "whiten" one's self-definition. In fact, a recent black movement campaign ("Campanha Censo 91") warned blacks against *"auto-embranquecimento"* (self-whitening) in responding to the official census. The campaign's punning slogan was "Nao deixe a sua cor passar em branco" or "Don't let your color be passed off as white/be a null vote." The Brazilian system, nevertheless, has generally been less concerned with ancestry than the North American: its racial spectrum nuances shades from *preto retinto* (dark black) through *escuro* (dark) and *mulato escuro* (dark mulato) to mulato claro (*light mulato, moreno* and *branco de Bahia* (Bahia-style white). These differences in racial perception are linked to the distinct modalities of Brazilian racism, which consists less in a binary, supremacist white-over-black than in the superimposition of an official integrationist ideology ("racial democracy") on a power structure that subtly enforces and promotes the idea that "white" is "better." Rather than a strident racism, Brazil's white elite favors a kind of "cordial" paternalism, a suffocating embrace which is in some ways even more difficult to "name" and thus to combat. Brazilian racism operates within a kind of patriarchal intimacy, and in this sense resembles sexism as much as it resembles North American racism. It takes the form not of virulent hatred but of a quasi-affectionate role stereotyping. Indeed, Brazil is the country of racial schizophrenia. In the privileged moments of Brazilian life, in carnival, for example, Brazil celebrates its own blackness. Yet if Brazil's soul is black, its persona and its ideal ego remain white. The many filmic homages to Afro-Brazilian culture are projected into a social conjuncture in which blacks are excluded from the centers of decision. Cultural victories mask political defeats.[24]

In both Brazilian and U.S. society, the dumb historical inertia of slavery structures current oppression. In Brazil, the structural mechanisms of the Brazilian social formation largely deprive blacks of economic, social, and political power. Blacks are vastly under-represented in positions of prestige and projection; they are virtually nonexistent in the higher echelons of the military, the diplomatic corps, higher education, and the government. There were only a dozen black representatives, out of 559, to the 1990 Constitutional Assembly, and among those few were some who did not identify with black causes. Roughly 40% of the non-white population is illiterate, while white illiteracy rates are 20%. Only 1% of black Brazilians define themselves

as "patroes" (bosses, owners) while 79% of whites so define them-
selves.[25] While under-represented in the universities and the diplo-
matic corps, blacks are over-represented in the favelas, the prisons,
and in the ranks of the unemployed. Many of these issues came up at
the time of the *centenario*, the 100th anniversary of the abolition of
slavery on May 13, 1988. Protest manifestoes and position statements
bore such titles as "March in Protest of the Farce of Abolition;" "100
Years of Lies;" and "Discommemoration," while a persistent editorial
leitmotif was the idea that "slavery has not really ended." We find the
same critical spirit in two Afro-Brazilian directors. Zozimo Balbul's
Abolicao (*Abolition*, 1988) exposes the limits of "racial democracy" a
century after the abolition of slavery, and Silvana Afram's *Mulheres
Negras* (*Black Women of Brazil*, 1986) examines the ways that Black
Brazilian women have coped with both racism and sexism while ex-
ploring collective identity through African-derived religion and music.

Blacks are vastly under-represented in the mass-media, certainly in
the cinema but especially in television and in advertising.[26] In terms of
the cinema, blacks have had only a minimal role in scripting, directing
and producing Brazilian films. While there are many black actors and
actresses (Grande Otelo, Tony Tornado, Milton Goncalves, Zeze Mot-
ta, Antonio Sampaio), there are only a handful of black directors—
Haroldo Costa, Antonio Pitanga, Waldyr Onofre, Odilon Lopes, Zo-
zimo Balbul—and few of them have managed to make second fea-
tures. Their films, furthermore, have not enjoyed the degree of success
generated by the films of Spike Lee, Charles Burnett, Julie Dash and
Bill Duke in the United States. Nor do they necessarily foreground ra-
cial themes. In television and the mass-media, blacks are even more
under-represented, so that televisual commercials, news programs, and
advertisements are more evocative of Scandinavia than of a black and
mulatto-majority country. A 1988 analysis of images of blacks in ad-
vertising found that out of 203 ads from TV and weekly newsmaga-
zines, blacks appeared in only 9.[27] The blonde TV star Xuxa, with her
fair skin, blond hair, and blue eyes seems to incarnate a certain ego
ideal for the country.[28] Even in Salvador, the most Africanized city in
Brazil, the news anchors tend to be white or very light-skinned mu-
latto. While the prime-time soap operas (*telenovelas*) have occasion-
ally foregrounded African-Brazilian themes, they have tended to
focalize white protagonists while relegating black characters to the
margins.

Certain features of Brazilian life and society give a superficially
humane face to what remains, in structural terms, a profoundly racist
society. Brazilian history since abolition has not been marked, for ex-
ample, by the virulent racism of the Ku Klux Klan. Unlike the United

States and South Africa, there is no tradition of ghettoes or racial seg-
regation, nor has there been a history of racially-motivated lynching
or murder, although a barely concealed racial subtext clearly lurks be-
hind such phenomena as the para-police murder of street children.
Brazilian film history features no white supremacist films like *Birth of
a Nation*. On the other hand, it also features no independent black
producer/directors like Oscar Micheaux or Spencer Williams, no *Do
the Right Thing* or *Sweet Sweetback's Baadasssss Song* or *Daughters
of the Dust*. Because of wide racial mixing, partially as a result of
slave-owner rape of slave-women, but also as a result of voluntary
unions going back to the earliest periods of Brazilian history, Brazil is
a deeply mestizo country. Unlike the United States of slavery days,
where white exploitation of black women was masked by a neurotic
obsession with racial purity and a hypocritical phobia about sexual
mixing, in Brazil less onus has been attached to interracial sex or mar-
riage. The carnivalesque festivities which greet the sexual liaison of
the ex-slave Xica and the powerful Portuguese official on the Minas
diamond frontier in *Xica da Silva*, would be quite simply unthinkable
in a North American context. Indeed, the legendary power which Xica
temporarily gathered in 18th-century Brazil would be inconceivable in
the United States of the same period.

On the other hand, the comparative racial perspective, once consid-
ered flattering to Brazil, is becoming less and less in the light of polit-
ical evolution in the world. Now that South Africa has moved to black
majority rule under Nelson Mandela, and now that it has become
commonplace in the U.S. to have not only black celebrities but also
black mayors, black generals, and black intellectual heroes, Brazilian
society is looking more and more retrograde. Brazilian racial dynam-
ics now seem, as Howard Winant puts it, "ossified and anachronistic,
plagued by something like a false consciousness."[29] At the same time,
many analysts point to a kind of racial convergence, as the United
States moves from black-white polarity to a more multipolar system,
and as Brazil moves toward the politicization of racial identities, with
some black activists calling for reparations.[30]

The causal relation between oppression and skin color is obscured
in Brazil by the relative (and only apparent) lack of racial tension and
by the fact that blacks and mulattoes often share similar living condi-
tions with many lower-class whites and near-white mestizos. This
sharing of life conditions means that many blacks and whites occupy
similar positions in the class structure. (Poverty is also at times shared
by blacks and poor whites in the United States, but in a situation of
segregation where divisions have been exploited by the power struc-
ture). This neighboring of blacks, mulattoes and poor whites also im-

plies a wide range of social intercourse between the two groups—
evidenced in films such as *Rio 40 o* (1954) or *Cinco Vezes Favela*
(*Five Times Favela*, 1962) or even *Pixote* (1980)—ranging from
friendly and superficial contacts on the job and in racially mixed
neighborhoods to more intimate friendships and marriages. Neverthe-
less, the fact that Brazilian capitalism oppresses poor whites as well as
blacks does not mean that this oppression is not also racial. Race, in
this sense, is both a kind of salt rubbed into the wounds of class, and
a wound in itself. A 1962 film *Asalto ao Trem Pagador* (Attack on
the Pay Train, 1962), a film about a multi-racial gang of thieves, in-
sists on this point by having a white member of the band tell a black
member that he, the black, will never be able to spend his stolen loot
since everyone would be suspicious of a black man with money. In a
scene somewhat exceptional for its naked racial hostility, the white
tells the black: "I'm the one who looks like a guy with money, not
you. I have blond hair and blue eyes, while you . . . look like a mon-
key!" The black then shoots him and orders the other gang members
to throw him in the river, so "the fish can feed on his blue eyes."

We find more contemporary echoes of disenchantment with the
Brazilian racial model in popular music, where the celebrants of *mes-
tizagem* begin to turn a critical eye on racial practices and ideologies.
The Gilberto Gil/Caetano Veloso rap song "Haiti," included in *Tropi-
calia II* (1993), compares Brazil, unflatteringly, to the Haiti of the
generals. The song's lyrics musically depict the intersection of race
and class in a country where:

> soldiers, almost all black
> beat up black *malandros*
> beat up mulatto thieves and other thieves, almost white
> but treated like blacks
> just to show to the others, almost black
> and they are almost all black
> and to the almost white, but poor like blacks
> how it is that blacks, poor people, and mulattoes
> and almost white, almost black from being so poor
> how it is that they are treated.

The same song speaks of the "massacre of 111 defenseless prisoners"
in São Paulo, where "prisoners are almost always black / or almost
black, or almost white / almost black from being so poor." At the
same time, the song hears the sounds of hope in the *batuque* of Olod-
um, the drumming of uniformed boys who convey "the epic grandeur
of a people in formation."

Slavery and Insurrection

Many of the questions pursued in this essay have to do with the representation of the racial history of Brazil. To what extent are historical events in which "the subaltern" played a major rule portrayed on the screen? Which events are omitted or distorted? How are the films inflected by contemporaneous debates among historians, sociologists and anthropologists? In the United States, at least up until the 1940s, blacks were generally depicted in American films within the context of the southern plantation tradition, usually as subservient types such as faithful servants or comic slave figures. These films often presented southern plantations as idyllic places peopled by charming aristocrats and contented slaves. The ante-bellum south was idealized in films such as *Birth of a Nation* (1915), *The Littlest Rebel* (1935) and *Gone with the Wind* (1939). Brazilian films almost never idealize slavery. Such an idealization was rendered unlikely both by the fact of the high proportion of black and mulatto citizens and by the relatively recent abolition of slavery, with the result that the Brazilian industry could not have "gotten away with" such a representation even if it had wanted to. Furthermore, Brazilian slavocrats never mounted a passionate defense of slavery.[31] Films such as Tom Payne/Oswaldo Sampaio's *Sinha Moca* (1953), a costume drama set around the time of abolition, show the institution of slavery as morally repugnant and even provide glimpses of black anger and concrete rebellion (flight from slavery, mass escapes, arson, people's trial of a slavedriver), something that would have been quite inconceivable in a Hollywood film of the same period. The revolt in the film, interestingly, comes not from the blacks in the "Big House"—who need to have abolition explained to them by whites!—but from the field laborers from the *senzala* (slave quarters).

Sinha Moca elicits comparison with *Gone with the Wind*. Both films are based on historical novels by women, the former by Maria Dezonne Pacheco Fernandes, the latter by Margaret Mitchell. Both are studio films, one from MGM, the other from Vera Cruz, the Brazilian studio that modelled its physical plant and its production methods on MGM. Both narrate key moments in national history which partially turn on race. But while *Gone with the Wind* is about how the Civil War brought tragedy to the South, *Sinha Moca* concerns the happiness brought to Brazilians by the abolition of slavery as the result of struggle by both blacks and whites. While the credit sequence of *Gone with the Wind* features docile black farmhands working in pastoral landscapes, the credits of *Sinha Moca* are superimposed on shots of the escaped slave Fulgencio fleeing from slavery; the spectator is immedi-

ately confronted with images of black rebellion. In *Gone with the Wind*, the slaves seem reconciled to their condition and even somewhat anxious about the outside threat to tranquility. The blacks pray for Confederate victory and cheerlead as the Confederate troops parade and march off to fight in the defense of "the spirit of the south" and indirectly for the perpetuation of human bondage. While *Gone with the Wind* idealizes the "Old South," and by implication the institution of slavery, *Sinha Moca* stresses the actual work—the whippings, the torture, the collective punishments—required to enforce slavery as an institution.

Both *Sinha Moca* and *Gone with the Wind* feature white female protagonists who are daughters of the plantation owner, but *Sinha Moca* suggests a parallel between the heroine's personal revolt against what we now call patriarchy and the black and white abolitionist struggle against slavery. Both films feature "auction" scenes, in which the female protagonist is offered for sale to benefit a cause; in the American film it is the confederate cause; in the Brazilian film it is the abolitionist cause. In one film, the male lead is a cynical profiteer; in the other he is an idealistic abolitionist who secretly sets slaves free. Both films feature dramatic scenes of burning: the burning of Atlanta, and the burning of the slave quarters. While the black characters of *Gone with the Wind* are invariably presented as "in service" to the white characters, the blacks of *Sinha Moca*, especially those not from the "Big House," operate on their own and separate from the whites. Unfortunately, *Sinha Moca* systematically privileges its white stars (as is obvious from a look at the publicity stills) and idealizes the white abolitionists. Unlike the Cuban film *El Otro Francisco* (*The Other Francisco*), *Sinha Moca* elides the economic forces and motivations shaping the abolitionist movement.[32]

Eurocentric history downplays not only the history of slavery itself but also the extent of black resistance to slavery. But blacks resisted everywhere, and in diverse ways. There was an ideological connective, as Cedric Robinson puts it, between "the African mutineers on the *Amistad* or the captors of the *Diane*; the maroon settlements in Pernambuco, Florida, Virginia, Jamaica, the Guianas and the Carolinas; the slave revolutionists of the Revolution in Haiti; the slave insurrectionists of the Caribbean . . . [and] the black rebels of the regions of the Great Fish River, the Limpopo and the Zambesi in Southern Africa."[33] The history of both the United States and Brazil was marked by incandescent moments of black rebellion: Nat Turner, Denmark Vesey, Harriet Tubman in the United States; Palmares, the Hausa revolt, and the Sabinada of Bahia in Brazil. Mainstream American cinema, if one excepts the TV series *Roots*, Herbert Biberman's

film *Slaves* (1974), and occasional documentaries, has rarely touched this theme. Brazilian Cinema has done considerably more with this tradition, partially because the revolts were more frequent and more significant and partially because a multi-racial audience was more ready to hear about them. *Sinha Moca*, as we have seen, treats the historical collaboration between abolitionists and rebel slaves. Oswaldo Sampaio's *A Marcha* (*The March*, 1977) features the soccer star Pele as a black freedman who liberates slaves on the eve of abolition. Walter Lima Jr.'s *Chico Rei* (1982) tells the story of Galanga, a Congo King kidnapped along with his family and forced to work in the mines of 18th century Brazil. He uses his mining skills to buy his own freedom and that of his family, while his son goes off to a maroon community. Two films, Carlos Diegues' *Ganga Zumba* (1963) and *Quilombo* (1984), pay homage to a historical act of the black political imagination, in odes to what the director calls the "first truly democratic society in the western hemisphere"—the seventeenth-century maroon community of Palmares. The black republic of Palmares lasted almost a century in the face of repeated assaults from both the Dutch and the Portuguese. At its height, it counted 20,000 inhabitants spread over numerous villages in the Northeastern interior, covering an area roughly one-third the size of Portugal. Palmares bears witness to the capacity of Afro-Brazilians not only to revolt against slavery but also to mobilize an alternative life. Economically self-sufficient, Palmares practiced the diversified agriculture the slaves remembered from Africa rather than the mono-agriculture characteristic of colonial Brazil, planting corn, beans, manioc, potatoes and sugar cane on communally shared land (as had been the pattern in much of Africa). Their kings were kings in the African rather than the European sense, not absolute monarchs but rather custodians of the common wealth. Although the penal code, especially in the later period, was harsh, the Palmarinos enjoyed basic civic and political equality. Along with the black majority, Palmares welcomed Indians, mestizos and renegade whites, ultimately becoming a refuge for the persecuted of Brazilian society. Palmares has great contemporary resonance in Brazil, as black nationalists invoke *quilombismo* and celebrate "Black Consciousness Day" on the anniversary of the death of the Palmarino leader Zumbi. Indeed, black farmers still cultivate the land that their ancestors settled, and a "quilombo clause" could give land titles to 500,000 descendants of the free black communities.[34]

Since the official history of Palmares was largely written by those who tried to defeat it—by Portuguese and Dutch generals and colonial administrators—Diegues opts in both films to meld the facts (but not the perspectives) of official history (and what is inferable from that

history) with popular myth and with his own political project of deco-
lonizing Brazil in the present. Based on a historical novel by Joao Fel-
icio dos Santos, *Ganga Zumba* (1963) focusses on a black slave who
discovers that he is the grandson of the king of Palmares. The film's
portrait of slavery highlights forced labor, cruel slavedrivers, whip-
pings, rape and murder, undercutting the idealized tableau of a benign
Lusitanian servitude portrayed by some of the more euphoric histori-
ans. *Ganga Zumba* assumes a black perspective throughout, showing
blacks not as mere victims but as active agents. A Fanonian ode to in-
surrectional violence, the film applauds the slaves' gesture as neces-
sary and even laudatory. One scene, in which a male slave has his
lover entice a slavedriver so they can kill him, would have been quite
simply unthinkable in an equivalent Hollywood film of the period.
More important, Diegues articulates popular memory in order to re-
stage the past and thus rethink the future. In a kind of "revolutionary
nostalgia," the film makes inseparable the memory of Africa and the
dream (and possibility) of insurrectionary freedom in the present: "In
Palmares people don't hide," says one character," the land there is
like the land our parents came from . . . without masters or slaves."
Reinforcing this link, another character (Aroroba) expresses a desire
to be buried in Palmares, "in a free land like ours across the sea."

Ganga Zumba ends at the symbolic threshold of liberation. The
characters, rescued by representatives of Palmares, only glimpse the
"promised land." In *Quilombo* (1984), with the advantage of a bigger
budget as well as of recent historical research by Decio Freitas,[35]
Diegues brings his characters into the promised land itself. The narra-
tive of *Quilombo* sweeps over a historical period from 1650 to 1695,
moving through three distinct phases. In the first, a group of slaves,
led by Ganga Zumba, flees from a sugar plantation and makes its way
to Palmares. In the second phase, Palmares, under Ganga Zumba, has
become a prosperous and independent community. In the third phase,
another leader, Zumbi, is forced to lead the struggle in an atmosphere
dominated by internal tensions and external aggressions. The Palmari-
nos are ultimately massacred and Zumbi himself is killed, but out-
breaks of resistance, as the final intertitles inform us, go on for
another century. The overall movement of the film, then, is from
spontaneous revolt to the construction of a community, to the violent
destruction of that community, and a final coda pointing to ongoing
struggle.

Quilombo's fascinating gallery of characters includes: Ganga
Zumba (Toni Tornado), the African prince who leads the slaves out of
bondage into the promised land of Palmares; Acotirene, a symbolic
figure associated with African strength and spirituality; Dandara (Zeze

Motta), associated with the African spirit Iansa, whose performance of religious rituals saves Ganga Zumba. The Jewish immigrant Samuel (Jonas Bloch), meanwhile, represents the many Jews and *marranos* who fled the Inquisition and took refuge in Brazil; his dialogue in the film brings to the flight of the slaves Biblical echoes of the Exodus, the parting of the Red Sea and the Promised Land. The film valorizes black culture by associating its characters with the *orixas* of *candomble*: Ganga Zumba is linked to Xango; Zumbi to Ogum (the *orixa* of metal, agriculture and war). At one point, a venerable slave refuses last rites in Latin and insists on singing in Yoruba. After his death, Ganga Zumba appears magically with Xango's ax in hand. (These allusions to Yoruba culture have the drawback of being historically inaccurate; Palmares was in fact culturally Bantu rather than Yoruba). Thus Diegues foregrounds the symbolic value of African culture, while also insisting on the need for struggle.

A didactic saga based on fact, legend, and imaginative extrapolation, *Quilombo* is part historical reconstruction and part musical, one partially drawing its style from the carnival pageants of Rio's "samba schools," whose spectacles also involve the fanciful recreation of historic events. At the same time, the film is self-designated "science fiction," in that it projects a utopian future.[36] Diegues aims at poetic synthesis rather than naturalistic reproduction, constructing a "historical hypothesis, anthropologically plausible but above all *poetically* correct." The challenge of conveying the historical grandeur of Palmares while retaining a sense of magic and surreality is not, unfortunately, always successfully met. The ritual costumes, the turbans, body paint and hairstyles, along with the quasi-theatrical lighting, at times suggest a kind of Afro-Brazilian Disneyworld. At its best moments, however, the film, with the help of the Gilberto Gil's indispensable soundtrack music—electronic Afro-derived samba-rock—not only evokes a historical utopia but also communicates a sense of what that utopia might have felt like.

In its affirmation of Afro-Brazilian culture, *Quilombo* reflects a broader tendency within Brazilian cinema. While the Cinema Novo directors tended to see Afro-Brazilian culture (and especially Afro-Brazilian religion) as alienated and marginal, the 1970s and 1980s films tend to see blackness as the vital source of the powerful originality of Brazilian culture as a whole. In their celebration of black rebellion, they continue the tradition of Lambertini's docu-fiction *A Vida do Cabo Joao Candido* (*The Life of Commander Joao Candido*, 1910), which celebrated the historical episode known as "A Revolta do Chibata" ("The Revolt of the Whip"), in which the black sailor Joao Candido led a multi-racial revolt against corporal punishment in

the Brazilian Navy. (Lambertini's film was the first to receive the ambiguous compliment of official censorship). The 1970s and 1980s films celebrate a variety of black historical heroes and heroines. The protagonist of *Xica da Silva*, while in many ways not a model heroine, is celebrated as an ex-slave who gained a kind of power through the only means available to her in eighteenth-century Brazil—sexual prowess and cultural imagination. Nelson Pereira dos Santos' *Tenda dos Milagres* (*Tent of Miracles*, 1976), meanwhile, celebrates a turn-of-the-century black culture hero Pedro Arcanjo, a composite figure based on a number of self-taught black intellectuals from Bahia (for example, Manuel Querino) who defended the Afro-Brazilian cultural inheritance against racist theoreticians and repressive police. Unfortunately, the film also advances the notion, common to Gilberto Freyre and Jorge Amado, of miscegenation as social panacea, through a generational progression from the black protagonist Pedro through his "mulatto" son Tadeu and his white bride Lou, suggesting a parable of whitening as "progress," an idea whose implicit racism has been denounced by progressive Brazilian intellectuals.

The Limits of the Stereotype

Much of the literature on blacks in North American cinema revolves around the existence of specific stereotypes, classically summarized in Donald Bogle's title: *Toms, Coons, Mulattoes, Mammies and Bucks.* To what extent, we might ask, are these stereotypes congruent in the United States and Brazil? Since both Brazil and the United States are white-dominated New World societies, certain congruencies in stereotypes are virtually inevitable. In both Brazil and the United States, slave society reassured itself through the figure of the noble, faithful slave—in the United States, the Uncle Tom, the Uncle Remus, and in Brazil the "Pai Joao" or *preto velho* (old black). Both societies also feature the female counterpart of the Tom, the devoted woman slave or servant; in the United States the "mammy," and in Brazil the *"mae preta"* (black mother). The *mae preta* figured in Brazilian theater (Jose de Alencar's *Mae*) and in the cinema, for example Vitoria in *Sinha Moca*). Celebrated in sentimental poetry, the *mae preta* was presented as long-suffering and devoted to the whites in her care—the obvious product of a slave society where the children of the master were nursed at the black mammy's breast.

With other stereotypes, the question of cross-cultural analogy becomes more complicated. In both Brazilian and North American literature, the figure of the mulatto was seen as "uppity," pretentious, vaguely ridiculous, a caricature of the whites he presumed to emulate.

Griffith's *Birth of a Nation* goes farther, obsessively scapegoating the mulatto as sinister and dangerous. (It goes without saying that the word "mulatto," etymologically derived from "mule," is pejorative and offensive). What is missing in Brazil is the "tragic mulatto" familiar from American fiction and Hollywood film. Certain characters in Brazilian films—Tonio in *Bahia de Todos os Santos* (1960), Jorge in *Compasso de Espera* (1973)—would at first glance seem to recall the "tragic mulatto" figure, but the context is radically different. Since Brazilian society has never been a strictly segregated society, the notion of "passing for white," so crucial to American films such as *Pinky* (1949) and *Imitation of Life* (1934, 1959), has little relevance in Brazil. Interestingly, the rare Brazilian counterpart to the late forties "social problem film"—Burle's *Tambem Somos Irmaos* (*We are Also Brothers*, 1949)—focuses not on "passing" but on discrimination. In Brazil, the "tragic mulatto" syndrome is foreclosed by the notion that the majority in Brazil is of mixed ancestry. All Brazilian families, it is often said, have a "foot in the kitchen," i.e. all have partial black ancestry, a point comically demonstrated in *Tent of Miracles* when the black protagonist Pedro Arcanjo reveals his racist adversary Nilo Argilo, the rabid critic of "mongrelization," to be himself part black.[37]

In North America, as a number of commentators have pointed out, there occurred a kind of Manichean splitting between the black woman slave as the sexless Mammy, saintly nurturer, and the black woman as the lascivious Jezebel.[38] Darker African-American women were seen as saintly but unattractive, while lighter-skinned women were seen as sexually desirable. Brazilian culture, for its part, is fond of the figure of the "sexy mulata"—the lascivious, sensuous product of racial mixing. The object of a purely sexual adoration during carnival, she is exploited (as maid, salesgirl, prostitute) during the rest of the year. In Brazilian art, this figure is found in literature, e.g. Vidinha in *Memorias de um Sargento de Milicias*, Rita Baiana in *O Cortico*, in many sambas, in theatrical reviews ("Oba Oba" in Rio), and in film. The figure of the sexy mulata was especially popular in 1970s pornochanchadas such as *Uma Mulata para Todos* (*A Mulata for Everyone*) and *A Mulata que Queria Pecar* (*The Mulata Who Wanted to Sin*). (Some of the light-skinned female pop stars of American music video are treated in a manner reminiscent of the "sexy mulata").

The black rebel figure, meanwhile, has literary antecedents going back to Victor Hugo's *Bugh-Jargal* (1883), partially inspired by the black Jacobins from Haiti, the first black country to conquer its independence in 1804, and in such plays/films as *The Emperor Jones*. In Brazil, as we have seen, we find the black rebel in Vera Cruz costume dramas, such as *Sinha Moca*, in commercial superproductions such as

A Marcha, and in more conspicuously politicized films such as *Ganga Zumba* and *Quilombo*. The Cinema Novo films of the sixties were especially fond of the anarchist-inflected black-rebels (almost invariably played by Antonio Pitanga)—the capoeirista in *Pagador de Promessas* (*The Given Word*, 1962), Chico Diabo (who tries to blow up the Shell Fuel Oil Reserves in Bahia, in *Grande Feira* (*The Big Market*, 1962), and Firmino, in *Barravento* (1962), who exhorts fellow blacks to abandon candomble for political activism. The later *Compasso de Espera* contrasts American-style militants who oppose their slogan—"Burn Baby Burn"—with their equally American-style pacifist counterparts, whose slogan (in English) is "Build, Baby, Build."

The *malandro* figure, meanwhile, is a typically Brazilian figure who corresponds in some ways to the "street-smart hustler" of the blaxploitation films. A trickster figure who survives by his wits, the malandro figure is perhaps more positively connoted in Brazil than a "hustler" would be in North America. In Brazilian literature, we encounter the malandro in Chico Juca in *Memorias de um Sargento de Miliacias*, in Firmino of *O Cortico*, in Ricardo Coracao-dos-Outros in *Policarpo Quaresma*, and in Macunaíma in the Mario de Andrade novel. The type was crystallized in popular music in the sambas of Wilson Batista and Ze Keti. A number of 1960s plays—Antonio Callado's *Pedro Mico*, Gianfrancesco Guarnieri's *Gimba*, and Nelson Rodrigues' *Boca de Ouro*—revolved around the figure of the malandro. Although all three were adopted for the cinema, only one, *Pedro Mico*, features a black actor (Pele) in the title role. The earliest film malandro appears in 1908, in Antonio Leal's *Os Capadocios da Cidade Nova*, which according to the marketing brochure included "capoeiras e malandros." Grande Otelo often played the role of the naive malandro, as in *O Cacula do Barulho* and *Amei um Bicheiro*. The adolescents of *Bahia de Todos os Santos*, as Joao Carlos Rodrigues points out, also qualify as malandros in that they survive through petty theft, contraband, and the sexual servicing of foreign tourists. The juvenile delinquents of *Pixote* are distant cousins of the malandro, as is the drug-dealer Bira in *Rio Babilonia* (1982), a modern and sympathetic entrepreneur with a sense of social responsibility. The malandro, however, is not necessarily coded as black. Walt Disney's Ze Carioca, animated star of *Saludos Amigos*, with his zoot suit and Panama hat, was literally green and yellow but symbolically white. White malandros also appear in such seventies films as Hugo Carvana's *Vai Trabalhar Vagabundo* (1973) and *Se Segura Malandro* (1978) and eighties films such as Ruy Guerra's *Malandro* (1986).

In the first book-length study of black Brazilian representation, Joao Carlos Rodrigues, in *O Negro no Cinema Brasileiro* (Rio: Globo,

1988), posits additional stereotypes within Brazilian film: (1) the *Negao* (literally "Big Black") is more or less assimilable to the North American figure of the "buck," i.e., a black man notable for brute strength and hyperbolic sexuality. We find the "negao" in literature in *O Bom Crioulo* and in the sexual fantasies of the white female protagonist of Nelson Rodrigues' play *Bonita mas Ordinaria*, adapted for the screen. In *A Menina e O Estuprador* (*The Girl and the Rapist*, 1983), a black man is accused of sexual crimes before he is proven innocent. We find a gay variant on the *negao* in the title character of Antonio Carlos Fontoura's *Rainha Diaba*, the black drag-queen and drug dealer who dominates the film. The muscle man in *Bye Bye Brazil* has the imposing strength of the *negao* combined with the docility of the *preto velho*. (2) The *martyr*—A classic figure in literature, was subsequently seen on the screen in Augusto da Silva Fagundes adaptation of a Gaucho legend, *O Negrinho do Pastoreio* (*Little Black of the Pastures*, 1973), a story about a black slave who is wrongly accused and sadistically abused by his master, but who is carried to heaven in recognition of his fundamental innocence. (3) The *black-with-a-white-soul*—the negro, who knows his place and conforms to dominant social codes. Rodrigues cites as examples the protagonist of *Joao Negrinho*, the lawyer in *Tambem Somos Irmaos*, the poet-advertising agent Jorge in *Compasso de Espera*, and Repo in *Aleluia, Gretchen*. (4) The *noble savage*. This stereotype traces its origins to literature, for example to Lope de Vega's *El Santo Negro*; in Brazilian cinema, Indians are more likely to be noble savages than blacks. (5) The *favelado*, or resident of the shantytowns of Rio (and elsewhere) was first portrayed cinematically in Humberto Mauro's *Favela dos Meus Amores* (1935). In the film a black favelado sings "por ser do morro e moreno/ e que eu soluco, e que eu peno" (To be from the favelas and black/that's why I sob, that's why I suffer . . .) Two fifties films by Nelson Pereira dos Santos—*Rio 40 Graus* (1954) and *Rio Zona Norte* (1957)—offer an equally sympathetic, but more socially conscious treatment of favelados. Other films which feature favelados are *Gimba*, *Pedro Mico* and *Ladroes de Cinema*. (6) The *crioulo doido* (or crazy nigger) dates back to figures of national folklore such as Saci, the one-legged black man who smokes a pipe and performs devilish tricks, and to specifically white traditions such as the Harlequin of commedia dell' arte. Its feminine equivalent is the "nega maluca" popular as a role in Rio's carnival. The *crioulo doido* combines comicity with naivete and childishness. In the cinema, Grande Otelo at times has aspects of the *crioulo doido*, as does the black member (Mussum) of the "Trapalhoes" (roughly, the "stooges"), Brazil's most popular comedians. (7) The *Musa*(muse) is encountered in the poetry

of black poets such as Luis Gama, who speaks of his "musa de Guine," black symbolist poet Cruz e Sousa, and mulatto novelist Lima Barreto. The figure is more or less absent, as Rodrigues points out, in Brazilian films.

Rodrigues' typology is useful, provocative, and historically informed. A number of his stereotypical figures, such as the *crioulo doido*, had not been explored in the cinema before, and he suggestively links the traits of the diverse stereotypes to the attributes of the diverse orixas in Afro-Brazilian religion. The typology suffers, unfortunately, from considerable redundancy: it is difficult to separate the "noble savage" from the "black with a white soul," while "the rebel," the "malandro," the "favelado," the *negao* and the *crioulo doido* often blur into one another. The typology, furthermore, is frustratingly heterotopic; some of the categories—the mulata, the pai joao—clearly constitute stereotypes in the classical sense, while others are cultural archetypes (the "martyr"), and still others merely designate place of social origin (favelado). Some of the types are not race-specific; the *malandro*, as we have seen, is as often white as black. Some filmic characters, finally, such as the black drag queen and underworld chieftain in Fontoura's *Rainha Diaba* (*Devil Queen*, 1975), since they form an amalgam of supposedly irreconcilable traits, confound all stereotypes and therefore fit uneasily into Rodrigues' schema. One can also question Rodrigues' claim that "racist manifestations are rare" in Brazilian films, and that when they occur "they are not intentional."[39]

Quite apart from the problems specific to Rodrigues' typology, the "stereotypes and distortions" approach in general needs to be interrogated from a theoretical-methodological standpoint. The exposure of negative images or stereotypes has been immensely useful insofar as it has highlighted: 1) structural patterns of prejudice in what had formerly seemed random phenomena; 2) the existential pain caused by stereotypes to those groups stigmatized; 3) the social functionality of stereotypes as forms of social control. (The purpose of the Uncle Tom or the *Pai Joao* figure, for example, was not to represent blacks but rather to reassure whites with comforting images of black docility; the buck, from *Birth of a Nation* to Willie Horton, serves to frighten whites). But the positive/negative image approach also entails severe problems, which could be summed up as *essentialism* (a complex diversity of portrayals is reduced to a limited set of reified stereotypes); *verism* (characters are discussed as if they were real); *ahistoricism* (a static analysis fails to allow for mutations, metamorphoses, altered contexts, changes of valence); *moralism* (social and political issues are treated as if they were matters of individual ethics); and *individualism* (the individual character, rather than larger social categories, is the

point of reference). The question of "positive" and "negative" images also elides the question of the social relativity of moral evaluation. It ignores the fact that oppressed people might have not only a different vision of morality, but even an opposite vision. Within slavery, as *Ganga Zumba* implies, it might be admirable and therefore "good" to lie to, manipulate, and even murder a slavedriver. The emphasis on character rather than social structure places the burden on oppressed people to be "good" rather than on the privileged to change the system. The oppressed, in order to be equal, are asked to be better.[40]

The analysis of stereotypes, furthermore, often fails to take both cultural and textual specificity into account. The humor of a film like *Macunaíma* (1969), is likely to be lost on a critic uninitiated into Brazilian cultural codes. Two sequences in which the title character turns from black to white, for example, often misread as racist by North Americans, are in fact sardonic comments on Brazil's putative "racial democracy." The first forms a satirical allegory critiquing the Brazilian "economic miracle" of the late sixties, while the second is best read as a sardonic comment of Brazil's putative "racial democracy" and the "ideology of whitening.[41] Indeed, the pedagogical experience of presenting *Macunaíma* in both Brazilian and North American contexts provides a lesson in the differential nature of spectatorship. In Brazil, a number of factors militate against the reading of the film as racist. (1) Brazilians of all races are likely to see Macunaíma as representing themselves and their national personality rather than some racial "other." They are more likely to see both the black and white Macunaímas as a national rather than a specifically black archetype. Brazilians often make comic reference to Macunaíma as a kind of figure for the national personality. References in everyday conversations to "o nosso lado Macunaíma" (our Macunaíma side) are not infrequent, reflecting a mixture of affection and, perhaps, a colonized self-depreciation as well. (2) In Brazil, there is a long tradition of affectionately self-mocking humor, and jokes by an ethnic insider are always experienced differently from those of an outsider (3) Most Brazilians, even if they had not read the novel, would be more likely to be aware of its status as a national classic by a Brazilian of mixed race; the novel had never been accused of being racist. (4) The complexity of the Brazilian racial situation makes Brazilians less likely to racially allegorize their own films. Since the whole issue of racial portrayal is somewhat less "touchy" in Brazil—an ambiguous fact in itself—the films are not made to bear such a strong "burden of representation." (5) North American viewers are less likely to be aware of what kinds of images and associations Brazilians bring to the image of Grande Otelo in the title role. In Brazil, the consciousness of

Grande Otelo as a veritable national institution, a multi-talented pres-
ence in the media since the thirties militates against a racist reading
by Brazilian spectators, who see his role in *Macunaíma* as just one
more role in a variegated career, not as emblematic of the black race.
(5) The misunderstanding also derives from an inherent difference be-
tween filmic and literary cinematic representation, between verbal
suggestiveness and iconic specificity. In the novel, we are told that
Macunaíma was transformed into a "principe lindo" (a beautiful
prince); there is no racial specification. The film, in contrast, is con-
strained to choose actors for roles, and actors come with racial charac-
teristics. Thus the fable-like evocativeness of "comely prince" gives
way to the physical presence of the white actor Paulo Jose, chosen for
his thespian talents and not for his whiteness, but leading to racial
misreadings. At the most, the director might be accused not of racism,
but rather of insensitivity; first, for appearing to posit a link between
Blackness/ugliness (a link with very painful historical/intertextual res-
onances for black people) and second, for failing to imagine the ways
that his film might be read in non-Brazilian contexts. At the same
time, the metaphor of the Brazilian "family," common to both novel
and film, should not be seen as entirely innocent, because the national
ideology of the mixed family glosses over the fact that the metaphor
has historically relegated Black Brazilians to the status of "poor cous-
ins" or "adopted children."

The case of *Macunaíma* also reveals that the "distortions and stere-
otypes" approach is often covertly premised on the desirability of
"rounded" three-dimensional characters within a realist-dramatic aes-
thetic. This aesthetic precludes a Brechtian approach, for example,
which might deploy stereotypes as a means to generalize meaning and
demystify established social structures. Grotesque realism of the kind
theorized by Bakhtin, similarly, also bypasses "positive images" while
yet performing an incisive critique of societal structures. A search for
positive images in the coded carnival of *Macunaíma* constitutes a kind
of "genre mistake" (Lotman). First, the novel is largely based on
Amazonian myths which take us out of the realm of realism alto-
gether. Second, both the film and the novel belong to a carnivalesque
genre favoring what Bakhtin calls "grotesque realism." It would be
wrong to see the black Macunaíma's "Ai que preguica! (literally
"what laziness!") as an indication of the protagonist's conformity to
the "lazy Sambo" stereotype, not only because the film's white Macu-
naíma shares this characteristic but also because all the film's charac-
ters are synthetic two-dimensional grotesques rather than rounded
three-dimensional characters, and the grotesquerie is democratically
distributed among the races. Virtually all the characters, white, black

and mulatto, exhibit elements of the grotesque. Indeed, the film's most archly grotesque characters are Pietro-Pietra, the white industrialist-cannibal, and his ghoulish spouse. The critique of the imagery in *Macunaíma*, in sum, should begin only *after* the film has been understood within Brazilian cultural norms, and not as the application of an a priori schema.

My purpose here, in any case, has been to suggest the potentialities of a historically informed comparative and dialogical approach, one which regards all the cultures and cinemas of the Americas as susceptible to "mutual illumination," as deeply and mutually implicated in one another, economically, politically and culturally.

Notes

1. See Ivan van Sertima, *They Came Before Columbus* (New York: Random House, 1975).

2. I place "red," "white" and "black" in quotation marks because the identification of specific races with colors is an ultimately achromatic trope. Since racial categories are socially and historically constituted, I will be using Portuguese terms for the Brazilian context and English terms for the United States context.

3. The Olavu Bilac phrase is found in his *Poesias* (Rio de Janeiro: Alvez, 1964). The fundamental reference for Gilberto Freyre is *Casa Grande e Senzala*, published in English as *The Masters and the Slaves*, trans. Samuel Putnam (New York: Knopf, 1956).

4. See Dain Borges, "Intellectuals and the Forgetting of Slavery in Brazil," *Annals of Scholarship* (September 1994).

5. I am grateful to Lula Buarque de Hollanda, who worked as a research coordinator on the project, for giving me a copy of the script of the proposed film.

6. "Anthropophagy" refers to the presumably real cannibalistic practices of the indigenous Tupinamba peoples, who devoured their dead enemies in order to appropriate their force, and to the metaphorical extrapolation of these practices by the Brazilian modernists in the twenties, who called for cultural anthropophagy, a devouring of the techniques and information of the super-developed countries as part of a struggle against colonialist domination.

7. See Tom Engelhardt, "Ambush at Kamikazi Pass," *Bulletin of Concerned Asian Scholars* (Winter-Spring 1971), Vol. III, No. 1.

8. See Doris Sommer, "Irresistible Romance: the Foundational Fictions of Latin America," in Homi K. Bhabha, ed., *Nation and Narration* (London: Routledge, 1990).

9. David Haberly argues that miscegenation was perceived as both blessing and curse by the Brazilian elite, who tended to project an "Edenic metaphor" whereby Brazilians were driven from paradise by the "sin" of miscegenation. See David T. Haberly, *Three Sad Races: Racial Identity and*

National Consciousness in Brazilian Literature (Cambridge: Cambridge University Press, 1983).

10. The role of Jewish producers in Hollywood is the subject of Robert Sklar's *Movie-Made America: A Cultural History of American Movies* (New York: Random House, 1975) and Neal Gabler, *An Empire of Their Own: How the Jews Invented Hollywood* (New York: Anchor, 1989.

11. On the subject of the systematic substitution of European immigrants for the newly-freed slaves, see Celia Maria Marinho de Azevedo, *Onda Negra/Medo Branco: O Negro no Imaginario das Elites Seculo XIX* (São Paulo: Paz e Terra, 1987.

12. See Warren Dean, "O Village ja Foi Brasileiro" (Greenwich Village was once Brazilian,) *Folha de São Paulo* (May 13, 1987).

13. For more on the Bakhtinian conception of "polyphony," see Mikhail Bakhtin, *Problems of Dostoevsky's Poetics* (Minneapolis: University of Minnesota Press, 1984).

14. See Mario de Andrade, "A Escrava que Nao e Isaura," in *Obra Imatura* (São Paulo: Martins, 1944).

15. I further explore the analogies between São Paulo and New York, and between *Macunaíma* and *Zelig* in "A Tale of Two Cities: Cultural Polyphony and Ethnic Transformation," in *East-West Film Journal*, Vol. III, No. 1 (December 1988).

16. See Mario de Andrade, *Poesias Completas* (São Paulo: Martins, 1972), pp. 203–4.

17. See Mario de Andrade, *Obra Imatura* (São Paulo: Martins, 1972), p. 266. For an excellent discussion of de Andrade's "harlequinate" identity, see David Haberly, *Three Sad Races*. For a discussion of the racial question within Modernism, see Zita St. Aubyn Nunes, *"Os Males do Brasil": Antropofagia e a Queestao da Raca* (Rio: SIEC, 1989).

18. A much later Brazilian artist, composer-singer Gilberto Gil, shows a similar capacity to evoke the polyphonic yet conflictual orchestration of racial identity in the Americas. In his song "From Bob Dylan to Bob Marley: A Provocation Samba," Gil deploys a number of broad cultural parallels and interactions, between Jewish symbology and Jamaican Rastafarianism, between the Inquisition's anti-semitism and the European suppression of African religions ("When the Africans arrived on these shores/there was no freedom of religion"), ultimately contrasting the progressive syncretism of a Bob Marley (who died "because besides being Black was Jewish") from the alienation of a Michael Jackson, who "besides turning white . . . is becoming sad."

19. Some of the key texts in the first wave of the comparative slavery debate are Frank Tannenbaum, *Slave and Citizen* (New York: Knopf, 1947); Stanley Elkins, *Slavery: A Problem in American Institutional and Intellectual Life* (Chicago: Univ. of Chicago Press, 1968); Eugene D. Genovese, *The World the Slaveholders Made* (New York: Vintage, 1971) and *Roll Jordan Roll: The World the Slaves Made* (New York: Pantheon, 1974); and Herbert Gutman, *The Black Family in Slavery and Freedom* (New York: Pantheon, 1976).

20. Tomas E. Skidmore makes this point in "O Negro no Brasil e nos Estados Unidos," *Argumento* No. 1 (1973).

21. See Carl N. Degler, *Neither Black Nor White: Slavery and Race Relations in Brazil and the United States* (Madison: Univ. of Wisconsin Press, 1986. For a critique of the Degler view, see Carlos A. Hasenbalg, *Discriminacao r Desiqualdades Raciais no Brasil* (Rio de Janeiro: Graal, 1979).

22. It should be pointed out, however, that the sexual exploitation of black women in North America led to a huge population of persons of mixed ancestry, thus leading, in places like New Orleans, to Byzantine racial classifications, in the post-bellum period, involving quadroons, octoroons and so forth.

23. Statistics cited in Jose Oscar Beozzo, *Situacao do Negro na Sociedade Brasileira* (Petropolis: Vozes, 1984), pp. 563–64.

24. "In no other country," writes Howard Winant, "is the *salience* of race so uncertain, so disguised in its quotidian manifestations, so explicitly denied and implicitly upheld." See Howard Winant, *Racial Conditions: Politics, Theory, Comparisons* (Minneapolis: University of Minnesota Press, 1994), p. 154.

25. See "Cem Anos, sen Qause Nada," *Veja* (April 20, 1988).

26. See Zelbert Moore, "Reflections on Blacks in Contemporary Brazilian Popular Culture in the 1980s" in *Studies in Latin American Popular Culture*, Vol. VII (1988).

27. Carlos Hasenbalg and Nelson do Valle Silva, "As Imagems do negro na publicidade," in *Estrutura Social, Mobilidade, e Raca* (São Paulo: Vertice, 1988), pp. 185–88.

28. See Amelia Simpson, *Xuxa: The Mega-Marketing of Gender, Race and Modernity* (Philadelphia: Temple University Press, 1993).

29. See Winant, *op. cit.*, p. 158.

30. On convergence, see the work of Howard Winant *op. cit.* and of Michael Hanchard. Hanchard distinguishes between the Africanist orientation of cultural groups such as *Olodum* and the "Americanist" orientation of the explicitly political groups. See Michael Hanchard, *Black Orpheus* (Princeton: Princeton University Press, 1994). Among those calling for reparations is Fernando Conceicao, journalist and author of *Negritude Favelada* (1988) and *Cala a Boca Calabar* (1987).

31. Dain Borges argues that Brazilian abolitionists "were not haranguing opponents across a Mason-Dixon line, but were attacking a familiar institution." The direct-action "Caifazes Club" in São Paulo required that every new member initiate himself by freeing a slave from his own family. See Dain Borges, "Intellectuals and the Forgetting of Slavery in Brazil," *Annals of Scholarship* (1994).

32. For analyses of Brazilian abolitionism, see Emilia Viotti da Costa, *Da Senzala a Colonia* (São Paulo: Diffusao Europeia, 1966), Robert Conrad, *Os Ultimos Anos da Escravatura no Brazil* (Rio: Civilizacao Brasileira, 1975). For black rebellion under slavery, see Clovis Moura, *Rebelioes da Senzala* (Rio: Conqusta, 1972); Joao Jose Reis, *Rebeliao Escrava no Brasil* (São Paulo: Brasiliense, 1986); Maria Helena P. T. Machado, *Crime e Escravidao*

(São Paulo: Brasiliense, 1987); Joao Jose Reis and Eduardo Silva, *Negociacao e Conflito* (São Paulo: Companhia das Letras, 1989); and Lana Lage da Gama Lima, *Rebeldia Negra e Abolicionismo* (Rio: Achiame, 1981).

33. Cedric Robinson, *Black Marxism* (London: Zed, 1983), p. 96.

34. Musical groups from Bahia, specifically Olodum and Ile Aiye, have organized support for the present-day descendants of the quilombos, composing lyrics such as "Quilombo, here we are/my only debt is to the quilombo/ my only debt is to Zumbi." See James Brooke, "Brazil Seeks to Return Ancestral Lands to Descendants of Runaway Slaves," *The New York Times* (Sunday, Aug. 15, 1993), p. 3.

35. See Decio Freitas, *Palmares: A Guerra dos Escravos* (Rio: Graal, 1974).

36. Carlos Diegues described *Quilombo* as a "kind of science fiction film, in the sense that I was not just interested in recounting what had happened in my country, but in projecting the future." See Carlos Diegues, "Choosing Between Legend and History: An Interview," in *Cineaste*, Vol. XV., No. 1 (1986), p. 12.

37. In her writings and artworks, Adrian Piper tries to explode the myth of racial separation, arguing that "after four hundred years of intermarrying" there are "no genetically distinguishable white people in this country." See Maurice Berger, "The Critique of Pure Racism: An Interview with Adrian Piper," *Afterimage* (October 1990), Vol. 18, No. 3).

38. Barbara Christian makes the point in Marlon Rigg's documentary *Ethnic Notions*, as does Michelle Wallace in "Slaves of History," in *Invisibility Blues: From Pop to Theory* (London: Verso, 1990).

39. Joao Carlos Rodrigues, *O Negro no Cinema Brasileiro* (Rio de Janeiro: Globo, 1988), p. 58 (translation mine).

40. These issues are further explored in Ella Shohat/Robert Stam, *Unthinking Eurocentrism: Multiculturalism and the Media* (London: Routledge, 1994).

41. See Randal Johnson's thorough and illuminating analysis in "Cinema Novo and Cannibalism: *Macunaíma*," in Randal Johnson and Robert Stam, *Brazilian Cinema* (Austin: University of Texas Press, 1985), as well as my "Of Cannibals and Carnivals" in *Subversive Pleasures: Bakhtin, Cultural Criticism and Film* (Baltimore: Johns Hopkins, 1989).

The Rise and Fall of Brazilian Cinema, 1960–1990

Randal Johnson

It was easy to chase the public away from the cinema; it's difficult to bring it back.

Júlio Bressane

Either we internationalize Brazilian cinema or they will internationalize us.

Murilo Salles

Brazilian cinema is dead.

Arnaldo Jabor

Introduction

From almost its very beginnings the Brazilian film industry has suffered a chronic lack of continuity, causing it to develop erratically, either in isolated and short-lived cycles far from the country's major metropolitan centers (e.g., the efforts, in the 1920s, of Humberto Mauro in Cataguases, Gentil Ruiz in Recife, or Eduardo Abelim in Porto Alegre), or in unsuccessful attempts at industrialization based on a studio model (Cinédia in the 1930s, Atlântida in the early 1940s, Vera Cruz in the late 1940s). This lack of continuity is also evident in the careers of many Brazilian filmmakers, some of whom have appeared with great promise only to make subsequent films with tremendous difficulty, if at all. The example of Lima Barreto, whose

IRIS No. 13 (Summer 1991), pp. 97–124. Reprinted by permission of the author.

O cangaceiro (1953) was a double prize-winner in Cannes, is a case in point.[1]

Recognizing the historical lack of continuity in Brazilian cinema and the inadequacy of a Hollywood-style studio model in a country with such a small domestic market, the internationally-acclaimed Cinema Novo sought, starting in the early 1960s, to develop new modes of cinematic production, opting for an *auteur* cinema based on an independent and inexpensive mode of production using, initially, small crews, location shooting, and non-professional actors. Cinema Novo represented not only a new start for Brazilian cinema, but also a new definition of the social role of the cinema, no longer conceived as a mere form of entertainment, but rather as a mode of artistic and cultural intervention in the country's socio-historical conjuncture. As such, it became an important site of resistance against the military regime imposed on the country in 1964. In the 1970s, Cinema Novo's alliance with the state through Embrafilme (Empresa Brasileira de Filmes) created a situation in which it seemed that Brazilian cinema would finally manage to solidify itself as an industry with the real potential for self-sufficiency.[2]

Yet today, thirty years after Cinema Novo first appeared on the scene with its harsh portrayals of Brazilian reality and twenty-one years after the founding of Embrafilme, the national film industry faces the most severe crisis of its history. Brazilian film production is now at its lowest level since the early 1940s, with no more than a dozen feature-length films underway.[3] Even worse, between 1981 and 1988, hardcore pornography accounted for an average of almost 68 percent of total production (Table 1). In 1988, 20 of the 30 top-drawing Brazilian films were pornographic (Table 2).[4]

In terms of the size of the market, the number of theaters in the country dropped from 3,276 in 1975 to less than 1,100 in 1988. Attendance figures for Brazilian films dropped from 1978's high of 60 million to less than 24 million in 1988. During the same period, the total number of spectators in the Brazilian market for both foreign and national films dropped from around 211.5 million to 108.5 million (Table 3). Attendance figures for 1984 represent only 43% of the 1978 figure (Concine 13).

Brazilian cinema is in many ways back to square one, a retrocession echoed—but not caused—by Fernando Collor de Mello's extinction of Embrafilme, Concine (the Conselho Nacional do Cinema) and the Fundação Brasileira de Cinema in one of his first acts as Brazil's first democratically-elected president since 1960. Given the increasing depth of the crisis that has faced Brazilian cinema over the past decade, Collor's action was more symbolic than real in its effects, since

TABLE 1
Brazilian Film Production, 1978–1988

YEAR	TOTAL	PORNOGRAPHIC	EMBRAFILME	OTHERS	%PORN
1978	100	15	13	72	15
1979	93	07	16	70	08
1980	103	32	18	53	31
1981	80	63	16	01	79
1982	85	59	22	04	69
1983	84	62	18	04	74
1984	90	64	22	04	71
1985	87	59	na	na	68
1986	112	69	na	na	62
1987	82	43	na	na	52
1988	90	68	na	na	76

SOURCE: Embrafilme, *Jornal da tela*, Ediçao especial ("Proposta para uma politica nacional do cinema"), March 1986, p. 3. Concine, *Relatório de atividades*, Segundo Semestre 1988 (1989): 219–23.

Embrafilme had long since ceased to be an effective agency of film industry development and, as filmmaker Eduardo Escorel has put it, its investments in the industry had largely ceased to be recognized as socially legitimate. One might say that yet another cycle has come to an end.

Over the past few years, numerous commentators, including many film industry professionals, have attempted to analyze the crisis and to offer potential solutions. Most point out quite correctly that in immediate terms the current crisis of Brazilian cinema reflects the larger crisis of the national economy in a period when the so-called economic "miracle" of the 1967–1973 period, characterized by high growth rates and relatively low inflation, was replaced by an economic nightmare with a 100 billion dollar foreign debt and near hyperinflation. The economic crisis forced the government to impose severe restrictions on imports, making film production costs rise dramatically and accentuating what is often called the "dollarization" of the film production process. Film production costs increased rapidly at a time when the market was shrinking, thus accelerating the process of decline, and ticket prices, which have long been controlled by the government, have not kept pace with inflation, further reducing the industry's income. The constant and massive presence of foreign— largely North American—films in the domestic market has only served to exacerbate the situation.

TABLE 2
Top-Drawing Brazilian Films, 1988

TITLE	SPECTATORS
1. Os heróis Trapalhoes	3,080,000
2. Os fantasmas Trapalhoes	2,689,380
3. Super Xuxa contra o Baixo Astral	1,627,667
4. O casamento dos Trapalhoes	1,351,038
5. Banana split	716,530
6. A menina do lado	490,271
7. Feliz ano velho	468,021
8. Luzia homem	345,876
9. Os Trapalhoes no Auto da Compadecida	233,930
10. As aventuras de Sérgio Malandro	222,936
11. A dama do Cine Shangai	195,861
12. Eles comem crú	177,298
13. Dedé Mamata	162,387
14. Coisas eróticas	162,387
15. O delicioso sabor do sexo	157,345
16. Senta no meu que eu entro no teu	147,291
17. No calor do buraco	142,810
18. Eternamente Pagu	141,253
19. Gemidos e sussurros	137,627
20. Aluga-se moças	115,824

(Note: Some films were originally released prior to 1988. In these cases, figures do not represent total number of spectators.)

SOURCE: Concine, *Relatório de atividades*, Segundo Semestre 1988 (1989): 12.

Many additional reasons exist for the decline of the Brazilian film industry since the early 1980s. High inflation rates have made filmgoing a luxury for much of the Brazilian population. Television, which has been so successful during this same period (due in part to considerable infrastructural public sector investments in the telecommunications industry), has provided Brazilians with inexpensive yet generally high-quality entertainment in the comfort of their homes. At the same time, unlike the United States and Western Europe, television has not provided the national film industry with a significant additional source of income since historically there has been little integration between the two media. By and large, the Brazilian television industry either produces its own programming—there have been few co-productions with the film industry—or broadcasts imported programming. It has rarely provided space for independent production, including that of the national cinema. In 1984, of 1,967 feature-length films shown on Brazilian television stations, only 82 were Brazilian.[5]

TABLE 3
Film Spectators in Brazil, 1974–1988

YEAR	BRAZILIAN FILMS	%	FOREIGN FILMS	%	TOTAL
1974	30,665,000	16	170,625,000	84	201,290,000
1975	48,859,000	18	226,521,000	82	275,380,000
1976	52,046,000	21	198,484,000	79	250,530,000
1977	50,937,000	25	157,398,000	75	208,335,000
1978	61,854,000	30	149,802,000	70	211,656,000
1979	55,836,000	29	136,072,000	71	191,908,000
1980	50,689,000	31	114,085,000	69	164,774,000
1981	45,911,000	33	92,981,000	67	138,892,000
1982	44,965,000	36	82,948,000	64	127,913,000
1983	33,774,000	32	72,762,000	68	106,536,000
1984	30,638,000	34	59,301,000	66	89,939,000
1985	21,928,000	24	69,372,000	76	91,300,000
1986	29,337,000	23	98,266,000	77	127,603,000
1987	25,123,713	21	91,806,019	79	116,929,732
1988	23,987,515	23	84,580,576	77	108,568,091

SOURCE: Concine, *Relatório de atividades*, Segundo Semestre 1988 (1989): 12.

But the crisis goes beyond mere economic considerations. Many commentators have pointed to the relationship between cinema and the state as a major contributing factor, focusing primarily on the corporativist and paternalistic nature of that relationship as it developed over the last twenty-five years. Along these lines I have argued elsewhere that the crisis represents the bankruptcy of the state-supported model of film production that led Brazilian cinema, in the mid-1970s, to truly remarkable levels of success, a model that did not derive from a far-sighted vision of the future of Brazilian cinema, and was authoritarian in many of its particulars, especially in relation to the exhibition sector (*The Film Industry in Brazil*). Although the policy contributed to the viability of many important film projects, including most of the Brazilian films distributed in the U.S. in recent years, it ultimately failed to reconcile the state's cultural and industrial responsibilities vis-à-vis the cinema and contributed to the meteoric fall of the Brazilian film industry during the last several years.

In this essay I will attempt to put the crisis in perspective, discussing in some detail a number of its fundamental causes. My focus will be on the shift in state policy toward the cinema in the early 1970s within the context of other cultural initiatives of the regime of General Ernesto Geisel and, in a broader sense, the political conjuncture which contributed to the shift. I will argue that the policy failed primarily because of its clientelistic nature, which led it to respond to the de-

mands of clients who occupied dominant positions in the cinematic field rather than attend to the real needs of the industry and provide infrastructural support which could have strengthened the industry as a whole. In addition, without placing blame or denigrating the multiple accomplishments of the Cinema Novo movement, I will suggest that the roots of this orientation are to be found in Cinema Novo's (and, by extension, Brazilian cinema's) insistence on an auteur model of cinematic practice and on the anti-industrialism of the movement's earliest phase, both of which contributed to a marked increase in hostility between the production and exhibition sectors.

The story of the rise and fall of Brazilian cinema is thus one filled with paradoxes, not the least of which is the alliance between a radical and highly creative film movement and the authoritarian state. Equally paradoxical is the fact that government support of the industry would come into being only during a period of military rule opposed by most sectors of the industry and that it has waned following the reinstitution of a more democratic system of government. It is also paradoxical, at the very least, that the state model of support for the film industry ultimately had a result that was precisely the opposite of its original intentions.

Although the state claimed that its goal was to make the cinema more competitive in its own market, the screen quota and the various forms of financial assistance it provided in fact suspended the rules of the marketplace for national films, which ceased to compete against foreign films in the domestic market and began to compete against each other in the reserve market. Embrafilme became the major source of production financing, creating a situation of dependence between the state and so-called "independent" filmmakers, and it itself became a marketplace where filmmakers competed against each other for the right to make films, thus exacerbating tensions within the industry and creating a situation in which the play of influences was often more important than the talent of the filmmaker or producer.[6] It is equally paradoxical that one of the few solutions to the crisis now appears to be association with foreign companies or with national exhibition groups, both of which have long been considered "enemies" of Brazilian cinema.

Cinema and the State in Brazil: A Historical Overview

To put the discussion in context, a brief overview of the historical development of state policy toward the film industry is in order. State intervention in the film industry dates from the early 1930s, when Getúlio Vargas implemented the first of what would turn out to be a

long series of protectionist measures, most in the form of a screen quota for national films, designed to give the industry a modicum of stability for future development in a market long dominated by foreign cinemas.[7] Since the 1930s, and especially after 1964, the state role evolved from that of regulator of market forces to active agent and productive force in the industry, especially through its various programs of film production financing (low-interest loans, advances on distribution, and co-production with private companies).

The state began its direct financial support of the film industry in 1966 with the creation of the Instituto Nacional do Cinema. The Institute, created by an executive decree of the Castello Branco regime, was the result of a long struggle by most sectors of the film industry (Johnson, *The Film Industry in Brazil* 107–12). It administered three major programs of support: first, a subsidy program providing all national films exhibited with additional income based on box-office receipts; second, a program of additional cash awards for "quality" films, selected by a jury of critics and film industry professionals; and, third, a film-financing program in which the Institute administered co-productions between foreign distributors and local producers using funds withheld from the distributor's income tax.[8] Although the first two were ultimately inadequate in terms of the amount of additional income offered, these programs were available for all interested filmmakers and thus tended to support the production sector as a whole.

The co-production program ended in 1969 with the creation of Embrafilme, which was originally intended to promote the distribution of Brazilian films in foreign markets, and the funds withheld from the distributor's income tax became a major source of the agency's budget. As early as 1970 Embrafilme began granting producers low-interest loans for film production financing, and between 1970 and 1979, when the loan program was phased out, Embrafilme partially financed over 25 percent of total national production in this manner. Carlos Diegues's *Bye Bye Brasil* (1980) was the last film financed under this program.

As initially formulated, decisions to grant production financing were ostensibly made on purely technical grounds, taking into consideration the size of the company, its production history, the number of awards it had won in national and international festivals, and its experience. Such a policy may seem reasonable for most economic sectors or most industries, but the film industry is different in that its product transmits cultural, social, and ideological values, and such "neutrality" was seen as unacceptable by many segments of Brazilian society. The influential *O Estado de São Paulo*, for example, editorialized on 28 January 1972 that Embrafilme should *not* be a merely technical agen-

cy, but rather should finance only films of high quality which contribute to the "moral foundations" of Brazilian society. Since a more neutral policy designed to foster Brazilian cinema as a whole led to the production of films deemed undesirable by many social sectors, including the military—and here I refer to the rash of *pornochanchadas* (erotic comedies) that began to appear in the early 1970s, many partially financed by the state—a reformulation of Embrafilme's production policy became inevitable.

The Reorientation of State Cinematic Policy

In 1975, during the Geisel regime, Embrafilme was reorganized and at that time absorbed the executive functions of the now-defunct INC. The Conselho Nacional do Cinema (Concine) was created the following year to assume INC's legislative role.[9] In 1973 Embrafilme had created its own nationwide distributor, long a goal of Brazilian producers, and in 1974 it initiated a program of co-production financing that gradually replaced the loan program. As initially formulated, the enterprise participated in selected film projects with up to 30 percent of total production costs and received in return a 30 percent share of profits. With an advance on distribution of another 30 percent, the state could cover up to 60 percent of a film's production costs. In the late 1970s, Embrafilme began providing up to 100 percent of a film's financing in some cases.[10]

Several factors explain the shift in state policy toward the film industry. I have already mentioned the fact that the state cinematic apparatus had come under severe criticism from diverse sectors of civil society and the state because of its financing of films of questionable quality. From a different angle, Renato Ortiz sees increased state investments in culture (including the cinema) during the 1973–1975 period as one result of the economic optimism produced by the "miracle" of 1967–1973 as reflected in the Second National Development Plan (1974). Previous governments had focused primarily on economic aspects of development, although they had given lip service to the need for the "humanization of development" or for "psychosocial development" to accompany economic development. The Geisel regime, according to this analysis, attempted to put such ideas into action and thus gave more attention to the area of culture (Ortiz 82).

Although there is no doubt some truth in Ortiz's interpretation, other factors are clearly of equal or greater importance. The years between 1969 and 1975 were the most repressive of military rule. Sparked by an impasse in its constitutional relationship with congress,

on 13 December 1968 the Costa e Silva regime decreed the Fifth Institutional Act, which "granted the president authority to recess legislative bodies, to intervene in the states without limit, to cancel elective mandates and suspend constitutional guarantees . . . [including] the right of habeas corpus" (Schneider 274). The AI-5 led to the imposition of the harshest censorship yet known in Brazil and forced a number of political leaders, intellectuals and artists, including some filmmakers, into exile. The appearance of armed movements in opposition to the regime led, in turn, to the institutionalization of torture and a national campaign by the military against "subversion."

This period of repression and censorship exacerbated the military's crisis of legitimacy, especially in relation to the intellectual/cultural field, and the increased activity in the cultural arena can be interpreted as one response to this crisis. In August, 1973, General Médici's minister of Education and Culture, Jarbas Passarinho, initiated a Program of Cultural Action which, according to Sérgio Miceli, was designed to provide financial (and political) credit to some areas of cultural production that had previously been ignored by the government and which constituted an official attempt to improve relations with artistic and intellectual circles (56). Film producer Luis Carlos Barreto, who was closely associated with Cinema Novo from the beginning, has explained that the reformulation of Embrafilme's program of production financing in the early 1970s grew out of conversations he and other film industry professionals, especially those associated with the Cinema Novo group, had during this period with Jarbas Passarinho (*Jornal da tela*, March 1990, 14).[11]

The state's attention to culture intensified under the Geisel regime with the creation of Funarte (Fundaçao Nacional de Arte), the revitalization of the Serviço Nacional de Teatro, the reorganization of Embrafilme, the creation of Concine, and the publication of the document "Política nacional de cultura," which formalized the regime's cultural policy (Ministério de Educaçao e Cultura).[12] The cultural offensive in the mid-1970s focused primarily on those areas—the plastic arts, music, theater, and the cinema—with a reduced market potential and a more personalized or even artisan mode of production (Miceli 64).

Geisel's Minister of Education and Culture Ney Braga managed to recruit cultural administrators who were either identified with the left of the cultural field or who had the confidence of the left (Roberto Farias and Gustavo Dahl in Embrafilme, Orlando Miranda in the SNT, Manuel Diegues Jr.—filmmaker Carlos Diegues's father—in the Departamento de Assuntos Culturais, which functioned as an umbrella agency within MEC with responsibility for overseeing all of the government's cultural activities). The optimism that reigned in the cul-

tural field at this time, despite the repression, was due in part to the feeling among different cultural sectors that they not only had the support of the government but that they were finally able to influence the shape of state policy toward their respective areas:

> Carlos Diegues (1975): "The current government has shown, in contrast to all other post-Vargas administrations, that it has a program for a cinematic infrastructure, and this is fundamental. I believe in Embrafilme's mission and in the aims of its current leadership, although I know that there are still many things to improve or create" ("As esperanças").
>
> Nelson Pereira dos Santos (1977): "All artists, not only in cinema but in theater and popular music also, who are considered to be of the left . . . were obligated to be more flexible, and we participated with independent producers on a common program and were able to place Roberto Farias, himself a filmmaker, as president of Embrafilme. Therefore, in reality, cinema today is a 'front populaire' . . . We do not participate in the decision making, but we have a great influence in the composition of forces within Embrafilme. . . ." (Johnson, "Toward a Popular Cinema" 228)

Miceli correctly points out that the success of this cultural offensive would have been impossible without a strong minister of Education and Culture with legitimacy in both the military government and the cultural field. A retired army general, Ney Braga's political career was consolidated through successive electoral victories in the state of Paraná (mayor of Curitiba [1954], federal deputy [1958], state governor [1960]) and service in non-military positions of the post-1964 period (he was minister of Agriculture under Castello Branco). In Paraná his political legacy included many important cultural initiatives, including the Fundaçao Educacional do Paraná, the Teatro Guaíra, and the Companhia Oficial de Teatro.

In addition, he was the central figure in what was then considered to be one of the strong civilian political "clans" in the country, which included such government officials as Karlos Rischbieter (president of the Banco do Brasil), Reinhold Stephanes (director of the Brazilian social security system), and Maurício Schulmann (director of the Banco Nacional de Habitaçao), among others. Together, Braga's group was said to control almost half of the national budget. The group also counted on the support of then secretary of Planning, Joao Paulo dos Reis Velloso, who was seminal in obtaining increased funding for Embrafilme (64–66).[13] This strong government support contributed significantly to the remarkable success of the Brazilian film

industry in the late 1970s. Unfortunately, neither the support nor the success lasted.

The co-production program described above marked a fundamental redirection in state policy toward the industry, much in line with what producers had proposed to Jarbas Passarinho in 1972. With this program, the granting of production financing became much more selective. When the state decides to co-produce a limited number of films, it must inevitably decide *which* Brazilian cinema it will support. This causes the state, on the one hand, to enter into competition with non-favored sectors of the industry and, on the other, to become a site of contention for competing groups. The reorientation of the state's financial assistance to the industry exacerbated conflicting positions among filmmakers (Ramos, chapter 4).

Two conflicts are particularly relevant to the present discussion: cultural versus commercial views of the state role, and "independent" versus concentrationist views of the proper industrial model the state should support. On the cultural side were filmmakers who felt that the state should support films based on their cultural importance, with no regard to commercial potential. In Brazilian film circles, this kind of film is known as a *miúra*. At the extreme of this position were documentarists such as Sílvio Tendler (*Os anos JK, Jango*) and some state bureaucrats who wanted Embrafilme limited to the production of cultural and educational films, much like the Instituto Nacional do Cinema Educativo, which was created by Getúlio Vargas in 1937 and later absorbed into INC. On the other side of this conflict were filmmakers and producers who thought that commercial potential should be the only thing that concerned the state enterprise in its attempts to support the industry's development. Pedro Rovai, known as a producer and director of *pornochanchadas*, argued that Embrafilme should finance production companies, much as the state does in other economic sectors, and not individual film projects. He saw the cultural/commercial division as a false dichotomy and believed, quite correctly, that once a film is projected on screen it transmits cultural values (Bernardet, *Cinema brasileiro*, 57).

The idea that only commercial potential should be considered derives from the notion, oft-repeated by exhibitors, that the public is the final judge of the value of cultural production. Such a notion does not consider historical distortions in the transmission and reception of cultural goods in a dependent, peripheral context. When film production began in Brazil on a fairly large scale after the turn of the century, the formal uses to which the highly technical cinematic apparatus could be put had already been largely determined. The early domination of the Brazilian market by foreign film industries fostered in the audi-

ence certain expectations concerning a film's quality as the foreign film became the standard against which all films would be judged. Although Brazilian films were relatively successful in the domestic market in the first decade of the century, they were by and large unable to attain the production values of foreign films and thus came to be seen by the Brazilian public as of poor quality and unworthy of support. The massive presence of foreign—largely American—films in the Brazilian market has tended to reinforce audience bias in their favor. This creates, for the Brazilian filmmaker, the dilemma of whether to imitate foreign films or attempt to create new modes of cinematic discourse based on what he or she perceives to be "national" values. The cultural/commercial dichotomy is one expression of this complex and perhaps unresolvable dilemma.[14]

Acutely aware of this dilemma, some directors, such filmmakers as Joaquim Pedro de Andrade, Nelson Pereira dos Santos, Carlos Diegues, Arnaldo Jabor, Leon Hirszman, Geraldo Sarno, Tizuka Yamasaki and Hector Babenco, among others, attempted with varying degrees of success to combine the cultural and the commercial, making films that spoke to the Brazilian people in culturally relevant terms and were also successful at the box office. Embrafilme attempted to please both camps. It set up programs for the production of cultural films and documentaries and financed beginning directors and others such as Rocha and Júlio Bressane, whose films have limited commercial appeal.

The "independent"/concentrationist split grows out of the cultural/ commercial dichotomy. "Independent" filmmakers have no firm commercial structure and few sources of production financing other than the state, and yet they have contributed decisively to the critical success of Brazilian cinema over the last twenty years.[15] Their production companies often consist of little more than a small office, a desk, and a telephone. They normally do not own complete filmmaking equipment, yet they constitute the vast majority of Brazilian cinematic activity.[16] Although they are not opposed to making successful films, they see commercial success as secondary to cultural or social relevance. By financing individual films rather than production companies, Embrafilme tended to support these "independent" filmmakers, reinforcing an atomized model of production rather than turning, as did Mexico, to a production model based on large studios.

In the 1970s the concentrationist group, and I use the term "group" very loosely, gained considerable strength and power within Embrafilme. The group is composed of medium-sized production companies which have complete or almost complete filmmaking facilities and fairly large and permanent staffs. Unlike the "independents," they nor-

mally produce several films a year (sometimes by "independents"), of-ten in partnership with private investors, both national and foreign. They called on Embrafilme to adopt a more entrepreneurial attitude leading to increased capital accumulation in the industry. As a means to that end, they favored the concentration of Embrafilme's resources in a few films with strong commercial potential. Some of them wanted Embrafilme, or at least its profitable sectors, to be sold to private concerns.[17]

The existence of such tensions, when set against the traditionally clientelistic nature of the Brazilian state, of which the agency was part, resulted in a general lack of direction in Embrafilme's policy. Since the state's precise role in relation to the film industry was never truly defined, Embrafilme tried to be too many things to too many people, often under the forms of political pressure inherent in a clientelistic framework, the result being that it did few things as well as it might have been able to do under different circumstances and with different operating principles. Embrafilme made viable many important film projects and contributed decisively to Brazilian cinema's becoming, for a brief period, the premier cinema in Latin America, but its policies obviously did not lead to the consolidation of Brazilian cinema as a self-sustaining industry.[18]

Among the perhaps unintended effects of state policy toward the film industry were the bureaucratization of cinematic practice and a dramatic increase in production costs. The former, which led, in objective terms, to Brazilian cinema being an officially sanctioned cinema (i.e., sanctioned by the state), is evident in the number of certificates a film needed to be recognized as a film, to benefit from cinematic legislation, and to legally enter the exhibition circuit. According to the legislation compiled by Alcino Teixeira de Mello, among such certificates have been a Censorship Certificate, a Certificate for Compulsory Exhibition, a Certificate of Origin, a Certificate of Brazilian Production, a Certificate-Guide for the obligatory "contribution" for film industry development, and a Certificate of Registration. In other words, a film does not exist as such in Brazil until legally recognized by the state bureaucracy.

On at least one occasion this process became a *de facto* form of censorship. In 1975 Jorge Bodansky and Orlando Senna co-directed *Iracema*. The film was shot in 16mm using a type of stock that Brazilian laboratories were apparently ill-equipped to develop. Consequently, the film was developed in West Germany, where the film had been picked up for distribution on German television. Since it was not developed in Brazil, the film did not technically conform to the legal definition of a "Brazilian film" and was therefore denied the necessary

Certificate of Brazilian Production, without which it could not be exhibited in the country. *Iracema* thus entered a sort of catch-22 situation; it could not be exhibited as a Brazilian film and enjoy the rights thereof (e.g., participation in the reserve market under the protectionist compulsory exhibition statutes), nor could it be submitted as a foreign film, since it was obviously Brazilian. The bureaucratic interdiction lasted until 1980 when it was finally released by Embrafilme as a Brazilian film. It also won top honors in that year's Embrafilme-sponsored Brasília Film Festival. Although bureaucrats argued that the film's interdiction was a technical, legal matter, there is no doubt that its controversial nature had something to do with its problems with the state.

Another effect of the shift in policy toward the financing of selected film projects was, it is often said, to "socialize losses and privatize profits" (Schild). Since the state assumed the lion's share of the financial risk involved in film production, many directors and producers tended to be less concerned with keeping costs down and, at least to some extent, with public acceptance of their films. This problem was compounded by the political favoritism or clientelism that came to characterize the selection process. Many critics and filmmakers have commented on the situation:

> Sérgio Augusto: "The worst thing was the damage caused by the corporative and cartorial policy [Embrafilme] fostered. Access to whatever funds were available for production was only easy —and at times too easy—for those who had political contacts or who screamed the loudest. Talent for making good or successful films became a secondary factor in Embrafilme's entrance exams."
>
> Hermano Penna: "Embrafilme has a paternalistic relationship [with the industry], with the total collusion of cinematographic professionals, because their relationship to the agency is not clear, partly because a film industry has never really been established in Brazil. It's a two way street: the agency paternalizes, but filmmakers also have a tendency to expect it" (*Jornal da tela*, March 1990, 13).
>
> Júlio Bressane: "Embrafilme preserved and exacerbated all the defects of state enterprises: nepotism, malversation, overcharging, in sum, all the characteristics of an organized gang, and it thus chased the public away from the cinema and destroyed the market" (*Jornal da tela*, March 1990, 14).
>
> Luiz Paulino dos Santos: "Another thing that is terrible in Embrafilme, besides the fact that one administration simply reverses the policies of the previous one, is the lack of criteria in

the choice of productions, which are always selected in the most subjective way possible by special interest groups" (*Jornal da tela*, March 1990, 15).

Eduardo Escorel: [Even after its 1987 reorganization] "the paternalistic nature of state support continued, through subsidized investments with no hope for return given the conditions of the market. Embrafilme's public image ended in tatters after being bombarded for years by accusations of favoritism and having even the legality of its operations questioned. Even so, filmmakers refused to admit that the agency had a fatal illness. Tested chameleons, directors and producers tried to go about business as usual as if nothing had happened. Despite their chronic dissatisfaction, they preferred to maintain their relationship of dependency with the state instead of admitting that Embrafilme . . . had ceased to serve the true interests of Brazilian cinema. Struggling to reach an illusory life raft—the signing of a contract with Embrafilme—they continued to participate in the farce: while they cursed Embrafilme in public, in private they fought tooth and nail for their slice of its meager resources. On the one hand the agency approved projects with no apparent criteria; on the other filmmakers were pressured to sign contracts they could not fulfill" ("Cinema e estado").[19]

Embrafilme's co-production program undeniably improved the technical quality of Brazilian cinema—virtually all of the Brazilian films exhibited in the United States during the last decade were produced under such programs—but by doing so it allowed production costs to be inflated to levels far above the market potential for return in the domestic market. According to Concine's own calculation, at an average cost of $500,000 a film would need to be seen by 1,800,000 paying spectators to break even. In 1988 only two films, both by the Trapalhoes comedy team, reached that level, although a third, *Super Xuxa contra o Baixo Astral*, came close (Table 2; Concine 130–31). While the process of rapidly increasing production costs was taking place, Embrafilme/Concine did little to improve and strengthen the industry's infrastructure. Its focus, at least in terms of financial support for the industry, was almost exclusively on production and on its own distribution sector.

By the mid-1980s, it become clear that the existing mode of state-supported cinematic production was obsolete and transformation of the relationship between cinema and the state was necessary. The urgency of the restructuring became clear, and Embrafilme once again the object of severe public criticism and debate, when the *Folha de São Paulo* published, in early 1986, a series of articles on the enter-

prise's management.[20] In an editorial titled "Cine catástrofe," (20 March 1986), the newspaper referred to Embrafilme's activities as a "moral, economic, and artistic disaster." Many film industry professionals recognized the need for a reevaluation of the relationship between cinema and the state. Cinema Novo veteran Carlos Diegues (*Bye Bye Brasil*), for example, referred to the enterprise as a "cultural Medicaid system that treats cancer with bandaids," and Embrafilme director Carlos Augusto Calil (1985–1987) asserted that the state could no longer attempt to substitute for private enterprise and that the existing model was simply no longer viable.[21]

Although minor changes in policy had occurred throughout the late 1970s and early 1980s, the next major attempt at transformation took place during the Sarney administration, with Celso Furtado as minister of Culture. Sarney restructured Embrafilme, separating its cultural and commercial activities, by creating a mixed-ownership enterprise (Embrafilme—Distribuidora de Filmes S.A.) housing all of the firm's commercial activities, and transferring its other sectors into a foundation (Fundaçao Brasileira de Cinema). In the past, some 15 percent of Embrafilme's capital has been designated for non-profit cultural activities, creating what many feel to be a financial burden on an enterprise designed to engaged in entrepreneurial activities in support of the national industry *qua* industry. Even under this new structure, Embrafilme's fundamental orientation—the support of individual film projects rather than the industry as a whole—remained unchanged, and the general situation of the Brazilian film industry continued to deteriorate.[22]

The Exhibitor as Enemy

One of the major reasons for the crisis, and one that has not yet received the serious public discussion it deserves, is the tension, if not outright antagonism, between the state-supported production sector and the exhibition sector. This antagonism goes back to the very beginnings of Brazilian cinema. In the early 1900s producers and exhibitors were normally one and the same. The development of independent distributors drove a wedge between producers and exhibitors, and the exhibition sector began to function almost exclusively for the benefit of foreign cinemas. In the 1930s, exhibition groups fought legislation initiating a timid screen quota for Brazilian short films, just as they have fought every attempt to expand the quota until today, arguing free trade and open markets in opposition to state intervention and manipulation of the rules of the marketplace.

Without a screen quota and other protectionist measures, Brazilian cinema very likely would have existed only on the most crass commercial basis. At the same time, state policy toward the film industry clearly contributed to a loss of profits for exhibitors and was at least partially responsible for the decline of the exhibition sector, which has been pernicious for the Brazilian film industry as a whole.

The relationship between the state and the exhibition sector deteriorated steadily over the last two decades and especially since the reorientation of state policy toward the industry described above. In 1974, *O Estado de São Paulo* ran an article with the headline "The Great Duel of National Cinema," referring to the duel between exhibitors and state-supported producers as analogous to a Western movie, with the producer as hero, the exhibitor as villain, and the state as sheriff. The "duel" would by 1980 become a "war," fought largely in the courts, as exhibition groups, sometimes in conjunction with distributors, continually filed suit and frequently obtained at least temporary injunctions against various aspects of state policy, especially the compulsory exhibition law (screen quota). In its report for the second half of 1988, Concine lists suits filed by thirty-two exhibition companies (not counting multiple co-litigants) representing over 10 percent of the total number of theaters in Brazil (Concine 314–17).

The "war" between exhibitors and producers was fought not only in the courts, but also in the theaters. Jorge Schnitman suggests that "historically, whenever exhibitors were forced to exhibit a large number of national films, they attempted to produce their own" (67 n. 1). As early as 1971, exhibition groups began joining together to form production companies with the expressed intention of making films to meet the requirements of the compulsory exhibition law. The result was the rash of poor-quality *pornochanchadas* that began to flood the reserve market in 1972–1973, leaving even less room for more culturally serious films. In the 1980s, such production would become even more noxious as the soft-core pornochanchada was replaced by hardcore pornography. Table 1 not only indicates the astonishingly high percentage of pornographic films after 1980, but also the inexistence of independent sources of film production financing and the almost total dependence of the production sector on either exhibitors (i.e., pornography) or the state.

Rather than go into more detail or discuss the merits of exhibitors' arguments, it is important to summarize legislation regarding the exhibition sector to attain an at least partial understanding of its situation. Brazilian cinematic legislation stipulates that exhibitors must show national films at least 140 days per year, regardless of the number of Brazilian films produced in a given year or the quality of those films.

Although exhibitors negotiate with distributors of foreign films, they are obligated to pay a minimum of 50 percent of net income for Brazilian films, and they must make payment within fifteen days of exhibition. They must show a national short subject as part of each program of foreign films, purchase standardized tickets and box-office income recording sheets from Embrafilme at inflated prices, and keep Brazilian films in exhibition as long as the average of total spectators for two weeks or more equals 60 percent of the previous year's weekly average.

In return, exhibitors have received virtually nothing from the state except the disdain which has long characterized producers' attitudes toward the sector. Although it was among Embrafilme's attributes to attend to the needs of the sector, it refused to divert funds from production and did not even provide subsidies or low-interest loans to help them renovate their equipment and theaters. The result of the authoritarian imposition of these unwelcome measures has been a decline in income and a deteriorating sector which has led to the closing of many theaters, especially in the interior of the country, and to the current crisis of Brazilian cinema. The proof of the failure of state policy toward the exhibition sector—and toward Brazilian cinema as a whole —is the dramatic decline in the number of theaters in operation in the country, now slightly over 1,000 for a country of 140 million. Today the only films that can cover costs in such a small market are children's films using popular television stars as actors (Xuxa, Sérgio Malandro, the Trapalhoes).

Cinema Novo, Exhibitors, and the Public

If the politically radical Cinema Novo movement was able to reach at least a tacit understanding with certain segments of the military regime regarding film production financing and the creation of a nationwide distributor within the framework offered by Embrafilme, why, then, was it unable to effect a rapprochement with the exhibition sector on mutually beneficial grounds? It would be simplistic to lay blame exclusively on the relationship between exhibitors and foreign film distributors, although there can be no doubt that that relationship has been a major contributing factor. For a full understanding, one must also go back to the origins of Cinema Novo, especially its attitude toward modes of cinematic practice and toward traditional film industry structures, and to the internal dynamics of the movement as it evolved in the 1960s.

An integral part of Cinema Novo's conception of social action through the cinema was a new attitude toward the development of the

national film industry, based on a rejection of the studio model, which had failed so dismally with Vera Cruz, and an insistence on the importance of an auteur model. In his seminal 1963 book *Revisao crítica do cinema brasileiro*, Glauber Rocha aligns himself and the movement with the French Nouvelle Vague and its struggle to free itself from the rigidity of industrial cinema and its norms, while at the same time politicizing the Nouvelle Vague's concept of *auteur*. The auteur, according to Rocha, revolts against the mercantilist mentality of industrial cinema, which puts profitability and easy communication above art. Rocha proposed an opposition between "commercial cinema," equated with illusionistic technique and untruth, and "auteur cinema," characterized by freedom of expression and a dedication to truth.

Cinema Novo thus rejected the studio system, a model borrowed from the "metropolis," as being dedicated by definition to the falsification of reality. Because of an extreme scarcity of finance capital for film production, Cinema Novo could not hope to equal the technical level of most foreign films. So rather than imitate dominant cinema, which would make their work merely symptomatic of underdevelopment, they chose to resist by turning, in Ismail Xavier's words, "scarcity into a signifier" (18). The critical realism of films marked by the "aesthetic of hunger" served an important tactical and political function by expressing the radical "otherness" of Brazilian cinema in relation to world cinema. In short, as part of their project for "decolonizing" Brazilian cinema and attempting to create a critical consciousness in the Brazilian people in opposition to the alienated consciousness supposedly fostered by Hollywood, Cinema Novo adopted a new attitude toward the industrial development of Brazilian cinema and a new attitude toward film aesthetics, privileging ideas over technical perfection, politics over commercial potential.

Despite the movement's real contributions along these lines, a paradox also appears in its strategies. Although it opposed traditional modes of cinematic production and the aesthetic forms accompanying them, its participants made no real attempt to create alternative or parallel exhibition circuits. Rather, they released their films in established commercial circuits which had been built primarily for the exhibition of foreign films. The Brazilian public, long conditioned by Hollywood's products, was generally unreceptive to the films of Cinema Novo, which became in many ways a group of films made by and for an intellectual elite and not for broad sectors of the Brazilian people or even of the film-going public.

Filmmaker Gustavo Dahl discussed the relationship between Cinema Novo, the public, and exhibitors in two 1966 articles, "Cinema

Novo e estruturas econômicas tradicionais," and "Cinema Novo e seu
público." In the first, Dahl argues that the Cinema Novo's initial suc-
cess among intellectual elites allowed its participants to glimpse "the
possibility of *making the old structures of Brazilian cinema collapse*
through a strategy of internal prestige and commercial success abroad
. . . [It] was a question of destroying the artistic and cultural vices of
[Brazilian] cinema from the inside out" (197; stress added). Using the
prestige gained in international film festivals, the movement's partici-
pants began making their first features with money from private pa-
trons or borrowed from banker José Luís de Magalhaes Lins's Banco
de Minas Gerais. But "since the new filmmakers found themselves
unconnected to the traditional structures of the Brazilian market—'*et
pour cause'*—nothing could prevent the repetition of the errors of São
Paulo's attempt at studio-based industrialization: the production of
films that had no guarantee of exhibition" (197). In other words, Cin-
ema Novo hoped to destroy traditional cinematic structures but para-
doxically found itself at an impasse because of the lack of alternative
or parallel structures of distribution.

Cinema Novo participants had naively overestimated their ability to
penetrate foreign markets beyond the festival circuit, and given their
frequently inexistent capital base, directors and producers came to de-
pend on distributors and even exhibitors for postproduction financing.
Dahl explains that "the exhibitor took advantage of this situation by
diminishing the producer's percentage, releasing the film without pub-
licity and using the film only to fulfill his compulsory exhibition
quota. The cultural prestige and artistic success obtained by the films
were insufficient to overcome either the pressure of the exhibitors or
the traditional estrangement between the public and the *serious* Bra-
zilian film" (197–98).[23] In other words, the ultimate cost of Cinema
Novo's new attitude toward modes of cinematic production, film in-
dustry development and film aesthetics was its inability to penetrate
the existing film market, where at least implicitly (and objectively)
less serious Brazilian films did find success. Dahl's initial and most
explicit explanation for this inability addresses what he calls the
"greatest problem" of the national cinema: "the struggle of Brazilian
exhibitors and foreign distributors against Brazilian producers and dis-
tributors" (200).

The problem with this argument is that it fails to link the exhibi-
tor's resistance—they frequently argued that Cinema Novo films were
too intellectual and hermetic for success in the marketplace—to the
widely recognized fact that the public by and large did not accept the
movement's films. If the public refused to see the films, the exhibitors
argued, why should they be forced to exhibit them? The problem of

public acceptance would perhaps be of less significance if the move-
ment had created stable parallel circuits for the exhibition of its films,
but it did not, choosing, rather, to attempt to penetrate traditional cir-
cuits where deeply-rooted economic interests and cultural habits fos-
tered traditional forms of cinema *qua* entertainment, precisely the type
of cinema that Cinema Novo, at least initially, virulently opposed.

In "Cinema Novo e seu público," Dahl acknowledges that the
movement's films did not reach their intended public (which he does
not define but which apparently includes the film-going public as a
whole) and asks whether that public would accept their films even if
they saw them. The public Cinema Novo did manage to reach—esti-
mated at around 50,000 people in Rio de Janerio—was composed
largely of students, liberal professionals, intellectuals, artists, film en-
thusiasts and even "some sectors of the bourgeoisie." But, Dahl sug-
gests, "even this public is not satisfied with the films produced by
Cinema Novo. Although it follows the movement with interest, it has
one criticism: it does not make films that please the public!" This sup-
portive yet restricted public recognized Cinema Novo as an important
cultural movement, but it regretted its hermeticism and its "divorce
from the masses." Thus the major question facing the movement:
"how to resolve the contradiction between a socially and aesthetically
responsible cinema and its acceptance by the public" (194).

Dahl does not have an answer to this question. Rather, he shifts to
the level of idealistic explanations ("film is an art . . . No one asks
Boulez how many records he has sold . . .") by comparing Cinema
Novo filmmakers (Rocha, Saraceni, Guerra, and Andrade, in this case)
to Antonioni, Godard and Resnais, whose films are frequently unsuc-
cessful at the box-office but who, unlike the Brazilians, are able to
salvage the situation through international sales or, in the case of Go-
dard, low budgets. Dahl thus displaces the argument from the concrete
question of Cinema Novo's relationship with the public to the impor-
tance of linguistic experimentation in modern auteur cinema, using
Godard as the paradigmatic example (195). Implicit in his formulation
is a charismatic, Romantic vision of the artist and an essentialist view
of the film as an *objet d'art*.[24] The importance of Cinema Novo, he
suggests, consists in "its ambition to be part of a worldwide search for
a new cinema" (198).

The basic problem remains unresolved. Cinema Novo, in its initial
phase, was not accepted by the Brazilian people, and the movement
did not seriously address "the fundamental question of the films' lack
of communication with the public and its repercussions on the levels
of language and ideology" (199). Who was to blame? Not the film-
makers; certainly exhibitors and foreign film distributors; perhaps

even the public. After all, in "Cinema Novo e estruturas econômicas tradicionais" Dahl had written that "the Brazilian public had followed the changes in taste of the worldwide public in its unbridled search for sex and violence, found in the plays of Nelson Rodrigues and cangaceiro adventures" (198).[25]

In "Cinema Novo e seu público" he continues the argument, recognizing the disjunction between the movement's political intentions and its objective inefficacy: "At first, the illusion was held that it would be sufficient to place the people in front of the films, as if before a mirror, for them to become aware of their alienation. Experience demonstrated exactly the opposite: the more they recognized themselves in their negative aspects, the more they protested. *It's dangerous to affirm that the public is not always right . . .*" (stress added). Some films of the movement's second phase—*Menino de engenho, São Paulo S.A., Matraga,* and *A grande cidade*—had more success, partially because they "overcame the exasperating slowness considered one of the characteristics of Brazilian cinema," but at the cost of a "dilution of ideological substance." Others, such as *O padre e a moça, A falecida,* and *O desafio,* with their "intransigent fidelity to the conceptions of an auteur cinema, their stylistic rigor, and their conspicuous personality . . . disconcerted the public" (200). The people, Dahl continues, "do not want to be made aware of their unhappiness and inferiority in relation to other nations. It is necessary . . . to reveal both their weaknesses and their strengths in order to prevent them from falling into either depression or euphoria. We must learn to entertain them with their problems, which is not easy, and make them believe that one day they will find a solution, which is even more difficult" (202).

One can clearly see in Dahl's statement of the problem the paternalistic didacticism of early Cinema Novo based, ultimately, on a Romantic vision of the artist (the auteur) as possessing a superior form of social and cultural knowledge as well as a self-attributed mission for making the people aware of their alienation and their supposed inferiority to other peoples as a means of helping them overcome their weaknesses and use their strengths to find solutions to their problems. If the people did not accept Cinema Novo's message, the difficulty must surely rest with them—or with the "colonial situation" which inculcated certain cinematic preferences—and not with the message itself or its aesthetic packaging.

In "A crise do cinema brasileiro e o plano Collor," critic Jean-Claude Bernardet discusses the insistence on a auteur mode of cinematic practice as a significant contributing factor to the crisis. Bernardet argues quite correctly that this insistence, combined with the inability or unwillingness to develop more stable modes of cine-

matic production—what he calls a "cinema de produtor" or a "producer's cinema"—led the independent cinema of the early 1960s to gradually become an "auteur-cinema-dependent-on-the-state." As Bernardet writes, "The model of auteur cinema comes from the days of silent film and reached its apogee with Cinema Novo and Marginal Cinema and its dependence on the state which was consolidated in the 1970s. This does not mean that beautiful films do not occasionally appear, but rather that the model does not offer a structural solution, that is, a form of production that attracts a public and is able to recuperate its means of production." In other words, the insufficiencies of the auteur model itself were a factor in the failure to develop a self-sustaining film industry with a strong financial basis in the support of the Brazilian public.[26]

Cinema Novo was left with two options: play by the exhibitor's rules and make popular films (in box-office terms) or change the public's viewing habits and preferences. Given the difficulty if not impossibility of the second—Dahl suggested, in "Cinema Novo e seu público," that such a change could occur only as a consequence of deep social transformations when the people would be "freed of the oppression of misery"—many of the movement's participants recognized that the production of more popular films became imperative if Cinema Novo was to continue to exist. To this end, it took a number of steps. First, producers and directors formed a distribution cooperative as a strategy for placing their films more easily in the market. Second, they began to make films they hoped would have a more popular appeal, turning more systematically toward literary classics and admitting comedy as an acceptable mode of discourse (early Cinema Novo, one might recall, was almost totally humorless).[27] In addition, they appealed to the state to guarantee, indeed impose, what the films themselves were unable to obtain: access to the market and a return on investments. One result of this appeal was the creation, within the INC, of subsidy and co-production programs, another was the increased screen quota for foreign films and the increased hostility between and polarization of producers and exhibitors.

The exhibitor was irreversibly cast in the role of villain with whom no dialogue was possible. In the I Congresso da Indústria Cinematográfica (First Film Industry Congress, 1972), the exhibitors' syndicate presented a twenty-one point proposal concerning the problems faced by the sector and focusing on financial assistance, standardized tickets and income reporting devices, and the compulsory exhibition law. Although many of the proposals were reasonable—such as a modification of the compulsory exhibition law so that no theater would be obligated to show a national film that had already been exhibited at

another theater within a one kilometer radius—none was accepted.[28] It was as if the exhibitors had no legitimate concerns to be addressed in a serious manner.

The future of Brazilian cinema is currently up in the air. Virtually all of the ideological alibis used in its defense over the last thirty years have crumbled along with the decimation of the domestic film market, the collapse of the production sector, and the at least temporary elimination of state support. The only solution to the current crisis—if there is one—may well be association with those long held to be the enemies of Brazilian cinema: foreign producers and exhibitors. Ironically, one of the few bright spots in the currently gloomy situation of Brazilian cinema is that Luiz Severiano Ribeiro Neto, owner of the largest exhibition network in Brazil, which was responsible for the immense success of the musical comedy (*chanchada*) in the 1940s and 1950s, is again entering production with low-budget, commercially-oriented films geared toward the true dimensions of the Brazilian market. The first such film—currently in production—is being directed by Sérgio Rezende. More importantly, however, if it is to survive the current crisis and remain a significant form of cultural expression Brazilian cinema must reexamine and redefine its relationship to the public and the state as well as its own position in the broader field of social relations.

Notes

1. After *O cangaceiro* Barreto was able to make only one other feature, *A primeira missa* (1961). Even award-winning Cinema Novo directors have been less-than-prolific, due primarily to structural and conjunctural problems. Joaquim Pedro de Andrade (*Macunaíma*, 1969) made only six features, including one documentary, between 1960 and his death in 1988, Leon Hirszman (1938–1988) only four.

2. The evolution of Cinema Novo's relationship to the state is outlined in Randal Johnson, *The Film Industry in Brazil*, especially chapters 4–6. The unprecedented level of stability and prosperity attained during this period is evident in the following statistics: between 1974 and 1978 the total number of spectators for Brazilian films doubled from 30 million to over 60 million, and total income increased by 288 percent, from $13 million in 1974 to over $38 million in 1978. Brazilian cinema's share of its own market increased from around 15 percent in 1974 to over 30 percent in 1978. From "Lei básica do cinema brasileiro," *Filme cultura*, 33 (May 1979): 114–16.

3. Given the complexity of the film production process, it is virtually impossible to know precisely how many films are currently underway. The figure given derives from conversations I had with a number of filmmakers in Rio de Janeiro and São Paulo in July 1990. Most of the films now in production are being financed by European television industries or by the municipal

government of São Paulo. Many projects were paralyzed by Collor's extinction of Embrafilme.

4. The 20 of 30 figure sheds a favorable light on the real proportion. Of the top-grossing 100 Brazilian films of 1988, only around 20 were not pornographic. Of the 50 top-grossing foreign films during the same period, none were pornographic. See Concine, *Relatório de atividades* 76–77, 91.

5. The situation has improved slightly since 1984, especially as other networks have begun to mount more serious challenges to the Globo network's virtual monopoly, but not enough to significantly change the situation.

6. Journalist/critic Sérgio Augusto sarcastically refers to those filmmakers who were able to obtain financing primarily through political contacts rather than talent and who depended almost entirely on the state for their sustenance as "Embrafilme's orphans."

7. The evolution of the screen quota was the following: 1932: One short for each program of foreign films; 1939: One feature per year; 1946: Three features per year; 1951: One feature for every eight foreign films; 1959: 42 days per year; 1963: 56 days per year; 1969: 63 days per year (provisional); 1970: 77 days per year (provisional); 1970: 112 days per year (not implemented); 1970: 98 days per year (not implemented); 1971: 84 days per year; 1975: 112 days per year; 1978: 133 days per year; 1980: 140 days per year (Johnson 1987: 185).

8. Among films financed under the co-production program were Joaquim Pedro de Andrade's *Macunaíma* (1969), Carlos Diegues's *Os herdeiros* (1968), and Nelson Pereira dos Santos's *Como era gostoso o meu francês* (1971). For a complete listing, see Johnson, *The Film Industry in Brazil* 202–4.

9. The texts of the decree-laws that founded and subsequently reorganized Embrafilme and founded Concine are in Mello, *Legislaçao*, 1: 11–29, 53–58.

10. Examples of such films are Glauber Rocha's *A idade da terra* (1980) and Leon Hirszman's *Eles nao usam black-tie* (1981).

11. Barreto and other producers formulated and presented to Passarinho a five-point program proposing, among other things, the restructuring of Embrafilme (Johnson, *The Film Industry in Brazil* 150).

12. According to the "Política nacional de cultura," the Brazilian government's cultural policy is founded on a number of basic principles that reflect the historical, social, and spiritual values of the Brazilian people. The document says explicitly that the state role includes support of spontaneous cultural production and in no way implies that the state has the right to direct such production or to in any way impede freedom of cultural or artistic creation. The state's responsibility, in other words, is ostensibly to support and stimulate cultural production, not control it. The document is infused with a nationalist sentiment that is broad enough to include virtually all Brazilian cultural production. It formulates a desire to construct a harmonious "national identity" on a symbolic level based on respect for regional and cultural diversity and the preservation of the nation's cultural and historical patrimony.

13. Velloso, who was an avid film fan and a friend of Cinema Novo veteran Nelson Pereira dos Santos, has explained the Geisel regime's support of the film industry in the following terms: "Our objective was not to make an experimental, formally sophisticated and hermetic type of cinema. Not that that was excluded, but it wasn't our primary objective. We had to make a kind of cinema that really reached the people, a culturally dignified cinema. . . . From the beginning there was an understanding that the government would not culturally restrain anyone. The filmmaker would have artistic freedom to make his film, but at the same time I warned them that although political cinema is certainly legitimate, they should not make a doctrinaire, propagandistic cinema" (in Tendler 164).

14. See Johnson, *The Film Industry in Brasil*, 19–23, 33–34.

15. The term "independent filmmaker" came into being with the Cinema Novo movement to distinguish between its mode of production and traditional modes of production based on a studio model. With the increasing dependence of such filmmakers on the state, the term has lost its original meaning and is in contradiction with their objective position in the cinematic field. Thus the quotation marks.

16. In an extensive interview granted after the release of his internationally-acclaimed *Pixote*, director Hector Babenco described his production company in the following manner: "My office is shameful. I have a typewriter I'm still making payments on and two telephone lines . . . I don't have anything, not even a lease . . . 'HB Filmes'! In fact, it's just me, an office and a secretary. When I'm sick, HB is sick; when I'm broke, HB is broke . . ." In Naves, et. al. *Cinema*, no. 5 (Fundação Cinemateca Brasileira, Spring 1980): 15. An abbreviated version of this interview, in English translation, can be found in *Studies in Latin American Popular Culture* 7 (1988), 241–54.

17. See, for example, comments by Luiz Carlos Barreto in *O Estado de São Paulo*, 12 September 1984.

18. Between 1974 and 1985 Embrafilme co-produced 194 feature films. For a complete listing, see Johnson, *The Film Industry in Brazil*, Appendix E, 213–20.

19. An important distinction is in order. Since Embrafilme's central offices were located in Rio de Janeiro, the agency was much more susceptible to pressure from Rio-based filmmakers than from those living in other parts of Brazil. São Paulo directors tended to use collective approaches to Embrafilme, devising more equitable forms of competition for funds within film industry organizations. Ozualdo Candeias describes their strategies in the following terms: "We in São Paulo never approach Embrafilme directly and say 'look, I have a film project for you to see.' We are united in an organization [the Associação Paulista de Cinema or APACI], and it is not our habit to act individually in relation to Embrafilme, perhaps partially because its relationship with São Paulo filmmakers has never been very good" (*Jornal da tela*, March 1990, 16). In the same issue, see additional comments by São Paulo filmmakers Joao Batista de Andrade and Sérgio Toledo.

20. See also, in the *Folha*: "L. C. Barreto diz que é credor da Embraf-ilme," 17 March 1986; Renata Rangel, "Co-produçao aumenta déficit da Em-brafilme," 18 March 1986; "Nova declaraçao de Massaini," 18 March 1986; "Cineastas pediram o fim da correçao," 19 March 1986; Carlos Diegues, "De quem é mesmo o dinheiro da Embra," 20 March 1986; "Calil investe no cul-tural e comercial," 21 March 1986; Sérgio Santeiro, "O modelo cinematográf-ico opressor," 21 March 1986; "Furtado quer mudar Embrafilme," 22 March 1986; "Embrafilme responde à reportagem da *Folha*," 23 March 1986; Luiz Gonzaga Assis de Luca, "Embrafilme, o consumidor é quem paga," 23 March 1986; "Decreto de Sarney determina o que é o filme brasileiro," 25 March 1986; Sérgio Toledo and Roberto Gervitz, "Embrafilme é um antídoto," 30 March 1986.

21. Diegues's remark came in an interview to the *Jornal do Brasil*, 23 February 1985, and Calil's in an interview to that same paper on 23 March 1986.

22. In fact, the Fundaçao Brasileira de Cinema was never funded, and dur-ing its brief existence its budget came from Embrafilme.

23. Glauber Rocha describes this situation in some detail in *Revisao crí-tica do cinema brasileiro*, especially on 140–41. Rocha's own solution to the problem of market access involves two steps: first, a reserve market of 51% for national films, and second, increased censorship under the aegis of the Ministry of Education and Culture. A censorship commission, made up of "intellectuals, critics, professors and men with a proven capacity for the cul-tural understanding of the cinema" rather than "ignorant police officials and puritan women," would screen both imported films and national films on the basis of "quality." His formulation constitutes an appeal for authoritarian solu-tions to the industry's problems (or at least for the problems of the "independent" directors and producers with whom Rocha was associated).

24. In the earlier article "Algo de novo entre nós" (1961), Dahl had writ-ten that "before being an industry, the cinema is an art," and "Art derives from the artist, the artist is the man [sic] who exists in freedom. The cinema, which is of man and Man [sic], is free, free above all from the economic pres-sure that industrial organization brings with it." The individual expression of an artist or auteur thus has priority over all other considerations.

25. It is perhaps ironic that one of the films Dahl mentions as being in-transigently faithful to the original conceptions of Cinema Novo and the ten-ets of auteur cinema—and a box-office failure—is Leon Hirszman's *A falecida* (1965), based on a play by Nelson Rodrigues. The first film by a Cin-ema Novo director drawn from Rodrigues was Nelson Pereira dos Santos's moderately successful *Boca de ouro* (1962). In the 1970s and 1980s films based on Rodrigues would constitute a rich vein (culturally and economically) in Brazilian cinema, with such works as Arnaldo Jabor's *Toda nudez será castigada* (1972) and *O casamento* (1975), Neville d'Almeida's *Dama do lo-taçao* (1978) and *Os sete gatinhos* (1980), Braz Chediak's *Bonitinha mais or-dinária* (1981), and Bruno Barreto's *O beijo no asfalto* (1981), among others.

26. São Paulo critic Inácio Araújo once suggested to me that Brazilian cinema suffers from a "Godard syndrome" in that filmmakers tend to be more interested in aesthetic experimentation and, consequently, in being recognized as a "new Godard," than in making films that might please a broad public. Although one should be careful not to make excessively broad generalizations—there are *many* cases where this does not apply—Araújo is certainly correct in some instances.

27. Toward the end of the 1960s the situation was in fact beginning to change, with Andrade's *Macunaíma* being the paradigmatic case of a film that was both politically radical and successful at the box-office. In Nelson Pereira dos Santos's words, 'The big turnaround came with *Macunaíma*, [which constituted] a rupture with didactic cinema, an anthropological openness and the end of the limiting stances of pre-conceived intellectual schemes" (Bojunga).

28. For a more detailed description of the exhibitors' proposals, see Johnson, *The Film Industry in Brazil* 147–50.

List of Works Cited

Augusto, Sérgio. "Governo estuda incentivos para filmes brasileiros." *Folha de São Paulo,* 5 July 1990.

Bernardet, Jean-Claude. *Cinema brasileiro: propostas para uma história.* Rio de Janeiro: Paz e Terra, 1979.

_____. "A crise do cinema brasileiro e o plano Collor." *Folha de São Paulo* (Letras F-3), 23 June 1990.

Bojunga, Cláudio. "Nelson: do Beco, da Boca, do humor entre dentes, do corpo fechado." *Jornal da tarde,* 31 October 1974.

Concine. *Relatório de atividades,* Segundo Semestre 1988 (1989).

Dahl, Gustavo. "Algo de novo entre nós." *O Estado de São Paulo (Suplemento literário),* 7 October 1961.

_____. "Cinema Novo e estruturas econômicas tradicionais." *Revista civilizaçao brasileira,* I:5/6 (March 1966), 193–204.

_____. "Cinema Novo e seu público." *Revista civilizaçao brasileira,* 11/12 (December 1966/March 1967), 192–202.

Diegues, Carlos. "As esperanças do cinema brasileiro." *Opiniao,* 26 December 1975, 21.

Escorel, Eduardo. "Cinema e estado." *Jornal do Brasil,* 10 April 1990, Caderno 1, 11.

Folha de São Paulo. "Cine catástrofe," 20 March 1986.

Johnson, Randal. *The Film Industry in Brazil: Culture and the State.* Pittsburgh: University of Pittsburgh Press, 1987.

_____. "Toward a Popular Cinema: An Interview with Nelson Pereira dos Santos." *Studies in Latin American Popular Culture,* 1 (1982), 225–36.

Jornal da tela (Embrafilme), Ediçao especial ("Proposta para uma politica nacional do cinema"), March 1986.

Jornal da tela (Embrafilme), Ediçao documento ("Embrafilme 20 anos"), March 1990.

"Lei básica do cinema brasileiro." *Filme cultura*, 33 (May 1979): 114–16.

Mello, Alcino Teixeira de. *Legislaçao do cinema brasileiro*, 2 vol. Rio de Janeiro: Embrafilme, 1978.

Miceli, Sérgio. "O processo de 'construçao institucional' na area cultural federal (anos 70)." In *Estado e cultura no Brasil*. Ed. Sérgio Miceli. São Paulo: Difel, 1984.

Ministério de Educaçao e Cultura. "Política nacional de cultura." Brasília: MEC, 1976.

Naves, Sylvia Bahiense, et. al. "Hector Babenco." *Cinema* (Fundaçao Cinemateca Brasileira), no. 5 (Spring 1980), 9–22. Abbreviated English translation: "'Beauty Must Be Convulsive': An Interview with Hector Babenco." Tr. Randal Johnson. *Studies in Latin American Popular Culture* 7 (1988), 241–54.

Ortiz, Renato. *Cultura brasileira e identidade nacional*. São Paulo: Brasiliense, 1985.

Pereira, Luiz Carlos Bresser. "Cultura e estado." *Folha de São Paulo*, 13 May 1990.

Ramos, José Mário Ortiz. *Cinema, estado, e lutas culturais*. Rio de Janeiro: Paz e Terra, 1983.

Rocha, Glauber. *Revisao crítica do cinema brasileiro*. Rio de Janeiro: Civilizaçao Brasileira, 1963.

Schild, Susana. "Embrafilme, um modelo falido," *Jornal do Brasil*, 23 March 1986.

Schneider, Ronald M. *The Political System in Brazil: The Emergence of a 'Modernizing' Authoritarian Regime, 1964–1970*. New York: Columbia University Press, 1971.

Schnitman, Jorge. *Film Industries in Latin America: Dependency and Development*. Norwood, N.J.: Ablex Publishing Company, 1984.

Tendler, Sílvio. "Cinema e estado: em defesa do miúra." M.A. Thesis, Pontifícia Universidade Católica, Rio de Janeiro, 1982.

Xavier, Ismail. "Allegories of Underdevelopment: From the 'Aesthetics of Hunger' to the 'Aesthetics of Garbage,'" Ph.D. Dissertation, New York University, 1982.

Chile

Chilean Cinema in Revolution and Exile

John King

I have faith in our nation and its destiny. Other men will prevail, and soon the great avenues will be open again, where free men and women will walk, to build a better society. Long live the people! Long live the workers! These are my last words. I know my sacrifice will not have been in vain.

Salvador Allende, 11 September 1973[1]

The Roots of New Cinema

The origins of a new film culture in Chile can be traced to the development of cultural activities in the Universidad de Chile in the 1950s. A cinema club was founded in the middle of the decade, which helped to consolidate a more sophisticated approach to film with a film journal, a program for the radio and weekly screenings of foreign films. This activity generated a desire to intervene in the filmmaking process itself and in 1959 the Center for Experimental Cinema was established in the University under the direction of Sergio Bravo, a young documentary filmmaker. Bravo speaks of these early pioneering years:

> We wanted to find a new language, to become totally independent from what we considered to be official Chilean cinema. We were very impressed by what Fernando Birri was doing. He had founded in 1956 the first Latin American documentary film school . . . in Sante Fe, Argentina. He defined his work as

John King, *Magical Reels: A History of Cinema in Latin America*. New York: Verso, 1990, pp. 169–87. By permission of the publisher.

"critical realism," a sort of neo-realism, although it was not ex-
actly the same. Many went to study in that school. We, in the
meantime, organized exhibitions of ceramics, of wicker-work
objects, we were fairly mad, discovering the light, our southern
light, which is a maritime light of great chromatic richness. . . .
I filmed all that I could.[2]

Bravo's own documentaries concentrated on local popular customs
and practices. He brought this interest in excavating and revealing lo-
cal popular culture to his courses at the university, encouraging a se-
ries of short documentaries from such incipient cineastes as Domingo
Sierra and Pedro Chaskel. Other artists were also actively engaged in
recuperating forgotten traditions. The musician Violeta Parra went
into the countryside, learning the folk traditions and songs of the rural
communities, and bringing them to a wider urban society. She also
exhibited *arpilleras*, women's patchwork embroideries, inserting the
popular into an art world dominated by European and North American
forms. Violeta Parra and Sergio Bravo were two of the educators of a
generation that began to transform Chilean culture in the sixties, part
of a broad political movement which supported the need for change
after the stagnation of the Alessandri and Ibáñez administrations of
1952 to 1964.

In the 1964 presidential elections, two candidates proposed sweep-
ing reforms of the social and economic system—the Christian Demo-
crat Eduardo Frei and the Socialist Salvador Allende—and received
over 90 per cent of the popular vote. Frei won the election on his pro-
gram of "Revolution in Liberty,"[3] which sought to articulate a new
middle way between the antagonistic poles of the right-wing and
Marxist political parties. Between 1952 and 1964, the size of the elec-
torate trebled and the Christian Democrats attracted a large share of
that vote, especially among women and also low-paid male urban
workers. They also became the party most favored by U.S. aid as
Chile became one of the test cases of the "Alliance for Progress,"
which sought to destroy the power of Marxist parties through eco-
nomic and social modernization. The fear of "another Cuba" haunted
North American policy-makers at the time. The United States financed
roughly half of the Christian Democrat electoral campaign. A great
deal of money was spent on media propaganda, featuring scenes of
what might happen if the "Red Peril" was elected: newsreel clips were
shown of priests hearing the confession of men about to be shot by
purported Marxist forces and the press was full of anti-Marxist scare-
mongering. At the same time, a documentary made by Sergio Bravo
of Salvador Allende's electoral campaign, *Banderas del Pueblo (Ban-*

ners of the People, 1964) was banned by the censors. Images of Russian tanks and Cuban militias, CIA-sponsored radio propaganda,[4] counterpointed with constant programs underlining the progressive, moderate nature of the Christian Democrats, had a considerable effect on the outcome of the election. The defeat of the left alliance caused a widespread internal debate not just about the electoral base (why the traditional left parties had not been able to attract the new voters), but also about the function of hegemony and the need for cultural workers to wrest "common sense" values away from the control of the right or Christian Democracy. The debate about strategy and tactics in the Marxist parties was, therefore, accompanied by a flowering of left activity in theater, music and the cinema.

This activity can be seen in many different cultural forms. Perhaps the most dynamic was music. By the time of her suicide in 1967, Violeta Parra had helped to stimulate a range of singers and musicians: in her own family (Angel and Isabel Parra), in the universities, with the appearance of groups such as Quilapayún, and Inti-Illimani, and in the wider society. Song celebrated popular culture and supported social change, in small clubs such as the Peña de los Parra, or massive political demonstrations, culminating in the election rallies of the late 1960s when hundreds of thousands would sing the lyrics of a Victor Jara or a Patricio Manns and would jump up and down on the spot shouting: "El que no salta es momio"—"If you're not jumping you're a fascist." Theater also experienced a renaissance, with experimental groups such as ICTUS, the El Aleph Group, the Teatro del Errante and the Teatro del Callejón. These groups often supplied the actors for the early films of new Chilean cinema. The poets were also in the public arena, led by the dominant figure of Pablo Neruda, who stood as the Communist Party candidate in the election for the leadership of the Popular Unity coalition in 1970. On the periphery, undermining Neruda's powerful rhetoric, was Violeta Parra's brother Nicanor, the anti-poet of the sixties generation. Cinema would form part of this general movement for social change.

Just as the Christian Democrats attempted some partial reforms, which did not radically confront the inequalities of Chilean society (the "Chileanization" of copper made the U.S. companies better off; agrarian reform was only very partial), so they made some timid moves to support cinema. They created a council to promote the film industry and in 1967 gave local producers a percentage of box-office takings.

Government support for Chilean films resembled its partial na-
tionalization of copper mines and its agrarian reform, in that it
attempted to reform current practices without basically affecting
fundamental interests. In the area of filmmaking, the above
course of action meant emphasizing supportive protectionist
measures without affecting distribution and exhibition commer-
cial practices or the hegemonic presence of foreign distributors.[5]

The years 1968 to 1969 are generally accepted as marking the
coming of age for young Chilean filmmakers. Five features were re-
leased: Raúl Ruiz's *Tres tristes tigres* (*Three Sad Tigers*); Helvio
Soto's *Caliche sangriento* (*Bloody Nitrate*); Aldo Francia's *Valpar-
aíso mi amor* (*Valparaiso My Love*); Miguel Littín's *El chacal de Na-
hueltoro* (*The Jackal of Nahueltoro*) and Carlos Elsesser's *Los testigos*
(*The Witnesses*). At this time, the cineastes could be seen as a group,
albeit with different ideological and aesthetic tendencies. All were
working with scarce resources: the films by Ruiz, Elsesser, Francia
and Littín were made consecutively, with the same camera. All were
part of the cultural effervescence of the late sixties and all were influ-
enced by the flowering of Latin American cinema as witnessed in the
meeting of Latin American filmmakers organized by Aldo Francia in
Viña del Mar in 1967.

The first film to appear in 1968, *Tres tristes tigres*, established Ruiz
as the most experimental cineaste of his generation. The very title of
the film, a tongue-twister in Spanish, points to a work which examines
the gaps between signifier and signified, explores genres and poses
problems of representation. At one level, it can be read literally: the
sad tigers are the petty-bourgeois protagonists, who hang out in bars
talking about everything and nothing, unable to relate to the changing
realities of society. Yet their language is both realist and highly liter-
ary: the model here is the arch-jester Nicanor Parra, a poet who, from
the 1950s, had attempted to break through the dominant Nerudian dis-
course of Chilean poetry in collections of sardonic "anti-poems"
which are extremely self-conscious, witty and caustic. Parra expresses
an anarchic sentiment which defines his work and also that of Ruiz:

Independently
Of the designs of the Catholic Church
I declare that I am an independent country
.....
May the Central Committee forgive me[6]

The film is dedicated to Parra, and it forces the spectator to revise his or her expectations about genre (in particular the melodrama) and about composition: characters constantly wander in and out of the frame. The position of the camera is also unconventional: "The idea was to put the camera not where it would see best, but where it should be, in the normal position. This means that there is always some obstruction and things are not seen from an ideal standpoint. There was also an anti-dramatic tendency. . . ."[7] Ruiz had studied for a time with Birri in the Santa Fe school in Argentina, but he was not convinced by its neo-realist documentary approach that taught "that it was the duty of every human being in Latin America to make documentary films."[8] His ironic, lucid examination of the strengths and weaknesses of political culture in Latin America would continue under the Popular Unity government (1970–73), when he would film in a number of different styles.

Aldo Francia, a pediatrician turned filmmaker, made use of his professional experience in his neo-realist *Valparaíso mi amor*, about the plight of children as the innocent victims of social injustice and underdevelopment. It is based on the true story of a man who is imprisoned for robbery and cannot prevent his family drifting into delinquency and prostitution. It is also a lyrical evocation of the port of Valparaíso. Soto preferred to paint a broader historical canvas in *Caliche sangriento* (*Bloody Nitrate*), which gave an anti-imperialist analysis of the 1879 War of the Pacific (Chile against Bolivia and Peru). The victor of these disputes, for Soto, was British commercial interest anxious to exploit nitrate resources in the area in conjunction with a clientelistic sector of the Chilean oligarchy. Chile's victory in the war allowed her to extend her territories by a third (into the nitrate-rich Atacama desert) and gave her the mineral wealth that would make up roughly half of government revenue for the following forty years.[9] In the film's analysis, the war was the beginning of imperialist penetration in the country's mineral resources, an imperialism that would pass from British into U.S. hands.

The most popular film of this group was *El chacal de Nahueltoro*, seen by some half a million people. Its political importance lay in the fact that although it was set in the period of the previous president, Alessandri, it effectively undermined one of the main claims of the Christian Democrat government: its attempt to develop a social policy for marginal groups to prevent their commitment to the Marxist parties. The Christian Democrats, prompted by the theoretician Jorge Ahumada, had promised to create a hundred thousand landholders among landless peasants. In the event, they fell well short of that target and the film examines the plight of the landless rural poor: a true

story of a man who murdered a homeless woman and her five children in a hopeless act of drunken violence. In 1960, the sensationalist press painted the man as a "jackal," but Littín reveals the social conditions of misery and deprivation that act as breeding grounds for such crimes, and also the rigid social and legal codes that both socialize and condemn its "criminals": "Alcohol, religion, smiles, law, gentleness—all are part of the system's tools to train and subdue men."[10]

Littín spent years researching the case and the film is framed as a documentary reconstruction offering different layers of competing information: the cold "facts," the sensationalist interpretations, the reconstructed "interviews" with key witnesses and interlocutors by a journalist, and finally the stumbling voice of the protagonist, José, himself.[11] These narrations are juxtaposed in the first half of the film with images which move from the "present" of José's capture and interrogation, against a background of crowds baying for his blood, to a "past" which traces key moments in José's life from his abandoned childhood to his miserable development as an adult in the poverty of the countryside, drifting through a series of menial jobs. The energetic, fluid camerawork and the movement between past and present of the first part of the film are replaced by a relatively stable narrative in the second half when, in prison, José is socialized into the laws and language of culture. Littín mercilessly exposes the ideological state institutions of the law, the penal code, education and religion which distort José's growing consciousness and then support his execution. He acquires feelings of solidarity (kicking a football in the prison yard) and also a number of skills, and is willing, unquestioningly, to put himself at the service of the state. If reprieved, he will be "humble, hardworking, useful to society and helpful to my mother." Yet even such malleable figures are ultimately sacrificed to society's misplaced notions of vengeance.

The Popular Unity Period

El chacal came out in the run-up to the presidential elections of 1970 and was an important element of popular mobilization. The Popular Unity coalition won these elections by the narrowest of margins: Salvador Allende received 36 per cent of the vote, Jorge Alessandri, the right-wing candidate, 35 per cent and the Christian Democrats 28 per cent. The right had thought they could win without entering an electoral pact with the Christian Democrats, and on the basis of fierce opposition to reformism or radicalism. Popular Unity felt a certain optimism since they believed that, with the Christian Democrat vote, over two-thirds of the country was in favor of reform. The constitu-

tion was upheld and Allende was elected to power; but he was to find his measures hampered at every stage by a united and vociferous opposition. Popular Unity itself was an electoral alliance, but Allende found it exceptionally difficult to overcome the main policy differences between the two Marxist parties. Faúndez's analysis is illuminating:

> The Popular Unity government did nothing to resolve the difference between Socialists and Communists. Indeed, instead of trying to resolve these differences, it circumvented them, expecting, mistakenly as it turned out, that they would be superseded by the political struggle. This unresolved conflict led in practice to innumerable policy deadlocks and contradictory policies. All this contributed, in turn, to reinforcing the opposition perception of the government as both ruthless and aimless: and the ultra-left's view of it as both hesitant and revolutionary.[12]

The communists assumed that an alliance with representatives of progressive bourgeois elements would lead to a national, democratic revolution. The socialists assumed that working through the existing state mechanisms would lead to a political impasse.

Popular Unity, therefore, lacked a well-planned strategy and was prey to external and internal forces: right-wing and foreign-directed subversion, constant opposition in congress, and conflict among its six-party membership which turned every decision into a fragile compromise. Yet despite all these difficulties, the government's initial measures were quite successful in taking over what were called the "commanding heights of the economy": nationalizing mainly U.S.-owned mineral resources, the banks, a number of manufacturing enterprises and nearly 2.5 million hectares of land.

The same successes and limitations were reflected in the film sector. The victory was greeted with euphoria and filmmakers put out an enthusiastic manifesto (penned by Miguel Littín); it promised, in the vaguest of terms, that Chilean cinema would become national, popular and revolutionary. It called on the cinema to bear witness to the heroes of Independence, to labor leaders and to the anonymous workers, and in this way to wrestle popular memory from the hegemony of the right. The manifesto also declared its aim to fight sectarianism and stifling bureaucratic controls and to educate the spectator into new ways of seeing.[13]

Miguel Littín was given the task of turning this rhetoric into a reality from the institutional base of Chile Films. He faced a number of difficulties. Firstly, distribution was run by a small number of compa-

nies, either U.S.-owned or owned by national capital which derived profits from U.S. cinema. Given the government's electoral promises to nationalize U.S. interests it was inevitable that the North Americans would take retaliatory measures against a country which, in Henry Kissinger's words, had been "foolish" enough to elect a Marxist government. IT&T, the communications network, had declared its intention to make the economy "scream."[14] After the nationalization of U.S. companies, an informal economic boycott (though not of arms supplies) was accompanied by increased CIA covert action, which included funding opposition newspapers and parties. As part of these "informal" measures, the head of the Motion Pictures Export Association, Jack Valenti, ordered the suspension of U.S. film imports from June 1971. U.S. distributors also demanded that small exhibition outlets should pay film rental in advance, a reversal of current practices. The prospect of empty screens and a closure of theaters was very real and Chile Films reacted by organizing a series of bilateral exchanges with Bulgaria, Cuba, Hungary and Czechoslovakia, which disappointed spectators and caused the right-wing press to claim that the market was being flooded with Marxist propaganda. Distribution and exhibition would remain problematic and there was no time to implement any effective policies. By mid 1973, Chile Films controlled only thirteen theaters and ran four mobile units. By 1973 the state-owned distribution company had 35 per cent of the market, but met with sustained opposition: on a number of occasions private theaters refused to screen the state's weekly newsreel.

Miguel Littín took over the directorship of Chile Films with great enthusiasm and a number of innovative ideas. Yet within ten months he had resigned, tiring of bureaucratic opposition (many officials had guaranteed jobs in Chile Films and could not be replaced) and interparty feuding, as the different members of Popular Unity demanded their own quota of resources. This rivalry led to a diffusion of energy and a lack of coordination. Littín proposed setting up a series of *talleres* (workshops) covering the main areas of cinema: documentary features, children's cinema; but little came of these ideas apart from some work on documentary. No feature films funded by Chile Films were completed under Allende. Increasingly, therefore, the filmmakers decided to make their own films outside the official sector, though they would still use the facilities of Chile Films. Littín, however, argued that some useful developments had occurred from within the state:

The official structure of the cinema led at least to a number of important things such as: the creation of a national distribution company, the progressive nationalization of cinema, the showing of films from the new Latin American cinema across the whole country. . . . the palpable improvement of technical resources, especially dubbing theaters, labs, camera equipment.[15]

Among those who benefited from these measures were young film-makers such as Sergio and Patricio Castilla and Claudio Sapiain, whose talents would later flower in exile. Differences of outlook, meager resources and the pace of events, however, denied the formation of a coherent group practice. The history of cinema under Popular Unity offers a mosaic of different tendencies.

Littín finished *La tierra prometida* (*The Promised Land*) just before the coup, but the post-production work was completed in Paris, where Littín was fortunate enough to take refuge as an exile. Arrested in a sweep of Chile Films after the coup, he was allowed to escape thanks to a sympathetic army sergeant who was an admirer of his work.[16] The film became a success on the international circuit as it seemed to predict with accuracy the bloody coup of 11 September 1973. Set in 1932, it has as its frame of reference the successful socialist rebellion of air commander Marmaduque Grove against the president, Estebán Montero. Grove's regime was to last a mere eleven days, but his real populist appeal (he had massive support from organized workers and the urban dispossessed) had made him the stuff of popular legend. Littín exploits this popular memory by tracing the odyssey of peasant leader José Durán and his companions, who sought to establish links with the progressive forces of Grove and form their own utopian socialist state in Palmilla in the south of Chile. He employs a number of devices which allow for historical, allegorical and mythic readings. An old man narrates his story of the 1930s events, a narration reinvented by memory. Folk songs continually punctuate the film, asserting their claim as an authentic popular history, preceding the hegemony of print culture. Figures from history, such as O'Higgins, appear alongside the protagonists. The patron saint of Chile, the Virgin of Carmel, gives support both to the rich and to the poor. The hyperbolic, non-naturalist modes of story-telling are used to great effect. Yet history as a text must be reconstructed and the events of the 1930s eerily parallel those of the early 1970s. After a long journey the workers take power; their relationship with the local bourgeoisie is hostile and vacillating; the established authorities control language and therefore power. José Durán says at one point: "Enough of words and discussion, because in words and discussion it's always the rich who

get the better of it." If the rich control language, they also control na-
ked power: the army intervenes to massacre Durán and his followers.
For Littín, the peaceful, democratic road to socialism was a strategic
and a tactical mistake.

Raúl Ruiz was the most productive filmmaker of the period, mak-
ing a number of films in different styles. He lucidly declared that Pop-
ular Unity cineastes should work in three areas: cinematic activism
(working with mass organizations), official cinema (arguing for gov-
ernment policies) and the cinema of expression (a more personal
mode).[17] His own films show this range. *Ahora te vamos a llamar her-
mano* (*Now We Are Going to Call you Brother*) is a didactic short. *La
colonia penal* (*The Penal Colony*, 1971) is a Kafkaesque tale set on an
island where everyone is dressed in military uniform—another presen-
timent of what was to come. All the characters speak a language in-
vented by Ruiz and the actors were asked to improvise many of the
scenes. Such an approach was seen in more dogmatic sectors of the
left as ludic wilfulness. *La expropriación* (*The Expropriation*) was
shot in four days late in 1971, not finished until 1973, and not given a
general release since it was considered to be too provocative: when
land is given to peasants through government expropriation, they do
not want the landowner to leave and end up assassinating the govern-
ment official. In 1973, *El realismo socialista* (*Socialist Realism*) dealt
with the problem of factory takeovers, once again in an ironic fashion.
It was aimed at provoking debates within the Socialist Party.

Raúl Ruiz was a Socialist Party militant, a party he found con-
genial since it had such fluid positions, ranging from the ultra-left to
social democracy, with members shifting positions with great alacrity,
as is portrayed in *El realismo socialista*. Yet increasingly he took an
ironic attitude towards official policies, against the kitsch of govern-
ment-led popular culture, a "Quilapayun" culture he once savagely
called it:

> It is not a question of pessimism, but for me irony is an impor-
> tant tool of political analysis. The present tragic situation is the
> result of a certain political process: it is important to be lucid
> rather than bemoan our fate; irony is necessary to refresh and
> clarify our perception of things.[18]

His 1971 film *Nadie dijo nada* stresses the bad faith of intellectuals
who believe that their world is all that exists. It is set, like *Tres tristes
tigres* in the twilight world of Santiago bars, a private city where in-
tellectuals can talk and drink the night away, only glimpsing at the
reality that lies beyond their class perspectives. Petty-bourgeois intel-

lectuals are also placed in an ambiguous situation in *El realismo socialista*. Ruiz supported the strategy of popular power, a radical grassroots movement which attempted to quicken the pace of Popular Unity's policies in the face of the right-wing offensive of late 1972. Attention was focused on the *cordones industriales* (industrial belts) which grew up around Santiago and in Concepción and Valparaíso. By August 1973, nearly half the workers in industrial areas belonged to a *cordón*, a fact which was a threat to the government—since initiatives were taken outside the channels of government agencies—and also to the organized unions, since the representatives of the *cordones* were elected by the workers themselves. Filmmakers analyzed the basic paradox of Popular Unity: it could not oppose popular power by naked force; on the other hand it could not be seen, since it was working within the state apparatus, as approving these actions.

The most exemplary film examining this process of radicalization which led to the coup, was Patricio Guzmán's *La batalla de Chile* (*The Battle of Chile*), a documentary in three parts which was edited in exile in Cuba. Guzmán had been a film student in Spain before returning to Chile with the victory of Popular Unity. Like a number of other filmmakers, he decided to work outside Chile Films. He obtained a grant and materials from the School of Communications at the Catholic University which enabled him to complete *El primer año* (*The First Year*, 1972), a documentary on the first few months of government.[19] He then planned to work on a fictional documentary of the Independence hero Manuel Rodríguez, which he shelved due to the quickening pace of political activity in late 1972. The lorry-drivers' strike of October 1972 was joined by taxi drivers, shopkeepers and local industrialists. Well organized, with CIA funding, it was greeted by an extraordinary left-wing mobilization as workers took over factories and controlled distribution networks. Guzmán filmed these events; the resulting documentary, *La respuesta de octubre* (*The Reply in October*, 1973) is somewhat monotonous in its recording of the emergence of the *cordones industriales*. It was after the events of October that Guzmán and his group decided to film the process that was developing rapidly, in order to produce an analytical rather than a denunciatory or agit-prop film.

The filming was planned like a military campaign by the Equipo Tercer Año (The Third Year Group) made up of Jorge Müller (a cinematographer who was used by most of the directors of the period, in particular Raúl Ruiz, and who "disappeared" with his *compañera*, the actress Carmen Bueno, in 1974), Federico Elton, José Pino, Patricio Guzmán and Angelina Vásquez. With borrowed equipment, a Nagra sound-recorder and an Eclair camera, and with film stock donated by

the French filmmaker Chris Marker, they began shooting in February 1973:

> The "screenplay" thus took on the form of a map, that we hung on the wall. On the one side of the room, we listed the key points of the revolutionary struggle as we saw them. On the other side, we would list what we had already filmed. . . . So we had the theoretical outline on the one side and the practical outline of what we had actually filmed on the other.[20]

They filmed nearly every day for seven months and gained access to all sectors of society through various guises, accumulating extensive and almost unique coverage of the developing class struggle. With the coup, the film stock was smuggled out of the country and edited in Cuba in the studios of ICAIC. The resulting structure is in three parts: "The Insurrection of the Bourgeoisie" deals with the middle-class offensive against the government in the media and in the streets: "The Coup d'état" continues the analysis of the first part, adding the dimension of the bitter quarrels among the left over strategy; the third part, "Popular Power," looks at the work of the mass organizations in 1973. The main analysis is given by protagonists in the film, but an authoritative voiceover narrator also offers background information and an analysis which is sustained or contradicted by the image track.[21] The film became Chile's most important testimony for the outside world and received worldwide distribution in the campaigns of solidarity.

Exile and Resistance

The coup, which many expected, was accompanied by a ferocious assault on left-wing and trade-union movements. Film workers were amongst the tens of thousands killed or disappeared, the hundreds of thousands imprisoned in temporary camps such as the National Stadium, or sent into exile. *The Battle of Chile* contained a chilling image from June 1973 which prefigured the later slaughter. An Argentine cameraman, Hans Herman, filming an army insurrection, actually filmed his own death. The footage shows soldiers from a truck aiming shots at the camera which keeps in focus for a long time before spinning out of control. The international solidarity campaign did offer many visas to Chileans and all the major directors apart from Aldo Francia, who resumed his work as a doctor in Valparaíso, went into exile.[22] Littín took up residence in Mexico, where he was fêted by the ebullient president, Luis Echeverría. Guzmán was offered facilities to edit his film in Cuba, where he joined Pedro Chaskel. Soto went to

France, as did Raúl Ruiz, who settled initially in the immigrant Parisian quarter of Belleville.

Within Chile, film production was effectively destroyed for a number of years. All the film schools and production centers were occupied by the military, installations were destroyed and old film stock burned.

> The state production and distribution company Chile Films bore the brunt of the repression. Its premises were occupied and its irreplaceable negative archives indiscriminately destroyed, including a priceless collection of the country's earliest newsreels. Its staff were sacked *en bloc*, many being arrested, imprisoned and tortured. Several died, including the director Eduardo Paredes . . . and, some months after the coup, Carlos Arévalo, who had distributed films to trade unions and shanty-town communities, and the cameraman Hugo Araya. Chile Films productions were banned. Film and sound-tapes were burned in the streets together with books, magazines, pamphlets, posters and university theses.[23]

The government's general censorship of the arts and the mass media was directed, in the film sector, by a Council of Cinematographic Censorship. Among the films it banned in the mid 1970s was *Fiddler on the Roof* (for Marxist tendencies!) and *The Day of the Jackal*, which was felt to encourage violent, anti-social tendencies. It would be a number of years before filmmaking within Chile was to make some tentative advances out of the destruction of late 1973. It is to the exile community that we must look for the significant developments in the 1970s.

Work in exile can be said, crudely, to take place between the two poles represented by the careers of Littín and Ruiz. Ruiz went penniless to Paris, with his wife, the editor and filmmaker Valeria Sarmiento. He began by making a film about the exile community in Paris, *Diálogo de exilados* (*Dialogue of Exiles*, 1974). However, instead of portraying an optimistic, exemplary group of expatriates, he shows how inappropriate their desires are to the new circumstances. He uses Brecht's words on exile ironically at the beginning of the film. "The best school of dialectic is emigration, the most skilful dialecticians are exiles. It is change that forced them into exile and they are interested only in change."[24] In counterpoint to this statement, the Chileans grouped in the long-corridored house, who kidnap a singer (a fascist sympathizer), go on hunger strike, collect money for the resistance or talk endlessly about their situation, are seen through an ironic

gaze. The reaction of the Chilean community was hostile; Ruiz, in a form of double exile, was forced to seek access to the world of French filmmaking.

He was fortunate in that his arrival coincided with changes in French television and the creation of a number of specialist institutions, including the INA, Institut National de l'Audiovisuel, which commissioned experimental work. It was the INA that was to support Ruiz's initial projects for television, offering him a range of sophisticated technical equipment and launching an extraordinarily productive career in France, where he is now widely recognized as the most important, innovative director working in that country. The director of *Cahiers du Cinema*, Serge Toubiana, in a special issue dedicated to Ruiz's work in 1983, gave the following homage:

> In contemporary French cinema, the small troupe that gravitates around this magician who makes the shadows move and allows all languages to be spoken within one language, is one of the most lively places that exists today. Ruiz's rhetoric is beautiful, cultivated, doubtless perverse, and above all happy, never plaintive. This rhetoric moves us out of our habitual French moroseness.[25]

Ruiz, his Christian name changed to Raoul to facilitate pronunciation, now runs the innovative arts center, the Maison de la Culture at Le Havre. Le Havre, of course, is a major sea port for the Americas, and it would be tempting to see Ruiz, the son of a sea captain, as constantly navigating the space between Europe and America.

Coded autobiographical traces can be found in many of these French films. Many seem to deal with the basic problem of exile, the absent center, the displaced home. Exile has its negative and positive aspects: to be eccentric implies the nostalgia for a center, but also offers the freedom of distance. *Les Trois couronnes du matelot* (*Three Crowns of a Sailor*, 1982) deals with the voyage of a displaced person in search of his roots. Origins might be found in childhood, a moment of possible harmony before the Fall, where grandparents weave fictions, telling endless ghost stories—yet a Ruiz child is rarely innocent. Origins might be found in the movies. In *La vie est un rêve* (*Life's a Dream*, 1986) a man goes back to the cinema of his childhood in order to find images of the Chilean resistance that he has suppressed in his subconscious. The dominant images he finds, however, are of Flash Gordon, Mongo, Captain Marvel: North American B-serials which were the staple diet of Ruiz's childhood film-going. B-serial movies can easily be read as crude forms of cultural imperialism, but

for Ruiz they also offer an interesting example of establishing an immediate rapport with an audience, and of direct, improvised filmmaking:

> There is a statement by Ford Beebe where he says that he was so pressed to finish a film (and often he only had a week to film) that when he wrote a story, he put down the first thing that came into his head and waited for a sort of inspiration. Without realizing it, he is describing techniques of automatic writing which he invented or reinvented for cinema. These are true surrealist films in the proper sense of the word.[26]

A sense of place might also be found in an institution such as a church or a political party. Yet Ruiz is far from the rhetoric of Neruda who could write an "Ode to My Party" (the Communist Party), as offering strength, unity and purpose. Ruiz's ode to a party is *La Vocation suspendue* (*The Suspended Vocation*, 1977), where the project for a new society is thwarted by the suspicions of the hierarchy and the stagnation of church institutions. A sense of place might also be found within the medium of cinema itself, within the fixities of genre and convention. Yet Ruiz constantly explores and parodies conventions: the documentary (*Des grands événements et des gens ordinaires*, *Of Great Events and Ordinary People*, 1979); the arts programme and the "thriller" (*L'Hypothèse du tableau vivant*, *The Hypothesis of the Stolen Painting*, 1978); the melodramatic photo-novel, mixed with Borges and Cervantes's "exemplary" novels (*Colloque des chiens*, The Colloquy of Dogs, 1977). As Ian Christie puts it, "Ruiz has devised a rhetoric or rather a play between rhetorics, which allows him to speak in terms recognizable to Europeans, without either wholly accepting their culture or betraying his own."[27] Each film is an exploration, a geographical exploration of forests, towns, gardens, chateaux or paintings, an exploration of all the narrative, technical, visual and sound possibilities of cinema and an exploration of all possible pictorial and literary styles in cinema[28] (in particular the "baroque" experiments of the Cuban novelist Lezama Lima). It is a remarkable oeuvre.

The trajectory of Miguel Littín has been very different. Circumstances allowed him to become the epic filmmaker of Latin American resistance, mainly thanks to the financial aid offered by the Mexican government under Echeverría. Without referring to Littín by name, Ruiz offers a critique of his style of filmmaking:

I think there is a version of the "official art" attitude which sets out to make "history" exist. They start with the history of Latin America, which is a history of betrayals and of imperialism, the massacres are mostly hidden and the record of the peasants' and people's movements is equally unknown. So there is an obvious point in making films to reveal this forgotten history and make known the secret massacres. But this is more difficult to accept when it becomes an imperative duty to follow the political line, showing even more massacres and creating a vast funeral ceremony.[29]

In fairness, however, Littín did not remain in that mode. He turned to two ambitious co-productions of literary works, *El recurso del método* (*Reasons of State*, 1977) and *La viuda de Montiel* (*Montiel's Widow*, 1979). *El recurso*, based on the Cuban Alejo Carpentier's novel about a roguish dictator who alternates between the civilization of Europe and the supposed barbarism of his native land and is quite surprised when he is overthrown by a Marxist rebellion, has some stylish set-pieces (such as the lavish carnival in Cuba) and a sustained central performance by Littín's preferred actor, the Chilean Nelson Villagra. But the weight of having to make an allegorical statement about early dictators in Latin America and their necessary overthrow by the people, sometimes traps the narrative in stereotypes. Also, in terms of its contemporary relevance to dictatorships in the subcontinent in the 1970s, the spectator is left wondering whether the technocratic dictators of the 1970s, the Pinochets, can be quite so easily laughed out of existence. The work, which had a clear internationalist and Latin Americanist perspective, was not given much distribution in Latin America and failed to convince European critics. Littín had been the darling of *Cahiers du Cinema* in the early seventies, when those critics had a Maoist, Third-Worldist orientation. By the end of the decade, critical ideologies had shifted, Ruiz had become the model for a more personal, impish, ironic form of filmmaking, and *Cahiers* laughed away *Recurso* in a short, sarcastic review in August 1978.

Montiel's Widow is Littín's attempt to film García Márquez, an author who would continue to obsess cineastes from the 1960s to the present: it seems to be the fate of any major Latin American filmmaker to try at least once. Littín achieves some impressive settings in the tropical landscape of Tlacotalpán (in Veracruz), for the "chaotic and fabulous hacienda of José Montiel,"[30] the hardman who had monopolized local business through terror. After death Montiel remains a presence in his widow's fantasies and in the alternative views of the townspeople. Geraldine Chaplin is competent as the widow but in the

end the narrative tension that Márquez can generate in a few pages eludes the director in his rather sprawling, two-hour film.

As the reign of Margarita López Portillo gradually deprived Mexican filmmaking of any resources, Littín made his next feature, *Alsino y el condor* (*Alsino and the Condor*, 1982), in Nicaragua, the first Nicaraguan feature film in color. He drew once again on a literary source, this time from a well-known novel of the 1930s by Pedro Prado, which was for a time obligatory reading in Chilean schools. This fable of a boy crippled after attempting to fly is given a new location (Nicaragua in the late 1970s) and a new optimism: the dream of flying becomes the dream of revolution come true with the overthrow of the Somoza dictatorship. Littín worked without the lavish resources available for his three previous films, and provided a film free of much of the grandiloquence that had marred these works: "The smile of Alsino, when he calls himself Manuel—this is the moment when he is going to join the guerrilla forces and in which he smiles for the first time in the film—becomes a sign of the imminent historical break, which is more vigorous and eloquent than the waving of a hundred red flags."[31] The will of the people is seen as overcoming the condors of U.S. imperialism, the helicopters of the counter-insurgency forces.

In 1985, Littín embarked on a dangerous project to film clandestinely in Chile. His movements have been registered and eulogized in a book by García Márquez,[32] written in the form of a long interview with Littín filtered through Márquez's very particular vision and language. Both the book and the film are a homage to the resistance of the Chilean people. Both succeeded well in "tying a donkey's tail on the dictatorship" in García Márquez's phrase. In November 1986, the military authorities in Valparaíso in Chile burned fifteen thousand copies of the book. *Acta General de Chile* (*General Statement of Chile*) is a massive four-part documentary which "rediscovers" the landscape of Chile through exile eyes, charts the struggles of the ordinary people, discusses the tactics of the guerrilla group, the Manuel Rodríguez Popular Front and pays homage to the symbol of revolution, Salvador Allende. It contains many lyrical evocative moments and has a particularly fine sequence of interviews which chart the last hours of Allende in the Moncada Palace as the troops prepare to enter and stifle the Chilean experiment in democratic Marxism. Littín is now filming the life of Sandino, another ambitious co-production.

Other filmmakers continued a remarkably fertile cinema in exile from different centers in Europe and Latin America. The critics David Valjalo and Zuzana M. Pick list a total of 176 films produced from 1973 to 1983, 56 full-length features, 34 medium-length and 86 shorts. Pick has analyzed the salient characteristics of this cinema in a

series of important essays [see Pick essay in this section].[33] Only a
few general comments are appropriate here. Firstly, the shock of the
Chilean coup had a widespread repercussion in the international com-
munity; the brutality of the regimes in Uruguay and later in Argentina
would never be highlighted in the same way. The United Nations
High Commission for Refugees could organize a massive refugee pro-
gram and certain countries such as Canada, Sweden and other Scandi-
navian countries reflected very quickly in granting visas. Chilean
political parties could also place their militants in Eastern Europe. The
trauma of exile was, therefore, softened to a certain extent by the pos-
sibilities of work, and by solidarity groups prepared to support cul-
tural activities. The filmmakers thus had some access to funds and
access also to a public: their films could serve as a basis for meetings
and discussion groups.

It was natural that these films initially should focus on the recent
past, be denunciatory and also attempt to reconstitute the resistance
abroad—see, for example, Helvio Soto's *Llueve sobre Santiago* (*It is
Raining on Santiago*, 1975) or Claudio Sapiaín, *La canción no muere
generales* (*The Song Does Not Die Generals*, 1975). Without the irony
of Ruiz, these films needed to posit some sort of utopian unity,
summed up in the phrase chanted at the end of every solidarity meet-
ing or concert: "El pueblo unido jamás será vencido" ("The people
united will never be defeated"), which necessarily glossed over the
fact that the "people" had not been united and had been defeated,
however temporarily. The work of Helvio Soto, Littín, Sebastián Alar-
cón, Orlando Lübbert and Sergio Castilla all made denunciatory fea-
tures aimed at consciousness-raising, in an effort to isolate the
dictatorship abroad.

The difficulties of exile and immigration would also become a ma-
jor theme in films of the period; one of its most exemplary practition-
ers was Angelina Vásquez, who looked at life in Finland. *Dos años en
Finlandia* (1975), is a portrait of the Chilean community there and
Presencia lejana (*Distant Presence*, 1975) traces the life of Finnish
twins who emigrated to Argentina. One returned to Finland, the other
stayed in Argentina, where she "disappeared" in 1977. Finland in this
film is seen from a Latin American perspective and vice versa. In her
feature film *Gracias a la vida* (*Thanks to Life*, 1980), a woman who is
carrying the baby of her torturer meets her husband and children in
Helsinki. The pain but also optimism of such experiences are por-
trayed with great skill. Other women directors, Marilú Mallet in Can-
ada and Valeria Sarmiento in France, have also treated the themes of
exile and immigration. Sarmiento's two most significant films, how-
ever, are not restricted to the thematics of exile: the documentary *El*

hombre cuando es hombre (*When a Man's a Man*, 1982) and the feature *Mi boda contigo* (*My Marriage with You*, 1984), deal instead with the construction of sexuality in Latin America, in the culture industry and in the wider society. In *El hombre*, filmed in Costa Rica, interviewees give an inadvertently amusing stereotypical view of male-female relationships. Sarmiento compounds the irony with a soundtrack taken from Jorge Negrete, the most macho of all of Mexico's singing *charros*. *Mi boda* explores the conventions and the pleasures of melodrama and the "rose" novel, or Harlequin Romance, adapting a novel by the Hispanic Barbara Cartland, Corín Telladao. This thematic diversity is part of a general broadening of the range of subjects treated by Chilean filmmakers.

As the film community developed abroad and the years of the dictatorship lengthened, filmmakers could not remain making and remaking films about Chile in their country of exile. Pablo de la Barra, who has directed successful films in Venezuela, and Ruiz who works exclusively in France are two examples of the vagueness of the term "Chilean filmmaker" after fifteen years of exile. At the same time, the radicalization of events in Chile after 1983 have allowed exiled filmmakers to return and film the struggle for democratization. Gastón Ancelovici, whose 1975 documentary *Los puños frente al cañon* (*Fists Before the Cannon*) traced the growth of the Chilean working class up to 1931, made the documentry *Historia de una guerra diaria* (*Story of a Daily War*, 1985), filming a whole range of cultural and political practices. *Dulce patria* (*Sweet Country*, 1985) by Andrés Racz, also showed a broad spectrum of life under dictatorship, and contained a memorable interview with the mother of Carmen Bueno, the actress who "disappeared" in 1974.

Returning filmmakers, a slackening of censorship and a growing militancy led to a growth of cinema within the country. Cinema in Chile was muted for most of the seventies, tourist documentaries and advertising shorts accounting for the bulk of the work produced. However, by the late 1970s there were some important signs of survival. Silvio Caiozzi had success with *Julio comienza en julio* (*Julio Begins in July*, 1979), a film which refers back to the early twentieth century, to a time when the rural aristocracy was losing its power to the industrial bourgeoisie. The site is a French-style country house, full of imported furniture: the owner, a feudal landlord, is trying to maintain his grip on power and create a son in his image and likeness. One important rite of passage for the fifteen-year-old boy is the loss of his virginity. The Argentines (Torre Nilsson and María Luisa Bemberg) have treated the theme with greater subtlety but Caiozzi at least had found a metaphor for talking in allegorical fashion about contempo-

rary Chile and put a Chilean film back into commercial cinemas in Santiago. For the situation in 1980, as Caiozzi points out, was gloomy:

> Aldo Francia no longer films. . . . Then we have people like Carlos Flores, a documentary filmmaker who made a film on José Donoso, our best-known novelist. . . . There is also Christián Sánchez, a film-school graduate who made two 16mm features in black and white, one co-directed and the other his own: *El zapato chino* which came out recently. These are experimental films directed at a certain public. . . . The government has no interest in cinema.[34]

Julio took three years to make, funded out of the director's earnings from commercials.

The ICTUS theater group made a number of videos on cultural figures and movements in the late 1970s. Increasingly filmmakers began to film in clandestine fashion and smuggle video footage of persecution and resistance out of Chile. A documentary prepared in Germany, *Chile: donde comienza el dolor* (*Chile, Where the Grief Begins*, 1983), shows the reaction of Chilean exiles to video footage filmed inside the country. Littín would make use of clandestine networks for his *Acta General de Chile*. The most important work of clandestine filmmaking, which illustrated and was a product of the growing radicalization was *Chile, no invoco en vano tu nombre* (*Chile, I Do Not Invoke Your Name in Vain*, 1983). Filmmakers in Paris edited and processed the raw material from Chile, bringing together in this enterprise the intellectual community fractured by exile.

From the mid 1980s, the opposition to Pinochet increased in intensity and effectiveness, culminating in the "No" Vote in the plebiscite of 1988, and the victory for the democratic coalition in the elections of November 1989. In both these campaigns, the opposition used television very successfully, a sign that techniques of filmmaking fostered abroad or at home could be put to good use. These conditions have allowed a revival of cultural activities in all spheres, and in particular in theaters.

The new freedom in cinema is exemplified in Pablo Perelman's feature film *Imagen latente* (*Latent Image*, 1987) which was filmed entirely in Chile with funds from the National Film Board of Canada. It contains many echoes of the brilliant Cuban feature *Memories of Underdevelopment* (1968) in its study of a Chilean photographer who cannot decide the nature and purpose of his political and artistic commitment. His brother, a militant of the MIR, disappeared in 1975;

many years later, he begins a search for this brother, paralleling his own search for his repressed political commitment. The film speaks boldly of armed struggle (with clear allusions to the failed attack on Pinochet in the mid 1980s); of torture, of disappearance, of the function of art in times of social change. Its treatment of the main character is deliberately ambiguous: the spectator feels both sympathy and hostility towards his doubts. Perhaps the future lies with the young student, the daughter of a disappeared prisoner, who finds her sense of self in political action. This is certainly the message of *A cor de seu destino* (*The Color of His Destiny*, 1986) a film made in Brazil by the exiled Chilean Jorge Durán: a depiction of a Chilean teenager in Brazil who comes to terms with his own identity and is thus reconciled to the memory of his dead brother.

These features were made with money from abroad. Within the country, work in video has become increasingly the norm, due to its lower cost and great flexibility. All the momentous events of the last few years have been captured on video. There are a large number of small production companies who work in advertising or sell programs to television. There is a great pool of talent available for future projects. At the moment of writing, the cultural priorities of the new democratic regime have not yet been formulated, but it is unlikely that there will be many funds available through the state, and the private sector will need convincing that films are a viable investment in a dwindling cinema culture. Yet the need to make films, to explore a fractured past and to imagine different futures, must be part of the new democratic project, one of the great avenues, in Salvador Allende's words, "where free men and women will walk, to build a better society."

Notes

1. Salvador Allende's last speech on the radio before his murder in the Moneda palace. I am using the translation in I. Allende, *The House of the Spirits* (London: Black Swan, 1986), p. 419.

2. Quoted in Jacqueline Mouesca, *Plano secuencia de la memoria de Chile* (Madrid: Ediciones del Litoral, 1988), p. 18.

3. My discussion on Frei is based on J. Faúndez, *Marxism and Democracy in Chile* (New Haven and London: Yale University Press, 1988), pp. 133–38.

4. For details of CIA activities in the 1964 electoral campaign see *Covert Action in Chile 1963–1973* (Washington: United States Senate Report, 1975) pp. 9 and 15.

5. Jorge A. Schnitman, *Film Industries in Latin America: Dependency and Development* (New Jersey: Ablex, 1984), p. 84.

6. Nicanor Parra, *La cueca larga*, Santiago 1958.

7. Quoted in Ian Christie and Malcolm Coad, "Between Institutions: Interview with Raúl Ruiz," *Afterimage* 10, 1982, p. 106.

8. Ibid., p. 116.

9. See Harold Blakemore's chapter on Chile (chapter 15) in Leslie Bethell, ed., *The Cambridge History of Latin America*, Vol. V (Cambridge: Cambridge University Press, 1986), p. 501.

10. "Miguel Littín: Film in Allende's Chile," in D. Georgakas and L. Rubenstein, eds. *Arts, Politics, Cinema: The Cineaste Interviews* (London: Pluto, 1985).

11. For a detailed analysis of the film, see Ana M. López, "Towards a "Third" and "Imperfect" Cinema," unpublished D. Phil Dissertation, University of Iowa 1986, pp. 461–70.

12. Faúndez, p. 280–81.

13. For the text of the manifesto, see M. Chanan, ed. *Chilean Cinema* (London: BFI, 1976), pp. 83–84.

14. Bertrand Russell Foundation, *Subversion in Chile: A Case Study in United States Corporate Intrigue in the Third World*, Nottingham 1972.

15. Miguel Littín, interview first published in *Cahiers du Cinema* 251–52. 1974. English version in Chanan, p. 58.

16. See Gabriel García Márquez, *La aventura de Miguel Littín, clandestino en Chile* (Mexico: Diana, 1986), pp. 35–38. Published in English as *Clandestine in Chile* (Cambridge: Granta and Penguin, 1989).

17. See F. Bolzoni, *El cine de Allende* (Valencia: Fernando Torres, 1974), pp. 123–24.

18. Interview with Ginette Gervais, *Jeune Cinéma* 87, May–June 1975, p. 27.

19. For a detailed analysis of Guzmán's work, see Patricio Guzmán, Pedro Sempere, *Chile: el cine contra el fascismo* (Valencia: Fernando Torres, 1977).

20. Interview with Burton in Julianne Burton, *Cinema and Social Change in Latin America: Conversations with Film-makers* (Austin: University of Texas, 1986), p. 55.

21. Ibid., p. 51.

22. For an account of the international campaign in favor of filmworkers, in particular the "Emergency Committee to Defend Latin American Filmmakers," see Alfonso Gumucio Dagrón, *Cine, censura y exilio en América Latina* (Mexico: STUNAM/CIMCA/FEM, 1984).

23. Malcolm Coad, "Rebirth of Chilean Cinema," *Index on Censorship* 9, 2, April 1980, p. 4.

24. I am using the translation quoted in *Afterimage* 10, p. 121.

25. Serge Toubiana, "Le cas Ruiz," *Cahiers du Cinéma* 345, March 1983, p. 1. This special issue is the best general guide to Ruiz's work. See also the long section dedicated to Ruiz in *Positif* 274, December 1983.

26. "Entretien avec Raoul Ruiz," *Positif* 274, December 1983, p. 24.

27. Ian Christie, "Snakes and Ladders: Television Games," *Afterimage* 10, p. 84.

28. Danièle Dubroux, "Les explorations du capitaine Ruiz," *Cahiers du Cinema* 345, p. 33.

29. Interview with Ruiz, in *Afterimage* 10, p. 111.

30. Garbriel García Márquez, "Montiel's Widow," in *No One Writes to the Colonel* (London: Pan, 1979), p. 116.

31. Mouesca, *Plano-secuencia*, p. 103.

32. Gabriel García Márquez, *La aventura de Miguel Littín*.

33. See David Valjalo, Zuzana M. Pick, "10 años de cine chileno 1973/1983," special issue of *Literatura Chilena, Creación y Crítica*, 27 January–March 1984, pp. 15–21. This issue is the most complete assessment of Chilean cinema of that decade.

34. "Silvio Caiozzi: Los restos del naufragio," *Hablemos de Cine* 73–74, June 1981, p. 30.

Filmmakers and the Popular Government

A Political Manifesto [1970]

A proclamation issued by filmmakers working under the Popular Unity government of Salvador Allende

Chilean filmmakers, it is time for us all to undertake, together with our people, the great task of national liberation and the construction of socialism.

It is time for us to begin to redeem our own values in order to affirm our cultural and political identity.

Let us no longer allow the dominant classes to uproot the symbols which the people have produced in the course of their long struggle for liberation.

Let us no longer permit national values to be used to uphold the capitalist regime.

Let us start from the class instinct of the people and with this contribute to the making of a class consciousness.

Let us not limit ourselves from going beyond our contradictions; let us develop them and open for ourselves the way which leads to the construction of a lucid and liberating culture.

The long struggle of our people for their emancipation has laid down for us the way to be followed. Let us recover the traces of those great popular struggles falsified by official history, and give back to the people the true version of these struggles as a legitimate and necessary heritage for confronting the present and envisaging the future.

Let us recover the tremendous figure of Balmaceda, anti-oligarchist and anti-imperialist.

Teshome H. Gabriel. *Third cinema in the Third World: The Aesthetics of Liberation*, Appendix A. UMI Research Press. Pp. 99–101. By permission of the publisher.

Let us reaffirm that Recabarren belongs to the people, that Carrera, O'Higgins, Manuel Rodríguez, Bilbao, as well as the anonymous miner who fell one morning, or the peasant who died without ever having understood the meaning of his life or of his death, constitute the essential foundations from which we emerge.

That the Chilean flag is a flag of struggle and liberation, it is the patrimony of the people and their heritage.

Against an anemic and neocolonized culture, a pasture for the consumption of an elite, decadent and sterile petite-bourgeoisie, let us devote our collective will, immersed within the people, to the construction of an authentically NATIONAL and therefore REVOLUTIONARY culture.

Consequently we declare:

1. That before being filmmakers we are men engaged within the political and social phenomenon of our people, and in their great task; the construction of socialism.
2. That the cinema is art.
3. That the Chilean cinema, because of an historical imperative, must be a revolutionary art.
4. That we mean by revolutionary that which is realized in conjunction between the artist and his people, united in a common objective: liberation. The people are the generators of action and finally the true creators; the filmmaker is their instrument of communication.
5. That the revolutionary cinema will not assert itself through decrees. Consequently we will not grant privilege to one particular way of making film; it must be that the course of the struggle determines this.
6. That, meanwhile, we shall regard a cinema removed from the great masses [will] become inevitably a product for the consumption of an elite petit-bourgeoisie which is incapable of constituting the motor of history. In this case the filmmaker will see his work politically nullified.
7. That we refuse all sectarianism aimed at the mechanical application of the principles stated above, in the same way that we oppose the imposition of official criteria on the practice of filmmaking.
8. That we maintain that the traditional forms of production are a veritable rampart enclosing young filmmakers. They imply, finally, a clear cultural dependency, for these techniques are derived from aesthetic conceptions foreign to the culture of our peoples.

9. That we maintain that a filmmaker with these objectives necessarily implies a different kind of critical evaluation; we assert that the best critic of a revolutionary film is the people to whom it is addressed, who have no need of "mediators who defend and interpret it."[1]

10. That there exists no such thing as a film that is revolutionary in itself. That it becomes such through the contact that it establishes with its public and principally through its influence as a mobilizing agent for revolutionary action.

11. That the cinema is a right of the people, and that it is necessary to research those forms which are most appropriate for reaching all Chileans.

12. That the means of production must be available to all workers in the cinema and that, in this sense, there exist no acquired rights; on the contrary, under Popular Government, expression will not be the privilege of some, but the inalienable right of a people marching towards their final independence.

13. That a people with a culture are a people who struggle, who resist and who free themselves.

CHILEAN FILMMAKERS, WE SHALL OVERCOME

Translated by Sylvia Harvey.

Notes

1. Julio García Espinosa, Cuban director.

Chilean Cinema in Exile, 1973–1986

Zuzana M. Pick

Introductory Remarks

The *coup d'etat* which toppled the elected government of Salvador Allende in 1973 forced many Chilean filmmakers into exile. Careers were interrupted, personal lives were disrupted while the events inside Chile showed that the military intended to wipe out all remnants of left-wing cultural activity. As filmmakers dispersed to countries in Europe and in the Americas—some having been given political asylum, others having obtained academic jobs, bursaries or other means to secure residence status—films which had been started before September 1973 also found their way out of the country. Materials shot by Patricio Guzmán and the Grupo Tercer Ano, for instance, were gathered in Havana. The completion of the three parts that make up *La Batalla de Chile* was the result of the support and help of the Cuban Film Institute (ICAIC). The first part of this film—*La Insurreccion de la Burguesia* (1975), and later, *El Golpe de Estado* (1976) and *El Poder Popular* (1979)—became "unique" documents of the events which preceded the coup in 1973.[1]

Between 1974 and 1976 filmmakers smuggled film footage and photographs out of the country, while journalists and television crews of different countries managed to document the first period of military rule.[2] A wealth of images became available to mount wide-ranging solidarity campaigns to bring to public attention the human rights violations of the Chilean military junta. The solidarity committees formed

Framework, No. 34, 1987, pp. 39–57. By permission of publisher and author.

in Europe and in the Americas, in Africa and in Australia, were linked
to diverse political organizations, labor unions and churches. The Chi-
lean groups in charge of co-ordinating political activity and the soli-
darity committees provided refugees with a militant space to pursue
their work. The international support for Chile gave exiles the possi-
bility of maintaining a sense of national cohesiveness. As musicians,
artists and writers actively participated in the events organized by the
solidarity organizations, filmmakers began working on films related to
the Chilean situation.

The circumstances which allowed the production of the first films
of Chilean exiles are varied. In general, they involved institutions and
organizations which supported the plight of the Chileans. *Il n'y a pas
d'oubli* (1975) was produced by the National Film Board of Canada.
Jorge Fajardo, Rodrigo Gonzalez and Marilu Mallet each directed a
short film to be brought together as a long feature. This film was
made because of the intervention of the NFB's unionized workers and
the wider network of groups mobilized in solidarity with Chile.

By 1978 an impressive number of films—documentary, fiction fea-
tures, animation shorts—had been produced by Chilean filmmakers in
exile. Miguel Littín had directed *Actas de Marusia* (1975) in Mexico
and *El Recurso del Metodo* (1977) in Cuba. Orlando Lubbert had di-
rected *El Paso* (1978) in East Germany. Percy Mattas had directed
Los Transplantados (1975) in France. Marilu Mallet had directed *Los
Borges* (1978) in Canada. Raúl Ruiz has directed *Dialogo de Exilados*
(1974), *La Vocation Suspendu* (1977), *L'hypothèse d'un Tableau
Volé*(1978) in France. Helvio Soto had directed *Llueve Sobre Santiago*
(1975) as a French-Bulgarian co-production and *La Triple Muerte del
Tercer Personaje* (1978) as a French-Spanish co-production. Chilean
filmmakers were working in Canada and the United States; in Swe-
den, Finland, East Germany, Rumania and the Soviet Union, in Bel-
gium, France, Germany and Spain. Others worked in Mexico, Cuba,
Nicaragua, Costa Rica, Colombia and Venezuela. The participation of
films made by Chilean filmmakers in international film festivals and
special retrospectives showed to what extent these exiles had pursued
their work. Younger filmmakers were becoming more active while
new filmmakers were directing their first works. Although the links
between these Chilean filmmakers and the Solidarity organizations be-
came more diffuse, these organizations provided the means to main-
tain some contact between filmmakers and individuals who were
interested in the cinematographic activity of the exiled Chileans.

Chilean cinema had been seen as marginal to the movement identi-
fied as the New Cinema of Latin America although in the period be-
tween 1967–1973—from the first Vina del Mar festival to the military

coup—it had occupied a prominent place within the cinema of the continent.[3] Following the coup and the dispersal of filmmakers, only certain films produced in exile were classified as "Chilean." These films were concerned with the Chilean situation and most were produced in Spanish. The term "Chilean cinema of the resistance" was used to categorize these films. The exclusion of films which did not fit into this term, for example Raúl Ruiz' work after *Dialogue of Exiles* (1974), posed a number of problems. The dispersal of filmmakers had already made problematic their identification within the Chilean national and cultural formation. But the selectiveness implied by the term "Chilean cinema of resistance" posed strict limitations on the compilation of individual filmographies. The distribution and exhibition of this "cinema of resistance" became more sporadic and limited to solidarity activity or alternative screenings. As more and more filmmakers were shifting thematic concerns, and their films were exhibited at festivals and distributed through television channels, the issue of Chilean cinema became very confusing. Some of these films dealt with Latin American issues, like the Nicaraguan insurrection and events in El Salvador. Therefore, these films could find a place within the New Latin American Cinema. The Havana International Festival of New Latin American Cinema in 1979 provided for the first time a public forum for this Chilean cinema produced outside the country and slowly films of all Chilean filmmakers have been programmed.

The Chilean cinema is a unique case and its characteristics make it a complex and challenging field of investigation. Chilean cinema in exile has never been a movement. The dispersal of filmmakers, the diverse conditions of production in the countries of residence, and the limited channels of distribution and exhibition available for these films have not been favorable to the establishment of a structured program for action. The development of a Chilean cinema in exile is due mostly to the efforts of individuals working within diverse social, cultural, historical and institutional formations and independent from an established program of action which could have imposed limitations and restraints. The voluntarism of political slogans might have been ill-suited to international audiences beyond those rallied around Solidarity committees. And the definition of a homogeneous strategy of production might have been antagonistic to the conditions of production available in the countries of exile. Hence each filmmaker has to re-define his/her practice in regard to the political priorities of a specific conjuncture and specific conditions available within a country of residence. Those who were worried that Chilean cinema, cut off from its natural audience, might become repetitive and irrelevant because of its contextual concerns, were proven wrong. They have realized that

the contrary has occurred. Most filmmakers have responded positively to their new cultural and social environments by expanding through their films the formal and thematic concerns of the Chilean and Latin American cinemas.

Their status as refugees and expatriates has given Chilean filmmakers a unique privilege: the identification with a cultural and social formation and the recognition of its difference within diverse cultural and social environments. Chilean cinema in exile has blended heterogeneous elements in the same manner as the cultural formations of Latin America have been forged by the contributions of diverse cultures. The cinema of Chilean filmmakers in exile is not only the result of an immersion in cultures and societies, mostly of the developed world. It is also the result of a questioning of the ideological formations that make up a "territorial" identification of cultural identity.

Exile, Politics and Culture

The textualized responses to exile and their representation open a critical space to identify the notion of exile as a discursive formation. What is at stake here are the social and political ramifications of exile, its effect on subjective and collective consciousness, its relevance to cultural production, its impact on spectator-text relationships and its effect on the situation of the Chilean cinema.

Latin American intellectuals today (writers, artists, musicians, journalists and filmmakers) can look back at a long tradition of exile as an important element of their cultural and political history. José Martí (Cuba), Domingo F. Sarmiento (Argentina), Simón Bolívar (Venezuela) and José Carlos Mariátegui (Peru), produced some of their most important work in exile. Lesar Vallejo (Peru), Alejo Carpentier (Cuba), Gabriela Mistral and Pablo Neruda (Chile), Julio Cortazar (Argentina), Gabriel García Márquez (Colombia), Mario Benedetti and Eduardo Galeano (Uruguay) have all contributed to the distinctiveness of Latin American culture. The experience of these Latin American expatriates and their consciousness of exile have permitted exchanges, encounters and confrontations otherwise impossible under "normal" conditions as they have responded to the conjunctural elements which forced them into exile. Moving from a subjective consciousness to a collective commitment, their cultural production foregrounds a strong sense of identification with a political and social struggle. It is a consciousness of exile that responds to antinomic ideological articulations—assimilation vs. liberation, imitation vs. authenticity, tradition vs. history—and acknowledges its "otherness" as a product of the conflict between "barbarism and civilization," depend-

ency and revolution. Writing in Europe, in the United States and in Latin America, these intellectuals have provided an influential model for the representation of cultural identity and a framework for a politically committed practice attached not only to their country of origin but to the continent as a whole.

But there are also those who live in "exile" inside their own country: those who would rather speak French or English and believe that Buenos Aires or Lima is Paris or London, those for whom the surrounding context is "foreign." Jorge Luis Borges (Argentina), Octavio Paz (Mexico), Herberto Padilla (Cuba), Jorge Edwards (Chile) are writers whose work moves into the wider confines of the European cultural tradition. Seeking "refuge" in a cosmopolitan position, the work of these writers recognizes itself within that culture as a means to overcome the shortcomings and underdevelopment of their own national and political formation. It is a cultural production located in the acknowledgement of insuperable boundaries and the appropriation of a "white mask" to disguise its "black skin."[4] Then there are those who live another type of "internal exile." In periods of increased political repression, some intellectuals have had to find alternative strategies in order to be able to effect a social and cultural conjuncture. Working clandestinely or anonymously, in prisons or in alternative cultural spaces, an oppositional cultural practice becomes an active response to the "official" silence imposed by the public sphere.

Because exile is usually understood as banishment, expatriation or forced emigration, it is basically related to the legal status of the exile. Marginality, censorship, alienation and indifference however, are other forms of "exile" which affect individuals or groups inside their own country. All these modalities of "exile" have an impact on identity, and on subjective and collective positions within a cultural, political and historical formation. Furthermore, they produce a distinct notion of cultural identity which is not circumscribed by "roots" and "place." It is tied to a complex network of social, political and historical factors. Insofar as it originates both in subjective and collective experience, the notion of cultural identity acquires a portability similar to the document which identifies an individual's nationality. It might be useful here to clarify what I understand by exile. It is a subject position produced by a series of political, social and cultural conditions tending to disengage human activity in the public sphere. In its most institutional forms, it is the harshest punishment for political opposition; and in its most liberal forms, it is a means of controlling social and political intervention.

As far as Latin American intellectuals are concerned, their encounter with other cultural formations has been traditionally of great rele-

vance to the notion of cultural identity either as a means to solidify a
sense of belonging or as a means to delineate the boundaries of differ-
ence.[5] Identity and place are crucial sites for the construction of the
boundaries that often define cultural practice. In a situation of exile
these notions allow subjectivity to be re-articulated in a complex pro-
cess that involves a network of discursive operations.

The history of oppression and domination of Latin America by for-
eign powers and its ensuing struggles for liberation has given rise to a
distinctive idea of continental unity. From Domingo F. Sarmiento's
positivism and José Martí's anti-imperialism, to Mario Benedetti's
revolutionary utopia and Eduardo Galeano's heterogeneity, the "idea
of Latin America" continues to provide a strong paradigm for collec-
tive identity. Foregrounding or rejecting those elements which are for-
eign or authentic, regressive or liberating, Latin American cultural
practice has responded to the struggle between antagonistic ideologi-
cal formations.[6] However, the social experience of Latin Americans
also includes slaves and imported laborers, immigrants and refugees
who have settled the continent for three centuries. This blending of
ethnic, racial and religious formations with the native elements of the
continent has given a sense of heterogeneity to its cultural and histori-
cal formations. It is therefore appropriate to recognize that the cultural
filiation of Latin Americans, including its exiles, is not limited to a
place but rather to the recognition of a subjective and collective rela-
tionship to a social, political and historical formation—Latin America
as a continental entity and its specific national components.

The emergence of a continental idea coincides in Latin America
with the displacement of the European colonial influence and it is
nourished by the potential of a socialist revolution. The conceptual
designations of this idea speak to a utopian longing for liberation, rev-
olution and self-determination. Through these designations, the conti-
nent is recognized as a battlefield of nations, cultures and ideologies
and its collective consciousness is identified in the historical resistance
to violence and oppression. These conceptual designations, in turn, al-
low the notion of resistance to be considered beyond its strict political
implications. Resistance is understood in terms of the struggle to con-
struct and maintain a cultural specificity by appropriating elements
that will characterize the diverse historical, social, cultural and politi-
cal contexts. This notion of resistance also permits one to reject the
elements that threaten the coherence of national formations and to in-
tegrate those that solidify its position in a continental formation. The
work of Mario Benedetti is symptomatic in this regard as it is
grounded in the distinctive features of the Cuban revolution. This
event takes on a particular meaning but its details recede to the back-

ground as the diversity of national contexts is recognized. Once this operation has taken hold, Cuba is transformed into a referent and is assigned a triggering function. Thus the Cuban revolution comes to embody the renewal of utopian aspirations and it becomes the propitious signal for cultural transformation. As such it mobilizes culture and transforms its practice as a dynamic ingredient of social change.[7]

Hence, the Latin American identity is constituted by the recognition of cultural boundaries that move in two different—if not opposing directions. It manifests itself through an epistemological shift that entrenches the diversity of nation-states as the original elements of its continental consciousness. On the one hand, the cultural relations between diverse countries are rooted in a shared historical experience and strengthened in the identification of common bonds. On the other hand, the geographical consolidation of the different states has imposed the search for a new identity originating in its own national idiosyncrasies and experiences. The construction of cultural identity through this double movement opens the way for multiple articulations by responding dialectically to specificity and difference. It is through an extended notion of culture that individuals and groups can come together in time and space and assume solidarity through generations and territorial borders. Insofar as Latin American cultural identity partakes of a continental idea, its practice becomes the historical and social account of resistance, and its textual strategies are the representational responses to the diversity of struggle. Alejo Carpentier's and Gabriel García Márquez' "magic realism," Jose Clemente Orozco's "social realism," Frida Kahlo's "surrealism," Oswald de Andrade's and Heitor Vila-Lobos' "modernism" are some of the manifestations of what Rodolfo Parada calls "*mestizaje definitivo*." They originate in a sense of belonging that is produced at that

> [. . .] moment in our history when we acquire the notion of our worth and in which we decide to follow our ambitions. When we decide not to be imitators and followers, we begin to see the world in relation to who we really are, in relation to the Americas, as Latin Americans. [. . .] It is only at that moment that we become conscious of being something new: an amalgam of "criollos" and "mestizos."[8]

It is obvious that this continental consciousness opens a space in which even the most disparate and hybrid elements are assigned a recognizable place within a cultural formation. It is in this manner that cultural practice can be seen as the privileged site for a constant search, development and transformation of those paradigms that make

up the notion of identity. As the notion of culture is no longer attached to a fixed set of codes and conventions, it is understood as a process. Cultural practice can then be located in the dynamic selection of contextually-relevant elements. By responding to history and actuality, its textual strategies are the preferred modes of articulation of social change. This is the process that inscribes political consciousness as a crucial element of cultural practice in Latin America.

It is in this context that a "conceptually-extended" notion of culture is useful.

> [If] . . . culture is used to designate not merely something to which one belongs but something that one possesses [then], along with that property process, culture also designates the boundary by which the concepts of what is extrinsic or intrinsic to the culture come into forceful play.[9]

In the case of the Chilean cinema in exile, the reformulation of the boundaries of culture and place opens the way for the notion of exile. Its intervention in the critical space traditionally assigned to nationality has the potential of expanding the strict link to "geographical" and "territorial" boundaries. The notion of place could then be made to cover all the nuances contained in sentences such as "belonging to a place" and "being at home in a place." With it comes a sense of reassurance, association and community but also a sense of "property" and "filiation" with a cultural formation. The notion of culture would contain the interrelation of other elements—those located both inside and outside its original boundaries—even if they seem incompatible at first view. What is at stake here is the ideological operation that consists in identifying those elements that can be appropriated and rejecting those that may be irrelevant. This operation is the means by which a cultural formation negotiates its specificity and represents its difference.

Latin American filmmakers have performed this operation by drawing from mainstream film practice the elements that are relevant to its transformation and to the needs of a specific cultural, social, political and historical context. The influence of Italian neo-realism on the cinema of Fernando Birri (Argentina), Nelson Pereira dos Santos (Brazil) and Tomás Gutiérrez Alea (Cuba), among others, is eloquent in this regard. Fernando Birri has explained that

> . . . neo-realism was the cinema that discovered amidst the clothing and the rhetoric of development another Italy, the Italy of underdevelopment. It was a cinema of the humble and the of-

fended which could be readily taken up by filmmakers all over what has since come to be called the third world.[10]

In Julio García Espinosa's text "For an Imperfect Cinema" (1970) it is possible to locate the means through which Latin American film practice can articulate its autonomy and its effects of differentiation [see volume one for essay by Espinosa]. The impossibility of practicing art as an "impartial activity"; popular art conceived as a dynamically active entity; and its revolutionary implications are the alternatives that "can supply an entirely new response [and] enables us to do away once and for all with elitist concepts and practices of art."[11]

The aesthetical consciousness of Latin American film practice is informed by its potential to contribute to/in the struggle for a continental cultural identity. As it has often been strongly linked to documentary and the most conventional forms of realism, little room has been left for its most innovative manifestations. However, its most experimental textual strategies have opened the way for an oppositional cinematographic practice that is characterized by a dynamic heterogeneity. The films of Fernando Birri, Leopoldo Torre-Nilson, Fernando Solanas (Argentina); Jorge Bodansky, Ruy Guerra, Leon Hirzman, Nelson Pereira dos Santos, Carlos Alberto Prates Correia, Glauber Rocha (Brazil); Santiago Alvarez, Sara Gómez, Tomás Gutiérrez Alea (Cuba); and Raúl Ruiz (Chile), among others, are the manifestations of a practice that has defied the narrow limitations of the political.

Exile and Cultural Practice. The Chilean Cinema in Exile

If one looks at the "catalogue" of films made by Chileans since 1973, the foregrounding of a consciousness of exile is paramount to the re-positioning of works within a social political and historical formation. This re-positioning implies a refusal to comply with the negative consequences of banishment. The disorienting alienation and marginality tend to prevent the exile from having an effect on a social and political context. By recognizing the privilege that the position of exile brings along, filmmakers have re-defined their practice as a means of cultural struggle. What I call the privilege of exile is the awareness of the possibility of this process. The capacity of operating dialectically within the heterogeneous allows the reaffirmation of political commitment and the re-contextualization as individual and collective activity. The work of the exiled intellectual and its recognition is not only linked to its "geographical" origin but to the context which produced his/her situation of exile. In the 1970s, Latin American intellectuals— especially Brazilians, Uruguayans, Chileans, Argentinians and Central

Americans—have been increasingly forced to take a position within a public sphere and be representatives of that position. Antonio Skár-meta writes

> The mention of origin inscribes the writer in the general prob-lematic of the country. It pressures and forces the writer into a pronouncement and an analysis. It does not admit any longer a bored grimace or a shrug of shoulders.[12]

The link between Chilean intellectuals in exile and the international solidarity committees goes, therefore, beyond a "space" to pursue their activity or affect the situation inside the country by reaching a larger audience. As a political activist, the intellectual is expected to be representative of a specific context and to assume a responsibility in regard to the Chilean situation. The intellectual must take a position in regard to the coup, the human rights violations by the military junta and the organized resistance inside the country. The representability of the exiled intellectuals is also relevant to the reception of their work. As far as Chilean cinema in exile is concerned, spectator-text relation-ships depend on a series of audience expectations. Formal strategies, contextual elements and representation of historical events are en-dowed with considerable value. If elements that belong to its original formations are unrecognized, the work of exiled Chilean filmmakers might have failed to communicate to its audience.

Therefore, the conjunctural specificity of these films is not only linked to a political climate but also to the means by which they chan-nel audience reaction. The first films produced in exile displayed an overwhelming concern with verisimilitude that allowed audience rec-ognition of origin, context and political formation. In historical recon-structions, filmmakers privileged the most obvious contextual elements that would be recognizable as belonging to the Popular Unity period and to Chile. The epic and spectacular properties of re-construction are increased by the systematic use of iconic images and indexical signs. The identification devices mobilized by these films gave them a dramatic and emotional charge often far beyond their cin-ematic value. But this reliance on verisimilitude is linked to the pres-ervation of images belonging to a cultural, social and political formation. This visual and sound archive preserves memory as a his-torical safeguard and contextualizes its commemorative practices into an organized system of subjective and collective experience. Salvador Allende addressing massive rallies during the Popular Unity period, the bombing of La Moneda Palace, the junta's soldiers burning books in the streets, the national stadium, and the funeral of Pablo Neruda

take on a referential function. Other visual materials like the mural paintings in Santiago, the grim shanty towns, the abandoned mines of the north and the open-pit copper mine of Chuquitamata acquire a function of recall. Together with the political songs of the period and the poems of Pablo Neruda, these iconic signs provide the Chilean exile with an emblematic set of codes. Most of the fiction films produced in the first years of the Chilean exile operate in this manner as they seek to construct links between historical and contemporary events. In *Actas de Marusia* (1975), Miguel Littín blends episodes of various miners' strikes that took place in the early part of the century. The workers' resistance to military intervention is told in images that recall the massacre at the Santa Maria de Iquique school in 1917. The violence of this episode and the brutal torture scenes that follow bring together the anecdotes of the film and the events of the 1973 coup. By inscribing actuality in history, *Actas de Marusia* has a forceful emotional impact that closes any other modality of spectator response. Helvio Soto in *Llueve Sobre Santiago* (1976) rebuilds the physical and social environment of Santiago during the last days of the Popular Unity government. He assigns to well-known actors the roles of historical figures but he modestly hides the face of Salvador Allende in order to preserve it as an icon of collective memory. The epic qualities of *Llueve Sobre Santiago* are produced by the mobilization of traditional devices and conventions of historical spectacles.

The textual function of verisimilitude is not simply a means of codifying a historical formation. As the indexical signs of the Popular Unity period are displaced from their national context, they are then appropriated into a process of cultural struggle and political resistance. However, this process involves a network of textual and rhetorical mediations and is most effective in the different short documentary films produced between 1974 and 1978. It consists in the use of editing devices and modes of address of the militant documentaries produced in the Popular Unity period. The use of these rhetorical strategies is designed to foreground the films' historical and cultural specificity. The spectator is placed in front of recognizable elements and the text is then reconstructed in this particular conjuncture. In Claudio Sapiain's *La Cancion no Muere, Generales* (*The Song Does Not Die, Generals*, 1975), familiar images of the Popular Unity are used as a visual background for a song performed in Stockholm, London and Verona by different Chilean musicians in exile. The archival footage is invoked in its function of recall and it is invested in its potential to trigger solidarity with Chile. The images of rallies and meetings in the various cities provide the record of the energy that mobilized Europeans and Chileans alike.

Even though the indexical signs of the Popular Unity period belong to a rhetoric of the past, the filmmakers have transformed them into "image-tracers" of a discursive formation. They articulate an event for the spectator but they foreground its historicity by activating its position within a tradition. It is the shift from the function of recall to an organized system of meaning that allows for the mobilization of codes into diverse social, cultural and political formations. As Terry Eagelton points out, images may become

> *Traces*, [. . .] the scars it has accumulated in the hands of its users, the visible imprint of its variable functions. [. . .] The erasure, preservation or revival of traces, then is a political practice that depends on the nature of the traces and the contexts in question: the object may need to be treated as a palimpsest, its existent traces expunged by an overwriting, or it may secrete blurred traces that can be productively retrieved.[13]

Queridos Compañeros (*Dear Comrades*, 1972–1978) was filmed by Pablo de la Barra in Chile and completed in Venezuela. It proceeds by bracketing its central anecdote and inscribing the displacement produced by exile through disruptions in the narrative. The images of a smog-covered Caracas skyline, accompanied by a voice-over, frame the actions of characters that belong to a militant cell in the Chilean city of Concepcion. A space is left open to question the political relevance of some of the anecdotal and formal elements. While some of them can be discarded, others are transformed into traces. The ideals that mobilized a whole generation of Chileans in the 1960s are the critical references for a renewed political practice. It is in regard to a "productive retrieval of traces" that *La Batalla de Chile* acquired an exceptional character. Although its social relevance shifted, the impact of its subject matter was re-directed. *La Batalla de Chile* ceased to be an exposition of contextual events. The last three months of the Popular Unity became a pretext for the analysis of a historical event, and those particular elements that addressed conjunctural concerns could be mobilized within political formations. *La Batalla de Chile* had a considerable impact in Europe due to its emphasis on the organizational strategies of the Left. Its relevance within particular formations expanded its field of political intervention.

It is important to point out that cultural practice in exile does not operate through the transposition of original elements into a new context. As the territorial boundaries of cultural identity have been dislocated by exile, its filiative elements also need to be rebuilt. This process involves the functionality of original elements within a new

formation. Irrelevant elements are discarded, others are preserved as residues of social and cultural practice, while others are absorbed by the new context. This process of selection has a contaminating effect on cultural identity. The lines of demarcation between the old and the new become extremely mobile. But even if the elements of the original formation might have receded to the background, they still affect cultural practice. What is at stake here is the resistance of residual elements to be incorporated by a dominant practice.

Exile displaces the intellectual to the margins of a dominant formation and forces a replacement within the original cultural social and political formation. This operation has been aptly described by Eduardo Galeano in "L'exil: entre la nostalgie et la création." It involves a disengagement from anguish, silence and stasis, and the movement towards challenge and resistance. It consists in the resistance to guilt, fear and forgetting. It is a challenge to accept and to question. It is a shift from "nostalgia" to "creation." Along with this process comes the reformulation of subjectivity because, as Galeano points out, "exile lays bare and makes evident the contradictions between the importance that the intellectual assumes and the real measure of his/her incidence on reality."[14]

Exile forces a dislocation between public and personal experience through the representability that individuals have to assume. It is at this point that subjectivity intervenes in order to displace the schizophrenia of exile. Foregrounding the subjective as a collectively-shared experience through the autobiographical gives political relevance to the personal. The work of Chilean women filmmakers offers an interesting critical space for the subjective implications of exile because it dislodges the political from the narrow boundaries of collective experience. In *Gracias a la Vida, o la Pequeña Historia de una mujer Maltratada* (*Thanks to Life, or the Story of a Mistreated Woman*, Finland, 1980) Angelina Vazquez exposes the difficult choices faced by victims of torture. Through the story of a pregnant woman who joins her husband and family in Helsinki, the effects of rape are located in subjectivity as individuals come into conflict with a collectively-orientated notion of violence. Repression and exile are placed in the perspective of birth and militancy, shedding light on contradictions that are usually censored by the political. Women are no longer treated as historical symbols and rape ceases to be a metaphor for continental oppression. *Gracias a la Vida* breaks away from films such as *Lucía* (Humberto Solás, Cuba, 1968) and *The Promised Land* (Miguel Littín, Chile, 1972–1975) by challenging the roles assigned to women in Latin American cinema.

Marilu Mallet in *Journal Inachevé* (*Unfinished Diary*, Canada, 1982) also makes a clear departure from the conventions associated with Latin American and Chilean documentary. This essay film fixes the fictional as an integral part of subjective and collective reality. Marilu Mallet claims a space for the most ambiguous and fragmenting elements of exile as she moves through her own daily experience. The shreds of a remembered past are obstacles thrown in the path of subjectivity. The urban landscape is the formal representation of displacement and the private environment is the site where a cultural, social and political voice can be re-appropriated. Marilu Mallet places the liberation of a repressed subjectivity in the conflictive contact between cultures.

The feminist concerns of these films mobilize exchanges between elements of diverse and opposing social and cultural formations. Valeria Sarmiento's films, for example, cannot be considered outside the means by which they negotiate the complex operations that codify the textual representations of Latin American machismo. In *El Hombre Cuando es Hombre* (U.K. title: *Macho*, 1982), Valeria Sarmiento deconstructs the social, cultural and historical codifications of machismo. Through popular forms of expression, folkloric dances and traditional songs, she draws a kaleidoscopic portrait of Latin American romanticism. The examination of its oppressive social ramifications is located in the ironical treatment of customs, cultural idiosyncrasies and the peculiarities of its social and subjective manifestations. This articulation of the subjective and the collective can be recognized as oppositional to the homogenizing tendency of dominant practice. Exile can then be considered as a site of cultural struggle. Its cultural practice foregrounds a constant process of dislocation and re-assessment, of grafting and metamorphosis. Language is no longer representative of a specific formation but tends towards extremes and limits. Subjective and collective experience is also re-articulated

> . . . not [as] a fair copy but a palimpsest whose deleted layers must be thrust to light, written together in their episodic rhythms rather than repressed to unruptured narrative.[15]

Cultural practice in exile engages the dynamics of cultural exchange, ambivalence and confrontation. In some recent films of Chilean exiles, the emblems of the past (events, situations and codes) have been disguised insofar as filmmakers have definitely moved away from reconstruction. They have begun to question and re-work the representational and rhetorical modes of Latin American and Chilean cinema. By identifying the disfunctionality of its modes of address

and subject positions, filmmakers have been able to transform the textual strategies of their original formation. This implies an ambiguous operation in which the paradigms of cultural practice enter into a process of exchange as they come into contact with dominant formations. It is not a matter of privileging one textual strategy over the other, one political position over the other. It is a matter of recognizing the need to reassess cultural practice. Thus, cultural idiosyncrasies are smuggled in through a process of bricolage that displaces them as emblematic elements of an original formation. As a result, these elements seem stranded in an almost unrecognizable orchestration of conflicting elements. The exceptional characteristics of Raul Ruiz' work are relevant in this context in as much as they have been a source of praise and controversy. His notoriety has been mostly the result of his unprecedented recognition as an experimental filmmaker. Although his work resists any attempt at assimilation into the aesthetic categories of an homogeneous practice, it has been assigned a place within the avant-garde.

The modernist stance of Ruiz' work lends itself to the critical enquiry of representation and discourse. But the French and British response to the work of this Chilean has so far failed to acknowledge the political ramifications of its origins and its transformations in exile. There is a tendency to diagnose the cultural ambivalence of certain films solely in terms of what appears to be a clear departure from a Latin American thematic. What is at stake here are the expectations assigned to cultural formations. By moving between a fascination with the European sources of his own culture and his experience of exile, Raúl Ruiz has drawn on the capacity to select and integrate elements from distinct cultural formations. His work in France is characterized by a dynamic proliferation of thematic and stylistic concerns but not as a means to break away from those of his Chilean practice. As it is possible to detect in some of his previous work a clear shift beyond the traditional modes of cultural codification, the French work of Raúl Ruiz moves a step further. *Tres Tristes Tigres* (1967) and *Nadie Dijo Nada* (1972) take advantage of the conventions of social realism to locate the most extreme aspects of social behavior. The ironical and almost perverse treatment of middle-class stereotypes already reflects the concern to break away from the generalized aesthetic assumptions of Latin American and Chilean cinema. Since 1974, Raul Ruiz probed deeper into the politics of representation by moving critically through the boundaries of cultural identity.

The palimpsest-effect in the narrative strategies of *Les Trois Couronnes du Matelot* (*Three Crowns of a Sailor*, 1982) is grounded in a *mise en scène* that acknowledges its diverse cultural, aesthetic and ci-

nematographic sources. The playful blend of textual codes in this film reproduces the use of pastiche not only as an ironic device but as a means to stage the psychological and physical wanderings of exile. *Le Toit de la Baleine* (*On Top of the Whale*, 1980), with its perplexing mixture of languages, recalls in many ways the strategies of *La Colonia Penal* (*The Penal Colony*, 1971). The geographical evocations that transform the Dutch flatlands into a mythical Patagonia are the disclaimers of the codes of conventional realism and, as the surrealist absurdities of the actors' performances, they are textualized responses to subjective, social and cultural dislocation. In this film, Ruiz moves into the familiar elements of a Latin American fantastic by appropriating the photographic effects characteristic of the French "poetic realism" of the 1930s. The same could be said about *La Ville des Pirates* (*City of Pirates*, 1984) and *Régime sans Pain* (*Regime without Bread*, 1985) where the elements of fairy-tale, horror and science fiction are blended as if Raúl Ruiz wanted to find a cinematographic equivalent to the literary modalities of Latin American "magic realism." The deconstructive strategies of *L'Hypothèse d'un Tableau Volé* (*The Hypothesis of a Stolen Painting*, 1979) and its simulacra of artistic discourse are ironic incursions into the institutional forms of "popular" painting. The pompous verbosity of its voice-over dislodges the didactical characteristics of traditional documentary and allows the spectator to take a critical position. The rhetorical and formal boundaries of documentary are brought into conflict as the symptomatic assumptions about "truth" and social relevance are vividly displaced in their discursive implications. And nowhere is this position more eloquent than in Raúl Ruiz' "documentary" films such as *Des Grands Evenements et des Gens Ordinaires* (*Of Great Events and Ordinary People*, 1979). In this film Raul Ruiz foregrounds oppositionality of exile as he reclaims the unexplored experimental possibilities of the practice that has nourished his Latin American work. Insofar as his *mise en scène* articulates the disjointed subjectivity of exile, Ruiz becomes the invisible manipulator and accomplice of his own schizophrenia. *Le Jeu de l'Oie* (*Snakes and Ladders*, 1981) and *Le Borgne* (*The One-eyed Man*, 1979) probe the labyrinths of fragmentation as its protagonists are projected into a deadly maze of mirrors and dazzling special effects. Hence, the temptation to categorize Raúl Ruiz' work as the quintessential "cinema of exile" because films that operate in such a manner tend to go unrecognized in regard to their original formation. They have taken on the quality of a hybrid and culturally androgynous practice, swaying between the recognition of its origin and its identification within foreign formations.

This is what can be called the *subjective paradox* of exile. And this is also why this Chilean cinema has eluded any attempt of critical categorization. Its fragile cultural heterogeneity, linked with a strong national and collective consciousness, poses problems in relation to the critical framework available for the study of a national cinema where issues of nationality are assigned very specific territorial boundaries. Insofar as it is possible to design a critical map that might allow us to view an "intra-national" phenomenon as a field of cultural struggle, the situation of Chilean cinema becomes a challenging field of work. Only then is it possible to go beyond the situation of exile as a monolithic response to a specific political event.

Notes

This article was presented in an abridged form at the "New Latin American Cinema in Iowa II" conference organized by the University of Iowa in October, 1986.

1. *Los Punos Frente al Canon* (directed by Gaston Ancelovici and Orlando Lubbert, 1972–1975), *Queridos Compañeros* (directed by Pablo de la Barra, 1972–1978) and *La Tierra Prometida* (directed by Miguel Littín, 1972–1974) were completed in Germany, Venezuela and Cuba respectively. These films were released as "Chilean films of exile" in Europe and in Latin America.

2. A list of these films is included in the Chilean chapter of Guy Hennebelle, Alfonso Gumicio-Dagron, eds. *Les Cinémas d'Amerique Latine* (Paris: Ed. Pierre Lherminier, 1981), pp. 226–27.

3. See Francesco Bolzoni, *El Cine de Allende* (Valencia: Fernando Torres, 1974), and Michael Chanan, *Chilean Cinema* (London: British Film Institute, 1976).

4. Frantz Fanon, *Black Skin, White Masks* (London: Pluto Press, 1986).

5. It might be worthwhile to recall that the colonial discourse operates in a similar manner through its modes of representation. "Otherness" becomes the validation of racism as a means to entrench the cultural superiority of the colonizer. See Robert Stam and Louise Spence, "Colonialism, Racism and Representation: An Introduction," *Screen*, (London), vol. 24, n. 2. (March–April, 1983), pp. 2–20.

6. D. F. Sarmiento, *Facundo; Civilizacion o Barbarie*; José Martí, *Nuestra America*; Mario Benedetti, *El Escritor Latino-Americano y la Revolución Posible*; and *Eduardo Galeano: Memorias del Fuego* (2 volumes).

7. Mario Benedetti, "El escritor latinoamericano y la revolución posible," (1973), op. cit., pp. 85–111.

8. R. Parada Lillo, "Identidad cultural y politica," in *Literatura Chilena, Creacion y Critica*, (Los Angeles, Madrid), vol. 10, n. 1 (n. 35), (January–March, 1986), pp. 9–10 (my translation).

9. Edward W. Said, *The World, the Text and the Critic*, (Cambridge, Mass.: Harvard University Press, 1983), pp. 8–9.

10. Michael Chanan, ed., *Twenty-five years of the new Latin American Cinema* (London: BFI, 1983), p. 2. See volume one for complete text of the essay by Birri.

11. In Michael Chanan, op. cit., p. 31.

12. Antonio Skármeta, "La reformulacion del status del escritor en el exilio," *Primer Cuaderno de Ensayo Chileno* (Ottawa: Ediciones Cordillera, 1980), p. 12 (my translation).

13. Terry Eagleton, *Walter Benjamin or Towards a Revolutionary Criticism*, (London: Verso, 1981), p. 32.

14. Eduardo Galeano, "L'exil: entre la nostalgie et la création," in *Amerique Latine: Luttes et mutations* (Paris: Ed. F. Maspero/Tricontinental, 1981), p. 117 (my translation).

15. Terry Eagleton, op. cit., p. 59.

Argentina

Popular Cinema and Populist Politics

Timothy Barnard

The influence of Argentine political life on the fortunes of the country's film industry, so forcefully felt during the period of the military dictatorship of 1976–83, has not always been the determining factor in the industry's discontinuous, at times paroxysmic, development. Thus the year 1931 marks, paradoxically, the birth of the national sound film industry, destined to become the continent's largest until its decline in the 1940s, one year after the country's first military coup. The political repression of the 1930s, *la decada infame*, did not impede the growth of the film industry, as the dictatorship of 1976–83 did so brutally. Nor did it prevent the birth of Latin America's first socially critical film genre, the "social-folkloric," that peaked in the late 1930s and early 1940s with films such as Mario Soffici's *Prisioneros de la tierra*(*Prisoners of the Earth*, 1939). Soffici and others built a tentative but extremely popular social criticism genre in the mainstream film industry, rooted in popular national culture, in spite of a censorship that Soffici has said kept him from examining religious issues and treating his political topics in as much depth as he would have liked. While the other genres that flourished in this era lack this element of social criticism they were, I will argue, fundamentally linked to Argentine popular culture and history in a way that had unmistakable political implications. In a country that has regularly seen pitched battles between the national bourgeoisie and the working classes for control of the culture industries, the film industry in this period was

Timothy Barnard, ed., *Argentine Cinema*. Toronto: Nightwood Editions, 1986, pp. 7–11, 49–63. By permission of author/editor.

the almost exclusive domain of the latter, producing popular genres in a characteristically national style.

The period of the film industry's rapid artistic and economic decline in the mid 1940s is another example of the independent course the industry has taken from national political life. Colonel Juan Domingo Perón first appeared in Argentine politics as a participant in the military coup of 1943. He subsequently became Secretary of Labor and Social Welfare and introduced the first legislation governing the Argentine film industry. In 1946 he began a decade of rule as President of the Republic, introducing a period of fierce economic and cultural nationalism, a populist brand of politics, and remarkably progressive labor and social welfare policies. This, then, was a period that might have been expected to nurture the growth and populist traditions of the national film industry. It was precisely during Perón's rule, however, for reasons I will discuss below, that the film industry abruptly turned its back on the popular form and national themes of the 1930s in favor of European sources and a bourgeois form. The result of this strategy was to alienate the industry's largest markets, the Argentine and Latin American working classes, and bring ruin to the industry. It should be clear, then, that the peculiar dynamics of the national film industry must be explained with reference to autonomous social and cultural forces as much as to the country's often calamitous political events of the past half-century.

It was not until 1973 that the film industry really took its cue from national political events: it was in that year that Perón returned to power from eighteen years of exile and the film industry collaborated in the political and social project that began to unfold in his name. For the first time since the early 1940s, the industry regained a synthesis of social criticism and a popular and distinctly Argentine style. Not coincidentally, it was in 1973 that production levels and attendance figures reached a level that had not been attained since that earlier era. In 1973, even the mainstream elements of the film industry had become politicized by the years of popular resistance that precipitated the military's downfall and Perón's return. It was in this context that Héctor Olivera's *La Patagonia rebelde* (*Rebellion in Patagonia*, 1974) was made. It was a strictly commercial endeavor by a mainstream director, and proved to be the most popular Argentine film during Perón's last presidency. The film is a gaucho epic of sorts, a traditional Argentine genre, but one laced with radical political rhetoric. As a depiction of the massacre of anarcho-syndicalist workers in Patagonia in the 1920s by a cold-blooded military, it was widely seen as an allegory for the bitter civil war that preceded Perón's return in 1973.[1] Today, as the country lives through a roughly analogous process—the

return to democracy and the rebirth of national culture—the production strategies of the mainstream of the film industry are vastly different, and it seems as if the goal of synthesizing a popular national style with social criticism has been abandoned. The reasons for this must be sought, first of all, in the events of 1976–83, but also in the long-standing national cultural conflict which is a product of the extreme polarization of Argentina's social classes.

The most recent and extreme period of political repression in Argentina—begun in 1974 by the Peronist Right after the death of Perón and intensified under the Junta of 1976–83—is coming to be characterized as a period of aberrational terror. Some political commentators of the non-Peronist Left, however, are insisting that the Junta's activities be seen instead as a culmination, even as a logical outgrowth, of Argentina's economic and political history.[2] This position shifts the focus of attention from newspaper-headline body-counts of atrocities to a consideration of what the Junta's long-term objectives were; whether, in fact, they were not at least partially achieved; and to what extent they continue to inform the political and social agendas of the highest levels of the national bourgeoisie.

Similar questions come to mind about the Junta's cultural policies (and it must be remembered that the Junta had a planned and ambitious cultural, economic, and political agenda. Theirs was neither a policy of containment nor of "blind terror" but a plan to restructure Argentine society on a scale without parallel in our hemisphere in this century). Beyond the assassinations, the exiles, and the blacklists, what were the effects of the Junta's policies on the Argentine film industry? What was the long-term cultural agenda of the Junta and how might it be seen as a culmination of long-standing conflicts in Argentine cultural history?

It is fairly simple to catalogue some of the structural effects of the Junta's rule on the film industry. Production fell to its lowest level in twenty years, since the period following Perón's overthrow in 1955. The industry was subsequently affected by massive unemployment and union activities were suspended. Foreign markets were lost—a disaster in an industry that has always relied on international sales for its survival. There were huge drops in domestic movie attendance and widespread movie theater closings, particularly in the interior of the country. The domestic market became dominated as never before by U.S. films—second-rate ones at that, as better productions were stopped at the border because of everything from nudity to references to homosexuality and other forms of "immorality." Production became concentrated in the hands of a few large firms—since 1977, there has been only one sound studio in the country. A distribution sector spe-

cializing in cheap U.S. imports was consolidated, as it became more advantageous to distribute foreign films and benefit from the lower capital investment they required and the greater rates of return they offered. Finally, a system of censorship was imposed that was not only so severe that meaningful social criticism became impossible, but so erratic and unpredictable that investment in national film production became a very risky proposition, as censored films would neither earn revenue in the domestic market nor be likely to be sold abroad. A censored film's producer would also be denied payment of promised state co-production assistance, which led to the ruin of at least one production company. Without going over each of these points in detail, it should be clear that such structural changes in the film industry must certainly be affecting current efforts to revive production, recover foreign markets, and re-establish a healthy domestic market.

Predictably, a decade of repression, an emasculated national production at drastically reduced levels, and a flood of generally poor foreign films led to a profound debasement of popular taste. Yet it is important to situate this process not just as a result of the policies and repression of the Junta but to relate it to a long-standing conflict in the national culture. Through its actions the Junta was simply enacting the agenda of one side in this conflict, albeit on an unprecedented scale. It should be noted that the Junta developed as apocalyptic a vision of national culture as it did of the country's political life. While the Junta believed that the entire Argentine political process had become tainted with the influences of "International Marxism," it remained for them a largely foreign threat, with Argentine agents.

Their analysis of popular culture was substantially different. Here, the danger lay within the unique political heritage of the country's popular culture, a heritage that had been revived and so forcefully expressed under Perón in the 1973–75 period. It thus became imperative to the Junta that they eliminate popular national culture in its entirety in order to "reconstruct" it. Culturally, perhaps even more so than politically, they had to shear off the cancer affecting Argentine society and start from zero, or lose the game. In this sense, the censorship, economic chaos, and genocide of the Junta's rule were just the growing pains of a project of "National Reconstruction" whose agenda was only beginning to be fulfilled.

The Years of Military Rule and of the Third Peronist Presidency: 1955–1983

Space restrictions limit me to extremely cursory comments on the period after Perón's overthrow by the military in 1955, an event fol-

lowed by the re-writing of film policy in 1957. Readers are referred to the articles by Fernando Birri, Octavio Getino, and Alfonso Gumucio Dagron, as well as to my own chronology of Argentine cinema elsewhere in this volume for a more complete picture of this period.[3]

Two major trends appeared in—or, more precisely, in the margins of—the film industry in the late 1950s. While diametrically opposed thematically and stylistically, they shared, to varying degrees, persecution by the authorities and a rejection of the decayed mainstream of the industry. In 1953 Fernando Birri returned to Argentina from studies at the Centro Sperimentale in Rome and in 1956 founded La Escuela Documental de Santa Fé, a documentary film school. Two years later he produced the school's first film, *Tire dié* (*Throw Me a Dime*), cited by Julianne Burton as the first Latin American social documentary and revealing the visible influence of Birri's studies with the Italian neo-realists. Birri's cinema was both more critical and less "popular" than the cinema under discussion in this article; "less popular" in the sense that his films were generally not seen through normal commercial channels and were often censored. Birri's main influence, though immense, thus lies not in the production of critical films in the mainstream but in his work as a teacher, theorist, and documentarist of the country's social reality, particularly in the interior.

The other trend to appear in the late 1950s was a movement labelled the Argentine nuevo cine. Composed of a handful of young directors, this movement was influenced by the auteurist renewal underway in European cinema at the time. This intellectual and introverted style was transposed by the nuevo cine filmmakers onto an urban Argentina, resulting in a cinema with little in common with the genres of the 1930s. Although itself defined by a European style, nuevo cine was also a strong reaction against the work produced in the 1940s. "There are no white telephones in my films," declared Leopoldo Torre Nilsson, who is generally considered a key member of the movement, though his entry into the industry preceded the real birth of nuevo cine by a few years.

Not only did these filmmakers renounce the forms of the 1940s, they combined this new European style with a return to Argentine authors (albeit authors a world apart from a novelist such as Alfredo Varela, an Argentine communist whose *El río oscuro* was the source for the country's last great social-folkloric film, *Las aguas bajan turbias* (*Troubled Waters*, by Hugo del Carril, 1952). *Nuevo cine* directors adapted instead the urbane work of novelists such as Julio Cortázar, Beatriz Guido (Torre Nilsson's wife), and David Viñas.[4]

The birth of *Cine Liberación* in the late 1960s (a process Octavio Getino describes in detail elsewhere in his essay in volume one) was

both a response to the state of the film industry in those years and a product of the social upheaval then underway in the country. At that time, the Argentine film industry, heavily censored since the end of a brief return to democracy in 1963, was composed of a thoroughly lifeless mainstream and a vigorous auteurist rump that was only beginning to produce features regularly, having long been marginalized. Neither the mainstream nor nuevo cine addressed themselves with any zeal to the political and social turbulence of the era. Perhaps this is due, on nuevo cine's part, to the censorship of quite innocuous films by two of its leading members, Manuel Antín and Fernando Ayala. The country's social turbulence was the result of the forging of an informal common front between the working and middle classes in a struggle against military rule. This process became particularly visible after 1969, a date that marked, not co-incidentally, *Cine Liberación*'s issuance of their "Towards a Third Cinema" manifesto [see volume one for the complete text of the manifesto]. In response to the political compromises required by auteurist production, and in the context of a growing acceptance of radical anti-imperialist theories by middle class intellectuals, *Cine Liberación* called for the creation of a "guerrilla cinema" that would join in the resistance. This cinema was based on principles of collective (and generally clandestine) production; parallel distribution, which involved audience discussion of the film; and unflinching political opposition to the military government. The group's first film, *La hora de los hornos* (*The Hour of the Furnaces*, by Fernando Solanas and Octavio Getino, 1966–68) was, as Getino reminds us, the first film to be used directly in the struggle for national liberation in a neo-colonized country.

For all *Cine Liberación*'s revolutionary political rhetoric, it collaborated in the democratic process that began in 1973 with the abdication of the military and the return of Perón as President after eighteen years of exile. To the dismay of some elements of the Left in Argentina and abroad who were intoxicated with the notions of "permanent revolution" and "guerrilla cinema," *Cine Liberación* put down its arms, as it were, to join in a democratic process that we are tempted, in retrospect, to view as inherently flawed and doomed from the start. The group collaborated on two fronts: first, by assisting in the elaboration of film policy, primarily through the presence of Getino as director of the film classification board; and second, by renouncing clandestine *agit* film production and joining, more or less, the mainstream of the industry with a view to producing commercial films for general release.

There can be no doubt that on both counts the experience was fruitful. The elaboration of film policy during this third Peronist presi-

dency was influenced more by the Peronist Left than were other social and economic policies. The abolition of censorship, the stimulation of production, and renewed efforts to limit the influence of foreign films in the domestic market all contributed to a cultural renaissance that benefitted from the participation of *Cine Liberación*.

In the context of a collective nostalgia for an imagined Argentine golden age (the affluent years of Perón's first presidency in the 1940s), the film industry undertook a remarkable revival of traditional Argentina film genres and themes. A number of important films were made by the country's best directors, films such as Olivera's *La Patagonia rebelde* (1974), Torre Nilsson's 1940s-style period piece "women's film" *Boquitas pintadas* (*Heartbreak Tango*, 1974), Leonardo Favio's *Juan Moreira* (1973) and Lautaro Murúa's *lumpen* drama *La Raulito* (*Tomboy Paula*, 1975). *Cine Liberación* directors contributed somewhat more radical visions of popular culture. Getino made *El familiar* (*The Relative*, 1973), financed by Italian television, based on a Tucumán legend. Fernando Solanas made *Los hijos de Fierro* (*The Children of Fierro*, 1972–77), a personal statement on the political events of the years of dictatorship and the success of the resistance movement. Gerardo Vallejo made *El Camino hacia la muerte del Viejo Reales* (*Old Man Reales' Road to Death*, 1970), a documentary of the three years he spent living with a rural family.

The course of political events after Perón's return is widely known. The national unity his return had promised, the unification of Argentina's polarized social classes behind a populist leader, failed to take root. Following his death fourteen months after returning to power, the internal contradictions of Peronism exploded into increasingly violent confrontations between a radical Peronist Left, which had spearheaded the resistance movement, and right-wing cronies and union bosses from earlier days. An undeclared civil war began that was only intensified and given a name after the military took power in 1976. To the non-Peronist Left, the whole experience is offered today as proof not only of the internal contradictions that affected (and affect) Peronism, but of the inherent inadequacy of populism as a political strategy in the continuing struggle for national liberation and meaningful democracy. This view contains far-reaching implications for a film industry whose most critical and democratic elements, whether tied to Perón or not, have always followed an essentially populist course.

Film Under Democracy: 1983 to the Present

I have already discussed, at the beginning of this essay, some of the problems facing the Argentine film industry today after a decade of

repression and economic chaos. The present composition of the industry is also discussed in some detail in the report prepared by *SICA* [see the next chapter in this volume]. I will return here briefly to a discussion of some of these points in order to make a few tentative final comments on the future of Argentine cinema under democracy. Unfortunately, a proper consideration of the nature of that democracy lies well outside the scope of this essay [and volume]. It might be noted in passing, however, that President Raúl Alfonsín's Radical Party seems determined not to antagonize the military. Show trials of nine former Generals and Presidents have therefore taken the place of a thorough inquiry into the activities of the Armed Forces during the years of terror, and of the necessary structural reform of the military. Alfonsin has also distanced himself from the radical positions of, most notably, Peru and Cuba on the foreign debt question, and he has endeavored to pay the Junta's U.S. $55 billion debt on better terms than those sought by the IMF. This is having an enormous effect on living standards in Argentina and on the country's social services, as well as on indicators such as illiteracy, which has risen considerably in the last decade and continues to rise under democracy. All of these factors, as *SICA* points out in its report, are hindering the revival of the national film industry.

During the dictatorship, with the production and popularity of domestic films at an all-time low, Argentine distributors began to distribute large numbers of foreign films, particularly of course U.S. films (to an even larger extent than is "normal" in a neo-colonial cultural situation). Because of the Junta's censorship and the relatively low rates of return they offered, very few Latin American films were included among these. The distribution of Latin American films within the region has been problematic at the best of times, and in the past there have been proposals for the establishment of a Latin American common market for film.[5] This call has not been taken up in Argentina today, as sales priorities have been oriented away from the Latin American market, for reasons I will discuss. Nor have Argentine distributors rushed to put Latin American films on Argentine screens since the return of democracy: in the first half of 1985, only six Brazilian films, and no other Latin American films, opened commercially in the country. Because of the political censorship in Argentina for most of the past twenty years, Cuban cinema, for example, is virtually unknown there. It is only through the efforts of cine clubs and *SICA* seminars that it and other regional cinemas are seen at all. This activity, however, is obviously no replacement for mainstream distribution, the lack of which is perpetuating Argentina's cultural isolation from the rest of Latin America.[6]

After nearly a decade of dictatorship, Argentina's working class, traditionally the strongest market for national production, had become a relatively poor consumer of Argentine films. This remains true today, after nearly three years of democracy, and only partially because of Argentina's high per capita ownership of television sets or of the austerity measures of the present government, which include a wage freeze alongside 40% inflation, leaving little money in working class households for outings to the cinema. Film attendance in the working class districts of Buenos Aires and in the industrial cities of Córdoba and Rosario fell substantially in 1985 after rising in 1984, the first year of democracy. While overall admissions to Buenos Aires movie theaters fell 6.1% between 1984 and 1985 (a startling and troublesome figure in itself), di Núbila, writing in *Variety*,[7] cites unnamed industry sources as saying that this figure doesn't approach the "disastrous" drop in attendance in the working class districts. The problem today is not simply one of a lost moviegoing habit compounded by an economic crisis that encourages people to stay home and watch TV. It is instead a result of a production strategy that emphasizes production for the national middle class and European markets while neglecting the national working class and Latin American markets.

In the production sector, the response to Argentina's historic dependence on foreign markets in order to maintain high levels of production has been to orient production to the lucrative West European and North American markets. This strategy has been vindicated by the success in these markets of such films as *Camila* (María Luisa Bemberg, 1984), *La historia oficial* (*The Official Story*, by Luis Puenzo, 1985) and *Tangos, el exilio de Gardel* (Tangos: the Exile of Gardel, by Fernando Solanas, 1985). In turn however, it has required the industry to virtually write off the Latin American market because of its fundamental incompatibility with the European market (I will discuss how Solanas' film represents an exception). Because of the Latin American debt crisis, government controls on foreign profit remittances, and widespread video piracy, to name just three of the problems currently affecting Latin American film industries, the present-day Latin American market offers few opportunities for substantial sales revenue. While the Argentine strategy is thus a response to the undeniable reality of film distribution in Latin America, it exacerbates at the same time the historic problem of the orientation of Argentine culture to European tastes. For this reason, the strategy is not without its detractors in Argentina today, who fear that an overriding concern with the success of Argentine films in the European market will eventually lead to a distortion of the national style. Already, it has visibly alienated the domestic working class market, as the best directors are

now working on prestigious productions aimed at foreign markets (the most notable examples of this in 1986 are Raúl de la Torre's *Pobre mariposa* (*Poor Butterfly*) and María Luisa Bemberg's *Miss Mary*. The latter was unfinished when I was in Argentina in May 1986, while the former had just gone into local release after representing the country in competition in Cannes. Primed as the prestige production of the year, it has been both an artistic and commercial disappointment, and it does not promise to match the domestic success of Solanas' *Tangos*).

Two of the three principal members of *Cine Liberación*, Gerardo Vallejo and Fernando Solanas, have returned to Argentina since the 1983 elections and have resumed film work there (the third, Octavio Getino, remains in Mexico). Vallejo has contributed another film to his ongoing project of developing a regional cinema in Tucumán, one of the most depressed regions in the Argentine interior. *El rigor del destino* (*The Sternness of Fate*, 1985), one of a very few Argentine films shot in the interior, is an emotional and nostalgic return to a rural social-folkloric theme. The release of Solanas' film this year, in contrast, heightened the debate over European versus Argentine styles. Set in Paris, begun in France while Solanas was in exile, winner of a Special Jury Award at the 1985 Venice Film Festival, *Tangos* has been criticized by some as being too "European" and "entertaining" for a Latin American political film. At the same time, a film such as *La historia oficial*, though thoroughly revisionist in its depiction of bourgeois anguish under the Junta,[8] has been praised for its ostensibly correct political line and the emotional power of its drama. This dichotomy, perpetuated mostly by foreign critics, seeks not only to relegate Latin American film production to the exclusively "political,"[9] but also misunderstands the historical context of progressive filmmaking in Argentina and skews the priorities of the reconstruction of a critical national culture.

La historia oficial spearheaded, by virtue of its bland international style and thematic attention to the Argentine middle class, the Argentine film industry's reorientation towards the national middle class and the European and U.S. markets. (It is interesting to note that Puenzo came to film from a background in publicity, common enough in Argentine cinema but evident nonetheless in the film's style). *Tangos*, on the other hand, despite what some call a "European art-house" look, has to be considered one of the most distinctly Argentine films to be made since 1983. It will probably prove—it has only just been released at the time of this writing—second only to *La historia oficial* in domestic box-office receipts and international sales to date. It is also

proving of greater interest to the more "popular" sectors of the Argentine and Latin American public.

In many respects, *Tangos* represents Solanas' return to the aborted project of 1973–75, the attempt to make entertaining mainstream films that combine social criticism with popular national culture. The lyrics of the tangos in the film were written by Solanas, who has a musical background, and the score was composed by the Argentine tango great Astor Piazzolla. But the film is also, according to Solanas, more than a tango musical; it is a *tanguedia*—part tango, part tragedy, part comedy, requisite ingredients of the national culture. The film is thus a clear homage to José Agustín Ferreyra, to his style and thematic concerns, and also of course to his own musical experimentation—*La muchacha del Arrabal* (1922), for which Ferreyra wrote lyrics to the film's live tango accompaniment. *Tangos*, however, presents a necessarily more radical view of Argentine popular culture: in Paris, the film's protagonists play tangos that have been banned by the military Junta that has forced them into exile.

It is hard to understand how an Argentine tango film, with cameo appearances from such historical personages as General San Martín and Carlos Gardel, could be regarded as more "European" than "Argentine" in style. Indeed, it is precisely in the context of a military Junta that banned certain tangos in its campaign to eliminate national culture that the political significance and cultural nationalism of the film should be clearly evident. The questions that this film should instead be raising concern the wisdom of a return to the golden age of the culture of the past, to tangos and to Ferreyra, in order to reconstruct a radical film culture in Argentina today.

Sectors of the non-Peronist Left have not failed to recognize the implicit cultural Peronism of *Tangos*—to recognize, in a word, its populism. As much as they disapprove of the internationalization of style by external market forces, they also reject a return to the "national-mythological" project that ended with the death of Perón over a decade ago. This approach, it is felt, might equally degenerate into a populist Latin American exoticism for the national working class and foreign markets alike.

An alternative approach can be seen in the work of Teo Kofman in his film *Perros de la noche* (*Dogs in the Night*, 1986, not yet released in Argentina or abroad at this writing). A gritty *lumpen* drama set in the shantytowns around Buenos Aires—a taboo topic—it is based on the caustic novel of the same name by Enrique Medina whose work, among other things, seeks to destroy the image of Buenos Aires as a cosmopolitan cultural capital, thus "Latin Americanizing" it. It is hard to tell, however, if this film, because of its fatalistic image of a social

group too often ignored in Argentina, will find wide commercial success.

Nevertheless, it remains true that the Argentine cultural Left, like the political Left, must now "abandon the myths and phantasms of the past," as one political commentator has put it, and rebuild a critical cinema, one that is responsive to the realities of contemporary Argentina. As I have mentioned, the death of populist politics has wide implications for the film industry, whose more progressive sectors have always followed a populist course. This does not mean, however, that the unique achievements and agenda of the 1973–75 period, the goal of widespread distribution and fidelity to popular national culture, should be abandoned.

Notes

1. See Tim Barnard, ed., *Argentine Cinema* (Toronto: Nightwood Editions, 1986), the entry regarding this film in the chronology of Argentine cinema, page 158, for an account of its impact on Argentine society.

2. See especially Alejandro Dabat and Luis Lorenzano, *Argentina: The Malvinas and the End of Military Rule (London: Verso, 1984).*

3. See Tim Barnard, *Argentine Cinema*, or volume one for essays by Birri and Getino.

4. The later work of nuevo cine director Manuel Antín represents an exception to this trend. After early collaborations with Cortázar, (*La cifra impar —The Odd Number*, 1961), he turned to *gaucho* themes in the films *Don Segundo Sombra* (1969, from the national literary classic by Ricardo Güiraldes) and *Juan Manuel de Rosas* (1970). Leopoldo Torre Nilsson as well filmed gaucho themes during this period, including an adaptation of José Hernández's *Martín Fierro* (1968).

5. Proposed by, among others, the former head of *Embrafilme* in Brazil, Roberto Farias, and by Octavio Getino.

6. Further evidence of the inadequacy of the Argentine film distribution sector is provided by the recent case of Jean-Luc Godard's film *Je vous salue, Marie* (*Hail Mary*, 1985). This film, as is well known, has aroused considerable controversy around the world, been denounced by the Pope, and is banned in many countries, including the newly democratic Brazil. Brazil's President succumbed to intense Catholic pressure and banned the film over the protests of his censor board. Its future was also hotly debated in Argentina, where the Catholic hierarchy may be even more conservative and powerful (many of the country's most powerful Church figures, for example, supported the Junta to the very end). Despite one prominent Catholic's claim that President Alfonsín personally assured him the film would not be allowed into the country, no such prohibition order followed. However, six months after the controversy, no Argentine distributor has bought the rights to it and it has not been seen in Argentina.

7. *Variety*, 12 March 1986.

8. The national bourgeoisie embraced the Junta with open arms in 1976 and for years refused to acknowledge its atrocities, benefitting at the same time from the Junta's *plata dulce* ("easy money") economic policies—noted only peripherally in *La historia oficial*.

9. Solanas, for example, has lamented in recent interviews that no one interviews him about film art, only about politics.

Report on the State of Argentine Cinema

Sindicato de la Industria Cinematográfica Argentina

*This report was presented by Jorge Ventura, the Secretary General of
SICA, the Argentine film workers' union, to the first-ever conference
of Latin American film workers' unions at the seventh Festival of New
Latin American Cinema, held in Havana, Cuba, in December 1985.
The report credits its sources as the book* El síndrome del cine na-
cional *by Jaime Lozano (1985), the Argentine film magazine* Heraldo
del cine *and SICA's own files.*

SICA comprises and represents film workers in any capacity. It is
affiliated with the *CGT (Confederación General de Trabajadores)*, the
only national trade union in Argentina. Those working in the produc-
tion of commercials, documentaries, shorts and feature films are le-
gally entitled to join the union, the only one recognized throughout
the country. Its members include the so-called transitory workers,
technicians whose workload depends on the duration of filming and
pre- and post-production, as well as permanent employees and film
and sound lab technicians.

SICA is almost a half-century old. Its influence was at first weak
and sporadic, as it joined solitary activists in fighting for just salaries
and working conditions. It is worth remembering that in the 1930s and
into the 1940s shooting days in Argentina were often eighteen hours
long, and it was common to see workers sleeping in the studios in or-
der to cope with such intense working days. Often, technicians would
work on one film in the morning and another in the afternoon.

Timothy Barnard, ed., *Argentine Cinema*. Toronto: Nightwood Editions, 1986, pp.
136–44. By permission of the editor.

The enormous popularity of film in those days led to the growth of a work force of 5,000 technicians working in the medium. Production at this time averaged forty-two feature films per year, in a country of 15 million inhabitants.

Nevertheless, the interruption of a popular political process, the instability of the industry, and the actions of foreign monopolies, with the complicity of the national liberal oligarchy, brought about the progressive erosion of our film industry and introduced a succession of periodic crises which have debilitated it.

Only twelve feature films were produced in 1983, the last year of the military dictatorship. This was the smallest number of films produced in many years. The population of Argentina was then thirty million inhabitants. During that year there was a veritable invasion of foreign films, 42% of which were North American. The active work force in the Argentine film industry was reduced to 1,200 people. Film labs laid off more than 50% of their personnel; in one case the dismissals accounted for 75% of the workers. Wages dropped, health and safety regulations were not observed, and the Collective Agreement was systematically violated.

From all this it is easy to note the consequences of this process of de-nationalization:

1. Lack of work;
2. Cultural and ideological penetration, with all the dangers this implies, including demoralization and lack of pride in our own work;
3. Subjection of a cultural medium to the goals of multi-nationals striving to sell their goods;
4. A de-culturation process that turns us into spectators and consumers of life, instead of being its protagonists.

Film under Democracy

The Constitutional Government that has been ruling Argentina for the past two years has taken some positive steps to protect citizens' rights and powers, in order to establish a basis for democratic development. This, in our judgement, must be complemented by economic measures that protect our industry and culture. This would allow for the development of a more just society, bringing us closer to our Latin American roots, the dream and necessity of our present epoch.

During this time film censorship has been abolished and a system has been implemented that protects minors while freeing the adult spectator from the protectors of his or her consciousness. The Instituto Nacional de Cinematografía has been returned to the control of film

people[1] and a 10% tax on film admissions has been reintroduced for use by INC. In 1984, twenty-six feature films were made.

By August of 1985, only fifteen films had been made; a result, in our minds, of the persistence of the control of the local market by the large film multi-nationals in alliance with their national representatives. The reluctance to intervene against this structure has produced inequalities that have forced independent national producers to limit production.

This problem has been aggravated in the past year by the argument of some larger producers (who are also distributors of foreign films)— an argument that has a certain amount of official support—that the problem of Argentine cinema is to be found in the production process. An attempt is being made on the basis of this argument to lower wages in the production sector and alter contract agreements. Without denying the possibility of rationalizing our production sector further, the country's film technicians, with the support of actors, directors and some independent producers, have vigorously countered this argument. A compromise has resulted, and INC has now undertaken to focus its efforts on the area of distribution and exhibition. A program of state production credits has subsequently acted as an incentive to small independent producers, who have put new films into production, which leads us to believe that by the end of the year we will approach 1984's output.[2]

The present state of the Argentine film industry is characterized by the following:

Production

1. Full thematic freedom exists.
2. State production credits, which mostly benefit small independent directors/producers, have been implemented.[3]
3. The possibility exists for producers to receive advance payments from distributors to defray the cost of the final processing of the film.
4. Some technicians, actors and directors are willing to defer their salaries in order to keep a film in production. This situation sometimes leads to the total loss of their wages due.
5. Large producers with their own equipment are few—only one has sound studios—and the themes they usually adapt are those that present the least commercial risk, those of the most passive kind.

The average cost of a film is approximately $280,000 U.S., of which 22% is paid to a technical team averaging 28 people. The average

length of production, including shooting and pre-and post-production, is seven weeks.

Distribution

There are three types of film distributors in Argentina:

1. Those that distribute mostly Argentine and some foreign films.
2. National distributors that distribute exclusively foreign films.
3. Subsidiaries of U.S. companies that distribute their own films.

Argentine distributors who buy films on the international market, mostly European films, are subjected to a "package" buying system. The packages contain a fixed number of films, containing only one or two films of interest and seven or eight films with little or no commercial or artistic value. In this way, fill-in material must be screened in order to recoup costs, further limiting the access of national films to the country's movie screens. This trash also contributes to a debasement of taste and represents an unnecessary drain of foreign exchange. Neither the Argentine distributors of foreign films nor the U.S. subsidiaries reinvest a single dollar of their huge profits in national film production, because there is no obligation for them to do so.

Some 4,400 foreign films have played in the Argentine market in the past fifteen years, averaging 293 per annum. The maximum number was reached in 1970, when 391 foreign films were screened, and the minimum was in 1975 with 204. Between 40 and 50% of these foreign films were imported from the U. S. by members of La Camara Argentino-Norteamericano de Distribuidores de Films (The Argentine-North American Chamber of Film Distributors / The Film Board), affiliated with the Motion Picture Association of America (MPAA), which groups together U.S. producers. The main members of the Film Board are the CIC (Cinema International Corporation, a merger of Paramount Universal, Metro Goldwyn Mayer and United Artists in 1982), Columbia, Fox, and Warner. The last three operate from the same building. All these firms form the great monopoly of world film distribution and are linked to huge trans-national corporations. The CIC, for example, has links with RCA, Pepsi Cola, the Hilton Hotels chain, and the owners of General Dynamics (builders of the fighter bomber Delta F-106). Metro Goldwyn Mayer has links with the Time-Life group and with Time-Life films. Warner Bros. belongs to the Kinner National Service Corporation (banks, insurance and communications); Columbia Pictures was acquired by Coca Cola in 1983; together with banks, airlines and building firms, United Artists

comprises the Transamerica Corporation; and Paramount is part of Gulf Western Industries (insurance companies, tobacco, raw materials, etc.).

All these firms are thus linked to those firms that help determine the protectionist policies of the U.S., expressed through measures such as dumping, overpricing of products, over-valuation of the dollar, arbitrary and excessive interest rates, and the decline in prices paid for raw materials coming from the so-called Third World, of which all of Latin America is a part. In a word, these companies represent the cream of the creditors of our foreign debt.

The local firms which comprise the Asociación Argentina de Distribuidores de Películas (The Argentine Association of Film Distributors) distribute the rest of the foreign films brought into Argentina. There are about ten firms of varying importance in this group.

Finally, distributors of Argentine films are grouped into two organizations: La Asociación de Productores (The General Association of Producers) and El Centro de Distribuidores de Películas Argentinas (CDPA—The Argentine Film Distribution Center). The first is composed of organizations such as Argentina Sono Film, Victoria Cinematográfica and Aries Cinematográfica. Over the past two years it has been possible to detect a marked increase in the number of foreign films distributed by these companies, as well as in the number of co-productions with U.S. companies they undertake. In the case of Aries, for example, five films have been made in co-production with Roger Corman and eight foreign films were distributed in 1984, rising to eighteen in 1985.

These companies began as film producers that later began to distribute their own films to ensure their exhibition. They have since been sought out by smaller independent producers to distribute their films. One can only expect this trend to progress in the future, leading to a relatively monopolistic situation.

To complete this brief sketch, 157 films were released in the first half of 1985. Only eleven of these were Argentine, and 75% of the remaining 146 were from the U.S. and the European Economic Community (EEC), countries with whom Argentina has the greatest foreign debt.[4] Of this total only six films were Brazilian and none were from other Latin American countries, Africa or Asia.

Last year, Argentine films accounted for 8.5% of the nation's screen-time and produced 18.7% of the spectators, or approximately ten million out of a total fifty-five million spectators.

Exhibition

There are now 1,117 movie theaters in Argentina. In 1967, the total was 2,200: in less than twenty years, the total number of cinemas has been reduced by nearly 50%. This illustrates the crisis affecting our industry. In most cases, the cinemas which have closed were in small provincial capitals, and their owners generally did not belong to any large circuit in the country. Most importantly, some of these cinemas were the only ones operating in certain towns in the interior of the country.

There are several reasons for this decline. The high per capita ownership of television in Argentina is just one of them. The lack of adequate protection of Argentine cinema in its own market; the sustained and growing invasion of foreign films; the increase in illiteracy in the interior of the country; rising unemployment and a decline in salaries; the increase in admission prices (peaking at the equivalent of $5.10 U.S. in 1982; today it is $1.40); the thematic impoverishment of the national cinema; the changes in taste brought on by the systematic alienation and depersonalization of television—these are the main reasons for the decline of our cinema.

Added to these is the problem of home video—in Buenos Aires alone 35,000 titles a month are being rented. A sociological phenomenon previously unseen in our country is now taking place. People are moving away from public entertainment, avoiding social contact and confining themselves to the solitude of home entertainment. In this way, cultural products are consumed without the opportunity of formulating a collective critical attitude.

Of all the sectors of the film industry, exhibition is the strongest because it recoups 50% of the net revenue of a film. In this sector, there are two dominant circuits: La Sociedad Anónima Argentina (SAC) and the chain Coll-Di Fiore-Saragusti, which has recently taken over the Lococo chain. These Buenos Aires-based companies also control the most important theatres in the provinces. Their main source of income is the box office percentage, in addition to the sale of advertising space in cinemas and the revenue from commercial trailers in the programs.

These monopolistic firms are the least likely to support measures to strengthen the Argentine film industry because their exclusive concern is profitability. Ninety percent of the material they show is foreign and they consistently reject Argentine films. It is also impossible to know if the number of patrons they declare really corresponds to the number of tickets sold.[5]

SICA

As we stated in the introduction to this report, the union represents the film workers and expresses their points of view. Our action is based on general labor legislation and the Collective Agreement in force in the industry since 1975. We have also taken part in the fight to strengthen the national cinema, transcending the limits imposed on us by the prevailing system. Thus, along with the Asociación Argentina de Actores (Argentine Actors' Association), Directores Argentinos Cinematográficos (Argentine Film Directors) and Argentores, SICA co-founded the Comité Permanente de Defensa del Cine Argentino (Argentine Cinema Defence Group), an organization founded in 1968 to fight against censorship and blacklisting.

The military Junta also took from our ranks our share of victims of the aberration to which this country was subjected. Some of us were exiled or have "disappeared," but we have been able to reappear to fight with renewed vigor in the fight that we know is that of all of Latin America. During the Junta, we lost our personal and professional contacts, dangerous generation gaps appeared, and there was an attempt to suppress all aspects of our Argentine character. In a word, we were being prepared to meekly accept our subjugated role as consumers of cultural goods imposed on us by others. Because of all this, we began to develop, during our first year of activity in 1985,[6] professional development courses for our members and for students.

In exchanges with other countries, we have been able to benefit from the insights of people like Nikita Mijailkov, Antonio Bardem, Tomás Guitiérrez Alea, and Fernando Birri, who prepared a seminar on New Latin American Cinema for us.

Our present activities have the following objectives:

1. To defend the rights of the film workers of Argentina.
2. To increase the professional capacity of our members, through exchange visits by technicians, particularly within Latin America.
3. To strive for the elimination of the conditions that have paralysed our industry, linked to the fight in Latin America against ideological penetration and deculturization.
4. To establish professional alliances, through the Comité Permanente de Defensa del cine Argentino, with all those suffering the problems of ideological and economic domination by the film multinationals.
5. To structure a film law that responds to the true needs of the national industry. We have already drafted a blueprint for consideration by Congress.

6. To extract all that is possible from the existing law. The Instituto Nacional de Cinematografía is mandated to do this and it must exercise this mandate.

7. To implement a system that would provide Argentine cinema better access to its own market.

8. To prevent the infiltration of foreign made dupes, which destroys sources of work for Argentine technicians.

9. To legislate the compulsory exhibition of the Argentine short film.

A Latin American cinema will develop not only through our individual efforts, but by co-operation. For that reason, we support co-productions between our countries.

Foreign debt and cultural penetration go hand in hand toward a single objective: the subjection of our people to the dictates of those who view life as a marketplace for their products.

Translated by Alex Zisman

Notes

1. INC was under direct military administration under the Junta. [T. Barnard]

2. Depending on how one calculates annual production (by completion or release date), 1985's production was almost exactly the same as the figure given here for production in 1984. [T. Barnard]

3. No discrimination is made in awarding the credits however, and Argentina's largest and most successful production houses benefit from them as well. [T. Barnard]

4. Argentina's foreign debt now stands at $55 billion U.S. [T. Barnard]

5. A reference to suspicions that some exhibitors were under-reporting their ticket sales in order to profit from the 10% admission tax collected on behalf of the film institute. To counter this, INC has introduced a monthly raffle (with large cash prizes), drawn from ticket stubs film patrons bring to the film institute, thereby discouraging exhibitor fraud. [T.Barnard]

6. SICA's activities were suspended under the Junta. [T. Barnard]

Contemporary Argentine Cinema

David William Foster

In 1983 Argentina returned to constitutional democracy after a decade of military dictatorship. The process of redemocraticization, officially sponsored by the new government and pursued vigorously throughout public and private sectors of the cultural establishment, brought with it an enormous renewed cultural production.[1] Traditional cultural forms like literary and general interest magazines, novels, and dramatic works constituted a particularly extensive part of this production.[2] Television programming was expanded to include not only enhanced national productions but also productions that echoed the goals of redemocratization. It augmented coverage of contemporary sociopolitical issues and contributed to the analysis of the devastating consequences for national life of the military government, including the "dirty war" against alleged subversives and the lamentable Malvinas (Falkland Islands) operation.[3]

One of the areas of cultural production that received special attention was filmmaking.[4] As B. Ruby Rich has observed: "the 1980s were a time for optimism regarding the revision and reinvention of the New Latin American cinema in a contemporary guise. The breaking of taboo and prohibition, the freeing of the imagination to fantasy, a respect for the mundane and everyday, the introduction of humor and music, the construction of new narrative strategies, and the reconsideration of the relationship to the audience, have all contributed to what I've defined as the monumental task of forging a new "collective sub-

David William Foster, *Contemporary Argentine Cinema* (Columbia, Missouri: 1992), pp. 1–3, 5–13, 150–54. By permission of the publisher.

jectivity.""[5] Argentina had a long tradition of commercial and art films dating from the earliest days of the industry in the late nineteenth and early twentieth centuries.[6] Numerous Argentine directors attained international recognition, and many Argentine film people have pursued their careers in the United States (Lalo Schifrin in soundtrack music and the actress Norma Aleandro are only two recent examples). Through the Instituto Argentino de Cinematografía, the elected government that assumed power in late 1983 undertook to promote its policies of redemocratization through the stimulation of film production. During the following five years, several dozen major Argentine films, in one way or another, explored sociopolitical themes brought to the fore by redemocratization and the analysis of recent Argentine history. By 1988 economic problems began seriously to curtail film production underwritten by the Instituto—problems that were exacerbated by the fact that few of the films it underwrote were big money-makers, having to contend during the postcensorship era with the flood of foreign imports, always more appealing to an Argentine audience than Argentine or other Latin American films.[7]

Some of the Argentine films, however, notably Luis Puenzo's *La historia oficial* (*The Official Story*), which won the 1986 Oscar for the best foreign film, attracted international attention and had wide distribution in the United States and Europe, being readily available in video stores. Puenzo's film is, in large measure, emblematic of the renewed cultural production. Films like *Camila* (filmed by Argentina's most prominent woman director, María Luisa Bemberg), Eliseo Subiela's *Hombre mirando al sudeste* (*Man Facing Southeast*), and Fernando Solanas's *Tango, el exilio de Gardel* (*Tango, the Exile of Gardel*) are all outstanding examples of films produced with a high degree of technical skill and commercial gloss while at the same time addressing in a conscientious fashion the sociopolitical issues. These films are accompanied by others that may not have received the same degree of public acclaim but that, nevertheless, also demonstrate the new vitality in Argentine filmmaking during the second half of the 1980s: Pablo César's *La sagrada familia* (*The Holy Family*), Raúl A. Tosso's *Gerónima*, Teo Kofman's *Perros de la noche* (*The Dogs of Night*), Américo Ortiz de Zárate's *Otra historia de amor* (*Another Love Story*), and María Luisa Bemberg's *Miss Mary*, to name only the most prominent.

Since this study pretends to go beyond the circumscribed, intrinsic analysis of film style and structure in order to examine a block of cinema productions as ideological texts, it is necessary to engage in a series of considerations concerning the relationships between film and society. Teshome Gabriel offers the following principles for the study

of what has come to be called the Third Cinema, or filmmaking in the Third World that rejects the traditional Hollywood view of films as mass-distributed and commercially profitable entertainment:

> The infant study of Third Cinema has already set as its point of departure the examination of the unique context—cultural and ideological—in which these films have been produced. The critical inquiry that has evolved must address jointly the areas of text and context and it is to that end that the following should be taken into account.
>
> Third Cinema must, above all, be recognized as a cinema of subversion. It is a cinema that emerges from the peoples who have suffered under the spells of mystified cinema and who seek the demystification of representational practices as part of the process of liberation. Third Cinema aims at a destruction and construction at the same time: a destruction of the images of colonial or neo-colonial cinema, and a construction of another cinema that captures the revolutionary impulse of the peoples of the Third World. It is a progressive cinema founded on folk culture whose role it is to intervene on behalf of the peoples of Africa, Asia and Latin America who must fight equally for political as well as cultural liberation.
>
> A critical examination of Third Cinema cannot take place outside of a comprehensive knowledge of the lives and struggles of Third World people, in both their past and their present histories. Lacking this historical perspective, the film critic or theorist can only reflect on the ways in which this cinema undermines and innovates traditional practices of representation, but he/she will lose sight of the context in which the cinema operates. An equally significant component of the critical perspective that must be adopted is the recognition of the TEXT that pre-exists each new text and that binds the filmmaker to a set of values, mores, traditions and behaviors—in a word, "culture"—which is at all moments the obligatory point of departure. Without the necessary understanding of this pre-existent TEXT, critical inquiry would fall into the trap of auteurist fallacies and "aesthetic" evaluative stances.[8]

There are several problems in extending Gabriel's position to the Argentine filmmaking of the period of redemocratization. Aside from the dangers inherent in sustaining a global notion like the Third World, no matter what validity it has Argentina is hardly a Third World country in the way that, say, Bolivia is. And although it may be argued that Argentina, beyond the Avenida General Paz that separates the federal capital from the rest of the country, does present per-

suasive continuities with the Third World, Buenos Aires, at least in its culture-generating and culture-consuming nucleus, is not only non-Third World but aggressively anti-Third World. This circumstance cannot fail to have implications for the sort of films to be produced in Argentina by even the most socially committed of directors. Gabriel speaks of the use of folklore motifs as a confirming characteristic of Third Cinema, which implies a disjunction with the Eurocentrist trappings notable in commercial productions. Such trappings provide images of actual spheres of Latin American modernity or facets of a wish fantasy that is assumed to be alluring to mass audiences. While some Argentine filmmaking has made use of that country's rich folkloric traditions and has sought to portray human lives lived in accordance with world-views other than those promoted by the Porteño cultural establishment, directors have not generally viewed the folkloric as the site of alternate social realities.[9] Both the urban lumpen and the rural margins tend to be viewed as clinging to little more than vestiges of the capitalist promise.

Fernando Birri, a legendary Argentine director who has lived in recent decades in Cuba, expresses a position that may have greater resonance for Argentine efforts.

WHAT KIND OF CINEMA DOES ARGENTINA NEED? WHAT KIND OF CINEMA DO THE UNDERDEVELOPED PEOPLE OF LATIN AMERICA NEED?

A cinema which develops them.

A cinema which brings them consciousness, which awakens consciousness; which clarifies matters; which strengthens the revolutionary consciousness of those among them who already possess this; which fires them; which disturbs, worries, shocks and weakens those who have a "bad conscience," a reactionary consciousness; which defines profiles of national, Latin American identity; which is authentic; which is anti-oligarchic and anti-bourgeois at the national level, and anti-colonial and anti-imperialist at the international level; which is pro-people, and anti-anti-people; which helps the passage from underdevelopment to development, from sub-stomach to stomach, from subculture to culture, from sub-happiness to happiness, from sub-life to life.

Our purpose is to create a new person, a new society, a new history and therefore a new art and a new cinema. Urgently.[10]

While there is still much of the Cuban-centered Third World rhetoric about Birri's statements, a rhetoric not easily subscribed to by sophisticated Buenos Aires cultural spokespersons, it is nevertheless quite evident that there are clear correspondences between the position

from which Birri is writing—the need for a thoroughgoing social rev-
olution—and the process of redemocratization in Argentina. The latter
was not committed, at either an official or popular level, to revolution
in the socialist sense underlying Birri's words. But the need to repu-
diate fascism and military rule, the need to reconstruct Argentine soci-
ety and its culture along meaningfully democratic lines, and the
imperative to offer cultural texts that would, in noncommercial and
nonexploitative ways, contribute to the new social and historical con-
sciousness of "never again" were determining factors in the cinemato-
graphic production being spoke of here. (*Nunca mas* [*Never again*]
was the title of the official government report on the disappeared.)

Moviemaking in Argentina in the postmilitary period undoubtedly
demonstrated a more pronounced break with the past than did other
forms of cultural production. Literature offered a sustained model of
cultural resistance during the tyranny, as did some manifestations of
popular music, popular art (like the magazine *Humor Registrado*
[*Registered Humor*]), and other print media.[11] The theater also in-
cluded significant works of a subversive nature; the Teatro Abierto
(Open theater) movement begun in 1981 represented such a loudly
defiant voice of cultural resistance that it became a symbol of the defi-
ance of censorship and repression at a time when military authority
had already begun to weaken.[12] But movies, along with television, be-
cause of the large capital investment required for production and dis-
tribution and their enormous public visibility, were severely
circumscribed during the Proceso de Reorganización Nacional (Pro-
cess of National Reorganization), the name given by the military to
the political programs it put into effect after the 1976 coup.

Although some innovative work with sociopolitical implications
was done outside Argentina by Argentine directors (for example, Héc-
tor Babenco in Brazil), film production in Argentina was almost ex-
clusively in the Hollywood mold—or, at least, films were produced
that could in no way pose a threat to the regime. Television program-
ming relied heavily on dubbed foreign, mostly American, syndica-
tions, with only some innocuous national productions.[13] Seditious
films were accessible through several underground means: importation
and viewing of cassettes of banned movies by small circles; private
screenings, ostensibly for publicity purposes, of films, including some
countercultural Latin American items that could not be publicly re-
leased without cuts by the censors; and word-of-mouth or ciphered in-
terpretations of commercially available foreign films, with or without
cuts. The latter could contribute allegorical readings of Argentina's
current political situation, either because they confirmed the structures

of fascism or because they could be argued to insinuate an opposition to it, if only a timid and perhaps contradictory one.

Thus the filmmaking that gathered momentum in Argentina after the return to democracy constituted a newly defined cultural component, whereas other cultural products only increased the quantity of their texts and the openness of sociopolitical themes. In this sense, film production was more closely coterminous with the process of re-democratization than were other cultural manifestations, lending it a greater symbolic aura and, because of its potential for mass consumption in ways that literature and the theater lack, allowing it a heightened internal and foreign distribution. Outside Argentina, the films produced after 1983 and throughout the rest of the decade have been widely accepted as indexes of that country's transcendence of military rule.

For President Raúl Alfonsín's government and the various permanent and ad hoc agencies involved in cultural production, culture was to play a key role in the process of redemocratization. This was natural, since the military, hardly underestimating, if not really understanding, the role of culture in society, had done much to destroy coherent cultural practices. Indeed, culture in Argentina had been besieged, with only brief respites in the late 1950s and early 1960s and in 1973, by all manner of military interventions since 1930, when a fascist coup installed José Félix Uriburu. As a consequence, redemocratization meant not just opposition to the dictatorship between 1976 and 1983 but, more significantly, the forging of a new institutionalism within the context of several generations of repeated aggressions—culture not only restored but an integral component of national consciousness.

Film deserved to be supported; Argentina could rightfully be proud of its historical leadership in Latin America in all aspects of filmmaking. The infrastructure of an industry was already in place and overlapped with the Buenos Aires theater world, still the driving force in Latin America, and with television, one of the largest enterprises on the continent and the first with color installations (thanks to the dictatorship's use of the 1978 World Soccer Cup in Argentina as a propaganda tool). Moreover, with regard to mass-distribution possibilities, not only did Buenos Aires enjoy a vast infrastructure for the showing of films, but films often appealed to an international audience in ways that few other cultural products could. Finally, and perhaps most important, film offered an all-enveloping illusion of reality far greater than television, the theater, or literature. Certainly, this illusion is fraught with ideological traps and allows precisely for the sort of manipulation of the spectator that is considered to be the worst aspect of

commercial filmmaking. Yet this illusionism allowed for a greater immediacy for images of sociopolitical reality and for a complex set of signs that could eloquently bring into play critical attitudes and revisionist/revolutionary modelings that were essential to reconfiguring the national consciousness as part of the process of democratization.

It will remain an open question whether this filmmaking—or, better, specific texts—should be viewed as modernist or postmodernist, as experimental or conservative.[14] The fact that these films essentially aspired to an appraisal of a well-defined sociopolitical reality—Argentina during the military tyranny and Argentina during the period of redemocratization—means that the self-reflexive and distancing procedures associated with experimental productions are inappropriate here. Moreover, modernist versus postmodernist postures are fundamentally bypassed, even when it is possible to talk about sophisticated spectator preferences that may condition response to certain texts. For example, postmodernist enthusiasms in Buenos Aires may have had much to do with a goodly amount of disdain for most of the films discussed in this study; individuals culturally raised at the movies viewed them as too transparent and ideologically naive, as technically clumsy, and as insufficiently engaged with the issues of a *cinéma internationale* to merit more than passing attention.

But, then, it is extremely dangerous to speak in generalities about an Argentine or a Porteño movie audience. There exist no published sociological or market studies about who goes to the movies in Argentina, and hence it is difficult to speak in any thing other than impressionistic terms about audience values, expectations, interpretive horizons, and the like. The reading of literature is a solitary act, and so we understand that literary criticism, no matter what level of complexity it assumes, is inescapably one person's reaction to a text. But the movies continue to be public spectacles, and even the home viewing of video cassettes tends to be done in a group. Yet film criticism, like any criticism other than a sociological survey of responses, is also a solitary analysis, a personal opinion.

But what seems to be more of a problem in the analysis of film vis-à-vis the spectator in Argentina is less a question of audience reaction in either personal or collective terms than of public preferences for foreign films. This preference was enhanced in the post-1983 period by the decensorship of imports; films were no longer banned or subjected to often confusing cuts, and there even arose a small but nevertheless significant exhibition of pornographic movies. The fact that audiences had access to so many movies that had never been shown in Argentina and to complete versions of movies that had been shown with cuts only served to increase the competition between Argentine

movies and foreign imports. As usual, American titles were abundant, but more significant was the considerable representation of key European films that had never passed the censors. The competition was further accentuated by the emergence of the home video industry. Video agencies and clubs seemed to have sprung up on every street corner, and their holdings were almost exclusively Hollywood productions, dubbed or subtitled. (One still visits them in vain looking for Argentine or Latin American films, which may be rented or bought only after extreme perseverance. This assertion is based on personal experiences in gathering copies of the films included in this study.) The result was that as production costs and ticket prices soared with inflation and the decline of the dollar in the late 1980s, the reemergent Argentine film industry also experienced heavy and, in the end, fatal competition from an industry whose profits were based virtually exclusively on the attraction of foreign imports.

While Argentine directors between 1983 and the end of the decade did not invest heavily in experimental cinematography, it is unquestionable that they did strive to stand in opposition to the commercial Hollywood norm and to make use of some of the principles of modernist and postmodernist filmmaking, or what D. N. Rodowick calls "counter-cinema."

[T]he reflexive structure of the text of political modernism is mapped onto a series of formal negations organized according to the opposition of modernism to realism. In this respect, the text of countercinema is marked by its interiorization and critical interrogation of the codes of Hollywood narrative cinema—for example, narrative transitivity (linear and teleological exposition); emotional identification with the characters and diegesis; representational transparency (masking of the means of production); a singular, unified, and homogenous diegetic space; textual closure presupposing a self-contained fiction—all of which are designed to yield a narrative pleasure aimed at pacifying the spectator.

In point of fact, . . . counter-cinema, which must accomplish the semiotic "deconstruction" of these elements of code, may be described in three points.

1. The text of political modernism cannot be conceived instrumental. . . .

2. Once the text has been opened up centrifugally—that is, once it has become intertextual—a difficulty in reading is imposed. . . .

3. This practice of reading imposed by the form of the modernist text generates a subjective response [called] "meaning effects."[15]

Surely, there is much about the Argentine production under consideration that exploits the narrativity of the Hollywood film, especially when critical or uncritical intertextualities appear together with the conventions of soap opera, as in Puenzo's *The Official Story* or Ortiz de Zárate's *Another Love Story*. Perhaps only Solanas's *Tango, the Exile of Gardel* and *Sur* (*South Side*) are unstintingly modernist, along with certain aspects of Subiela's science-fiction *Man Facing Southeast*. Yet all are marked by the sign of political modernism in the imperative to stimulate critical attitudes on the part of the spectator and to counteract the tradition of pacification Rodowick identifies as an essential component of the Hollywood mode—pacification in the sense of accepting reality as it is judged to be and refusing to entertain any ideological-dialectical critique of history. Perhaps few of the formulations are specifically Marxian, but the questioning of history, understood either in its conventional accumulated-past sense or as the Marxist here-and-now, is a unifying thread of the Argentine process of redemocratization, and it is in this sense that these films stand in opposition to the bulk of the commerical imports.

A number of recurring features of the films examined herein are characteristic of the resistance to narrative readability and the promotion of a critical and self-reflective countercinema of the type that Rodowick describes. One such feature is an appeal to allegorical configurations. While *allegory*, like so many of the conceptual terms used in literary criticism and extended to film analysis, is often overly flexible in its applications, the use of it here means to refer to the way in which characters, places, situations, and events have a historical meaning beyond their immediate, personal signification. A transparent semiosis implies that nothing has any meaning beyond itself and that, as a consequence, no story has any transcendent meaning beyond the trivially circumstantial, the essence of escapist meaning. Allegory, however, directs the spectator to understand how the personal is political and how the particular is historical, because every element in the social fabric is an interwoven part of the whole. In *The Official Story*, Gaby *is* Gaby as part of an intensely personal world, but she is also a sign for the destruction of innocence by military tyranny through the violent manipulation of individual destinies. Gaby's particular story is also the story of expanding spheres of Argentine social life, and spectator anxiety over her uncertain future at the end of the film points also toward the unresolved dilemmas of national existence. The re-

pression of Rantes in Subiela's *Man Facing Southeast* and the perse-cutions of the gay lovers in *Another Love Story* are intrinsic to a set of personal lives, but both repression and persecution are constituents of a social dynamic the respective films are concerned to elucidate.

Documentalism is another sustained characteristic of the films of the Argentine period of redemocratization. Documentary, in either a literal sense or in the sense of the documentary-like re-creation of events from an earlier era, is an important form of contemporary film-making, and there are a number of Argentine monuments in this gen-re, such as Fernando Solanas's *La hora de los hornos* (*The Hour of the Furnaces*), Octavio Getino and Solanas's *La Patagonia rebelde* (*Rebellious Patagonia*), Héctor Olivera's *Los hijos de Fierro* (*The Sons of Fierro*), and Eduardo Mignogna's *Evita, quien quiera oír, que oiga* (*Evita, Let He Who Wants to, Listen*). Documentary films, how-ever, engage in a number of strategies to ensure audience recognition of the fact that fictional elements, if present at all, are only adjuncts to a core of archival material presented via a filmic exposition. Docu-mentalism, by contrast, incorporates into a fictional narrative archival material as part of the expository texture of the narrative: the actual footage in *The Official Story* of the Madres de Plaza de Mayo (Moth-ers of Mayo Plaza) marching, veristic images of urban slums in Kof-man's *The Dogs of Night*, television journalism footage in Bebe Kamín's *Los chicos de la guerra* (*The Boys of the War*).

Documentalism serves to anchor a narrative in a specific socio-po-litical reality in order to trigger allegorical associations in the specta-tors' interpretation of a film. Cultural texts create an illusion of reality, beginning with the use of sign entities identified as human characters, while often at the same time reflecting facile decodifica-tions of fictional reality as being merely transparent images of real life. Real life, of course, is not what takes place in cultural texts, at least not as such, although films (like television dramas) are particu-larly susceptible to being taken as open windows on actual life. Cul-tural texts, rather, are semiotic reconfigurations of real life, and the sense of meaning they propagate allows signs to posit a denser, over-determined signification that the haphazard, random, and essentially infinite components of lived experience cannot have. Cultural texts expropriate signs from the latter and conscientiously structure them so that they will enter into processes of meaning spectators can contem-plate or extrapolate in a manner specifically focused by the cultural event, or the entire ceremony associated with seeing a movie and de-riving something from it. Cultural texts mediate and thereby defer real life, and yet documentalism and the overall appeal to verisimilitude in many cultural texts function to anchor the texts in recognizable social

and historical realities. Argentine post-1983 films are historical in any sense of the adjective, and documentalism is one way of enhancing continuities with acknowledged historical material.

History in the conventional sense of an accumulated past is also a component of these films, the most notable example being Bemberg's *Camila*, which is based on an actual event from the mid-nineteenth century. The implication is that the structure of repression and tyranny of that period prefigures recent Argentine history, and the film is both historically accurate in its details and anachronistic in the foreshadowing of contemporary reenactments of bloody narrative programs.

Postmodernist deconstructive recodifications of science fiction in *Man Facing Southeast*, of Nazi propaganda films in Héctor Babenco's *Kiss of the Spider Woman*, of the soap opera in *Another Love Story*, and of pornographic erotica in *The Dogs of Night* represent yet another dimension of turning transparent narrativity into analytical countercinema without aspiring to an uncompromisingly experimental cinematography. Any attempts to embrace the latter would have, more than likely, reduced these films' audience, whose numbers were already threatened, to the vanishing point by the attraction of decensored foreign commercial imports.

One of the sustained concerns of the analyses of the above films is to assess the ideological consequences, first, of the appeal to parameters of meaning established by the overall climate of redemocratization and, second, the utilization of semiotic strategies to ensure the films' function as texts that are not Hollywood competitors but entries in a new socially analytical Argentine filmography.

II

Perhaps it would be exaggerated speculation to assert that film is the most representative manifestation of the culture of Argentine redemocratization. Film is a highly visible commercial product and one that can now be safely, although not exclusively, inscribed within the orbit of high or elite culture. As such, it ought not distract attention from the truly heterogeneous display of popular culture processes that have emerged since censorship was lifted and the market demand took hold for a multiplicity of products that could in no way have been possible under the dictatorship: rock music and songs appealing to diverse sectors of Argentina's extensive youth culture; television programming with both a national and international focus; magazines of all types, especially humor and satirical publications; mass spectacles, including concerts and broad-audience reviews; paraphernalia, such as bumper stickers, buttons, t-shirts, and posters, that proclaim previously pros-

cribed feelings or identities, even those relating to sex. In the face of this wealth of cultural production, one would be well advised not to inflate the importance of genres that, while they may be of interest because of the concentrated originality of creative effort underlying them, may perhaps have not had the general societal impact enjoyed by mass consumer products.

Despite an unfavorable economic situation that has even worsened under democracy since the artificial supports of the tyranny were removed, redemocratization unleashed in the early 1980s, in an Argentina always ready to consume enthusiastically the latest cultural fashions, an intense desire to assimilate products that the dictatorship had suppressed. As I have argued from the outset of this essay, the appeal of the filmmaking during the period of redemocratization turned out to be severely circumscribed by the greater priority of audiences to see the many foreign films that had either been banned by the junta's censors or shown in cut versions.

Yet when one examines the privileged position of filmmaking vis-à-vis other high culture genres during the period in question, there is an undeniable basis for viewing it as exceptionally significant. Theater made its greatest contribution in the form of Teatro Abierto, which between 1981 and 1983 defied in dramatic terms (double entendre intended) the structures of repression. Although some denunciatory works of fiction, such as those by Marta Lynch, Jorge Asís, and Enrique Medina, did circulate during the tyranny, it was probably the most visible form of Argentine culture in exile, in both Spanish and in translation, as witnessed by the works of David Viñas, Manuel Puig, Griselda Gambaro. Poetry always has a select appeal, although the poet Alejandra Pizarnik, who committed suicide in 1972, emerged as something of a cult figure. Her *La condesa sangrienta* (*The Bloody Countess*), on the sadistic exploits of the seventeenth-century lesbian Hungarian countess Erzébet Báthory, was reissued in 1976 and understandably read as a metaphor of human rights abuses.[16] And the sociopolitical essay, which enjoyed some prominence during the transition between the periods of the military and of constitutional democracy, can be viewed as a more focused derivative of the many voices of oppositional journalism that found channels of expression during the military period, especially since most of the authors of book-length exposés after 1983 were professional journalists.[17]

Filmmaking since 1983 is essentially coterminous with the process of redemocratization. Thus, all of the films examined herein bear directly on questions of sociopolitical dissent, whether understood in terms of explicit public acts or interpreted under the aegis of the slogan "the private is political," which suggests the way in which ideo-

logical interpretations are drawn from a consideration of the erotic and the sexual. Even those films that, on the one hand, deal with intensely intimate questions (like *Another Love Story*) or, on the other, deal with superficially local-color issues (like *South Side*) can only with great effort not be read as dealing with larger, unresolved tensions in Argentine society, despite the much vaunted return to institutional democracy. Certainly, the return to democracy provided the opportunity to deal with these questions. And cultural products like the film were inevitably going to invite the spectator to view them as examining critically precisely those topics that the constitutional government had been unable to address satisfactorily. And, to the extent that Argentina viewed itself as modeling for other Latin American countries emerging from a decade or more of military tyranny the possibilities of a thoroughly redemocratized society, a highly international cultural phenomenon like the film lent itself eloquently to a process of interpretation leading from the immediately personal or the immediately local to larger and abiding questions of Latin American society. Those questions concerned individuals' legitimate control of their own bodies, the opportunities to question established authority and to unmask its disingenuous strategies for self-perpetuation, and the structures whereby sociopolitical repression remains unchanged despite manifest revisionary attitudes. In this sense, the despair of the psychiatrist at the end of *Man Facing Southeast* enunciates all of the concern these films sought to activate over the true process of social—and, therefore, personal—reorganization that remains yet to be enacted.

Films that were produced in Argentina before 1983 and under the shadow of the junta were in the main commercial ventures with inconsequential or nonexistent artistic dimensions. Or, at any rate, the films that were made with artistic pretensions could hardly have anything to do with the facts of military rule, for example, Mario Sabato's 1979 *El poder de las tinieblas* (*The Power of Darkness*), based on the novel *Sobre héroes y tumbas* (*On Heroes and Tombs*) by his father, Ernesto Sabato. As Peter B. Schumann has written:

> The consequences [of the military dictatorship] were disastrous for Argentine cinematography. A great many filmmakers saw themselves forced to go abroad to escape the death threats: Gerardo Vallejo and Lautaro Murúa, who only by chance survived the bombs that exploded in their homes; Octavio Getino and Fernando Solanas, Humberto Ríos and Rodolfo Kuhn, Mauricio Beru and Jorge Cedrón, and including, although only for a short time, Leopoldo Torre Nilson, along with many others, the majority of the most well known figures. Some were

kidnapped and probably killed, as occurred with Raymundo Gleyzer and Pablo Szir; likewise with the authors and scriptwriters Haroldo Conti and Rodolfo Walsh. Others, like Enrique Juárez, were executed.

The exodus, the repression, the prohibitions on exercising the profession, and the censorship undermined the substance of Argentine cinematography. The amount of films released dropped from 35 in 1975 to 16 in 1976, to again rise to 32 in 1979 and, finally, reached its lowest point in 1982 with only 17 full feature films; all this as a consequence of the disastrous political economy, of the lack of state incentives, and of the problems stemming from censorship.[18]

The fact that redemocratization meant that by late 1983 films could be made without the restrictions of censorship or the threats of violence against those involved and the fact that the Alfonsín government was willing to provide subsidies provided in a confluence of circumstances affording film as a cultural genre a clearly defined fresh beginning. And the steady economic decline that occurred throughout the Alfonsín period and on into the presidency of Carlos Menem, which began in 1989, translated into the cessation of government subsidies, which itself translated into the effective demise of an independent cinematography driven primarily by creative considerations. The need to turn a profit may not necessarily imply artistic or ideological compromises, but within the overall precarious panorama of Latin American film production it cannot be considered a stimulus either. To judge by the uneven quality of María Luisa Bemberg's 1990 film on Sor Juana Inés de la Cruz, *Yo, la peor de todas* (*I, the Worst of All*), which was severely circumscribed by financial difficulties, one must recognize that the momentum of a new, redemocratized Argentine filmmaking is now very much a part of national cultural history.

This temporal circumscription provides the films with a privileged position not readily ascribable to other cultural genres. Of course, no claim can be made for the universal excellence of the several dozen films produced under the aegis of the redemocratization efforts, and a study more devoted to technical and artistic features than the present one might dwell at length on a recurring problem of symbolic pretentiousness and an ill-advised patina of Hollywood-ishness—allegedly part of the attempt to tap into international interest in Argentine and Latin American postdictatorship societies. These are some of the reasons why John King has been able to assert that, as a body, these films constitute an "imperfect cinema."[19] Yet from a strictly ideological frame of reference, the coincidence of this film production with

the period of redemocratization provides it with a particular privilege as a record of the aspirations and limitations of that process. At the same time, one must recognize that the historicization of recent Argentine cinematography is, perhaps, what has limited its attractiveness to international audiences, which are likely to care little for the facts of Argentine history. The analyses herein, while centered on only a limited number of films—those that arguably represent the principal tendencies and recognized successes of their directors—have dealt with the interaction between cinematographic semiosis and the goals of redemocratization to analyze recent and long-range national history, to interpret the social and political forces at play during the dictatorship, and to project the collective and personal mentalities necessary for the shift in Argentine society that can impede the development of future tyrannies. No one can assume, protestations of Nunca más to the contrary, that the military will never come to power again in Argentina. Nor can anyone hope to provoke profound modifications in a country's deeply rooted social structures through a six-year politically based action program. But culture is a slowly evolving and immensely complex process. Because film is, after all, a recent but highly public cultural genre, it may be difficult to see its processes of ideological analysis and social impact from the sort of distanced perspective from which one views canonical genres like poetry or the theater. That is, it is all too easy to expect too much from, and to attribute too much to, a circumscribed production like the moviemaking examined in this study. Yet it can be only through the patient examination of this production that it will eventually be possible to ascertain its historical importance.

Notes

1. Basic position statements include Marcos Aguinis, *Mientras se consolida la democracia* (Buenos Aires: Fundación Demos; Fundación San Telmo, 1985); Javier Torre and Adriana Zaffaroni, "Argentina: Its Culture during the Repression and during the Transition," in *Redemocratization of Argentine Culture, 1983 and Beyond*, edited by David William Foster (Tempe: Arizona State University, Center for Latin American Studies, 1989), pp. 11–21; and Oscar Landi, "Campo cultural y democratización en Argentina," *Políticas culturales en América Latina*, edited by Néstor García Canclini (Mexico City: Grijalbo, 1987), pp. 145–73.

2. See, for example, the cultural products analyzed by Aníbal Ford, Jorge B. Rivera, and Eduardo Romano, *Medios de comunicación y cultura popular* (Buenos Aires: Editorial Legasa, 1985).

3. See Aguinis, *Mientras se consolida la democracia*; Mónica Peralta-Ramos and Carlos H. Waisman, eds., *From Military Rule to Liberal Democ-*

racy (Boulder, Colo.: Westview, 1987); and *Hacia una Argentina posible* (Buenos Aires: Foundación Bolsa de Comercio de Buenos Aires, 1984).

4. Peter B. Schumann, *Historia del cine latinoamericano*, translated from the German by Oscar Zambrano (Buenos Aires: Editorial Legasa, 1987), pp. 38–51; John King and Nissa Torrents, eds., *The Garden of Forking Paths: Argentina Cinema* (London: British Film Institute, 1988), 74–97.

5. B. Ruby Rich, "An/Other View of New Latin American Cinema," *Iris: revue de théorie de l'image et du son 13 (1991): 5–28.*

6. *Historia del cine argentino*(Buenos Aires: Centro Editor de América Latina, 1984).

7. One dimension of economic circumstances in Argentina, alongside the rise of video clubs and home viewing, was the drastic reduction in the number of movie houses. According to statistics released by the Sindicato de la Industria Cinematográfica Argentina, in 1970 there were over 2,000 movie houses in Argentina; by the 1980–1982 period, the number had dropped to 900; in October 1991, there were 427; and in January 1992, there were approximately 380 (Teo Kofman, private communication based on documents in his possession).

8. Teshome H. Gabriel, *Third Cinema in the Third World: The Aesthetics of Liberation* (Ann Arbor: UMI Research Press, 1982), p. 95.

9. *Porteño* refers to the cultural establishment of Buenos Aires, an international port city.

10. Fernando Birri, "Cinema and Underdevelopment," in *Twenty-five Years of the New Latin American Cinema*, edited by Michael Chanan (London: British Film Institute, 1983), p. 9. The full text of this tract is reprinted in volume one.

11. For example, the papers included in *Ficción y política: la narrative argentina durante el proceso militar*, edited by Beatriz Sarlo (Buenos Aires: Alianza Editorial, and Minneapolis: Institute for the Study of Ideologies and Literature, 1987).

12. Carlos Ferreira, *Por un cine libre* (Buenos Aires: Corregidor, 1983).

13. Heriberto Muraro and José G. Cantor Magnani, "La influencia transnacional en el cine argentino," *Comunicación y cultura* 5 (1987): 19–69.

14. D. N. Rodowick, *The Crisis of Political Modernism: Criticism and Ideology in Contemporary Film Theory* (Urbana: University of Illinois Press, 1988).

15. Ibid., 52–54.

16. David William Foster, "Fiction and the Sociopolitical Text: Violence, the Body, and Cultural Responses in Argentine Literature in the Context of Military Tyranny," manuscript in author's possession.

17. David William Foster, "Argentine Sociopolitical Commentary, the Malvinas Conflict, and Beyond: Rhetoricizing a National Experience," *Latin American Research Review* 22, no. 1 (1987): 7–34.

18. Schumann, *Historia del cine latinoamericano*, 35.

19. John King and Nissa Torrents, eds., *The Garden of Forking Paths*, 93.

Bolivia, Ecuador, and Peru

Andean Images

Bolivia, Ecuador and Peru

John King

Today the rupture is complete. Indigenism, as we have seen, is gradually uprooting colonialism. . . . From abroad we simultaneously receive various international influences. But under this swirling current, a new feeling and revelation are perceived. The universal, ecumenical roads we have chosen to travel, and for which we are reproached, take us ever closer to ourselves.

José Carlos Mariátegui[1]

Bolivia

The story of modern Bolivian cinema begins with the aftermath of the National Revolution of 1952. The problems that the revolutionary government of the MNR (Nationalist Revolutionary Movement) had to face were enormous. James Dunkerley paints the picture of Bolivian society on the eve of the Revolution:

Bolivia was notoriously backward. Its gross domestic product (GDP) was a meager $118.6 per capita, making it the poorest country in the hemisphere with the sole exception of Haiti. . . . A country the same size as France, Italy and West Germany combined possessed a population of 2.7 million, of which just 22 per cent lived in settlements of over 7,000 people. Only 31 per cent of Bolivia's population was literate; 8 per cent had completed secondary education. In 1950 there were 3,700 registered students in the country's five universities which issued 132

John King, *Magical Reels: A History of Cinema in Latin America*. New York: Verso, 1990, pp. 189–206. By permission of the publisher.

degrees in that year. . . . Nearly three children in ten died in the
first year of life and the life expectancy at one year fell well
short of fifty.[2]

In the aftermath of the Revolution progressive measures were
taken. The mines were nationalized, a sector that produced 25 per cent
of GDP. This was a potentially provocative measure, since some 20
per cent of Simón Patiño's shareholders were North American. On the
eve of the Revolution Patiño controlled 10 per cent of the world's tin
production. However, President Paz Estenssoro managed to keep the
U.S. government neutral, and eventually achieved the reluctant agree-
ment of the companies themselves. An agrarian reform was passed,
but its effect on land tenure was not rapid or profound: between 1954
and 1968, about eight million of the thirty-six million hectares of cul-
tivable land was redistributed.[3] Universal franchise was granted, the
army was restructured and worker, student and peasant organizations
received arms. The first years of the Revolution, therefore, witnessed
rapid change.

In July 1952, a department of cinematography was created as part
of a Press and Propaganda Ministry and this was replaced in 1953 by
the Bolivian Film Institute, the ICB, which was run until 1956 by
Waldo Cerruto, the president's brother-in-law. The country did not
have sufficient trained cineastes adequately to cover the revolutionary
events of 1952. Two young Argentines, Levaggi and Smolij, caught
some of the effervescence of those months, in a short documentary
Bolivia se libera (*Bolivia Liberates Herself*). The ICB produced regu-
lar newsreels, mainly government propaganda, eulogies of leaders or
descriptions of folklore,[4] though Sanjinés remembers some striking
scenes of "the presence of thousands of peasants from all over the
country who, with arms at the ready, kept watch over the signing of
the Agrarian Reform Decree in Ucureña; the processions of brave and
fierce miners, swathed in cartridges of dynamite, carrying those arms
seized from the army of oligarchy."[5] More often than not, however,
the images would be of rites of power, such as the visit of Vice Presi-
dent Siles Zuazo to the coronation of Queen Elizabeth in London.[6] In
general, Dunkerley is right that, with regard to film,

> Bolivia was too backward and the revolution too early to exploit
> to the full its symbolic and propaganda effort, let alone dynam-
> ize creative effort . . . only one poor documentary was made in
> the aftermath of the April rising and over thirty years since,
> there has been no film of it, fictional or otherwise, in contrast to
> the cases of Mexico, Cuba, Nicaragua or even El Salvador.[7]

The INC did, however, give training to technicians and directors which would bear fruit in the next decade.

The most important filmmaker of the 1950s, Jorge Ruiz, did not become involved with the ICB until 1956. He made a remarkable short ethnological film, *Vuelve Sebastiana* (*Sebastiana, Come Home*), in 1953, with the Chipaya Indians from Santa Ana de Chipaya, a people who were gradually dying out or being acculturated. Sebastiana Kespi, a twelve-year-old Chipaya girl, meets a young boy on the *altiplano*, where she is tending the family animals. He takes her to an Aymara town which has assimilated many Western values. Fascinated but frightened by the new surroundings, she is rescued by her grandfather, who leads her back to the village, communicating all his wisdom to her on the way. On reaching the village, he dies of exhaustion, but the oral tradition has ensured that Sebastiana is now the living embodiment of her culture. Despite its idealism, the film demonstrates a clear preoccupation with the Indian communities: it is respectful and never intrusive. *Vuelve Sebastiana* is a clear precursor of the work of the Ukamau group in the 1960s: Sanjinés has called it an "extraordinary" film and it received the favorable attention of the veteran filmmaker John Grierson when he visited Bolivia in the late 1950s.

Ruiz joined the ICB in 1956 and made what is considered to be the first major feature-length sound film in Bolivian history, *La vertiente* (*The Watershed*). Filmed in 35mm with direct sound, it was very much a group project. This was a clear example of a state institute supporting the government's rural developmental projects: the people of a rural community fight for drinking water, which is obtained through their best efforts of mutual aid and with some prompting by a young schoolteacher doing her training in an outlying community. She might offer some wisdom and guidance on irrigation but she is introduced to love by a very macho alligator hunter. This rudimentary attempt to fuse romance and melodrama (the death of a child galvanizes the village into action) with social documentary worked well within the country.[8] Ruiz, however, would increasingly spend time on contract work for U.S. aid agencies in Bolivia and in other parts of Latin America.

Ruiz's shift to making U.S.-funded films reflects broader patterns of change in the country. The Revolution could not maintain its early momentum. The government of Siles Zuazo (1956–60) attempted a more conservative course of bringing runaway inflation under control with massive financial support from the United States. The stabilization plan of 1956 was "monetarist" and signalled economic as well as political offensives against the syndicalist working class. Under Siles

Zuazo, and later again under Paz Estenssoro, Bolivia became the showcase for the Alliance for Progress attempt to support non-Marxist reformist governments. At the same time it received the highest U.S. aid per capita of any country in the world. It became increasingly difficult for the government to accept U.S. funds and influence over policies, while at the same time remaining true, even rhetorically, to the anti-imperialist drives of the Revolution. It could not eventually resolve these contradictions and was dismissed by a military coup in 1964.

Bolivian social cinema grew up in these contradictory times. Its main impulse came from Jorge Sanjinés and the Ukamau group. Sanjinés had travelled to Chile for his university education and enrolled in the Catholic University's newly opened film school under Sergio Bravo. Returning to Bolivia, he formed a friendship and a partnership with Oscar Soria, Bolivia's most important scriptwriter, who had worked with Ruiz throughout the 1950s. Together they founded some short-lived institutions, a journal, a film society and a film school, and began making shorts on contract. The first major independent collaboration by Sanjinés and Soria was the ten-minute *Revolución* (*Revolution*, 1964) a silent montage of images punctuated only by guitar music and percussion revealing the exploitation in the country and the workers' resistance which led to the Revolution of 1952.

The military takeover in 1964, paradoxically, gave Sanjinés further opportunity to develop his ideological and aesthetic positions. The Barrientos government dismissed the personnel of the INC, but then appointed Sanjinés to its directorship in 1965. Some among the left felt that Barrientos would usher in a Bonapartist regime, but this view was shown to be hopelessly misconceived between May and September 1965 when the regime moved to smash workers' organizations in the mines, with widespread repression, assassination and arrests. Sanjinés would thus be uneasily positioned working with a state organization, trying to make socially responsible documentaries and features at a time when open authoritarianism was on the increase. His film *Ukamau* would eventually lead to his dismissal from the INC in 1967, as Bolivia entered into its darkest hour with the killing of Che Guevara and the massacre of miners on the night of San Juan in June 1967. From that time, all his films would be made independent of any state organizations.

Sanjinés has coherently analyzed the development of his filmmaking in a number of articles and conferences.[9] He dismisses his early documentaries made for the ICB as demonstrating but not analyzing the suffering of the working classes:

We began to realize that the people were not interested in seeing films that did not contribute to anything, films that merely satisfied their curiosity to see themselves reflected on the screen. We realized that the people knew much more about misery than any filmmaker who might aspire to show it to them. Those workers, miners and peasants are the protagonists of misery in Bolivia. Except for bringing tears to the eyes of a few pious liberals, the kind of films we had been making were good for nothing.

What these people were interested in was rather "an explanation, a deconstruction of the mechanisms of power."[10] This self-criticism is too harsh for, in Western eyes at least, a film such as *Aysa* (*Landslide*, 1964) is a powerful statement on the great perils of the mining process. On this feature, Sanjinés assembled what would become his regular crew: the scriptwriter Oscar Soria, the cameraman Antonio Eguino and the producer Ricardo Rada. He would also find two non-professional actors in the mining community whom he would use in his next two films, Benedicta Huanca and Vicente Verneros.

Ukamau (*That's How It Is*, 1966), was shot among the Ukamau Aymara Indians, and is spoken in Aymara, with Spanish subtitles. It tells the story of a young couple living on an island in Lake Titicaca. When the protagonist Andrés Mayta is away, the *mestizo*, who buys local produce from the Indians and sells it to the town, rapes and kills his wife. The film traces how Mayta tracks down and kills the murderer, following him across the landscape of the *altiplano*, his presence signalled on the soundtrack by the music of a solitary *quena* (Andean reed instrument). Critics of the film accuse it of being in the mode of *indigenista* writers such as Alcides Arguedas,[11] who felt a paternalist sympathy for the Indians but viewed them as mere objects of oppression, with no history and no conscious political strategy of their own; and who collapsed class struggle into an analysis of race (the good white man, the cunning, devious *mestizo* and the noble Indian). These judgements seem unduly severe. The *mestizo* is indeed portrayed as a stock evil character, but the critique of the city merchants who use such figures as agents of their exploitation is very clear. Also the Indians are far from being the "Bronze Race" of Arguedas's famous novel, creatures both strange and exotic but also threatening. The Indian is a social and political force, not a racial "problem." Luis Espinal, the critic who was murdered by a right-wing death squad in March 1980, saw this clearly: "The picture is not merely anecdotal. The final struggle between those isolated men in the middle of the Altiplano is a symbol of the class struggle. There is also a parallelism between the *mestizo* taking away his wife and taking away the fruits of his labor;

the violator and the exploiter are the same person."[12] The film has an extraordinary plasticity and shows clearly the force of the landscape that the figures move through, without falling into telluric essentialism or into an aesthetic of poverty. For Sanjinés, however, the main fault was that it still showed the struggle of an individual rather than a collective protagonist.

The film enjoyed great success at home and abroad. This irritated Barrientos, who felt that such a theme did not show the country in a favorable light. The whole team, now named Ukamau in homage to the film, was dismissed from the ICB, and the institute was eventually closed down. The group formed their own independent company and in 1968 produced *Yawar Mallku* (*Blood of the Condor*). They found a theme—the forced sterilization of women in the countryside by U.S. aid agencies such as the Peace Corps—which gave substance to the nature of imperialism, otherwise just a distant abstraction to local communities. But they still had a great deal to learn about the nature of the Indian peoples among whom they wanted to film. Sanjinés tells how when they went up to the chosen Indian village, a long and difficult journey, they found that the people ignored them, treated them with mistrust and refused to cooperate. After two weeks, when the project was about to fall through, the film crew realized that they were approaching the community the wrong way. They had contacted the mayor, thinking that he was the appropriate power, but then, "we realized that the mayor did not have power. The power was really democratic, it resided in an assembly. The individual was only important as part of a collectivity."[13] They then asked for the village assembly to discuss their project and have the local shaman read the coca leaves to verify their honesty. In this way they were accepted; the scene of the shaman appears in the film.

The film moves between the country and the city. It charts the gradual awareness in the Indian village that their women's barrenness is due to the young, rather caricatured, North Americans from the "Progress Corps" who run a medical center. The community leader, Ignacio, discovers that they are sterilizing the women, following the logic that, in Galeano's evocative phrase, it is more convenient to kill future *guerrilleros* in their mother's womb. The community make a decision to castrate the North Americans. Repression follows swiftly, many are killed and Ignacio is badly wounded. He is taken to La Paz where his brother undertakes a journey through the landscape and social classes of La Paz in a desperate search to find money for medical treatment. The reaction is callous and indifferent, and Ignacio dies in hospital. In a *prise de conscience* the brother returns to the village, joining the Indians in the beginnings of armed resistance. The film is

structurally quite complex, with constant use of flashbacks and inter-cutting of scenes in the city with earlier events in the countryside. It uses suspense and also examines individual psychologies, both strate-gies that the group would later question.

The film was hugely successful. According to Sanjinés, it was seen by 250,000 people in Bolivia alone in its first years (before Sanjinés's films were banned during most of the 1970s). It also started up a pub-lic debate and a campaign against the activities of the U.S. Peace Corps, expelled from Bolivia by General Torres in May 1971. But it did not satisfy the group at the level of form since it still seemed to impose the cultural expectations of the dominant classes on the indig-enous people. We should remember that the nation-state of Bolivia is the result of the creole domination over the Indian Aymara, Quechua and Guarani nations, a domination that was only partly successful. In 1950 a million people spoke only Quechua, 664,000 only Aymara, and Spanish was a minority language. By 1976, over a fifth of the population still spoke no Spanish.[14] It was not enough for Ukamau to film in the native languages:

> It was not that they could not understand what was being said, it was rather a formal conflict at the level of the medium itself which did not correspond to the internal rhythms of our people or their profound conception of reality. The substantial differ-ence lay in the way in which the Quechua-Aymara people con-ceive of themselves collectively, in the non-individualistic form of their culture. The organizing principle in this society is not the isolated individual, but society in its totality.[15]

This attitude would mean rethinking forms that privileged the individ-ual over the social: the close-up, the psychological examination of in-dividual motivation, the standard conventions of the fiction film. Filmmaking would in future deal with the history of the collective, seeking to reactivate the popular memory denied by the hegemonic powers.

Ukamau's development coincided with an attempt by two military regimes to combat popular mobilization by directing their own form of left or revolutionary nationalism. Generals Alfredo Ovando (Sep-tember 1969 to October 1970) and Juan José Torres (October 1970 to August 1971) tried to walk the tightrope between the extremes of mass mobilization and repression. The experiment failed and would be replaced by the conservative dictatorship of Hugo Banzer (1971–78). It did, however, allow a great deal of temporary freedom, a product of which was Ukamau's *El coraje del pueblo* (*Courage of the People*,

1971),[16] which had funding from Italian television. This dramatized documentary reconstructs the massacre of miners in the Siglo XX mines in June 1967. The official version given by Barrientos was that

> the reds and corrupt old union leaders declared the three most important mines in the country to be *territorio libre*, where nobody could enter without their permission. Because of this the government instructed the armed forces to occupy the mines and restore order and authority. This would have happened in any country.[17]

The film makes it very clear where the responsibility lay: an early sequence names the massacres of miners through history and those government leaders who ordered them. Ukamau use the survivors of the massacre as the sources of information, an extraordinarily well-organized and disciplined community who attended the funeral of their colleagues in tens of thousands and called a two-week protest strike despite the army occupation of the camp. These witnesses also become the protagonists of the film, which recreates the collective memory of persecution and resistance. Sanjinés was making films "junto al pueblo," alongside the people, not imposing his views from above, but allowing the community to "speak" through the filmmakers. Multiple narrators take up the task of recounting the history. There are no privileged "heroes," instead the film taps in to what the filmmaker calls the "atavistic solidarity of the group."[18]

While the group was engaged on post-production work on the film in Italy, the Banzer coup of 1971 ushered in a new hard-line regime. The film could not be shown in Bolivia for nearly a decade and the group split in two. Eguino and Oscar Soria returned to Bolivia to make films. Sanjinés and Rada were forced into exile. They chose to remain in the Andean region and succeeded in making *El enemigo principal* (*The Principal Enemy*, 1973) in Peru and *Fuera de Aqui*, (*Get Out of Here*, 1976) in Ecuador until the fall of Banzer allowed them to return temporarily to Bolivia in 1979.

A rare example of trans-Andean cultural cooperation, *El enemigo principal* takes the group's theoretical discussion a stage further.

> We introduced the sequence-shot [long shot] as essential to the coherence of the film. The narrator who presents the facts intervenes during the film, breaking up the flow of the plot to give the audience greater possibility for reflection. The sequence-shot allows us to attempt a more democratic structure . . . because of its breadth it offers the viewpoint of the participating audience

who can move inside the scene, attracted by the most interesting points.[19]

The film begins with a narrator on Machu Picchu whose function is to anticipate the history/story so that it can be analyzed during the narration. He tells of the struggle of a community to find justice against a murdering landowner maintained in power by the principal enemy, the imperialist forces of the United States. Although its ambiguous analysis of guerrilla *foco* strategy (the guerrillas support the people, but they also leave them to be massacred) has been supplanted by the impact of The Shining Path guerrillas in contemporary Peru, the film remains a clear testament of Ukamau's theoretical and political work in the mid 1970s.

Fuera de aqui, an openly didactic film on imperialist penetration in Ecuador, had an enormous impact there. According to researchers of the University of Quito, which part-funded the project, the film was seen by some three million people, out of a population of eight million, with widespread distribution in alternative circuits throughout the country.[20]

In Bolivia, throughout the seventies, Eguino and a new production company offered an alternative strategy to that of Sanjinés: making commercial but socially responsible films that could be shown in the normal theater circuits. He proposed not an overtly militant cinema which would have been banned immediately by the military regimes, but one aimed at regular cinema-goers who might ignore the unequal nature of Bolivian society. *Pueblo chico* (*Small Town*, 1974) addresses this problem through the narration of a young landowner's son who gradually becomes conscious of the need for a thoroughgoing agrarian reform. *Chuquiago*, 1977 (the Aymara name for La Paz) offers an analysis of the city and its social stratification through four social types: Isico, an Indian child lost in the huge city; Johnny, a *mestizo* trying to move up and out of his class through the adoption of North American culture; Carloncho, a petty-bourgeois public employee, trapped in *anomie*; and Patricia, a student who becomes a revolutionary. These four "chapters" reveal clearly the limitations of each "type" and the lack of any communication or social cohesion between them. *Chuquiago* fulfilled its director's intentions:

> Almost five hundred thousand people saw our film, and no other film in Bolivia has achieved this. . . . Step by step, we are creating our own cinema, we are talking to Bolivians in their own language and, what is for us very important, we are gaining screen time by replacing, little by little, the alienating commer-

cial cinema, basically backed by American distribution monopolies, that invades us.[21]

After some interruption, the two Ukamau groups have been able to make films in Bolivia in the 1980s. Sanjinés's *Banderas del amanecer* (*Banners at Dawn*, 1983) charts the people's struggle for democracy from the democratic interlude of 1979 through the vicious but eventually unsuccessful dictatorship of General García Meza (1980–82). This film offers another collective protagonist—this time the whole of the working class in the towns and in the countryside. The group was about to begin work on another documentary reconstruction when events overtook them and their only option was to film what was happening in the social arena. In the main, however, Sanjinés prefers the documentary reconstruction since it is easier to control the material. Ukamau has never had the funds to field teams of camera-operators in different parts of the country to capture the immediacy of history in the making.

La nación clandestina(*The Secret Nation*, 1989) reworks a number of Sanjinés's persistent themes. It tells the story of a man who has been dismissed from his Indian village, an isolated community in the *altiplano*, and seeks to atone for his corrupt past by dancing to death in a sacred ritual, a homage to the last Aymara great dancing lord. He sets off from La Paz, buckling under the weight of the ceremonial mask, on a *via crucis* to his village, where he will perform the dance. The journey takes Sebastián from the complex and corrupting city across the severe and beautiful landscape of Bolivia: as in *Ukamau*, Sanjinés reaffirms the majesty of the terrain and the rhythms of life that this imposes on indigenous communities. The film could be called, in the line of Ruiz's earlier documentary, *Vuelve Sebastián*.

As Sebastián travels through space, he reviews his life in a series of flashbacks, a return to a technique that Sanjinés had increasingly abandoned after *Blood of the Condor*. Interestingly, his present and his remembered past all take place under autocratic or military regimes: the democratic and revolutionary interludes of recent history are not referred to. The narrative present is the García Meza coup of July 1980, where Sebastián's decision to leave the city coincides with the early stages of the takeover. As he travels, he meets peasant and workers' resistance groups and an army convoy seeking out a middle-class intellectual. When he finally returns to the village, many of the active population are away helping to fight with the mining community. The hunted intellectual is eventually killed since he does not understand the landscape or the indigenous people that he purports to speak for: his language is Spanish and theirs is Aymara. Just as he is

cursing an uncomprehending couple as "shitty Indians' the army convoy shoot him.

Memory takes Sebastián back to three points in the past. In his early childhood he witnesses the death dance, the complex ritual of community life, but also the grinding poverty before the Revolution of 1952, where Indians are treated literally as beasts of burden for the creole elite and where families are dismembered by poverty and power relations: he is given as a servant to a city-based family. The second privileged moment of memory follows the Barrientos coup of 1964, when Sebastián returns as a young soldier to his village demanding that his brother and the rest of the villagers give up their arms. This ideological conflict between brothers is an echo of the film *Los hermanos Cartagena*. The third moment coincides with the Banzer regime of the mid-seventies, where Sebastián is acting as a civilian paramilitary, but is persuaded by his brother to return to his father's death bed. His father had fought in the Chaco War of 1932 to 1935, when tens of thousands of Indians, political pawns from the high Andes, fought and died in the oppressive heat of the plains. After his funeral, Sebastián remains and becomes the village leader. He betrays them, however, by siphoning off U.S. aid money. The community try him and expel him. It is only after the dance of death, where he is accompanied by the old men of the community who still remember the rituals, that he is resurrected as a member of his village.

Sanjinés's analysis, therefore, deals with the relationship between the individual and the community, the dynamic cultures of survival and resistance, the city and the *altiplano*, Spanish and Aymara, the fight against present and past dictatorships. As yet, however, he gives no analysis of how the left in Bolivia negotiate the complex compromises of civilian rule. James Dunkerley argues that the contemporary left in Bolivia have a clear strategy of resistance to military regimes but find it difficult to find a new political perspective for the different conditions of the 1980s. The focus of this film seems to point to this dilemma.[22]

Eguino filmed the ambitious *Amargo mar* (*Bitter Sea*) in 1984, a film that explores the events of the Pacific War of 1879, where Bolivia lost its coastline to the victorious Chileans. It was the first film to attempt a historical reconstruction of events that had been forgotten or shrouded in state rhetoric, a project similar to the Chilean film *Caliche sangriento*. It reveals not only the imperialist aggression of Chilean and British interests, but also an incapacity on the part of Bolivia to produce a coherent political and military strategy. It was an important exercise in historical revisionism.

Bolivian cinema in the sixties and seventies is encapsulated in the work of the Ukamau group(s). A younger generation has begun to make films since the late 1970s: the Italian Paolo Agazzi, Hugo Boero, Danielle Caillet, Alfonso Gumucio, Juan Miranda, Pedro Susz and Alfredo Ovando.[23] Increasingly, younger filmmakers are working exclusively with video. Gumucio has worked in establishing super-8 workshops in rural and city areas in Bolivia and later in Nicaragua. Perhaps the most successful director of this younger generation is Paolo Agazzi with *Mi socio* (*My Partner*, 1982), which follows the Eguino line of making critical films for middle-class consumption, using Bolivia's "star" actor and comedian David Santalla in its leading role, and *Los hermanos Cartagena* (*The Cartagena Brothers*, 1984), the first serious adaptation of a literary text (based on the novel *Hijo de opa* by Gaby Vallejo de Bolívar).

Independent filmmaking in Bolivia has been limited by the severe economic climate of the 1980s, in particular the great tin crash of the mid 1980s, where prices fell by 50 per cent on the international market. People living in the United States are some thirty times better off than the Bolivian mining community.[24] Schoolteachers were earning at that time the equivalent of U.S. $15 a month and needed at least $17 simply to pay for transport.[25] In such conditions, going to the cinema is out of the economic range of most of the population, even with low admission prices. It is impossible therefore to recoup even a small percentage of a film budget from the domestic market. The best-known cineaste of his generation, Jorge Sanjinés, who has a world-wide reputation, spends up to 90 per cent of his time looking for money: it has taken him six years to complete his latest feature. This precarious economic situation had slowed down the advances made by Bolivian cinema, which up to 1984 was massively well attended in the country. The future would seem to lie in video and super-8 work, with the occasional feature made by an established director.

Ecuador

Despite Sanjinés's intervention, filmmaking in Ecuador has remained weak. The first talking picture *Se conocieron en Guayaquil* (*They Met in Guayaquil*) was not produced until 1950 and Ecuadorian cinema was dominated by North American and Mexican imports. Documentary pioneers such as Agustín Cuesta in the 1960s had to struggle against almost impossible odds, with rudimentary equipment and no infrastructure for national production. The oil boom of the 1970s exacerbated tensions in the country and led to a wave of protests which were violently repressed by a military junta which ruled between 1972

and 1978. This climate of radicalization, however, did produce some didactic short documentaries, the most important of which were *Quién mueve las manos* (*Who Moves the Hands*, 1975), which showed the crushing of a strike in a factory, and *Asentamientos humanos, medio ambiente y pétroleo* (*Human Settlements, Environment and Oil*, 1976), a university-produced short on the dislocations caused in the communities by oil exploration and development. Sanjinés's *Fuera de aquí* thus crystallized a moment of anti-imperialist struggle. Only one short feature film appeared in this period: Gustavo Guayasamin's *El cielo para la Cushi, caraju* (*Cushi Goes to Heaven, Dammit*, 1975) based on Ecuador's famous indigenous novel, *Huasipungo*. The film was a great disappointment, containing none of *Huasipungo*'s brutal social-realist power, nor any of the artistry displayed by Guayasamin's brother, the great indigenous painter. The eighties have witnessed a more populist mediation of social tensions, but cinema remains an isolated activity. There have been socially responsible documentaries from such organizations as the Kino group, seeking to emerge from the multinational monopolies of advertising and television, and in the 1980 to 1985 period some fifty documentaries have been made, stimulated by a government policy of tax exemptions for film.

Peru

In Peru, the problem of unity is much greater, since here it is not a question of resolving a plurality of local or regional traditions but rather a duality of race, language and feeling, born from the invasion and conquest of autochthonous Peru by a foreign race which has not managed to become fused with the indigenous race, or eliminate it, or absorb it.[26]

As these words of José Carlos Mariátegui reveal, one of the major areas of concern for Peruvian filmmakers would be to find an appropriate language for portraying the Peruvian Indian. At the same time, the fascination and disgust for the capital city, "Lima the horrible" in Sebastián Salazar Bondy's terms, would inform a number of recent films. Against the trend of censorship and repression in other areas of Latin America in the 1970s—in Brazil, Argentina, Uruguay, Paraguay, Chile—Peruvian cinema can be said to have come of age in the mid 1970s, as a result of legislation put forward by the reformist military regime of General Juan Velasco Alvarado(1968–75), which guaranteed compulsory exhibition for shorts and would later help to promote feature films. This "new" Peruvian cinema, however, should be seen in terms of continuity and breaks with the past.

The 1950s in Peru were a barren period for the development of cinema. According to the figures compiled by Paranaguá, only *one* feature film was made in the period 1948 to 1960. Successive governments, from the dictatorship of General Manuel Odría (1950–56) to the civilian rule of Manuel Prado and Fernando Belaúnde Terry (1956–68), took no positive measures to promote cinema, and filmmaking was only possible through individual, high-risk initiatives. One movement, however, did lay the ground for future development: the arts movement in Cuzco, which included the photographer Martin Chambi and the filmmakers Manuel Chambi and Luis Figueroa. The work of Martin Chambi has recently received international attention,[27] but the activities of a Cine Club and of documentary filmmakers in the area are no less remarkable. From 1955 the Cine Club Cuzco registered on film different aspects of Andean life, the first concerted effort to document the life of the Andean Indians in Peru. In 1956, Figueroa and Chambi directed *Las piedras* (*The Stones*), an examination of pre-Inca, Inca and colonial architectural forms in Cuzco. A year later Chambi produced two documentary shorts in colour: *Carnaval de Kanas*, a carnival in the province of Cuzco, and *Lucero de nieve* (*Light of the Snow*), on a local religious festival. Chambi and Eulogio Nishiyama also filmed *Corrida de toros y condores* (*Bull and Condor Fight*) in that year. These films were shown in Lima in 1957 on the initiative of the great writer José María Arguedas.[28] We should remember that Arguedas's most famous novel, *Los ríos profundos* (*Deep Rivers*), was published in 1958 and begins with the young narrator in Cuzco rediscovering aspects of his Indian heritage through the "speaking stones" of Inca architecture: the thematic parallels are clear.

Other documentary shorts followed, together with a feature-length film *Kukuli*, directed by Nishiyama, Luis Figueroa and César Villanueva, which intertwines documentary with mythical legend (the myth of the bear who disguises himself as a human in order to seduce women). Some years later Nishiyama and Villanueva completed the cycle of the "Cuzco School" with *Jarawi* (1966), another feature-length documentary/fiction, based on a short story by Arguedas. The Cuzco school gradually became more socially conscious in their filmmaking—*Jarawi* for example offers a clear critique of rural exploitation. Manuel Chambi stated in 1974: "I should point out that in my first works I thought more about cinema, now I think more about the reality of my country and I am not obsessed by the formal beauty of cinema."[29] Yet the Cuzco school was clearly to influence such contemporary filmmakers as Federico García. If Chambi can be said to have "revindicated" the Indians by focusing on their customs and lifestyle, García would add the dimension of social struggle, even though

he would try to deny his precursors. The Cuzco school, he argues, "is indigenist . . . ours is political. We feel a much greater affinity with the Bolivians Sanjinés and Eguino than with the Cuzco school."[30]

The spread of television in Peru helped to stimulate filmmaking in the sixties, by training technicians and directors of commercials, but the works produced were mediocre melodramas, comedies and big-screen spin-offs of successful television programs. The consolidation of a modern film culture in Lima is found in the theoretical discussions of a group of young cinephiles and critics grouped around the magazine *Hablemos de Cine* (1965–84), directed by Isaac León Frías. Also in 1965, the University Cinemathèque was founded in Lima. At first, however, the theory was much more advanced than the practice: the critics could talk about the origins of "new" cinema in Cuba and Brazil, but had little to support in their own country. The only "author" of the period was Armando Robles Godoy, but the *Hablemos de Cine* critics did not consider him to be a model: "The alibi of *cinema d'auteur* has served as a justification for what is just a precarious version of a self-styled new cinema which is pretentious and surely inappropriate to the conditions of cinematographic activity in Peru."[31] Harsh words for a filmmaker who, at least in films such as *En la selva no hay estrellas* (*In the Jungle There are No Stars*, 1966), tried to impose his own personal style and offered training to young filmmakers such as Nora de Izcué, Jorge Suárez and Fausto Espinoza.

In 1968, the military government of General Velasco nationalized several important companies in Peru and expropriated the large coastal landholdings. Its radical gestures and its high spending (borrowing cheap money in the early 1970s, quadrupling the public-sector foreign debt between 1970 and 1975, laying the basis for contemporary Peru's intractable debt crisis) caused a great deal of enthusiasm in the country. These nationalist measures included support for cultural initiatives. In cinema, Law No. 19,327 granted several concessions. It lifted import duties on materials and equipment and at the same time decreed that Peruvian films should receive "obligatory exhibition" within the country. Since there was no great tradition of feature films, the area that benefited immediately was the production of documentary shorts. Within a brief period, over a hundred and fifty production companies were set up to provide films for this new exhibition space. More than seven hundred shorts were produced in a decade and were shown throughout the countryside, the producer recouping his/her investment from box-office receipts. Cineastes could thus gradually afford to invest in equipment and began working in groups. Within a few years, the first features would be made, although these were a much more risky investment.[32] Such a system was, of course, open to

abuse. The state body COPROCI (Commission for the Promotion of
Cinema) approved the films that would be given obligatory exhibition;
this led to censorship and also to arbitrary aesthetic judgements. Large
numbers of cineastes appeared, interested in commercial gain rather
than the promotion of cinema:

> The short invaded, literally, the cinema screens. But what a sad
> spectacle. What deplorable standards. With a few exceptions,
> nothing can be salvaged. . . . And the worst films received the
> best conditions for exhibition. A mafia of distributors has been
> established to fight for the best places to exhibit their wares.
> Nelson García has called it, accurately, "the banquet of the wild
> beasts."[33]

The serious filmmakers could share, however marginally, in the
banquet. Luis Figueroa, Federico García, Arturo Sinclair, Francisco
Lombardi and Nora de Izcué all made significant documentaries and
the "Cine Liberación sin Rodeos" group produced a number of politi-
cal shorts, though these had distribution problems, especially after the
military government moved to the right in 1975. The year 1977 saw
the release of several memorable features.[34] Luis Figueroa, the co-
founder of the "Cuzco School" adapted Ciro Alegría's novel, *Los per-
ros hambrientos* (*The Hungry Dogs*, 1976), a work of populist
reformism from the late 1930s, which concentrates on the relationship
between man and nature, rather than on the social relationships. There
are some elements of social criticism in the novel and the film—the
relationship between the landowner and the Indians and *cholos* (*mesti-
zos*), corruption, centralism—but Figueroa is faithful to the novel by
avoiding detailed analysis of land ownership and class structures. The
symptoms are analyzed, but not the causes. Figueroa would film Ar-
guedas's novel *Yawar Fiesta* (1941) in 1980, wrestling with but never
resolving Arguedas's own attempts at transculturation, outlined by the
Uruguayan critic Angel Rama:

> Arguedas lived within a game of mirrors, which sent him from
> one hemisphere to another as an Indian; he sought to insert him-
> self within the dominant culture to appropriate a foreign lan-
> guage (Spanish) by forcing it to express another syntax
> (Quechua), to find the "subtle disorderings which would make
> Castilian a fit vehicle, an adequate instrument," in short, to im-
> pose his cosmovision and his protest on a foreign territory, but
> simultaneously he is transculturating the literary tradition of the
> Spanish language by appropriating an Indian cultural message
> with both a specific thematic and an expressive system.[35]

This dilemma, shared by filmmakers such as Sanjinés and García, was that of adopting a "universal" film language to specific provincial needs.

Federico García's *Kuntur Wachana* (*Where the Condors are Born*, 1977) is a clear break with an ahistorical and idealist indigenist world. Produced by an agrarian cooperative near Cuzco set up by the agrarian reform movement, its director had been a member of SINAMOS (National System for the Support of Social Mobilization, a government office set up under the government of General Velasco), working on documentary filmmaking. SINAMOS produced some radical documentaries which failed to receive "obligatory exhibition" from another state body, the Central Office of Information. The film can stand as a reflection on the "first phase" of military government, 1968 to 1975, in its approach to agrarian reform. García recounts the Indian struggles in the years preceding the reforms, the confrontations between the Indians and the authorities and their local representatives. Its study bears some similarity to Sanjinés's *El enemigo principal*, shot in Peru in 1973, in that it deals with the fight for justice through or outside the legal system. Most important, however, is Sanjinés's example of working on documentary reconstructions. García uses the vehicle of testimonial cinema, because

> it is a reconstruction of facts from the peasants' perspective and with their participation. . . . For us, cinema is not an end in itself, but rather a means. For me this type of testimonial cinema, where they take part and where their own emotional feelings are involved, is much more subversive and more effective than a simple, cold documentary organized by a narrator.[36]

Many Indians acted their own life stories in the film.

1977 also saw the first feature-length film by Francisco Lombardi, *Muerte al amanecer* (*Death at Dawn*), which proved to be a great box-office success, seen by over half a million people in Peru. This was the first Peruvian film to cover its costs in the internal market. Like Littín's *Jackal of Nahueltoro*, the protagonist is a celebrated child murderer, the "monster of Armendáriz" and again like Littín, Lombardi is interested in analyzing the mechanisms of power in society: the forces on the prison island become a microcosm of Peru. Unlike Littín, Lombardi prefers to work within the codes of traditional Hollywood cinema with a linear structure, suspense, a concentration on the psychology of protagonists and the build-up towards a moment of violent climax.

These filmmakers have developed their work in the past decade.
Lombardi, the most commercially successful filmmaker in Peru, re-
constructed another well-known crime of violence in *Muerte de un
magnate* (*Death of a Magnate*, 1980) in which an Indian gardener
captures and kills an important businessman. He then turned to two
adaptations of literary texts, *Maruja en el infierno* (*Maruja in Hell*,
1983) and *La cuidad y los perros* (*The City and the Dogs*, 1986).[37]
The first of these films concentrates on the "city," the second on the
"dogs," the military cadets of Vargas Llosa's important novel. *Maruja*
offers a dystopic vision of Lima from the enclosed space of a factory
which recycles urban rubbish, populated by weak, deranged and de-
formed beings. It became the biggest box-office success of Peruvian
history. *La cuidad y los perros* strips down Vargas Llosa's long com-
plex novel with its multiple narrators, flashbacks, stories within stories
and juxtapositions into a linear narrative which deals almost exclu-
sively with the military establishment, and with the cadets' incorpora-
tion into its violent and hierarchical codes of "honor" and machismo.
Even though many of the nuances of Vargas Llosa's novel are ironed
out, the film offers a clear critique of militarism and an ambiguous
view of its middle-class, intellectual hero Alberto, a poet. Alberto is a
story-teller: he is both a narrator and a liar.

How to tell a truthful story of Peru's principal guerrilla group Sen-
dero Luminoso ("The Shining Path") is the subject of Lombardi's film
La Boca del Lobo (*The Mouth of the Wolf*, 1988). He takes the cadets
from Vargas Llosa's military establishment and puts them in another
enclosed, claustrophobic setting, the site of many Westerns: a small
remote village under siege by the Shining Path. *Sendero* is not dis-
cussed, it is just there, like the forces in John Carpenter movies, ter-
rorizing the villagers and mutilating and killing the soldiers who leave
the encampment. The army and its links to political forces are not an-
alyzed: all the attention is focused on two figures: the cadet and the
officer sent out to discipline and give leadership to the frightened
troops. The cadet is both a hero and a traitor; the heroic officer turns
out to be a macho psychopath, who orders the massacre of many vil-
lagers to cover up his own errors. The suspense is magnificently or-
chestrated and the Russian-roulette confrontation between the young
soldier and his officer is a clear homage to *The Deer Hunter*. Yet in
the end, the film avoids many important issues: the nature of the guer-
rillas, and the response to them from civil society and the army. It is
difficult to see how the lieutenant can be an allegory of the army com-
mand structures—massacres cannot be explained away by aberrant
psychologism. In the end the filmmaker, like his protagonist, runs
away from the horror of it all.

Federico García has continued an active career with two further films on indigenous themes, *Laulico*, 1979, and *El caso Huayanay* (*The Huayanay Case*, 1981), using the Indian community once again as inspiration and protagonists of Manichean political dramas. After this he made a trilogy of historical films in coproduction with Cuba. Paranaguá points out the limitations of this later work:

> The portrayal of Melgar (*Melgar*, 1982), a young seminarian and provincial intellectual who becomes part of the Independence struggle is a rather primitive work. *Tupac Amaru* (1983) is more solid and careful. However Federico García scarcely departs from a rather burdensome didacticism, reinforced by an omniscient offscreen narrator. . . . The companion of God in the next film (*El socio de dios*, 1986) is a contemporary of Fitzcarraldo, who takes us into the Amazonian jungle: here is a pretext for a dubious mixture of heteroclite mysticism, basic symbolism and an exposé of the conflict of interests among the great powers.[38]

Young filmmakers such as José Carlos Huayhuaca and Alberto Durant have also made interesting features in the 1980s but the most sustained work in production, distribution and exhibition has come from the Grupo Chaski (Chaski is an indigenous word for messenger), a cooperative of some thirty filmmakers, producers and technicians.[39] The group is the major distributor of Peruvian films in the country, supplying commercial cinemas, universities and trade unions. It organizes an active alternative distribution and exhibition network, taking films into the countryside and into the neighborhoods of the big cities. The group has also produced a number of important documentaries and features, including an ironic look at the Miss Universe competition in Peru (Vargas Llosa was one of the judges). Its most important feature to date, *Gregorio*, traces the life of a young country boy forced by poverty to migrate to Lima, there to be caught up in a life of petty crime. *Gregorio* was seen by a million spectators in cinemas, neighborhoods and even in prisons. The most recent feature, *Juliana* (1988), continues in the same vein, charting the picaresque adventures of a girl who disguises herself as a boy in order to become part of a "Fagin's kitchen" of street beggars and entertainers. The realist narrative is broken on two occasions by the boys talking straight to the camera, expressing their fears and desires. A final utopian scene posits the possibility of harmony outside the grinding poverty and society.

Utopia, of course, means "no such place," and the future for Peruvian cinema seems bleak in a worsening economic crisis and spirall-

ing political violence. At the moment of writing, Mario Vargas Llosa, the novelist, could lead Peru into the 1990s, but his center-right coalition would face enormous problems, from civil war in the countryside to the huge urban sprawl of Lima:

> Over the past few years, I've also gotten used to seeing stray kids, stray men, and stray women along with the stray dogs, all painstakingly digging through the trash looking for something to eat, something to sell, something to wear. The spectacle of misery was once limited exclusively to the slums, then it spread downtown, and now it is the common property of the whole city, even the exclusive residential neighborhoods—Miraflores, Barranco, San Isidro. If you live in Lima, you can get used to misery and grime, you can go crazy, or you can blow your brains out.[40]

Vargas Llosa's writing of the eighties has returned insistently to visions of the apocalypse. It is to be hoped that these nightmares do not become the realities of the next decade.

Notes

1. José Carlos Mariátegui, *Seven Interpretive Essays on Peruvian Reality* (Austin and London: University of Texas Press, 1971), p. 287.

2. James Dunkerley, *Rebellion in the Veins: Political Struggle in Bolivia 1952–82*, (London: Verso, 1984), p. 5.

3. Ibid., p. 73.

4. Carlos Mesa Gisbert, *La aventura del cine boliviano 1952–1985*, (La Paz: Gisbert, 1985), pp. 47–53.

5. Jorge Sanjinés's Group Ukamau, *Teoría y práctica de un cine junto al puelblo*, (Mexico: Siglo XXI, 1979), p. 37.

6. A. Gumucio Dagrón, *Historia del cine boliviano*, (Mexico: UNAM, 1973), p. 179.

7. Dunkerley, *Rebellion in the Veins*, p. 52.

8. See Mesa Gisbert, *La aventura*, pp. 65–67 and Gumucio, *Historia del cine boliviano*, pp. 187–91.

9. For a major collection of these articles, see Jorge Sanjinés and Group Ukamau, *Teoría*.

10. In J. Burton, *Cinema and Social Change in Latin America: Conversations with Film-makers*, (Austin: University of Texas Press, 1986), p. 38.

11. See Gumucio, *Historia del cine boliviano*, pp. 212–13 and Mesa Gisbert, *La aventura*, p. 85.

12. Carlos Mesa Gisbert, *El cine boliviano según Luis Espinal*, (La Paz: Don Bosco, 1982), p. 136.

13. Interview with the author, Birmingham, April 1986.

14. Dunkerley, *Rebellion in the Veins*, p. 23.

15. J. Sanjinés, "We Invent a New Language Through Popular Culture," *Framework* 10 (1979): 31.

16. An earlier project, *Los caminos de la muerte* (*Roads of Death*) had to be abandoned when an original negative was ruined in a processing laboratory in Germany. Sanjinés is convinced that the accident was sabotage.

17. Rubén Vásquez Díaz, *Bolivia a la hora del Che*, Mexico, 1976, p. 14.

18. See Sanjinés and Group Ukamau, *Teoría*, p. 23.

19. Sanjinés, "We invent," p. 32.

20. Interview with the author.

21. Antonio Eguino, "Neorealism in Bolivia," in Burton, *Cinema and Social Change*, p. 166.

22. I am grateful to James Dunkerley for discussing this aspect of his study of recent Bolivian politics with me. Also for sharing his perceptions of this film. See Dunkerley, "Political Transition and Economic Stabilisation: the Case of Bolivia, 1982–1989," Research Paper, Institute of Latin American Studies, University of London, 1990.

23. For an analysis of their work, see Mesa Gisbert, *La aventura*, pp. 144–67.

24. See Latin America Bureau, *The Great Tin Crash*, London, 1988.

25. Figure given by Sanjinés in his Guardian lecture at the National Film Theatre, London, March 1986.

26. Mariátegui, *Seven Interpretive Essays*, p. 335.

27. Including an exhibition in London and a fine BBC documentary directed by Paul Yule.

28. Isaac Leon Frías, "Pérou" in G. Hennebelle and A. Gumucio Dagrón, eds., *Les Cinémas de l'Amérique Latine*, p. 428.

29. Quoted in *Cinematográfico* 2 (1974): 5.

30. "Encuentro con Federico García," *Hablemos de Cine* 75 (May 1982): 18.

31. Isaac Leon Frías, "Pérou," p. 431.

32. See O. Getino, *Cine latinoamericano: Economía y nuevas tecnologías audiovisuales*, (Mérida: Universidad de los Andes, 1987), p. 55.

33. "Cine peruano. ¿Borrón y cuenta nueva?," *Hablemos de Cine* 67 (1975): 14.

34. See Isaac Leon Frías, "La búsqueda de una voz propia en el largometraje peruano," *Hablemos de Cine* 69 (1977–78): 16–19.

35. Angel Rama, *Transculturación narrativa en América Latina*, (Mexico: Siglo XXI, 1982), p. 207. I am using Gerald Martin's translation in his *Journeys through the Labyrinth*, (London: Verso, 1989), p. 89.

36. "Encuentro con Federico García," p. 24.

37. For an analysis of Lombardi's work, see Paulo Antonio Paranaguá, "Francisco Lombardi et le nouveau cinéma péruvien," *Positif* 338 (April 1989): 34–48.

38. Ibid., p. 35.

39. The information on the Group Chaski comes from an interview by the author with several of its members in Havana, December 1986.

40. Mario Vargas Llosa, *The Real Life of Alejandro Mayta*, (London: Faber and Faber, 1986), p. 4.

Select Bibliography

Adelman, Alan, ed. *A Guide to Cuban Cinema*. Pittsburgh: Center for Latin American Studies, 1981.

Agosta, Diana, and Patricia Keeton. "One Way or Another: The Havana Film Festival and Contemporary Cuban Film." *Afterimage* 22, no. 2 (1994): 7–8.

Alea, Tomás Gutiérrez. *Memories of Underdevelopment*. New Brunswick, NJ: Rutgers University Press, 1990.

_____. *The Viewer's Dialectic*. Havana: Jose Marti Publishing House, 1988.

Armes, Roy. *Third World Film Making and the West*. Berkeley, CA: University of California Press, 1987.

Aufderheide, Pat. "Toronto Tiempo." *Film Comment* 22, no. 6 (1986): 45–49.

Barnard, Tim. "After the Military: Film in the Southern Cone Today." *Review: Latin American Literature and Arts*, no. 46 (1992): 29–36.

_____, ed. *Argentine Cinema*. Toronto: Nightwood Editions, 1986.

Barnard, Tim, and Peter Rist. *South American Cinema: A Critical Filmography, 1915–1994*. Hamden, CT: Garland Publishing, 1996.

Berg, Charles Ramírez. *Cinema of Solitude: A Critical Study of Mexican Film, 1967–1983*. Austin: University of Texas Press, 1992.

Bernardet, Jean Claude. "A New Actor: The State." *Framework*, no. 28 (1985): 4–19.

Bruce, Graham. "Music in Glauber Rocha's Films." *Jump Cut*, no. 22 (1980): 15–18.

Burns, E. Bradford, ed. *Latin American Cinema: Film and History*. Los Angeles: UCLA Latin American Center, 1975.

_____. "National Identity in Argentine Films." *Americas* 27, nos. 11–12 (1975): 4–10.

Burton, Julianne. "The Camera as 'Gun': Two Decades of Culture and Resistance in Latin America." *Latin American Perspectives*, no. 16 (1978): 49–76.

_____. "The Hour of the Embers: On the Current Situation of Latin American Cinema." *Film Quarterly* 30, no. 1 (1976): 33–44.

_____. *The New Latin American Cinema: An Annotated Bibliography, 1960–1980*. New York: Smyrna Press, 1983.

_____. "Revolutionary Cuban Cinema." *Jump Cut*, no. 19 (1978): 17–20.

_____. "Sing, the Beloved Country: An Interview with Tizuka Yamasaki on *Patriamada*." *Film Quarterly* 41, no. 1 (1987): 2–9.

_____, ed. *Cinema and Social Change in Latin America: Conversations with Filmmakers*. Austin: University of Texas Press, 1986.

_____. *The Social Documentary in Latin America*. Pittsburgh, PA: University of Pittsburgh Press, 1990.

Burton, Julianne, and Zuzana Pick. "The Women Behind the Camera." *Heresies*, no. 16 (1983): 46–50.

Cabral, Amilcar. *Return to the Source*. New York: Monthly Review Press, 1973.

Chanan, Michael. *The Cuban Image: Cinema and Cultural Politics in Cuba*. London: British Film Institute and Bloomington, IN.: Indiana University Press, 1985.

_____, ed. *Twenty-Five Years of the New Latin American Cinema*. London: British Film Institute, 1983.

_____. ed. *Chilean Cinema*. London: British Film Institute, 1977.

"Cinema Novo vs. Cultural Colonialism: An Interview with Glauber Rocha." *Cineaste* 4, no. 1 (1970): 2–9.

Corman, Tanyan. "Nicaragua's Independents Organize: An Interview with Fernando Somarriba, Director of ANCI." *Release Print* 12, no. 6 (1989): 5–6, 15–16.

Crowdus, Gary and Irwin Silber. "Film in Chile: An Interview with Miguel Littin." *Cineaste* 4, no. 4 (1971): 4–9.

Csicsery, George. "Individual Solutions: An Interview with Hector Babenco." *Film Quarterly* 36, no. 1 (1982): 2–15.

Cyr, Helen W. *A Filmography of the Third World, 1976–1983*. Metuchen, NJ: Scarecrow Press, 1985.

Desnoes, Edmundo. "The Photographic Image of Underdevelopment." *Jump Cut*, no. 33 (1988): 69–81.

Downing, John D. H., ed. *Film and Politics in the Third World*. New York: Autonomedia, 1987.

Dratch, Howard, and Barbara Margolis. "Film and Revolution in Nicaragua: An Interview with INCINE Filmmakers." *Cineaste* 15, no. 3 (1987): 27–29.

Fanon, Frantz. *The Wretched of the Earth*. New York: Grove Press, 1964.

Foster, David William. *Contemporary Argentine Cinema*. Missouri: University of Missouri Press, 1992.

Fox, Elizabeth, ed. *Media and Politics in Latin America: The Struggle for Democracy*. London: Sage Publications, 1988.

Fusco, Coco. "Choosing between Legend and History: An Interview with Carlos Diegues." *Cineaste* 15, no. 1 (1986): 12–14.

_____. "The Tango of Esthetics & Politics: An Interview with Fernando Solanas." *Cineaste* 16, no 1–2 (1987/88): 57–59.

_____. "Things Fall Apart: An Interview with Sergio Bianchi." *Afterimage* (January 1990): 15–16.

_____, ed. *Reviewing Histories: Selections from New Latin American Cinema*. Buffalo, NY: Hallwalls, 1987.

Gabriel, Teshome. *Third Cinema in the Third World: The Aesthetics of Liberation*. Ann Arbor, MI: UMI Research Press, 1982.

_____. ed. "Cinema Novo and Beyond . . . A Discussion with Nelson Pereira dos Santos." *Emergences*, no. 2 (1990): 49–82.

Garcia Tsao, Leonardo. "Mexican Tinderbox." *Film Comment* 21, no. 3 (1985): 36–38.

Gauhar, Altaf. *Third World Affairs 1985*. London: Third World Foundation, 1985.

_____. *Third World Affairs 1988*. London: Third World Foundation, 1988.

Georgakas, Dan. "Breaking the Blockade: A Conversation with Cuban Filmmaker Tomás Alea." *Radical America* 20, no. 4 (1987): 35–44.

Goldman, Ilene S. "Behind Every Flower a Death: Love, Women and Flowers." *Jump Cut*, no. 38 (1993): 33–38.

Gupta, Udayan. "Neo-Realism in Boliva: An Interview with Antonio Equino." *Cineaste* 9, no. 2 (1978/79): 26–29, 59.

Hall, Stuart. "Cultural Identity and Cinematic Representation." *Framework* 36 (1989): 68–81.

Hershfield, Joanne. "Assimiliation and Identification in Nicholas Echeverria's *Cabeza de Vaca*." *Wide Angle* 16, no. 3 (1995): 6–24.

Huaco-Nuzum, Carmen. "Matilde Landeta: An Introduction to the Work of a Pioneer Mexican Film-Maker." *Screen* 28, no. 4 (1987): 96–105.

Johnson, Randal. *Cinema Novo x 5: Masters of Contemporary Brazilian Film*. Austin, TX: University of Texas Press, 1984.

_____. *The Film Industry in Brazil*. Pittsburg, PA: University of Pittsburgh Press, 1987.

Johnson, Randal, and Robert Stam, eds. *Brazilian Cinema*. East Brunswick, NJ: Associated University Presses, 1982.

King, John. *Magical Reels: A History of Cinema in Latin America*. New York: Verso, 1990.

King, John, Ana M. López, and Manuel Alvarado, eds. *Mediating Two Worlds: Cinematic Encounters in the Americas*. London: British Film Institute, 1993.

Kleinhans, Chuck. "Afro-Cuban Filmmaking Today: *The Other Francisco* and *One Way or Another*." *The Pan-Africanist*, no. 9 (1982): 77–79.

Kotz, Liz. "Unofficial Stories: Documentaries by Latinas and Latin American Women." *The Independent* 12, no. 4 (1989): 21–27.

Kovacs, Katherine S. "Revolutionary Consciousness and Imperfect Cinematic Forms." *Humanities in Society* 4, no. 1 (1981): 101–12.

Levinson, Sandra. *Cuba: A View from Inside: Short Films by/about Cuban Women*. New York: Center for Cuban Studies, 1992.

Littín, Miguel. "Coming Home." *American Film* 11, no. 4 (1986): 43–45.

––––––. "The Nova Republica and the Crisis in Brazilian Cinema." *Latin American Research Review* 24, no. 1 (1989): 124–39.

––––––. "*Xica Da Silva*: Sex, Politics, and Culture." *Jump Cut*, no.22 (1980): 18–20.

López, Ana. "The Melodrama in Latin America." *Wide Angle* 7, no. 3 (1985): 5–13.

––––––. "An 'Other' History: The New Latin Amerian Cinema." *Radical History Review*, no. 41 (1988): 93–116.

––––––. "The 'Other' Island: Cuban Cinema in Exile." *Jump Cut*, no. 38 (1993): 51–59.

––––––. "Through Brazilian Eyes: *America*." *Wide Angle* 13, no. 2 (1991): 20–30.

López, Ana, and Nicholas Peter Humy. "Sergio Giral on Filmmaking in Cuba." *Black Film Review* 3, no. 1 (1986/87): 4–6.

Luhr, William, ed. *World Cinema Since 1945*. New York: Ungar, 1987.

MacBean, James Roy."A Dialogue with Tomás Gutiérrez Alea on the Dialectics of the Spectator in *Hasta Cierto Punto*." *Film Quarterly* 38, no. 3 (1985): 22–29.

––––––. *Film and Revolution*. Bloomington: IN: Indiana University Press, 1975.

––––––. "La Hora de los Hornos." *Film Ouarterly* 24, no. 1 (1970): 31–37.

Machado, Arlindo. "Inside Out and Upside Down—Brazilian Video Groups: TVDO and Olhar Electronico." *The Independent* 14, no. 1 (1991): 30–33.

Mattelart, Armand. *Multinational Corporations and the Control of Culture: The Ideological Apparatuses of Imperialism.* Brighton: Harvester Press, 1982.

Mongil Echandi, Ines, and Luis Rosario Albert. "Films with a Purpose: A Puerto Rican Experiment in Social Films." *The Independent* (July 1987): 11–14.

Mora, Carl J. *Mexican Cinema: Reflections of a Society, 1896–1988.* Berkeley, CA: University of California Press, 1982; 1989.

Myerson, Michael, ed. *Memories of Underdevelopment: The Revolutionary Films of Cuba.* New York: Grossman, 1973.

Naficy, Hamid. *The Making of Exile Cultures: Iranian Television in Los Angeles.* Minneapolis: University of Minnesota Press, 1993.

Newman, Kathleen, ed. *Iris,* no. 13 (1991).

Noriega, Chon A., ed. "Border Crossings: Mexican and Chicano Cinema." *Spectator* 13, no. 1 (1992).

_____. *Chicanos and Film: Representation and Resistance.* Minneapolis: University of Minnesota Press, 1992.

Noriega, Chon A., and Steven Ricci, eds. *The Mexican Cinema Project.* Austin, TX: University of Texas Press, 1994.

"Nuevo Cine Latinoamericano." *Arieto* 10, no. 37 (1984).

Okrent, Neil. "At Play in the Fields of the Lord." *Cineaste* 19, no. 1 (1992): 44–47.

Osiel, Mark. "Bye Bye Boredom: Brazilian Cinema Comes of Age." *Cineaste* 14, no. 1 (1985): 30–35.

Paranagua, Paulo Antonio. "Letter from Cuba to an Unfaithful Europe: The Political Position of the Cuban Cinema." *Framework,* no. 38/39 (1992): 5–26.

_____. "News from Havana: A Restructuring of the Cuban Cinema." *Framework,* no. 35 (1988): 88–103.

_____. "Pioneers: Women Film-makers in Latin America." *Framework,* no. 37 (1989): 129–137.

Pena, Richard. "Nelson Pereira dos Santos: Presentation and Interview." *Framework,* no. 29 (1985): 58–75.

Pick, Zuzana M. *The New Latin American Cinema: A Continental Project.* Austin, TX: University of Texas Press, 1993.

_____. "The Politics of Modernity in Latin America: Memory, Nostalgia and Desire in *Barroco.*" *CineAction,* no. 34 (1994): 41–50.

Pines, Jim, and Paul Willemen, eds. *Questions of Third Cinema.* London: British Film Institute, 1989.

Ramirez, John. "*El Brigadista*: Style and Politics in a Cuban Film." *Jump Cut,* no. 35 (1990): 37–49, 58.

Ranucci, Karen. *Directory of Film and Video Production Resources in Latin America and the Caribbean.* New York: FIVF, 1989.

Ranvaud, Don. "Interview with Fernando Solanas." *Framework,* no. 10 (1979): 35–38.

———. "Interview with Raul Ruiz." *Framework,* no. 10 (1979): 16–18, 27.

Resolutions of the Third World Film-Makers Meeting, Algiers, Dec. 5–14. New York: Cineaste, 1973.

Reyes Nevares, Beatriz. *The Mexican Cinema: Interviews with Thirteen Directors.* Albuquerque, NM.: University of New Mexico Press, 1976.

Rocha, Glauber. "History of Cinema Novo." *Framework,* no. 12 (1979): 19–27.

———. "Humberto Mauro and the Historical Position of Brazilian Cinema." *Framework,* no. 11 (1979): 5–8.

Sanjinés, Jorge. "We Invent a New Language Through Popular Culture." *Framework,* no. 10 (1979): 31–33.

Sanjinés, Jorge, and the Ukamau Group. *Theory & Practice of a Cinema with the People.* Willimantic, CT: Curbstone Press, 1979; 1989.

Sauvage, Pierre. "Cine Cubano." *Film Comment* 8, no. 1 (1972): 24–31.

Schnitman, Jorge A. *Film Industries in Latin America.* Norwood, NJ: Ablex Publishing Corporation, 1984.

Shohat, Ella, and Robert Stam. *Unthinking Eurocentrism: Multiculturalism and the Media.* New York: Routledge, 1994.

Solanas, Fernando. "Cinema as a Gun: An Interview with Fernando Solanos." *Cineaste* 3, no. 1 (1960): 18–26.

Solano, Claudio. "Brazilian Independents: Some Background Notes." *Framework,* no. 28 (1985): 125–43.

Stam, Robert. "*The Fall*: Formal Innovation and Radical Critique." *Jump Cut,* no. 22 (1980): 20–21.

———. "Hour of the Furnaces and the Two Avant-Gardes." *Millenium Film Journal,* no. 7/8/9 (1980–81): 151–64.

———. "Land in Anguish: Revolutionary Lessons." *Jump Cut,* nos. 10–11 (1976): 49–51.

———. "Samba, Condomble, Quilombo: Black Performance and Brazilian Cinema." *Journal of Ethnic Studies* 13, no. 3 (1985): 55–84.

———. "Sao Nelson." *Film Comment* 31, no. 1 (1995): 82–88.

———. "Slow Fade to Afro: The Black Presence in Brazilian Cinema." *Film Quarterly* 36, no. 2 (1982–83): 16–32.

Stam, Robert, and Louise Spence. "Colonialism, Racism, and Representation." *Screen* 24, no. 2 (1983): 2–20.

Stam, Robert, and Ismail Xavier. "Recent Brazilian Cinema: Allegory/ Metacinema/Carnival." *Film Quarterly* 41, no. 3 (1988): 15–30.

Steven, Peter, ed. *Jump Cut: Hollywood, Politics and Counter-Cinema.* New York: Praeger, 1985.

Straubhaar, Joseph D. "Television and Video in the Transition from Military to Civilian Rule in Brazil." *Latin American Research Review* 24, no. 1 (1989): 140–54.

Taylor, Anna Marie. "*Lucia.*" *Film Quarterly* 28, no. 2 (1974/75): 53–57.

Trevino, Jesus Salvador. "The New Mexican Cinema." *Film Quarterly* 32, no. 3 (1979).

Tunstall, Jeremy. *The Media Are American: Anglo-American Media in the World.* London: Constable, 1977.

Turner, Terence. "Visual Media, Cultural Politics and Anthropological Practice." *The Independent* 14, no. 1 (1991): 34–40.

Usabel, Gaizka S. de. *The High Noon of American Films in Latin America.* Ann Arbor, MI: UMI Research Press, 1982.

Vieira, Joao Luiz, and Robert Stam. "Parody & Marginality: The Case of Brazilian Cinema." *Framework*, no. 28 (1985): 20–49.

Weber, Devra. "Revolutionary Film in El Salvador Today." *Jump Cut*, no. 33 (1988): 92–99.

West, Dennis, and Joan M. West. "Alice in a Cuban Wonderland: An Interview with Daniel Diaz Torres." *Cineaste* 20, no. 1 (1993): 24–27.

―――. "Conversation with Marta Rodriguez." *Jump Cut*, no. 38 (1993): 39–44, 19.

―――. "Reconciling Entertainment and Thought: An Interview with Julio García Espinosa." *Cineaste* 16, no. 1–2 (1987/88): 20–26, 89.

―――. "Slavery and Cinema in Cuba: The Case of Gutiérrez Alea's *The Last Supper.*" *The Western Journal of Black Studies* 3, no. 2 (1979): 128–33.

―――. "*Strawberry and Chocolate*, Ice Cream and Tolerance: Interviews with Tomás Gutiérrez Alea and Juan Carlos Tabio." *Cineaste* 21, nos. 1–2 (1995): 16–20.

Will, David. "Interview with Diego Risquez." *Framework*, nos. 26–27 (1985): 122–31.

Wilson, David. "Venceremos! Aspects of Latin American Political Cinema." *Sight and Sound* 41, no. 3 (1972): 127–31.

Woll, Allen L. *The Latin Image in American Film.* Los Angeles: UCLA Latin American Center, 1977.

Wood, Robin. "Notes for the Exploration of Hermosillo." *CineAction*, no. 5 (1986): 32–38.

Contributors

Timothy Barnard has worked in broadcasting and in human rights and arts administration. He is editor of *Argentine Cinema* (1986) and co-editor of *A Critical Filmography of South American Cinema, 1915–1994* (1996).

Catherine Benamou is a writer and film critic.

Charles Ramírez Berg is assistant professor of radio-television-film at the University of Texas at Austin. Among his publications is the book-length study *Cinema of Solitude: A Critical Study of Mexican Film, 1967–1983* (1992).

Julianne Burton is professor of literature and coordinator of the Latin American Studies Program at the University of California at Santa Cruz. She is a central protagonist in the development of English-language scholarship of Latin American film and in the promotion of Latin American cinema in the U.S. Her most recent publications include *The Social Documentary in Latin America* (1990) and *Cinema and Social Change in Latin America: Conversations with Filmmakers* (1986).

Carlos Diegues is a Brazilian filmmaker and original member of the Cinema Novo movement. His films include *Xica da Silva* (1976); *Bye Bye Brazil* (1980); *Ganga Zumba* (1963); and *Quilombo* (1984).

David William Foster is Regents' Professor of Spanish at Arizona State University. His most recent books include *Contemporary Argentine Cinema* (1992); *Alternate Voices in the Contemporary Latin American Narrative*; and *The Argentine Generation of 1880: Ideology and Cultural Texts.*

Paulo Emílio Salles Gomes was a film scholar and critic who helped to formally establish film studies at the Universities of Brazilia and São Paulo. His books on Brazilian cinema are *70 Anos de Cinema Brasileiro* (1966) and *Humberto Mauro, Cinearte, Cataguases* (1974).

John Hess is an assistant professor in the Cinema and Photography Department of the Roy H. Park School of Communications at Ithaca

College. He is a founding editor of *Jump Cut, A Review of Contemporary Media* and the author of essays on Latin American film and media.

Randal Johnson is professor and chair in the Department of Spanish and Portuguese at the University of California, Los Angeles. Among his numerous publications are *The Film Industry in Brazil: Culture and State* (1987), *Cinema Novo X 5: Masters of Contemporary Brazilian Film* (1984), and *Brazilian Cinema* (co-edited with Robert Stam, 1982).

John King is senior lecturer in Latin American cultural history at the University of Warwick. His most recent book is *Magical Reels: A History of Cinema in Latin America* (1990).

Marvin D'Lugo is director of the Screen Studies Program at Clark University and author of *The Films of Carlos Saura: The Practice of Seeing* (1991).

David R. Maciel is a professor of history and film studies at the University of New Mexico. His numerous publications include "El Norte: The U.S.-Mexico Border in Contemporary Cinema," and *Chicanos Toward Century's End* (1996).

Michael T. Martin is a professor in the Department of African Studies and co-director of the African American Film Institute at Wayne State University. He is co-editor of *Studies of Development and Change in the Modern World* (1989), and editor of *Cinemas of the Black Diaspora: Diversity, Dependence and Oppositionality* (1995). He has also directed and co-produced (with Robert Shepard) the award-winning feature documentary on Nicaragua, *In the Absence of Peace* (1989).

Carl Mora is the author of *Mexican Cinema : Reflections of a Society, 1896–1988* (1982; 1989) and co-translator of *The Mexican Cinema: Interviews with Thirteen Directors* (1976).

Frances Negrón-Muntaner is a Philadelphia based scholar, writer and filmmaker. She is completing a Ph.D. in comparative literature at Rutgers University, New Brunswick. Among her film/video works are *Puerto Rican I.D.* (1995), *Brincando el charco: Portrait of a Puerto Rican* (1994), *School Is Cool* (1994) and the award winning *Aids in the Barrio* (1989). Her most recent essays have appeared in *The Ethnic Eye* and *Global Feminisms*, and she is editor (with Ramón Grosfoguel) of *Beyond Nationalism and Colonialism: Rethinking the Puerto Rican Political Imaginary* (1995), and *The Limits of Silence: Latino Poets in Philadelphia* (1994).

Paulo Antonio Paranaguá is a filmmaker, critic and scholar. Among his many projects, he has organized film exhibitions devoted to the promotion of Latin American cinema in Europe. His published books and essays are numerous, including *Cinema na América Latina: Longe de Deus e perto de Hollywood* (1985); *Amérique Latine: Luttes et mutations, Tricontinental* (1981); *Dictionnaire du cinéma* (1991); *Le Cinéma Brésilien* (1987); *Les cinémas de l'Amérique Latine* (1981); *Le Cinéma Cubain* (1990); and *Le Cinéma Mexicain* (1992).

Zuzana M. Pick is an associate professor of film studies at Carleton University. Among her publications are *Latin American Film Makers and the Third Cinema* (1978) and *The New Latin American Cinema: A Continental Project* (1993).

John Ramírez is associate professor of communication studies at California State University, Los Angeles, and the author of several essays on documentary film practices in Nicaragua.

Glauber Rocha was a founding member of Cinema Novo. His films include *Barravento* (1962); *Black God, White Devil* (1964); *Antônio Das Mortes* (1968); and *Claro!* (1976).

Robert Stam is author of two books in Portuguese (*Espetaculo Interrompido* and *Bakhtin*), and five books in English: *Brazilian Cinema* (with Randal Johnson); *Reflexivity in Film and Literature; Subversive Pleasures; New Vocabularies in Film Semiotics;* and (with Ella Shohat) *Unthinking Eurocentrism: Multiculturalism and the Media.* He is professor of cinema studies at New York University.

Ismail Xavier teaches cinema studies at the University of São Paulo. He has authored numerous books, including *Sertão/Mar: Glauber Rocha e a estetica da fome* (1983) and *O Desafio do Cinema* (1985).

Index

Books in the Contemporary Film and Television Series

Cinema and History, by Marc Ferro, translated by Naomi Greene, 1988

Germany on Film: Theme and Content in the Cinema of the Federal Republic of Germany, by Hans Gunther Pflaum, translated by Richard C. Helt and Roland Richter, 1990

Canadian Dreams and American Control: The Political Economy of the Canadian Film Industry, by Manjunath Pendakur, 1990

Imitations of Life: A Reader on Film and Television Melodrama, edited by Marcia Landy, 1991

Bertolucci's 1900: A Narrative and Historical Analysis, by Robert Burgoyne, 1991

Hitchcock's Rereleased Films: From Rope to Vertigo, edited by Walter Raubicheck and Walter Srebnick, 1991

Star Texts: Image and Performance in Film and Television, edited by Jeremy G. Butler, 1991

Sex in the Head: Visions of Femininity and Film in D. H. Lawrence, by Linda Ruth Williams, 1993

Dreams of Chaos, Visions of Order: Understanding the American Avant-garde Cinema, by James Peterson, 1994

Full of Secrets: Critical Approaches to Twin Peaks, edited by David Lavery, 1994

The Radical Faces of Godard and Bertolucci, by Yosefa Loshitzky, 1995

The End: Narration and Closure in the Cinema, by Richard Neupert, 1995

German Cinema: Texts in Context, by Marc Silberman, 1995

Cinemas of the Black Diaspora: Diversity, Dependence, and Opposition, edited by Michael T. Martin, 1995

The Cinema of Wim Wenders: Image, Narrative, and the Postmodern Condition, edited by Roger Cook and Gerd Gemünden, 1996

New Latin American Cinema (2 vols.), edited by Michael T. Martin, 1997

For an updated listing of books in this series, visit our Web site at http://wsupress.wayne.edu